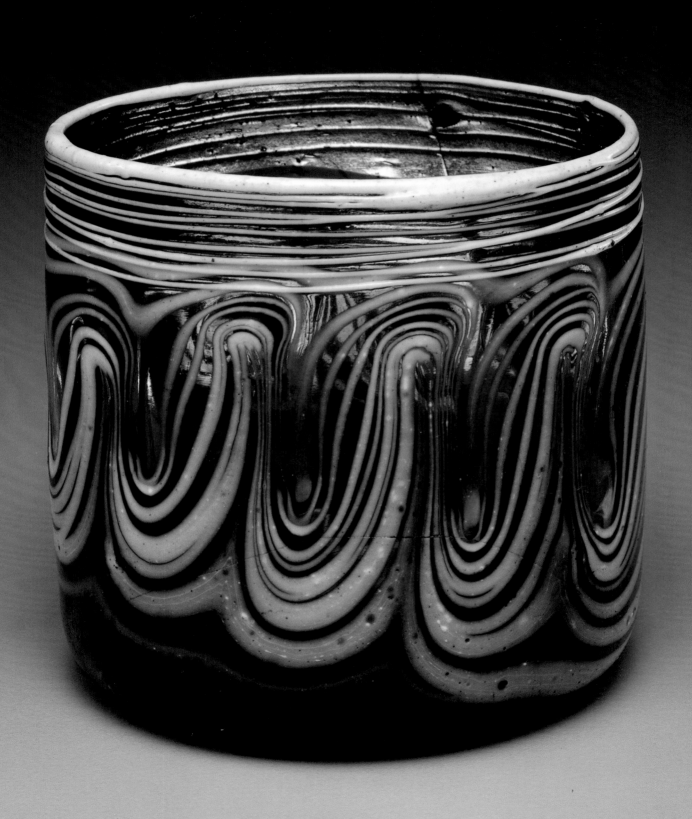

# GLASS FROM ISLAMIC LANDS

STEFANO CARBONI

**Thames & Hudson**

in association with

The al-Sabah Collection

Dar al-Athar al-Islamiyyah, Kuwait National Museum

First published in the United Kingdom in 2001 by Thames & Hudson Ltd,
181A High Holborn, London WC1V 7QX
www.thamesandhudson.com

British Library Cataloguing-in-Publication Data
A catalogue record for this book is available from the British Library

ISBN 0-500-97606-6

Designed by Maggi Smith

Printed and bound in Singapore by C.S. Graphics

# CONTENTS

# PREFACE

## by Sheikh Nasser Sabah al-Ahmad al-Sabah

I BEGAN TO DISCOVER my love of historic art during my schooling in Jerusalem in the 1960s. I was particularly enthralled by the monuments of that ancient city, especially her Islamic monuments, which number in the scores and span the seventh to the twentieth centuries. As part of my own heritage, these filled me with pride and planted a seed of curiosity about the extent of Islamic artistic achievements.

This awakened consciousness found expression in the inception of my collecting of Islamic art objects, in the mid-1970s. From the beginning, I had an urge to share my enthusiasm for these thrilling remains of the past, an urge shared by my wife and eventual director of our museum, Sheikha Hussah Sabah al-Salim al-Sabah. Our efforts culminated in the installation of the Collection in its own building in the Kuwait National Museum Complex, opening in February 1983, where it was housed and exhibited until the Iraqi invasion in 1990. It is a source of real gratification that during that period and since, the Collection has been viewed by scholars and art lovers from all over the world, including the Kuwaiti public, officials and foreign delegations, and has formed the centerpiece for academic conferences, lecture series, and school programs. The Collection was and is of a broad and comprehensive nature, and has continued to be augmented over the years.

My very first Islamic object was a large glass bottle, an intact representative of spectacular Mamluk enameled glass from fourteenth-century Egypt or Syria (cat. 101). Over the decades, we have continued to actively collect Islamic glass, broadening the scope and enhancing the picture of this important and innovative branch of Islamic art. From the early luster-painted, diamond-engraved, and wheel-cut types, through the enameled and gilded Mamluk corpus, and on to the eighteenth- and nineteenth-century wheel-cut, painted, and etched groups of India, Islamic glass affords near-endless interest. The creativity and artistic sensibility incorporated in this colossal body of work bear eloquent witness to the skills of the anonymous craftsmen and to the tastes of their patrons, who ranged from the middle classes through royalty.

With this volume, we are able to share with the art-historical community and the wider public our love of Islamic glass as assembled in the Collection. We do so in the hope that this will stimulate further fruitful research on the part of the former, afford delight to all, and evoke a deeper appreciation of those long passed who were responsible for its creation.

Cat. 99

*This work is dedicated to the memory of my father, Mario.*

# ACKNOWLEDGMENTS

I WOULD FIRST LIKE TO THANK Sheikh Nasser Sabah al-Ahmad al-Sabah and Sheikha Hussah Sabah al-Salim al-Sabah, who form a splendid partnership as collectors and patrons; it is only through their generosity, support, and enthusiasm that I was able to undertake and complete this work. Katie Marsh, the Collection's representative in London, first contacted me with the suggestion that I might be interested in surveying the glass holdings. Manuel Keene, the curator, has been a generous colleague during my numerous visits to Kuwait; he has also contributed to a complex entry (cat. 73). Sue Kaoukji, the extraordinarily able and knowledgeable assistant curator of the Collection, has, in addition to her tireless efforts toward the accuracy of the data incorporated here, made me feel like a part of her family and circle of friends in Kuwait; I cannot thank her enough for her continuous help in all matters, for her friendship, her sense of humor, and her commitment to the Collection. Her husband, Ossama, and their children, Tariq, Dwan, and Nur, made me feel welcome whenever I had the opportunity to see them.

The team of conservators, who always dealt patiently with my many requests and questions and provided answers that are an important part of this work, has been instrumental in the creation of this catalogue; this highly professional group includes Lieve Hibler-Vandenbulcke, Kirsty Norman, Frances Halahan, and Maria Mertzani.

The great efficiency and good humor of Aurora Luis, administrative secretary, and Benjamin Hilario, museum assistant and adjunct conservator, improved the quality and the productivity of my work in Kuwait. I am also grateful to Laila al-Mossawi, the librarian and skilled epigraphist who helped me with several inscriptions, and Muhammad Ali al-Awadi, who photographed all the objects for study purposes. I also want to thank all the drivers, cooks, housekeepers, and others linked to the Collection who made my time in Kuwait free from many everyday concerns.

While in Kuwait, I had the opportunity to meet and befriend many people who were generous and inquisitive hosts on many occasions, including Hussein Afshar, Paula al-Sabah, Lucy Topalian, Aruna and Ghazi Sultan, Farida al-Salim, Tariq and Jihan Rajab, Geza Fehervari, Sandra Shinn and her husband Badr Bu'ayjan, Stefano and Nicoletta Beltrami, Marc and Yasmine Barety, and Jochen Sokoly.

At the Metropolitan Museum of Art, Philippe de Montebello, Director, and Daniel Walker, Patti Cadby Birch Curator in charge of the Department of Islamic Art, generously allowed me to siphon the time and energy away from my demanding job as a curator to work on this publication and embark on numerous trips to Kuwait.

The generosity of Sheikh Nasser and Sheikha Hussah allowed me to work on this publication with a team of experts and colleagues, and I am extremely grateful to everyone involved for contributing in such a professional and generous fashion: Pamela Barr, editor; Ladan Akbarnia, adjunct editor and research assistant; Rochelle Kessler, artist and colleague in the Islamic field; Mark Wypyski, research scientist; Bruce White, photographer; and the staff at Thames and Hudson.

The following individuals were also extremely helpful to me, generously offering their time, advice, and expertise: Qamar Adamjee, Jiayao An, Julia Bailey, George Bass, Marie-Hélène Bayle, Sheila Blair, Robert Brill, Sheila Canby, Annabelle Collinet, Mary Comstock, Jean-François de Laperouse, Layla Diba, Henrietta Eliezer-Brunner, Massumeh Farhad, Marcus Fraser, Deborah Freeman, Donald Frey, Abdallah Ghouchani, Melanie Gibson, Sidney Goldstein, Lisa Golombek, Ernst Grube, William Gudenrath, Oren Gutfeld, Navina Haidar, Jessica Hallett, Rachel Hasson, Angelika Heinrich, Georgina Herrmann, Renata Holod, Akihito Iijima, Anatoliy Ivanov, Gusta Jacobson, Marilyn Jenkins-Madina, Derek Kennet, Dick Keresey, Rochelle Kessler, Tom Knotts, Sandra Knudsen, Linda Komaroff, Stephen Koob, Jens Kröger, Elizabeth Lambourn, In-Sook Lee, Reino Liefkes, Ursula Lienert, Stephen Little, Louise Mackie, Maan Madina, Sophie Makariou, Aygul Malkeyeva, Stephen Markel, Tomoko Masuya, Ken Moore, Mona Mouazzin, Sultan Muhaysin, Muhammad Muslim, Bernard O'Kane, Jutta-Annette Page, Lisa Pilosi, Venetia Porter, Maria Queiroz Ribeiro, William Robinson, Yoko Shindo, Marianne Shreve Simpson, Dylan Smith, Priscilla Soucek, Laure Soustiel, Hugh Tait, Jill Thomas-Clark, Antoine Touma, Marco Verità, Kjeld von Folsach, Rachel Ward, Oliver Watson, David Whitehouse, and Patricia Whitesides.

Finally, I cannot thank my wife, Maria Yakimov, enough for enduring my long days at work for the past few years and for understanding how important this project is to me. She listened, advised, read drafts, and never complained. If I cannot give her back the time we could have spent together, I at least know that she now has a great appreciation for glass, one more aspect of life we can share.

# INTRODUCTION

IN 1994, when I was asked to survey the glass holdings of the al-Sabah Collection and write a proposal for a publication on the subject, the holdings comprised about 150 inventoried items as well as the Islamic glass collection of the late Ernst Kofler, acquired shortly before the invasion of Kuwait in 1990. At the time, I was captivated by both the geographical and the chronological range of the holdings and arranged, with the Collection, to research and publish the entire collection of complete or nearly complete objects and a representative selection of the many fragments formerly belonging to Mr. Kofler. I did not, however, take into account Sheikh Nasser al-Sabah's enthusiasm for collecting glass. Thus, the Collection has grown steadily and impressively, to my delight, while the concept behind the catalogue has remained much the same. The result is this weighty publication that includes virtually all the holdings of glass as we go to press.

A select number of objects that deserve closer attention are studied and discussed in extensive entries that include an attribution, a description, notes, comparative material, and an illustration. This comprehensiveness is satisfactory for two reasons. The first concerns the paucity of publications devoted to glass from the Islamic lands in general and, in particular, to entire collections. Usually, only the most representative works in a given collection are published—again and again—while the rest of the objects remain known to only the few specialists who have physical access to them. A comprehensive publication that discusses both the most meaningful objects as well as those of lesser quality is, therefore, a useful reference tool.

Second, the great variety of techniques and decoration and the wide range of works in the Collection allow for a more complex approach than that adopted by most authors. Although the layout of this publication reflects its primary function as a descriptive catalogue of the glass in the al-Sabah Collection, the underlying intention is to provide a better understanding of Islamic glass in general—in the framework of both the Islamic artistic vocabulary and of glass production before the advent of Islam and beyond the Islamic world. Unfortunately, our current understanding of this subject has far too many gaps. Glass objects rarely bear inscriptions providing vital information; in addition, glass was shipped long distances and was often discarded or reused as cullet. These factors make the study of Islamic glass more complex and difficult than that of other media, and it is only

through the concerted effort of art historians, archaeologists, and specialists in Arabic and Persian literature that progress can be made.[1] The time for a manual on Islamic glass has, therefore, not yet arrived, but I trust that catalogues such as this one represent a step in the right direction.

One subject that I intended to research when I began this project was the original Arabic and Persian sources, which I hoped would be decisive in identifying shapes, decoration, and other useful details. However, a survey of the sources published by Carl Johan Lamm[2]—perhaps his greatest contribution to the field of Islamic glass, without diminishing the importance of the remainder of his work—convinced me that the effort required would not have produced the desired results. Detailed texts on glassmaking may lie undisclosed in libraries in the Arabic and Persian world, yet known sources have been useful only in identifying glassmaking centers and in understanding the importance of glass as a trade commodity and in society; they almost never identify specific objects, techniques, raw materials, decorative typologies, artists, or patrons. The discovery of new sources will require more patience and time than were at hand during the preparation of this complex catalogue.

I have met with many helpful curators and scholars and researched many glass collections. The only institution with major glass holdings that was not taken into account in the preparation of this publication (except for a few published objects) is the Nasser D. Khalili collection of Islamic Art, London, since its glass catalogue is being compiled at the same time as the present one. I hope the two works will complement and support each other rather than provide differing attributions and conclusions. It goes without saying that all errors, omissions, and inaccuracies, which I hope my readers will dutifully report, are solely my responsibility.

## The Catalogue

The catalogue is broadly divided into five chapters, each organized chronologically. The first and last chapters have a general chronological scheme and represent, respectively, the first two centuries of the Islamic era, when glassmaking was influenced by earlier traditions (the so-called transitional period), and post-sixteenth-century Islamic works. The three central chapters deal with techniques of glass production and include works ranging from the eighth to the fourteenth century. This broad division is

necessary, since precise attributions are often too tentative, given the present state of research, but the physical description of the objects and the comparative discussion of technical details and shapes will be useful in compiling data for future reference. Nonetheless, chronological distinctions are possible within groups of different types of glass. For instance, stained (or luster-painted) and cold-cut glass flourished only in the early Islamic period (Chapter 2), while enameled and gilded glass was made only in Syria and Egypt in the thirteenth and fourteenth centuries (Chapter 4). The majority of glass from the Islamic lands, however, was produced in a vast area and over a long period: Chapter 3 is, consequently, entitled "Continuity Over Time" and includes five subchapters devoted, respectively, to undecorated blown glass and to glass with applied, molded, impressed, and marvered decoration. An introduction precedes each chapter and subchapter.

## Catalogue Numbers

The catalogue includes a total of 108 **primary** and 127 **secondary entries**, many of which are multiple (indicated in lowercase letters following the number; for example, cat. 9a–d includes four objects). The primary entries cover a selection of 311 objects and fragments that, because of their artistic significance, deserve closer attention and fuller discussion. The secondary entries include an image, a physical description of the object, and, when necessary, critical or bibliographical notes; there is no discussion. The primary entries are numbered consecutively 1 through 108; the secondary entries are distinguished by the number of the chapter to which they belong, followed by a period and a consecutive number. Thus, cat. 1 is the first primary entry in the catalogue; cat. 1.1 is the first secondary entry in Chapter 1; and cat. 2.1 is the first secondary entry in Chapter 2. The total number of objects included in the catalogue is difficult to determine precisely, since it includes fragments (especially in Chapters 2 and 4) and groupings (for example, cat. 1.13a consists of sixteen gaming pieces). As we go to press, the Collection includes some seven hundred inventory numbers (LNS 1–444 G, LNS 1058–1076 G, LNS 1374–1407 G, and LNS 1–223 KG). An effort was made to publish the entire glass collection, excepting those objects that do not belong to the Islamic area or period (pre-Islamic Egyptian and Roman, modern); numerous fragments; a few seals, weights, jewels, and spindle whorls; rock-crystal and other stone objects; reworked pieces of little significance; and, finally, objects that were acquired too recently to be included here. The table of concordance, organized by inventory number, contains the objects excluded from the catalogue and explains why they were omitted.

## General Information

Each object is identified by its **title**, **inventory number**, attribution to a **geographical area**, and **date**. The title refers to the object's shape (bowl, beaker, fragment, and so forth), insofar as the English language distinguishes between such forms.

Given the difficulty of suggesting precise geographical or dynastic places of production, the Islamic world has been divided into broad areas that correspond to diversified glassmaking traditions from a historical standpoint. All the objects in the catalogue, therefore, are assigned to either the Egyptian, Syrian, Mesopotamian, Iranian, Central Asian, Indian, or Turkish areas, in addition to a few European works made for the Indian market (Chapter 5). Most areas are well defined (for example, Mesopotamia corresponds roughly to modern Iraq; Central Asia includes the modern ex-Soviet republics in addition to Afghanistan). The only problematic region, called simply "Syrian," corresponds to the eastern Mediterranean area of the former Roman provinces (modern Lebanon, Israel, Palestine, Syria, and Jordan). This region was central to the Islamic world for a long time, with Damascus a recognized center of glass production; consequently, an "eastern Mediterranean" attribution seemed somewhat belittling.

The same broad distinction is necessary for chronological attributions, which often span two centuries, especially in the early Islamic period, and can seldom be more precise. Entries throughout chapters and subchapters are nevertheless organized in chronological order, since the chronology of Islamic glass is presently better understood than its geographical origins.

## Detailed Information and Physical Description

This section, which is common to all entries, includes **dimensions**, **color(s)**, **techniques**, **description**, and present **condition**.

Following the common linear dimensions (maximum height [hgt.] and diameter [diam.] of objects, width [w.] and length [l.] of fragments), which are given in centimeters, are measurements of the thickness (th.), weight (wt.), and capacity (cap.) of a vessel. The thickness is estimated in most cases, since an intact or complete object can be measured with a caliper only at its rim, which is invariably thicker than its walls. This dimension is, however, useful in understanding how extensively and skillfully the parison was blown on the pipe. As a general rule, those vessels with walls less than 0.20 centimeters thick are finely blown, those between 0.20 and 0.40 centimeters are average, and those above 0.40 centimeters are solid and heavy.

The weight, given in grams, is the product of size, thickness, and chemical components of the glass. Although figures are exact and consistent, since all vessels were weighed on the same

electronic scale, the weight can be entirely accurate only when an object is intact and the surface is in good condition. Heavy weathering, breakage, repair with fills, or fragmentation inevitably alters the weight. This figure, which is not often included in the case of glass vessels, helps understand the appearance of an object.

The basic function of any blown-glass vessel is to contain liquids—from water to wine, perfume to oil. Industrially produced containers today hold a fixed amount of liquid (for example, a can of Coca-Cola contains twelve ounces, a wine bottle 750 milliliters). In the Islamic world there were comparable general, though less precise, rules. For this reason, the capacity of a vessel is important information. Since, for conservation reasons, it is not possible to put ancient glass in contact with liquids, each object was filled, depending on its size and the diameter of its neck, with either rice, lentils, sesame seeds, or white bauxilite micropowder (an inert glassy powder that does not damage the glass surface) and the mass was then "translated" into a measure of capacity given in milliliters. The result is not as accurate as a measurement with liquids, but it is consistent and acceptable. Small seeds were apparently first used to measure the capacity of fragile objects in 1637, when the method was established to verify the capacity of the Portland Vase (now in the British Museum) using millet seeds at the suggestion of Nicolas-Claude Fabri de Peiresc.[3]

Describing glass color is a tricky business, mainly because glass is translucent. The color of the final product depends not only on the chemical components mixed in the batch but also on the type of manipulation to which it is subjected. For example, a dark green batch of glass will remain dark green if the vessel has thick walls, but it will become progressively paler if the vessel is blown, diminishing its thickness. Consequently, greenish colorless, pale green, green, and dark green vessels could, in theory, all originate from the same dark green batch that was blown and manipulated differently. In addition, the color of the same vessel may vary in appearance when viewed under reflected or through transmitted light, and the intensity and type of the light source also affect how it appears to the eye. In the case of ancient glass, the weathering of the surface can also dramatically influence the understanding of the color. For these reasons, no tables (such as, for example, those in *The Munsell Book of Color* for opaque pigments[4]) are available for glass colors, and their description has, until now, depended entirely on the viewer's perception. In this subjective case it is, of course, essential that all objects be examined under the same source of light (transmitted or reflected). In an effort to be more scientific, we decided to take the unprecedented step of presenting a table of glass colors consisting of details of objects in the Collection photographed with a macrolens in a darkened room under a halogen light source. The light was transmitted through the glass, which was partially covered with tracing paper, illuminating only the area to be photographed, and all surrounding areas were blocked off with black paper. Nineteen representative objects were chosen to indicate selected degrees of color intensity (six degrees of green, four of blue, three of yellow or brown, two of purple, and four of colorless glass with a slight tinge), roughly covering the range of Islamic glass. The photographs were taken in Kuwait by conservator Lieve Hibler-Vandenbulcke. We hope that this method, though imperfect, represents a step toward a less subjective description of the colors of glass.

The technique section provides a concise explanation of how the object was blown (free or mold blown), which method of decoration was used (for example, applied, impressed, enameled, gilded, and so forth), and whether a pontil was utilized to manipulate the vessel during the decorative process. (The pontil is a metal rod attached to the base of the object when the blowpipe is cut off from its opening.)

The description of each object is narrative. As a general rule, the shape of the vessel (in order: body, base, and neck) is given first, followed by a description of the decoration. Other details follow as necessary.

The condition is related to the physical appearance of the object in addition to the quality of the glass. Four basic distinctions are made with regard to the vessel's completeness. Thus, it can be intact; complete (broken or cracked and repaired; all its parts survive); broken and repaired (a high percentage of the original vessel survives; all or most missing parts are replaced); or fragmentary (little of the original vessel survives). If the subject of an entry is a fragment—that is, an object that does not allow for a reconstruction of the shape of the original vessel—this is indicated in the title.

The surface condition is deeply affected by weathering, principally due to prolonged burial. A humid environment slowly attacks the glass surface, "eating" away at it until the object crumbles. Depending on the length of burial, the type of soil, and the chemical composition of the glass, the surface can present a milky white film, an opaque coating of different colors, pitting, iridescence, and combinations thereof.[5] The catalogue indicates the extent of weathering and the resulting physical effect on the surface.

Finally, Islamic glass almost invariably presents bubbles of varying dimensions, either circular or elongated (the latter due to manipulation). Their occurrence is indicated, together with possible foreign inclusions (for example, minute pebbles that did not fuse) and streaks of differently colored glass in the batch.

## Provenance and Literature

Whenever known, the provenance of an object prior to its acquisition is indicated. This description may include a former owner (for example, all the vessels inventoried as "KG," or Kofler glass, were acquired from the late Swiss collector Ernst Kofler), hearsay origin, place of earliest acquisition when it comes from a reliable source, and/or the auction sale where it was purchased.

If the object is published—that is, at least a photograph and a description have appeared in print (with the exclusion of auction catalogues)—this information follows the provenance, in chronological order in the case of multiple publications.

## Related Works

This section, together with the discussion that follows it, is found in only the 108 primary entries. It includes a list of objects, numbered consecutively, that represent relevant parallels for the object, or group of objects, discussed in the entry. The list is arranged according to the collections, either public or private, that house these comparative pieces; multiple objects in a single collection are identified by their inventory numbers. An inventory number is indicated for every object except in several cases when it was impossible to obtain this information. The location of each object is followed by the publication(s) in which it has appeared. Priority was given to pieces in public and private collections that have been published; in a few cases, unpublished objects were too relevant to be excluded. As a general rule, works published in auction catalogues—the whereabouts of which are therefore usually unknown—have not been included as Related Works.

## Chemical Analysis

Twenty-four objects were chosen because they are of special interest or have a problematic attribution. The results of EDS analyses (energy dispersive X-ray spectrometry) attached to a scanning electron microscope (SEM), performed by Mark Wypyski of the Department of Objects Conservation at the Metropolitan Museum of Art, are published under the individual entries and discussed in the text. These analyses are principally intended to confirm, or challenge, my attributions. Wypyski's findings and final report, which are supportive of most attributions, are integrated throughout the entries as part of the discussion.

Samples of material found inside a few vessels were analyzed in different laboratories in England under the conservators' supervision in the hopes of determining their content and, therefore, their function. In two cases, analyses revealed kohl and yellow orpiment (see cat. 2.27, 2.28j).

## Photographs and Drawings

Every object and fragment discussed in the catalogue is published in color. Sometimes, several views were necessary to provide a better understanding of the work. Since many entries are multiple, a single image often includes several objects, encouraging an understanding of comparative proportions. All photographs were taken in Kuwait by Bruce White.

A photograph—even with multiple views—cannot, in some cases, identify details of the decoration, which can be rendered only in a drawing. The drawings throughout the catalogue are by Rochelle Kessler.

## NOTES

1 On the study of Islamic glass, see Carboni 1999, pp. 169–70.

2 Lamm 1929–30, pp. 484–521.

3 See Jaffé 1989.

4 The tables of the American painter Albert Henry Munsell (1858–1918) are generally considered the most successful attempt at constructing a color system that provides standard samples while also taking into account the perceived affinity of colors (Munsell 1929).

5 In particular, iridescence has often fascinated collectors in the past, since this quality "enhances" the aesthetic appearance of a vessel. The idea behind Tiffany's Favrile glass, for example, was based on this concept. Of course, an iridescent effect was never intended by glassmakers of the past.

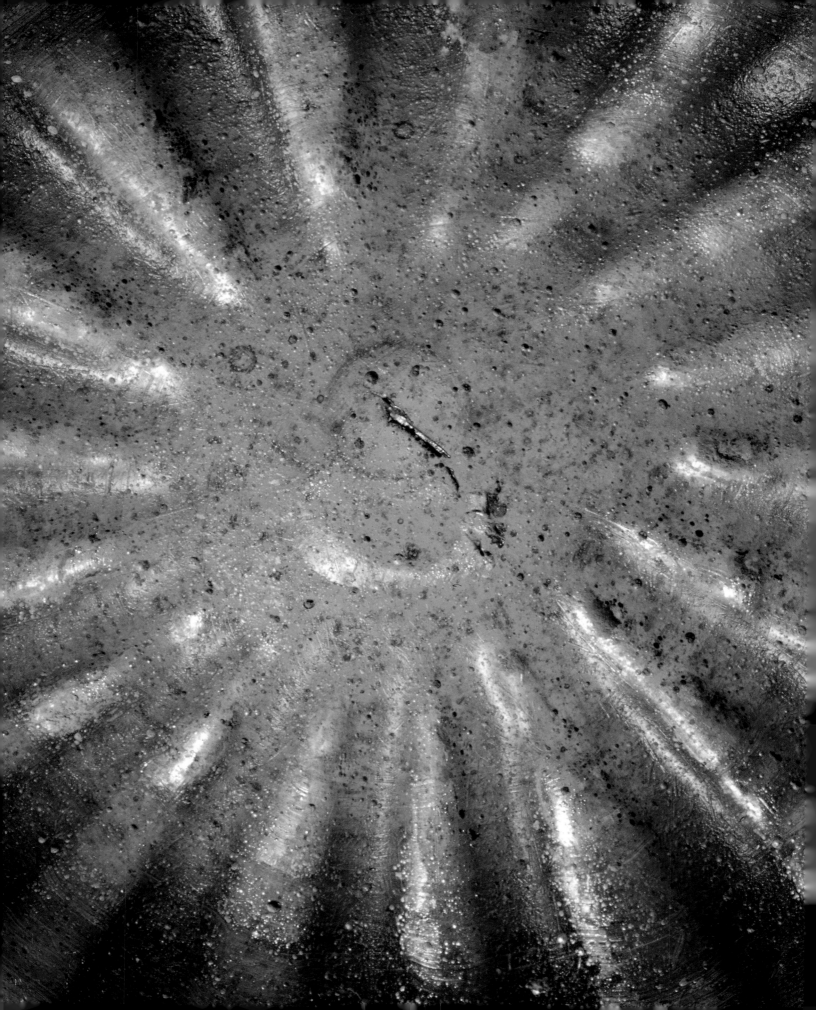

# 1

# A TRANSITIONAL PERIOD:
# THE LEGACY OF ROMAN AND SASANIAN GLASS

### (ca. late 6th to early 10th century)

THE HISTORY OF ISLAMIC ART of the early period can be divided into two broad phases. The watershed is represented by the foundation of Samarra, the 'Abbasid capital for about fifty years during the mid-ninth century, and by the birth of a new artistic language that would become widespread in the rest of the Islamic world. Art under the Umayyads and during the first century of the 'Abbasids was indebted to the traditions that existed and survived in the area from late Antiquity and struggled to find its own identity until the ninth century.

The development from the pre-Islamic period to the middle of the ninth century is clear in architecture and in architectural decoration, including works in stone, plaster, and wood. It is less clear, though still recognizable, in other media, such as metalwork and pottery. With glass, however, the separation between the late antique and the early Islamic eras becomes blurred and attributions to one period or another are difficult.

The scenario of unnoticeable changes in glass production between the fifth and eighth centuries is seemingly supported by the absence of objects with molded inscriptions in Arabic, which would indicate that glass was granted an official status as one of the products made for the new Umayyad rulers and their supporters. Yet the surviving glass objects from this period point to an industry that persisted and thrived at some distance from the main centers of power and almost in spite of the new rulers. Indeed, the enormous political changes that occurred shortly after the death of the Prophet Muhammad did not necessarily disrupt the quiet life of the glassmakers who had been blowing glass in their workshops along the eastern Mediterranean coast and in Egypt for more than six centuries before the advent of Islam and the arrival of the new rulers.[1] In addition, it is impossible to know whether a significant number of glassmakers converted to Islam early or, since glassmaking was mainly a prerogative of Jewish artisans, not at all.[2]

It would be unfair to say *tout court* that the Umayyad rulers and the affluent people of the time did not sponsor glassmaking in the Near East on the basis of the diffusion of glassblowing and the consequent paucity of high-quality glass after the crumbling of the Roman Empire. It is, however, undeniable that the spread of the glassblowing technique, which represented a major revolution in a formerly time-consuming and often difficult technology, allowed glass to become more accessible for everyday use and thus made it less attractive to affluent patrons of the time.

It is within this perspective that the production of glass just before and after the advent of Islam must be understood. There is no real reason to enforce a separation between the two eras, though it is difficult to escape established classifications such as "late Roman," "late antique," "eastern Mediterranean," "early Islamic," and so forth. A few of the glass objects included in this chapter are attributed to a period that spans late Antiquity and early Islam. In order to solve the dilemma of proper classification, this period can perhaps be defined as "proto-Islamic," since the objects it includes carry over pre-Islamic shapes and techniques into the Islamic period and slowly develop them into recognizable Islamic forms.

Two broad groups can be identified that developed from diverse traditions. The first, and by far the larger, includes the glass products that represent a direct continuation of the great Roman legacy. The second group was influenced by the Sasanian artistic tradition in Mesopotamia and Iran.

Late Roman glass made along the coasts of modern Syria, Lebanon, Israel, and Egypt is usually classified as "eastern Mediterranean." This term designates those Roman provinces that belonged to the eastern expansion of the empire and contributed an artistic glass production that differed from that in Italy or northern Europe. The term cannot be used to describe any of the

Cat. 3 detail of base

objects made in these lands after the Umayyads came to power and named Damascus their capital, since the implication of "provincial" was then lost, the region having become the very center of the Umayyad Empire.

Characteristic of this eastern Mediterranean production, which continued into the early Islamic period, are cat. 1–7 and 1.1–1.14. The most prominent feature is the decoration of the basic shapes of these functional objects—vase, goblet, bottle, bowl —with applied trails that could be pulled either from the same glass batch as the blown vessel and are thus the same color (cat. 2a, 1.6) or from a different batch and in a contrasting color, usually darker than the vessel they decorate (cat. 1, 1.7). Applied trails of a different color represented a decorative element but were often also used for the functional applied components of the vessel, such as handles and feet; commonly, the differently colored trail was patterned in zigzags or simple spirals around the neck and body (cat. 1, 1.6, 1.7b). When trails of the same color were utilized, the decorator required more creativity to create a final, appealing product. Thus, the trails were manipulated with a pointed tool or a fine pincer after they were applied to the vessel. The bottle and the goblet (cat. 2a, b)—the latter an especially successful piece, as it includes trails of two colors—are good examples of such manipulation, in which a simple trail around the body of the vessel was turned into a festoon or a series of arches. This type of decoration was sometimes pulled into the so-called spectacle pattern.

A peculiar object produced in the proto-Islamic period is the cage flask (cat. 4). Here, the trailing in different colors, built around the vessel and rising from its footed support, is three-dimensional and is part of the structure of the object itself rather than its decoration. While weathering, due to burial, often prevents a full appreciation of the chromatic as well as the sculptural appeal of these cage flasks, many have survived in excellent condition and still convey a playful charm.

Plastic decoration also includes patches of glass of different shapes applied at regular intervals to the surface of the vessel (cat. 5, 6). Globular bottles and vases, small flasks, and ewers (cat. 6) were the favored shapes during the Islamic period. The decorative patches took either regular circular forms (discs, roundels, ovals, prunts; see cat. 5, 6, 1.9, 1.10) or irregular geometrical shapes (triangles, six-pointed stars, composite figures; see cat. 5, 6, 1.8, 1.11) that have sometimes been interpreted as animal hides (cat. 5) or masks (cat. 1.11). The majority of such vessels were decorated with patches of the same color, since their shape and distribution on the surface would be sufficient to emphasize the ornamental pattern. But some exceptions, such as cat. 1.8, demonstrate that bichromatism also had some appeal.

Molded glass represented an important part of the late Roman production in the eastern Mediterranean as well. It seems, however, that few patterns of molded glass enjoyed popularity in the proto-Islamic period. Of these, vertical ribbing, often finished with a twist outside the mold to obtain a swirling effect, was certainly the most widespread. Cat. 3 is a classic example of a thick vertical-ribbed bowl that was made, with few changes, for several centuries. Glass of bright deep colors, such as emerald green or cobalt blue, was often chosen to produce richer vessels.

Within a different time frame but certainly relevant to this chapter are the mosaic millefiori objects (cat. 7, 1.13, 1.14). Rather than representing a development over time, millefiori glass tells of a revival throughout the millennia. Its Islamic manifestation, conceivably limited to ninth-century Mesopotamia and Syria at the height of ʿAbbasid power, happens to follow its Roman phase of the second century B.C. to the first century A.D. The Roman legacy in Islamic millefiori production can therefore be explained as an imitation and duplication of a technique that had been forgotten for centuries. Islamic millefiori never attained the popularity of its earlier counterpart and never matched its exquisite technical achievements. Nevertheless, the manufacture of glass canes represented a remarkable accomplishment, since the tradition had been interrupted and every phase had to be reconstructed on an experimental basis. The most spectacular Islamic objects must have been the large tiles used for the floors of a palace in Samarra, fragments of which survive. Some average-sized shallow bowls are probably the best technical achievement (the fragment, cat. 1.14, is perhaps related to this group) while the majority of surviving millefiori is represented by diminutive shallow plates or bowls of uncertain function (cat. 7a, b) and, especially, by gaming pieces (cat. 1.13).

The second group of objects, which developed from a different tradition, consists of glass that was produced in the Iranian or Mesopotamian areas from the eighth to the tenth century using a facet-cut decoration—that is, a decoration created by grinding the curved surface of the glass vessel with slightly convex cutting wheels to produce areas that are flat or somewhat concave (cat. 8, 9, 1.15–1.17). These facets are invariably circular or oval on Islamic vessels.[3] When the circular cuts are particularly deep and overlap (cat. 9a), the overall decorative effect is a "honeycomb" pattern. The decoration is sometimes called a "quincunx" pattern if the round facets are contiguous but do not overlap (cat. 9b).[4] The inspiration for these objects came from the late Sasanian tradition.

At present, there appears to be a gap of about two hundred years—from the sixth to the eighth century—during which facet-cut decoration was not produced in Islamic lands. It is more likely,

however, that its manufacture continued uninterrupted and that its chronology has not been properly understood. While scholars are presently aware of the beginning and the end of production, represented by hemispherical bowls in the Sasanian period and by long-necked globular bottles in the ninth and tenth centuries (cat. 9), the possibility exists that almost unnoticeable but steady changes also occurred in the Irano-Mesopotamian area during the proto-Islamic period.

Glass production in the Sasanian period took place in both the Mesopotamian and the western Iranian regions, as confirmed by numerous excavations.[5] These two areas, whose glass products were more distinctive during the early Islamic period, shared many aspects relating to facet-cut glass during the Sasanian era and thus may be studied together in this regard.

Glass cutting and engraving were also popular for high-quality objects during the Roman Empire, when these practices developed in Europe, especially in Italy, rather than in the eastern Mediterranean. The role of Roman glass cutting in the making of Sasanian glass has yet to be fully established, but it was at least as relevant as the earlier local Iranian tradition from the Achaemenid period. Bowls and cups with facet-cut decoration produced in Europe in the first and second centuries have also been found in the Mediterranean area,[6] but scholars usually regard them as coming from western Syria or Egypt.[7] The same tradition, though producing inferior works, continued in eastern Syria, where it probably met with the former Achaemenid heritage and inspired Sasanian production, which was destined to become celebrated and exported as far as Japan.

**Cat. 1 PITCHER (LNS 258 G)**
**Syrian region**
**6th–7th century**

Dimensions: hgt. 10.4 cm; max. diam. 5.2 cm;
th. 0.2 cm; wt. 57 g; cap. 80 ml

Color: Translucent pale green (green 1)
with applied greenish blue (blue 3)

Technique: Free blown; tooled; applied;
worked on the pontil

Description: After the pale green parison was blown,
the neck of this globular vessel was
tooled and the mouth was shaped into
a trefoil opening; the central lobe
functioned as the spout. A roundel of
blue glass was applied to the opposite
end to provide the base. A handle in
blue glass, containing inclusions of
reddish glass, was attached to the rim,
curved, and then pulled to join the
shoulder. The decoration consists of
a single blue trail applied in a zigzag
pattern just below the rim and then
turned into a spiraling pattern around
the neck, ending at the base of the
neck. The body was left undecorated.

Condition: The object is intact. The surface is
lightly weathered, resulting in a milky
white film and iridescence. The glass
includes frequent small bubbles.

Provenance: Kofler collection; gift to the Collection

Related Works: 1. Oppenländer collection, inv. nos.
2235, 2240, 2370 (von Saldern et al.
1974, nos. 669, 671, 682)

2. Private collections
(Lucerne 1981, nos. 440–43)

3. Kyŏngju National Museum, Kyŏngju
City, South Korea, inv. no. 123
(*Korea National Museums* 1989,
no. 25)

This pitcher is probably the most "Roman-looking" of this group and may have been produced before the advent of Islam. It does not, however, correspond precisely to similar objects usually attributed to the fourth- or fifth-century eastern Mediterranean world of late Antiquity (see Related Works 1–3). Individual features, such as the trefoil mouth, the spiraling, the zigzag decoration in a different, darker color, and the applied foot and handle, were common in pre-Islamic Syria, though their combination in a single vessel probably dates this pitcher later and much closer to, if not within, the Islamic period. The high curve of the handle, the globular body, and the presence of the pontil mark under the base also point to late Antiquity or the early Islamic period. Fourth- and fifth-century Roman examples usually show a lower curve of the handle, which is often bent sharply to form an L-shape. In addition, the body tends to be piriform rather than globular. The use of the pontil for tooling and decorating glass objects seems to have become more common in the Syrian region about the time of the Muslim invasion, while its absence would certainly indicate a pre-Islamic dating.

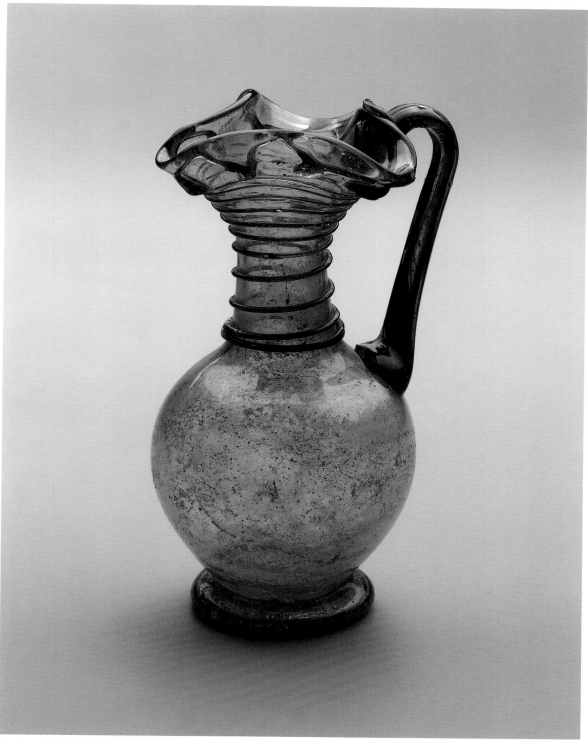

Cat. 1

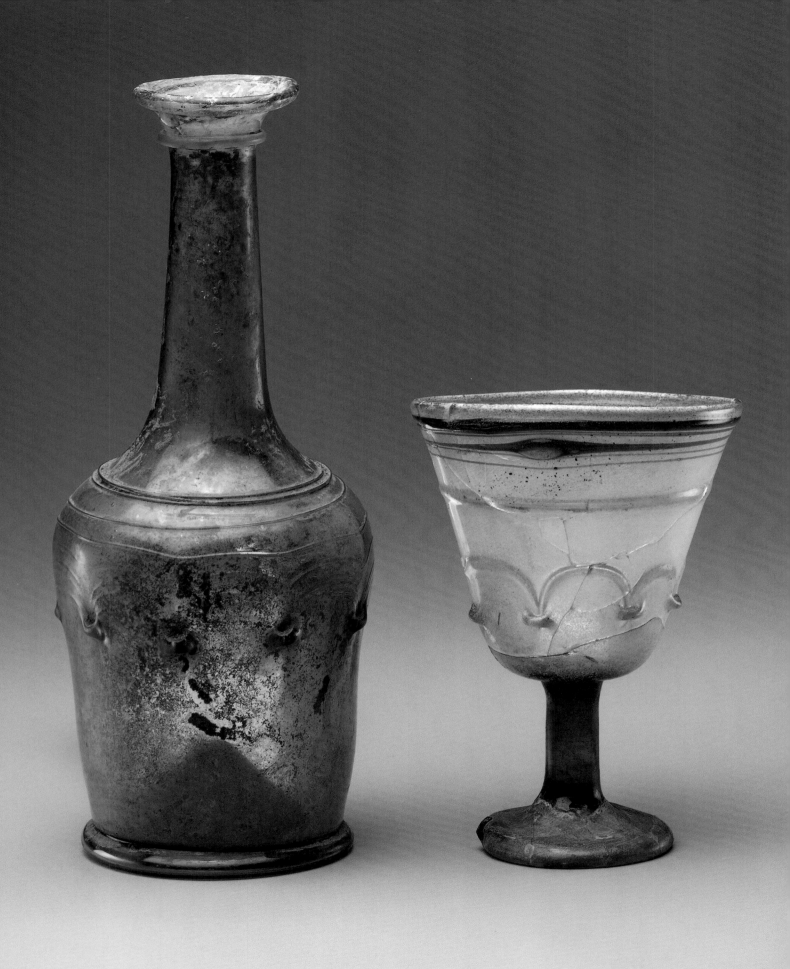

**Cat. 2a BOTTLE (LNS 324 G)**
**Probably Egyptian region**
**6th–8th century**

Dimensions: hgt. 19.5 cm; max. diam. 7.9 cm;
th. 0.21 cm; wt. 112 g; cap. 350 ml
Color: Translucent olive green (green 2)
Technique: Free blown; tooled; applied;
worked on the pontil
Description: The body was tooled into a cylindrical,
slightly flared shape; the neck is slightly
tapered and ends in a splayed mouth.
The base was applied. A thick glass
trail from the same batch was applied
under the mouth; a much thinner trail
of the same color was applied at the
shoulder and tooled into a spiral
around the body. The spiral decoration
at the center of the body was turned
into a festooned pattern of nine
consecutive arches by dragging it
downward with a sharp point into the
molten glass at regular intervals, thus
attaining the base of each arch, which
also protrudes in low relief. The base
presents a deep conical kick made
with the pontil.
Condition: The object is intact. The surface is
partially weathered, resulting in a pale
brown coating, especially inside the
neck. The glass includes scattered
small bubbles.
Provenance: Reportedly from Mardha, Syria

**Cat. 2b GOBLET (LNS 85 G)**
**Probably Egyptian region**
**7th–8th century**

Dimensions: hgt. 11.2 cm; max. diam. 8.5 cm;
th. 0.23 cm; wt. 68.7 g; cap. 176 ml
Color: Translucent pale green (green 1)
with applied dark blue (blue 4)
Technique: Free blown; tooled; applied;
worked on the pontil
Description: The cup was shaped into a cone with a
rounded base. The stem and foot were
applied to the bottom of the cup and
the edge of the foot was bent down, so
that the goblet stands on the rim of the
foot ring. A dark blue trail was applied
and tooled into a spiral below the
mouth. A pale green trail the same
color as the goblet was applied and
pushed into the glass under the blue
spiral decoration. A second pale green
trail was applied under the first one
and turned into a festooned pattern of
seven consecutive arches in the same
manner as the decoration of cat. 2a.
An unwanted drop of dark blue glass
is visible on the foot.
Condition: The object was broken and repaired;
it is almost complete except for a few
small fills. The surface is lightly
weathered, resulting in a milky white
film. The glass is of good quality and
includes small bubbles.

Literature: Keene 1984, no. 31; and Atıl 1990,
no. 12
Related Works: 1. CMG, inv. no. 55.1.97
(Smith 1957, no. 425)
2. V&A, inv. nos. C164-1932,
C172-1932, C58-1960
3. Oppenländer collection, inv. no. 2593
(von Saldern et al. 1974, no. 716)
4. Kelsey, inv. no. 69.3.37
(Soucek 1978, no. 34)
5. Sylvia and Sol Ivrey collection,
inv. no. AG13 (Higashi 1991, no. 48)
6. MMA, inv. nos. X.21.210, 17.194.291,
65.173.1 (Jenkins 1986, nos. 8, 9, 16);
40.170.451 (Kröger 1995, no. 151)
7. Private collection
(Ohm 1975, no. E26)
8. NM, Damascus, inv. no. 16032
(Damascus 1964, no. 182)

These two vessels share the peculiar decoration of a festooned pattern created from an applied trail that was reworked with a pointed tool or a pincer. This type of decoration was used continuously from the late Roman phase of the fourth and fifth centuries (Related Works 1, 3, 5) and survived into the Islamic period in the Egyptian region until the eighth century (Related Work 4). Sometimes, the same decorative technique was used to originate the so-called spectacle pattern, in which the trails were joined in the center at regular intervals instead of being dragged down as in this case, so that the pattern would appear to be a series of spectacle-like ovals. Two bottles in the Metropolitan Museum of Art (Related Work 6, inv. nos. X.21.210, 17.194.291) present either a festooned or a spectacle pattern, but the absence of a pontil mark suggests they belong to the pre-Islamic period.[8] The two patterns, especially the spectacle, became popular in the Islamic world; similar fragments of a tall beaker were unearthed at Fustat, in Egypt, and traveled all the way to eastern Iran to reach Nishapur (Related Work 6, inv. no. 40.170.451).[9] The bottle seems to be closer to Roman models and is probably earlier than the goblet, perhaps dating even before the advent of Islam. The goblet has a more "Islamic" look, since its shape was fairly widespread in the central Islamic lands until the eighth to ninth century (see Related Works 2 [inv. no. C172-1932], 6 [inv. nos. 65.173.1, 40.170.451], 7, and 8). This peculiar decorative technique was probably the prerogative of a limited number of glass factories in a relatively small geographical area. The great majority of objects of this type are said to have come from Egypt,[10] and the beaker found at Fustat seems to confirm the hypothesis of an Egyptian origin for the group. The isolated fragment excavated at Nishapur should probably be regarded as an import from Egypt to the east, part of the extensive glass trade from the western Islamic lands to eastern Asia.

**Cat. 3 BOWL (LNS 127 G)**
**Probably Syrian region**
**7th–8th century**

Dimensions: hgt. 4.0 cm; max. diam. 9.4 cm;
th. 0.7 cm; wt. ca. 250 g; cap. 160 ml

Color: Translucent dark bright green (green 6)

Technique: Mold blown; tooled;
worked on the pontil

Description: The parison was blown in a one-part
cylindrical mold formed by seventeen
vertical sunken ribs. The pontil was
applied in the center of the base and
pushed inward, so that the bowl
actually rests on the protruding ribs
rather than on the base, which is
slightly kicked. The ribs are interrupted
at about 1 cm below the thick rim,
which was ground and polished.

Condition: The object is intact. The surface is
partially weathered, resulting in pale
brown pitting, some iridescence
(especially inside the cup), and slight
corrosion. The glass includes frequent
small bubbles, one large bubble at the
base, and some dark streaks.

Provenance: Sotheby's, London, sale, April 18, 1984,
lot 335

Literature: Qaddumi 1987, p. 104; and Atıl 1990,
no. 14

Related Works: 1. CMG, inv. no. 54.1.108
2. Art Institute, Chicago
(Lamm 1939, pl. 1443a)
3. NM, Stockholm
(Lamm 1935, pl. 18b)

Mold-blown ribbed bowls were commonly produced in first- and second-century glassmaking centers scattered throughout the Roman Empire. They were usually made in pale colors or in green or blue glass and their shape differed from that of the present bowl, the walls being more rounded and the mouth longer and straight or, sometimes, slightly splayed.[11] The shape was perhaps taken up by the Sasanians in the fifth or sixth century, since excavations at Kish have revealed similar fragments that appear to have been produced locally.[12] In the Islamic period, these bowls assumed the shape of a low cylindrical vessel with a straight rim, and the ribs were often twisted to obtain a more artistic effect. A bowl in Corning (Related Work 1) is virtually identical to the present example in color and in number of ribs (seventeen), which suggests that the same mold was used for both vessels, though the ribs of the Corning bowl were subsequently tooled and twisted.

Such bowls are usually regarded as Iranian, following Lamm.[13] Since some examples were found in that region and traveled as far as Afrasiyab (Samarqand), where a twisted-rib type was discovered, this hypothesis is valid.[14] The present bowl, however, seems to be closer to Roman prototypes than the objects reported to come from Iran, both because of the thick rounded rim and the extension of the ribs under the base. In addition, while the simple decorative pattern could have been produced in many areas of the Islamic world, brightly colored molded glass was certainly more widespread in the former Roman areas than in Iran. For these reasons, this small but extremely appealing bright emerald green bowl was probably made in the Syrian region.

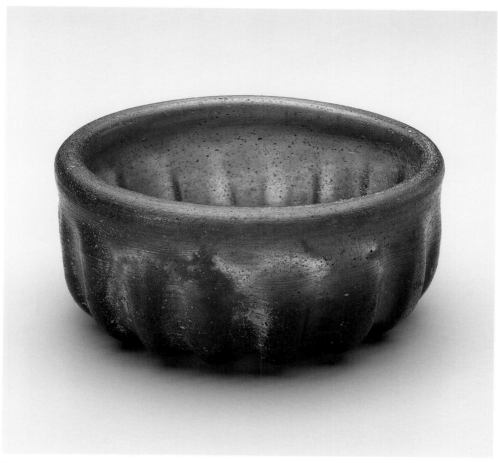

Cat. 3

### Cat. 4a  CAGE FLASK (LNS 126 G)
Syrian region
7th–8th century

Dimensions: (overall) hgt. 11.2 cm;
max. diam. 6.0 cm; th. 0.14 cm;
wt. 118 g; cap. 26 ml
(flask) hgt. 7.5 cm; max. diam. 2.8 cm

Color: Translucent greenish colorless; green
(green 3); yellowish colorless

Technique: Free blown; applied; tooled;
worked on the pontil

Description: This flask was blown and tooled, giving
shape to its irregular cylindrical body,
angular shoulder, bulging neck, and
slightly flaring mouth. The circular
support in green glass, which stands on
four applied feet of yellowish colorless
glass, was tooled separately. The four-
legged base was attached to the center
of this support. Subsequently, a cage
was built around the bottle, separated
from it by means of three tiers of
applied trails in green (the two lower
layers) and greenish colorless glass
(the uppermost tier); the lowermost
tier is attached to the base. The neck
of the flask projects about 4 cm above
the cage. A thumb rest in greenish
colorless glass was applied on one side.
A chipped protrusion is visible on the
opposite side.

Condition: The object is intact except for the
chipped protrusion opposite the thumb
rest. The surface is entirely weathered,
resulting in a grayish brown coating
and pitting with dark spots that barely
allow for a reading of the colors.

Provenance: Sotheby's, London, sale, April 18, 1984,
lot 335

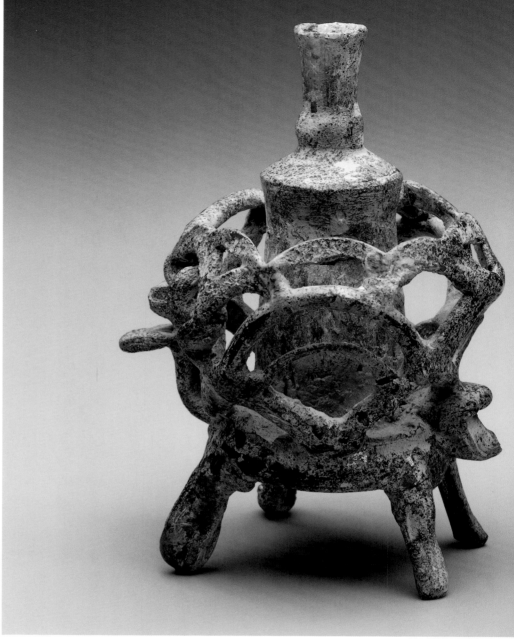

Cat. 4a, b

Based on a comparison with cat. 4b, which is nearly intact, the chipped protrusion on
one side of the cage of cat. 4a probably once showed the head of a horse, a camel, or
another quadruped; the surviving thumb rest represents the animal's tail. This type of
vessel, described by various names in the literature,[15] represents a domestic animal carrying
its burden in the form of a perfume or essence container, which is safely protected by a
wicker basket or cage.

Such figurines, which were likely produced in the Syrian region from the sixth or
seventh century until the eighth, are the most lively and distinctive glass objects with trailed
decoration made in the early Islamic period. A large number of these elaborate flasks are
found in museums around the world.[16] Each one is unique, since the shape of the flask
and of the animal's head and tail were freely tooled by the glassmaker. In a few cases, the
animals are paired (see Related Work 2, inv. no. 69.153). Although such flasks might have
been used for kohl and provided with a rod, their shape, the protrusion of the neck above
the cage, the presence of the animal's tail that can be used as a thumb rest, and the fact that

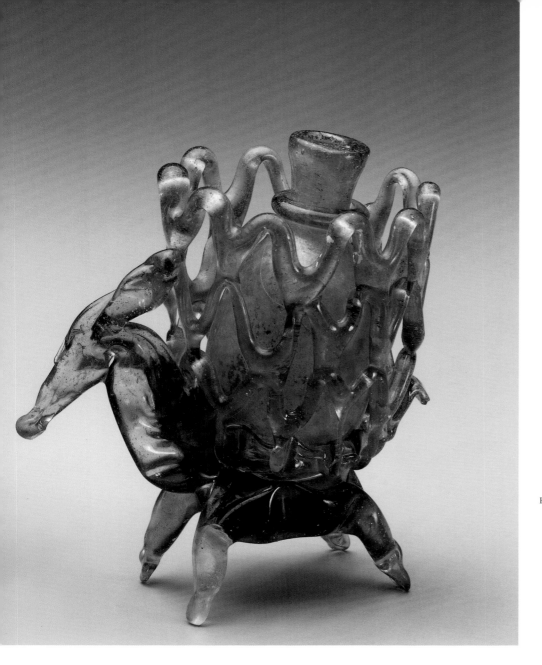

**Cat. 4b  CAGE FLASK (LNS 377 G)**
**Syrian region**
**7th–8th century**

Dimensions: (overall) hgt. 9.8 cm; max. diam. 5.6 cm;
l. 8.8 cm; wt. 91.6 g; cap. 32 ml
(flask) hgt. 8.0 cm; max. diam. 2.8 cm

Color: Translucent brown (yellow/brown 3)

Technique: Free blown; applied; tooled;
worked on the pontil

Description: The construction of this cage flask is
similar to that of cat. 4a, though only
one color was used. The container has
an irregular cylindrical body and a ring
was applied around the neck. The cage
was built in three tiers of applied trails.
The neck of the flask projects about
1 cm above the cage. The base is shaped
like a quadruped with long ears,
perhaps a donkey.

Condition: The left foreleg of the animal, part of
its tail, and small chips of the cage are
missing; the remainder of the object is
intact. The missing leg was restored to
allow for proper standing. The flask is
cracked and the inner surface is heavily
weathered, resulting in a pale beige
coating. The remaining surface is in good
condition, showing only a light milky
white film. The glass contains numerous
tiny bubbles and black inclusions.

Provenance: Sotheby's, London, sale, June 13, 1996,
lot 167

Related Works: 1. Toledo, inv. nos. 23.2044, 23.2047,
23.2048 (Toledo 1969, fig. p. 36)
2. MMA, inv. nos. 12.212.6, 15.43.233,
69.153 (Jenkins 1986, no. 1:69.153)
3. BM, inv. no. OA 1913.5-23.115
(Tait 1991, fig. 153)
4. DC, inv. no. 49/1979
(von Folsach 1990, no. 224)
5. Chrysler Museum, Norfolk
(Norfolk 1989, fig. 13)
6. MFA, inv. no. 29.967
(von Saldern 1968, no. 64)

they fit comfortably in the hand suggest that their contents, either perfume or balsam,
were meant to be poured.

The production of cage flasks supported by an animal's back is probably a late
antique, eastern Mediterranean synthesis of two trends. The first is the use of a zoomorphic
shape, which originated in the glassmakers' widespread production of toys, pendants, and
small containers inspired by animals, especially domesticated ones. The second, more noble
inspiration is the celebrated *vasa diatreta* of the third to fourth century, the most famous
of which are the so-called Trivulzio bowl, the Lycurgus cup, and the Situla Pagana.[17] These
extraordinary achievements in cut glass were soon imitated in Alexandria, where vases were
made with cages of trailed glass rather than expensively carved from a glass block. These
objects are usually known as *pseudodiatreta*.[18] No doubt cage flasks for preserving essences
derive from such *pseudodiatreta*, married to the idea of a support with a four-legged animal
form. The result is an unusual object that can be simultaneously regarded as sophisticated
and folk, time-consuming and uncomplicated, elaborate and naive.

**Cat. 5a BOTTLE (LNS 39 KG)**
Syrian region
7th–8th century

Dimensions: hgt. 8.8 cm; max. diam. 6.5 cm;
th. 0.24 cm; cap. 150 ml
Color: Translucent pale brown
(yellow/brown 2)
Technique: Free blown; applied; pinched; tooled;
worked on the pontil
Description: A narrow flared neck was pulled from
the almost spherical body of this bottle.
A ring was applied at the base to form
the foot. The main applied decoration
consists of four roughly H-shaped six-
pointed figures, alternating with four
pairs of circles placed one above the
other. A large thread, which overlaps
at its seam for a few centimeters, was
applied on the upper part of the body,
then pincered all around to obtain
a riblike decoration in relief. The
applied decoration is from the same
glass batch as the bottle.
Condition: The object is intact. The surface
is heavily weathered, resulting in a
golden iridescence and some corrosion.
The glass is of good quality and
includes scattered small bubbles.
Provenance: Kofler collection
Literature: Lucerne 1981, no. 517

**Cat. 5b VASE (LNS 47 KG)**
Syrian region
7th–8th century

Dimensions: hgt. 6.5 cm; max. diam. 5.7 cm;
th. 0.16 cm; cap. 83 ml;
max. diam. of neck 3.3 cm
Color: Translucent yellow (yellow/brown 1)
Technique: Free blown; applied; pinched; tooled;
worked on the pontil
Description: A flared neck was shaped from the
almost spherical body of this vase.
A ring was applied at the base to form
the foot. The main applied decoration
consists of three roughly H-shaped six-
pointed figures, alternating with three
pairs of circles placed one above the
other. A large thread, which overlaps
at its seam for a few centimeters and
touches the tips of two of the H-shaped
figures, was applied on the upper part
of the body, then pincered all around
to obtain a riblike decoration in relief.
The applied decoration is the same
color as the vase.
Condition: The object is intact. The surface is
heavily weathered, resulting in a golden
brown iridescence, especially on the
interior, and corrosion. The glass is of
good quality and includes frequent
small bubbles.

Provenance: Kofler collection
Literature: Lucerne 1981, no. 515
Related Works: 1. NM, Damascus, inv. no. 12720-
A/5138 (Damascus 1964a, fig. 48)
2. Private collection, Tokyo
(Fukai 1977, no. 82)
3. KM, Düsseldorf, inv. no. P1973-71
(Ricke 1989, no. 53)
4. CMG, inv. no. 50.1.35
(Perrot 1970, no. 52x)
5. The Madina collection, New York,
inv. nos. G0052, G0054
See also cat. 1.4–1.8

Like cage flasks (cat. 4), numerous bottles, vases, and flasks with applied decoration in the same color as the vessel itself or sometimes in a contrasting color were produced in the Syrian region from the pre-Islamic until the early Islamic period. Peculiar to many of these globular vessels and cylindrical flasks is a decoration that can be described either as an H-shaped six-pointed figure, a squat six-pointed star, or, using some imagination, a stylized animal hide.[19] Many examples are found in museums and private collections.[20]

Globular bottles, which never exceed a height of ten centimeters, are more common than cylindrical flasks. One example (National Museum, Damascus) has a detailed provenance from Jabal al-Durūz in southern Syria and is datable to the seventh century (Related Work 1). Its shape is virtually identical to that of cat. 5b, though its decoration does not present circles between the H-shaped figures and it is somewhat larger in size. These two vessels also show the two types of necks common to these objects: the narrow opening of cat. 5a and the large mouth of cat. 5b. This variation probably reflects their different functions as, respectively, a perfume sprinkler and a pouring vessel for less precious liquids.

Such decorated containers were once dated exclusively to the pre-Islamic period;[21] more recent literature suggests they were produced between the seventh and ninth centuries.[22] A dating to the proto-Islamic period (seventh to eighth century) seems most likely, since these objects do not have an immediate parallel with known late Roman pieces. On the other hand, they were certainly produced before the codification of shapes and decorative patterns that occurred in the ninth century.

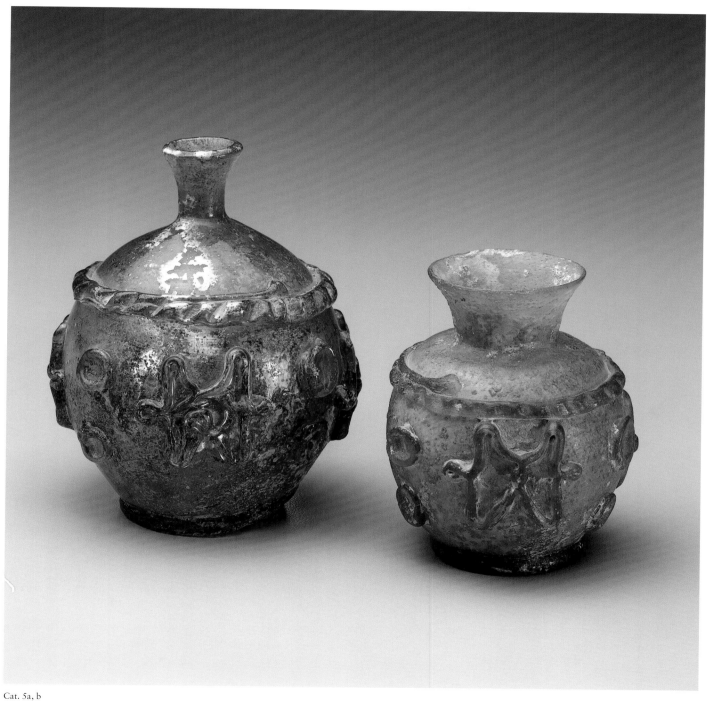

Cat. 5a, b

**Cat. 6 PITCHER (LNS 48 KG)**
**Probably Syrian region**
**8th century**

Dimensions: hgt. 12.2 cm; max. diam. 6.3 cm;
wt. 117 g; cap. 160 ml
Color: Translucent yellow (yellow/brown 1)
Technique: Free blown; applied; tooled;
worked on the pontil
Description: The spouted opening of this piriform
pitcher is in the shape of a heart, which
was made by tooling. A thick roundel
was applied around its base. The main
decoration consists of four applied
triangular figures alternating with three
simple discs placed between the vertices
of the triangles. A trail surrounds the
shoulder of the vessel, just above the
applied decoration. A curved handle
was attached from the shoulder (where
it overlaps the applied trail) to the rim;
a thumb rest and fold were shaped near
the attachment to the rim. The applied
glass is the same color as the vessel.
Condition: The object is intact except for a small
section of the trail applied around
the shoulder. The surface is entirely
weathered, resulting in a golden brown
coating. The glass is of good quality.
Provenance: Kofler collection
Literature: Lucerne 1981, no. 512
Related Works: 1. MIK, inv. no. I.4048
(Kröger 1984, no. 128)
2. Whereabouts unknown
(Smith 1957, no. 494)
See also cat. 1.8

Cat. 6

The decoration of this pitcher is related to that of cat. 5 and the same general discussion
applies. Distinctive to this type of pitcher is the triangular-shaped pattern that replaces the
H-shaped six-pointed design of cat. 5. In this example, discs alternate with the triangles.
Such discs are often applied on vessels that are unmistakably Islamic, as they include
stamped Arabic inscriptions or zoomorphic figures.[23] On two other objects of this type in
the Collection (see cat. 1.8a, b), the triangular pattern is complemented instead by a zigzag
trail in a different, darker color.

The combination of triangles and discs is rather unusual, but the most peculiar and
appealing feature of this pitcher is its shape. In fact, the only objects known to the author
that bear this type of applied decoration are globular vessels or cylindrical flasks (see the
discussion at cat. 5). The amalgamation in a single vessel of piriform body, heart-shaped
mouth, round handle with its fold near the rim, and high thumb rest safely places this
object in the Islamic period, probably in the eighth century, thus helping to date many
other pieces with similar decoration. The result is particularly harmonious in this case,
since shape and decoration nicely complement each other.

**Cat. 7a SMALL BOWL (LNS 1062 G)**
**Mesopotamian region**
**9th century**

Dimensions: hgt. 2.3 cm; max. diam. 6.6 cm;
th. 0.25 cm; wt. 33.9 g; cap. 37 ml
Color: Opaque pale and dark green, yellow,
and red
Technique: Mosaic (millefiori)
Description: This small shallow bowl has a curved
profile and stands on a low solid disc
(hgt. 0.3 cm) made from the same
batch, which is attached to the bottom.
The object was created using the
mosaic technique by joining small
roundels of colored glass. The roundels
were fused together by slow reheating in
the kiln after they had been placed side
by side on a mold that gave shape to the
vessel. Each roundel, which assumed an
irregular oval shape during fusion, was
originally circular, since it was sliced
from a multicolored glass cane.
Condition: The object is intact. The surface is
partially weathered, resulting in a
whitish coating, iridescence, and
corrosion.
Provenance: Bonhams, London, sale, April 29, 1998,
lot 92

The history of mosaic glass in the so-called millefiori technique[24] is one of the most fascinating in the field. Its vivid, enthralling appearance seems to defy the very nature of glass, which is weightless, hyalescent, and watery by definition. The intriguing history of millefiori, which has appeared, disappeared, and reappeared in different geographical areas, began in Egypt about 1400 B.C., then continued in Rome and Alexandria in the second century B.C., in Islamic Mesopotamia in the ninth century A.D., and in Venice in the fifteenth century. Millefiori reappeared during the first half of the nineteenth century in Venice, and subsequently spread throughout Europe (especially to France and Bohemia), where it enjoys popularity to this day.[25] Unlike other decorative techniques, however, the production of millefiori glass never lasted more than two or three centuries—and sometimes much less—in any given location, thus making it possible to say that it was "rediscovered" each time.

In the Islamic period, this rediscovery happened in Mesopotamia in the ninth century —or perhaps earlier, in the eighth century—and was likely linked to the central 'Abbasid power established in Baghdad and Samarra. The only fragments of millefiori glass found during archaeological excavations, and probably produced locally, were unearthed in Samarra, which was the 'Abbasid capital between 836 and 892.[26] These fragments, flat and rather thick, almost certainly belonged to the floor of the throne room and the harem of the palace where they were found, the Jawsaq al-Khāqānī, which had been the residence of the caliphs and their families since the founding of the new city.[27] The production of millefiori glass was probably initiated following known Roman examples, and the glass was meant to impress

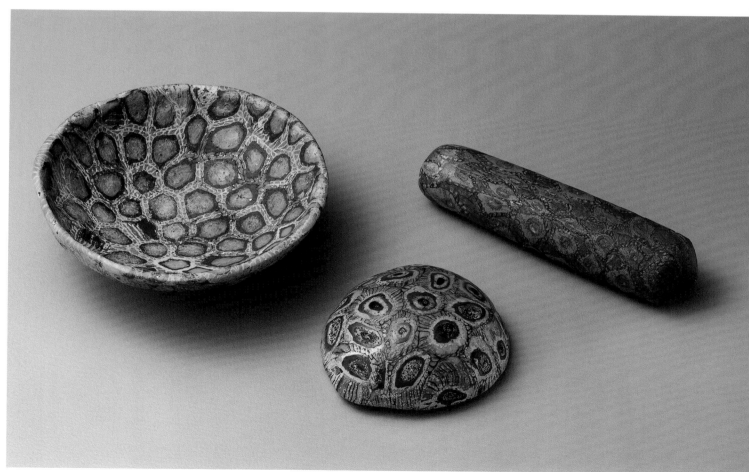

Cat. 7a, b, c

## Cat. 7b BOSS OR MINIATURE BOWL (LNS 63 G)
### Mesopotamian region
### 9th century

Dimensions: hgt. 1.2 cm; max. diam. 4.1 cm;
th. 0.21 cm; wt. 13.6 g; cap. 10 ml
Color: Opaque green, yellow, red, white,
and black
Technique: Mosaic (millefiori)
Description: This diminutive, shallow, slightly
lopsided object with a curved profile
was created using the same mosaic
technique described at cat. 7a.
Condition: The object is intact. The surface is
partially weathered, resulting in a
whitish layer on the convex side
(the interior) and slight corrosion.
Literature: Atıl 1990, no. 13
Related Works: 1. BM, inv. no. 1973.6-23.1
(Tait 1991, no. 156)
2. CMG, inv. no. 76.1.9
(*JGS* 19, 1977, p. 170, no. 11)
3. DC, inv. no. 38/1977
(von Folsach 1990, no. 241)
See also cat. 1.13, 1.14

## Cat. 7c KNIFE HANDLE (LNS 1378 G)
### Mesopotamian region
### 9th century

Dimensions: max. diam. 1.7 cm; l. 7.1 cm;
th. 0.40 cm; wt. 35.2 g
Color: Opaque dark red, orange,
pale and dark green, and yellow
Technique: Mosaic (millefiori)
Description: This cylindrical knife handle tapers
slightly toward the blade; the finial is
pointed. A small channel with an oval-
shaped section (ca. 0.4 x 0.6 cm) runs
through the entire object (l. 6.5 cm).
Condition: The object is intact except for the
missing blade. The surface is partially
weathered, resulting in a whitish
coating and corrosion.
Related Work: 4. DC, inv. no. 40/1977
(von Folsach 1990, no. 243)

the viewer. For this reason, the inspiration for its production might have come from the caliph himself or from his advisers at the time the new palace in Samarra was being designed. The effect of walking over a multicolored, brilliant, and light-reflecting layer of cold glass was certainly more stunning than the feeling of a flower-patterned rug underfoot.

In the millefiori technique, individual roundels of glass were sliced from long canes, which were created by gathering glass of different colors around a core. In the case of cat. 7a, the core is yellow. Wrapped around the core is a red layer and the last and outermost layer alternates pale and dark green glass, forming a bicolored frame. In cat. 7b, the core is black. The layers wrapped around the core are, in order, white, red, and yellow, while the last and outermost layer alternates yellow and green glass, forming a bicolored frame. The single elements of cat. 7c are set in a dark red bed; each sliced cane is formed by a red core encircled by green, wide orange, and the last and outermost layer alternates pale and dark green glass. Once all the layers were applied, the cylinder thus obtained was reheated and pulled from both ends, resulting in a much longer and thinner object. After it cooled, this thin cane was then sliced off, so that each small slice would show the same pattern created when forming the initial cylinder.

This time-consuming but not overly complicated technique enjoyed success for a short time and initiated, in particular, the manufacture of objects such as gaming pieces (see cat. 1.13) and shallow dishes or bowls, the latter possibly in imitation of Roman prototypes (see Related Works 1–3). Cat. 7a and b are among the few surviving objects of the "shallow bowl" type. The function of cat. 7a as a small container is clear, considering the presence of a low foot. The diminutive size of cat. 7b and the absence of a foot suggest that it may not have functioned as a shallow bowl, like many of its larger counterparts, but that it was meant instead to be embossed into a plaster wall as part of an architectural decoration. Only the interior surface is weathered, sharing this detail with Related Work 1, which suggests that they had a similar function, presently unknown. The knife handle (cat. 7c) is an unusual piece that also attests to a utilitarian use for objects created in the time-consuming mosaic technique (see also Related Work 4).

### Cat. 8 MINIATURE BOWL (LNS 156 G)
**Iranian region**
**7th–9th century**

Dimensions: hgt. 2.0 cm; max. diam. 6.6 cm;
th. 0.24 cm; wt. 29.3 g; cap. 30 ml
Color: Translucent pale yellowish green
(green 1)
Technique: Blown; tooled; cut; worked on the pontil
Description: This small bowl has a splayed rim
created by wheel-cutting. The decoration
consists of three rows of oval facets that
were cut close to one another, creating
pentagons and hexagons. The pontil
mark under the base was ground away
to give a more polished look to the
vessel but is still partially visible.
Condition: The object was broken and repaired.
It is almost complete, except for cracks
and a chip under the base. The surface
is lightly weathered, resulting in
abrasion. The glass includes frequent
small bubbles.
Provenance: Reportedly from Afghanistan
Related Work: Tenri Museum, Japan (Fukai 1977,
no. 23)
See also cat. 1.15

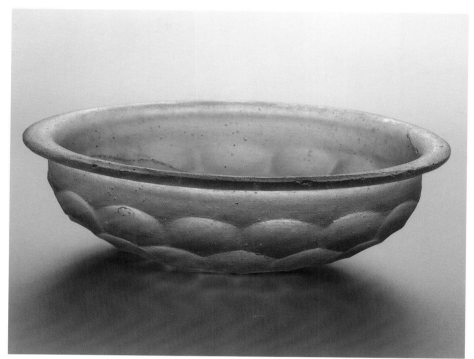

Cat. 8

Notwithstanding its simple appearance, this diminutive bowl is indebted to the famous facet-cut hemispherical bowls of Sasanian Iran. The two best-known extant examples of these bowls are in Japan, one in the treasury of the Shōsō-in Temple and the other in the National Museum, Tokyo. The latter, named the "Ankan bowl" after the emperor for whom it was made, can be securely dated to the sixth century, since Ankan died in 535.[28]

All the facet-cut Sasanian bowls are made of colorless glass and the majority are hemispherical, though some fragments excavated at Kish belonged to shallower bowls that are closer in shape to cat. 8.[29] Another exception is a conical cup (see Related Work), which, in the simplicity of its facet-cut decoration, probably provides the closest parallel to the present example.

The low profile of this miniature bowl and its flaring rim, which are rather different from those on the Sasanian objects, suggest that it was made during the early Islamic period.

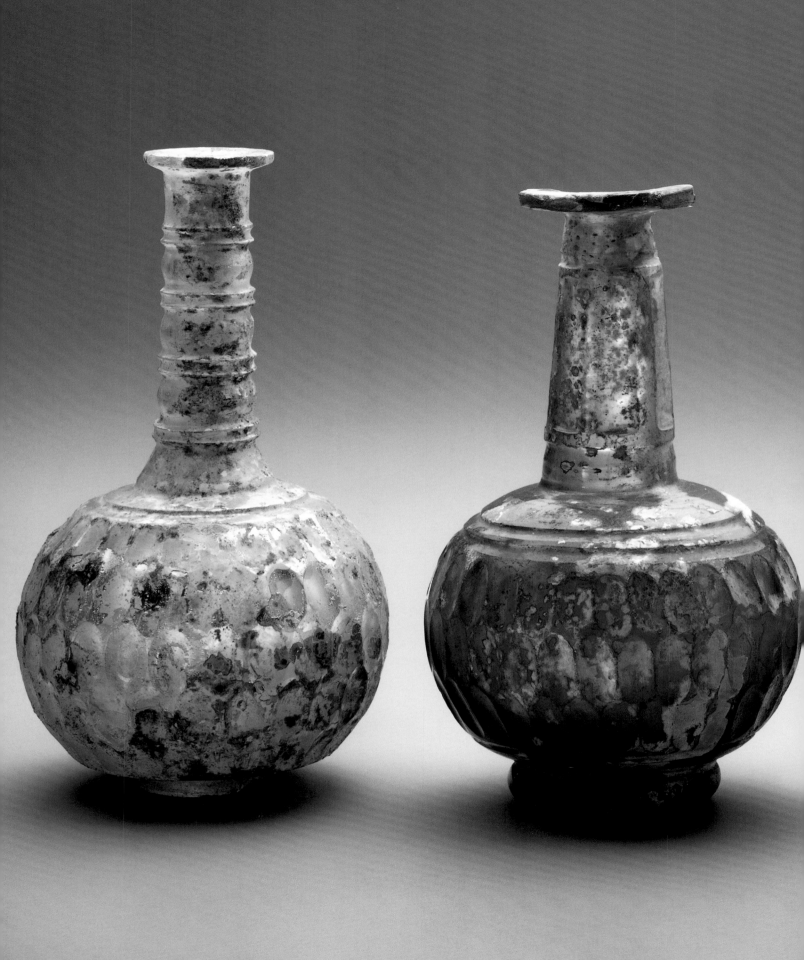

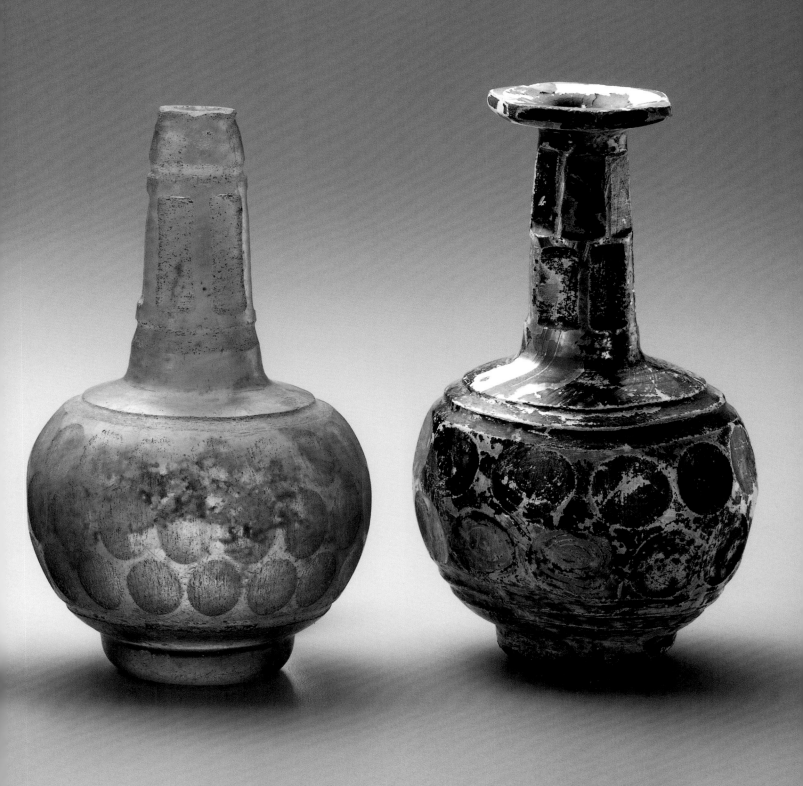

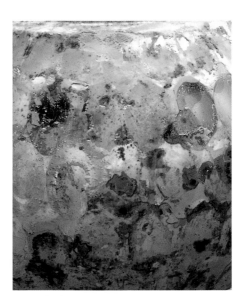

Cat. 9a detail

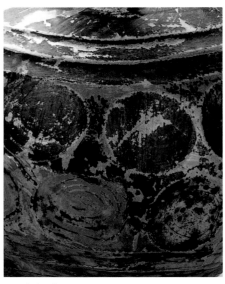

Cat. 9b detail

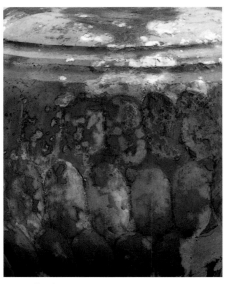

Cat. 9c detail

**Cat. 9a** BOTTLE (LNS 4 KG)
**Iranian region**
**8th–10th century**

Dimensions: hgt. 15.8 cm; max. diam. 7.9 cm;
th. 0.30 cm; wt. 203 g; cap. 225 ml
Color: Translucent yellowish colorless
Technique: Blown; tooled; cut; worked on the pontil
Description: This globular bottle has a long straight
neck and a splayed horizontal opening.
The wheel-cut decoration consists of
five rows of shallow ovals (the longer
side is ca. 1.5 cm) placed close together.
They often overlap, so that they
resemble a hexagonal honeycomb
pattern, alternately sunken and in relief.
The base was deeply cut to form a
small tapering foot that includes a tiny
circle in the center, underneath the base,
where the pontil mark was ground. The
shoulder is deeply grooved, so there is
an evident transition between the body
and the neck. The neck is subdivided
into three bulging compartments
separated by four double horizontal
lines in relief. The splayed opening
was also created by cutting.
Condition: The object is intact except for a chip
at the base. The surface is entirely
weathered, resulting in a milky white
film, golden iridescence, and corrosion.
The glass is of good quality.
Related Works: 1. MMA, inv. no. 63.159.5
(Jenkins 1986, no. 31)
2. MK, Frankfurt, inv. no. HST 9/3499
(Ohm 1973, no. 72)
3. V&A, inv. no. C559-1923
4. MM, inv. no. G5
(Hasson 1979, fig. 18)
5. DC, inv. no. 21/1985
(von Folsach 1990, no. 217)
6. IPM, inv. nos. 8285, 8287 (Pinder-
Wilson–Ezzy 1976, no. 122, 125)
See also cat. 1.16

**Cat. 9b** BOTTLE (LNS 360 G)
**Iranian region**
**8th–10th century**

Dimensions: hgt. 13.5 cm; max. diam. 7.7 cm;
th. 0.40 cm; wt. 186.4 g; cap. 205 ml
Color: Translucent pale greenish blue (blue 1)
Technique: Blown; tooled; cut; worked on the pontil
Description: This globular bottle has a straight
neck, a splayed hexagonal opening, and
a low foot. The decoration consists of
two rows of twelve roundels (diam. ca.
1.8 cm), evenly distanced, which create
a honeycomb pattern. Simple grooves
encircle the bottle just below and above
the honeycomb pattern. Two rows of
six rectangles, orientated vertically,
were cut around the neck. The foot was
facet cut with a series of eight small
ovals.
Condition: The object is intact except for a small
chip around the mouth. The surface
is entirely weathered, resulting in a
silvery dark gray coating and silvery
iridescence.
Provenance: Reportedly from Maimana (Faryab),
Afghanistan

**Cat. 9c** BOTTLE (LNS 432 G)
**Iranian region**
**8th–10th century**

Dimensions: hgt. 14.6 cm; max. diam. 8.6 cm;
th. 0.40 cm; wt. 209.5 g; cap. 255 ml
Color: Translucent pale greenish blue (blue 1)
Technique: Blown; tooled; cut; worked on the pontil
Description: This globular bottle has a straight neck,
a splayed hexagonal opening, and a low
foot. The wheel-cut decoration consists
of five rows of shallow ovals (the longer
side is ca. 1.5 cm) placed close together.
The facets often overlap and the
composition resembles a hexagonal
honeycomb pattern. Grooves encircle
the bottle just above and below the
honeycomb pattern. A row of vertical
rectangles was cut around the neck.
Condition: One-half of the neck is missing; the
remainder of the object is intact. The
surface is heavily weathered, resulting
in a golden pale brown coating, brown
pitting, and golden iridescence. The
glass includes frequent small bubbles.
Provenance: Christie's, London, sale, October 23,
1997, lot 22

◄ Cat. 9a, c, d, b

Cat. 9d detail

## Cat. 9d BOTTLE (LNS 46 G)
### Iranian region
### 8th–10th century

Dimensions: hgt. 13.5 cm; max. diam. 8.0 cm; th. 0.38 cm; wt. 182.9 g; cap. 200 ml

Color: Translucent pale greenish blue (blue 1)

Technique: Blown; tooled; cut; worked on the pontil

Description: This globular bottle has a tapered neck and a straight opening. The decoration consists of three rows of shallow ovals placed close together at even intervals, which create a honeycomb pattern. Simple grooves encircle the bottle just below and above the honeycomb pattern, near the base, and at the top of the neck. Six rectangles, oriented vertically, were cut around the neck, between the grooves. The bottom was cut to produce a flat base; the pontil mark was ground away; the opening was also ground and smoothed.

Condition: The object once ended in a splayed mouth (like cat. 9a, b), which is now missing. The surface is partially weathered, resulting in a pale gray coating, especially on the interior, and some corrosion. The glass includes scattered small bubbles.

Related Works: 7. MIK, inv. nos. I.26/63, I.4039 (Kröger 1984, nos. 185, 189)
8. Tenri Museum, Japan (Fukai 1977, no. 71)
9. LACMA, inv. no. M.88.129.159 (von Saldern 1980, no. 153)
See also cat. 1.16, 1.17

Cat. 9a–d belong to a well-defined group of globular bottles with honeycomb-cut decoration, long straight necks, and splayed openings. While their decoration is based on Sasanian models (primarily hemispherical bowls; see cat. 8), their shape is entirely Islamic and represents a hallmark of Iranian glass production from the eighth through the twelfth and thirteenth centuries. A remarkable number of these bottles are extant and present various degrees of sophistication and complexity in the cut decoration of the globular body and long neck.[30]

The number of rows of the so-called honeycomb pattern on the body can vary from two to five, as in the present examples, but it is the quality of the cutting that differs greatly from piece to piece. It is clear that the glass cutter of cat. 9a and, to a certain degree, of cat. 9c did a painstaking job of scooping away the curved surface of the bottle, producing the effect of a true honeycomb pattern, where light and shadow play a decorative role and enhance the shape of the vessel. In the case of cat. 9d, on the other hand, the surface was cut away in a flatter and less precise manner. This bottle is appealing for its pale bluish color rather than for its decoration, which is barely noticeable as an ornamental pattern. The same applies to the decoration of their necks: cat. 9a shows a deeply carved, sophisticated horizontal composition, while the shallow-cut vertical rectangles of cat. 9d seem inferior in comparison (it should, however, be noted that this bottle has lost the upper part of its neck, as suggested by its tapering shape). Cat. 9b lies in between: it has an appealing color, but its decoration is neither as sophisticated nor as simplistic as that of cat. 9a and 9d, respectively.

Cat. 1.1

## Cat. 1.1 VIAL (LNS 14 KG)
### Syrian or Egyptian region
### 5th–7th century

Dimensions: hgt. 10.6 cm; max. diam. 1.1 cm
(interior); th. 0.30 cm; wt. 45.3 g;
cap. 6 ml
Color: Translucent blue (blue 3)
Technique: Rod-formed(?);[31] tooled; applied
Description: A long narrow tube was heavily tooled
to produce twisted ribs along the
surface. The short neck was created
with pincers; the opening bulges
under the rim. The twisted ribs were
constrained at the bottom into an
applied disc that provides the base of
this vessel. Two small S-shaped handles
were attached at the neck and above
the opening. The interior is extremely
polished, which suggests that the object
was formed and tooled around a metal
rod that was taken out of the tube only
after the object was finished. The
absence of a pontil mark under the
base further supports this hypothesis.
Condition: The object is intact. The surface is
entirely weathered, resulting in a
silvery gray coating that barely
allows for a reading of the color.
Provenance: Kofler collection
Literature: Lucerne 1981, no. 482

## Cat. 1.2a HANGING LAMP(?)
### (LNS 42 KG)
### Egyptian region
### 6th–8th century

Dimensions: hgt. 8.5 cm; max. diam. 6.5 cm;
th. 0.21 cm; wt. 71 g; cap. 150 ml
Color: Translucent dark olive green (green 5);
opaque yellow and white
Technique: Free blown; dappled; applied; tooled;
worked on the pontil
Description: The bulbous tapered body of this vessel
has a short neck and splayed opening.
The base is curved and the object cannot
stand. The decoration was created by
rolling the vessel on a marver strewn
with chips of opaque yellow and white
glass. The vessel was then reblown and
tooled, resulting in a patched texture,
with the glass chips sometimes marvered
into the glass surface and sometimes
in relief. The overlapping of the two
opaque colors often produced a third,
pale brown color.[32] Four thin handles of
the same green color as the vessel were
applied from the shoulder to the middle
of the body.
Condition: The object is intact. The surface is lightly
weathered, resulting in a pale brown film
and some corrosion. The glass includes
frequent bubbles. There is a large lump
of glass where the pontil was cut off.
Provenance: Kofler collection

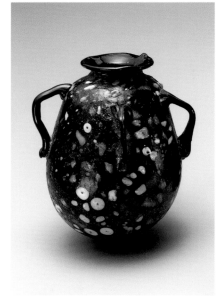

Cat. 1.2a

## Cat. 1.2b VASE (LNS 51 KG)
**Egyptian region**
**6th–8th century**

Dimensions: hgt. 7.0 cm; max. diam. 7.5 cm;
th. 0.21 cm; wt. 83.3 g; cap. 200 ml
Color: Translucent turquoise; opaque yellow
and white
Technique: Free blown; dappled; tooled;
worked on the pontil
Description: This irregularly shaped, lopsided vase
has a squarish body and a short neck
with a flared opening. The decoration
is similar to that of the lamp (cat. 1.2a).
Dappled glass is found mostly on the
upper part of the piece, leaving the
lower part almost undecorated.
The base is kicked.
Condition: The object was broken and repaired
and part of the rim is missing. The
surface is lightly weathered, resulting
in a whitish film. The glass includes
frequent bubbles.
Provenance: Kofler collection

## Cat. 1.2c JUG (LNS 53 KG)
**Egyptian region**
**6th–8th century**

Dimensions: hgt. 12.0 cm; max. diam. 9.0 cm;
th. 0.20 cm; wt. 105.1 g; cap. 305 ml
Color: Translucent purple; opaque yellow
and white
Technique: Free blown; dappled; applied; tooled;
worked on the pontil
Description: This globular jug has a large
cylindrical neck and a straight opening.
The decoration is similar to that of
the lamp (cat. 1.2a). Dappled glass
is equally distributed over the entire
surface of the vessel. A thin handle of
the same purple color as the jug was
applied from the middle of the neck to
the body. The base is deeply kicked.
Condition: The object, though broken and repaired,
is complete. The surface is lightly
weathered, resulting in a golden brown
film. The glass includes frequent bubbles.
Provenance: Kofler collection

## Cat. 1.2d BOTTLE (LNS 55 KG)
**Egyptian region**
**6th–8th century**

Dimensions: hgt. 8.8 cm; max. diam. 6.2 cm;
th. 0.16 cm; wt. 50.7 g; cap. 118 ml
Color: Translucent dark blue (blue 5);
opaque yellow and white
Technique: Free blown; dappled; tooled;
worked on the pontil
Description: This globular bottle has a flat base,
a flared neck with a pronounced bulge,
and a slightly flared opening. The
decoration is similar to that of the lamp
(cat. 1.2a). In this case, the opaque
glass chips are mainly in the shape of
long strips concentrated around the
neck. The base has a pronounced kick.
Condition: The neck was broken and repaired; the
object is intact except for a small fill
near the rim. The surface is lightly
weathered, resulting in a whitish film.
The glass includes frequent bubbles.
Provenance: Kofler collection

## Cat. 1.2e FRAGMENTARY NECK
## OF A BOTTLE (LNS 152 KGa, b)
**Egyptian region**
**6th–8th century**

Dimensions: max. hgt. 2.9 cm; max. diam. 4.1 cm;
th. 0.11 cm
Color: Translucent purple (purple 2);
opaque white
Technique: Free blown; dappled; tooled
Description: The fragment, formed by two adjoining
sections, includes about three-quarters
of the opening and a portion of the
cylindrical neck. The thick rim folds
outward twice. The purple glass is
dappled with opaque white glass.
Condition: The surface is lightly weathered,
resulting in a milky white film.
Provenance: Kofler collection

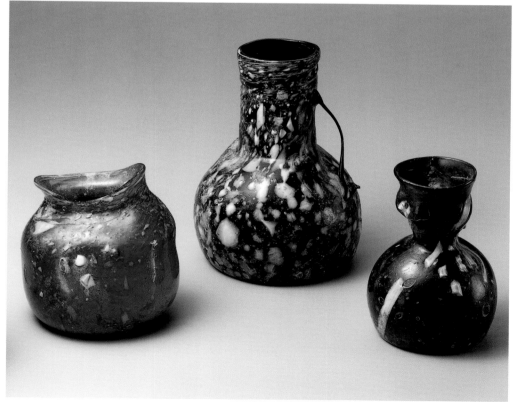

Cat. 1.2b, c, d

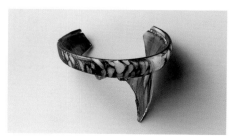

Cat. 1.2e

**Cat. 1.3  BOWL (LNS 380 G)**
**Syrian region**
**7th–8th century**

Dimensions: hgt. 5.2 cm; max. diam. 9.4 cm;
         th. 0.30 cm; wt. 85.5 g; cap. 200 ml
Color: Translucent greenish colorless
Technique: Free blown; applied; tooled;
         worked on the pontil
Description: This slightly flared, curved bowl has
         a flat base and a slightly lipped rim.
         A thin ring applied underneath the
         base (max. diam. 5.6 cm) provides
         the foot on which the bowl stands.
Condition: The object is intact. The surface is
         heavily weathered, resulting in a milky
         white coating and a metallic gray film
         on the interior. The glass includes
         frequent tiny bubbles.
Provenance: Reportedly from Hawran, Syria

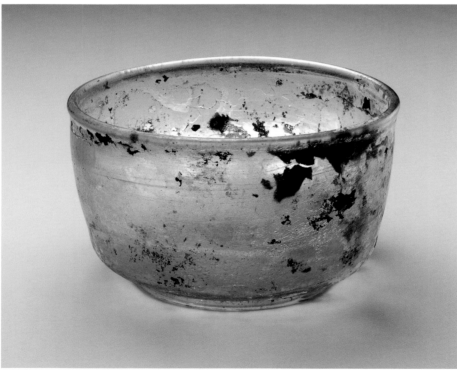

Cat. 1.3

**Cat. 1.4a  FLASK (LNS 29 KG)**
**Syrian region**
**7th–8th century**

Dimensions: hgt. 9.5 cm; max. diam. 3.5 cm;
         wt. 48.5 g; cap. 37 ml
Color: Translucent yellow (yellow/brown 1)
Technique: Free blown; applied; tooled; pinched;
         worked on the pontil
Description: This flask has an irregular cylindrical
         shape that tapers toward a short neck
         that ends in a bulging opening. A ring
         applied at the base provides a foot.
         The main decoration consists of three
         H-shaped six-pointed figures applied
         around the body; a thread placed just
         above the H-shaped figures (it touches
         their tips) was pincered all around to
         produce a riblike decoration in relief.
         The decoration is of the same yellow as
         the flask and was pushed rather deeply
         into the surface, modifying the profile
         of the object.
Condition: The object is intact. The surface is
         entirely weathered, resulting in golden
         iridescence and slight abrasion. The
         glass includes frequent elongated
         bubbles.
Provenance: Kofler collection

**Cat. 1.4b  BOTTLE (LNS 63 KG)**
**Syrian region**
**7th–8th century**

Dimensions: hgt. 9.0 cm; max. diam. 7.0 cm;
         wt. 83.1 g; cap. 150 ml
Color: Translucent yellowish colorless
         or yellow (yellow/brown 1)
Technique: Free blown; applied; tooled; pinched;
         worked on the pontil
Description: This globular bottle has a short narrow
         neck that ends in a bulging opening.
         A ring was applied at the base to
         allow the bottle to stand. The main
         decoration consists of six H-shaped six-
         pointed figures, unevenly spaced around
         the body; a thread was applied around
         the shoulder and pincered all around to
         produce a riblike decoration in relief.
         The tips of one of the H-shaped figures
         are clearly placed above the thread;
         thus, in this case, unlike cat. 5 and 1.4a,
         the thread was certainly applied before
         the H-shaped figures. The decoration
         is of the same yellowish color as the
         bottle and was applied rather carelessly.
         The base is slightly kicked.
Condition: The object is intact. The surface is
         entirely weathered, resulting in golden
         iridescence, gray pitting, and heavy
         corrosion.
Provenance: Kofler collection
Related Works: Cat. 5a, b

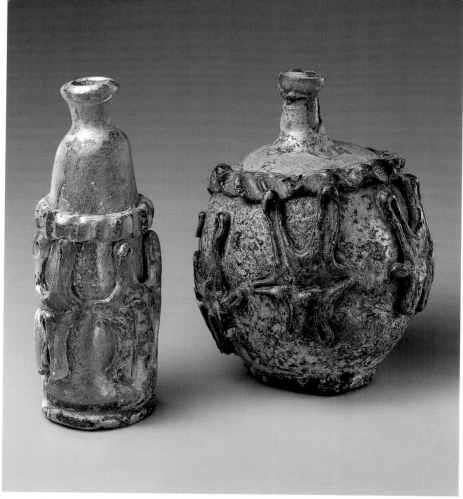

Cat. 1.4a, b

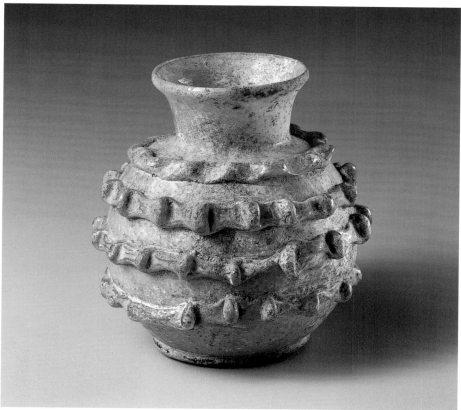

Cat. 1.5

**Cat. 1.5 VASE (LNS 26 KG)**
**Syrian region**
**7th–8th century**

Dimensions: hgt. 7.0 cm; max. diam. 6.5 cm;
th. 0.23 cm; wt. 67.2 g; cap. 125 ml

Color: Translucent yellow (yellow/brown 1)
or grayish colorless

Technique: Free blown; applied; tooled; pinched;
worked on the pontil

Description: This globular vase has a short neck
with a flared opening. The base is
slightly kicked and a ring was applied
around it. The decoration consists of
four trails of the same yellow as the
vase, arranged horizontally around
the body. The trails were tooled at
uneven intervals, so that the pinched
sections stand in relief.[33]

Condition: The object is intact. The surface is
entirely weathered, resulting in a
brown coating and gray pitting,
especially on the interior. The glass
includes frequent small bubbles.

Provenance: Kofler collection

Literature: Lucerne 1981, no. 519

Related Works: Cat. 5a, b

**Cat. 1.6a VASE (LNS 67 KG)**
**Syrian region**
**7th–8th century**

Dimensions: hgt. 4.7 cm; max. diam. 4.5 cm;
    th. 0.13 cm; wt. 18.8 g; cap. 34 ml
Color: Translucent yellowish colorless
Technique: Free blown; applied; tooled;
    worked on the pontil
Description: This globular vase has a short flared
    neck. It stands on three small feet that
    were applied and pinched at its base.
    The applied decoration is of the
    same yellowish color as the vase.
    A horizontal trail around the shoulder,
    another horizontal trail near the base,
    a wide zigzag pattern, and one of the
    three feet were applied in a single
    uninterrupted trail.
Condition: The object is almost intact, except for
    part of the neck, which is broken. The
    surface is partially weathered, resulting
    in a whitish coating and brown pitting.
    The glass is of good quality.
Provenance: Kofler collection
Literature: Lucerne 1981, no. 509

**Cat. 1.6b BOTTLE (LNS 376 G)**
**Syrian region**
**7th–8th century**

Dimensions: hgt. 6.5 cm; max. diam. 4.6 cm;
    th. 0.19 cm; wt. 35.7 g; cap. 42 ml
Color: Translucent pale brown
    (yellow/brown 2)
Technique: Free blown; applied; tooled;
    worked on the pontil
Description: This globular bottle has a short narrow
    neck that ends in a bulge. The applied
    decoration is in the same yellow as the
    object. A single trail winds in a spiral
    from the shoulder before turning into
    a network of irregular rhomboids.
    The bottle stands on three small feet
    created by further tooling of the same
    trail. An L-shaped handle was applied
    from the rim to the shoulder.
Condition: The object is intact but a thumb rest
    may be missing from the handle. The
    surface is entirely weathered, resulting
    in gray and pale brown coatings.
Provenance: Reportedly from Syria

**Cat. 1.6c VASE (LNS 296 G)**
**Syrian region**
**7th–8th century**

Dimensions: hgt. 5.3 cm; max. diam. 4.4 cm;
    th. 0.22 cm; wt. 43.3 g; cap. 25 ml
Color: Translucent dark blue (blue 4)
Technique: Free blown; applied; tooled;
    worked on the pontil
Description: This flattened globular vase has a long,
    slightly flared, large neck. The decoration
    appears to have been applied in a single
    trail running around the neck, shoulder,
    and body in a zigzag pattern, then
    continues around the base, forming
    the foot. This trail is chipped in places
    but the impression left by the diagonal
    sections is still visible on the surface.[34]
Condition: The object is intact. The surface is
    entirely weathered, resulting in dark
    gray and pale brown coatings that
    prevent a reading of the color of the
    applied trail, which may differ from
    that of the vase. The glass includes
    frequent small bubbles.
Provenance: Reportedly from Herat, Afghanistan
Related Works: Cat. 5a, b

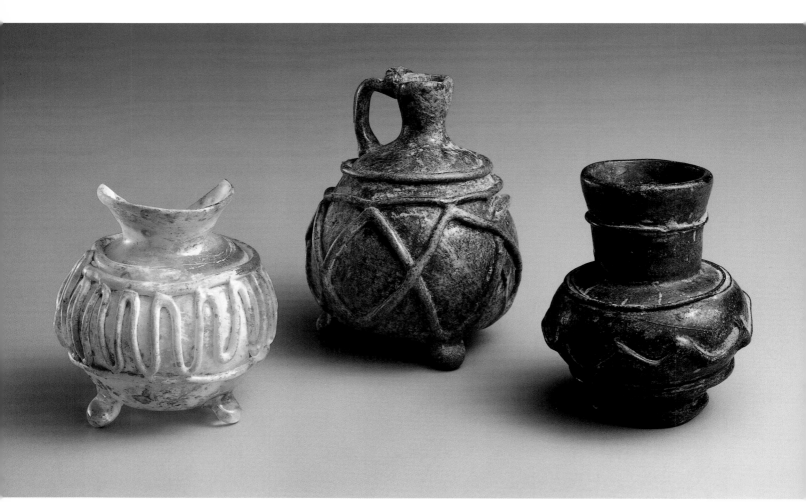

Cat. 1.6a, b, c

## Cat. 1.7a BOTTLE (LNS 21 KG)
**Syrian region**
**7th–8th century**

Dimensions: hgt. 4.5 cm; max. diam. 4.0 cm;
th. 0.20 cm; wt. 18.5 g; cap. 24 ml
Color: Translucent greenish colorless with
applied opaque black(?)
Technique: Free blown; applied; tooled;
worked on the pontil
Description: This small globular bottle has a short
narrow neck with a slightly flared
opening. A roundel was applied at the
base. The decoration consists of a
single trail that creates an irregular
network framed by two horizontal
trails. The trail appears to be an
opaque black or perhaps a dark
translucent purple or green.
Condition: The object is intact except for a small
chip at the mouth and chips in sections
of the trailing. The surface is entirely
weathered, resulting in gray and milky
white coatings and some corrosion.
Provenance: Kofler collection
Literature: Lucerne 1981, no. 508

## Cat. 1.7b BOTTLE (LNS 54 KG)
**Syrian region**
**7th–8th century**

Dimensions: hgt. 4.0 cm; max. diam. 3.0 cm;
th. 0.20 cm; wt. 7.7 g; cap. 16 ml
Color: Translucent dark brown with applied
opaque red
Technique: Free blown; applied; tooled;
worked on the pontil
Description: This small globular bottle has a short
narrow neck ending in a rounded
opening. The decoration consists of a
single opaque red trail around the body,
patterned into a wide zigzag motif that
ends in a simple trail around the neck.
Condition: The object is intact except for a small
hole on the body. The surface is in good
condition. The glass includes frequent
small bubbles.
Provenance: Kofler collection
Literature: Lucerne 1981, no. 449
Related Works: Cat. 5a, b

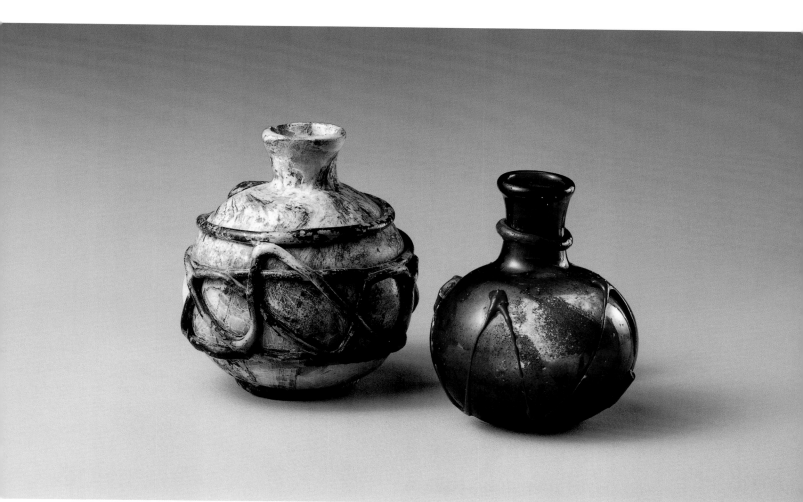

Cat. 1.7a, b

### Cat. 1.8a BOTTLE (LNS 62 KG)
**Syrian region**
**7th–8th century**

Dimensions: hgt. 8.5 cm; max. diam. 7.0 cm;
wt. 72.3 g; cap. 138 ml

Color: Translucent yellow (yellow/brown 1)
with applied blue(?)

Technique: Free blown; applied; tooled;
worked on the pontil

Description: This globular bottle has a short narrow
neck that ends in a bulging opening.
An applied ring pushed deeply into the
base enables the bottle to stand. The
decoration consists of a zigzag trail
applied around the shoulder and ten
unevenly spaced triangular shapes
around the body, alternately upright
and upside down. The vertices of most
of the triangles touch the zigzag trail,
slightly overlapping it; thus, they were
probably applied after the trail. The
decoration is in two colors, though it
is difficult to identify the darker one:
the trail is probably blue; the triangles
alternate between the same yellow
as the bottle and the darker color;
the ring at the base is yellow.

Condition: The object is intact. The surface is
entirely weathered, resulting in a brown
coating and gray pitting that barely
allow for a reading of the color used
for the body or the applied decoration.
The glass is of good quality.

Provenance: Kofler collection

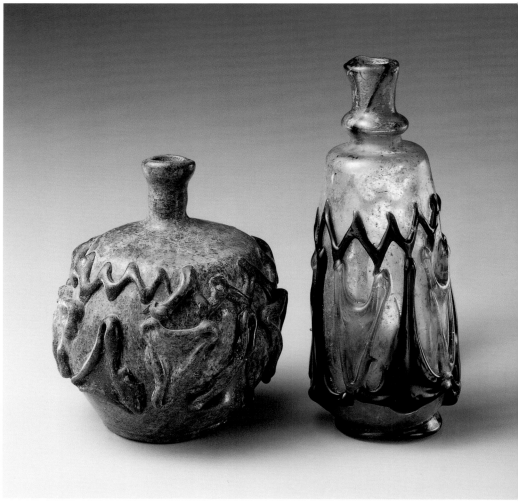

Cat. 1.8a, b

### Cat. 1.8b FLASK (LNS 64 KG)
**Syrian region**
**7th–8th century**

Dimensions: hgt. 11.2 cm; max. diam. 4.5 cm;
wt. 63.3 g; cap. 75 ml

Color: Translucent olive green (green 2)
with applied brownish purple

Technique: Free blown; applied; tooled;
worked on the pontil

Description: This tapered cylindrical flask has an
angular shoulder, a short neck with a
bulge near the shoulder, and a slightly
bulging opening. A roundel was applied
under the base, providing a foot. The
decoration consists of eight unevenly
spaced, irregular triangles alternately
upright and upside down. A zigzag trail
was applied above the triangles, often
touching their tips, but the trail does
not go completely around the flask.
The decoration is in two colors: the
trail and the upright triangles are in
brownish purple glass while the
alternate triangles are in the same
green as the body. The roundel at
the base is green.

Condition: The object is intact. The surface
is lightly weathered, resulting in a
whitish film, especially on the interior.
The glass includes scattered bubbles
and a darker streak on the neck.

Provenance: Kofler collection

Related Works: Cat. 5, 6

## Cat. 1.9 FLASK (LNS 24 KG)
**Probably Syrian region**
**7th–8th century**

Dimensions: hgt. 8.0 cm; max. diam. 3.0 cm;
wt. 44.6 g; cap. 30 ml
Color: Translucent pale brown
(yellow/brown 2)
Technique: Free blown; applied; tooled
Description: This irregularly shaped flask has a
slightly bulbous body, a slightly flared
neck, and a bulging opening. The
decoration consists of three rows of
three large protruding prunts evenly
spaced around the body.[35] A trail was
applied around the neck. The base is
formed by a small roundel (max. diam.
2.2 cm) applied at the bottom, which
does not display a pontil mark;
therefore, the object was probably
worked while attached to the blowpipe.
Condition: The object is intact except for one
prunt in the lowermost row. The
surface is entirely weathered, resulting
in iridescence and scratches. The glass
includes scattered small bubbles.
Provenance: Kofler collection
Literature: Lucerne 1981, no. 502

## Cat. 1.10 FLASK (LNS 58 KG)
**Probably Syrian region**
**7th–8th century**

Dimensions: hgt. 12.0 cm; max. diam. 3.5 cm;
th. 0.23 cm; wt. 73.0 g; cap. 60 ml
Color: Translucent yellow (yellow/brown 1)
or yellowish green colorless
Technique: Free blown; applied; tooled
Description: This cylindrical, slightly tapered flask
has a short straight neck. A roundel
was applied under the base, as in
cat. 1.9. The applied decoration
consists of three large oval medallions
of the same yellowish color as the flask.
These flat medallions are evenly spaced
and almost entirely cover the body.[36]
Condition: The object appears intact except
for the upper part of the neck. The
surface is entirely weathered, resulting
in gray pitting, golden iridescence,
and corrosion that barely allow for
a reading of the color.
Provenance: Kofler collection
Literature: Lucerne 1981, no. 521

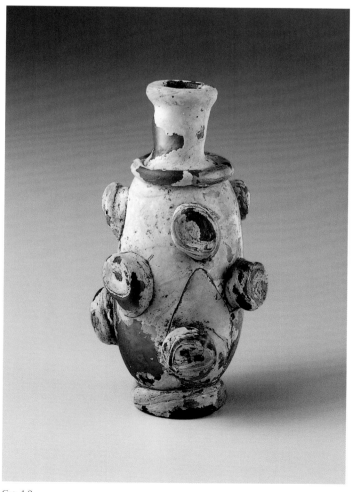

Cat. 1.9

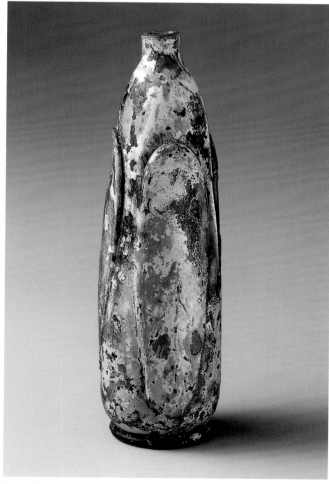

Cat. 1.10

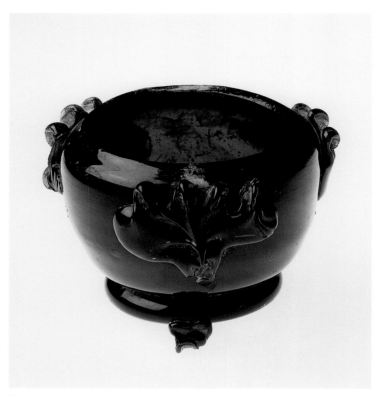

Cat. 1.11

## Cat. 1.11 BOWL (LNS 65 KG)
### Syrian region
### 7th–8th century

Dimensions: hgt. 6.0 cm; max. diam. 7.0 cm;
th. 0.25 cm; wt. 139.1 g; cap. 120 ml
Color: Translucent dark olive green (green 5)
Technique: Free blown; applied; tooled;
worked on the pontil
Description: This small curved bowl has a rim that
turns inward. The base is formed by
a thick roundel to which three small
pincered feet were applied; this base
was then attached to the bottom of
the bowl. The main decoration consists
of three large medallions of the same
green color as the bowl. They are evenly
spaced around the body and are the
same height as the walls of the bowl.
Tooled with a pincer, each medallion
vaguely resembles a mask or the head
of a fantastic animal.[37]
Condition: The object is intact except for chips
on the surfaces of the medallions. The
surface is lightly weathered, resulting
in a golden brown film and iridescence.
The glass is of good quality and
includes a few scattered bubbles.
Provenance: Kofler collection
Literature: Lucerne 1981, no. 520

## Cat. 1.12 DRINKING VESSEL
### (LNS 110 KG)
### Probably Iranian region
### Probably 7th–9th century

Dimensions: hgt. 10.5 cm; max. diam. 5.5 cm;
th. 0.23 cm; wt. 65.9 g; cap. 110 ml
Color: Translucent dark blue (blue 4)
with applied pale green (green 1)
Technique: Free blown; applied; pincered; tooled
Description: This drinking vessel is in the shape
of a stylized boot with flaring walls.[38]
The foot was formed with the aid of
pincers and was filled with additional
glass to prevent spilling of the liquid
it was destined to hold. A round pale
green glass handle was applied halfway
up the boot, then pincered to create
a decorative pattern in relief.
Condition: The object is intact except for a section
of the rim and wall, which has been
filled in. The surface is partially
weathered, resulting in golden
iridescence. The glass includes
scattered small bubbles.
Provenance: Kofler collection
Literature: Lucerne 1981, no. 389

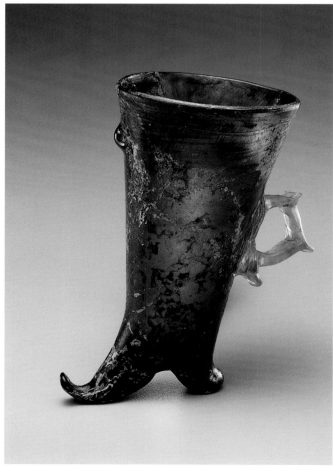

Cat. 1.12

## Cat. 1.13a SIXTEEN GAMING PIECES OR WEIGHTS FOR A SCALE[39]
(LNS 109 Ga–p)
Mesopotamian region
8th–9th century

Dimensions: a: hgt. 1.2 cm; max. diam. 1.8 cm; wt. 5.4 g
b: hgt. 1.6 cm; max. diam. 2.0 cm; wt. 6.5 g
c: hgt. 0.8 cm; max. diam. 1.9 cm; wt. 3.2 g
d: hgt. 1.4 cm; max. diam. 2.0 cm; wt. 3.4 g
e: hgt. 2.2 cm; max. diam. 2.2 cm; wt. 10.8 g
f: hgt. 2.5 cm; max. diam. 2.2 cm; wt. 12.3 g
g: hgt. 2.2 cm; max. diam. 2.3 cm; wt. 10.3 g
h: hgt. 2.5 cm; max. diam. 2.3 cm; wt. 12.1 g
i: hgt. 1.9 cm; max. diam. 2.2 cm; wt. 10.8 g
j: hgt. 1.8 cm; max. diam. 2.4 cm; wt. 11.4 g
k: hgt. 1.7 cm; max. diam. 2.4 cm; wt. 11.8 g
l: hgt. 1.9 cm; max. diam. 2.4 cm; wt. 12.1 g
m: hgt. 1.8 cm; max. diam. 2.1 cm; wt. 11.4 g
n: hgt. 1.6 cm; max. diam. 2.3 cm; wt. 11.1 g
o: hgt. 1.9 cm; max. diam. 2.3 cm; wt. 13.7 g
p: hgt. 1.8 cm; max. diam. 2.1 cm; wt. 10.3 g

Visible colors: Opaque dark green, pale blue, and white (a); opaque black (c, d); opaque grayish green and red (f); opaque grayish green (h, i); opaque bluish green (j); opaque emerald green (k); opaque green and yellow (l, m, n, o); colors uncertain (b, e, g, p).

Technique: Mosaic (millefiori)

Description: These pieces are in the shape of a rounded dome (a, c); a pointed dome (b, d, i–p); a pointed cone (e–h). The pattern of the single roundels sliced from the colored canes is in the shape of concentric circles with a central button (a, b, i, j, l–p); a star with a central button (c); a star (d); concentric circles and streaks (f); and an unclear pattern (e, g, h, k).

Condition: The surfaces of these pieces are weathered to varying degrees, resulting in light corrosion (a); a pale brown coating and light corrosion (b); a golden brown coating and heavy corrosion (c); a whitish coating (d); a pale brown coating (e); a pale brown coating and golden iridescence (f); a golden brown coating (g–i); a golden brown coating and iridescence (j); a whitish coating and heavy corrosion (k, l); a pale brown coating (m, n); a pale brown coating and corrosion (o); total corrosion (p).

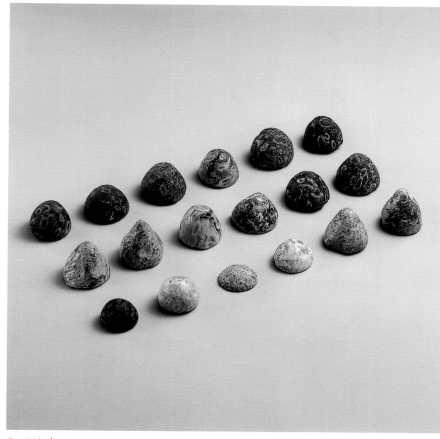

Cat. 1.13a, b

## Cat. 1.13b TWO GAMING PIECES OR WEIGHTS FOR A SCALE
(LNS 161 Ga, b)
Mesopotamian region
8th–9th century

Dimensions: a: hgt. 1.9 cm; max. diam. 2.0 cm; wt. 10.9 g
b: hgt. 2.2 cm; max. diam. 2.3 cm; wt. 14.3 g

Colors: Opaque green, yellow, and white (a); opaque green, red, and white (b)

Technique: Mosaic (millefiori)

Description: Both pieces are in the shape of a pointed dome. The decoration of the roundels sliced from the colored canes is formed by concentric circles with a central button (a) and a star with a central red button (b).

Condition: The surfaces of both pieces are heavily corroded.

Provenance: Reportedly from Afghanistan

Related Works: Cat. 7a–c

Cat. 1.14

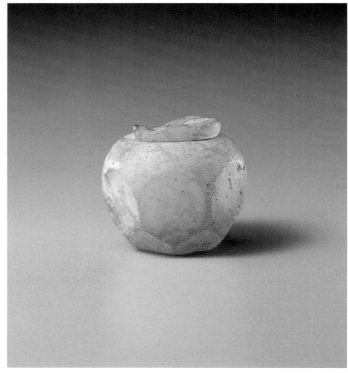

Cat. 1.15

**Cat. 1.14 FRAGMENT OF THE BASE OF
A PLATE(?) (LNS 158 KG)
Mesopotamian region,
9th century, or Eastern
Mediterranean Roman provinces,
2nd–3rd century**

Dimensions: max. w. 3.9 cm; max. l. 2.7 cm;
th. 0.25 cm
Color: Opaque red and white
Technique: Mosaic (millefiori)
Description: This fragment is flat. Attached on one
side is a curving rod of glass that may
once have functioned as the foot ring
of the original vessel, probably a large
plate with a flat base. The decoration
of the roundels sliced from the colored
canes consists of concentric circles in
alternating red and white layers;
one of them includes both colors.
Provenance: Kofler collection
Related Works: Cat. 7a–c

**Cat. 1.15 MINIATURE VASE (LNS 27 G )
Iranian region
8th–10th century**

Dimensions: hgt. 2.4 cm; max. diam. 2.5 cm;
th. 0.25 cm; wt. 11.9 g; cap. 3.5 ml
Color: Translucent yellowish colorless
Technique: Blown; tooled; cut; worked on the
pontil
Description: This miniature vase, originally globular,
was cut to create the flat base, short
flaring neck, and decoration. Two
rows of ovals were scooped around
the body—one forming the main
decoration, the second near the base
to give the facets a pentagonal shape.
The pontil mark is visible under
the base.
Condition: The neck is broken; the remainder
of the object is intact. The surface
is partially weathered, resulting in
a milky white film and a rusty spot.
The glass is of good quality.
Related Works: Cat. 8, 9

## Cat. 1.16a BOTTLE (LNS 409 G)
### Iranian region
### 8th–10th century

Dimensions: hgt. 7.0 cm; max. diam. 5.0 cm;
    th. 0.26 cm; wt. 61.3 g; cap. 44 ml
Color: Translucent grayish colorless
Technique: Blown; tooled; cut
Description: This globular bottle has a flat base and
    a slightly flared neck. The decoration
    consists of two rows of twelve ovals
    that were scooped away at even,
    close intervals to produce a regular
    honeycomb pattern. The base was
    deeply cut to form a low circular foot.
    The shoulder was deeply grooved
    twice, so that there is an evident
    transition between the body and the
    neck. The neck was cut into six sides,
    making the opening hexagonal.
Condition: The object is intact. The surface is
    partially weathered, resulting in a
    milky white film and abrasion.
    The glass is of good quality.
Provenance: Reportedly from Herat, Afghanistan

## Cat. 1.16b VASE (LNS 408 G)
### Iranian region
### 8th–10th century

Dimensions: hgt. 5.0 cm; max. diam. 6.4 cm;
    th. 0.23 cm; wt. 81.5 g; cap. 70 ml
Color: Translucent grayish colorless
Technique: Blown; tooled; cut; worked on the pontil
Description: This vase has a depressed globular shape,
    a flat base, and a short neck with a
    slightly splayed opening. The decoration
    consists of two rows of fifteen ovals that
    were scooped away at even, close intervals
    to produce a honeycomb pattern. Two
    concentric circles in relief were cut
    underneath the base, which still shows
    traces of the pontil mark. The shoulder
    was grooved, while the short neck was
    probably simply tooled and left uncut.
Condition: The object is intact. The surface is
    entirely weathered, resulting in a silvery
    dark gray coating and iridescence. The
    glass includes scattered small bubbles.
Provenance: Reportedly from Mazar-i Sharif (Balkh),
    Afghanistan
Related Works: Cat. 9a–d

## Cat. 1.17 BOTTLE (LNS 45 G)
### Iranian region
### 9th–10th century

Dimensions: hgt. 12.5 cm; max. diam. 7.0 cm;
    th. 0.38 cm; wt. 152.3 g; cap. 216 ml
Color: Translucent yellowish colorless
Technique: Blown; tooled; cut; worked on the
    pontil
Description: This dome-shaped bottle has a flared
    neck and a flat base that shows a
    ground pontil mark.[40] The decoration
    consists of five rows of depressed
    shallow ovals that are evenly spaced
    and well distanced. The uppermost row
    is enclosed between two grooved lines,
    forming a decorative band. The neck
    was cut into six sides.
Condition: The object is intact. The surface is
    entirely weathered, resulting in heavy
    iridescence and corrosion, making it
    difficult to read the decoration; three
    shallow ovals present small holes. The
    glass includes frequent small bubbles.
Related Works: Cat. 9d (similar decoration), cat. 24
    (related shape)

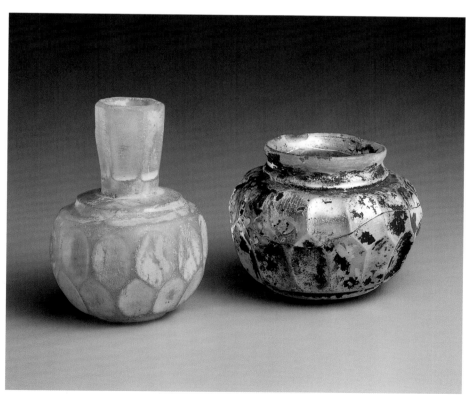

Cat. 1.16a, b

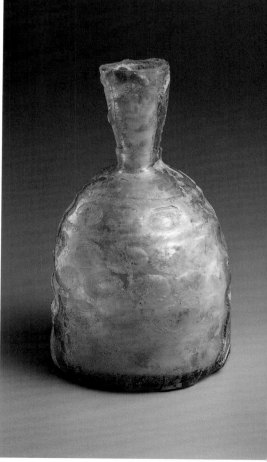

Cat. 1.17

# NOTES

1　The discovery of the glassblowing technique, as opposed to the earlier techniques of glass molding or cutting or core-formed glass, is reputed to have taken place in the eastern Mediterranean area in the first century B.C.

2　In addition to the numerous references to Jewish glassmakers in the documents of the Cairo Geniza (see, for example, Goitein 1968–93, vol. 1, p. 94), see also Bezborodko 1987, esp. pp. 41–42.

3　When referring to nineteenth-century glass produced in England and the United States, these shallow concavities are usually called "printies." Circular facets are also termed "ball cut" and ovals are called "thumb marks" or "finger cut." The term "clover cut" is applied when the facets overlap.

4　See Newman 1977. The term is explained as an "overall diaper pattern so that groups of five are in the form of the five dots on dice or symbols on playing cards, one central and one at each corner." This term does not, however, seem fitting or self-explanatory and will not be used here.

5　Mariamaddalena Negro Ponzi is the leading scholar in the field of excavations in modern Iraq. Glass of this type also came to light at Kish and Susa in present-day Uzbekistan and Iran. Among many excavation reports, see Lamm 1931; Langdon–Harden 1934; Negro Ponzi 1968–69; Kervran 1984; Whitcomb 1985; and Negro Ponzi 1987.

6　For example, a cup in the British Museum (inv. no. 96.2-1.200) was found in Cyprus (see Harden et al. 1968, no. 102).

7　See Harden et al. 1968, pp. 39–40.

8　Jenkins (1986, nos. 8, 9) dates them eighth to ninth century. A bottle in the Newark Museum, almost identical to Jenkins no. 8, is attributed to the sixth or seventh century in Auth 1976, no. 193.

9　Scanlon 1966, pl. 36, no. 25.

10　See Kröger 1995, p. 151.

11　See von Saldern et al. 1974, nos. 249–67.

12　Lamm 1935, p. 10.

13　Ibid.

14　Abdurazakov 1972, fig. 1, no. 4.

15　Horse balsamarium, balsamarium in the form of a quadruped, animal "dromedary" flask, animalistic vase, and so forth.

16　Related Works 1–6 include vessels that are close in shape and construction to cat. 4a and b. In addition to the ten flasks cited under Related Works, there are also examples in the Corning Museum of Glass; Los Angeles County Museum of Art; Virginia Museum of Fine Arts, Richmond; Carnegie Museum of Natural History, Pittsburgh; Museum für Kunst und Gewerbe, Hamburg; Museum für Islamische Kunst, Berlin; Musée du Louvre, Paris; and Art Museum, Kiev. Many other pieces are in private collections or have appeared at auction. Twenty-one cage flasks are known to the author at this time.

17　There is a type of *diatretum* commonly called a "cage cup," such as the Trivulzio bowl in the Museo Archeologico, Milan, and another in the Römisch-Germanisches Museum, Cologne; see Harden 1987, nos. 134–39, pp. 238–49; Newman 1987, s.v. "cage cup," "diatretarii," and "vasa diatreta," pp. 55, 94, 324–25.

18　An example in excellent condition, presently in the Musée Guimet, Paris, was part of the Roman glass treasury found at Begram, in Afghanistan; see Bussagli–Chiappori 1991, fig. p. 65.

19　The idea of the applied patterns as animal hides

was suggested in Damascus 1964a, fig. 48 (see Related Work 1) and Jenkins 1986, p. 11. If the imaginative interpretation is correct, then this production would be even more closely related to cage flasks (see cat. 4). In addition, the shape of flasks with this type of decoration is often similar to that of the flasks carried inside the cage in cat. 4.

20　In addition to Related Works 1–4 and cat. 1.6, 1.7, there are also examples in the Toledo Museum of Art; Victoria and Albert Museum, London; Benaki Museum, Athens; and L. A. Mayer Memorial, Jerusalem. Lamm (1929–30, pls. 20:14–23, 25, 23:8–12) includes a number of bottles and flasks with H-shaped decoration scattered in European collections, and many others have been sold at auction in Europe and the United States.

21　Lamm (1931, p. 361) dates them fifth to sixth century.

22　See, for example, Lucerne 1981, p. 124, nos. 513–17.

23　An outstanding example with zoomorphic figures is a large vase in the Metropolitan Museum of Art (inv. no. 37.56; Jenkins 1986, no. 7). Inscriptions that refer to capacity are often found on measuring vessels.

24　The term *millefiori* is formed by two Italian words meaning "one thousand flowers," after the multicolored flowerlike appearance of many of the small glass slices. The term originated in Venice in the sixteenth century and was re-adopted in the mid-nineteenth century, when the technique was revived.

25　For an overview of periods other than the Islamic, see Tait 1991, pp. 33, 48–50 (Egyptian, Roman); Harden 1987, no. 12, p. 35 (Roman); Sarpellon 1990 (nineteenth-century Venetian).

26　Fragments of two bowls, one almost complete, were unearthed at Dvin, Armenia, among other material imported from Iraq between the seventh and ninth century (see Djanpoladian–Kalantarian 1988, pls. 29:1, 29:2). For historical background and bibliography on Samarra, see *EI²*, 8, pp. 1039–41. Random fragments were found at Susa and Nishapur (Lamm 1931, pl. 79.10; and Kröger 1995, p. 113, no. 162).

27　Lamm 1928, pp. 109–10, pls. 8, 9.

28　For a general discussion, see von Saldern 1973, pp. 7–16, esp. pp. 10–12; and Fukai 1960, pp. 169–76. Both the Shōsō-in and the Ankan bowls have been published in Laing 1991, pp. 109–21, figs. 25, 26.

29　Langdon–Harden 1934, pp. 131–36.

30　See the recent discussion of this type of vessel in Kröger 1998, pp. 320–22.

31　Barag (1975, pp. 131–40) demonstrates that this type of balsamarium, or kohl tube, was probably rod-formed in the first millennium B.C. This technique has plausibly been applied to later vessels as well, though there is no continuity of production. A pre-Islamic, rather than Islamic, date is more likely for such handled tubes. A large number are found in museums, all virtually identical in shape and, surprisingly, almost all of identical blue color, suggesting that they originated from a single production site. They are reported to have been found in either Syria or Egypt. See examples in Lamm 1929–30, pls. 8:2–4; Auth 1976, pp. 147, 225; and von Saldern et al. 1974, nos. 250–52. Two unpublished vials are in the Corning Museum of Glass (inv. no. 50.1.21) and the Victoria and Albert Museum, London (inv. no. C137-1910).

32　This type of dappled decoration has its origins in

glass produced both in Europe and Syria in the first century A.D. The technique was probably revived later, for a short period, in Egypt, since vessels with similar shapes and white opaque trailing were found in the area of Fayyum. Objects decorated in this manner that were found in Egypt are in the Museum of Islamic Art, Cairo (inv. nos. 3291, 3292), the Victoria and Albert Museum, London (inv. nos. C137-1926, C138-1926, C139-1926, C140-1926), and the Toledo Museum of Art (inv. nos. 17.141, 23.2163, 27.195, 27.196); see Lamm 1929–30, pls. 24, 33; Charleston 1990, no. 14.

33　Numerous vessels with almost identical decoration are found in various collections. A bottle in the Victoria and Albert Museum, London (inv. no. C139-1910), is reported to have come from Raqqa, and one in the National Museum, Damascus (Damascus 1964a, no. 174), was found in an unknown location in Syria.

34　A vase almost identical to cat. 1.6a is in the Victoria and Albert Museum, London (inv. no. C136-1910). On that piece, the applied trail forms a foot ring, as it does on cat. 1.6c. On cat. 1.6a the trail probably fell short, meaning that the glassmaker only had enough glass to complete one foot and then added the other two feet separately. In the case of cat. 1.6b the trail was long enough to complete all three feet. An object similar to cat. 1.6a was found at Susa (see Lamm 1931, pl. 76, no. 4). Although cat. 1.6c is reportedly from the eastern Islamic world, its decoration leaves little doubt that it is an export piece.

35　Flasks with large prunts are not as common as those with other types of applied decoration, such as cat. 5, 6, 1.4–1.18. Although probably part of the same general group and produced in Syria, vessels with prunts seem to have enjoyed more popularity in the eastern Islamic world, as examples have been found in Iran (see Lamm 1931, pl. 76, no. 3; Fukai 1977, no. 81 [right]; Kordmahini 1988, p. 135). A comparable prunted flask is in Corning (inv. no. 68.1.6). The possibility of a Mesopotamian or an Iranian origin seems remote, though it should not be discounted.

36　This type of decoration is rather unusual, the only good parallel being another flask found at Susa (Lamm, 1931, pl. 76, no. 6), which has smaller medallions applied in two rows. The shape also recalls the taller, barrel-shaped, undecorated bottles with long narrow necks that were excavated at Nishapur, one of which is in the Metropolitan Museum (inv. no. 40.170.70; see Kröger 1995, nos. 93–95). However, as in the case of cat. 1.9, technical parallels seem to link this vessel to the Syrian region rather than farther east.

37　This unusual object has a companion piece, formerly in the R.W. Smith collection and now in the Virginia Museum of Fine Arts, Richmond (see Smith 1957, no. 493), which was acquired in Syria. A comparable cup with applied human faces or masks is in the Oppenländer collection (inv. no. 2279); it is catalogued as nineteenth century in von Saldern et al. 1974, no. 738.

38　Were it not for a piece in an identical shape in the Newark Museum (inv. no. 50.1899; see Auth 1976, no. 214), this drinking vessel, or rhyton, could be dismissed as an object that originally came from the broken neck of a bottle and was recently reworked. In light of the object in Newark, however, cat. 1.12 is probably an early Islamic version of Achaemenid

and Sasanian drinking horns. Other boot-shaped drinking vessels are found in the Corning Museum of Glass (inv. no. 71.1.1; see *JGS*, 15, 1973, p. 189, no. 15) and the Victoria and Albert Museum, London (inv. no. C75-1967). A fragment excavated at Fustat is now in the Museum of Islamic Art, Cairo (Pinder-Wilson–Scanlon 1973, pp. 23–24, figs. 24, 25).

39  These objects are usually identified as gaming pieces. Evidence for a different use, namely as weights for a small scale, is found in a jeweller's *mīzān* (scale) set in the al-Sabah Collection (LNS 836 M). Dating from eighteenth- or nineteenth-century Mughal India, the box includes a set of weights in agate of different dimensions whose profile is virtually identical to the supposed gaming pieces. Two other glass objects in the Collection (LNS 355 Ga, b) of similar shape and dimensions but presenting a drilled hole have been identified as spindle whorls or loom weights and will therefore be included in a future catalogue of textiles. One is made of gray, white, and red marbled opaque glass; the other is opaque bright yellow.

40  Dome-shaped bottles, in both glass and metal, were common in ninth- and tenth-century Iran. The decoration of well-distanced shallow ovals on this bottle and on cat. 9c was widespread and derived from the facet-cut vessels discussed at cat. 8 and 9. A large number of facet-cut dome-shaped bottles are in public and private collections. A nearly identical example is in the Victoria and Albert Museum, London (C121-1929); another in the Nationalmuseum, Stockholm, was reportedly found at Rayy (Lamm 1935, pl. 6a).

# 2

# THE EARLY PERIOD

## (ca. late 7th to 11th century)

## STAINED ("LUSTER-PAINTED") GLASS

ADISCUSSION ON EARLY ISLAMIC stained glass must begin with a technical explanation, since this particular type of decorated glass is usually referred to as "luster-painted" rather than "stained." The technique of luster-painting represents one of the highest achievements in Islamic pottery from the ninth century onward. This Islamic production influenced fifteenth- and sixteenth-century Spanish lusterwares (in particular, those produced at Manises and Valencia) and later European ceramics in general. Painting on glass that achieves a similar lustrous effect to that on pottery was thought to be intimately related to luster pottery and is thus usually described as "luster-painted" in the literature on the subject. However, the chemical changes that take place on the surface of glass when a pigment containing silver and/or copper is applied and fired at a low temperature are quite different from those that occur on the glazed surface of pottery. The final result is also dissimilar, since the surface of ceramic objects acquires an iridescent metallic film and remains lustrous, while the surface of glass changes color, but can only in a small number of cases be described as truly lustrous.[1]

Painters of glass decorated an object by applying a substance that contained silver and, in some cases, also copper, in order to obtain varied results.[2] When fired at a low temperature, the silver ions reacted with the glass surface and replaced the sodium ions in the chemical composition, while the latter migrated to fill diverse positions in the silicate network of the glass structure. In other words, the painted pigment migrated, or was "absorbed," beneath the glass surface, thus coloring it permanently while being imperceptible to the touch. To use a familiar analogy, this process is comparable to a greasy stain penetrating the fibers of cloth. Silver-based paints became yellow when fired then slowly turned amber-colored and, eventually, deep brown. The longer the color was fired, the darker it became.[3] Monochrome amber and brown

stains, which rarely show a truly lustrous surface, represent the largest class of stained-glass objects produced in the Islamic period (see cat. 10–12, 14, 2.1a, 2.4a–i).

Chemical changes were more complex in the presence of copper or copper mixed with silver, and excellent control was required of the glassworker. Copper stains turned yellow for a moment then changed into reddish and ruby red colors as soon as the cuprous oxide grains started to develop (cat. 2.3e–h). The copper, reduced in the atmosphere of the kiln, was eventually deposited on the glass surface and imparted a lustrous effect comparable to that in ceramic production. This effect does not appear very often in Islamic glass. The glass decorators seem to have achieved better control of the quick deepening of the reds by adding silver to the composition. In this way, the growth of the cuprous oxide grains was slowed, so that yellow and orange stains could also be obtained (cat. 13, 2.3a, b, 2.3j–p).

In a few instances, namely when cuprous oxide grains were left to develop into a deep red color, a metallic film, otherwise typical of luster-painted pottery, is clearly noticeable on the glass surface. In all other cases, even taking into account the wear and tear of age and burial, which might have caused the surface to lose its metallic qualities, the term "luster" hardly seems appropriate. For this reason, the term "stained" will be used here to describe Islamic glass decorated in this manner.

The origin of glass staining harks back to the pre-Islamic, circa third-century Roman period in Egypt, when silver and copper alloys were used as a substitute for gold on different media, including glass, before they were applied to a surface using heat in a furnace.[4] The heating of silver-based pigments was in all probability "invented" by Coptic glassmakers in Egypt in the sixth or seventh century. This attribution seems to be confirmed by a small number of surviving cups decorated with late antique motifs

and by a fragment excavated at Fustat bearing a date in Coptic numerals equivalent to A.D. 779.[5]

Egyptian and Syrian glassmaking factories probably had a monopoly on stained-glass production until the twelfth century. Isolated objects and fragments of stained glass have been excavated in such remote lands as modern Tajikistan, Sri Lanka, and China, but this phenomenon should be regarded as a result of the extensive glass trade between the Near East and eastern Asia.[6] The overwhelming majority of fragments and partial vessels decorated with staining were found in Egypt or were reported as having an Egyptian provenance. An exception is the ninth-century material excavated at Samarra, which, in general, looks rather different from the standard stained glass attributed to Egypt.[7] Lamm proposed that a brief period of stained-glass production was inspired in Samarra by Egyptian glass painters who emigrated to the new 'Abbasid capital (also giving impetus to luster-painted pottery) and by the taste for polychrome glass surfaces stimulated by the production of millefiori glass.[8]

Altogether missing from Lamm's picture, however, is the Syrian area. As he was writing in 1941, the most important piece of information had yet to be found: two stained-glass cups and a bowl (now in Cairo, Corning, and Damascus) discovered in the 1950s and 1960s.[9] All three objects are inscribed in Kufic and provide, directly or indirectly, a place of production. The inscriptions on the Corning cup and the Damascus bowl, the latter found at Raqqa in Syria, plainly state that the objects were made in Damascus. In addition, the former includes a legible numeral 1[...] as part of its date, which proves that it was made in the second century A.H. (A.D. 718–815). The second cup, possibly a goblet without its stem, was excavated at Fustat in Cairo in 1965 and it has been suggested that was commissioned by a governor of Egypt who was in office for only one month in A.D. 772. These objects are evidence that stained glass was produced both in Syria, and almost certainly in Egypt, in the eighth century. This dismisses speculation that pieces made in Damascus were decorated in Egypt or that the supposed 'Abbasid governor ordered his cup in Syria and had it brought to Cairo. The extant material, however, is too scant to allow a proper understanding of the characteristic traits of the two productions and leaves room for speculation about what was made where. It is probably safe to say that stained glass was produced mainly in Egypt and that a smaller amount was made in Syria.

Lamm established an internal chronology of stained glass in the Islamic period that has been embraced, with minor variations, here. His chronology was based mainly on his firsthand study of the numerous fragments of Egyptian provenance in museums in Cairo, Athens, and, to a lesser extent, Stockholm[10] and was, therefore, largely inductive. To Lamm's credit, his chronology is corroborated by the above-mentioned objects discovered after he wrote his publication, which were unquestionably produced in the eighth century.

Based on late Roman and Coptic prototypes,[11] silver stains were applied on early Islamic glass in one or more colors, all of them various shades of amber and brown, on both sides of a vessel when the open shape (of a cup or bowl, for example) made this technically possible (cat. 10, 11, 2.1a, b). It is not clear whether this was a sophisticated, deliberate way to obtain subtle effects of shading when the painting was seen through the glass, or if it represented a mere continuation of a previous tradition of glass painting that lasted until the staining technique gained popularity; the latter hypothesis seems more likely. Double-sided painting was popular in the eighth century, as confirmed by the goblet excavated at Fustat mentioned above.

Later, better control of the firing temperature, the utilization of copper mixed with silver, and the search for new chromatic effects gave rise to a production of yellow, orange, and red stains (cat. 13, 2.3b, c, j–p). Usually, dark glass—either blue, green, or purple—was chosen for these stains in order to achieve even more vivid effects. These colored stains are often applied on both sides of a vessel, not to obtain subtle shading effects but, rather, to impress the viewer by "hiding" the glass surface with colorful coatings. One side is usually coated with one color while the other presents two or three mottled, overlapping, and mixed colors (cat. 13). This "polychrome" phase, for which a date in the ninth or tenth century seems appropriate as part of the Samarran legacy brought about in Egypt under the Tulunids, probably lasted until the innovative Fatimid artistic language took shape.

The last phase of stained glass falls into the Fatimid and early Ayyubid periods, approximately in the eleventh and twelfth centuries, though it reappears in the Mamluk era (see cat. 99). This period is probably the best from an artistic point of view, since painting on glass seems to have become an established art form, along with painting on more familiar media, such as pottery and plastered wall panels. Scenes inspired by sophisticated ivory and wood carvings, including animals and human figures, were depicted on glass, admittedly with mixed results but certainly at a generally high artistic level. Double-sided painting was in most cases abandoned in order to concentrate attention on a single pictorial surface; the glass itself regained the hyalescent texture that was abandoned during the previous polychrome phase and became once again the background, colorless or slightly tinged, on which figures and patterns were drawn (cat. 14, 2.4a–i).

Although the extant fragments do not allow definitive assertions, the eleventh century is also the period when luster-painting on pottery and staining on glass found a common stylistic

ground. This relation is manifest, for example, in the so-called styles of the pottery painter Muslim and of the *sa'd* group (early and mid-eleventh century) and in a similarly decorated glass fragment in the Benaki Museum, Athens, which also includes the word *sa'd*, thus suggesting, albeit not proving, that the same artists could have worked in both media.[12] An almost complete stained-glass bowl with flaring sides in the Metropolitan Museum, thus far attributed to the ninth century, may well be part of the same group.[13]

The last period of stained-glass production, spanning the late Fatimid and the early Ayyubid periods, includes painting in greenish stains on colored surfaces, mainly dark blue and purple. Abstract decoration predominates, in the form of geometric motifs and zigzag patterns filled with indistinct vegetal ornaments (cat. 15). For unknown reasons, possibly related to the temporary blackout of Fustat as the main center of glass production after 1168, stained glass became increasingly less popular and became confined to minor areas when other methods of surface decoration, especially enameling combined with gilding, rose to excellence and continued an unsurpassed tradition of glass decoration for the next two centuries.

**Cat. 10 CUP (LNS 319 G)**
**Syrian or Egyptian region**
**7th–8th century**

Dimensions: hgt. 7.5 cm; max. diam. 8.5 cm;
th. 0.18 cm; wt. 35.1 g; cap. 234 ml
Color: Translucent pale blue or bluish colorless
(blue 1); yellowish brown stain
Technique: Free blown; tooled; pinched; stained;
worked on the pontil
Description: This cup has a rounded base and
flaring, slightly curving sides that end in
a somewhat bulging rim. Eleven small
feet, on which the cup stands, were
created by pinching the base of the
vessel outward. The main stained
decoration is enclosed between simple
bands: it shows three figures wearing
long tunics and carrying flowers or
stemmed leaves alternating with three
winged quadrupeds. The main outlines
were painted on the external surface of
the cup; details, such as heads, belts,
leaves and dots, were drawn inside.
Condition: The object was broken and repaired
and several small gaps were filled
during conservation. The base is intact
but parts of the stained decoration
are missing. The surface is in good
condition. The glass is of good quality
and includes scattered small bubbles.
Provenance: Reportedly from Raqqa, Syria
Related Works: 1. MFI (Pinder-Wilson–Scanlon 1973,
figs. 40–42)
2. CMG, inv. nos. 79.1.67; 69.1.1;
64.1.33 (*JGS* 22, 1980, p. 104, no. 9;
*JGS* 12, 1970, p. 174, no. 22)
3. CMNH, inv. no. 26543/7
(Oliver Jr. 1980, no. 271)
4. NM, Damascus, inv. no. 16022
(Damascus 1964, no. 29)

The decoration on this cup cannot be regarded as one of the most accomplished artistic examples of silver-stained glass. Nonetheless, the paucity of nearly complete objects of this type, as well as the presence of an atypical base formed by small pinched feet, make it an interesting piece. The cup fits well into the group of standard stained objects, showing such typical features as good-quality pale aquamarine-colored glass, fine blowing, and a monochrome brownish stain painted on both sides. A small number of cups have the same, or a similar, conical profile, including the piece excavated at Fustat that is possibly datable to the last third of the eighth century and the cup in Corning that was made in Damascus (see Related Works 1, 2 [inv. nos. 69.1.1, 79.167], and 3).[14] This conical shape might suggest that these cups were once part of goblets, the stems of which are missing: the object from Fustat (Related Work 1) has a sharp break at the base that may represent the remains of a stem rather than a pontil mark; the piece in Pittsburgh (Related Work 3) is, indeed, an intact goblet.

The pinched feet of the present cup, however, leave no doubt that it is a finished product. The tiny knobs pinched out from the glass were traditionally a feature of glass produced in the Mesopotamian and Iranian regions in the Sasanian period, rather than in Egypt and Syria—that is, the areas where silver-stained glass was produced. Fragments have been excavated at, for example, Tell Mahuz and Seleucia in Iraq and have also been found in Gilan, Iran, and at the site of Mantai, northern Sri Lanka, the latter in an Islamic context.[15] These knobs form a circular pattern, a sort of crown close to the base, which at times was intended to give more stability to the object but was also often meant as a purely decorative device.

The decoration of this cup is sketchy and difficult to read. A number of other objects and fragments belonging to this group also present such unaccomplished decoration. The winged quadrupeds holding a twig in their mouth cannot be better identified. In addition, it is not clear whether the standing figures are offering the flowers (or leaves) to the fantastic creatures or if they are just depicted in a manneristic circular procession. A good parallel for the quadrupeds is offered by an even more sketchily painted cylindrical bowl in Corning (Related Work 2, inv. no. 64.1.33) on which the creatures can probably be identified as birds with animals' heads, but their profiles are so stylized that the figures are indistinct. In addition, the bodies of these birds are filled with dots exactly like the animals' wings and the standing figures' skirts of cat. 10. A cylindrical cup in Damascus (Related Work 4) shows the same use of dots to fill geometrical areas. In general, an attribution to Syria for cat. 10 seems more likely than Egypt.

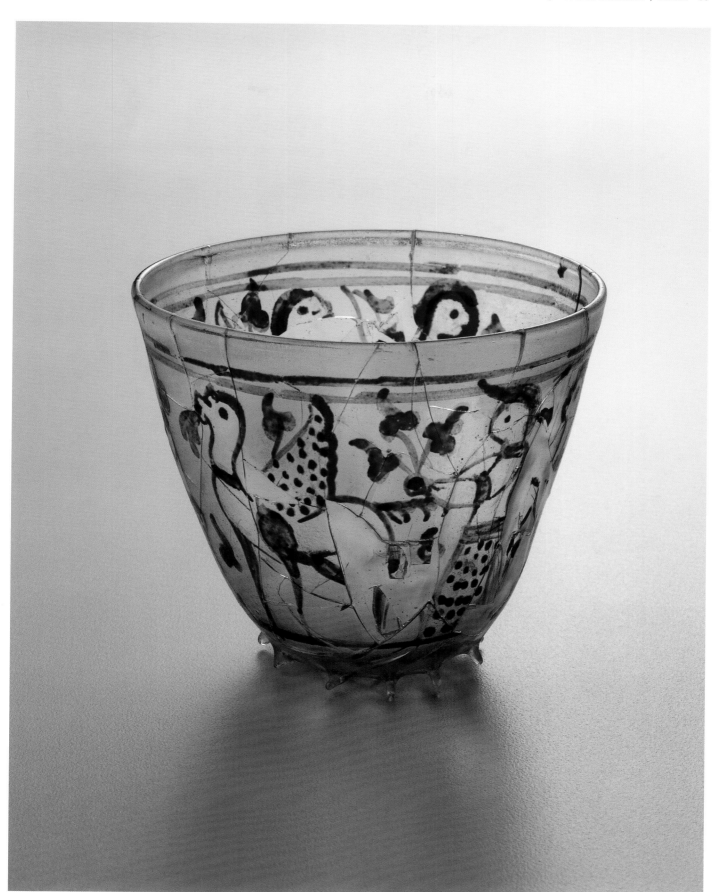

Cat. 10

Cat. 11

## Cat. 11 FRAGMENT OF A BOWL
### (LNS 180 G)
### Egyptian or Syrian region
### 8th century

Dimensions: max. w. 8.6 cm; max. l. 6.2 cm;
th. 0.18 cm
Color: Translucent grayish colorless;
reddish brown stain
Technique: Blown; stained
Description: This fragment is from the rim and wall
of a cylindrical bowl, and is painted on
both sides. Under the band, just below
the rim, a complex, dense vegetal
pattern, including a large branch,
scrolls, and three-lobed and pointed
leaves, fills the entire surface of this
fragment. Most of the details are
drawn on the outer surface, while
highlights are painted on the inside.
Condition: The surface is lightly weathered,
resulting in a milky white coating.
The glass includes scattered tiny
bubbles.
Provenance: Kofler collection; gift to the Collection

This outstanding fragment once belonged to one of the most accomplished monochrome stained bowls produced in the early Islamic period, probably in the eighth century. Its profile suggests that, when intact, the vessel would have been a cylindrical bowl with either a flat or a rounded base, both typologies being fairly common.[16] The vegetal decoration, painted on both sides, fills the entire background and was freely drawn in an artistic manner. Perhaps the fragmentary semicircular pattern on the right side represents the forepart of a bird perched among the vegetation, a detail that would have made this bowl even more appealing and comparable to similar scenes in late Umayyad and early 'Abbasid art.

Although the parallel is not so immediate, stylized vegetal decoration is also present on two well-known conical bowls in the Museum of Islamic Art, Cairo and in Corning.[17] These two objects are especially important for the study of stained glass because the former was excavated at Fustat and the latter has an inscription that mentions it was produced in Damascus.[18] The decoration on this fragment was drawn in a freer, less stylized manner than that on its celebrated counterparts. It is therefore difficult to suggest either a Syrian or an Egyptian provenance for it. A dating to the eighth century seems to be the most acceptable considering the original shape of the vessel, the color of both glass and staining, and the decoration applied on both sides of the bowl.

## Cat. 12 DISH (LNS 44 G)
### Probably Egyptian region
### 8th–9th century

Dimensions: hgt. 3.4 cm; max. diam. 22.5 cm;
th. 0.15 cm; wt. 204.4 g

Color: Translucent pale green (green 1–2);
yellowish brown stain

Technique: Free blown; tooled; stained;
worked on the pontil

Description: The shape of this dish was produced
by tooling after the parison was blown,
attached to the pontil, opened, and
spun. The dish presents a flared wall
with its rim folded outward. The base
has a "wavy" profile and a kick in the
center. The silver-stained decoration,
painted on only the interior surface,
is monochrome brown and shows a
central eight-petaled flower; in the
spaces between the petals are eight
triangular figures, each including an
unpainted circle in the center. Two
circular bands, one of them filled with
brown stain, enclose the central pattern.
An inscription in Kufic was copied
around the interior of the wall. A
second band filled with brown stain
runs above the inscription and another
band was painted on the rim. A partial
reading of the inscription is as follows:

بركة وخير من ما[ كول] ...؟/ ...؟
مودعك [ ح] د[ ي]ـث قاعها لما
اكتحلت من الغزال الأغيد

("Blessing and well-being from [the
food] eaten [from this dish?] . . . . I
shall tell you a story, the essence of
which lies in the moment my eyes were
embellished with kohl when I saw the
gazelle with a curving neck")

Condition: The object was broken and subsequently
repaired. About one-fifth of the surface
was missing, including small parts of
the stained decoration, and was filled
in. The surface is lightly weathered,
resulting in a milky white film. The
glass is of good quality and includes
scattered small bubbles.

Provenance: Sotheby's, London, sale, April 21–22,
1980, lot 297

Literature: Jenkins 1983, p. 29; and Sa'diya 1989,
p. 67

Related Works: 1. CMG, inv. no. 55.1.152
(Smith 1957, no. 520)
2. Famen Buddhist Temple Museum,
inv. no. FD5:003 (An 1991, fig. 10)
3. Ex coll. Prince Yusuf al-Kamal,
Cairo (Lamm 1929–30, pl. 34:8)
4. CMG, inv. no. 99.1.1
5. MFI (Lamm 1929–30, pl. 36:1; and
Pinder-Wilson–Scanlon 1973,
figs. 40–42)

This dish represents one of the few complete, or nearly complete, vessels decorated with the technique of silver staining. Flat-bottomed flared bowls as well as round-bottomed cylindrical bowls are the most common; plates and dishes are rare and their profiles may vary (see Related Works 1–4). The decoration of this dish is unparalleled, though a number of fragments provide fairly good matches (see Related Work 5) and the figure of a multipetaled flower, or rosette, that radiates from the center of the base of some bowls and cups is common in the early examples of silver-stained glass. The famous cup found in Fustat (Related Work 5) that has been tentatively dated 772, shows a twelve-petaled rosette at the bottom. Cups and bowls assigned to this early period are usually painted on both sides (see cat. 10–11) while some of the few known plates, including the present one, are decorated on only one side, namely the interior, or the side facing the viewer. Dishes probably were not decorated on both sides as their nearly flat surface would not have provided the subtle chromatic effect offered by a bowl or a cup, which were meant to contain liquids.

The Kufic inscription on cat. 12 is only partially legible because of damage, making it difficult to read and reconstruct the entire sentence. The inscription, however, seems to be related to the function of this object as a food tray. The calligraphic style helps to confirm a dating about the eighth to ninth century for the dish. The beginning of the sentence offers common wishes; the remainder is a poetic phrase in praise of feminine beauty in meter *kāmil*.

Cat. 12

**Cat. 13 FRAGMENT (LNS 140 KG)**
**Egyptian region**
**9th–10th century**

Dimensions: max. w. 4.8 cm; max. l. 4.5 cm;
th. 0.39 cm
Color: Translucent cobalt blue (blue 5);
orange and pale yellowish green stain
Technique: Blown; stained
Description: This slightly curving fragment is
painted on both sides. The main
decoration is on the convex side and
shows different types of vegetal scrolls
arranged in three bands. The concave
side shows a coating of orange stain
without decorative elements.
Condition: The surface is slightly abraded but in
good condition. The glass is of good
quality.
Provenance: Kofler collection
Literature: Lucerne 1981, no. 626

Cat. 13

The types of vegetal scrolls depicted on this fragment were drawn freely to create an effect of movement and of superimposition of forms. The vivid contrast of colors—deep blue for the glass itself and bright orange and pale green for the colored stains—adds to the appeal of the decoration. As mentioned previously, orange stains were in use from the seventh through the tenth century.

Vessels decorated in this colorful manner, of which only fragments survive apart from an outstanding, almost complete jug in Corning,[19] compare in many ways to the taste for millefiori glass in ninth-century Samarra (see cat. 7a–c) and thus seem datable to the same period in Egypt. An Egyptian provenance for this fragment is strongly supported by another fragment excavated at Fustat, also in Corning.[20] The colors of the glass and the stains as well as the decoration of large scrolling leaves against a dotted background are virtually identical in the two fragments, making it possible to suggest that they once belonged to the same vessel. Another fragment in the Nationalmuseum, Stockholm, probably earlier and, according to Lamm, "perhaps the most splendid example of the entire class I have ever seen,"[21] shows a somewhat similar vegetal decoration though painted on greenish, instead of blue, glass.

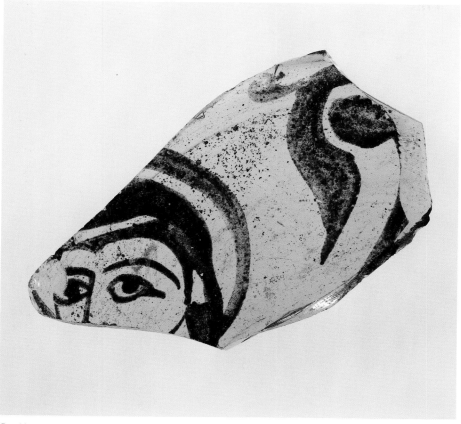

Cat. 14

**Cat. 14 FRAGMENT OF THE BASE
OF A PLATE OR BOWL
(LNS 169 KG)
Egyptian region
11th century**

Dimensions: max. w. 6.5 cm; max. l. 4.7 cm;
th. 0.32 cm
Color: Translucent greenish colorless;
yellowish brown stain
Technique: Blown; stained
Description: This fragment, painted on one side,
once belonged to the base of a vessel,
perhaps a flat-bottomed bowl or a
plate. The decoration includes a
fragmentary male head: the eyes, a
section of the nose, the left ear, and
part of the long hair and of the halo
that surrounds the head are still visible.
A small section of a complex vegetal
pattern is discernible on the right.
Condition: The surface is in good condition. The
glass includes tiny scattered bubbles.
Provenance: Kofler collection
Literature: Lucerne 1981, no. 626

This fragment of a plate or bowl was once part of one of the most refined silver-stained glass paintings produced in the Fatimid period in Egypt. Analyzing the extant objects and fragments, it may be said that the artistic quality of stained painting varied but rarely matched contemporary production on pottery or plaster. In addition, scenes with human figures were rare compared to the large number of vegetal and geometric patterns. During the Fatimid period in the eleventh and twelfth centuries, skilled artists evidently also painted on glass, narrowing the artistic gap between media.

This small fragment clearly demonstrates the close relationship between painting on glass and contemporary painting. The haloed figure's open eye, with its extended line on the side, his long eyebrow, the single brushstroke used to draw both eyebrow and nose, and the head in quarter profile are all characteristic of the finest Fatimid painting. A number of examples on pottery, paper, and plaster provide good comparisons for this figure, among them a fragment of the base of a luster-painted bowl in the Keir collection (11th–12th century);[22] the head and shoulders of a youth from a paper fragment found at Fustat, also in the Keir collection (12th–13th century);[23] and some fragments from the painted walls (more precisely, the *muqarnas*) of the *hammam* of Abū Su'ūd, south of Cairo, now in the Cairo Museum (11th–12th century).[24] These examples help date and provide an appropriate context for this small fragment. They also emphasize the relationship between luster-painted pottery and silver-stained glass, a connection that is discernible only in the Fatimid period.

Cat. 15a–c

**Cat. 15a FRAGMENT OF A CYLINDRICAL BOTTLE**
(LNS 178 Ga)
**Egyptian region**
**11th–early 12th century**

Dimensions: max. hgt. 2.3 cm; max. diam. 5.0 cm; th. 0.20 cm
Color: Translucent purple; silvery greenish stain
Technique: Blown; stained; worked on the pontil
Description: This fragment once belonged to the base and body of a cylindrical bottle. The pontil mark is still visible in the center of the base. The remaining stained decoration, painted on the exterior, shows scrolling patterns inside circles that are repeated around the wall, near the base. The same pattern probably once filled the entire surface of the bottle.
Condition: The surface is in good condition.
Provenance: Kofler collection; gift to the Collection

**Cat. 15b FRAGMENT OF A POLYGONAL BOTTLE**
(LNS 178 Gb)
**Egyptian region**
**11th–early 12th century**

Dimensions: max. l. 5.4 cm; max. w. 3.7 cm; th. 0.28 cm
Color: Translucent purple; silvery greenish stain
Technique: Mold blown; stained
Description: This fragment is from the body of a molded polygonal bottle. Of the original six, or perhaps seven, sides, two sides and a fraction of a third have survived. A fraction of the flat base also remains. The stained decoration was painted on the exterior wall. One side shows a vegetal scrolling ornament, the other has a zigzag pattern filled with sketchy scrolls.
Condition: The surface is in good condition.
Provenance: Kofler collection; gift to the Collection

**Cat. 15c FRAGMENT OF A POLYGONAL BOTTLE**
(LNS 163 KG)
**Egyptian region**
**11th–early 12th century**

Dimensions: max. l. 6.6 cm; max. w. 3.1 cm; th. 0.33 cm
Color: Translucent dark purple; greenish yellowish stain
Technique: Mold blown; stained
Description: This fragment is from the body of a molded polygonal bottle, two sides of which have survived. The stained decoration was painted on the exterior wall. The ornament on one side is divided into squares, the second is formed by a zigzag pattern. Both sides are filled with sketchy vegetal patterns.
Condition: The surface is in good condition. The glass includes frequent small bubbles and some larger ones.
Provenance: Kofler collection
Literature: Lucerne 1981, no. 626
Related Works: 1. MFI, inv. nos. 3661, 5632 (Lamm 1929–30, pls. 40:10, 40:11)
2. Benaki, inv. no. 3.516a (Clairmont 1977, pl. 9, no. 140)

Two almost complete polygonal bottles in brownish purple glass decorated with stains are preserved in the Museum of Islamic Art, Cairo (Related Work 1). They suggest that cat. 15b and c once belonged to similar elongated, molded, six- or seven-sided bottles with a total height of about 18 cm. These bottles had funnel-shaped necks and their entire surfaces were decorated with stains. Another published fragment is in the Benaki Museum, Athens (Related Work 2) and about fifty more fragments belonging to this group are in the Cairo Museum.[25]

Cylindrical purple bottles, as suggested by cat. 15a, are reported in the literature less frequently, since only small fragments survive and it is more difficult to reconstruct their original shape and diameter.[26] However, their stained decoration and glass color suggest that they should be discussed within the same group as the multisided vessels.

Toward the end of the Fatimid period, stained decoration on glass became abstract and simplified, consisting of sketchy vegetal scrolling motifs inside zigzag patterns and geometric ornaments.[27] Vividly colored glass, either purple or blue, was used to produce dramatic effects in spite of the simplified decorative motifs. It is possible to suggest that Fatimid cylindrical stained bottles inspired a slightly later twelfth-century production of similar purple and dark blue bottles decorated with gilt and enamel. An origin for these bottles has not been firmly established: they were found in Corinth, Cyprus, Dvin in Armenia, and especially in Novogrudok; therefore, both a Mediterranean and a Russian origin have also been suggested.[28]

### Cat. 2.1a FRAGMENT OF A BOWL
### (LNS 68 G)
### Egyptian or Syrian region
### 8th century

Dimensions: max. w. 5.0 cm; max. l. 4.3 cm;
th. 0.21 cm
Color: Translucent pale green (green 1);
yellowish brown stain
Technique: Blown; stained
Description: This slightly curved fragment is
probably from the side of a bowl. The
decoration was painted on both sides in
a yellowish brown silver stain: a plant
growing from a horizontal line at the
bottom was drawn on the outside wall
and a large leaf was painted inside.
Condition: The surface is partially weathered,
resulting in gray and pale brown
pitting. The glass is of good quality.

### Cat. 2.1b FRAGMENT (LNS 181 G)
### Egyptian or Syrian region
### 8th century

Dimensions: max. w. 5.1 cm; max. l. 3.1 cm;
th. 0.25 cm
Color: Translucent bluish colorless; yellowish
brown and reddish brown stains
Technique: Blown; stained
Description: This curved fragment is painted on both
sides. The decoration shows stylized
vegetal motifs in yellowish brown stain
on the convex side, and in dark reddish
brown on the concave side.
Condition: The surface is lightly weathered,
resulting in a milky white coating.
The glass is of good quality.
Provenance: Kofler collection; gift to the Collection

### Cat. 2.1c FRAGMENT (LNS 219 KG)
### Egyptian or Syrian region
### 8th century

Dimensions: max. w. 4.0 cm; max. l. 1.4 cm;
th. 0.13 cm
Color: Translucent pale blue (blue 1);
brown and bluish green stains
Technique: Blown; stained
Description: This curved fragment is painted on
both sides. The decoration is unclear.
A brown stain was painted on the
convex side and the pattern is
highlighted by the bluish green
stain on the concave side.
Condition: The surface is lightly weathered,
resulting in a milky white coating.
The glass includes frequent bubbles.
Provenance: Kofler collection

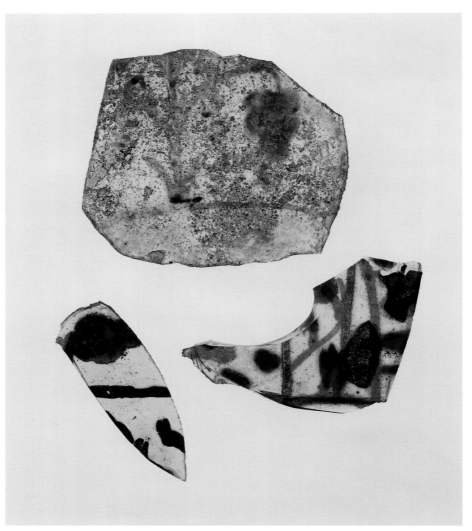

Cat. 2.1a–c

## Cat. 2.2 FRAGMENT (LNS 195 KG)
### Egyptian or Syrian region
### 8th–9th century(?)

Dimensions: max. w. 2.6 cm; max. l. 2.0 cm;
th. 0.14 cm

Color: Translucent pale bluish green;
blue, red, and yellow stains(?)

Technique: Blown; stained(?)[29]

Description: This small fragment is painted in blue,
red, and yellow on one side. The colors
were applied with a brush in haphazard
blotches, and often overlap and mix.

Condition: The surface is in good condition though
it presents some scratches.

Cat. 2.2

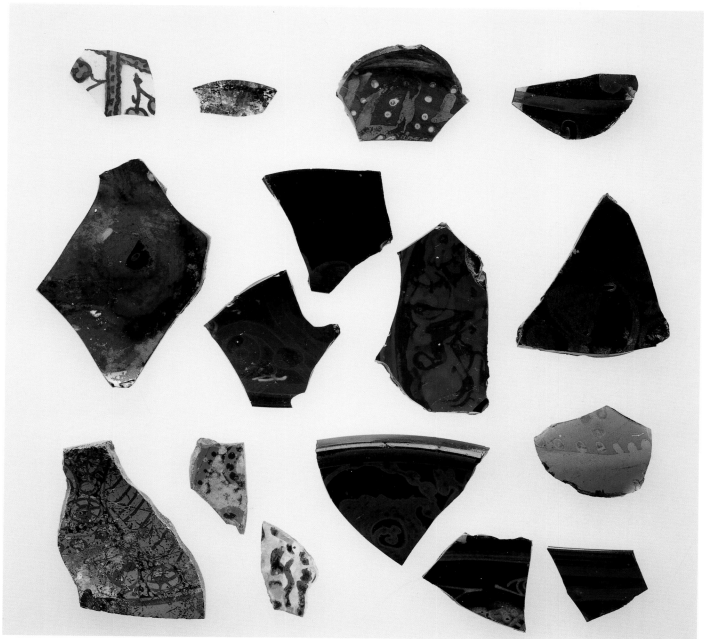

Cat. 2.3a–p

**Cat. 2.3a FRAGMENT (LNS 182 KGg)**
**Egyptian or Syrian region**
**9th–10th century**

Dimensions: max. w. 3.2 cm; max. l. 2.3 cm;
th. 0.06 cm
Color: Translucent colorless; dark and
pale brown stains
Technique: Blown; stained
Description: This slightly curved fragment is painted
on both sides. The decoration is unclear
but seems to include stylized vegetal
motifs set within square sections. One
side is painted with pale brown stain,
while a darker brown coating highlights
the motifs on the other side.
Condition: The surface is lightly weathered,
resulting in a faint whitish film.
Provenance: Kofler collection
Literature: Lucerne 1981, no. 626

**Cat. 2.3b FRAGMENT (LNS 176 KG)**
**Egyptian or Syrian region**
**9th–10th century**

Dimensions: max. w. 2.9 cm; max. l. 1.3 cm;
th. 0.13 cm
Color: Translucent bluish colorless; bluish
green, mustard yellow, and dark
brown stains
Technique: Blown; stained
Description: This curved fragment is painted on both
sides. The decoration is unclear. Bluish
green and vivid mustard yellow stains
were painted on the concave side and a
dark brown stain coats the convex side.
Condition: The surface is lightly weathered,
resulting in a milky white coating. The
dark brown stained coating is abraded.
The glass includes scattered bubbles.
Provenance: Kofler collection
Literature: Lucerne 1981, no. 626

**Cat. 2.3c FRAGMENT OF THE BASE**
**OF A VESSEL (LNS 187 KG)**
**Egyptian region**
**9th–10th century**

Dimensions: max. w. 4.5 cm; max. l. 4.0 cm;
th. 0.23 cm
Color: Translucent yellowish green (green 3);
dark purple, pale brown, and whitish
stains
Technique: Blown; stained
Description: This fragment from the base and wall
of a vessel is painted on both sides with
a purple coating. The unclear decoration
shows pale brown strokes and dots
painted in a whitish yellow stain.
Condition: The surface is in good condition. The
glass includes scattered small bubbles.
Provenance: Kofler collection
Literature: Lucerne 1981, no. 626

**Cat. 2.3d FRAGMENT (LNS 141 KGa)**
**Egyptian region**
**9th–10th century**

Dimensions: max. w. 4.1 cm; max. l. 2.1 cm;
th. 0.19 cm
Color: Translucent green; red and pale
yellowish green stains
Technique: Blown; stained
Description: This curved fragment is painted on
both sides. The decoration shows a red
band and an unclear vegetal pattern in
yellowish green stain on the concave
side. The other side has a plain red
coating.
Condition: The surface is in good condition.
The glass includes frequent small
bubbles.
Provenance: Kofler collection
Literature: Lucerne 1981, no. 626

**Cat. 2.3e–h FOUR FRAGMENTS**
**(LNS 183 Ga–d)**
**Egyptian region**
**9th–10th century**

Dimensions (largest fragment) max. w. 8.0 cm;
max. l. 6.1 cm; th. 0.20 cm
Color: Translucent dark olive green (green 4);
red and green stains
Technique: Blown; stained
Description: These fragments are painted on both
sides (cat. 2.3e, g, and h probably
belonged to the same vessel, possibly
a bowl); cat. 2.3e is from the base of a
vessel, since it includes a pontil mark;
cat. 2.3g includes part of the rim of the
same vessel. The decoration, in vivid
red stain, shows a green vegetal pattern
inside the bowl and a plain red coating
on the exterior. The remaining fragment
(cat. 2.3f) comes from a different vessel
but was decorated in a similar manner.
Condition: The surfaces are lightly weathered,
resulting in a milky white coating.
Provenance: Kofler collection; gift to the Collection

**Cat. 2.3i FRAGMENT OF A BOWL**
**(LNS 179 G)**
**Egyptian region**
**9th–10th century**

Dimensions: max. w. 6.0 cm; max. l. 4.3 cm;
th. 0.37 cm
Color: Translucent dark olive green (green 4);
brown and green stains
Technique: Blown; stained
Description: This curved fragment, probably from
a bowl, is painted on both sides. The
decoration shows stylized vegetal motifs
painted in brown stain on the convex
side; a coating of green stain was given
a mottled effect on the concave side.
Condition: The surface is in good condition. The
glass includes scattered tiny bubbles.
Provenance: Kofler collection; gift to the Collection

## Cat. 2.3j FRAGMENT OF THE BASE OF A DISH OR BOWL (LNS 308 G)
**Egyptian region**
**9th–10th century**

Dimensions: max. w. 7.5 cm; max. l. 4.1 cm; th. 0.60 cm
Color: Translucent dark blue (blue 4–5); mustard yellow, reddish brown, and green stains
Technique: Blown; stained
Description: This curved fragment of uneven thickness is from the base of a dish or a bowl. It is painted on the interior side in a pattern including circles and unclear larger figures in three differently colored stains: mustard yellow, reddish brown, and green. The opposite side is too weathered to establish if it was originally stained or left plain.
Condition: The surface is entirely weathered, resulting in a gray coating on the exterior. The stained surface is scratched and pitted. The glass includes frequent small bubbles.
Provenance: Reportedly from Syria

## Cat. 2.3k, l TWO FRAGMENTS (LNS 139 KGa, b)
**Egyptian or Syrian region**
**9th–10th century**

Dimensions: (larger fragment) max. w. 3.8 cm; max. l. 2.2 cm; th. 0.27 cm
Color: Translucent colorless; orange and dark reddish brown stains
Technique: Blown; stained
Description: These two small fragments are body shards. The decoration was painted on one side in orange and reddish brown stains. Cat. 2.3k includes orange bands filled with dark dots on the convex side; cat. 2.3l displays snaky bands filled with dark streaks on the concave side.
Condition: The glass is of good quality. The surfaces are partially weathered, resulting in a milky white coating and abrasion.
Provenance: Kofler collection
Literature: Lucerne 1981, no. 626 (cat. 2.3k only)

## Cat. 2.3m, n TWO FRAGMENTS (LNS 129 KGa, b)
**Egyptian region**
**9th–10th century**

Dimensions: (larger fragment) max. w. 5.8 cm; max. l. 4.7 cm; th. 0.17 cm
Color: Translucent olive green (green 3); dark red, olive green, and yellowish green stains
Technique: Blown; stained
Description: These fragments are both painted with similar unclear patterns of dark red, olive and yellowish green stains but they belong to different vessels. Cat. 2.3m is from the splayed rim of a shallow bowl; cat. 2.3n is a slightly curved fragment of the body of another vessel. The interior of both fragments is coated with the same colors as the exterior surface.
Condition: The surfaces are in good condition. The glass of cat. 2.3n includes a large bubble.
Provenance: Kofler collection
Literature: Lucerne 1981, no. 626

## Cat. 2.3o FRAGMENT (LNS 175 KG)
**Egyptian region**
**9th–10th century**

Dimensions: max. w. 3.8 cm; max. l. 3.2 cm; th. 0.26 cm
Color: Translucent dark blue (blue 5); mustard yellow stain
Technique: Blown; stained
Description: This curved fragment is from the body of a vessel. It is painted in a mustard yellow stain on the concave side in a pattern of dots, next to a narrow band.
Condition: The surface is in good condition though it presents some scratches. The glass includes scattered bubbles.
Provenance: Kofler collection
Literature: Lucerne 1981, no. 626

## Cat. 2.3p FRAGMENT OF A BOWL (LNS 122 KGa)
**Egyptian region**
**9th–10th century**

Dimensions: max. w. 3.2 cm; max. l. 2.6 cm; th. 0.14 cm
Color: Translucent brown(?); golden brown stain
Technique: Blown; stained
Description: This fragment is from the rim of a finely blown bowl. Red opaque inclusions are mixed with the brown glass. It is painted with a coating of golden brown stain on the interior wall and with an unclear pattern of the same color on the exterior.
Condition: The surface is lightly weathered, resulting in a milky white coating.
Provenance: Kofler collection

## Cat. 2.4a–d FOUR FRAGMENTS
**(LNS 185 KGa–d)**
**Egyptian region**
**10th–11th century**

Dimensions: (largest fragment) max. w. 3.6 cm;
max. l. 2.9 cm; th. 0.17 cm
Color: Translucent bluish and yellowish
colorless; yellowish brown stain
Technique: Blown; stained
Description: These four fragments once belonged
to different vessels. Cat. 2.4a, which
includes part of the rim of a cylindrical
bowl, is in bluish colorless glass; the
remaining three fragments are yellowish
colorless body shards. The decoration
of the four fragments was painted on
one side only in yellowish brown silver
stain. The most complex, though
unclear, patterns are found on cat. 2.4a
and b; cat. 2.4c probably includes part
of an inscription; cat. 2.4d shows two
simple bands.
Condition: Cat. 2.4a is in good condition; it
includes small elongated bubbles near
the rim. The surfaces of cat. 2.4b–d are
lightly weathered, resulting in a milky
white coating; cat. 2.4c is pitted with
pale beige spots.
Provenance: Kofler collection
Literature: Lucerne 1981, no. 626 (except cat. 2.4b)

## Cat. 2.4e–g THREE FRAGMENTS
**(LNS 208 KGa–c)**
**Egyptian region**
**10th–11th century**

Dimensions: (largest fragment) max. w. 3.8 cm;
max. l. 3.0 cm; th. 0.09 cm
Color: Translucent yellowish and brownish
colorless; yellowish brown stain
Technique: Blown; stained
Description: These three fragments probably
belonged to two different vessels.
Cat. 2.4e and g, the latter from the rim
of a bowl, are yellowish colorless and
may have belonged to the same vessel;
cat. 2.4f is brownish colorless but it has
a decoration of simple bands similar
to that on the other two fragments.
Yellowish brown silver stain was
applied on one side of the three
fragments. Remains of an inscription
are present on cat. 2.4e.
Condition: The glass is of good quality. The
surfaces are lightly weathered,
resulting in a milky white coating.
Provenance: Kofler collection
Literature: Lucerne 1981, no. 626

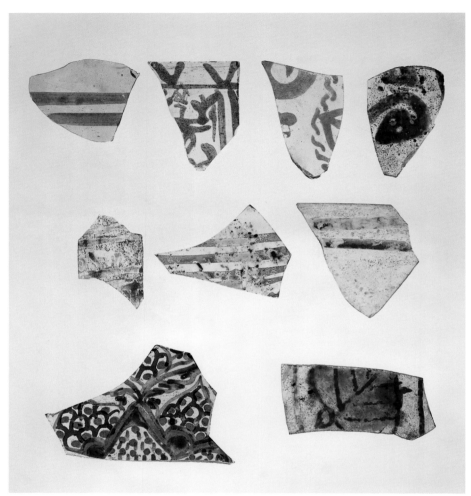

Cat. 2.4a–i

## Cat. 2.4h, i TWO FRAGMENTS
**(LNS 182 Ga, b)**
**Egyptian or Syrian region**
**10th–11th century**

Dimensions: (larger fragment) max. w. 6.1 cm;
max. l. 3.7 cm; th. 0.22 cm
Color: Translucent bluish colorless;
brown and yellowish brown stains
Technique: Blown; stained
Description: These two fragments, almost flat in
profile, are from two different vessels.
Both display stylized vegetal decorations
painted on one side in two tones of
brownish silver stains. Cat. 2.4h
includes small dots and lines filling
geometric compartments; cat. 2.4i
shows a large stylized leaflike pattern.
Condition: The surface is in good condition. The
glass includes frequent small bubbles.
Provenance: Kofler collection; gift to the Collection

# NOTES

1 On the technical and chemical differences between stained glass and luster-painted pottery, see Caiger-Smith 1985, pp. 24–29.

2 For detailed information on glass staining, see Brill 1970; see also Heaton 1948 and Lillich 1986.

3 If glass is fired too long, chemical changes make a stain all but disappear almost magically, thus restoring the glass to its pre-painted state.

4 Caiger-Smith 1985, p. 25, n. 3.

5 One such cup is in the Victoria and Albert Museum, London (inv. no. C24-1932; see Lamm 1941, pl. 9 [left] and Caiger-Smith 1985, pl. 6). The fragment is in the Museum of Islamic Art, Cairo (see Pinder-Wilson–Ezzy 1976, no. 119, p. 136). C. J. Lamm wrote a pioneering study on the development of stained glass in the early Islamic period, strongly arguing that its birthplace was Egypt. His well-known statement "The present writer . . . regrets the necessity of defending a theory which ought to-day to be regarded as a truism: *lustre was invented by Egyptian glassmakers*, probably as early as the 4th century" (Lamm 1941, pp. 18–19) is often quoted in the literature on the subject.

6 Raspopova 1985; Carboni forthcoming, pp. 30–31; and An 1991, p. 130, fig. 10.

7 Lamm 1928, pp. 93–98, pls. 7, 8; and Lamm 1941, pl. 11.

8 Lamm 1941, pp. 30–33.

9 See, respectively, Pinder-Wilson–Scanlon 1973, figs. 40–42; *JGS*, 12, 1970, p. 174, no. 22; and Damascus 1964a, no. 28.

10 Lamm 1941, pp. 7–57; and Clairmont 1977, pp. 36–55

(Clairmont reworked Lamm's notes on the Benaki's collection for his publication).

11 Another term used by Lamm (1941, p. 20) to describe the earliest type of lusterware produced in Egypt in the late Roman and Coptic periods is "fused-in enamel." As Brill (1970, p. 355, n. 6) explains, the term "fused-in enamel" is a misleading description of stained glass.

12 For a general assessment of glass production during the Fatimid period, see Carboni 1999.

13 See Lamm 1941, pp. 47–50, pls. 15, 17, and 18:1. The bowl in the Metropolitan Museum (inv. no. 1974.74) is published in Jenkins 1986, pp. 22–23, no. 20. The style of the Kufic inscription as well as similarities with Fatimid luster pottery of the eleventh century suggest that it may have been produced in this period. It must be noted, however, that the pigment was applied in more than one color and on both sides, a feature that, as explained above, points to an earlier dating.

14 See also cat. 11, 12.

15 See Negro Ponzi 1968–69, fig. 157, no. 68; Negro Ponzi 1970–71, fig. 55, no. 130; Fukai 1977, no. 15; and Carboni forthcoming, p. 21.

16 See, for example, cat. 10, Related Works 2 (inv. no. 64.1.33) and 4. See also a bowl in the Eretz Museum in Tel Aviv, excavated at Hurbat Migdal (Jacobson 1990–93).

17 See cat. 10, Related Works 1 and 2 (inv. no. 69.1.1). The bowl in Cairo is also briefly discussed at cat. 12 (Related Work 5).

18 National Museum, Damascus, inv. no. 16021 (Damascus 1964a, no. 28).

19 Inv. no. 79.1.33; see Sotheby Park Bernet, New York, sale, December 13, 1979, lot 259; and *JGS* 22, p. 89, no. 10.

20 See Brill 1970, fig. 3 (bottom left).

21 Lamm 1941, p. 22, figs. 6:2, 7:2.

22 Grube 1976, no. 93.

23 Robinson 1976, pl. 4, no. I.10A.

24 Hasan 1937, pls. 3, 5. Grube (1985, pp. 93–94, fig. 3) questions a Fatimid dating and suggests that the paintings might be as early as the ninth century.

25 Lamm 1929–30, vol. 1, p. 119.

26 Ibid., pls. 40:5–9.

27 Lamm 1941, p. 46.

28 A firm relationship between the two productions cannot be established presently, though they share a number of features, including similar dimensions; see Davidson 1940; Megaw 1959; Shelkolnikov 1966; and Djanpoladian–Kalantarian 1988.

29 The colors on this fragment are unusual, since they do not present the typical sheen of stained glass. As a matter of fact, they are reminiscent of later enameled products rather than stained ones. Nonetheless, the technique seems related to staining and may represent an experimental link between stains and enamels. A similarly blotched fragment, in opaque turquoise glass with silver staining and dated to the ninth or tenth century, is in the Benaki Museum, Athens (inv. no. 3.503; see Clairmont 1977, pl. 9, no. 132). See also an intact bottle decorated in a similar way at Christie's, London, sale, October 12, 1999, lot 321.

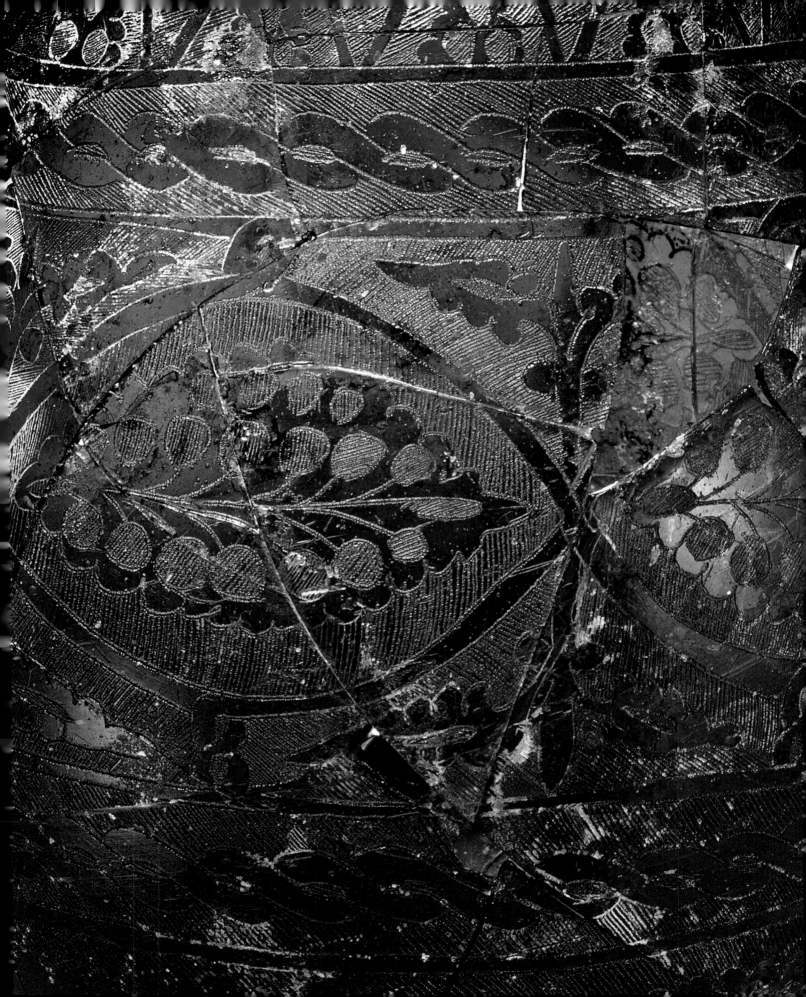

# GLASS WITH CUT DECORATION

CUT DECORATION IS DISCUSSED in Chapter 1 in reference to the Sasanian tradition and, to a lesser degree, to the Egyptian and Syrian areas under late Roman domination. In the middle of the early Islamic period, especially in the ninth and tenth centuries, cut glass became the most prominent form of decoration and took various forms, from complex relief patterns created with the use of mechanically operated stone, metal or wooden wheels and drills of different sizes to hair-width incisions made with a stone, probably diamond, point.

The Iranian contribution to early Islamic cut glass began in the Sasanian period and continued, probably uninterrupted, until the eleventh century. An example of continuity is provided by facet cutting (see cat. 8, 9, 1.15–1.17), which developed into the so-called honeycomb pattern in the most accomplished objects. A similar analysis can be made for cat. 16, 2.6, and 2.7, in which the decoration is represented by the so-called omphalos (from the Greek for "navel") motif, which appears as a roundel in relief with a protruding prunt, or small boss, in the center. The omphalos-cut type is covered in this chapter, rather than earlier, because there is no proof that such a pattern was used on glass vessels during the transitional period spanning the late Sasanian era and the advent of Islam. It is likely that the pattern was taken up later by Iranian glass cutters as a well-known "old" motif that was versatile enough to be adopted for the decoration of glass vases, bottles, and bowls.

The majority of the vessels decorated with the cutting technique were wheel-engraved. A principal technical distinction can be made between patterns created by means of incisions below the glass surface and those made by grinding away the surface in order to leave the desired pattern in relief. The former technique is usually referred to as intaglio (see cat. 26), the latter as relief cut (see cat. 22). Variations of these two techniques were common.

The grooves produced using the intaglio method were usually shallow but could vary in width and cross section according to the different sizes of the rotating wheel and the angles at which the wheel intersected the glass surface. Simple linear and geometric patterns were created in intaglio, but this technique was virtually limitless in its application and was also used to make rather sophisticated compositions with animals and vegetation.[1] Two large bottles (cat. 25) are typical of the austere and simple decoration of many intaglio objects.

In his recent publication on glass excavated at Nishapur, Kröger distinguishes between linear, intermediate, and slant-cut styles.[2] The first two styles differ in the wheel's angle of approach to the surface, either perpendicular or at a slight angle. The linear style presents a U-shaped cross section, while the cross section of the intermediate style is slightly wider and cut at a slant. Thus, more glass has been ground away than it would be to produce a simple line. The slant-cut style is the most visually successful, since it includes broad slanting cuts with a cross section in the shape of a check ($\sqrt{}$). The slant-cut style is commonly known as beveled[3] and, though it is related to both the intaglio and relief-cut techniques, it truly stands apart from both (see, for example, cat. 29, 33, 34). Kröger prefers the term "slant-cut" to "beveled" because "there seems to be no general understanding about [the latter's] actual meaning."[4] The term "beveled" is commonly used by Islamic art historians to describe a type of carving in which the lines meet the surface obliquely, so that the wall of the object acquires a strongly plastic quality. When "beveled" is applied to the effect created on the surface of cut glass, rather than to specific Samarran artistic motifs and compositions, the term seems more satisfactory and meaningful than the somewhat formal "slant-cut" definition. Ettinghausen and Grabar have described the major characteristics of the beveled style, usually known as Samarra

"Style C" or "Third Style": "repetition, beveling, abstract themes, total covering, and symmetry . . . the purest and most severe example of that 'delight in ornamental meditation and aesthetic exercise' which has been called *arabesque*."[5] The impact of Samarra "Style C" was immediate, probably for its abstract qualities and sculptural vibrancy, and was bound to last for centuries.

As in the case of intaglio, the beveled style includes simple geometric motifs as well as complex patterns; dome-shaped and cylindrical bottles (cat. 23) are good examples of the repetition of simple geometric patterns that, in a few cases, can turn an object into a masterpiece when the quality and precision of the cutting are outstanding and the ornamental composition is particularly close to the repertoire of Samarra (see cat. 24). The bowl (cat. 19), with its combination of bold vegetal motifs and a fantastic *senmurv*-like animal under the base, is one of the best examples of the complexity and accomplishment achieved in the beveled style.

Islamic glass cutters of this period are especially celebrated for their efforts in the relief-cut technique, which was time-consuming and complex. The most accomplished objects decorated in this technique are astonishing for their quality and attention to detail. Motifs in relief were produced by grinding the background, making the decorative patterns stand in relief. The raised areas were also countersunk so that the outlines of the design would be more evident. The outlines were often crossnotched, while some inner areas were hatched or crosshatched to give emphasis to specific motifs, such as a bird's wing or a lion's mane. Sometimes, in imitation of the Roman cameo technique, colorless glass was covered with a layer of vividly colored glass that was partially ground away in order to create a bold bichromatic contrast (see cat. 18). The success of these objects is mainly due to the remarkable skill of the glass cutters: in order to create patterns in high relief, the background of the original surface, which was often as thick as one centimeter, was ground down to one or two millimeters without breakage. The results are seemingly weightless objects that nevertheless have a strong sculptural appeal.[6]

True three-dimensional miniature sculptures are represented by the so-called molar flasks (cat. 27, 2.28a–r). The simple decoration of these small square bottles consists of geometric shapes in high relief at the sides and corners, and four wedged or pointed feet cut at the bases (hence the name "molar," as in the pointed root of a molar tooth). Although the majority of these thick flasks, which contained essences or perfumes, were blown and subsequently cold cut, some of them were created from solid blocks of glass, since it is evident that the surface decoration was wheel cut and that the interior chamber (the receptacle for the precious liquids) was drilled and not blown.[7] Because they are utilitarian objects by nature, they most likely were produced in every workshop where glass was cut. Although it is not possible to differentiate between various workshops, the Egyptian region was probably the leading producer.

A variation of the molar flask is the fish-shaped container (cat. 32). These miniature vessels are deeply cut and are supposed to lie on one side, rather than stand, or perhaps hang from the neck, thus revealing the stylized profile of a fish. The archaeological context related to cat. 32 suggests that these vessels were also produced in the Egyptian, and perhaps Syrian, regions in the Fatimid period. They represent a rare instance in the production of Islamic glass in which an animal figure was used for the shape of the vessel itself rather than as surface decoration. The fish shape can also be linked to the Roman tradition that produced rather large bottles in the form of fish, which was passed on to the Islamic glassmakers, as were the cage flasks discussed earlier (see cat. 4).

Like the molar flasks and fish-shaped containers, many small and medium-sized bottles were created by deeply grinding away the surface of globular vessels and turning them into multisided objects. These bottles, well represented by cat. 28, usually do not present any surface decoration. Cat. 29, however, exemplifies a greater degree of sophistication, for its polyhedral shape and the subtle incisions along its sides create the illusion of an arcade.

Another method of decorating the glass surface with sharp tools was the execution of hair-width incisions with a hard stone point. Since these incisions barely scraped away the surface, the objects decorated in this way are usually described as "scratch decorated," or produced using the sgraffito technique. Once again, this technique was applied to create simple linear and geometric patterns (cat. 2.9a, b) as well as intricate and spectacular combinations of designs, including vegetal and geometric motifs (cat. 17a, b), figures of birds (cat. 17d), and Arabic inscriptions (cat. 2.9c).[8] The glass used to produce these objects was usually vividly colored (blue, purple, deep amber), probably because the fine incisions would leave more visible, permanent whitish marks against the dark surface. This group, which includes about thirty complete or nearly complete objects (the number grows year by year with newly published or discovered pieces) and a large number of fragments from distant areas of the Islamic world, has assumed great importance after the recent discovery of six plates in northeastern China in a context datable before A.D. 874. Thanks to its peculiarity, scratch-decorated glass is easily identified and described and represents a fortunate instance in which an archaeological discovery helps to suggest a fairly accurate dating. The question of its place or places of production is still open, but it is hoped that a proper description and discussion of this

interesting group as a whole will throw light on this aspect. As suggested at cat. 17, the evidence seems to point to the Syrian or Mesopotamian region and to the early to mid-ninth century.

The unusual small plaque with a Qur'anic inscription (cat. 31), which was probably part of the decoration of a casket, is an isolated example that suggests that glass, thus far recognized as a purely functional and secular medium, was used also in a religious context.[9]

Besides representing one of the most complex types of decoration, glass cutting is also one of the most controversial among scholars of Islamic art,[10] mainly because the contribution of glass cutters from the Iranian region is widely accepted and prominently represented in all collections, while the role played by their Egyptian or Syrian colleagues is more vague. The clearest example of this controversy involves the high-quality relief-cut glass mentioned above. The relief-cut group, which is well represented in the al-Sabah Collection (cat. 18–22), includes some of the most celebrated masterpieces of Islamic glass (such as the "Corning Ewer")[11] and seems to fit logically into the Iranian region for a number of reasons, the most obvious being the eastern Islamic features of the majority of the animals depicted on these objects. An exclusively Iranian origin, however, is seriously challenged by the relief-cut glass excavated at Fustat, in Egypt, and by the obvious technical and artistic relationship between the finest relief-cut glass objects and the famous Fatimid rock-crystal ewers, the Egyptian origin of which has never been seriously questioned. The most logical explanation for this apparent incongruity is that the production of relief-cut glass started in Iran and Mesopotamia and was so successful among the Tulunids and the early Fatimids that Iranian artists were called to Egypt to work and to train local craftsmen, who produced both carved glass and rock-crystal objects. There is, however, no evidence to support this explanation, and it is equally possible that relief-cut glass was produced only in Iran and exported to Egypt, where it was instrumental in stimulating the local production of carved rock crystal, or that both relief-cut glass and rock-crystal objects were made only in Egypt for both local and long-distance trade and that some objects were thus produced in an "Iranian" style for export to the eastern Islamic world.

Unfortunately, these hypotheses merely help to demonstrate that the study of relief-cut glass is still in its infancy. Archaeological excavations or the discovery of explicit original literary sources may someday be instrumental in achieving a fuller understanding.

**Cat. 16a BOTTLE (LNS 426 G)**
**Iranian region**
**8th–9th century**

Dimensions: hgt. 8.8 cm; max. diam. 6.8 cm;
th. 0.30 cm; wt. 105.7 g; cap. 145 ml
Color: Translucent pale green (green 2)
Technique: Blown; worked on the pontil; cut
Description: This cylindrical bottle has a flat base
with a kick in the center, a seven-sided
shoulder, and a flared six-sided neck. It
stands on a foot ring created by cutting
(diam. 4.9 cm), which is depressed in
the center because of the deep kick
of the pontil. The main decoration
consists of two rows of seven roundels
in relief (diam. ca. 2.0 cm each) with a
protruding prunt in the center known as
an omphalos pattern; the elements were
cut at even intervals and the two rows
were staggered, creating a more varied
pattern. Each omphalos is inscribed
in a pentagon, providing a regular
geometric background. The transition
between shoulder and neck includes
three concentric circles in low relief.
Condition: The object is intact. The surface is
lightly weathered, resulting in brown
spots (especially on the interior), a
milky white film, and abrasions. The
glass includes frequent small bubbles.
Provenance: Bonhams, London, sale, April 24, 1997,
lot no. 286

**Cat. 16b BEAKER (LNS 443 G)**
**Iranian region**
**8th–9th century**

Dimensions: hgt. 11.7 cm; max. diam. 12.8 cm;
th. 0.22 cm; wt. 572 g; cap. 900 ml
Color: Translucent grayish colorless
Technique: Blown; worked on the pontil; cut
Description: This cylindrical beaker has a flat base
with a sunken circle in the center and a
straight opening. The main decoration
consists of two rows of six omphalos
roundels (diam. ca. 4.3 cm each) cut at
even intervals. The space between each
group of four roundels is filled with
a square lozenge in relief; a triangle
with the base upward was cut between
each roundel on the upper row, under
the horizontal line that frames the
patterned area under the beaker's rim.
The lowest roundels are not complete at
the base of the beaker, forming a series
of short "feet" that support the object.
Condition: The object was broken and repaired;
about one-third is missing. The surface
is entirely weathered, resulting in
iridescence, brown spots (especially on
the interior), a milky white film, and
abrasions. The glass includes frequent
small bubbles.
Provenance: Reportedly from Herat, Afghanistan

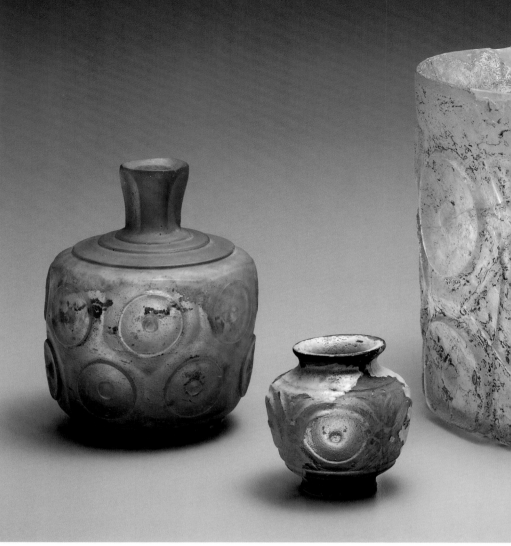

Cat. 16a, c, b, d

The vessels included in this group—a bottle, a beaker, a jar, and a vase—provide another link between the cutting technique of the late Sasanian and early Islamic periods. The only other objects decorated with omphalos patterns are bowls of various shapes. According to the majority of finds[12] and to strong evidence provided by comparative material, this peculiar decorative pattern belongs to the Iranian region, though it was probably imitated in other regions of the Islamic world.

Unlike the faceted objects discussed in Chapter 1 (cat. 8, 9), it does not seem appropriate to include the "omphalos" group in the transitional period, since there are no exact parallels in the late Sasanian epoch. The shapes of objects decorated with omphalos roundels and their small size suggest that the entire group is an Islamic creation. Nonetheless, larger vessels, such as flared bowls—only fragments of which survive—may derive directly from Sasanian prototypes and provide a link between the two productions.[13]

The omphalos roundel can be described as a raised disc with another small disc, or more often a prunt, in relief at its center. The depth of cutting may vary and, in the less elaborate examples, the pattern was created by incising the glass rather than cutting away the surface. Variations in the diameter of the roundels and the size of the prunts (sometimes they are oval or ovoid; see cat. 2.7) are frequently encountered. The omphalos motif was simple yet effective, and it required good skills from the glass cutters to create regular and even discs in high relief from a thick globe of blown glass.

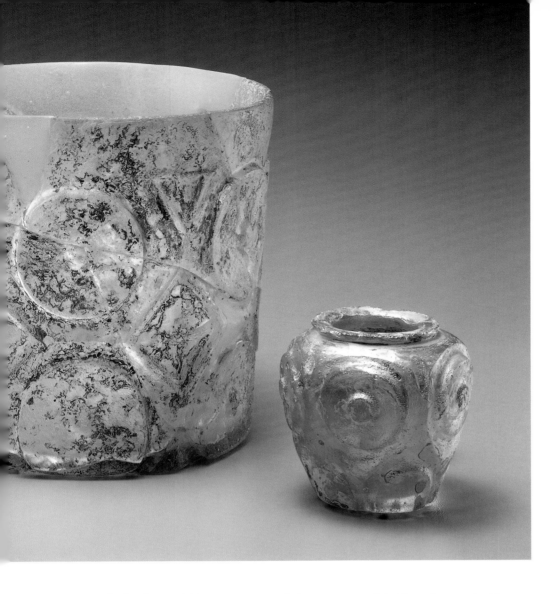

### Cat. 16c  VASE (LNS 47 G)
**Iranian region**
**8th–9th century**

Dimensions: hgt. 4.5 cm; max. diam. 4.5 cm;
th. 0.25 cm; wt. 23.7 g; cap. 35 ml
Color: Translucent pale blue (blue 2)
Technique: Blown; cut
Description: This nearly globular vase has a low
circular foot, a short neck, and a flared
mouth created by cutting. The main
decoration of five omphalos roundels
is framed by two horizontal grooves.
The empty spaces between the roundels
were decorated with curved lines that
meet in the center, separated by
horizontal grooves.
Condition: The object is intact. The surface is
weathered, resulting in a heavy golden
iridescence and slight abrasion. The
glass includes scattered small bubbles.

### Cat. 16d  JAR (LNS 27 KG)
**Iranian region**
**8th–9th century**

Dimensions: hgt. 5.7 cm; max. diam. 5.7 cm;
wt. 98.6 g; cap. 72 ml
Color: Translucent yellowish colorless
Technique: Blown; worked on the pontil; cut
Description: This flared jar curves at the shoulder
and has a flat base that shows traces
of the pontil mark. A short splayed
mouth extends from the upper side of
the shoulder. The main decoration on
the central part of the body consists
of five omphalos roundels. Five
semiovals, rising from the base at
regular intervals, were cut in relief.
Condition: The object is intact except for a small
chip at the rim. The surface has a
heavy golden iridescence and abrasions.
The glass is of good quality.
Provenance: Kofler collection
Literature: Lucerne 1981, no. 588
Related Works: 1. BM, inv. no. OA1959.2-18.3
(Tait 1991, fig. 141)
2. MIK, inv. no. I.2224
(Kröger 1984, no. 178)
See also cat. 2.6, 2.7

The bottle (cat. 16a) represents one of the most successful objects decorated with omphalos motifs. Unusual in shape and color (the great majority have a globular body and are almost colorless),[14] this small object nonetheless has a forceful sculptural appearance that is enhanced by the honeycomblike background and the concentric circles in relief that mark the transition between shoulder and neck. The large squared beaker (its diameter is almost equal to its height) shows a simpler and more static geometric composition (cat. 16b); nevertheless, the overall pattern, which combines large circles, smaller lozenges, and even smaller triangles, has an orderly appeal that is enlivened by the incomplete roundels at the base.[15] The small vase and the jar (cat. 16c, d), though heavily weathered, are also good examples of omphalos patterning: both display additional decorative motifs and were cut into harmonious shapes. The pale blue color of cat. 16c enhances the appeal of this small object. Also typical are the three cubic miniature vases, almost toylike objects, that complete this group (cat. 2.6d–g).

These vessels are also related to a small group of pieces of great importance that includes, for example, a bowl in the Treasury of St. Mark's in Venice. The possibility, which cannot be addressed here,[16] of a Byzantine, late Sasanian, or early Islamic attribution for such objects may provide another missing link between Sasanian and early Islamic manufacture or shed light on the poorly understood production of Byzantine glass.

## Cat. 17a FRAGMENTARY BOTTLE
(LNS 375 G)
**Syrian or Mesopotamian region**
**9th century**

Dimensions: hgt. 32.3 cm; max. diam. 13.5 cm;
th. 0.30 cm; cap. ca. 1900 ml

Color: Translucent dark blue (blue 4)

Technique: Free blown; tooled; worked on the
pontil; incised

Description: This large, pear-shaped, fragmentary
bottle rests on an applied tapered low
foot. The surface is almost entirely
decorated with finely incised motifs set
inside horizontal bands; only about 3 cm
above the foot was left undecorated.
Starting from the top, the motifs
include a sawtooth pattern (hgt. 1 cm)
framed at the base by a horizontal line;
a rope motif (hgt. 1.7 cm); a zigzag
pattern (hgt. 2.7 cm) that creates
alternately upright and upside-down
triangles, each filled with a pointed
flower drawn in reserve against the
hatched background; and a second
rope motif (hgt. 1.5 cm). A larger band
(hgt. 6.5 cm) in the center contains a
complex series of eight large ovals
created by sinuous interlacing bands
that are joined by loops to the two
horizontal lines that frame this section;
a branch bearing round leaves or fruit
was subsequently drawn inside each
oval. The triangular areas limited by the
ovals and the horizontal bands are filled
with vegetal motifs formed by pairs of
leaves or flowers (similar to those in the
zigzag pattern above) departing from a
single stalk that ends in a point. Below
the main band is a third rope motif
(hgt. 2 cm) and, finally, a series of
vertical rectangles with rounded upper
sides placed contiguously (hgt. 2 cm).
Large areas of the background are
hatched, while geometric and vegetal
patterns, as a rule, are drawn in reserve.

Condition: At the time of acquisition, the object
was broken, repaired, and heavily
restored. The upper part was completed
with a cylindrical neck and a large
splayed opening. After having
dismantled, cleaned, and examined the
object, conservators observed that part
of the neck, the entire mouth, part of
the shoulder, and one large area and
several small areas of the body had
been replaced with modern glass. The
interior of the vessel had been painted
with a wash of black paint in order to
disguise the differences between the
original glass and the paler colored,
foreign glass fragments used for
restoration. Although large areas of the
body are missing, it was possible to
reconstruct the original shape, except
for the neck and mouth. The surface is
lightly weathered, resulting in a milky

white film, iridescence, and abrasion.
The glass, of good quality, includes
scattered tiny bubbles.

Composition: Na$_2$O: 15.6; MgO: 4.3; Al$_2$O$_3$: 2.3;
SiO$_2$: 62.7; SO$_3$: 0.3; Cl: 0.7; K$_2$O: 2.8;
CaO: 7.7; TiO$_2$: 0.2; MnO: 1.1; Fe$_2$O$_3$:
1.5; CoO: 0.2; CuO: 0.2; ZnO: 0.3

Provenance: Christie's, London, sale, April 26, 1994,
lot 317

Related Works: 1. KM, Düsseldorf, inv. no. P1974-19
(Ricke 1989, no. 64)
2. Whereabouts unknown (Sotheby's,
London, sale, April 21–22, 1980,
lot 298)
3. Famen Buddhist Temple Museum,
inv. no. FD5: 018 (An 1991, fig. 5)
4. NM, Aleppo
5. NM, Damascus, inv. no. R.508c
(al-'Ush 1971, fig. p. 203)
6. CMG, inv. nos. 55.1.112, .113, .115, .119

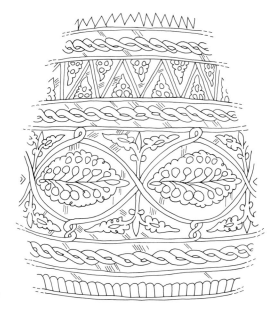

These objects represent one of the most diagnostic groups in the production of early Islamic glass. The group is easy to identify by its sgraffito technique, created using a hard stone, possibly diamond point,[17] on a glass surface, vividly colored in most cases. (The fine scratches leave a permanent whitish mark that is more conspicuous against a deep blue, purple, or amber background). In some instances, however, pale blue, green, or yellow glass was chosen.[18]

The group includes a wide variety of shapes, four of which—a bottle (cat. 17a), two types of bowls (cat. 17b, c), and a ewer (cat. 2.9a)—are represented in the Collection. Dishes, large cylindrical beakers, goblets, and high-walled bowls are among the other shapes. The large number of extant fragments testifies to an even greater variety.

Although the quality of the decoration varies and each object has its own characteristics, there are some common features that make this a coherent group. All pieces show fine hatching of the background, usually meant to highlight a decorative element that stands out in reserve or, sometimes, to fill smaller enclosed areas. This hatching is always diagonal for the background, although it may also be vertical or horizontal for smaller areas. Two decorative patterns appear on many of the most accomplished objects. The first is a "sawtooth" motif, formed by a row of small hatched triangles that crowns the uppermost register of the decoration (see cat. 17a, 2.9a) or frames the outermost circle on the bottom of a dish or a bowl (see cat. 17c). The second motif is a "rope" pattern that takes its name from two tightly woven interlacing bands that seem to imitate a rope or a chain. This motif was used in a manneristic fashion, since it is usually placed between elaborately decorated bands (see cat. 17a, c) as a transitional pattern.

Other decorative motifs of varying degrees of complexity and accomplishment include vegetal patterns in the form of round, oval, lobed, or multisided leaves, either isolated or radiating from a stalk. These leaves may be enclosed within triangular, oval, or square sections and are naturalistic to varying degrees. Cat. 17a includes a wide selection of the

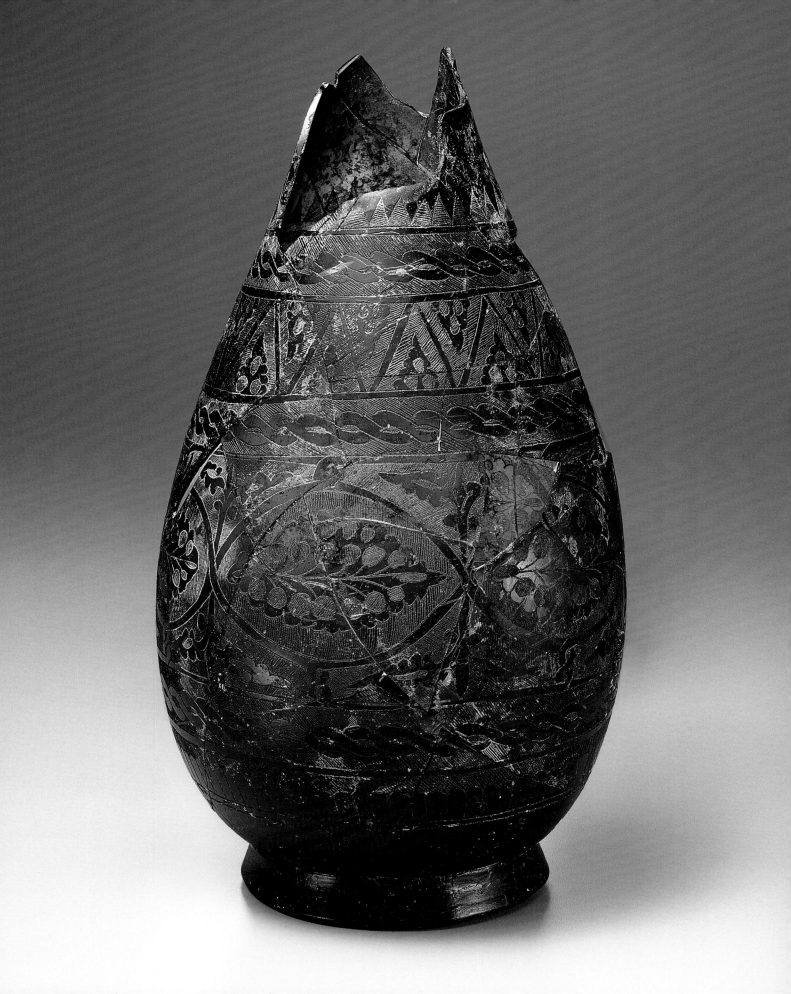

### Cat. 17b BOWL (LNS 318 G)
**Syrian or Mesopotamian region**
**9th century**

Dimensions: hgt. 6.0 cm; max. diam. 17.6 cm;
th. 0.25 cm; wt. 337.6 g; cap. 1000 ml

Color: Translucent vivid purple

Technique: Free blown; tooled; worked on
the pontil; incised

Description: This bowl, which curves slightly inward,
rests on an irregular base with a
pronounced kick in the center. The
glass thickens and forms a sort of lip
just below the rim. A small folded
handle was applied on the exterior
surface. The exterior wall is entirely
decorated with finely incised patterns
executed inside three horizontal bands.
The largest and lowermost band
includes a laurel-like wreath motif with
pointed oval leaves oriented toward
the left. The central narrow band shows
a rope motif, its twists alternately
hatched and left blank; the handle
was applied over this central band.
The uppermost band includes pointed
ovals with a hatched center alternating
with groups of three hatched roundels.

Condition: When acquired, the object was broken
and repaired; two types of adhesives
had been used and small areas had been
filled and retouched with matching
paint. Conservators took the bowl apart
and then reassembled it. The object
is almost complete and the attached
handle is almost certainly original.
The surface is entirely weathered,
resulting in a milky white coating,
silvery iridescence, and heavy corrosion.
The incised motifs are still visible,
however, as corrosion caused the
patterns to be transmitted from one
layer to the next. The glass includes
frequent small bubbles.

Composition: $Na_2O$: 14.9; $MgO$: 5.0; $Al_2O_3$: 2.1; $SiO_2$:
63.6; $SO_3$: 0.2; $Cl$: 0.6; $K_2O$: 2.9; $CaO$:
7.2; $TiO_2$: 0.1; $MnO$: 2.4; $Fe_2O_3$: 0.9

Provenance: Reportedly from Syria

Related Works: 7. MIK, inv. no. I.13/65
(Kröger 1984, no. 146)
8. Benaki, inv. no. 3.231
(Clairmont 1977, pl. 16, no. 254)

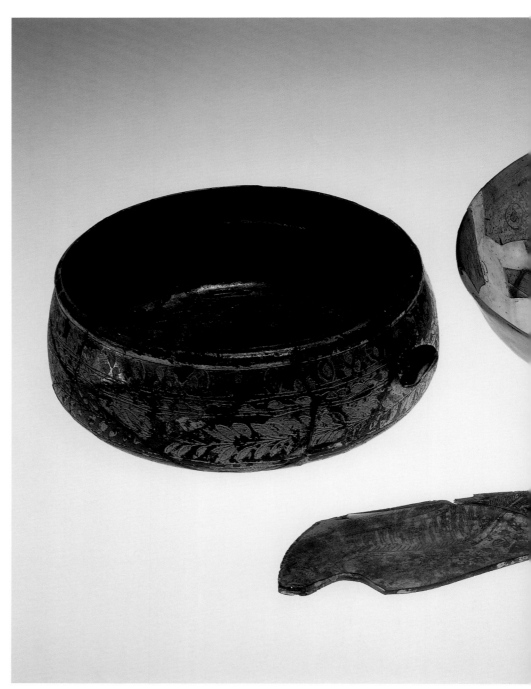

Cat. 17b–d

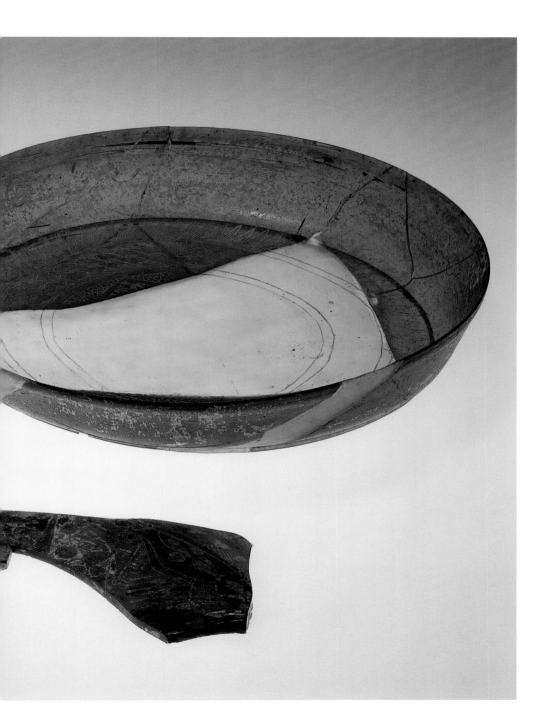

## Cat. 17c FRAGMENTARY BOWL
### (LNS 320 G)
### Syrian or Mesopotamian region
### 9th century

Dimensions: hgt. 4.4 cm; max. diam. 27.6 cm;
th. 0.18 cm; wt. 444.6 g; cap. 2000 ml

Color: Translucent blue (blue 2–3)

Technique: Free blown; tooled; incised

Description: This fragmentary large bowl has flared
walls. A trail (meant to act as a foot
ring) was applied under the base, but
the base itself curves to such an extent
that the bowl stands on it rather than
on the foot ring. The interior is
decorated with finely incised patterns
and the exterior is plain. Around the
sides, four-petaled flowers alternate
with roundels at even intervals; when
intact, the bowl would have included
twelve such elements. The entire bottom
is decorated with two concentric bands
created by pairs of thin lines. The central
circle (diam. ca. 13 cm) once contained
a square filled with vegetal patterns,
and the empty spaces outside showed
a scale motif. A sawtooth or sunray
pattern, the single elements of which
are elongated triangles (hgt. ca. 1.8 cm)
that lean to the right, surrounds the
central circle. The second band includes
a rope motif in reserve against a
hatched background (hgt. 2.0 cm).

Condition: The object was in seventeen fragments
at the time of purchase. About one-
half of the restored bowl is original,
allowing a proper reconstruction of the
original shape. The surface is heavily
weathered, resulting in a milky white
coating, silvery iridescence, and slight
abrasions. The glass includes frequent
small bubbles.

Composition: $Na_2O$: 15.3; $MgO$: 5.0; $Al_2O_3$: 2.2;
$SiO2$: 63.5; $P_2O_3$: 0.4; $SO_3$: 0.2;
$Cl$: 0.7; $K_2O$: 2.8; $CaO$: 7.5; $TiO_2$: 0.1;
$MnO$: 1.0; $Fe_2O_3$: 1.1; $CoO$: 0.1

Provenance: Reportedly from Homs, Syria

vegetal repertoire of this group. A variation is also offered by the laurel-like wreath pattern that surrounds cat. 17b.

A date *ante quem* for the group is provided by the important discovery of six intact plates in the crypt of a stupa sealed in A.D. 874 (see Related Work 3).[19] These objects are of dark blue glass, are decorated in the same technique, and exhibit all the typical decorative motifs of this group. The site, known as the Famen Temple (Famensi), is in Shaanxi Province, in northeastern China, and was established during the eastern Han dynasty (A.D. 25–220). In 874, during the Tang dynasty, a stupa was built to preserve the bones of the Sakyamuni Buddha. An archaeological team excavated the site after the partial collapse of a later building atop the stupa. A treasury composed of Chinese gold, silver, porcelain, and silk objects as well as nineteen pieces of Islamic glass was unearthed. The discovery was exceptional because it proved that Islamic glass was sought after during the Tang dynasty and that it was transported via the Silk Route. The find allowed for an unquestionable dating of all the glass objects before A.D. 874.

Vividly colored glass with finely incised decoration was, therefore, traded as high-quality artwork, from its place of production in the Islamic world all the way to northeastern China. We know that an important stop along this trade route was Nishapur, in northeastern Iran, since a fragmentary dark blue plate that is related to the group found in China was excavated at Nishapur by a Metropolitan Museum team in the 1930s.[20] For many years, this plate and other related fragments have been presented as evidence for an Iranian attribution of the entire group.[21] However, the material recently discovered in China and at other sites, combined with a more thorough understanding of the excavations at Nishapur and with art-historical considerations, present convincing evidence that the origin of the group must be farther west, in the Syrian or Mesopotamian regions.

The most interesting fact related to the chemical composition of this material is that, though they are all soda-lime glasses, they can be either of the plant-ash or of the natron type. Four samples belong to the former group (cat. 17a–c, 2.9a), two to the second (cat. 17d, 2.9b). The existence of these two types of glass is confirmed by other available results, though the proportion seems to be reversed, with natron glass being more common than the plant-ash type.[22] Unfortunately, similar decorative patterns are common to both types. Thus, it is not possible to suggest clear geographical distinctions based on chemical analysis alone. Useful information is also related to the presence of traces of zinc in two cobalt-oxide blue samples (cat. 17a, 2.9b). The earliest widespread use of a cobalt source containing zinc, possibly from Syria, appears to have begun around the ninth century. The combination of a natron glass type and the association of cobalt and zinc in a single glass (cat. 2.9b) strongly suggests that it dates no earlier than the ninth century and no later than the tenth, thus confirming the proposed attribution of the entire group.

A thorough analysis of the available material is beyond the scope of this catalogue, but it is possible to point out a few key arguments supporting a central Islamic origin for the group. Finely incised glass fragments of various degrees of sophistication have surfaced consistently throughout the Islamic world, with the exclusion of Spain and the Maghrib.[23] Three fragmentary objects found in Syria are presently in the collections of the National Museums in Damascus and Aleppo (see Related Works 4, 5). In addition, the majority of the complete, or nearly complete, pieces that have appeared on the market in recent years are allegedly from

Syria: dealers and collectors have consistently reported that such pieces were found in the regions of Larisa (Shayzar) and Raqqa. Cat. 17b and 2.9a are among these objects.

Nishapur, another site where this type of glass was discovered, was a thriving commercial center in the ninth century and a place for the exchange of goods brought by caravans from both the Chinese and the Islamic worlds. The Iranian city was also an active center for the production of crafts and artifacts. Therefore, the material that has come to light was either created locally or imported. Since, in many cases, it is impossible to determine where an object was made, the chance that it was acquired en route is equally valid. We know that finely incised glass was exported to China (thanks to the Famen Temple discovery); consequently, Nishapur may have represented either the place of manufacture or merely a stop along the way. The odds against a Nishapur origin seem to be greater than those in its favor: vividly colored glass was more commonly produced in Syria and, especially, in Mesopotamia.[24] Furthermore, according to the general distribution of the finds of this type of glass, the focus of activity seems to have been the central, rather than the eastern, Islamic lands. In addition, the trading of glass had a definite west-to-east direction within the Asian continent in the early Islamic period, as opposed to a radial distribution centered in the Iranian region.[25]

The decorative motifs on the objects belonging to this group do not find immediate parallels in the Iranian world. Rather, contemporary luster pottery produced in Mesopotamia provides the best comparison. For example, a large dish in the Victoria and Albert Museum[26] includes individual elements as well as the square-within-a-circle composition common to many plates of the group (see cat. 17c); and a number of tiles that decorate the upper part of the mihrab of the Great Mosque in Kairouan also show patterns that are similar to those reproduced on these glass vessels.[27]

In summary, the origin of this group that, though varied, is homogeneous as far as technique, decoration, and glass colors, cannot be precisely identified. A few workshops were probably involved in the production, and it is theoretically possible that vessels made at one site were transported elsewhere to be decorated. The region of manufacture, however, was certainly limited and was probably Syria or Mesopotamia. On one hand, archeological evidence seems to point to northern Syria, in the vicinity of Raqqa. Art-historical considerations, on the other hand, would indicate that Mesopotamia, especially the ninth-century 'Abbasid capital Samarra, is most likely where the group was made. Its characteristic, often accomplished, and peculiar appearance makes "scratched" glass the type of early Islamic glass that is most likely to be given a precise attribution in the near future.

**Cat. 17d FRAGMENT OF A DISH OR BOWL (LNS 56 KG)**
**Syrian or Mesopotamian region**
**9th century**

Dimensions: max. w. 8.8 cm; max. l. 22.5 cm; th. 0.32 cm
Color: Translucent brown (yellow/brown 3)
Technique: Free blown; tooled; incised
Description: The curved shape of this fragment and its thickness suggest that it belonged to the base of a large plate or bowl similar to cat. 17c. The decoration, finely incised on the interior, shows two large confronted birds with long open beaks. The background is filled with heart-shaped and round leaves on thin stalks. A pointed triangle in the space between the two birds may represent the tip of the beak of a third bird or, perhaps, part of a lost geometric motif. The birds are enclosed within concentric bands, as may be inferred from two sections containing wavy hatched patterns at the upper right corner.
Condition: Two large fragments are joined. The surface is heavily weathered, resulting in a milky white coating and iridescence. The glass includes scattered small bubbles.
Composition: Na$_2$O: 14.2; MgO: 0.7; Al$_2$O$_3$: 2.6; SiO$_2$: 68.4; Cl: 1.2; K$_2$O: 0.5; CaO: 9.6; TiO$_2$: 0.2; MnO: 0.1; Fe$_2$O$_3$: 1.1
Provenance: Kofler collection
Related Works: Cat. 2.9a, b

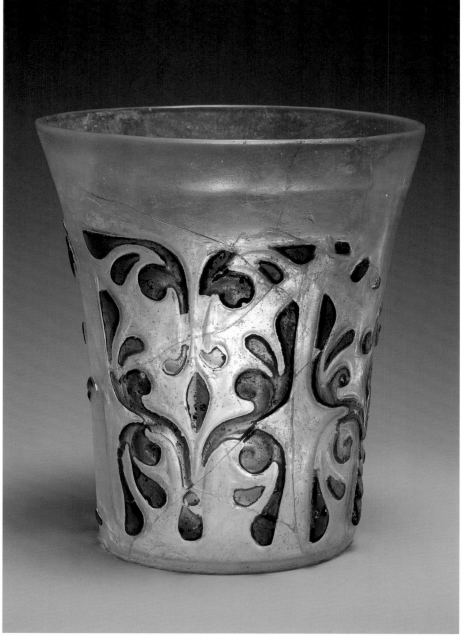

Cat. 18a

**Cat. 18a BEAKER (LNS 1407 G)**
**Mesopotamian or Iranian region**
**Second half of the 9th century**

Dimensions: hgt. 11.0 cm; diam. 9.6 cm; th. 0.13 cm;
wt. 117 g; cap. 450 ml

Color: Translucent grayish colorless and
green (green 2)

Technique: Blown; layered; tooled; relief cut
(cameo technique); worked on the
pontil

Description: This cylindrical beaker flares near
the opening and has a flat base. The
decoration on the exterior was made
by laying green glass over a colorless
vessel, excluding a band below the
opening. The green layer was then cut
away to create four similar panels, each
including two symmetrical palmettes in
relief branching from the same stem at
the base, a central oval button, and two
symmetrical semipalmettes above.

Condition: The object was broken and repaired;
about two-thirds of the original vessel
is extant and one-third represents
restoration. The surface is partially
weathered, resulting in a milky white
film and iridescence.

Provenance: Christie's, London, sale, April 11, 2000,
lot 288

Overlayed and cut glass (better known as cameo glass) represents one of the most
fascinating types of Islamic glass. Like millefiori glass (see cat. 7), Islamic cameo glass is
unusual and may have been part of the revival of the Roman tradition during the ninth-
century 'Abbasid period. High-quality relief-cut glass was common in early Islamic
Mesopotamia and Iran (see cat. 19–22), so this technique had been refined by the time
glassmakers developed an interest in Roman cameo glass. This type of two-layered,
bicolored decoration, which apparently was produced for about two centuries in the Islamic
world, probably originated in ninth-century Mesopotamia (see cat. 7), as suggested by a
number of fragments unearthed at Samarra, the only archaeological site where cameo-glass
pieces have been found.[28] The group of known cameo-cut vessels comprises ewers, bowls,
beakers, bottles, and fragments thereof.

**Cat. 18b PLAQUE OR SMALL BOWL
(LNS 76 G)**
**Mesopotamian or Iranian region**
**Second half of the 9th century**

Dimensions: hgt. 1.5 cm; w. 6.3 cm; l. 3.9 cm;
th. 0.26 cm; wt. 28.3 g; cap. 15 ml

Color: Translucent bright yellow and
emerald green (green 5)

Technique: Blown; layered; tooled;
relief cut (cameo technique)

Description: This shallow oval object was decorated
in the same manner as cat. 18a. The
green layer was cut away to create
four half-palmettes in relief that are
arranged symmetrically and radiate
from a central square button.
Additional small squares complete
the pattern, filling areas near the rim.
The rim was grooved to impart an
effect of higher relief to the overall
pattern. The concave, or interior,
surface was left undecorated.

Condition: The object was broken; about three-
quarters of the original vessel is extant
and one-quarter represents restoration.
The surface is partially weathered,
resulting in a milky white film.

Literature: Lucerne 1981, no. 485

While the beaker (cat. 18a) is not of the quality of masterpieces created using this technique, such as the so-called "Corning Ewer,"[29] it is nevertheless a remarkable and well-preserved example of this type of glass. Its decoration has a free-flowing, spontaneous quality that finds parallels in details of fragments with relief-cut motifs of plants excavated in Samarra and Nishapur,[30] though it is perhaps not as exquisite as that of cat. 19. Its somewhat squat profile is unusual, anticipating shapes that became more common in the twelfth and thirteenth centuries (see, for example, cat. 47).

The diminutive bowl (cat. 18b) is unique among known cameo-cut objects. It may have functioned as a cosmetic palette[31] or as a decorative plaque to be set on plastered walls.[32] Its bright yellow color, confirmed under the microscope to be original, is unusual, since in virtually all other cases lightly tinged or colorless glass was chosen as the base over which a layer of bright blue or green glass was applied and subsequently cut.[33] The decoration, which consists of four half-palmettes springing from a central button, is comparable to that of cat. 18a, though it is more stylized and formal.

The designs of both objects appear to be related to ninth-century Samarra and its decorative language rather than to established Iranian models. Therefore, though unparalleled in the group of relief-cut objects and thus difficult to date, these works may tentatively be dated to the ninth century, rather than the tenth, and to the Mesopotamian, rather than the Iranian, region.

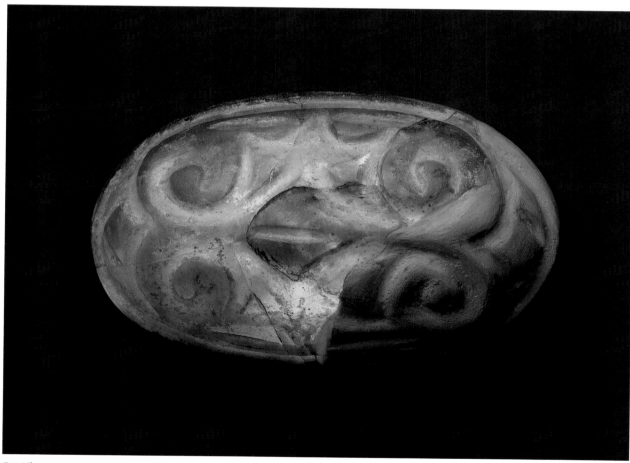

Cat. 18b

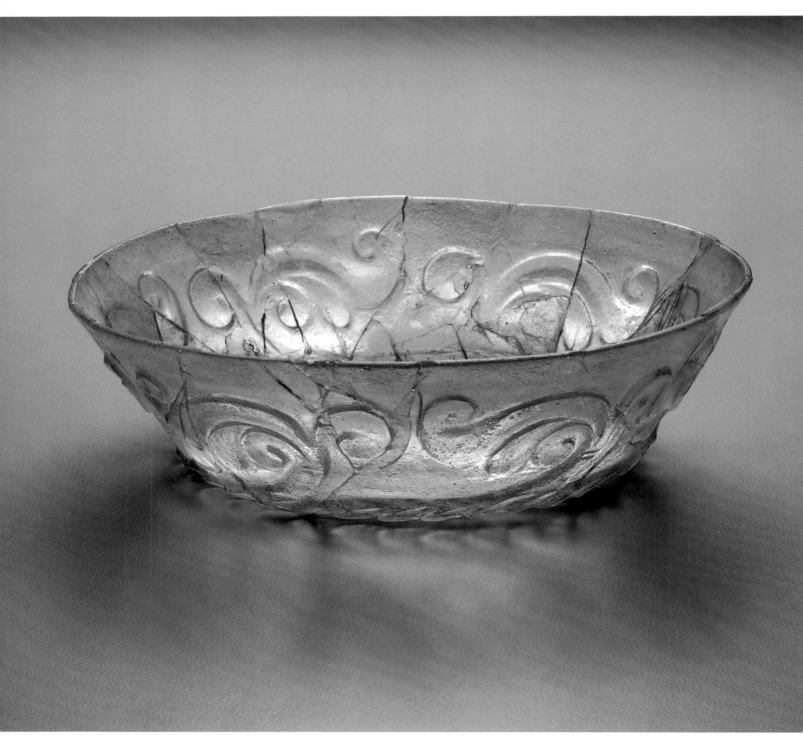

Cat. 19

**Cat. 19 BOWL (LNS 113 KG)**
**Iranian region**
**Second half of the 9th–**
**early 10th century**

Dimensions: hgt. 4.2 cm; max. diam. 13.5 cm;
th. 0.18 cm; wt. 94.8 g; cap. 370 ml
Color: Translucent yellowish colorless
Technique: Blown; tooled; relief cut
Description: This bowl has flared walls and a flat
base. Relief-cut decoration is present on
the exterior walls and underneath the
base. The profile of the figure of a
fantastic animal was cut under the base.
The composite beast has a pointed wing
and a large scaled tail. Its head seems
to be viewed from above and has two
curly ramlike horns and a pointed face,
though the final result is a flowerlike
motif. A bent, hoofed leg is visible in
the foreground, and an unclear curling
pattern represents the rear part of the
animal. The pontil mark in the center
was ground and turned into a sunken
roundel that becomes part of the
decoration of the animal's hatched wing.
The walls include a relief-cut pattern
of six elaborate, free-flowing, half-
palmettes that stem from a chainlike
scaled motif marking the transition
between the base and the walls.
Condition: The object was broken and repaired
and is almost complete except for small
fillings added during restoration. It
suffered further damage when it was
taken to Baghdad following the 1990
invasion of Kuwait. The surface is
lightly weathered, resulting in a milky
white film, iridescence, and slight
abrasion. The glass includes scattered
small bubbles.
Provenance: Kofler collection
Literature: Lucerne 1981, no. 621

This bowl, which has a rather unusual shape for an object in relief-cut glass, is one of the most accomplished pieces of the entire group. The fantastic animal underneath the base and the elaborate free-flowing vegetal scroll encircling the walls, executed in a clear and confident cutting technique, make it one of the few truly masterful objects of this type. The figure of the composite creature has no known parallels in Islamic cut glass; however, its prototype is certainly the Sasanian representation of the *senmurv*, a fantastic composite beast of good omen—part bird, part feline, part canine—that played a prominent role in Iranian iconography from early Antiquity.[34]

Fragments of glass showing freely drawn half-palmettes and vegetal motifs stemming from a base (meant to represent a grassy foreground) were excavated in Samarra as well as Nishapur, but this bowl seems to be the only extant complete, or nearly complete, example of its kind.[35] More stylized and formal vegetal motifs are present both on tenth-century relief-cut glass and on late tenth- and eleventh-century Fatimid rock crystal, but this ornamentation is not directly related to that of the bowl. For this reason, as well as the presence of the *senmurv*-like creature on the base, it is possible to suggest a ninth- or early tenth-century dating for this outstanding work. This early dating is also partially supported by the presence of sparse dots drilled on the body of the animal, a decorative device that is discussed at cat. 20b and 22.

This bowl was most likely a freestanding object, though the prominent decoration underneath the base may suggest that it was meant to be seen while hanging and is, therefore, a lamp. A number of other bowls with more rounded and higher walls are decorated in the same manner, though it is unlikely that they were used as lamps.[36] The decorative pattern on the bowl is also visible, in reverse, when viewed through the inside of the base.

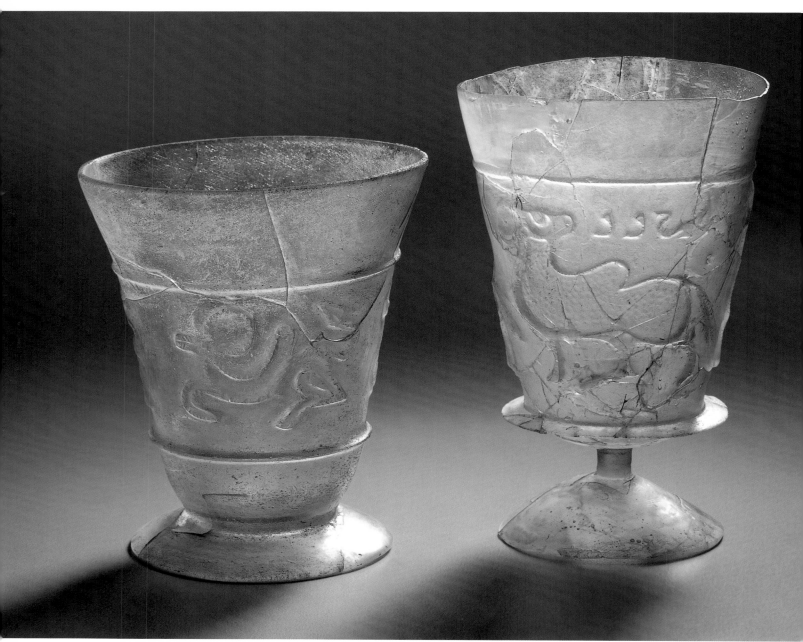

Cat. 20a, b

Cat. 20a BEAKER (LNS 31 KG)
Iranian region
Probably late 9th–
early 10th century

Dimensions: hgt. 8.8 cm; max. diam. 7.5 cm;
th. 0.18 cm; wt. 62.6 g; cap. 175 ml
Color: Translucent yellowish colorless
Technique: Blown; tooled; relief cut
Description: This flared conical beaker rests on a low
splayed foot with a convex bottom that
was carved from the same block of
glass. The decoration, enclosed within
two simple horizontal bands in relief,
consists of three stylized running bulls
seen in left profile. Each bull has long
curved horns, a small nondescript head,
a large hump, a long curved tail that
ends in a heart-shaped tassel, long bent
hindlegs, and short curved forelegs.
The three animals were cut in slightly
countersunk relief and outlined by thin
hatched bands.
Condition: This object was broken and repaired
and is almost complete except for a
section of the rim and part of the foot.
It suffered further damage when it was
taken to Baghdad following the invasion
of Kuwait of 1990. The surface is
lightly weathered, resulting in a pale
brown coating, iridescence, and slight
abrasion. The glass includes scattered
small bubbles.
Provenance: Kofler collection
Literature: Lucerne 1981, no. 616

Cat. 20b GOBLET (LNS 78 KG)
Iranian region
Second half of the 10th century

Dimensions: hgt. 10.5 cm; max. diam. 6.4 cm;
th. 0.06 cm; wt. 30.4 g; cap. 175 ml
Color: Translucent grayish colorless
Technique: Blown; tooled; relief cut
Description: This slightly flared, conical goblet has a
cup with a concave base and its bottom
is attached to the short stem of an
outsplayed conical foot with a convex
bottom. The original thickness of the
walls, before the decoration was
executed, was about 0.4 cm, which
corresponds to the width of a horizontal
ring that protrudes around the base of
the cup. The decoration, enclosed within
the protruding band and another similar
band at about 4 cm below the rim,
consists of three standing bulls viewed
in left profile. The areas inside their
bodies were countersunk and filled with
numerous drilled dots. Each of the
proportionally large animals stands on
straight legs, has a conspicuous hump, a
long straight tail, a head turned backward

and presented in multiple perspective
(both horns are visible though the head is
nearly in full profile), and with a detailed
nose and eye (the latter is countersunk
and crescent-shaped). Words were cut out
in Kufic style and countersunk between
the bulls' heads. Although partially
damaged, they seem to read:

بقا بقا يمن ود[وله]

("Lasting life, lasting life, happiness
and good [fortune]").
Condition: The object was broken into fragments
and was repaired before entering the
Collection. It suffered further damage
when it was taken to Baghdad following
the 1990 invasion of Kuwait. About
80 percent of the original remains. It was
entirely reconstructed by conservators in
the Collection (the reconstruction of the
foot is only approximate). The surface is
lightly weathered, resulting in a pale brown
film, iridescence, and slight abrasion.
The glass includes scattered small bubbles.
Provenance: Reportedly from Nishapur; Kofler
collection
Literature: Ohm 1975, pl. 28; and Lucerne 1981,
no. 618

These two drinking vessels represent the most common shapes produced in the Iranian region between the ninth and the eleventh century. The conically shaped beaker (cat. 20a), which was more common in combination with relief-cut decoration, rests on a splayed foot that was carved out of the same block of glass; the stemmed goblet (cat. 20b) stands on an applied splayed foot and a short stem. The former can be compared to the beaker with applied decoration (cat. 42). The stemmed goblet finds numerous parallels in undecorated objects that occasionally have a ring added around the middle of the stem;[37] the carved-out ring that protrudes near the base of the present example may represent the remains of such a ring (see also cat. 41).

The glass cutters who represented the same animal on the two vessels adopted very different approaches. Cat. 20a shows lively bulls in running postures, with slim bodies and exaggerated humps and horns; the figures are stylized yet playful. Their bodies are outlined with a narrow ribbed band. The carving technique on this beaker is not particularly accomplished or detailed.

In comparison, the bulls of cat. 20b are more refined. Their postures are formal, their heads turned back, their bodies well proportioned. Their horns, which create a crescent shape and are viewed from a different perspective than their heads, add to the animals' dignified posture. The decorative treatment of the surface, which is entirely filled with drilled dots, suggests that these figures belong to a later development of relief-cut glass, dating closer to the production of the best-known pieces, such as the "Corning Ewer," the Cairo bowl, cameo-cut objects, and, ultimately, Fatimid rock-crystal vessels.[38]

If the chronology proposed by Harper and Whitehouse for relief-cut glass is fully accepted,[39] the lively and naive bulls of cat. 20a represent the earlier phase, while the formal bulls of cat. 20b date to the late tenth century and may perhaps be attributed to Egypt rather than Iran (in this case, however, an Egyptian attribution can be discounted in light of the typically Iranian profile of the goblet). The Kufic inscription carved on cat. 20b seems to provide another link to the late stage of production of relief-cut glass.[40]

Some of the features of this relief-cut goblet are shared by cat. 20 and 22. Its shape, with the stem attached to the cup, was almost certainly identical to that of cat. 20b. The quality of the decoration of the figures, eagles in this case, is close to that of the bulls on the beaker (cat. 20a), with their simple and naive composition and cutting technique, though the overall result is somewhat stiffer and more formal. The calligraphy of the inscription is very similar to that of cat. 20b, but is placed vertically (instead of horizontally) between the three birds: this orientation is less common on relief-cut glass but is sometimes found on molded or tong-impressed glass.[41] The curl on the birds' wings, which is like a half-palmette, is comparable to the motif representing the thigh on the hare/stag of cat. 22 as well as to the vegetal decoration of cat. 19.

Birds are commonly represented on cut glass and appear on many different objects.[42] They are often associated with inscriptions. It is usually difficult to identify species precisely; thus the birds can be generically described as wading, predatory, pigeonlike, or quail-like. The large curved beak, stance, and tail of the birds depicted on this goblet leave no doubt that they are meant to represent birds of prey.

It is difficult to date this goblet with confidence because it seems to incorporate individual features that have been attributed to different periods within the span of production of this type of glass—that is, from the middle of the ninth century to the end of the tenth. Thus this object further suggests that the proposed chronology, though useful and well supported by the existing evidence, needs some adjustment.[43]

**Cat. 21 GOBLET (LNS 84 G)**
**Iranian region**
**Mid-9th–10th century**

Dimensions: hgt. 10.9 cm; max. diam. 5.9 cm; th. 0.11 cm; wt. 37.3 g; cap. 94 ml
Color: Translucent grayish colorless
Technique: Blown; tooled; relief cut
Description: This slightly flared, conical goblet has a cup with a concave base and its bottom was once attached to the short stem of a foot, as in cat. 20b. The original thickness of the walls was about 0.6 cm, which corresponds to the width of the horizontal ring protruding around the base of the cup. The decoration, enclosed between the protruding band around the base and another band about 2 cm below the rim, consists of three standing eagles viewed in left profile. The areas inside the birds are countersunk and the outlines are hatched. The eagles stand on their legs, the long tails reach the ground, the chests are broad, the bodies include a decorative wing shaped like a half-palmette, and the heads, looking forward, have a drilled eye and a long hooked beak. Drop-shaped elements with a drilled hole in the center, perhaps meant to represent clouds, are carved in relief between the birds' heads. Inscriptions in Kufic were cut out vertically between the eagles; the words seem to read, in the correct sequence:
بركة ويمن وبقاه
("Blessing and happiness and lasting life").
Condition: The object was broken in numerous fragments and repaired. It suffered further damage when it was taken to Baghdad following the 1990 invasion of Kuwait. At the time of its acquisition by the Collection, a stemmed foot similar to that of cat. 20b was attached to the bottom. Conservators established that the foot was not original to the vessel and removed it (now catalogued as LNS 84 Gb; not included here). The cup is nearly complete, except for the protruding ring, about half of which is missing. The surface is partially weathered, resulting in a milky white film and iridescence. The glass includes frequent tiny bubbles.

Cat. 21

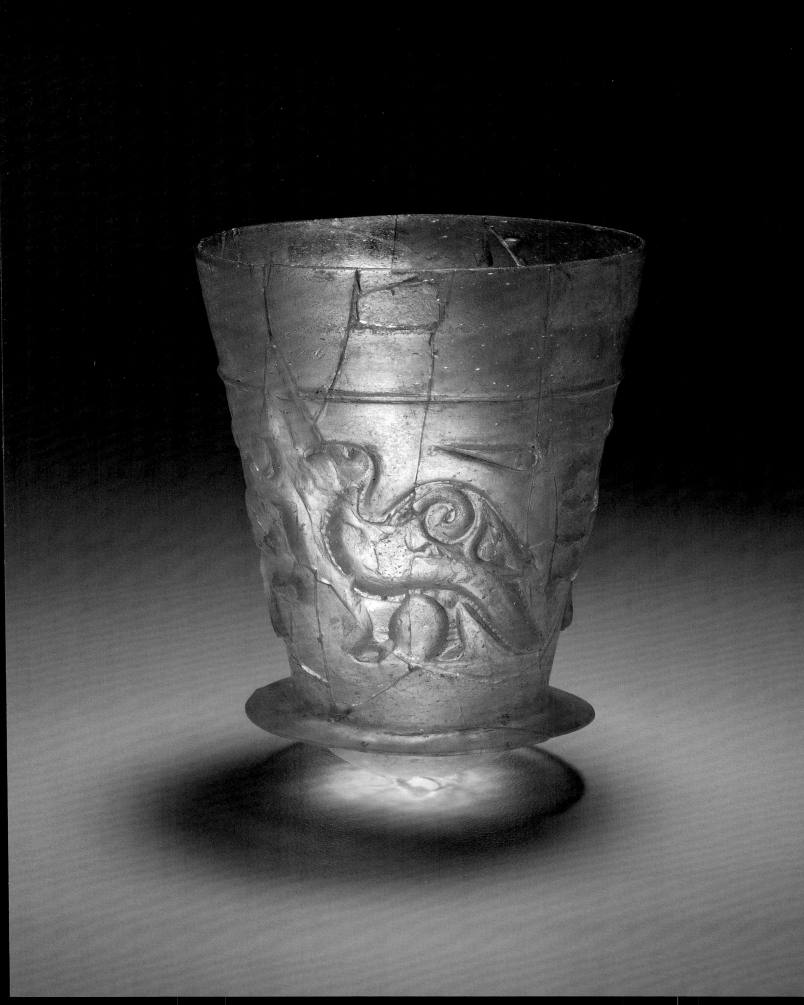

**Cat. 22 FRAGMENTARY BOWL**
(LNS 77 G)
**Iranian region**
**First half of the 10th century**

Dimensions: hgt. 5.3 cm; max. diam. 10.0 cm;
th. 0.26 cm; wt. 115.7 g
Color: Translucent grayish colorless
Technique: Blown; tooled; relief cut
Description: This bowl has slightly flared, curved
walls and rests on a low foot formed by
a countersunk circle in relief created by
cutting. The pontil mark in the center
was ground. A second, larger ring was
cut in lower relief to highlight the
transition between the base and the
walls. The decoration consists of two
pairs of confronted quadrupeds in a
running posture, only one of which is
complete. This animal has a pointed
face with a round drilled eye; the mouth
was created with a simple horizontal
groove and the area inside the long
straight horn (or ear) is filled with a
herringbone pattern. Five small circles
were drilled on the neck and body,
which is outlined by a narrow hatched
band and is countersunk, so that the
joints of the legs are seen in higher
relief. The rear part is lifted on long
curved hind legs. The hooves (or paws)
and the large bushy tail are decorated
with hatched patterns, and the creature
holds half of a palmette-shaped leaf on
a stem in its mouth. Sections of another
pair of quadrupeds are extant. The first,
of which only the head survives, faces
the animal described above and seems
to represent the same creature. The rear
part of a second animal remains; it
is similar to the intact quadruped
described above but has a longer, thin,
curved tail and a curved wing and thus
depicts a different creature.
Condition: About 60 percent of the original object
is extant in four fragments, two large
and two small. The surface is slightly
weathered, resulting in gray pitting and
abrasion. The glass is of good quality.
Provenance: Reportedly from Nishapur
Literature: Ohm 1975, no. 135a, pl. 14; and
Lucerne 1981, no. 620

A drawing published by Ohm before this bowl entered the Collection suggests that the second pair of animals consisted of two fantastic, *senmurv*-like, winged quadrupeds with bird's heads.[44] Their present fragmentary condition makes it impossible to confirm such an interpretation. Ohm identifies the extant quadruped and the fragmentary second one of the pair as hares, but they are probably a fantastic composite animal: the general shape of the body is rabbitlike[45] but the tail is too long and large and the herringbone motif that fills the inner area may represent a stylized stag's horn rather than an ear.[46]

The depiction of imaginary composite animals (see also cat. 19) was not unusual in the Islamic world, where sphinxes, harpies, and griffins took their place in the iconography after the eleventh century. Previously, the *senmurv* of Sasanian Iran and Central Asia was the most commonly depicted fantastic animal.[47]

Although the composite hare/stag creature on this bowl has no exact parallel, it shares a number of technical features with related objects and fragments. These features include the narrow ribbed band that outlines the creature's body, the sparse decorative dots drilled on its neck and body, and the imaginative curl on the hind leg that represents the thigh. Comparable examples are found on a bowl in Berlin; two fragments excavated at Nishapur and Samarra that include both the ribbed band and the drilled dots; and numerous other fragments that show the ribbed band or the curly thigh.[48] The blue glass fragment from Nishapur is particularly relevant because the head of the winged creature—with its pointed shape, drilled eye, and grooved mouth—is almost identical to that of the hare/stag.

The suggested chronology for these works ranges from the second half of the ninth century to the middle of the tenth century. A date in the first half of the tenth century seems the most likely for this fragmentary bowl, without a doubt one of the most accomplished products of relief-cut glass featuring figures of fantastic animals.

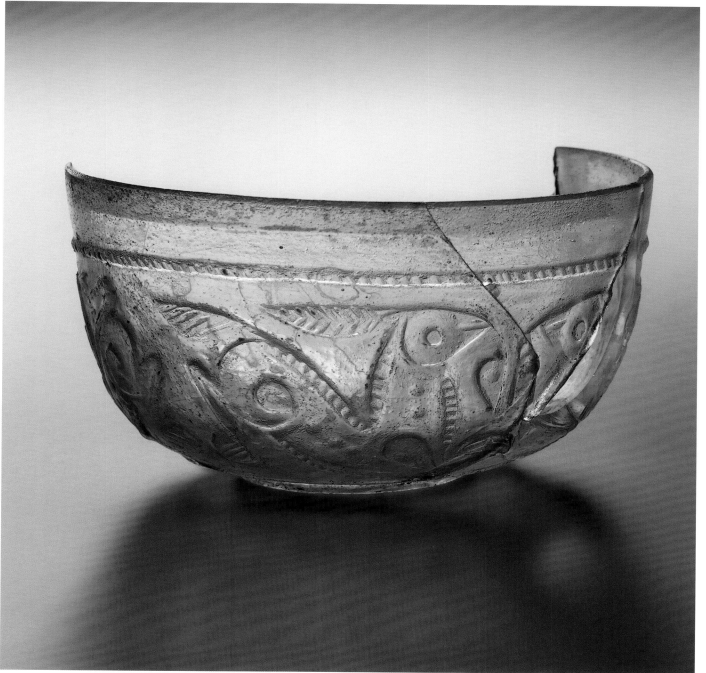

Cat. 22

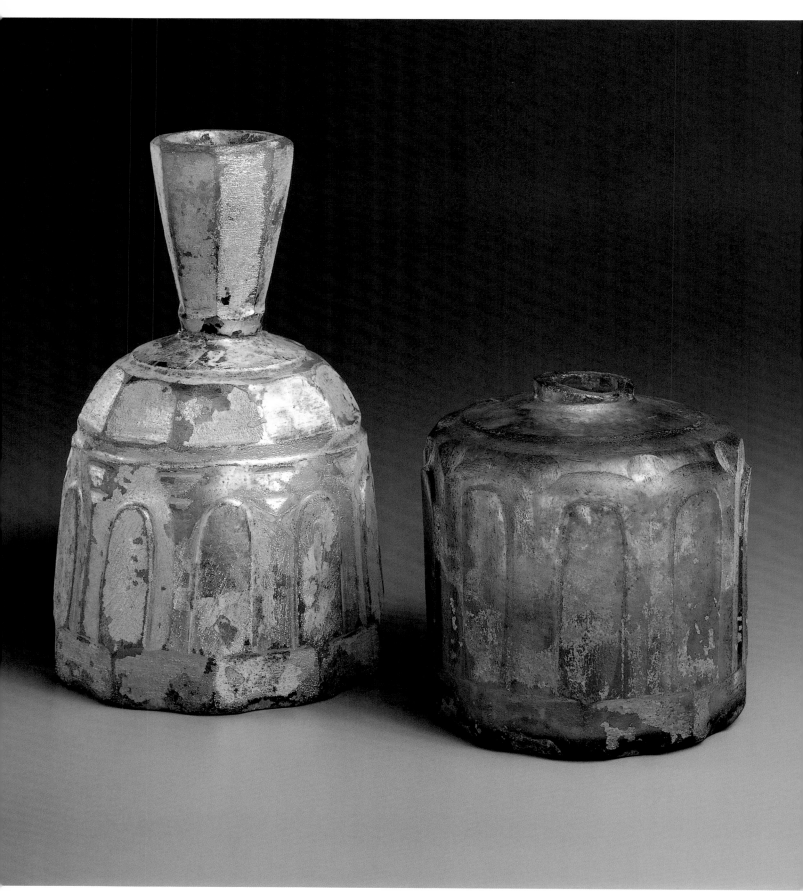

Cat. 23a, b

## Cat. 23a BOTTLE
### (LNS 79 KG)
### Probably Iranian region
### 9th–10th century

Dimensions: hgt. 14.8 cm; max. diam. 8.5 cm;
th. 0.36 cm; wt. 261.2 g; cap. 315 ml
Color: Translucent grayish colorless
Technique: Free blown; tooled; relief cut
Description: This dome-shaped bottle has a flat base
and a flared seven-sided neck with a
heptagonal opening. The pontil mark
under the base was ground and a roundel
in relief was cut in its place. The main
decoration consists of ten elongated
arches in relief at even intervals;
between the arches is a barely noticeable
pattern of slender columns with a
triangular capital on top, also created
by cutting. Additional faceting is visible
below the arches, which creates a sort
of sunken foreground for the arcade.
A second tier of ten arches that form
a continuous pattern and are not
separated by columns was carved above
the main arcade. The two sets of arches
are separated by horizontal grooves.
Condition: The object is intact. The surface is
entirely weathered, resulting in a milky
white coating and iridescence. The
glass includes frequent small bubbles.
Provenance: Kofler collection
Literature: Lucerne 1981, no. 594

## Cat. 23b FRAGMENTARY BOTTLE
### (LNS 41 G)
### Probably Iranian region
### 9th–10th century

Dimensions: hgt. 8.8 cm; max. diam. 7.4 cm;
th. 0.48 cm; wt. 228 g; cap. 267 ml
Color: Translucent pale bluish green (green 1)
Technique: Free blown; tooled; relief cut
Description: This cylindrical bottle, missing its neck,
has a flat base. The pontil mark under
the base was ground and a roundel in
relief was cut in its place. The
decoration consists of nine elongated
arches in relief at even intervals with
countersunk inner areas. Additional
cutting is visible below the arches,
creating a kind of sunken foreground
for the arcade. Facets are cut around the
shoulder at the meeting of the arches.
Grooves are present at the transition
between the shoulder and the neck.
Condition: The bottle entered the Collection with a
long cylindrical neck that did not belong
to the object and was removed. The
surface is heavily weathered, resulting
in iridescence and slight abrasion.
The glass includes scattered bubbles.

Related Works: 1. Toledo, inv. no. 47.6
(Toledo 1969, fig. p. 38)
2. CMG, inv. no. 73.1.30
(Charleston 1989, fig. 13)
3. Private collection, Tokyo
(Fukai 1977, no. 77)
4. NM, Baghdad, inv. no. 5436
('Abd al-Khaliq 1976, pl. 15a, fig. 94)
5. MMA, inv. no. 65.172.2
(Jenkins 1986, no. 32)

Dome-shaped bottles with a flat base and a flared neck were popular in the Iranian region between the ninth and the eleventh century, especially in glass and in metal. It is not possible, however, to determine whether metalworkers inspired glassmakers or vice versa, but both art forms certainly flourished at the same time (see also cat. 1.17).

These bottles, along with the many similar objects found in collections around the world (Related Works 1–5 are but a representative sampling), were decorated with the popular pattern of "empty arches" (see also cat. 29). Such arches were created in relief by cutting away the background. Often a second, smaller tier of arches was carved above the main one (see cat. 23a and Related Works 1, 4, 5); in many other examples, only one arcade was created (see cat. 23b and Related Works 2, 3).

Cat. 23a shows a remarkable degree of sophistication in the quality of the carving and in the creation of slender columns with stylized capitals between the larger arches. This abstract effect is similar to that on the Corning bottle (Related Work 2), the most accomplished object of this type.

The popularity of the arcade pattern inspired the production of a large number of glass bottles of various shapes with relief-cut decoration. A typical example is cat. 23b, a straight cylindrical bottle decorated with a series of evenly distanced arches that originally had a long narrow neck. In comparison, the quality of the cutting on bottles of cylindrical shape, such as cat. 23b, seems cruder in execution and generally less inventive.

## Cat. 24 BOTTLE (LNS 292 G)
### Iranian or Mesopotamian region
### Late 9th–10th century

Dimensions: hgt. 11.9 cm; max. diam. 7.8 cm;
th. 0.37 cm; wt. 157.6 g; cap. 240 ml

Color: Translucent pale bluish green (green 1)

Technique: Free blown; tooled; relief cut

Description: This dome-shaped bottle has a flat base
and a slightly flared neck. The neck is
six-sided, but its facets do not reach the
rim; thus the opening is circular and
somewhat bulging. The pontil mark
under the base was ground, creating
a sunken area in the center. The main
decoration, in relief, consists of a
pattern created by two intersecting
rows of tear-shaped medallions that
are arranged upright in the upper row
and upside down in the lower one;
the inner areas of the medallions were
countersunk. The overall effect is that
of a continuous sinuous pattern.
Additional cutting includes a band
with dense vertical hatching around
the shoulder.

Condition: The object is intact. The surface is
heavily weathered, resulting in a brown
coating on the interior, brown pitting
and whitish spots on the exterior, and
slight abrasion. Conservators have
pointed out that the weathering is
inconsistent with the expected surface
deterioration and are, therefore,
suspicious about the object's
authenticity. The author is inclined to
believe that the bottle is authentic. The
glass includes frequent small bubbles.

Provenance: Christie's, London, sale, October 19,
1993, lot 323

Related Work: MIK, inv. no. I.2673
(Kröger 1984, no. 183)

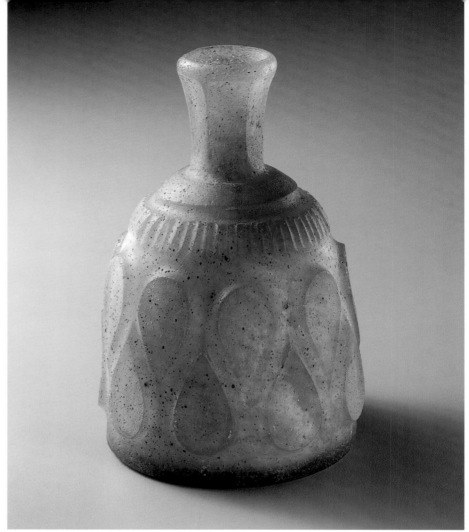

Cat. 24

The shape of this bottle is obviously related to that of cat. 23a. Here, the arcaded pattern was replaced by a vigorous, lively motif that brings new life to this piece and makes it one of the best examples of a relief-cut object with abstract decoration. Its sure, precise execution, together with its generally good condition, makes this bottle stand out among the many similar objects produced in the same period.

The decoration has no known published parallels, though the overall composition, especially the ribbed band around the shoulder, recalls a bottle in Berlin (see Related Work), which, however, is cruder in execution. The pattern of intersecting tear-shaped elements, which is neither complex nor elaborate, finds parallels in the so-called "Style C" of ninth-century 'Abbasid Samarra.[49] This decorative style, executed principally for architectural carved plaster panels, was assimilated and elaborated throughout the Islamic world from the end of the ninth century onward. The present bottle seems to be one of the few glass objects to bear Samarran motifs.[50] Its shape places it in the group of relief-cut dome-shaped bottles that were almost certainly produced in the Iranian region (see also cat. 23a). Its direct relation to Samarran patterns, however, suggests that it may be one of the few surviving pieces that can be attributed to the Mesopotamian region.

## Cat. 25a BOTTLE (LNS 79 G)
### Iranian region
### 9th–10th century

Dimensions: hgt. 22.5 cm; max. diam. 12.0 cm; th. 0.39 cm; wt. 359.1 g; cap. ca. 1350 ml

Color: Translucent yellowish colorless

Technique: Free blown; tooled; worked on the pontil; linear cut; facet cut

Description: This nearly cylindrical bottle has a slightly tapered neck that ends in a splayed mouth. The base is slightly kicked. The decoration consists of shallow horizontal grooves, either single or paired, cut above the base, in the middle, and above and below the shoulder. Rows of shallow, evenly distanced facets were cut just above the base (below the groove) and at the shoulder. The neck presents a somewhat more elaborate decoration: two rows of seven rectangular facets alternating with a row of eight parallelograms.

Condition: The object is intact. The surface is lightly weathered, resulting in a milky white film and faint iridescence. The glass includes frequent small bubbles and some large ones.

## Cat. 25b BOTTLE (LNS 59 G)
### Iranian region
### 9th–10th century

Dimensions: hgt. 11.7 cm; max. diam. 7.0 cm; th. 0.29 cm; wt. 119.8 g; cap. 218 ml

Color: Translucent yellowish colorless

Technique: Free blown; tooled; worked on the pontil; linear cut; facet cut

Description: This bottle has a nearly cylindrical body and neck. The decoration is almost identical to that of cat. 25a. The decoration on the neck is cut more deeply than the rest of the decoration, with a horizontal groove and a row of six vertical rectangular facets, unevenly spaced.

Condition: The neck is broken and the opening is missing; the remainder of the object is intact. The surface is heavily weathered, resulting in a milky white coating and iridescence. The glass includes frequent small bubbles.

Related Works: 1. MMA, inv. nos. 40.170.61, 48.101.10, 48.101.270 (Kröger 1995, nos. 170–72)
2. CMG, inv. no. 53.1.8 (Corning 1974, p. 26)

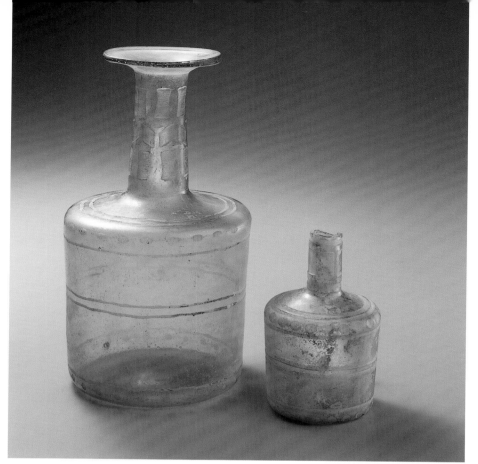

Cat. 25a, b

Like cat. 16, these two bottles might have been included in Chapter 1, as their faceted decoration derives from the group of vessels of Sasanian influence (see cat. 8, 9). Their shape, however, is entirely Islamic and far removed from Sasanian prototypes, hence their inclusion here.

As with cat. 16, an Iranian origin for these bottles seems unquestionable, since almost identical objects were found in Nishapur, in the areas of Qanāt Tepe and Tepe Madraseh, in an apparently tenth-century context (see Related Work 1). The most remarkable of all objects belonging to the group is a large, unique bottle in the Corning Museum (Related Work 2), which is made of opaque pale turquoise glass. All the related objects have identical shapes, though they may vary in size, and share identical decorative patterns: shallow horizontal grooves; well-distanced, evenly spaced round facets; and deeper facets on the neck that create rectangular facets or parallelograms.

These bottles seem to correspond to the last stage of the great tradition of faceted glass in Iran (see cat. 8, 9) that was to disappear shortly after the tenth century. The round facets, which were once placed so close together that they provided a reflective, mirrorlike surface, became distanced and shallow. The allover surface decoration of the earlier vessels became subdivided into horizontal bands with shallow grooved lines. If, on one hand, these objects are considered representative of the decline of a great tradition of glass cutting, they are, on the other hand, appealing for the simplicity of their decoration and their well-defined shapes.

Interesting parallels for this group of Iranian bottles are provided by numerous finds from North Africa, specifically at Sabra Mansuriyya, at the Qal'a of the Banu Hammad, and at Sidi Khrebish (Bengasi).[51] The shape of those vessels, probably produced in Tulunid or Fatimid Egypt, seems to have derived from Iranian works and, though the overall decoration is very different, some features (for example, the horizontal grooves) are common to both groups.[52]

**Cat. 26a SHALLOW BOWL (LNS 88 G)**
Iranian region
9th–10th century

Dimensions: hgt. 2.9 cm; max. diam. 13.9 cm;
th. 0.34 cm; wt. 151.1 g; cap. 228 ml
Color: Translucent pale blue (blue 1)
Technique: Free blown; tooled; linear cut;
relief cut; worked on the pontil
Description: This shallow bowl, or dish, has curved
walls and a rounded rim. The decoration
on its underside was created with large
shallow cuts that are U-shaped in cross
section. The pontil mark was partially
ground away and is still visible in the
center of a series of relief-cut concentric
circles, a six-pointed starlike design
surrounds the concentric circles and the
star pattern is inscribed within additional
circles. The outermost design, which
extends to the walls of the dish, consists
of twelve pairs of simple patterns that
look like sets of parentheses.
Condition: The object, though broken and
repaired, is complete. The surface is
partially weathered, resulting in whitish
and pale brown coatings. The glass
includes frequent small bubbles.
Literature: Atıl 1990, no. 15

**Cat. 26b SHALLOW BOWL (LNS 423 G)**
Iranian region
9th–10th century

Dimensions: hgt. 3.9 cm; max. diam. 13.2 cm;
th. 0.25 cm; wt. 120.0 g; cap. ca. 300 ml
Color: Translucent yellowish colorless
Technique: Blown; tooled; linear cut;
worked on the pontil
Description: This dish, or shallow bowl, stands on
a small flattened base, has curved walls
and a rounded rim. Two concentric
circles are cut in the center around
the partially ground pontil mark.
The decoration on its underside was
created with large shallow cuts that are
U-shaped in cross section. The pattern
consists of a large six-petaled flower
made by three intersecting rectangles
with curved shorter sides; the triangular
sections formed by the intersecting
rectangles create a central six-pointed
star with a fine hatched surface. Three
small pointed ovals are drawn at every
other intersection of the petals, and
small raised buttons are cut in the
center of each petal.

Condition: The object was broken and repaired;
small parts of the rim and walls were
filled. The decoration has not suffered
and is entirely legible. The surface is
heavily weathered, resulting in a milky
white film, iridescence, and abrasion.
The glass is of good quality.
Provenance: Sotheby's, London, sale, April 24, 1997,
lot 20
Related Works: 1. V&A, inv. nos. C138.1936,
C139-1936 (Buckley 1939, pl. 11)
2. MK, Frankfurt, inv. no. 12697/5194
(Ohm 1975, no. 71)
3. CMG, inv. no. 55.1.140
(Smith 1957, no. 535)
4. BM, inv. no. 1966.12-12.1
(Harden et al. 1968, no. 141)
5. LACMA, inv. no. M.88.129.156
(von Saldern 1980, no. 150)

Dishes or shallow bowls with abstract linear patterns created by grinding away the surface
to produce wide shallow grooves were fairly common in the Iranian region. As a rule, these
objects were incised on only the outer surface; consequently, it has been suggested that they
could have been used as lids rather than dishes. This hypothesis, however, seems farfetched
considering their rather large size (several are more than twenty-five centimeters in
diameter), their pale color that allows the pattern to be clearly legible through the glass, and
the absence of any reported vessels having a diameter large enough to be regarded as possible
bowls for such lids.

The two bowls (cat. 26a, b) are among the smallest of this type that have been
reported in the literature. The pseudogeometric decoration may vary in terms of complexity
and elaboration but the quality of the engraving is always rather crude and basic. Squares
within circles, small circular facets, and plain lines are the most common patterns (see
Related Works 1–3); rosettes and other floral motifs are sometimes encountered (see Related
Work 5).[53] The dish in the British Museum (Related Work 4) is unusual, since it includes a
cruciform pattern in the center.[54]

The patterns of stars and parentheses on cat. 26a are rare in the repertoire; its pleasant
pale blue color makes it one of the most appealing vessels in this group. The decoration
of cat. 26b is somewhat difficult to read because of the bowl's condition. Although it is
based on the simple intersection of three rectangles with rounded corners, the geometric
composition is successful because the figures thus created are clearly distinct and offer the
viewer different readings of the pattern (for example, the hatched triangles highlight the
figure of a six-pointed star, while the raised dots in the center of the rounded sections
emphasize the flower pattern).

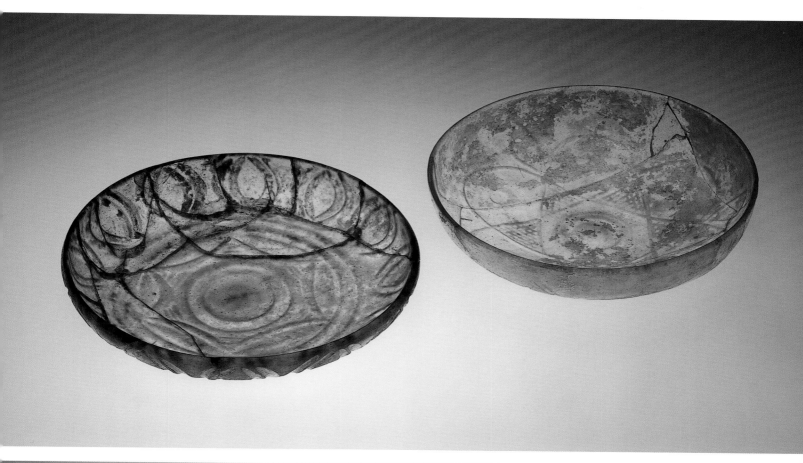

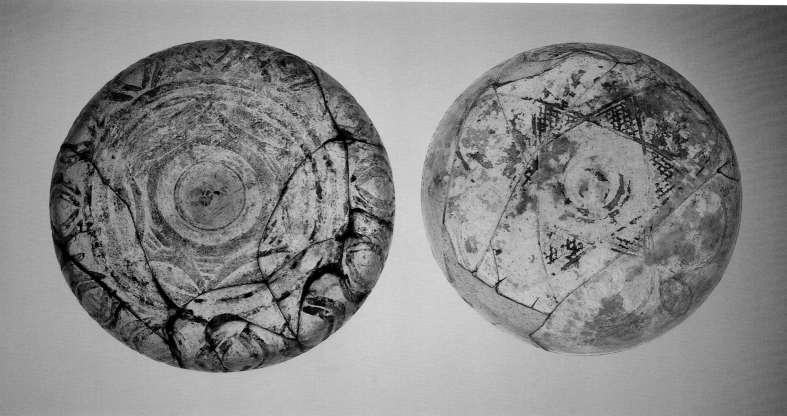

Cat. 26a, b

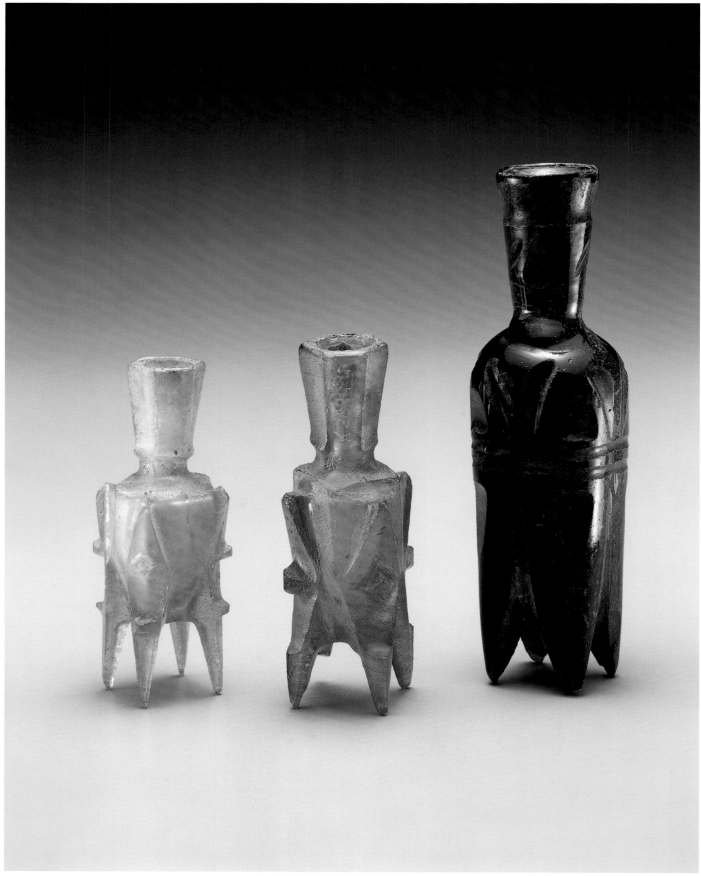

Cat. 27a–c

### Cat. 27a MOLAR FLASK (LNS 122 G)
**Possibly Egyptian region**
**9th–10th century**

Dimensions: hgt. 6.2 cm; w. 1.8 cm; l. 1.8 cm;
th. 0.18 cm; wt. 18.8 g; cap. 3 ml
Color: Translucent yellowish colorless
Technique: Blown; cut; drilled
Description: The body of this square flask is divided
into three equal sections—feet, body,
and neck—each about 2 cm in height.
The long slender feet are wedge-shaped
and pointed. The main decoration on
the deeply cut body consists of a prunt
protruding from a lozenge-shaped motif
in relief at each corner; additional
prunts were cut at each corner, at the
transition point between the body
and the feet. The shoulder is angular.
The six-sided, flared neck is grooved
at the base. The neck and the interior
chamber, which is tear-shaped, were
drilled.
Condition: One foot and other small parts are
slightly chipped; the remainder of
the object is intact. The surface is
lightly weathered, resulting in slight
iridescence and some abrasion.
A whitish granular powder with gray
spots is present inside the vessel.[55]

### Cat. 27b MOLAR FLASK (LNS 15 KG)
**Possibly Egyptian region**
**9th–10th century**

Dimensions: hgt. 6.8 cm; w. 2.0 cm; l. 2.0 cm;
th. 0.22 cm; wt. 25.6 g; cap. 4 ml
Color: Translucent brown (yellow/brown 3)
Technique: Blown; cut; drilled
Description: This square flask has slender feet that
are wedge-shaped and end in a point.
The main decoration on the deeply cut
body consists of a prunt protruding
from a sunken lozenge-shaped motif
at each corner. The shoulder is angular.
The six-sided, flared neck is grooved
at the base. The neck and the interior
chamber, which is tear-shaped, were
drilled.
Condition: One foot is chipped; the remainder
of the object is intact. The surface is
lightly weathered, resulting in slight
iridescence and abrasion. The glass
includes scattered small bubbles.
Provenance: Kofler collection
Literature: Lucerne 1981, no. 607

### Cat. 27c MOLAR FLASK (LNS 40 KG)
**Possibly Egyptian region**
**9th–10th century**

Dimensions: hgt. 10.0 cm; w. 3.0 cm; l. 3.0 cm;
th. 0.26 cm; wt. 53.3 g; cap. 17 ml
Color: Translucent dark blue (blue 4)
Technique: Blown; cut
Description: This square flask has short wedge-
shaped feet. The simple decoration
on the body was created with grooves:
two horizontal grooves encircle the
body and deeply cut, sunken tear-
shaped patterns are above and below
the grooves on each side and corner.
The shoulder is rounded. The flared
neck presents a large groove just below
the opening, which is circular, and
additional tear-shaped facets below
the groove.
Condition: The object is intact except for chips
on the feet. The surface is entirely
weathered, resulting in a dark gray,
almost black coating that prevents
proper reading of the color.
Provenance: Kofler collection
Literature: Lucerne 1981, no. 612

"Molar" flasks, so-called after the shape of their four elongated, wedge-shaped, pointed feet that vaguely resemble the root of a molar tooth, are perhaps the most common perfume or essence containers among the finds of early Islamic glass. Every public or private collection owns a number of them and they are consistently found during excavations throughout the Islamic world, from the Maghrib to Central Asia and farther east.

The raison d'être for these small solid bottles was commercial rather than aesthetic or artistic, and they were no doubt transferred from their places of production to the perfume manufacturers and from there traveled along trade routes by land and sea. It is easy to imagine these flasks, tightly packed inside wicker baskets and wrapped in straw, traveling around the Islamic world. The exact way they were shipped, however, is not known, in the absence of original sources describing the process. The bottles were probably filled with the precious liquid and tightly sealed before shipping.

The wheel-cut decoration on their bodies and necks has no functional purpose and must be interpreted as purely aesthetic, while the presence of the four feet must have had a practical explanation that is not entirely clear. One possibility is that these flasks were arranged upright in the baskets in order to minimize the possibility of spillage and that the feet would have provided better balance in the straw that separated the various layers. Whatever their practical function, molar flasks became one of the most successful shapes in glass production and in all probability provided the models for similar products in bronze, ivory, and rock crystal.[56]

Judging from the many examples in the Collection (twenty in all, including cat. 27a–c, 2.29a–r), the size of these flasks is generally consistent while the quality and the elaboration of their decoration vary greatly. Therefore, it would be relatively easy to arrange them into categories according to different patterns, dimensions, length of their feet, and complexity and depth of the cutting process. For example, individual small prunts cut in relief against

the background of a lozenge-shaped medallion at each corner distinguish cat. 27a and b and, to a certain degree, cat. 2.29a and g. Cat. 2.29h and i can be set apart because of their platformlike bases, created by a deep horizontal groove and supported by four short, squarish feet. The surface of a large number of objects (see cat. 27c, 2.29m, n) was simply grooved or scooped away, representing a much less elaborate decoration. Many additional subgroups could be formulated, based on the distinctions mentioned above as well as others.

The large number of decorative motifs, the differences in the shapes of the feet, and the complexity and elaboration of the cutting suggest that there were multiple places of production for these objects. Many leading glass manufacturers based in important commercial centers where perfumes were also produced, such as Fustat in Egypt, probably had their own line of molar flasks. Different decorative patterns, depth of cutting, drilling of the interior receptacle, and shape and length of the feet can therefore be attributed to diverse centers and, possibly, to different periods within the accepted timeframe of production—that is, the ninth and tenth centuries. These flasks are usually attributed to Egypt because the majority seem to have been found there or they have been given such a provenance by dealers and collectors. Here, this common attribution has been reluctantly accepted, principally because there is not enough evidence to assign specific patterns or technical details to particular areas of the Islamic world. It may, however, be possible that Iranian glass cutters were also involved in the production of molar flasks, although the form nonetheless originated in Egypt.

## Cat. 28a BOTTLE (LNS 55 G)
**Probably Iranian region
9th–10th century**

Dimensions: hgt. 8.8 cm; max. diam. 5.6 cm; th. 0.39 cm; wt. 121.3 g; cap. 128 ml
Color: Translucent yellowish colorless
Technique: Free blown; cut; worked on the pontil
Description: This small bottle and its six-sided neck have straight walls. A twelve-sided vessel was created by cutting off vertical "slices" around the body.
Condition: The object is intact. The surface is partially weathered, resulting in a milky white coating and slight abrasion. The glass includes scattered bubbles.

## Cat. 28b BOTTLE (LNS 56 G)
**Probably Iranian region
9th–10th century**

Dimensions: hgt. 7.4 cm; max. diam. 5.3 cm; th. 0.34 cm; wt. 64.0 g; cap. 74 ml
Color: Translucent yellowish colorless
Technique: Free blown; tooled; cut; worked on the pontil
Description: This small bottle and its neck have straight walls. The body was left undecorated; the simple decoration on the neck consists of six vertical cuts, creating a hexagonal opening.
Condition: The object is intact. The surface is heavily weathered, resulting in a milky white coating, iridescence, and scratches. The glass includes tiny scattered bubbles.

## Cat. 28c BOTTLE (LNS 58 G)
**Probably Iranian region
9th–10th century**

Dimensions: hgt. 6.4 cm; max. diam. 4.7 cm; th. 0.31 cm; wt. 52.1 g; cap. 58 ml
Color: Translucent yellowish colorless
Technique: Free blown; cut; worked on the pontil
Description: This small bottle and its seven-sided neck have straight walls. An eleven-sided vessel was created by cutting off vertical "slices" around the body. The base is slightly concave; consequently, the vessel does not stand flat.
Condition: The object is intact. The surface is entirely weathered, resulting in golden iridescence and abrasion.
Related Works: 1. Glass and Ceramics Museum, Tehran (Tehrani 1987, p. 17)
2. LACMA, inv. no. M.88.129.166 (von Saldern 1980, no. 160)
3. MIK, inv. no. I.2313 (Kröger 1984, no. 186)
4. Louvre, inv. no. MAO S 530 (Lamm 1931, pl. 78:4)
5. NM, Stockholm (Lamm 1935, pls. 35f–h)
6. Egyptian Museum, Cairo (Lamm 1929–30, pl. 58:4)

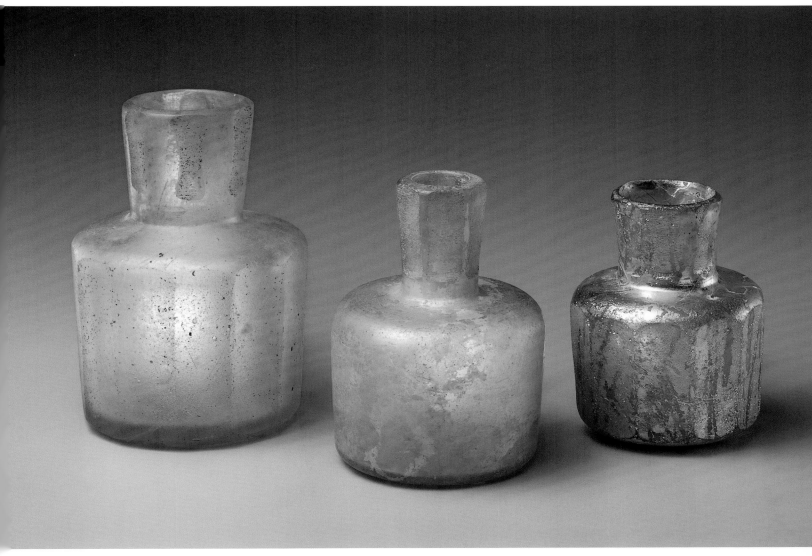

Cat. 28a–c

Among the less elaborate vessels that have a shape created using the cold-cut technique
are small bottles and vases with a flat base, straight profile, and slightly flared neck whose
bodies and/or necks were "sliced" into vertical panels, transforming each vessel into a
multisided object. The proportions between height and width, or between the height of the
body and the neck, may vary, but these bottles tend to be rather squat (see also cat. 2.34).

The production of these objects was widespread in the Iranian region and was
understandably common to many workshops with the technology necessary to cut glass on
the wheel. Oddly enough, however, none of these vessels was excavated at Nishapur, which
represents the yardstick against which Iranian products are usually measured. The
simplicity of the cut patterns and the commercial use of these vessels, like those of the
molar flasks discussed previously (cat. 27), probably prompted imitations in other areas of
the Islamic world, both in the Iranian and the Syro-Egyptian regions, as they are reported
to have been found, for example, in Iran, Egypt, and the Caucasus region (Related Works
4–6 surfaced during excavations at Susa and Rayy, in Iran, and Mit Rahina, in Egypt,
respectively).[57] Many objects belonging to this group are found today in public and
private collections.

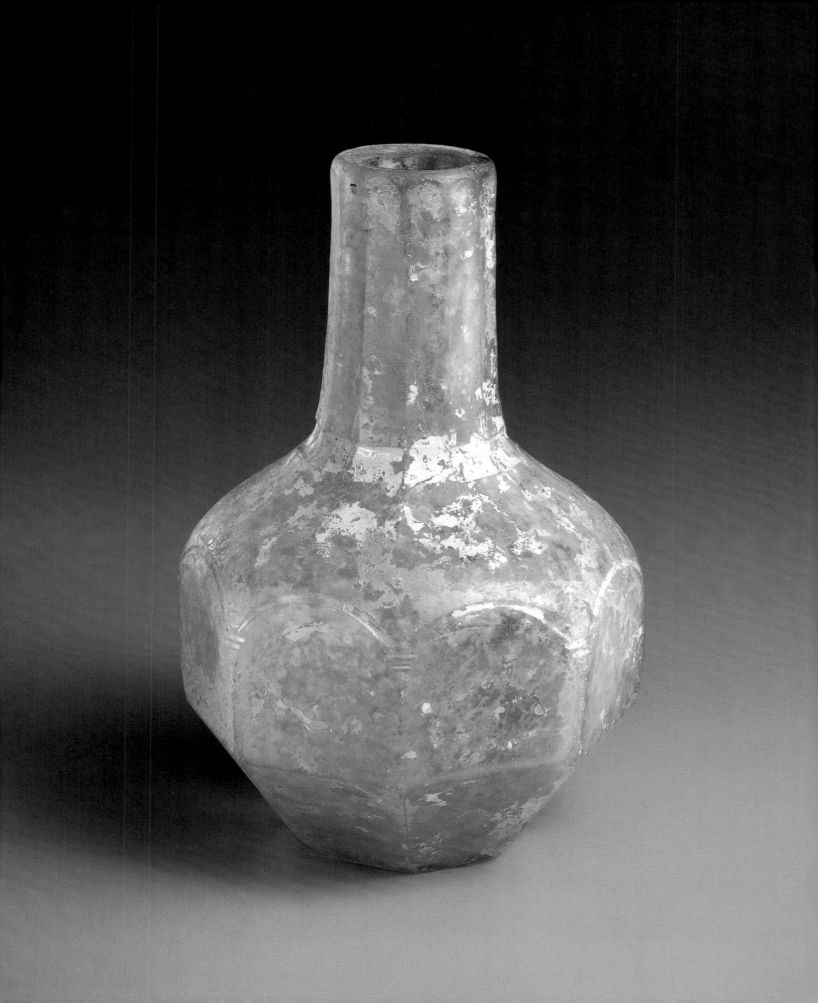

**Cat. 29 BOTTLE (LNS 67 G)**
**Iranian region**
**9th–10th century**

Dimensions: hgt. 13.1 cm; max. diam. 8.0 cm;
th. 0.40 cm; wt. 153.7 g; cap. 67 ml

Color: Translucent grayish colorless

Technique: Free blown; tooled; cut; incised

Description: This small bottle has a cylindrical neck
and a flat base. The vessel began as
thick and globular; the final multisided
shape was created using the cold-cut
technique. The body is thinner than the
neck, the surface of which was cut away
only superficially. The result is a slightly
irregular eight-sided polyhedron. There
is a horizontal groove around the base
of the neck, which was cut into thirteen
regular facets that begin just below the
opening, which is circular. Shallow
incisions around the midsection of the
vessel create a subtle arched pattern;
short horizontal lines are drawn at
the point of conjunction of the arches,
creating a pattern of capitals atop
columns.

Condition: The object is intact. The surface is
partially weathered, resulting in a
milky white coating, iridescence,
and abrasion.

Literature: Jenkins 1983, p. 30

This bottle stands apart for both its shape and its decoration (see also cat. 2.37). Thick globular vessels with surfaces greatly reduced by cutting to create multisided, diamondlike, polyhedric shapes are uncommon and are rarely reported in the literature.[58] The relative thickness of their necks, the surfaces of which were also sliced away, albeit not as deeply, provides a counterpart to the lightness of their heavily pared-down bodies, thus putting the weight of these bottles curiously off-balance, so to speak, when they are handled.

The decoration of the so-called empty-arch design[59] on this bottle is unique, though it is sometimes found on cylindrical bottles and, especially, beakers. What is remarkable about cat. 29 is that the polyhedric shape of the body itself dictated the decorative pattern: the points where the vertical faces of the polyhedron meet are suggestive of pillars (so that it was unnecessary to engrave their pattern), and simple incised lines and short horizontal grooves were sufficient to create arches and to suggest the idea of capitals, respectively.

The arch design seems to have grown out of late antique patterns[60] and found its place as an Islamic motif exclusively in the Iranian region. Three examples—a bottle shaped similarly to those discussed at cat. 25 and two beakers—were found at Nishapur.[61] Other examples are in the Corning Museum of Glass, Newark Museum, and Museum of Underwater Archaeology at Bodrum.[62] The Bodrum beaker, a tall flared object showing the pattern of a single arcade (the others include a two-tiered motif), was found in the early eleventh-century shipwreck of Serçe Limanı; since it represents the only known exception of a reputed provenance outside the Iranian world, its presence would suggest that part of the cargo from the shipwreck may have come from the eastern Islamic world rather than from the Syrian region alone.[63]

**Cat. 30a SPOON (LNS 326 G)**
**Iranian or Central Asian region**
**10th–11th century**

Dimensions: l. 23.3 cm; w. 3.9 cm; th. 0.28 cm;
wt. 34.4 g
Color: Translucent pale brown
(yellow/brown 2)
Technique: Tooled; cut
Description: This oval spoon has a raised shoulder
with two protrusions on its sides and
a narrow straight handle that curves
downward at the end and terminates
in a double point. The cut decoration
includes horizontal grooves, chevron
patterns, and an elongated pointed
medallion.
Condition: The object was broken in three pieces.
An earlier restoration was indicated by
the presence of adhesive at the breaks.
After the adhesive was removed, the
bowl and handle did not fit together
properly. Therefore, either a small part
is missing or the bowl and the handle
do not belong together; since the glass
colors and decoration of the two
sections are virtually identical, the
former hypothesis is far more likely.
The surface is entirely weathered,
resulting in a milky white coating
and iridescence. The glass includes
scattered small bubbles.
Provenance: Reportedly from Mardha, Syria

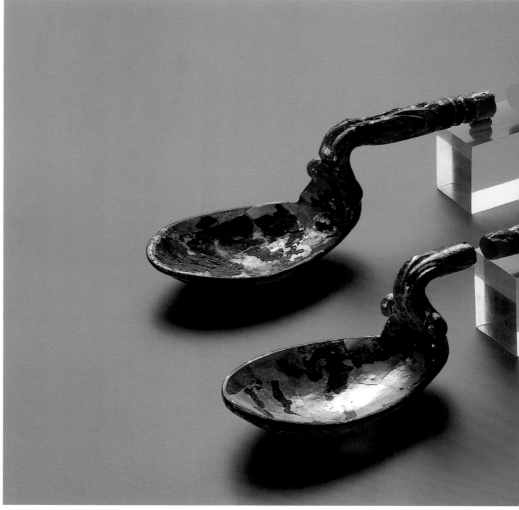

Cat. 30a, b

Glass spoons are rare in Islamic art. Some spoons presenting relief-cut decoration are
known from Roman times,[64] but the few Islamic examples that have been reported are
almost invariably attributable to the eastern Islamic regions; therefore, neither a direct
Roman influence nor a stylistic continuity over time can be established between the two
productions. It must be said, however, that Roman spoons in bronze with a curved handle,
similar to that of cat. 30a and b, usually ending in a human or animal head, were common
and may have traveled as far as Central Asia.[65] A bronze spoon with a cast segmented handle
ending in a female head, reminiscent of the cut decoration of the two glass spoons, was
excavated in Uzbekistan in the Kashkadarya region, Soghdiana, in a tenth- to twelfth-
century context, though it seems to date about two centuries earlier.[66] This spoon may
provide an ideal link between the Roman tradition and the Islamic production. Another
cast bronze spoon or ladle in the Collection (LNS 781 M) has a curved profile that is
similar to that of cat. 30a and b and probably dates from the same period.

The closest parallel for cat. 30 is provided by a greenish blue glass spoon that was
sold at Sotheby's, London, in 1990 (Related Work). The pointed oval motifs carved on
the back and curved end of the handle are common to both. There are also noticeable
differences: the decoration of the Sotheby's spoon was carved entirely on the less visible
side of the object—that is, on the back of the handle and the bowl, while the handles of

**Cat. 30b SPOON (LNS 327 G)**
**Iranian or Central Asian region**
**10th–11th century**

Dimensions: l. 23.5 cm; w. 3.8 cm; th. 0.24 cm;
wt. 29.7 g
Color: Translucent pale brown
(yellow/brown 2)
Technique: Tooled; cut
Description: This object is virtually identical to
cat. 30a, except that the decoration
of the handle is in higher relief.
Condition: The object was broken in four pieces.
Its condition, including its history of
restoration, is the same as cat. 30a.
Provenance: Reportedly from Mardha, Syria
Related Work: Whereabouts unknown
(Sotheby's, London, sale, October 11,
1990, lot 62)

cat. 30a and b were decorated on the front and the bowls were left undecorated. In addition, the handle of the Sotheby's spoon terminates in a ram's head in place of the abstract bifurcated motif of cat. 30a and b. The omphalos pattern on the reverse of the bowl and the ram's head at the end of the handle called for a ninth- to eleventh-century dating for the Sotheby's object, and its decoration seems to hark back to the earlier Roman and Sasanian traditions. Cat. 30a and b represent instead a stylization of the existing tradition and are probably one or two centuries later than the Sotheby's piece.

Only three other Islamic glass spoons have been published in the literature. One, in colorless glass, was excavated at Fustat in a ninth-century context; its handle was decorated with two carved-out rings and a floral-shaped finial. The second spoon, rather similar to the one from Fustat, was sold at auction in Dubai in 1985. The third is a simpler bluish green spoon with a short cylindrical handle and trailed spiral decoration that was found at Afrasiyab and is datable to the ninth century.[67]

Cat. 30a and b were obviously produced in the same workshop: they are almost identical in size, color, and decoration. The only noticeable differences are the quality of the carving, which is deeper and more refined in cat. 30b, and negligible details of the decoration. Although they are reported to have been found in Syria, they can be attributed with some degree of confidence to the eastern Islamic world.

**Cat. 31 INSCRIBED PLAQUE**
**(LNS 187 G)**
**Possibly Egyptian region**
**9th–11th century**

Dimensions: w. 0.9 cm; l. 5.9 cm; th. 0.24 cm;
wt. 2.7 g

Color: Translucent yellowish colorless

Technique: Molded(?); incised; cut

Description: One side of this small rectangular plaque is flat and the other side is slightly curved. The two long sides of the flat side were cut at a diagonal angle. An inscription from Qur'an 2:255 (*āyat al-kursī*) was incised in Kufic script in reverse on the flat side:

لا إله إلا هو الحي القيوم لا تأخذه
سنة ولا نوم له

("There is no god but He, the Ever-living, the Self-subsisting by Whom all subsists. Slumber overtakes Him not, nor sleep").

Condition: The object is chipped at one corner but is otherwise intact. The surface is heavily weathered, resulting in milky white and pale brown coatings. A brown substance along the sides of the inscription is probably traces of glue.

Provenance: Kofler collection; gift to the Collection

This small plaque is an extremely unusual object in glass and its original function cannot be definitively explained. The brownish substance along its flat side suggests that it was once glued to a surface (probably made of wood), perhaps as an element of a piece of furniture, a casket, or another wooden object.

The contents of the inscription, a few words from the beginning of verse 255 from the second Qur'anic chapter (the so-called Throne Verse or *āyat al-kursī*), further suggest that the object to which this plaque was once attached had a religious, rather than a secular, significance. The inscription was incised in mirror image in neat unsophisticated Kufic calligraphy on the flat side. This face was the one once glued to a surface; therefore, the inscription would be read correctly through the glass once the plaque was attached to the object, perhaps against gold or silver leaf to enhance its legibility. It is now difficult to read due to the weathering of the surface.

The *āyat al-kursī* is a rather long verse and one can assume that a number of plaques similar to the present one would have included the continuation of the verse and were arranged sequentially on the object they decorated. Unfortunately, this is all that can be inferred at the moment since, to the writer's knowledge, no similar plaques, let alone portable objects decorated with inscribed glass plaques, have surfaced.

The Kufic calligraphic style helps to partially clarify the dating for this plaque, but it sheds no light on either its function or its provenance. The quality of the calligraphy is rather average and seems to fit into the early Islamic period, most likely the ninth to tenth century. Its simplicity, however, makes a slightly later date possible. Details such as the shapes of the initial and final letter *h* (ه), the median *ḥ* (ح), and *dh* (ذ), *w* (و), and *lam-alif* (لا) find good parallels in examples dating from the ninth through the eleventh century. The split ends of the vertical shafts of the letters *alif* seem to indicate that the text was copied after carved tombstones or other stone monuments rather than manuscripts.[68]

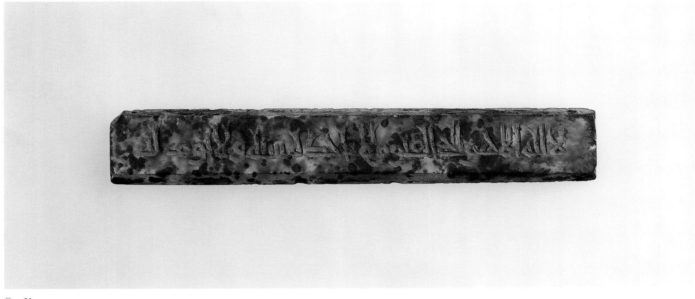

Cat. 31

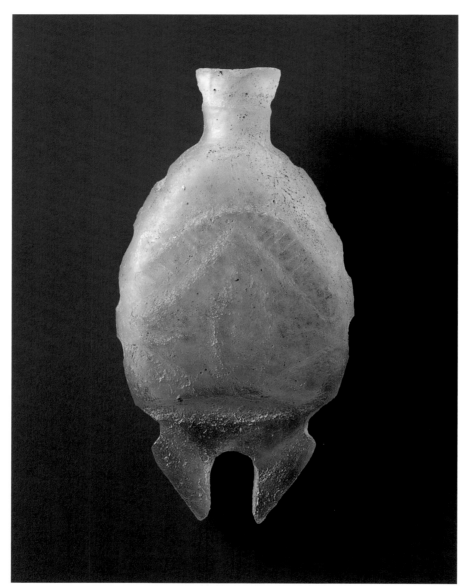

Cat. 32

**Cat. 32 FISH-SHAPED CONTAINER**
(LNS 307 G)
Syrian or Egyptian region
Late 10th–early 12th century

Dimensions: hgt. 6.3 cm; w. 3.2 cm; l. 1.7 cm;
th. 0.14 cm; wt. 13.2 g; cap. 8 ml
Color: Translucent grayish colorless
Technique: Blown; tooled; cut
Description: This small container was cut in the
stylized shape of a fish with a curved
body, long bifurcated tail, and slightly
flared neck. The two sides are convex.
The decoration consists of simple
elongated ovals whose inner areas were
hatched. Simple grooves are present at
the base of the neck and on the sides
of the vessel.
Condition: The object is intact. The surface is
lightly weathered, resulting in
iridescence and abrasion. The glass
includes scattered small bubbles.
Provenance: Reportedly from a hoard of gold
jewelry found in Greater Syria
Related Works: 1. MM, Dobkin Bequest
(Hasson 1979, p. 28, no. 27)
2. MFI (Lamm 1929–30, pl. 62:23)
3. Benaki, inv. nos. 3.294, 3.296
(Clairmont 1977, nos. 301, 302)
See also cat. 2.40a–g

Containers in the shape of a naturalistic, albeit stylized, fish have a long history that began in the first centuries of the Christian era. From the first to the third century Roman glassmakers produced molded bottles, a small number of which are extant in museums worldwide.[69] Other free-blown fish-shaped glass vessels with applied threads dating from the third and fourth centuries survive from the eastern Mediterranean region.[70] The rather large mold-blown bottles of earlier centuries were not produced in the Islamic period, but a stylized fish shape survived in small objects in glass, rock crystal, precious metals, and beads of diverse materials.[71] Glass versions are almost invariably small to miniature, but there are a few exceptions (see cat. 2.40g). Their shape was usually created by cutting the original base into the form of a stylized bifurcated fish tail, with both sides convex (hence these objects are often described as "lentoid flasks"). Decorative incisions on the two convex sides as well as around the scalloped short sides are often suggestive of fish scales (see cat. 2.40b–f).

These vessels suggest direct comparison with Fatimid rock-crystal, fish-shaped, relief-cut flasks, as exemplified by two vessels now in the Museum of Islamic Art, Cairo, and in the Victoria and Albert Museum, London.[72] Both objects are only slightly larger than the average glass vessels but are more "naturalistic," since the fins and gills are better defined. Their tails are different, as they are formed by a single bulged element rather than a bifurcated form.

Fish-shaped beads were also common in the medieval period. An opaque turquoise glass bead cut into the form of a fish and subsequently perforated was unearthed at Nishapur, and some of the glass beads with trailed and marvered decoration belonging to a necklace in the Metropolitan Museum may perhaps be identified as stylized fish shapes.[73] Two identical gold beads from the same necklace, fabricated from sheet and wire and decorated with plain and twisted wire, are in the Metropolitan Museum and the Museum für Islamische Kunst in Berlin.[74] Five compositions of three stacked fish made of filigree work, which represent elements from a sumptuous gold belt attributed to al-Andalus in the Taifa period (late 10th or early 11th century), are presently in Baltimore.[75]

The talismanic symbolism of the fish was passed onto the seventh- and eighth-century Islamic world from late Antiquity, long before the influence of Chinese artistic traditions in the Iranian world made its presence ubiquitous in Ilkhanid and Mamluk art (see cat. 85a, 95a). Other than glass containers, the few fish-shaped objects that survive belonged to necklaces or belts—that is, they were elements designed to be worn on the body and were thus imbued with a powerfully auspicious meaning.

It has always been assumed that the numerous extant glass vessels in the shape of a fish were containers for perfumes, oils, and essences. However, the provenance of cat. 32, combined with the obvious symbolic meaning of the fish, may in part disprove this theory. This small container was found along with a hoard of gold jewelry consisting of an amulet case, a pair of earrings, a ring, and fragments of bracelets and armlets.[76] It therefore was either precious enough to be regarded as a piece of jewelry or cherished enough to be considered an amulet. The first possibility can be discounted on the grounds that it is too large to have functioned as a bead and does not have a hole through it. The second interpretation is more likely: as an amulet carrying the apotropaic symbolism of the fish, the object could have been tied to a string by its tail and worn around the neck; as an amulet container, it could have held in its small interior cavity a tightly rolled paper amulet that was sealed with the aid of a metal cap. In either case, its presence in a jewelry hoard that also contained a gold filigree amulet case would have been justified. Obviously, this is not to suggest that all fish-shaped vessels were used as amulets or amulet boxes but that their function as containers for precious liquids may have not been exclusive.

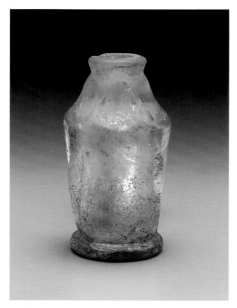

Cat. 2.5

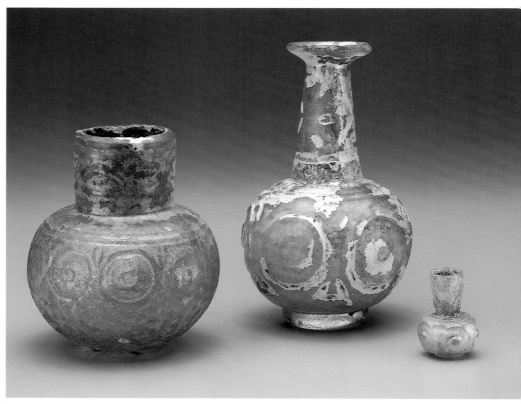

Cat. 2.6a–c

### Cat. 2.5 BOTTLE (LNS 419 G)
**Mesopotamian or**
**Iranian region(?)**
**7th–8th century**

Dimensions: hgt. 5.7 cm; max. diam. 3.0 cm;
wt. 52.0 g; cap. 6 ml
Color: Translucent colorless
Technique: Cut; drilled
Description: This slightly flared, cylindrical bottle
has a protruding base with a circle in
relief underneath and a short neck.
The simple decoration consists of
six facets created at the shoulder that
reach the base of the neck. The interior
chamber was drilled: the narrowest
diameter, at the center of the neck,
is about 0.35 cm; the largest, near
the shoulder, is about 1.9 cm.
Condition: The object appears to be intact but
part of the neck was probably broken
and its sharp edges were subsequently
ground. The surface is partially
weathered, resulting in rusty brown
spots and a milky white film on the
interior and iridescence and abrasion
on the exterior. The base is cracked but
complete. The glass includes scattered
small bubbles.
Provenance: Reportedly from Adra' (suburbs of
Damascus)[7]

### Cat. 2.6a VASE (LNS 87 KG)
**Iranian region**
**8th–9th century**

Dimensions: hgt. 9.0 cm; max. diam. 8.0 cm;
th. 0.40 cm; wt. 157.8 g; cap. 198 ml
Color: Translucent yellow (yellow/brown 1)
Technique: Tooled; linear cut
Description: This globular vase has a convex base
that was ground in the center to
allow the object to stand and a large
cylindrical neck. The opening was also
ground and tapers slightly. The main
decoration on the body consists of
two rows of incised circular omphalos
patterns with a central button in relief,
the lower row being formed by slightly
ovoid elements. A circular band in relief
surrounds the base, which is further
decorated with shallow grooves. The
neck was incised with a wavy pattern.
Condition: The object is intact. The surface is
heavily weathered, resulting in a gray
coating on the interior and golden
iridescence and abrasion on the
exterior. The glass includes frequent
small bubbles.
Provenance: Kofler collection
Literature: Lucerne 1981, no. 590

### Cat. 2.6b BOTTLE (LNS 80 KG)
**Iranian region**
**8th–9th century**

Dimensions: hgt. 12.8 cm; max. diam. 7.5 cm;
th. 0.37 cm; wt. 169.5 g; cap. 160 ml
Color: Translucent grayish colorless
Technique: Tooled; incised; cut
Description: This globular bottle has a low circular
foot created with deep cuts at the base,
a tapered neck, and a splayed mouth;
the opening is hexagonal. The main
decoration consists of a row of six large
omphalos patterns in low relief, with a
central button in higher relief. The neck
was incised with X-shaped motifs and
a horizontal groove near its base.
Condition: The object is intact. The surface is
entirely weathered, resulting in a
whitish coating, golden iridescence,
and abrasion.
Provenance: Kofler collection
Literature: Lucerne 1981, no. 591

### Cat. 2.6c MINIATURE BOTTLE (LNS 403 G)
**Iranian region**
**8th–9th century**

Dimensions: hgt. 3.6 cm; max. diam. 2.5 cm; th. 0.20 cm; wt. 11.5 g; cap. 3 ml
Color: Translucent grayish colorless
Technique: Blown; cut
Description: This miniature globular bottle has a flat base and a flared neck. The base has a low circular foot created by cutting and the neck is faceted with a hexagonal opening. The decoration consists of five omphalos-patterned roundels. Five short vertical grooves were incised above the base in the space left between each roundel.
Condition: The object is intact except for a chip at the opening. The surface is heavily weathered, resulting in iridescence and corrosion.
Provenance: Reportedly from Balkh, Afghanistan

### Cat. 2.6d MINIATURE POT (LNS 117 KG)
**Iranian region**
**8th–9th century**

Dimensions: hgt. 3.2 cm; max. diam. 3.7 cm; th. 0.32 cm; wt. 24.1 g; cap. 15 ml
Color: Translucent colorless
Technique: Blown; cut
Description: This miniature pot, originally of globular shape, was turned into a nearly cubic object by cutting. The base is flat and shows two shallow grooves underneath arranged in an X-shape. The opening was ground flat. The decoration consists of four omphalos-patterned roundels, one on each side. Four short vertical grooves were incised on the shoulder, one at each corner.
Condition: The object is intact, unless it once had a neck, now missing. The surface is entirely weathered, resulting in a milky white coating, iridescence, abrasion, and flaking. The glass includes scattered small bubbles.
Provenance: Kofler collection
Literature: Lucerne 1981, no. 589

### Cat. 2.6e MINIATURE POT (LNS 16 G)
**Iranian region**
**8th–9th century**

Dimensions: hgt. 1.8 cm; max. diam. 1.6 cm; wt. 7.1 g; cap. 1 ml
Color: Translucent pale blue (blue 1)
Technique: Blown; cut
Description: This miniature pot is nearly identical to cat. 2.6d. Four vertical grooves were incised below the rim, one at each corner.
Condition: The object is slightly chipped but is otherwise intact. The surface is partially weathered, resulting in a milky white coating and some abrasion. The glass includes scattered small bubbles.

### Cat. 2.6f MINIATURE POT (LNS 170 G)
**Iranian region**
**8th–9th century**

Dimensions: hgt. 2.3 cm; max. diam. 2.3 cm; wt. 12.8 g; cap. 2 ml
Color: Translucent colorless
Technique: Blown; cut
Description: This miniature pot has the same shape as cat. 2.6d. The base is flat and shows an engraved four-petaled flower underneath. Four large vertical grooves were incised on the shoulder, one at each corner.
Condition: The object is intact. The surface is entirely weathered, resulting in a brownish gray coating and iridescence that prevents an accurate reading of the color, which probably had a pale tinge.
Provenance: Reportedly from Afghanistan

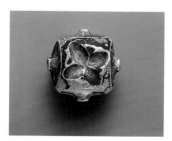

Cat. 2.6f detail of base

### Cat. 2.6g MINIATURE POT (LNS 417 G)
**Iranian region**
**8th–9th century**

Dimensions: hgt. 1.4 cm; max. diam. 1.7 cm; th. 0.30 cm; wt. 4.0 g; cap. 0.3 ml
Color: Translucent colorless
Technique: Blown; cut
Description: This miniature pot has the same shape as cat. 2.6d. Each of the four omphalos-patterned roundels has a pointed central button. Four short vertical grooves were incised on the shoulder, one at each corner.
Condition: The object is intact. The surface is lightly weathered, resulting in milky white pitting and extensive abrasion. The glass includes scattered small bubbles. Gray soil is present inside the pot.
Provenance: Reportedly from Damascus, Syria

### Cat. 2.6h MINIATURE POT (LNS 264 G)
**Iranian region**
**8th–9th century**

Dimensions: hgt. 2.9 cm; max. diam. 3.2 cm; th. 0.29 cm; wt. 14.8 g; cap. 10 ml
Color: Translucent grayish colorless
Technique: Blown; cut; worked on the pontil
Description: This miniature pot, originally of globular shape, was turned into a slightly tapered and curved object by cutting. The base is flat and shows remains of the pontil mark. The opening was ground flat. The decoration consists of five omphalos-patterned roundels near the base. Five vertical grooves were incised on the shoulder, corresponding to the empty spaces between the roundels.
Condition: The object has a deep crack under the base but is otherwise intact. The surface is weathered, resulting in iridescence and considerable abrasion. The glass includes frequent small bubbles.
Provenance: Kofler collection; gift to the Collection
Related Works: Cat. 16a–c

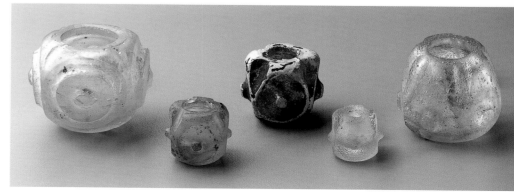

Cat. 2.6d–h

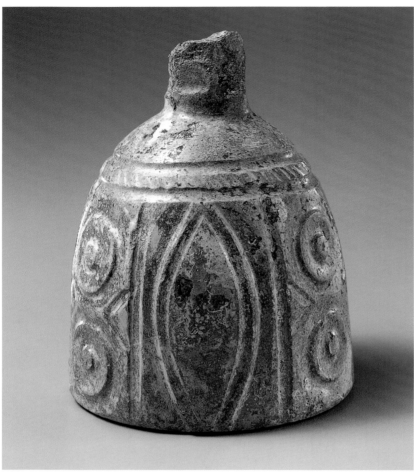

Cat. 2.7

### Cat. 2.7 BOTTLE (LNS 33 KG)
### Probably Iranian region
### 8th–10th century

Dimensions: hgt. 15.0 cm; max. diam. 8.7 cm;
    wt. 217.8 g; cap. 300 ml
  Color: Translucent
Technique: Free blown; tooled; cut
Description: This dome-shaped bottle has a flat base
    and a flared neck, which was originally
    faceted. The pontil mark under the
    base was ground. The cut decoration
    consists of six sections in two different
    alternating patterns: one is formed
    by two omphalos motifs in relief,
    arranged vertically within an octagon;
    the second is a pointed oval formed by
    two wide, shallow, and curved grooves.
    A horizontal band hatched with
    diagonal cuts within two horizontal
    grooves is visible above the decoration.
Condition: A large section of the neck is missing;
    the remainder of the object is intact.
    The surface is entirely weathered,
    resulting in a pale gray coating that
    prevents further reading of the color.
Provenance: Kofler collection
Literature: Lucerne 1981, no. 595
Related Works: Cat. 16a–c, 23, 24

### Cat. 2.8 BOTTLE (LNS 32 G)
### Iranian region
### 8th–9th century

Dimensions: hgt. 7.5 cm; max. diam. 5.3 cm;
    th. 0.44 cm; wt. 171.7 g; cap. 67 ml
  Color: Translucent bluish green (green 4)
Technique: Free blown; cut
Description: This bottle and its hexagonal neck are
    nearly cylindrical. The body was cut
    to create six sides. Each face presents a
    central oval in relief that is countersunk
    in the middle and ends at the bottom
    in a short foot that was created by
    cutting away the bottom of the base.
    The bottle stands on the six feet thus
    created. A central roundel underneath
    the base was further decorated with
    grooves arranged in a stylized flower.
Condition: The object was broken and repaired
    and is complete with the exception
    of some chips. The surface is entirely
    weathered, resulting in a pale brown
    coating, encrustation, and corrosion.
Related Work: Cat. 16b (similar base)

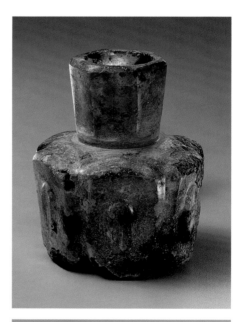

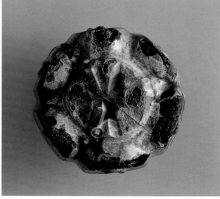

Cat. 2.8 and detail of base

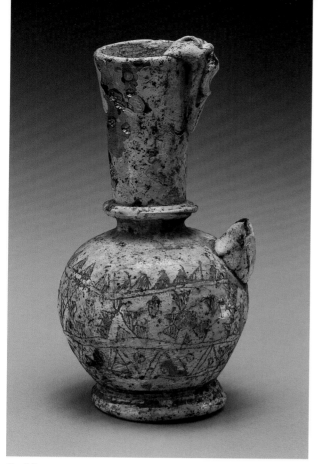

Cat. 2.9a

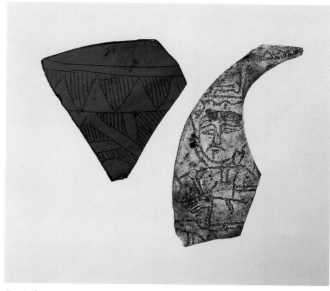

Cat. 2.9b, c

### Cat. 2.9a EWER (LNS 90 KG)
**Syrian or Mesopotamian region**
**9th century**

Dimensions: hgt. 7.5 cm; max. diam. 4.0 cm;
th. 0.21 cm; wt. 32.1 g; cap. 28 ml
Color: Translucent greenish blue (blue 2)
Technique: Free blown; tooled; applied; incised;
worked on the pontil
Description: This globular ewer has a long, slightly
flared neck. The foot, handle (only its
attachment is extant), and trail around
the base of the neck were applied. The
incised decoration, executed rather
crudely, includes (from top to bottom,
horizontally) a sawtooth pattern, a
large band that encloses a series of
triangular figures alternating with small
ovals, and a lower band with a zigzag
pattern that forms rows of triangles.
The inner surface of most patterns
was hatched.
Condition: The object is intact except for a missing
handle. The surface is entirely
weathered, resulting in pale brown
encrustation, iridescence, and extensive
corrosion. The color, seen through the
crust, appears to be blue.
Composition: $Na_2O$: 17.0; MgO: 2.8; $Al_2O_3$: 1.7;
$SiO_2$: 67.3; $SO_3$: 0.2; Cl: 1.0; $K_2O$: 2.6;
CaO: 5.6; $TiO_2$: 0.1; MnO: 0.1;
$Fe_2O_3$: 1.7; CoO: 0.1
Provenance: Kofler collection
Literature: Lucerne 1981, no. 585

### Cat. 2.9b FRAGMENT (LNS 156 KG)
**Syrian or Mesopotamian region**
**9th century**

Dimensions: max. w. 4.4 cm; max. l. 4.2 cm;
th. 0.20 cm; wt. 6.5 g
Color: Translucent blue (blue 4–5)
Technique: Blown; tooled; incised
Description: This slightly curved fragment probably
belonged to a bowl or beaker. The
visible decoration, finely incised and
hatched, includes a sawtooth pattern
and an unclear motif set against a
hatched background.
Condition: The surface is in good condition. The
glass includes scattered tiny bubbles.
Composition: $Na_2O$: 16.2; MgO: 0.6; $Al_2O_3$: 2.2;
$SiO_2$: 66.7; $SO_3$: 0.2; Cl: 1.0; $K_2O$: 0.5;
CaO: 9.4; $TiO_2$: 0.2; MnO: 0.2;
$Fe_2O_3$: 1.8; CoO: 0.2; CuO: 0.2;
ZnO: 0.5
Provenance: Kofler collection
Literature: Lucerne 1981, no. 586 (not illustrated)

### Cat. 2.9c FRAGMENT (LNS 185 G)
**Syrian or Mesopotamian region**
**9th–10th century(?)**

Dimensions: l. 7.2 cm; w. 2.7 cm; th. 0.30 cm
Color: Translucent brownish colorless
Technique: Blown; incised with a drill point
Description: This curved fragment, perhaps from a
bowl or bottle, reveals part of a male
figure viewed slightly in left profile
and sitting with his knee raised. He is
dressed in a tunic with a *tiraz* band,
and his arms are raised as if he is
addressing a man on his right or
receiving something from him. He is
crowned and wears earrings. His mouth
turns downward, suggesting a stern or
sad expression. The inscriptional band
above his head perhaps once identified
this ruler, though only three letters,
in Kufic script, remain: الد (*al-d. . .*).
An unclear geometric motif was drawn
above the band.
Condition: The fragment has sharp edges.
The surface is partially weathered,
resulting in a milky white film and
pale brown pitting.
Provenance: Kofler collection; gift to the Collection
Related Works: Cat. 17a–d

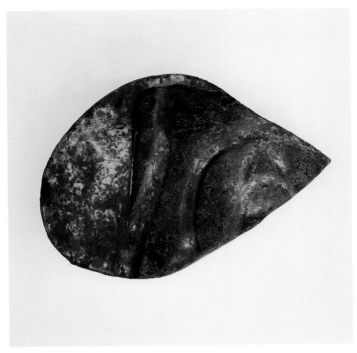

Cat. 2.10

Cat. 2.11

### Cat. 2.10  CAMEO FRAGMENT
### (LNS 149 KGa)
### Iranian or Mesopotamian region
### Probably 9th century

Dimensions: w. 5.0 cm; l. 3.5 cm; th. 0.29 cm;
   wt. 7.3 g
Color: Translucent colorless and green (green 3)
Technique: Blown; layered; tooled; cut
   (cameo technique)
Description: This curved fragment is decorated on
   the convex side with colorless glass over
   green in the cameo technique. The
   green layer was cut away to create an
   unclear pattern of a pointed figure and
   a triangle inscribed in a circle in reserve.
Condition: The surface is heavily weathered,
   resulting in a brown coating.
Provenance: Kofler collection
Related Work: Cat. 18

### Cat. 2.11  FRAGMENT (LNS 177 KG)
### Iranian region
### 9th–early 10th century

Dimensions: max. w. 3.6 cm; max. l. 3.6 cm;
   th. 0.20 cm
Color: Translucent bluish colorless or
   pale blue (blue 1)
Technique: Blown; tooled; relief cut
Description: This slightly curved fragment is
   decorated on the convex side with two
   confronted relief-cut half-palmettes.
Condition: The surface is heavily weathered,
   resulting in a milky white coating
   and abrasion.
Provenance: Kofler collection
Related Works: Cat. 18, 19 (similar decoration)

Cat. 2.12a  CUP (LNS 430 G)
Iranian region
Second half of the 9th–
early 10th century

Dimensions: hgt. 8.9 cm; max. diam. 9.7 cm;
th. 0.29 cm; wt. 172.4 g; cap. ca. 600 ml
Color: Translucent grayish colorless
Technique: Blown; tooled; cut; worked on the pontil
Description: This cylindrical cup has a flat base and
a straight rim. The decoration was
outlined with U-shaped grooves to
achieve an effect of relief within the
various sections. The pontil mark
was ground. The decoration consists
of two sets of half-palmettes with long
curved stems that depart in opposite
directions from the lower vertex of an
omphalos-patterned rhomboid. Two
larger omphalos roundels separate the
main motifs.
Condition: The object was broken in several pieces.
After restoration, about one-seventh
of the rim and part of the walls were
filled in. The surface, which appears
rather dull, is heavily weathered,
resulting in a milky white film, pale
brown coating, some iridescence, and
abrasion. The glass includes frequent
tiny bubbles and some larger ones.
Provenance: Bonhams, London, sale, October 15,
1997, lot 62

Cat. 2.12b  CUP (LNS 431 G)
Iranian region
Second half of the 9th–
early 10th century

Dimensions: hgt. 8.5 cm; max. diam. 9.8 cm;
th. 0.20 cm; wt. 179.6 g; cap. ca. 550 ml
Color: Translucent bluish colorless
Technique: Blown; tooled; cut; worked on the pontil
Description: This cylindrical cup has a flat base and
a plain opening. The decoration, in
relief, was created by grinding away
the background and further modeling.
The pontil mark was ground. The
decoration consists of three sets of
half-palmettes with long curved stems
that depart in opposite directions from
the bottom of a large palmette; each
stem bears two half-palmettes (one
polylobed, the other of a simpler shape)
that flank the central palmette. These
three sets were drawn so close to one
another that their stems touch, forming
a continuous pattern; simple rhomboids
were also drawn above the point of
conjunction of the stems.[78]
Condition: The object was broken in several pieces.
After restoration, about one-quarter
was filled in. The surface is heavily
weathered, resulting in a milky white
film, golden brown coating, heavy
iridescence, and extensive abrasion.
The glass includes scattered small
bubbles and some larger ones.
Provenance: Bonhams, London, sale, October 15,
1997, lot 67
Related Work: Cat. 19

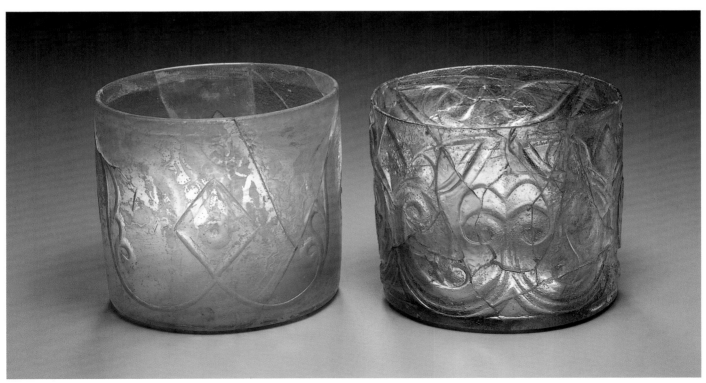

Cat. 2.12a, b

### Cat. 2.13 CUP (LNS 83 G)
**Iranian region**
**9th–10th century**

Dimensions: hgt. 7.8 cm; max. diam. 6.1 cm;
th. 0.20 cm; wt. 90.9 g; cap. 125 ml
Color: Translucent yellowish colorless
Technique: Blown; tooled; cut
Description: This elegantly shaped, cylindrical cup
stands on a small circular foot; the
flared section that links the foot to the
bottom of the cup was created with
deep cuts. The decoration, which
occupies almost the entire height of
the vessel, consists of ten elongated,
vertical, countersunk ovals in relief.
The sunken band just below the rim was
also created with the cutting technique.
Condition: The object is almost intact except for
a small section near the base and at
the rim, which were restored, and a
few cracks. The surface is partially
weathered, resulting in a brown coating,
iridescence, and abrasion. The glass
includes frequent small bubbles.

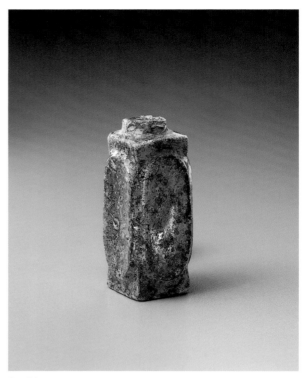

Cat. 2.14

### Cat. 2.14 SMALL BOTTLE (LNS 163 G)
**Iranian region**
**9th–10th century**

Dimensions: hgt. 4.4 cm; w. 1.8 cm; l. 1.8 cm;
th. 0.29 cm; wt. 23.9 g; cap. 1 ml
Color: Translucent brownish colorless
Technique: Blown; tooled; cut
Description: This square bottle has an angular
shoulder and a flat base. The
decoration consists of elongated,
vertical, countersunk ovals in relief,
one on each side, which occupy
almost the entire height of the bottle.
Condition: The object is intact except for the neck,
the base of which survives. The surface
is entirely weathered, resulting in
whitish and gray coatings.

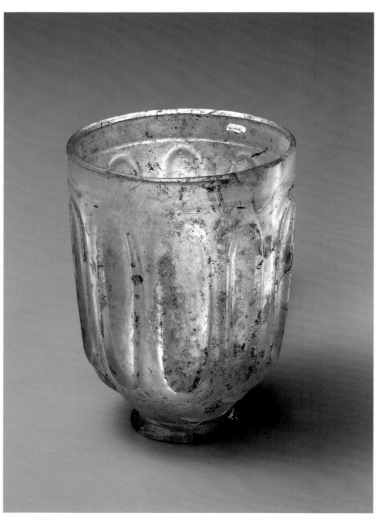

Cat. 2.13

## Cat. 2.15 BOTTLE (LNS 421 G)
### Iranian region
### 9th–10th century

Dimensions: hgt. 9.6 cm; max. diam. 3.1 cm;
th. 0.29 cm; wt. 60.5 g; cap. 16 ml
Color: Translucent green (green 3–4)
Technique: Tooled; cut
Description: This flared bottle has a flat and circular
base, a rounded shoulder, and a flared
faceted neck with an octagonal
opening. The body was facet cut with
regular confident strokes, creating
a ten-sided object that is one of the
best of its type. It is decorated with
additional circular facets at the
shoulder and above the base.
Condition: The object is intact. The surface is
heavily weathered, resulting in a pale
brown coating and slight encrustation
at the base of the neck. The glass
includes frequent small bubbles.
Provenance: Reportedly from Maimana (Faryab),
Afghanistan

Cat. 2.16

## Cat. 2.16 MINIATURE BOWL
### (LNS 356 G)
### Iranian region
### 9th–10th century

Dimensions: hgt. 3.3 cm; w. 4.6 cm; l. 2.7 cm;
th. 0.32 cm; wt. 20.7 g; cap. 8 ml
Color: Translucent yellowish colorless
Technique: Blown; tooled; cut
Description: This miniature boat-shaped bowl,
whose shape was created by cutting,
has a flat base. The entire surface was
ground away, leaving the rim in low
relief. The decoration, in relief, consists
of a tear-shaped motif on the short
sides and a pattern that follows the
shape of the vessel on the longer sides.
Condition: The object is intact except for abrasions
along the rim, though it may have been
reworked from a larger discarded piece.
The surface is partially weathered,
resulting in a milky white coating and
some iridescence. The glass includes
scattered large and small bubbles.
Provenance: Reportedly from Iran
Literature: Melikian-Chirvani 1997, fig. 8

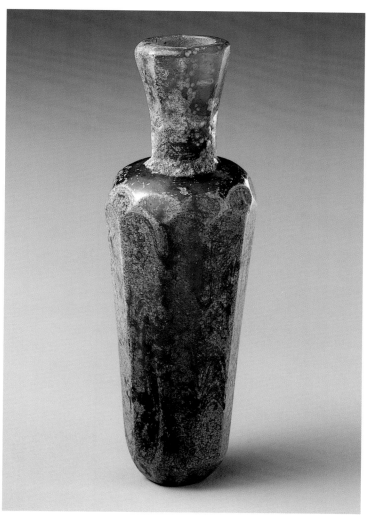

Cat. 2.15

## Cat. 2.17a  BEAKER (LNS 78 G)
**Iranian region**
**9th–10th century**

Dimensions: hgt. 16.1 cm; max. diam. 12.2 cm;
th. 0.13 cm; wt. 218 g; cap. 1000 ml
Color: Translucent yellowish colorless
Technique: Blown; tooled; linear cut
Description: This tall slightly flared beaker has a flat
base. The decoration, incised with wide
shallow linear cuts, consists of three
stylized birds evenly spaced and facing
left. The birds are framed by two pairs
of horizontal grooves. Each sketchily
drawn bird stands on its feet, has a
pointed tail that touches the line of
the foreground, a protruding chest, a
pointed beak, and a round eye in relief.
Some areas of the body were hatched. It
is unclear whether the birds are meant
to be holding a leaf in their beaks.
Condition: The object was broken and repaired
and there are numerous small fills. The
surface is partially weathered, resulting
in a milky white coating. The glass
includes scattered small bubbles.

## Cat. 2.17b  SMALL VESSEL (LNS 168 G)
**Iranian region**
**9th–10th century**

Dimensions: hgt. 6.4 cm; max. diam. 2.9 cm;
th. 0.26 cm; wt. 24.1 g; cap. 19 ml
Color: Translucent pale green (green 2)
Technique: Blown; tooled; linear cut
Description: The decoration of this small, slightly
flared vessel, incised with wide shallow
linear cuts, consists of two stylized
birds seen in left profile within oval
medallions. The birds are framed by
deeply cut horizontal grooves. Each
bird was sketchily drawn, like those in
cat. 2.17a. Areas outside the medallions
were incised to create decorative
geometric patterns.
Condition: The object is the neck of a bottle that
was reworked, decorated, and turned
into a small drinking vessel. The surface
is partially weathered, resulting in a
milky white coating on the interior and
some iridescence on the exterior. The
glass includes scattered small bubbles.
Provenance: Reportedly from Afghanistan

## Cat. 2.17c  CYLINDER (LNS 153 G)
**Iranian region**
**9th–10th century**

Dimensions: hgt. 3.4 cm; max. diam. 2.8 cm;
th. 0.48 cm; wt. 26.2 g
Color: Translucent pale brown
(yellow/brown 2)
Technique: Blown; tooled; linear cut
Description: This small, hollow, slightly tapered
cylinder has no apparent function. The
decoration, incised with wide shallow
linear cuts, consists of four stylized
walking birds facing right. The birds
are framed by incised horizontal
grooves and are close to one another.

Each sketchily drawn bird has a plump
body, two feet that touch the line of
the foreground, and a long beak.
Condition: As with cat. 2.17b, this object may
have been reworked from the neck of
a discarded bottle. As it is, it seems
finished and is intact except for a
crack. The interior surface is partially
weathered, resulting in a brown
coating. The glass includes scattered
bubbles.
Provenance: Reportedly from Afghanistan

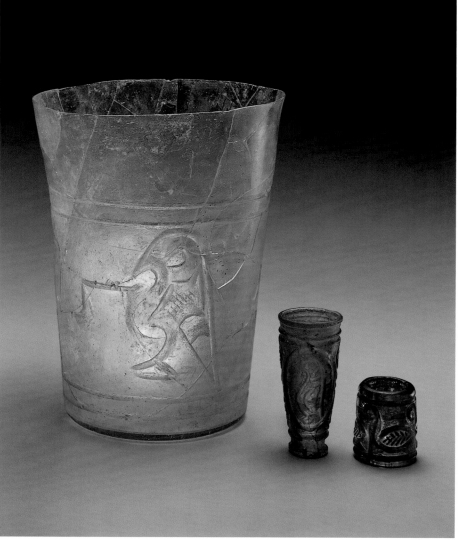

Cat. 2.17a–c

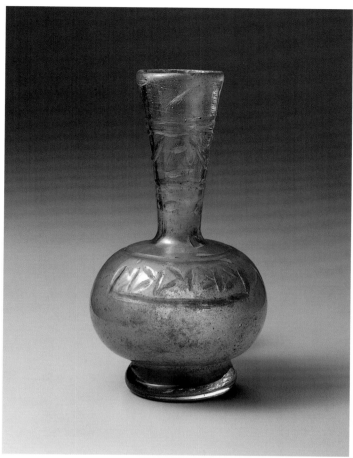

Cat. 2.19

## Cat. 2.18 BOTTLE (LNS 29 G)
**Iranian region**
**9th–10th century**

Dimensions: hgt. 11.8 cm; max. diam. 3.5 cm;
th. 0.25 cm; wt. 42.8 g; cap. 42 ml
Color: Translucent dark blue (blue 4–5)
Technique: Molded; tooled; linear cut
Description: This flared bottle has a small, flat
square base, a rounded shoulder,
and a cylindrical neck. The sketchy
decoration was incised with shallow
vertical, horizontal, and diagonal
cuts in unclear geometric patterns.
Condition: This object is intact. The surface is
entirely weathered, resulting in a pale
brown coating, golden iridescence,
and abrasion.

## Cat. 2.19 BOTTLE (LNS 52 G)
**Perhaps Syrian region**
**9th–10th century**

Dimensions: hgt. 10.9 cm; max. diam. 5.7 cm;
th. 0.27 cm; wt. 63.0 g; cap. 80 ml
Color: Translucent brownish colorless
Technique: Tooled; linear cut; worked on the pontil
Description: This compressed, globular bottle has a
low circular foot and a long flared neck.
The only decoration consists of an
incised horizontal band that extends
about one-third of the circumference
and is filled with irregular geometric
patterns that resemble letters from
non-Arabic alphabets.[79] A small drop-
shaped medallion with a central vertical
incision appears in the final third of
the circumference. A horizontal groove
is incised above the shoulder. The neck
is decorated with shallow horizontal
grooves that create bands filled with
crescent-shaped patterns and round
facets.
Condition: The object is intact. The interior
surface is heavily weathered, resulting
in a pale brown coating; the exterior
is in good condition. The glass includes
frequent small bubbles.

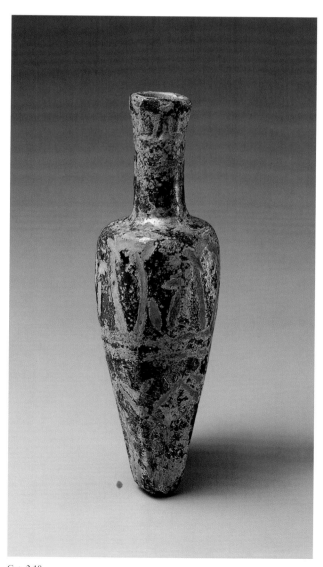

Cat. 2.18

**Cat. 2.20a BOTTLE (LNS 36 KG)**
**Perhaps Egyptian region**
**9th–10th century**

Dimensions: hgt. 7.0 cm; max. diam. 1.8 cm;
th. 0.22 cm; wt. 19.6 g; cap. 7 ml
Color: Translucent greenish colorless
Technique: Blown; tooled; linear cut
Description: This slender cylindrical bottle has a flat
circular base created by cutting and a
flared faceted neck with a heptagonal
opening. The decoration, incised with
shallow linear cuts, consists of a central
horizontal groove and a number of
diagonal and vertical lines that create
alternating upright and upside-down
triangles.
Condition: The object is intact except for a small
chip at the base. The surface is lightly
weathered, resulting in a milky white
film. The glass is of good quality.
Provenance: Kofler collection
Literature: Lucerne 1981, no. 604

**Cat. 2.20b BOTTLE (LNS 7 KG)**
**Perhaps Egyptian region**
**9th–10th century**

Dimensions: hgt. 5.8 cm; max. diam. 3.7 cm;
th. 0.14 cm; wt. 23.7 g; cap. 19 ml
Color: Translucent brownish colorless
Technique: Blown; tooled; linear cut
Description: This domed bottle has a flat base and
a flared faceted neck with a hexagonal
opening. The decoration, incised with
linear cuts, consists of a series of
triangular rounded shapes, one inside
the other. The triangles thus created are
alternately upright and upside down.
Deep horizontal grooves just above the
base and between the shoulder and the
base of the neck highlight the main
decoration.
Condition: The object is intact. The interior is
lightly weathered, resulting in a pale
brown coating; the exterior is in good
condition. The glass includes scattered
small bubbles.
Provenance: Kofler collection
Literature: Lucerne 1981, no. 599

**Cat. 2.20c BOTTLE (LNS 349 G)**
**Perhaps Egyptian region**
**9th–10th century**

Dimensions: hgt. 4.8 cm; max. diam. 1.5 cm;
th. 0.18 cm; wt. 10.0 g; cap. 4 ml
Color: Translucent pale blue (blue 1)
Technique: Blown; tooled; cut
Description: This slender, cylindrical bottle has a
circular foot with a flat base created by
deep cutting. The decoration, repeated
four times, consists of three triangles in
relief, one inside the other. Two upside-
down triangles are alternated with two
that are upright.
Condition: The neck is missing and the circular
foot is chipped; the remainder of the
object is intact. The surface is partially
weathered, resulting in a milky white
coating. The glass includes frequent
small bubbles.
Provenance: Eliahu Dobkin collection; Bonhams,
London, sale, October 18, 1995, lot 376

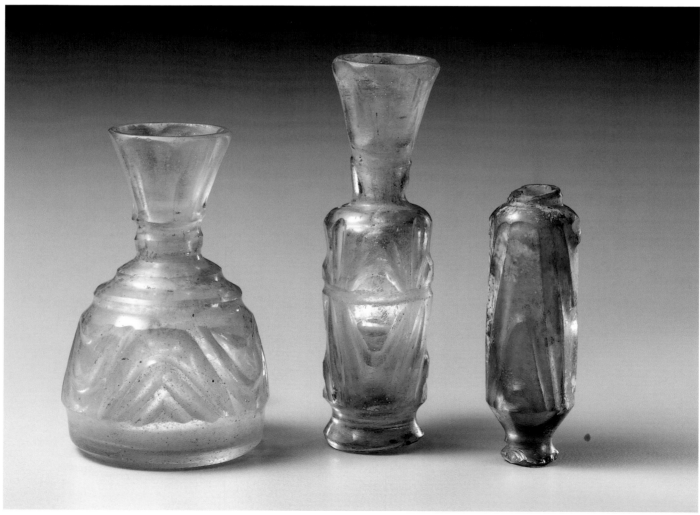

Cat. 2.20b, a, c

### Cat. 2.21 VASE (LNS 95 KG)
**Perhaps Egyptian region**
**9th–10th century**

Dimensions: hgt. 6.0 cm; max. diam. 4.2 cm;
th. 0.29 cm; wt. 60.5 g; cap. 35 ml
Color: Translucent emerald green (green 5–6)
Technique: Blown; tooled; linear cut
Description: This nearly spherical vase has a
flattened base and a slightly flared neck.
The decoration, incised with linear
cuts, consists of five circular medallions
joined by horizontal lines. Two
horizontal grooves are present above
the shoulder. An incised wavy band
decorates the center of the neck. Two
concentric circles were cut underneath
the base.
Condition: The object is intact. The surface is
lightly weathered, resulting in a whitish
coating, especially on the neck and the
interior of the vessel. The glass is of
good quality.
Provenance: Kofler collection
Literature: Lucerne 1981, no. 598

### Cat. 2.22a BOTTLE (LNS 69 KG)
**Perhaps Egyptian region**
**9th–10th century**

Dimensions: hgt. 6.5 cm; max. diam. 3.5 cm;
th. 0.30 cm; wt. 46.4 g; cap. 22 ml
Color: Translucent dark blue (blue 4)
Technique: Blown; tooled; linear cut;
worked on the pontil
Description: This cylindrical bottle has a flat base
and a slightly flared neck. The
decoration, incised with large linear
cuts, consists of X-shaped patterns
enclosed within square sections; two of
these sections present highly stylized
and unclear patterns, perhaps intended
to represent a bird. Plain horizontal
grooves are incised below the shoulder
and at the base of the faceted neck.
Condition: The object is intact except for some
small chips. The surface is partially
weathered, resulting in a milky
white coating and some iridescence.
The glass is of good quality.
Provenance: Kofler collection
Literature: Lucerne 1981, no. 597

### Cat. 2.22b MINIATURE VASE (LNS 442 G)
**Perhaps Egyptian region**
**9th–10th century**

Dimensions: hgt. 3.0 cm; max. diam. 2.5 cm;
th. 0.17 cm; wt. 11.9 g; cap. 5 ml
Color: Translucent colorless
Technique: Blown; tooled; linear cut; worked on
the pontil
Description: This miniature cylindrical vase has a
flat base, a slightly curved shoulder,
and a cylindrical neck. The decoration,
incised with large U-shaped cuts,
consists of two alternating patterns
enclosed inside four square sections,
created by means of vertical cuts.
Two of these sections include a simple
rhomboid, the others show a crescent-
shaped groove above an upside-down
triangle. The neck was left uncut.
Condition: The object is intact. The surface is
entirely weathered, resulting in heavy
silvery iridescence and gray pitting.
Soil is present inside the vessel.
Provenance: Reportedly from Herat, Afghanistan

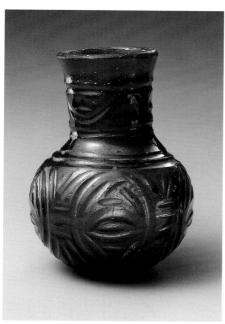

Cat. 2.21

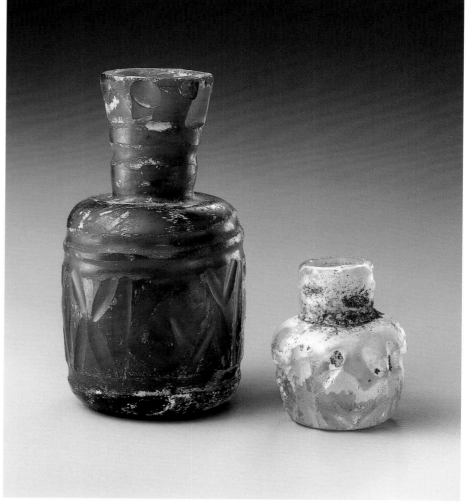

Cat. 2.22a, b

### Cat. 2.23 BEAKER (LNS 328 G)
**Iranian region**
**9th–10th century**

Dimensions: hgt. 7.4 cm; max. diam. 7.3 cm;
th. 0.06 cm; wt. 50.6 g; cap. ca. 170 ml
Color: Translucent grayish colorless
Technique: Blown; tooled; linear cut
Description: This finely blown cylindrical beaker
has a flat base. The opening was cut
diagonally. The decoration consists of
a geometric pattern of triangles and
squares filled with short grooves.
Condition: The object was broken in numerous
fragments and reconstructed. About
80 percent remains; a section from the
rim to the base is missing. The surface
is entirely weathered, resulting in a
pale brown coating, iridescence, and
corrosion. The object was decaying
rapidly prior to conservation.
Provenance: Reportedly from Mardha, Syria

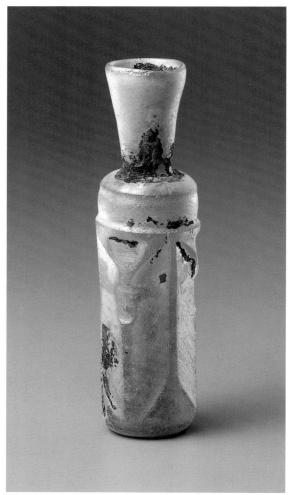

Cat. 2.24

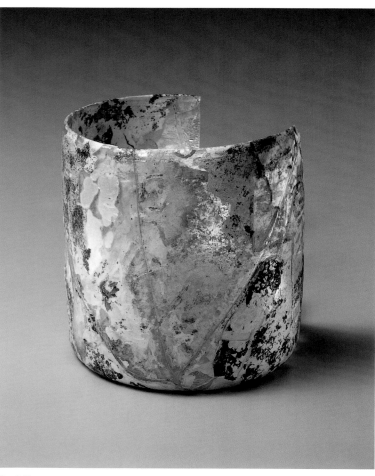

Cat. 2.23

### Cat. 2.24 BOTTLE (LNS 407 G)
**Probably Iranian region**
**9th–10th century**

Dimensions: hgt. 7.7 cm; max. diam. 2.1 cm;
th. 0.15 cm; wt. 18.4 g; cap. 10 ml
Color: Translucent yellowish colorless
Technique: Free blown; tooled; worked on the
pontil; cut
Description: This cylindrical bottle has a slightly
kicked base and an uncut flared neck.
The decoration, carved inside a sunken
area, consists of three slender columns
below a rectangular abacus and a
triangular capital; each column is in
slight relief while the abacus and the
capital were incised. A grooved
horizontal band is visible between
the capitals and the shoulder.
Condition: The object is intact. The surface is
partially weathered, resulting in a
dark brown coating and iridescence.
The glass includes a few scattered
small bubbles.
Provenance: Reportedly from Afghanistan
Related Work: Cat. 23

## Cat. 2.26 BOTTLE (LNS 424 G)
### Probably Iranian region
### 9th–10th century

Dimensions: hgt. 8.3 cm; max. diam. 2.9 cm;
th. 0.21 cm; wt. 36.2 g; cap. 14 ml

Color: Translucent greenish colorless

Technique: Blown; tooled; cut

Description: This flared bottle has a small, flat
circular base created by cutting, a
rounded shoulder, and an irregularly
cut, flared neck with a heptagonal
opening. The main decoration consists
of tear-shaped medallions alternately
upright and upside down, so that the
overall pattern seems continuous. Two
rows of small circular facets were cut
above the base. Another row of circular
facets below the shoulder is separated
from the main sinuous pattern by a
deep horizontal groove.

Condition: The object is intact. The surface, both
on the interior and exterior, is entirely
weathered, resulting in a pale brown
coating.

Provenance: Bonhams, London, sale, April 24, 1997,
lot 284

Related Work: Cat. 24

## Cat. 2.27 BOTTLE (LNS 348 G)
### Perhaps Iranian region
### 9th–10th century

Dimensions: hgt. 7.8 cm; max. diam. 2.0 cm;
th. 0.21 cm; wt. 23.6 g; cap. 10 ml

Color: Translucent grayish colorless

Technique: Blown; tooled; cut

Description: This slender cylindrical bottle has a flat
base. The cut decoration covers the
body almost entirely and consists of a
complex faceted pattern consisting of a
central rhomboid motif in relief that is
countersunk and surrounded by circular
facets. This motif is repeated three
times. A section above the base was
deeply cut to provide a kind of foot.
The wide horizontal groove below the
shoulder contrasts with the elaborate
decoration of the rest of the body.
The base of the six-sided neck includes
a deep horizontal groove.

Condition: The object is intact. The surface is
partially weathered, resulting in a milky
white coating. The glass includes
frequent small bubbles. A gray granular
mass with bluish spots is present inside
the vessel at the base.[80]

Provenance: Eliahu Dobkin collection; Bonhams,
London, sale, October 18, 1995, lot 376

Cat. 2.25

## Cat. 2.25 FRAGMENT (LNS 186 G)
### Possibly Mesopotamian region
### 9th–10th century

Dimensions: max. w. 8.0 cm; max. l. 5.0 cm;
th. 0.15 cm

Color: Translucent yellowish colorless

Technique: Blown; tooled; cut

Description: This curved fragment once belonged to
the rim of a cylindrical beaker or bowl.
The decoration is incised about 2 cm
below the rim and consists of an overall
scaled pattern; short horizontal and
vertical grooves were incised inside
each scale.

Condition: The surface is entirely weathered,
resulting in a whitish coating.

Provenance: Kofler collection; gift to the Collection

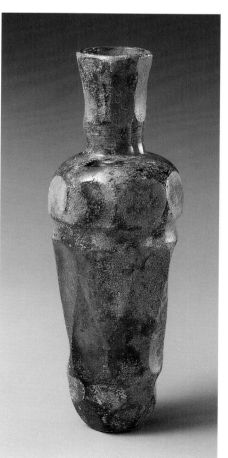

Cat. 2.26

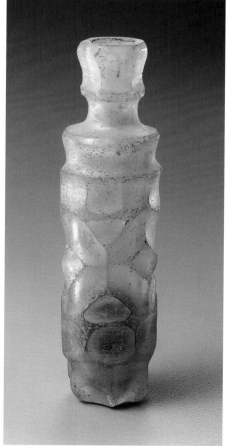

Cat. 2.27

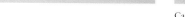

### Cat. 2.28a MOLAR FLASK (LNS 31 G)
**Possibly Egyptian region**
**9th–10th century**

Dimensions: (without neck) hgt. 4.1 cm; w. 2.1 cm;
l. 2.1 cm; th. 0.30 cm; wt. 26.5 g;
cap. 5.5 ml
Color: Translucent yellowish colorless
Technique: Molded; cut
Description: The feet of this molar flask are short
and square and the shoulder is angular.
The decoration consists of lozenge-
shaped motifs, deeply carved at each
corner. The cylindrical neck, now
separated from the rest of the body
(hgt. 2.1 cm; diam. 1.3 cm), was also
incised with simple grooves.
Condition: The object is broken in two pieces at
the attachment of the neck. The two
sections were not reassembled, since
close investigation revealed that the
joins did not fit. It is therefore possible
that the two fragments do not belong
together. The surface is heavily
weathered, resulting in a milky
white coating and corrosion.

### Cat. 2.28b MOLAR FLASK (LNS 16 KG)
**Possibly Egyptian region**
**9th–10th century**

Dimensions: hgt. 5.5cm; w. 1.8 cm; l. 1.8 cm;
th. 0.23 cm; wt. 19.8 g; cap. 2 ml
Color: Translucent grayish colorless
Technique: Molded; cut
Description: The feet of this molar flask are short
and wedge-shaped and the shoulder is
angular. The decoration consists of
pointed elements standing in relief at
each corner against deeply sunken
facets. The base of the six-sided neck
was grooved and the opening is
hexagonal.
Condition: The feet and shoulder are chipped; the
remainder of the object is intact. The
surface is entirely weathered, resulting
in a milky white coating and corrosion.
The glass is of good quality.
Provenance: Kofler collection
Literature: Lucerne 1981, no. 606

### Cat. 2.28c MOLAR FLASK (LNS 287 G)
**Possibly Egyptian region**
**9th–10th century**

Dimensions: hgt. 3.9 cm; w. 2.2 cm; l. 2.1 cm;
wt. 19.4 g; cap. 5 ml
Color: Translucent yellowish colorless
Technique: Molded; cut
Description: The feet of this molar flask are wedge-
shaped and the shoulder is angular.
The decoration consists of a pointed
element standing in relief at each corner
against deeply cut facets.
Condition: The neck is missing and the feet are
slightly chipped. The surface is lightly
weathered, resulting in a milky white
coating and encrustation. The glass
includes frequent small bubbles.

### Cat. 2.28d MOLAR FLASK (LNS 331 G)
**Possibly Egyptian region**
**9th–10th century**

Dimensions: hgt. 5.0 cm; w. 1.8 cm; l. 1.8 cm;
th. 0.36 cm; wt. 19.0 g; cap. 0.5 ml
Color: Translucent
Technique: Molded; cut
Description: The shoulder of this molar flask is
rounded and the neck is flared, ending
in a circular opening. The decoration
consists of pointed elements standing
in relief at each corner against deeply
cut facets. A vertical groove is present
at the center of each side.
Condition: The feet are missing. The surface is
entirely weathered, resulting in a
whitish encrustation that prevents
a proper reading of the color.
Provenance: Reportedly from Mardha, Syria

### Cat. 2.28e MOLAR FLASK (LNS 286 G)
**Possibly Egyptian region**
**9th–10th century**

Dimensions: hgt. 5.6 cm; w. 2.1 cm; l. 2.1 cm;
th. 0.21 cm; wt. 18.8 g; cap. 5 ml
Color: Translucent yellowish colorless
Technique: Molded; cut
Description: The shoulder of this molar flask is
angular. The base of the neck was
grooved. The neck was multisided and
probably flared. The grooved decoration
consists of a horizontal band, V-shaped
elements at each corner below the
shoulder, and circular facets at the
attachment of the feet, which are short
and wedge-shaped.
Condition: Most of the neck and parts of the
feet are missing. The surface is entirely
weathered, resulting in a milky white
coating, iridescence, and heavy
corrosion. The glass includes scattered
bubbles.

### Cat. 2.28f MOLAR FLASK (LNS 268 G)
**Possibly Egyptian region**
**9th–10th century**

Dimensions: hgt. 4.8 cm; w. 2.0 cm; l. 2.0 cm;
th. 0.27 cm; wt. 23.4 g; cap. 1 ml
Color: Translucent greenish yellowish colorless
Technique: Molded; cut
Description: The feet of this molar flask are long
and pointed and the shoulder is
angular. The decoration consists of
pointed elements standing in relief at
each corner against deeply cut facets.
A deep horizontal groove separates the
body from the feet. Circular facets are
present on each foot, below the groove.
Condition: The neck is almost entirely missing
and only one foot is intact; the other
three are either chipped or missing.
The surface is heavily weathered,
resulting in iridescence and abrasion.
Provenance: Kofler collection; gift to the Collection

### Cat. 2.28g FRAGMENTARY MOLAR
FLASK (LNS 290 G)
**Possibly Egyptian region**
**9th–10th century**

Dimensions: hgt. 4.8 cm; w. 2.0 cm; l. 1.9 cm;
th. 0.30 cm; wt. 31.0 g
Color: Translucent emerald green (green 5)
Technique: Molded; cut
Description: The shoulder of this molar flask is
angular and the base of the neck was
grooved. The neck was probably flared.
The decoration consists of pointed
elements standing in relief at each corner
in the middle of a pointed oval. Although
the feet are missing, the decoration,
shape, and dimensions leave no doubt
that the flask was of the molar type.
Condition: The lower part, feet, and most of the
neck are missing. The surface is lightly
weathered, resulting in a milky white
coating. The glass is of good quality.
Soil is present inside the vessel.

**Cat. 2.28h MOLAR FLASK (LNS 83 KG)**
**Possibly Egyptian region**
**9th–10th century**

Dimensions: hgt. 6.0 cm; w. 1.4 cm; l. 1.4 cm;
th. 0.22 cm; wt. 16.3 g; cap. 1 ml
Color: Translucent yellowish colorless
Technique: Molded; cut
Description: A deep groove separates the body from
the feet, which are short and square,
thus creating a sort of platform on
which the flask stands. The shoulder
is angular and the neck is six-sided.
The decoration consists of pointed
elements standing in relief at each
corner against deeply cut facets.
Condition: The neck and one foot are chipped;
the remainder of the object is intact.
The surface is partially weathered,
resulting in iridescence and heavy
abrasion. The glass is of good quality.
Provenance: Kofler collection
Literature: Lucerne 1981, no. 610

**Cat. 2.28i MOLAR FLASK (LNS 267 G )**
**Possibly Egyptian region**
**9th–10th century**

Dimensions: hgt. 4.2 cm; w. 1.5 cm; l. 1.3 cm;
th. 0.23 cm; wt. 13.4 g; cap. 2 ml
Color: Translucent brownish colorless
Technique: Molded; cut
Description: A horizontal groove separates the body
from the feet, which are short and
square, creating a sort of platform on
which the flask stands. The upper part,
just below the rounded shoulder, was
grooved to create an archlike pattern
on each side. The decoration consists
of pointed elements in relief at each
corner.
Condition: The neck is missing; the remainder
of the object is intact. The surface is
weathered, resulting in abrasion. The
glass includes scattered small bubbles.
Provenance: Kofler collection; gift to the Collection

**Cat. 2.28j MOLAR FLASK (LNS 15 G)**
**Possibly Egyptian region**
**9th–10th century**

Dimensions: hgt. 6.7 cm; w. 2.2 cm; l. 2.2 cm;
th. 0.24 cm; wt. 25.9 g; cap. 11 ml
Color: Translucent brownish colorless
Technique: Molded; cut
Description: The feet of this molar flask are short
and pointed. The shoulder is rounded
and there is a groove at the base of the
neck. The six-sided neck is flared. The
decoration consists of vertical grooves
in the center of each side.
Condition: The object is intact. The surface is
heavily weathered, resulting in a pale
brown coating, iridescence, and
abrasion. A hard granular lump is
present inside the vessel.[81]

**Cat. 2.28k MOLAR FLASK (LNS 405 G)**
**Possibly Egyptian region**
**9th–10th century**

Dimensions: hgt. 3.1 cm; w. 0.9 cm; l. 0.9 cm;
th. 0.08 cm; wt. 2.4 g; cap. 0.2 ml
Color: Translucent yellowish colorless
Technique: Blown; cut
Description: This miniature molar flask has a
straight profile and a flared neck. The
base stands on four short feet created
by cutting. The six-sided neck has a
hexagonal opening. The decoration
consists of four deep vertical grooves
that create four irregular sides. Two
opposite sides present a central
protruding button.
Condition: The object is intact. The surface is
entirely weathered, resulting in brown
and golden coatings, iridescence,
corrosion, and flaking.
Provenance: Reportedly from Balkh, Afghanistan

**Cat. 2.28l MOLAR FLASK (LNS 152 G)**
**Possibly Egyptian region**
**9th–10th century**

Dimensions: hgt. 6.2 cm; w. 2.1 cm; l. 2.1 cm;
wt. 27.5 g; cap. 3 ml
Color: Translucent colorless
Technique: Molded; cut
Description: The feet are short and wedge-shaped
and form a sort of platform on which
the flask stands. A deep horizontal
groove separates the body from the
feet. There is no transition between
the shoulder and the base of the neck.
The decoration consists of V-shaped
cuts of different depths that create
triangular sections at each corner.
Condition: The neck, which is not original to
the vessel, was probably replaced in
Antiquity. The surface is entirely
weathered, resulting in a pale brown
coating and gray pitting that prevent
an accurate reading of the color.
Provenance: Reportedly from Afghanistan

**Cat. 2.28m MOLAR FLASK (LNS 85 KG)**
**Possibly Egyptian region**
**9th–10th century**

Dimensions: hgt. 5.1 cm; w. 1.5 cm; l. 1.5 cm;
th. 0.32 cm; wt. 17.3 g; cap. 0.5 ml
Color: Translucent grayish colorless
Technique: Molded; cut
Description: The feet of this molar flask are short
and wedge-shaped and the shoulder is
angular. The simple decoration consists
of horizontal and vertical grooves on
each side and V-shaped cuts on each
foot. A groove was cut around the base
of the flared neck, which has a circular
opening. Four facets are present around
the neck.
Condition: The object is intact except for one
chipped foot. The surface is partially
weathered, resulting in a milky white
coating. The glass is of good quality.
Provenance: Kofler collection
Literature: Lucerne 1981, no. 609

**Cat. 2.28n MOLAR FLASK (LNS 30 G)**
**Possibly Egyptian region**
**9th–10th century**

Dimensions: hgt. 8.1 cm; w. 1.8 cm; l. 1.8 cm;
th. 0.24 cm; wt. 31.6 g; cap. 8.5 ml
Color: Translucent dark blue (blue 4)
Technique: Molded; cut
Description: The shoulder of this molar flask is
rounded and the neck is slightly flared.
The simple decoration consists of
shallow grooves. Two horizontal
incisions at the center separate the
upper and lower divisions. Deeper
cuts create triangular patterns at each
corner. An incision was cut around the
base of the neck, which is decorated
with shallow grooves.
Condition: The lower parts of the feet are missing
and the opening is chipped; the
remainder of the object is intact. The
surface is entirely weathered, resulting
in golden iridescence and considerable
abrasion.

### Cat. 2.28o MOLAR FLASK (LNS 288 G)
**Possibly Egyptian region**
**9th–10th century**

Dimensions: hgt. 5.9 cm; w. 2.3 cm; l. 2.2 cm;
th. 0.27 cm; wt. 39.1 g; cap. 5 ml
Color: Translucent greenish yellowish colorless
Technique: Molded; cut; drilled
Description: The feet of this molar flask are short
and wedge-shaped and the shoulder is
rounded. The base under the drilled
chamber is so thick that the color seems
much deeper. The simple decoration
consists of a cross-shaped groove in the
middle of each face and small facets at
each corner.
Condition: The neck is missing and the feet are
chipped. The surface is lightly
weathered, resulting in a milky white
coating and slight abrasion. The glass
includes frequent small bubbles.

### Cat. 2.28p MOLAR FLASK (LNS 263 G)
**Possibly Egyptian region**
**9th–10th century**

Dimensions: hgt. 4.6 cm; w. 2.2 cm; l. 2.2 cm;
th. 0.22 cm; wt. 18.9 g; cap. 5.5 ml
Color: Translucent yellow (yellow/brown 1)
Technique: Molded; cut
Description: The feet of this molar flask are short
and wedge-shaped. The simple
decoration on the squat square body
consists of a horizontal groove
separating the body from the feet and
of deep triangular facets at each corner.
The neck was probably slightly flared.
Condition: Most of the neck and parts of the feet
are missing. The surface is partially
weathered, resulting in a milky white
coating, gray pitting, and iridescence.
Provenance: Kofler collection; gift to the Collection

### Cat. 2.28q MOLAR FLASK (LNS 289 G)
**Possibly Egyptian region**
**9th–10th century**

Dimensions: hgt. 6.7 cm; w. 2.2 cm; l. 2.1 cm;
th. 0.28 cm; wt. 39.9 g; cap. 3 ml
Color: Translucent dark green (green 3–4)
Technique: Molded; cut
Description: The feet of this molar flask are short
and wedge-shaped, the shoulder is
rounded, and the neck is slightly flared.
The simple decoration consists of a
cross-shaped groove in the middle of
each face and small circular facets at
each corner.
Condition: Portions of the neck and feet are
missing. The surface is heavily
weathered, resulting in a pale brown
encrusted coating and considerable
corrosion.

### Cat. 2.28r FRAGMENTARY MOLAR FLASK (LNS 335 G)
**Possibly Syrian or Mesopotamian region**[82]
**9th–10th century or earlier**

Dimensions: hgt. 3.8 cm; w. 2.9 cm; l. 1.6 cm;
th. 0.25 cm; wt. 28.2 g; cap. 4 ml
Color: Translucent grayish colorless
Technique: Mold blown; cut; drilled
Description: The simple decoration of this unusual
rectangular molar flask consists of a
groove that follows the curve of each
side, producing an archlike effect.
The base is hatched, creating a narrow
band at the bottom of each side. Tiny
circular facets are visible at each corner.
Condition: The neck and the feet are missing, but
there is no doubt that the flask is of
the molar type. The surface is heavily
weathered, resulting in a whitish
coating and abrasion.
Provenance: Reportedly from Mardha, Syria
Related Work: Cat. 27

### Cat. 2.29 BOTTLE (LNS 162 G)
**Egyptian region(?)**
**9th–10th century**

Dimensions: hgt. 5.1 cm; max. diam. 3.0 cm;
wt. 29.5 g; cap. 8 ml
Color: Translucent greenish colorless or pale
green (green 1)
Technique: Blown; tooled; cut
Description: The body of this deeply cut square
bottle is slightly flared. A square base,
stemlike section, large protruding ring,
and four large square facets were
created on the lower part of the vessel.
The upper part is decorated in high
relief with triangles with a protruding
center and triangles with a grooved
decoration.
Condition: The neck is missing. The base may
once have included another section,
now missing. The object is chipped in
many places. The surface is entirely
weathered, resulting in a whitish
coating.

Cat. 2.28r

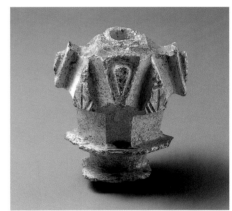

Cat. 2.29

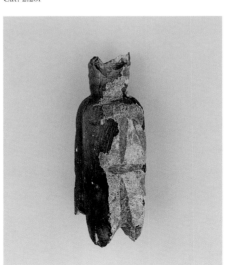

Cat. 2.28q

### Cat. 2.30a MINIATURE BOTTLE (LNS 24 G)
**Egyptian region(?)**
**9th–10th century**

Dimensions: hgt. 2.5 cm; max. diam. 1.2 cm;
 th. 0.17 cm; wt. 3.3 g; cap. 0.5 ml
Color: Translucent pale blue (blue 1–2)
Technique: Tooled; cut
Description: This miniature bottle has a cylindrical
 body and a slightly flared neck. The flat
 circular foot was created with deep cuts
 at the base. The decoration consists of
 triangular patterns in relief, alternately
 upright and upside down. The neck
 shows an unclear pattern created with
 diagonal cuts.
Condition: Part of the neck is missing; the
 remainder of the object is intact. The
 interior surface is heavily weathered,
 resulting in a pale brown coating; the
 exterior is in good condition. The glass
 includes scattered small bubbles.

### Cat. 2.30b MINIATURE BOTTLE (LNS 25 G)
**Egyptian region(?)**
**9th–10th century**

Dimensions: hgt. 2.3 cm; max. diam. 0.9 cm;
 th. 0.11 cm; wt. 1.6 g; cap. 0.3 ml
Color: Translucent grayish colorless
Technique: Tooled; cut
Description: This miniature bottle has a slightly
 flared body and a six-sided neck with
 a hexagonal opening. The flat circular
 foot and the protruding ring above it
 were created by deeply cutting the base.
 The decoration is simple but difficult to
 read due to the condition of the surface.
Condition: The object is intact except for some
 chips on the neck. The surface is
 weathered, resulting in iridescence
 and considerable corrosion.

### Cat. 2.30c SMALL BOTTLE (LNS 13 KG)
**Egyptian region(?)**
**9th–10th century**

Dimensions: hgt. 4.0 cm; max. diam. 1.1 cm;
 th. 0.20 cm; wt. 6.9 g; cap. 0.8 ml
Color: Translucent pale blue (blue 1)
Technique: Tooled; cut
Description: This small cylindrical bottle has a
 slightly flared neck. The flat circular
 foot was created with deep cuts at the
 base. The decoration consists of sunken
 triangular patterns, alternately upright
 and upside down. The neck shows a
 grooved pattern at the base and the
 upper portion is not decorated.
Condition: The object is intact. The surface is in
 good condition. The glass is of good
 quality.
Provenance: Kofler collection
Literature: Lucerne 1981, no. 602

### Cat. 2.30d SMALL BOTTLE (LNS 84 KG)
**Egyptian region(?)**
**9th–10th century**

Dimensions: hgt. 5.0 cm; max. diam. 1.5 cm;
 th. 0.20 cm; wt. 11.4 g; cap. 4 ml
Color: Translucent brownish colorless
Technique: Tooled; cut
Description: This small cylindrical bottle has a
 flared faceted neck with a pentagonal
 opening. The flat circular foot was
 created by deeply cutting the base.
 The decoration consists of triangular
 patterns in relief, alternately upright
 and upside down.
Condition: The object is intact. The interior
 surface is lightly weathered, resulting
 in a grayish coating; the exterior is in
 good condition. The glass is of good
 quality.
Provenance: Kofler collection
Literature: Lucerne 1981, no. 603

### Cat. 2.30e SMALL BOTTLE (LNS 416 G)
**Egyptian region(?)**
**9th–10th century**

Dimensions: hgt. 4.1 cm (with metal neck);
 max. diam. 1.6 cm; wt. 7.8 g; cap. 1 ml
Color: Translucent grayish colorless
Technique: Tooled; cut
Description: This small cylindrical bottle has a flat
 circular foot and short stem created
 with deep cuts at the base. The
 decoration consists of triangular
 patterns in relief, alternately upright
 and upside down; the latter are larger
 than the former. Small circles and
 crescent-shaped cuts are present inside
 each triangle.
Condition: The metal neck is an old repair, left in
 place as it is part of the history of the
 restoration. The base is chipped but
 the remainder of the object is intact.
 The surface is heavily weathered,
 resulting in a milky white film.
 Whitish soil is present inside the vessel.
Provenance: Reportedly from Damascus, Syria

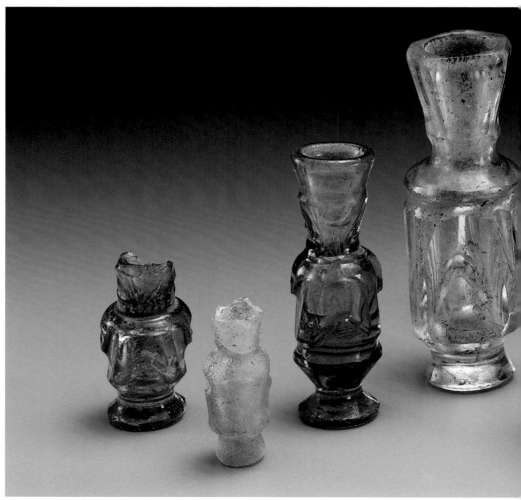

Cat. 2.30a–h

**Cat. 2.30f SMALL BOTTLE (LNS 89 KG)**
**Egyptian region(?)**
**9th–10th century**

Dimensions: hgt. 4.8 cm; max. diam. 2.0 cm;
th. 0.15 cm; wt. 9.8 g; cap. 6 ml
Color: Translucent brownish colorless
Technique: Tooled; cut
Description: This small cylindrical bottle has a
slightly flared neck. The flat circular
foot was created by deeply cutting the
base. The decoration consists of two
rings in relief that divide the surface
into three horizontal sections; the
uppermost includes a pattern of
triangles in relief, alternately upright
and upside down. The neck presents
two rings in relief; the uppermost
functions as the rim.
Condition: The object is intact except for several
chips near the opening. The surface is
lightly weathered, resulting in a milky
white film. The glass includes frequent
small bubbles.
Provenance: Kofler collection
Literature: Lucerne 1981, no. 601

**Cat. 2.30g MINIATURE BOTTLE**
**(LNS 266 G)**
**Egyptian region(?)**
**9th–10th century**

Dimensions: hgt. 2.7 cm; max. diam. 1.4 cm;
wt. 4.8 g; cap. 1 ml
Color: Translucent brownish colorless
Technique: Tooled; cut
Description: This miniature cylindrical bottle has
a flat circular foot created by deeply
cutting the base. The decoration
consists of three upside-down triangles
in relief.
Condition: The neck is missing; the remainder
of the object is intact. The surface
is partially weathered, resulting in a
milky white coating. The glass includes
scattered small bubbles.
Provenance: Kofler collection; gift to the Collection

**Cat. 2.30h MINIATURE BOTTLE**
**(LNS 406 G)**
**Egyptian region(?)**
**9th–10th century**

Dimensions: hgt. 3.2 cm; max. diam. 1.0 cm;
th. 0.13 cm; wt. 3.5 g; cap. 0.3 ml
Color: Translucent brownish colorless
Technique: Blown; cut
Description: This miniature cylindrical bottle has
a flared neck. The flat circular foot
and short stem were created by deeply
cutting the base. The decoration
consists of five archlike facets and
a deep horizontal groove below the
shoulder.
Condition: The object is intact. The surface is
entirely weathered, resulting in a
milky white coating, brown pitting,
and iridescence.
Provenance: Reportedly from Balkh, Afghanistan

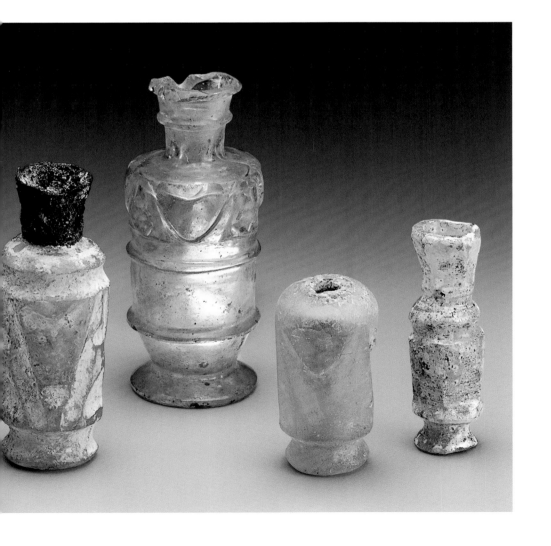

### Cat. 2.31 SMALL VASE (LNS 9 KG)
**Mesopotamian region,
probably Samarra
9th–10th century**

Dimensions: hgt. 4.6 cm; max. diam. 2.3 cm;
th. 0.21 cm; wt. 11.2 g; cap. 9 ml
Color: Translucent brownish colorless
Technique: Tooled; cut
Description: This cylindrical vase has a splayed
opening and a pointed base created by
deep cutting.[83] The decoration is divided
into two sections by a horizontal
groove: the lower portion includes
grooved triangular patterns, alternately
upright and upside down; the upper
section consists of simple faceted
arches.
Condition: The object is intact. The surface is
entirely weathered, resulting in a
whitish coating, gray pitting, and
iridescence.
Provenance: Kofler collection
Literature: Lucerne 1981, no. 613

### Cat. 2.32a SMALL BOTTLE (LNS 20 G)
**Iranian or Mesopotamian region
9th–10th century**

Dimensions: hgt. 4.7 cm; w. 1.9 cm; l. 1.9 cm;
th. 0.35 cm; wt. 26.7 g; cap. 3 ml
Color: Translucent pale brown
(yellow/brown 2)
Technique: Tooled; drilled; cut
Description: This square bottle has a flat base
created by deep cutting; a deep groove
below the shoulder parallels that of
the base. The six-sided neck is faceted
and the opening is hexagonal.
Condition: The neck and base are chipped; the
remainder of the object is intact.
The surface is weathered, resulting
in whitish pitting and considerable
scratching. The glass is of good quality.

### Cat. 2.32b BOTTLE (LNS 34 KG)
**Iranian or Mesopotamian region
9th–10th century**

Dimensions: hgt. 6.0 cm; w. 2.5 cm; l. 2.5 cm;
th. 0.34 cm; wt. 51.2 g; cap. 6 ml
Color: Translucent brownish colorless
Technique: Tooled; cut
Description: This bottle is similar to cat. 2.32a.
The decoration, on each face, consists
of a ribbed band just above the base,
a horizontal groove above the band,
and an arched pattern that fills the
remaining surface.
Condition: The base is chipped; the remainder
of the object is intact. The surface is
entirely weathered, resulting in a milky
white coating, iridescence, and abrasion.
Provenance: Kofler collection
Literature: Lucerne 1981, no. 611

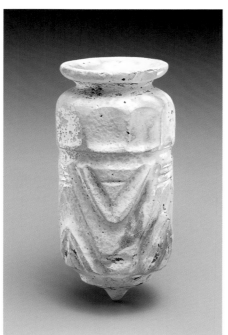

Cat. 2.31

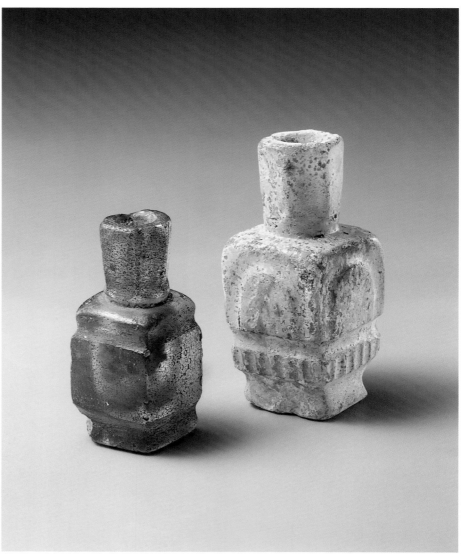

Cat. 2.32a, b

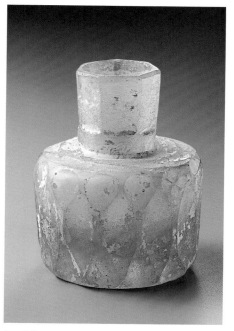

Cat. 2.33

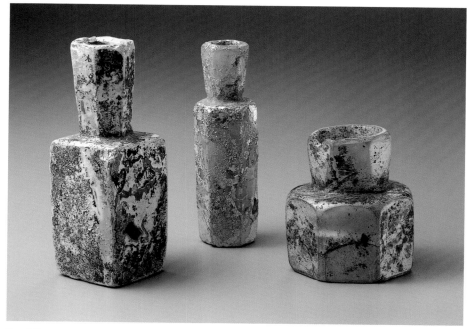

Cat. 2.34a–c

### Cat. 2.33 BOTTLE (LNS 33 G)
**Iranian region(?)**
**9th–10th century**

Dimensions: hgt. 7.8 cm; max. diam. 5.5 cm;
           th. 0.28 cm; wt. 159.8 g; cap. 83 ml
    Color: Translucent yellowish colorless
Technique: Free blown; tooled; cut
Description: This small bottle and its neck are nearly
           cylindrical. The base is flat and the
           shoulder is angular. The seven-sided
           neck is faceted and the opening is
           heptagonal. The decoration consists of
           vertical oval-shaped facets and heart-
           shaped facets around the shoulder and
           above the base, creating a continuous
           pattern.
Condition: The object was broken and repaired
           and part of the shoulder was restored.
           The surface is partially weathered,
           resulting in a milky white coating and
           iridescence. The glass includes scattered
           small bubbles.

### Cat. 2.34a BOTTLE (LNS 366 G)
**Probably Iranian region**
**9th–10th century**

Dimensions: hgt. 8.4 cm; w. 3.0 cm; l. 3.0 cm;
           th. 0.41 cm; wt. 87.9 g; cap. 15 ml
    Color: Translucent colorless
Technique: Blown; tooled; cut
Description: This square bottle has a slightly flared
           neck, a flat base, and an angular
           shoulder. The six-sided neck is faceted
           and the opening is hexagonal.
Condition: The object is intact but the base and
           neck are chipped. The surface is entirely
           weathered, resulting in a silvery gray
           coating and silvery iridescence.
Provenance: Reportedly from Dawlatabad,
           Afghanistan

### Cat. 2.34b BOTTLE (LNS 370 G)
**Probably Iranian region**
**9th–10th century**

Dimensions: hgt. 7.7 cm; max. diam. 2.2 cm;
           th. 0.28 cm; wt. 26.2 g; cap. 12 ml
    Color: Translucent yellowish colorless
Technique: Blown; tooled; cut
Description: This six-sided faceted bottle has a
           slightly flared neck, a flat base, and an
           angular shoulder. The six-sided neck is
           faceted and the opening is hexagonal.
Condition: The object is intact. The surface is
           entirely weathered, resulting in a
           whitish coating, a large rusty brown
           spot, and golden iridescence.
Provenance: Reportedly from Mazar-i Sharif
           (Balkh), Afghanistan

### Cat. 2.34c BOTTLE (LNS 371 G)
**Probably Iranian region**
**9th–10th century**

Dimensions: hgt. 5.1 cm; max. diam. 4.3 cm;
           th. 0.25 cm; wt. 85.6 g; cap. 18 ml
    Color: Translucent greenish or yellowish
           colorless
Technique: Blown; tooled; cut
Description: This straight, seven-sided, faceted
           bottle has a slightly flared neck, a flat
           base, and a slightly curved shoulder.
           The seven-sided neck is faceted and
           the opening is heptagonal.
Condition: The object is intact except for chips
           at the opening. The surface is entirely
           weathered, resulting in a brown coating
           and bluish iridescence.
Provenance: Reportedly from Afghanistan
Related Work: Cat. 28

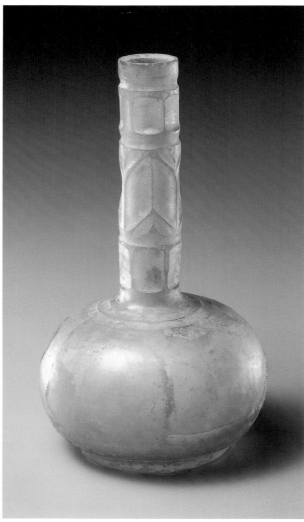

Cat. 2.35

### Cat. 2.35 BOTTLE (LNS 42 G)
**Iranian region**
**9th–10th century**

Dimensions: hgt. 15.0 cm; max. diam. 8.2 cm;
th. 0.35 cm; wt. 140.7 g; cap. 98 ml
Color: Translucent brownish colorless
Technique: Tooled; incised; cut
Description: This depressed globular bottle has
a low circular foot created by deep
cutting and a long cylindrical neck with
a circular opening. The decoration
consists of shallow grooves near the
attachment of the neck and just above
the base. The long neck shows a more
complex decoration that includes a
large central band filled with chevron
patterns and enclosed by small
rectangular facets separated by grooves.
Condition: The object was broken and repaired but
is almost complete except for some
chips. The surface is heavily weathered,
especially on the interior, resulting in a
milky white coating. The glass includes
scattered tiny bubbles.

### Cat. 2.36a MINIATURE JAR (LNS 174 G)
**Probably Iranian region**
**9th–10th century**

Dimensions: hgt. 2.2 cm; max. diam. 2.6 cm;
wt. 13.4 g; cap. 4 ml
Color: Translucent brownish colorless
Technique: Blown; tooled; cut
Description: This slightly tapered miniature jar
has a flat base and a minute opening.
The simple decoration consists of six
facets around the body and additional
facets above the base.
Condition: The object is intact. The surface
is partially weathered, resulting in
whitish and gray coatings. The glass
is of good quality.
Provenance: Reportedly from Balkh, Afghanistan

### Cat. 2.36b MINIATURE JAR (LNS 367 G)
**Probably Iranian region**
**9th–10th century**

Dimensions: hgt. 1.9 cm; max. diam. 1.7 cm;
th. 0.15 cm; wt. 5.2 g; cap. 1 ml
Color: Translucent grayish colorless
Technique: Blown; tooled; cut
Description: This tapered miniature jar has a flat
base. Three drop-shaped patterns in
relief decorate the body.
Condition: The object is intact except for a few
small chips. The surface is heavily
weathered, resulting in a pale brown
coating, iridescence, and abrasion. The
glass includes scattered small bubbles.
Provenance: Reportedly from Maimana (Faryab),
Afghanistan
Related Work: Cat. 28

Cat. 2.36a, b

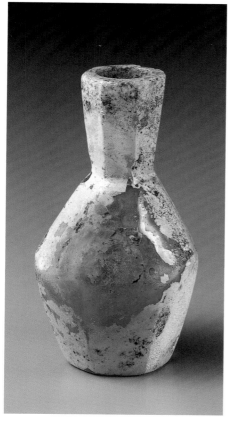

Cat. 2.37

Cat. 2.38

### Cat. 2.39 FLASK (LNS 164 G)
**Syrian region(?)**
**9th–10th century**

Dimensions: hgt. 7.8 cm; max. diam. 3.0 cm;
th. 0.30 cm; wt. 32.4 g; cap. 8 ml
Color: Translucent colorless with tinge
Technique: Blown; tooled; cut
Description: This flattened ovoid flask has a small,
circular, flat base and a slightly flared,
six-sided neck with a hexagonal
opening. The decoration covers the
entire body and consists of a grooved
herringbone pattern on the two larger
sides and a fish-scale pattern on the
flattened sides.
Condition: The object is intact except for chips
at the neck. The surface is entirely
weathered, resulting in pale brown and
whitish coatings and abrasion that
prevent a proper reading of the color.
Related Work: Cat. 32

### Cat. 2.37 BOTTLE (LNS 293 G)
**Iranian region**
**9th–10th century**

Dimensions: hgt. 7.8 cm; max. diam. 4.2 cm;
th. 0.37 cm; wt. 54.8 g; cap. 30 ml
Color: Translucent grayish colorless
Technique: Free blown; tooled; cut
Description: This small, slightly irregular, seven-
sided bottle was created by making
deep cuts around an originally globular
vessel with a flat base. The slightly
flared, seven-sided neck is faceted
and has a heptagonal opening.
Condition: The object is intact. The surface is
entirely weathered, resulting in gray
and pale brown coatings and silvery
iridescence. The glass includes
scattered small bubbles.
Provenance: Reportedly from Afghanistan
Related Work: Cat. 29

### Cat. 2.38 FRAGMENT OF A BOWL
**(LNS 333 G)**
**Possibly Egyptian region**
**9th–11th century**

Dimensions: max. w. 3.1 cm; max. l. 2.8 cm;
th. 0.60 cm
Color: Translucent pale brown
(yellow/brown 2)
Technique: Blown; incised
Description: This small fragment is from the rim of
a rather thick bowl. An inscription was
incised in reverse on the exterior below
the rim. Copied in Kufic script, it seems
to repeat the word احد ("one") twice.[84]
Condition: The surface is heavily weathered,
resulting in a pale brown coating
and corrosion that prevents a proper
reading of the color.
Provenance: Reportedly from Mardha, Syria
Related Work: Cat. 31

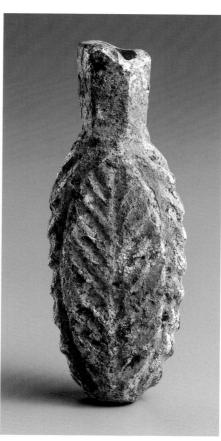

Cat. 2.39

**Cat. 2.40a FISH-SHAPED CONTAINER (LNS 28 G)**
**Syrian or Egyptian region**
**Late 10th–early 12th century**

Dimensions: hgt. 3.8 cm; w. 2.4 cm; l. 1.2 cm; th. 0.20 cm; wt. 11.0 g; cap. 1 ml
Color: Translucent yellowish colorless
Technique: Tooled; cut
Description: This miniature container, entirely shaped by deep cuts, has a rounded and flattened body, a slightly flared neck, and two pointed feet that do not allow proper standing. The decoration on the two larger sides includes an oval pattern in relief that encloses vertical grooves. The decoration of the neck includes a horizontal groove at the base and facets below the opening.
Condition: Part of the neck is missing. The surface is partially weathered, resulting in a milky white coating, especially on the interior. The glass is of good quality.

**Cat. 2.40b FISH-SHAPED CONTAINER (LNS 157 G)**
**Syrian or Egyptian region**
**Late 10th–early 12th century**

Dimensions: hgt. 2.8 cm; w. 2.6 cm; l. 1.0 cm; th. 0.22 cm; wt. 8.0 g; cap. 1 ml
Color: Translucent grayish colorless
Technique: Tooled; cut
Description: The scalloped body of this miniature container is decorated on the two larger sides with a simple rounded pattern in relief and a groove at the base.
Condition: Most of the neck and of the two feet are missing. The surface is weathered, resulting in faint iridescence and abrasions. The glass includes scattered small bubbles.
Provenance: Reportedly from Afghanistan

**Cat. 2.40c FISH-SHAPED CONTAINER (LNS 110 G)**
**Syrian or Egyptian region**
**Late 10th–early 12th century**

Dimensions: hgt. 5.0 cm; w. 3.5 cm; l. 1.5 cm; th. 0.25 cm; wt. 23.8 g; cap. 7 ml
Color: Translucent yellowish or brownish colorless
Technique: Tooled; cut
Description: The scalloped body of this container is elaborately decorated on the two larger sides with two stylized half-palmettes, arranged vertically and hatched with horizontal grooves; a deep horizontal groove marks the transition between base and body.
Condition: The entire neck and one foot are missing. The surface is heavily weathered, resulting in iridescence and abrasion.

**Cat. 2.40d FISH-SHAPED CONTAINER (LNS 8 KG)**
**Syrian or Egyptian region**
**Late 10th–early 12th century**

Dimensions: hgt. 5.5 cm; w. 3.0 cm; l. 1.3 cm; th. 0.21 cm; wt. 13.2 g; cap. 8 ml
Color: Translucent pale blue (blue 1)
Technique: Tooled; cut
Description: The scalloped body of this short-necked container is decorated on the two larger sides with two shallow concentric ovals and a horizontal groove in the middle.
Condition: The short neck may have been longer; the remainder of the object is intact. The interior surface is partially weathered, resulting in a milky white coating on the interior and heavy abrasion on the exterior.
Provenance: Kofler collection
Literature: Lucerne 1981, no. 615

**Cat. 2.40e FISH-SHAPED CONTAINER (LNS 291 G)**
**Syrian or Egyptian region**
**Late 10th–early 12th century**

Dimensions: hgt. 4.4 cm; w. 2.2 cm; l. 1.3 cm; th. 0.31 cm; wt. 9.6 g; cap. 3 ml
Color: Translucent yellow (yellow/brown 1)
Technique: Tooled; cut
Description: The scalloped body of this miniature container is decorated on the two larger sides with shallow crescent-shaped grooves above and below a horizontal line in the center.
Condition: Most of the neck is missing; the remainder of the object is intact. The surface is lightly weathered, resulting in iridescence and abrasion. The glass includes scattered small bubbles.

**Cat. 2.40f FISH-SHAPED CONTAINER (LNS 35 KG)**
**Syrian or Egyptian region**
**Late 10th–early 12th century**

Dimensions: hgt. 5.5 cm; w. 2.1 cm; l. 1.1 cm; th. 0.16 cm; wt. 8.5 g; cap. 4 ml
Color: Translucent pale greenish blue (blue 1)
Technique: Tooled; cut
Description: The scalloped body of this container is decorated on the two larger sides with a pattern of shallow concentric rhomboids created with diagonal grooves. The lower part of the neck was faceted, creating a wavy pattern; the upper part was left undecorated.
Condition: The object is intact except for a crack on the neck. The interior surface is lightly weathered, resulting in a pale brown film; the exterior is in good condition. The glass includes scattered bubbles.
Provenance: Kofler collection
Literature: Lucerne 1981, no. 614

**Cat. 2.40g FRAGMENT OF A FISH-SHAPED CONTAINER (LNS 350 G)**
**Syrian or Egyptian region**
**Late 10th–early 12th century**

Dimensions: hgt. 5.7 cm; w. 6.0 cm; l. ca. 2.7 cm; th. 0.20 cm; wt. 28.7 g
Color: Translucent yellowish colorless
Technique: Tooled; cut
Description: This fragment is from a large container. The visible decoration on the remaining part of one of the two larger sides of the body includes an almond-shaped pattern in relief and stylized half-palmettelike motifs on the sides.
Condition: Five joining fragments, forming about one-half of the lower part of the original vessel, are extant. The surface is heavily weathered, resulting in grayish golden iridescence. The glass is of good quality.
Provenance: Eliahu Dobkin collection; Bonhams, London, sale, October 18, 1995, lot 376
Related Work: Cat. 32

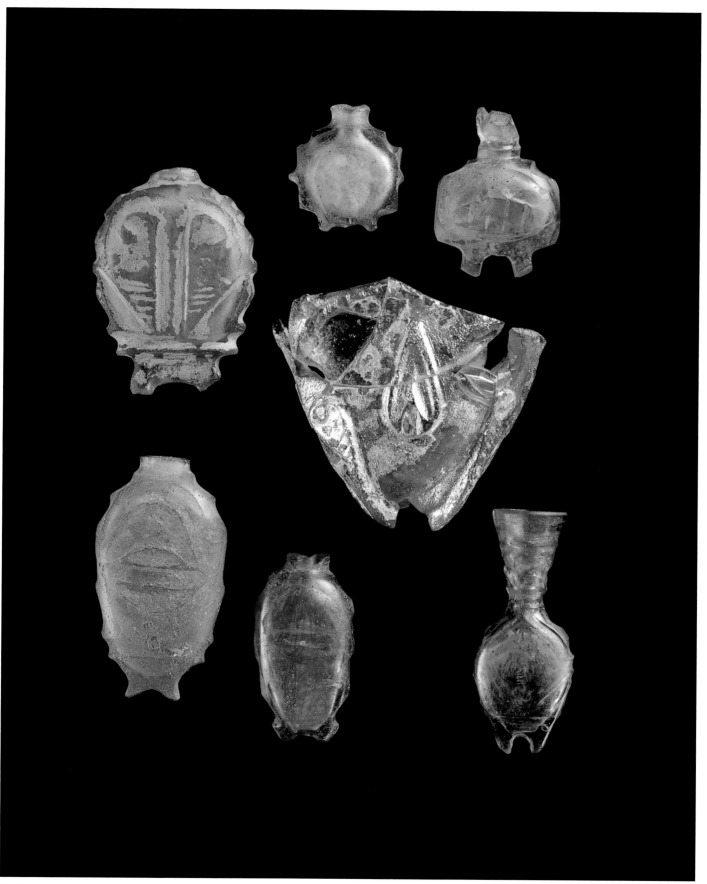

Cat. 2.40a–g

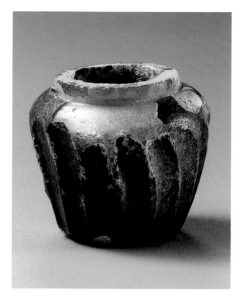

Cat. 2.41

## Cat. 2.41 MINIATURE VASE (LNS 404 G)
### Iranian region
### Probably 10th–11th century

Dimensions: hgt. 2.0 cm; max. diam. 2.2 cm;
th. 0.23 cm; wt. 7.7 g; cap. 2.5 ml
Color: Translucent grayish colorless
Technique: Blown; cut
Description: This miniature vase has a flared body, a
flat base, a curved shoulder, and a short
straight neck. The bottom of the base
was carved into a stylized six-petaled
flower. The decoration consists of
seventeen contiguous vertical grooves
that run from the base to the shoulder
and curve slightly to the left.
Condition: The object appears to be intact, though
it originally may have had a longer
neck. The surface is entirely weathered,
resulting in a dark brown coating and
heavy iridescence.
Provenance: Reportedly from Balkh, Afghanistan

# NOTES

1 See, for example, Kröger 1995, nos. 199, 202.
2 Ibid., pp. 146–64.
3 Charleston 1989, p. 302.
4 Kröger 1995, p. 161.
5 Ettinghausen–Grabar 1987, p. 104.
6 One of the best examples in a public collection is in the Metropolitan Museum of Art (inv. no. 1974.45; see Jenkins 1986, p. 27, no. 26; and MMA 1987, p. 17).
7 The drilling of the chamber, paralleled in rock-crystal objects almost certainly produced in Tulunid and Fatimid Egypt, may represent another clue toward the attribution of this group of molar flasks to Egypt.
8 Inscriptions do not often appear on these vessels. A goblet in the Metropolitan Museum (inv. no. 65.173.1) features the inscription "Blessings from Allah to the owner of the goblet. Drink!" (Jenkins 1986, p. 19, no. 16); a beaker in the David collection, Copenhagen, bears a similar inscription (von Folsach 1990, no. 212). An intriguing dark blue bottle appeared at auction in 1980: the sale catalogue states that the inscription is the artist's signature ("the work of Fairūz al-ʿĀmilī"; see Sotheby's, London, sale, April 21–22, 1980, lot 298). Since the whereabouts of this object is not known and it is not possible to verify its condition, the inscription will not be included in this discussion.
9 Glass tiles painted with pseudovegetal motifs were used to decorate the stucco qibla wall and mihrab of a small mausoleum in Cairo. The building, which includes the coffin with the remains of the sufi Sulaymān al-Rifāʿī, was erected in the last decades of the thirteenth century (see Lamm 1927; Lamm 1929–30, pl. 49:2; and Carboni 1997a).
10 See, for example, Harper 1961; Pinder-Wilson–Scanlon 1973, pp. 25–28; Goldstein 1982; and Whitehouse 1993.
11 Whitehouse 1993.
12 For example, at Rayy and Nishapur; see Lamm 1935, pls. 31i–j; and Kröger 1995, nos. 174–84.
13 See Kröger 1995, nos. 182, 183.
14 A good example of globular shape, reported to have been found at Nishapur, is in the Museum für Islamische Kunst in Berlin (inv. no. I.55/65; see Kröger 1984, no. 180).
15 Two fragments of beakers with similar omphalos/lozenge decoration were excavated in Nishapur and Samarra; see Kröger 1995, no. 181; and Samarra 1940, pl. 122.
16 The subject is addressed in some detail in Kröger 1995, pp. 129–30, which includes a bibliography.
17 Although there is no evidence of the use of diamond points in this early period, the engraving was certainly done using a very hard stone.
18 Among the best-known light-colored objects are a blue goblet in the Metropolitan Museum of Art (inv. no. 65.173.1; see Jenkins 1986, no. 16), a long-necked blue bottle in the Corning Museum (inv. no. 68.11.1), a pale green beaker in the David collection in Copenhagen (inv. no. 23/1987; see von Folsach 1990, no. 212), and a bowl in the National Museum, Damascus (inv. no. A 16043; see al-ʿUsh 1971, ill. p. 200).
19 An 1991, pp. 123–24, figs. 3–8; and Koch 1998, pp. 499–502, pls. 138, 139.
20 Inv. no. 40.170.131; see Kröger 1995, no. 164, pp. 117–19, which includes a bibliography and a list of finely incised glass found during other excavations.
21 The most recent attribution to Iran is in ibid., p. 117. Kröger does leave open the possibility that the group was produced in Mesopotamia.
22 Brill 1999, vol. 2, pp. 194–96.
23 Kröger (1995, pp. 118) mentions the sites of Susa, Samarra, Iraq, Dvin, al-Mina, Raqqa, and Nessana, in addition to Nishapur, Fustat, and the Famen Temple.

It is possible to add al-Ṭūr (Sinai), the Naʿaman area of the Belus River, and Caesarea (Palestine) to this list, which is probably incomplete.
24 See the report of the glass finds from Mantai, in Sri Lanka, in Carboni forthcoming.
25 The export of glass to China from Syria in the Roman period and from Baghdad in the Islamic period is well documented; see, for example, Hirth–Rockhill 1911, pp. 73, 103, 116, 138, 227–28. At the ports of Basra and Siraf, large quantities of glass were collected and shipped eastward, as either cullet or intact vessels, along the Indian Ocean route. It is unlikely that eastern Iranian products would have been transported via land to the Persian Gulf and shipped by sea to India and Southeast Asia.
26 Inv. no. C45-1952; see Caiger-Smith 1985, fig. 4. Charleston (1989, p. 302) observed that the fragmentary glass plate from Nishapur in the Metropolitan Museum (see note 4 above) "echoes the motifs of Mesopotamian lustre ware of the 3rd/9th century" but added that it "also has strong affinities with the wall paintings found in Nishapur itself." He concluded: "There seems little reason to think that it is of other than Persian origin." The present writer believes that the evidence for a Mesopotamian origin is much stronger than Charleston.
27 See the numerous reproductions in Marçais 1928. Parallels between the motifs found on this group of glass vessels and those on ʿAbbasid bichrome luster pottery are discussed also in Hallett 1996. I am grateful to Jessica Hallett for sharing her thoughts on this material.
28 Lamm 1928, p. 78, nos. 247–50. Harper (1961, p. 22), quoting Honey (1946, p. 41), notes that fragments were found also at Fustat and Ehnesya. Honey's report, however, is vague.
29 For a list of the most accomplished pieces, see Whitehouse 1993; and Goldstein 1982.
30 See, for example, Lamm 1928, pls. 6:242, 243, 246; 8:249; and Kröger 1995, nos. 194–97. One of the most refined objects showing relief-cut plant decoration is a bowl formerly in a private collection in Kuwait; see Louisiana Revy 1987, p. 67, no. 16.
31 A larger (w. 6.0 cm; l. 9.3 cm) though similarly shaped object in colorless glass with linear cuts is in the Museum für Kunst und Gewerbe, Hamburg (inv. no. 1965.96). A few similarly shaped millefiori glass objects are known (see cat. 7).
32 This represents its only other possible function which, considering its size, seems to be more plausible.
33 Two small bowls of pointed oval shape in the millefiori technique (see cat. 7) combine the same two colors (bright yellow and green). This detail further links the two productions, as suggested above, and gives more impetus to the possibility that both millefiori and cameo glass originated in ninth-century ʿAbbasid Iraq. The two bowls are in the Museum für Islamische Kunst, Berlin (inv. no. I.3/73; see Kröger 1984, no. 141) and in private hands, respectively.
34 The senmurv is one of the most commonly depicted animal figures in Sasanian art because of its beneficent power and apotropaic significance. Its complex genesis is fully discussed in Trever 1938; its art-historical aspects are covered in SPA, vol. 1, pp. 737–38 and, more recently, Harper 1961a.
35 Lamm 1928, pls. 6:246, 8:249; and Kröger 1995, nos. 194–97.
36 For example, the "ibex and bird" bowl in the Corning Museum (inv. no. 53.1.109; see Kröger 1995, fig. 9) and a bowl showing running horses in the Museum für

Islamische Kunst, Berlin (inv. no. I.20/65; see Kröger 1984, no. 193).

37 See, for example, Oliver Jr. 1980, nos. 247, 248.

38 Harper 1961, fig. 28; London 1976, no. 130; and Whitehouse 1993, figs. 1–5, 7, 8, 11.

39 Harper 1961; and Whitehouse 1993.

40 The supposedly later objects, either in monochrome or cameo-cut glass, include inscriptions more often than do the earlier pieces. There are published examples of ninth-century inscribed relief-cut glass, however, on which the calligraphy is virtually identical to that on these later objects (see Kröger 1995, pp. 139–40, no. 192).

41 A good example with impressed decoration is a cup in the Metropolitan Museum of Art (inv. no. 1974.15; see Jenkins 1986, no. 17).

42 See Kröger 1995, pp. 139–40, no. 192; and Harper 1961, figs. 4–6, 16–18, 26, 27.

43 See note 39.

44 Ohm 1975, p. 41.

45 Hares are often depicted on relief-cut objects, the most famous of which are the green and the turquoise bowls in the Treasury of Saint Mark's in Venice (Gabrieli–Scerrato 1979, figs. pp. 483, 485) and numerous fragments (Harper 1961, figs. 12, 14, 15).

46 Rabbit ears in cut glass are, as a rule, either left plain or hatched; the author knows of no example decorated with a herringbone pattern. A silver plate in the Hermitage, St. Petersburg, supposedly from tenth-century eastern Iran, provides a good example of a stag's horn turned into a stylized pattern (see Marschak 1986, fig. 129). Thirteenth-century and later miniature paintings included in bestiaries and cosmographical works maintained the same stylized iconography for the representation of the stag's horns.

47 See note 34.

48 The bowl is in the Museum für Islamische Kunst in Berlin (inv. no. I.20/65; see Kröger 1984, no. 193); the fragment from Nishapur is in the Metropolitan Museum of Art (inv. no. 40.170.181; see Kröger 1995, no. 193); the fragment from Samarra is published in Lamm 1928, pl. 6:245; relevant fragments from the Corning Museum appear in Harper 1961, figs. 22, 24.

49 See, for example, Herzfeld 1923, pls. 51–54, 59.

50 See also cat. 18.

51 See, respectively, Marçais–Poinssot 1952, pls. 55–60; Smith 1957, figs. a, b; Golvin 1965, fig. 98; and a forthcoming publication on excavations in Libya by Derek Kennet.

52 A detailed study of these vessels could shed light on the relation between the eastern and the western Islamic glass productions. On the shape of the Iranian bottles, with their angular shoulder, versus those of their western counterparts, with a more rounded shoulder, see cat. 35.

53 See also a fragmentary bowl excavated at Nishapur (Kröger 1995, no. 198).

54 A similar dish appeared at Sotheby's, London, sale, April 21–22, 1980, lot 258.

55 Analysis showed that the material is anglesite (lead sulphate) with potassium lead chlorite, potassium lead sulphate (palmierite) and gypsum (calcium sulphate), but the purpose and use of this mixture is not clear.

56 These vessels provide one of the few cases in which the number of surviving glass objects of a specific shape is overwhelmingly larger than those in metal, thus suggesting that glass influenced the production in metal. For a published example in bronze, see Melikian-Chirvani 1982, no. 4. The Collection also owns one example in ivory and one in rock crystal (inv. nos. LNS 91 I and LNS 225 HS, respectively).

57 The bottle found in the Caucasus is published in Lamm 1929–30, pl. 58:3.

58 Two pieces, virtually identical to cat. 2.37 (one is 2 cm higher, the other almost 2 cm shorter), are published in Smith (1957, no. 600) and Kröger (1984, no. 172), respectively. Two similar bottles without their original necks are in the Corning Museum of Glass (inv. nos. 53.1.31, .32; not published).

59 As defined in Kröger 1995, p. 155.

60 See ibid., p. 155, who mentions examples in glass from Dura Europos as well as Sasanian ones.

61 Ibid., nos. 209–11.

62 The first is unpublished (inv. no. 64.1.24); for the second and third, see Auth 1976, no. 229; and van Doorninck 1990, fig. 68 (left), respectively.

63 This exceptionally important material is being catalogued and studied in the Museum of Underwater Archaeology in Bodrum. Although most of the glass was probably produced in the Syrian region, the beaker discussed here is not the only object that would support an eastern origin for part of the cargo; see Carboni 1999, pp. 174–75.

64 See Harden 1936, p. 287, figs. 4m–o.

65 Rainwater–Felger 1976, figs. 12, 13.

66 Abdullaev et al. 1991, no. 558.

67 See, respectively, Pinder-Wilson–Scanlon 1973, p. 30, no. 26; Sotheby's, Dubai, sale, December 3–5, 1985, lot 47; and Abdullaev et al. 1991, no. 643. The Dubai spoon looks rather suspicious from the color photograph published in the catalogue and may be a reproduction inspired by the object found in Fustat. A fourth object excavated at Mersin, southern Turkey and signed by a certain Qāsim is described (without an illustration) as an eighth- or ninth-century "colorless glass spoon (?)" in Day 1953, p. 261.

68 See, for instance, a tombstone dated A.H. 259 / A.D. 872 in the Museum of Islamic Art in Cairo (Zayn al-Din 1968, fig. 12).

69 See Oliver Jr. 1980, p. 71, no. 66.

70 See von Saldern 1980, p. 113, no. 113.

71 A vessel seemingly produced in the pre-Islamic tradition that was found in Samarra represents the only exception in the Islamic period; see Lamm 1928, p. 14, fig 1.

72 The object in the Victoria and Albert Museum, now mounted as a pendant in a fourteenth-century French niello setting, is inv. no. 110-1966 (Contadini 1998, p. 36, pl. 1); the second object, formerly in the Harari collection, Cairo, is presently in the Museum of Islamic Art, Cairo (Lamm 1929–30, pl. 74:9).

73 The turquoise bead is also in the Metropolitan Museum (inv. no. 48.101.235; see Kröger 1995, no. 276). The necklace is inv. no. 1973.347 (Jenkins 1986, pp. 54–55, no. 77).

74 Attributed to greater Iran in the twelfth or thirteenth century; Metropolitan Museum of Art, New York (inv. no. 1980.541.13; see Jenkins–Keene 1982, no. 27) and Museum für Islamische Kunst, Berlin (inv. no. I.14/55; see von Gladiss 1998, no. 55).

75 Walters Art Gallery, Baltimore (inv. no. 57.1596; see New York 1992, no. 19, pp. 222–23). The belt elements are catalogued together with numerous other gold elements.

76 The entire hoard is in the al-Sabah Collection (inv. nos. LNS 1216–1222 J).

77 This small bottle was apparently found in Syria together with Umayyad coins and Byzantine metal fragments. Its early origin is thus ascertained, though its color and decoration suggest that it was imported from the Islamic world east of Syria.

78 The complex design is technically more ambitious than that of cat. 2.12a and closer in quality to the bowl (cat. 19). Details of the cutting technique, however, make it less sophisticated than cat. 19.

79 A similar bottle with comparable decoration was found in the shipwreck of Serçe Limanı (Bass 1984, fig. 2g).

80 The material consists of galena, anglesite (lead sulphate), and cerussite (lead carbonate). The latter minerals are often found with galena and the composition is consistent with an identification as kohl. The same composition was found inside cat. 2.28j.

81 According to chemical analysis this lump has the same composition as that found inside cat. 2.27 (galena, anglesite or lead sulphate, and cerussite or lead carbonate), which is consistent with its identification as kohl.

82 A similar flask, though seemingly without feet, was excavated at Ctesiphon in a late Sasanian or early Islamic context. The object is in the Metropolitan Museum (inv. no. 32.150.114).

83 A larger object of blue green glass, in a similar shape and having the same peculiar base, was found during excavations at Samarra (see Lamm 1928, p. 73, no. 212, pl. 7).

84 Ibn al-Athīr (p. 66) reports a story related to Bilāl ibn Rabāḥ, the African adjutant, mace-bearer, and muezzin of the Prophet, in which the same expression احد احد (aḥadun aḥadun) was used.

# 3

# CONTINUITY OVER TIME

## UNDECORATED GLASS

THE SURFACES OF THE MAJORITY of utilitarian objects were not decorated. In some instances, glassmakers did use applied glass to finish a vessel (for example, the suspensions loops of an inkwell, such as cat. 33a, b), but this technique cannot be considered decorative, since the applied glass had the practical purpose of making the object functional.

Since glass objects were principally designed for everyday use, it is safe to assume that the percentage of undecorated objects preserved today in complete or fragmentary form is much higher than that of any other type of vessel. This observation is randomly confirmed by material excavated at every Islamic site, where plain glass fragments always amount to at least 60 to 70 percent of the total findings. This percentage of plain versus decorated glass is reversed in the case of private and public collections that include Islamic glass (except those composed exclusively of excavated material) where the ratio is 30 to 70 percent in favor of artistically decorated glass. The reason is simple: undecorated objects are usually regarded by collectors as archaeological or "study" pieces; consequently, they choose vessels that are more accomplished from an artistic point of view and thus more rewarding to the eye. The al-Sabah Collection is no exception.

The following objects (cat. 33–37) were selected principally because their particular practical functions deserved a more detailed explanation (for example, inkwells, alembics, or cupping glasses; see cat. 33, 34) or because their shape, combined with appealing colors, made them a good candidate for a more focused art-historical discussion (see the large emerald green bottle [cat. 35], the pitchers [cat. 36a, b], and the *qamāqim* [cat. 37a, b]).

The study of undecorated glass vessels and fragments is as vital to an understanding of Islamic glass as that of elaborately embellished objects. Placed in the proper context and analyzed within the general framework of glass production, a plain glass vessel's shape, color, and technical details, such as the pontil mark or the tooling of the rim, may be as revealing as those of any decorated object. For this reason, archaeological reports, which deal mainly with fragmentary undecorated glass, are essential to any serious study of this subject. The nearly cylindrical bottle (cat. 35) is a useful example, since its shape is known from archaeological excavations in Iran while variations of its profile can be attributed to geographical regions west of Iran. This type of bottle—in its colorless version—was often decorated in the tenth and eleventh centuries with incised stylized patterns (geometric, vegetal, and figural) that can therefore be ascribed to the same area and time. These patterns, combined with recurring vessel shapes, are important in the understanding of a basic vocabulary that will facilitate the attribution to the same period of a number of objects with similar decoration but different shapes, thus leading toward a more accurate art-historical grasp of the subject. This type of systematic study, which begins with the profile and method of creation of a plain vessel and continues with the analysis of a similar object that bears decorative patterns, is often applicable to the study of Islamic glass, providing links that would otherwise be difficult to understand. The Central Asian pitcher and the Egyptian or Syrian *qamāqim* (cat. 36a, 37) do not offer the same immediate links to decorated objects as do the Iranian bottles. A number of molded objects and enameled bottles, however, can be related to the two basic shapes of cat. 36 and 37; consequently, they may also be analyzed in the same context.

Two types of glass inkwells (cat. 33a–c)—namely, a cylindrical vessel with an inserted tube and suspension rings and a glass bowl encased within a body of plaster—offer insight into the use of glass in the art of writing, calligraphy being one of the most celebrated and best-known areas of Islamic art production. The use of glass for inkwells was apparently related to the fact that

"neither dirt nor powder can accumulate" inside these vessels and they "can easily be cleaned." In addition, "various Islamic writers prohibited the use of inkwells and pen-boxes made of precious metals."[1] This prohibition probably explains why a small glass bowl was placed inside a metal inkwell and utilized as the actual container for the ink. The widespread use of plain glass vessels for writing purposes shows how glass was commonly produced for use during the activities of higher social status, which took place in *scriptoria,* manuscript production and letter-copying centers.[2]

Alembics and cupping glasses (cat. 34a–c) testify to the widespread use of undecorated glass for scientific purposes throughout the centuries. Medicine was one of the most important and best-studied disciplines in the Islamic world. Cupping glasses with long curved tubes were used by physicians for bloodletting. As far as is known, these were the only glass tools employed in the practice of medicine, but the pharmacist's shop included a great many glass vials, flasks, and bottles used as containers for various medications, powders, and liquids. Cups similar to bloodletting instruments (cat. 34b, c) but having a straight tube instead of a curved one were used by alchemists as alembics (cat. 34a). Glass bottles and bowls whose function is not clear today because they are separated from their original sets were also used in alchemy.

## Cat. 33a INKWELL (LNS 80 G)
### Probably Iranian region
### 9th–10th century

Dimensions: hgt. 8.3 cm; max. diam. 7.0 cm;
wt. 296.7 g; cap. ca. 200 ml

Color: Translucent brownish yellowish
colorless

Technique: Molded; applied; worked on the pontil

Description: This heavy hexagonal inkwell was
made in a mold and has a flat base.
A cylindrical tube was inserted through
the opening (diam. ca. 1.6 cm); the
upper part of the tube overlaps around
the opening to create a band about
1.3 cm wide. Six small handles were
applied around the shoulder at equal
intervals. The inserted tube and the
handles are the same color as the
vessel. The pontil mark is visible
underneath the base.

Condition: The object was broken and repaired but
is virtually complete. The surface is
lightly weathered, resulting in a milky
white film. The glass includes frequent
small bubbles.

Literature: Qaddumi 1987, pl. p. 109

Related Works: 1. MAIP, inv. no. 6849
(London 1976, no. 117)
2. Formerly Derek Hill collection,
London (London 1976, no. 118)

These three objects represent the two basic glass inkwell types identified thus far, though any small container in the shape of a bottle with an opening and a neck large enough to receive a reed pen could have been used for the purpose.[3]

The first type (cat. 33a, b) is a cylindrical object with a tube inserted in the center and finished with a varying number of small applied suspension loops. The tube is attached to the opening of the vessel by a wide rim that overlaps the opening itself and thus seals the rim. This inserted tube was meant to prevent the ink from splashing and probably replaced the so-called *līq*, a piece of ink-soaked felt or wool placed inside other types of inkwells that had the same function.[4] The ink placed in these containers was in a liquid form and consisted for the most part of a mixture of gallnuts and vitriol called *ḥibr*; hence the name *miḥbara* for the inkwell,[5] known in Persian as *dawāt*. The suspension rings, which can vary in number from one[6] to six, were used to hang the inkwell from the scribe's left wrist or belt by means of cords.[7] Assuming, however, that the loops on inkwells of the early Islamic period were truly functional (not only decorative, inspired by earlier Roman or Chinese models), one cannot help noticing that the majority of these objects have thick walls (such as cat. 33a) and consequently are too heavy to be comfortably supported by a human arm for a prolonged time. The possibility that they were hung at the belt is more likely, or they may conceivably have been suspended from brackets or niches in the wall during use.

Cat. 33a represents the polygonal subtype, which was cast in a mold; its shoulder was then tooled and rounded before the loops were attached. Other square, hexagonal, or octagonal vessels are known (see Related Works 1, 2);[8] one of them was excavated at Siraf, on the northern coast of the Persian Gulf, in a ninth- to tenth-century context (Related Work 1).

The second subtype, with a cylindrical profile, is exemplified by cat. 33b and was by far the most common in the Iranian area. The cylindrical type was probably molded but could have been free blown and shaped on the marver. Well represented in collections around the world (see Related Works 3–7), at least two of these cylindrical inkwells were found during excavations in Iran (Related Works 3, 6), at Rayy and Nishapur, respectively.

Inkwells of the first type (cat. 33a, b) continued to be used until at least the twelfth or thirteenth century. A small number of extant examples with decorative motifs on their walls can be linked to a phase of production later than the ninth or tenth century. Two of these[9] are decorated with applied curls similar to those on a pitcher (cat. 40) that is datable to the tenth or early eleventh century. Another inkwell that was mold blown[10] presents a combination of a honeycomb pattern and vertical ribs; it may be included in the group of Iranian objects from the twelfth and thirteenth centuries described at cat. 64–68. In general, these later inkwells are also more finely blown and lighter in weight than the earlier examples.

**Cat. 33b INKWELL (LNS 89 G)**
**Probably Iranian region**
**9th–10th century**

Dimensions: hgt. 7.2 cm; max. diam. 7.3 cm;
wt. 171.2 g; cap. 195 ml

Color: Translucent green (green 2)

Technique: Blown; applied; tooled on the pontil

Description: This cylindrical inkwell was probably
free blown and tooled; the base is
slightly kicked in the center. A
cylindrical tube was inserted through
the opening (diam. ca. 1.7 cm); its
upper part overlaps around the opening
to create a band about 1.8 cm wide.
Two small handles were applied
between the shoulder and the edge of
the overlapping band at opposite sides.
The inserted tube as well as the handles
are of the same color as the vessel.
The pontil mark is visible underneath
the base.

Condition: The object was broken and repaired
but is complete. The surface is heavily
weathered, resulting in a milky white
coating and iridescence. The glass
includes frequent small bubbles
and a large bubble.

Literature: Qaddumi 1987, pl. p. 108

Related Works: 3. NM, Stockholm
(Lamm 1935, pls. 3E, 15K)
4. CMG, inv. no. 50.1.38
5. MM, inv. no. G86
(Hasson 1979, no. 10)
6. MAIP, inv. no. 20381
(Kröger 1995, no. 229)
7. TRM (Kuwait 1994, pl. p. 61)

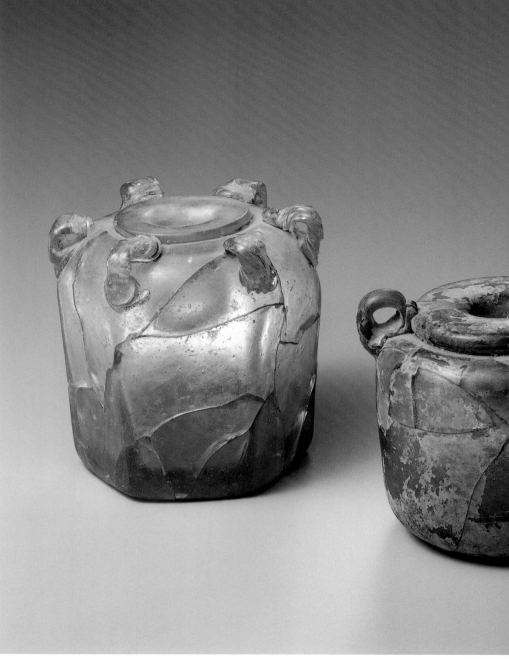

Cat. 33a–c

The second type of inkwell (cat. 33c, 3.3) is a small glass jar or vase set into a body of plaster that provides a solid and heavy base. These inkwells never have suspension rings and were supposed to lie flat on a surface. Given the larger size of the opening of the glass jar, it is possible that several scribes used the same one at the workshop. Small glass jars set into a ceramic or a metal vessel contained the ink, as glass was among the materials recommended for this purpose.[11] In his entry on the only plaster-and-glass inkwell found in Nishapur, which was unfortunately discarded by the excavators, Kröger offers an exhaustive list of plaster holders that, in all probability, once contained a small glass vessel and therefore were inkwells.[12]

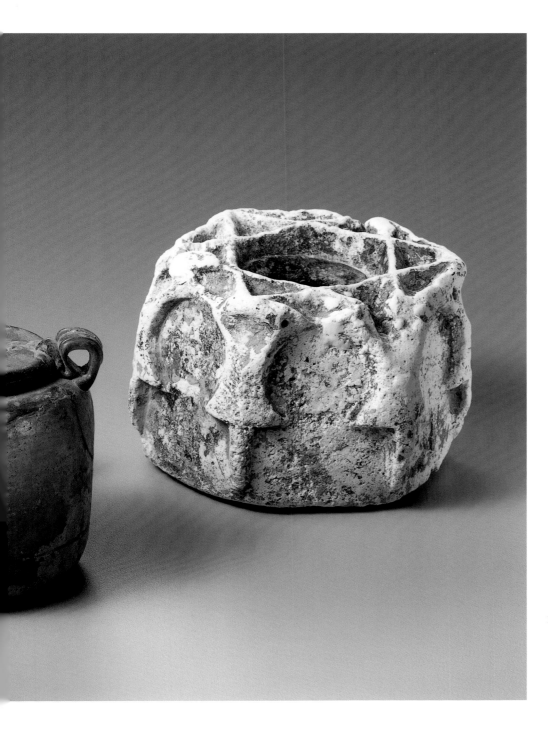

**Cat. 33c INKWELL (LNS 372 G)**
**Iranian or Central Asian region**
**9th–10th century**

Dimensions: (glass inkwell) hgt. 4.5 cm;
diam. 4.0 cm at mouth; cap. 73 ml
(plaster vessel) hgt. 7.0 cm;
max. diam. 11.0 cm; wt. 483.2 g

Color: Probably translucent pale brown
(yellow/brown 2)

Technique: Blown; tooled; inserted into a bed
of plaster

Description: This inkwell was embedded in a heavy
hexagonal plaster vessel. The inkwell
has a curved profile with a pronounced
shoulder and ends in a splayed opening.
Its base is slightly kicked, suggesting
that the vessel was worked on the
pontil. The six sides of the plaster
container were molded and each one
includes the motif of a horseshoe arch
resting on slender columns at each
corner. The arches are alternately
painted blue (lazurite, according to
chemical analysis) or not painted.
Viewed from the top, a six-pointed star
is visible around the opening, the points
of which are alternately blue or
unpainted.

Condition: The object is intact except for a chip at
the rim. The interior is entirely covered
with soil and coated with a black
substance, possibly ink.[14]

Provenance: Reportedly from Dar-i Suf
("Canyon of Caves"), near Mazar-i
Sharif, Afghanistan

Related Works: 8. MIK, inv. no. I.7/62
(Kröger 1984, no. 18)
9. CMG, inv. no. 56.1.108
10. Whereabouts unknown
(Smith 1957, no. 457)
11. MHC, Samarqand, inv. no. A-64-1
(Paris 1992, no. 315)

During the early Islamic period, the second type of inkwell was probably as popular as the first (see cat. 33a, b). As with the first type, evidence points to the Iranian and Central Asian areas for the production and use of plaster-and-glass inkwells,[13] though the molded decoration that is present on the sides of the plaster blocks is not helpful in clarifying this supposition. In fact, such decorative motifs, which consist principally of stylized arches and pseudovegetal ornaments, are also common to the Syrian and Mesopotamian regions in the late Umayyad and early 'Abbasid periods.

## Cat. 34a ALEMBIC (LNS 427 G)
### Probably Iranian region
### 9th–12th century

Dimensions: hgt. 18.5 cm; max. diam. 14.0 cm; l. 22.0 cm; th. 0.26 cm; wt. 458.5 g; cap. ca. 1000 ml

Color: Translucent pale green (green 2)

Technique: Free blown; tooled; worked on the pontil

Description: This vase-shaped cup with curved walls has an angular shoulder, a sunken transition between the shoulder and the neck, and a slightly tapered neck with a plain opening (diam. 5.9 cm). The pontil mark, which may represent a broken finial, is visible at the domed top of the cup. A long straight pipe, now broken (l. ca. 8.0 cm from the shoulder; diam. 1.5 cm at the break), was attached to one side of the cup.

Condition: The cup of this object is intact, while the pipe is broken (about two-thirds is missing). A finial may also be missing from the domed top of the cup. The surface is heavily weathered, resulting in milky white coating and brown spots. The glass includes frequent small bubbles.

Provenance: Bonhams, London, sale, April 24, 1997, lot 287a

Related Works: 1. V&A, inv. no. 337-1900 (al-Hassan–Hill 1986, fig. 6.3; and Maddison–Savage-Smith 1997, fig. 3)
2. Science Museum, London, inv. no. 1978.219.220 (Anderson 1983)
3. Museum of the Bimaristan, Damascus
4. Khalili collection, London, inv. no. GLS 199 (Maddison–Savage-Smith 1997, no. 130)

## Cat. 34b CUPPING GLASS (LNS 90 G)
### Probably Iranian region
### 9th–12th century

Dimensions: hgt. 5.5 cm; max. diam. 4.6 cm; l. 9.8 cm; th. 0.14 cm; wt. 30.5 g; cap. 64 ml

Color: Translucent green (green 2–3)

Technique: Free blown; tooled; worked on the pontil

Description: This deep cup has slightly curved walls; the rim folds inward, forming a band about 0.5 cm high. The pontil mark is visible at the domed top of the cup. A long curved pipe was attached to one side of the cup.

Condition: The cup of this object is intact, while the pipe is broken (about one-third is missing). The surface is heavily weathered, resulting in a golden brown coating and iridescence. The glass includes scattered small bubbles.

Literature: Qaddumi 1987, pl. p. 108

Glass vessels composed of a deep cup and a long spout, or pipe, have been found throughout the Islamic world, from Tunisia to Uzbekistan.[15] A large number of almost intact pieces (part of the fragile pipe is often broken) or fragmentary objects were found during excavations and are presently in various collections. The Iranian area seems to have the best share of excavated finds of this type, though this may be due to coincidence and to the larger number of digs that have been reported and published there.[16] In addition, many of these vessels lack a reputed provenance.[17]

Some confusion regarding the function of these vessels exists in the literature, but the two basic interpretations are that they are either alembics or cupping glasses.[18] Only Lamm and Clairmont have distinguished between the two functions, variously identifying a number of vessels though not giving clear reasons for their differentiations.[19] Kröger addressed the problem in his study of the glass from Nishapur, explaining that "despite the widespread occurrence of these vessels, very little is known about their actual use."[20]

Although it is sometimes difficult to offer a clear identification of some of these vessels as either alembics or cupping glasses—because of their fragmentary condition or the unusual profile of the pipe or the cup—it is not difficult to recognize the two types according to the different functions they served.

Alembics were used in distillation (taqṭīr) apparatuses that were formed by at least three vessels: the cucurbit (qarʿa), where the liquid would be heated; the alembic (anbīq), where the vapor or gas would turn into a liquid state; and the receiving bottle or flask (qābila or muqābala), into which the liquid would flow through a narrow pipe. These sets were used in chemistry, pharmacology, and alchemy for the distillation of alcohol, petroleum, perfumes, rosewater, date wine, and essential oils.[21] The existence of these apparatuses is proved by at least two complete distillation sets presently in the Science Museum, London, and in the small museum of scientific instruments in the Bimaristan, Damascus (Related Works 2, 3).[22] Other alembics are in Toronto and Stockholm.[23] Since the cup of the alembic was arranged upside down to serve as a cap for the cucurbit, the vessel would have to be provided with a long, straight, or only slightly curved tube running diagonally from a higher to a lower point in order to let the liquid flow into the receptacle. In addition, the cup would have to be in the shape of a vase whose neck would fit into the opening of the cucurbit while its shoulder would rest—well balanced—over the rim of the cucurbit. This type of alembic, represented in the Collection by cat. 34a, is illustrated by the complete vessel in the Victoria and Albert Museum (Related Work 1).

Cupping glasses were used in medicine for bloodletting. This does not mean, as has perhaps been implied in the literature on glass,[24] that the pipe attached to the cup was supposed to serve as the tube for collecting blood; on the contrary, its function was simply to allow the physician to suction the air from inside the cup after the vessel was laid on the patient's back, so that it would become a true suction cup. After the blood was pulled to the surface of the skin by the action of the cupping glass, the cup was removed and the physician made a small incision on the patient's skin to allow the blood to flow out. For this reason, such cups are called in Persian today shākh-i ḥajāmat ("the horn of the cupper," from the Arabic ḥajjām) or bād-gīr ("air-pulling device"). In classical Arabic, a cupping

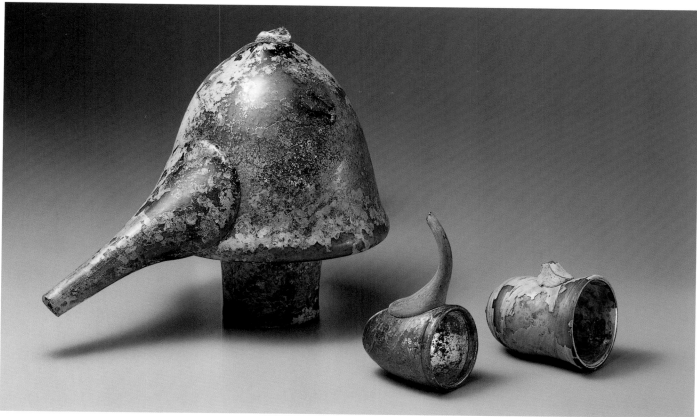

Cat. 34a–c

glass is known as *mihjama* or *mifsada*.[25] The long pipe of the "horn of the cupper" had to be long and curved to facilitate the physician's task of sucking the air from the cup. Consequently, all the vessels of this type that are formed by a deep cup—rather than a vaselike cup, as in the case of the alembics—and a pipe that curves in the opposite direction of the opening of the cup must be identified as cupping glasses. This is unquestionably the case for cat. 34b and is also likely for cat. 34c, though the missing pipe makes the latter identification less certain.

An attribution to a precise time and place for alembics and cupping glasses is extremely difficult, as these chemical and medical vessels were produced throughout the Islamic world, from the early Islamic period onward. Perhaps only a limited number of glass factories specialized in such scientific supplies, and it may one day be possible to distinguish them according to the shape of the cup, the rim type, or the length and curvature of the pipe.[26] At the moment, however, more information is needed before such precise attributions can be made.

**Cat. 34c CUPPING GLASS (LNS 347 G)**
**Probably Iranian region**
**9th–12th century**

Dimensions: hgt. 7.0 cm; max. diam. 5.3 cm; th. 0.28 cm; wt. 39.3 g; cap. 82 ml

Color: Translucent pale green (green 1–2)

Technique: Blown; tooled; worked on the pontil

Description: This deep cup with a curved profile is somewhat compressed in the central section; the rim is slightly lipped. The pontil mark is visible at the domed top of the cup. Only the attachment of a spout is present at one side of the cup.

Condition: The cup of this object is intact, while the pipe is almost entirely missing (ca. 1 cm of the original tube remains). The surface is entirely weathered, resulting in a milky white coating and golden iridescence. The glass includes scattered tiny bubbles.

Provenance: Eliahu Dobkin collection; Bonhams, London sale, October 18, 1995, lot 383

Related Works: 5. Dobkin collection, Jerusalem (Hasson 1979, fig. 1)
6. MMA, inv. no. 38.40.195 (Kröger 1995, no. 240)
7. MAIP, inv. nos. 20530, 8246 (Kröger 1995, no. 239; Ruhfar 1996, glass section, unnumbered no. 1)
8. NM, Stockholm (Lamm 1935, pl. 15c)
9. CMNH, inv. no. 22653/1 (Oliver Jr. 1980, no. 246)

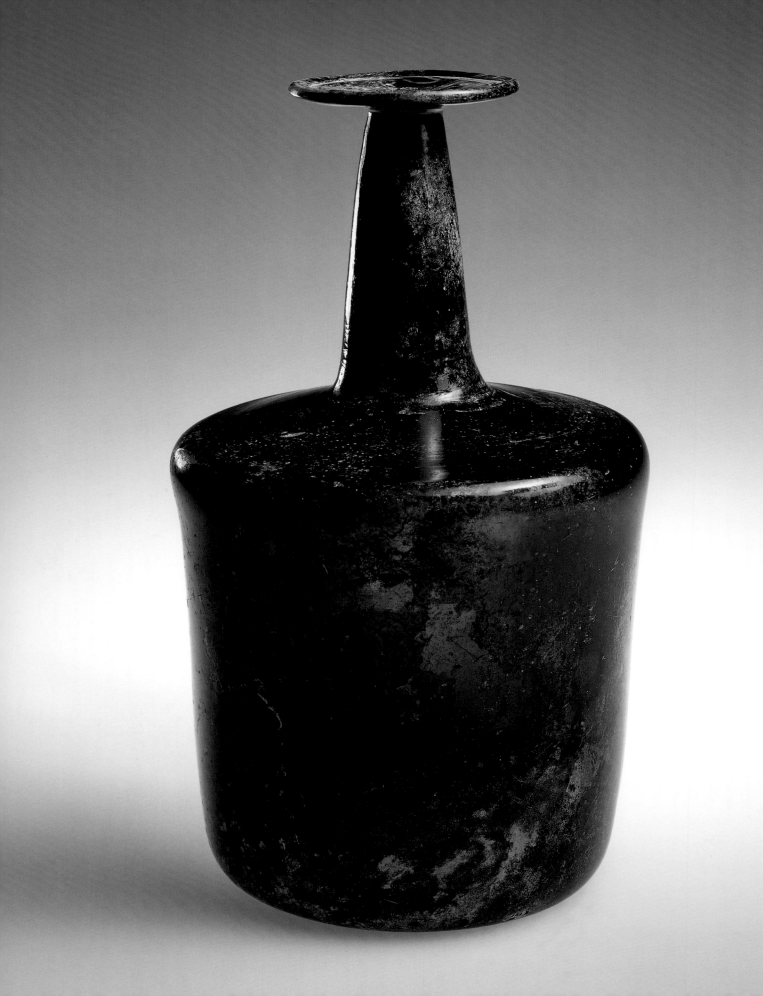

**Cat. 35 BOTTLE (LNS 7 G)**
**Iranian region**
**10th–11th century**

Dimensions: hgt. 25.2 cm; max. diam. 14.5 cm;
th. 0.45 cm; wt. 516.1 g; cap. ca. 1950 ml

Color: Translucent dark emerald green
(green 5)

Technique: Free blown; tooled; worked on
the pontil

Description: This nearly cylindrical, slightly flared
bottle has an angular shoulder, a long
tapered neck, and a large splayed
opening with a folded rim. The flat base
has a kick in the center and the pontil
mark is visible.

Condition: The object is intact. The surface is
lightly weathered, resulting in milky
white and grayish films.

Related Works: 1. CMG, inv. no. 69.1.14
(Perrot 1970, no. 49)
2. MAIP, inv. nos. 20325, 22014
(Kröger 1995, no. 109; and
Kordmahini 1988, p. 99)

Large bottles with a nearly cylindrical, slightly flared body, a flat base, and a tapered neck with a large splayed opening were commonly produced in the Islamic lands from the ninth through the twelfth century. Although it is difficult to suggest precise attributions, regional variations of this type of vessel can be isolated according to the shape of the shoulder. A basic distinction can be made between Iranian and Syro-Egyptian products: the former type is represented by a high angular shoulder that conveys the impression of an almost cylindrical, sturdy container (often incorrectly described as "mallet-shaped"); the latter type consists of a bottle with a wider curved shoulder that makes the profile of the vessel more gracious and delicate.

The first type is well illustrated by cat. 35, the appeal of which is enhanced by the stunning dark emerald color, and by Related Works 1 and 2, which were excavated in, or reportedly found in, Iran. The two bottles in Tehran (Related Work 2) were recovered at Nishapur; hence this type of bottle is usually attributed to this site. Given its utilitarian function as a container of nonprecious or semiprecious liquids (such as oil or wine), it is possible that this kind of bottle represented a typical product of Nishapur's glassmakers, though its sturdiness and compact shape would have allowed it to travel for some distance without immediate risk of breakage and it may therefore have reached Nishapur from nearby areas.

The second type, which is not represented in the al-Sabah Collection, is exemplified by finds in North Africa (for example, at the Qal'a of the Banū Ḥammād in Algeria, at Sabra Mansuriyya in Tunisia, at Sidi Khrebish [Bengasi] in Libya, and at Fustat in Egypt) as well as from the eleventh-century shipwreck of Serçe Limanı.[27] The material excavated from the ship also revealed a variation of the second type consisting of a profile that shows the same curvature of the base and the shoulder, though the central part of the body is compressed.[28]

When undecorated, as in the present case, these bottles are usually a vivid green or blue. The dark coloring may have been intended to increase their appeal and perhaps to better preserve the liquids they contained. As it is evident from cat. 25a and 55, however, the majority of extant bottles of this type present either relief-cut, linear-cut, or molded decoration showing a variety of vegetal and geometric ornaments. As a general rule, these decorated bottles, unlike the plain ones, were made of either pale or colorless glass in order to better reveal their surface patterns.

Cat. 35

**Cat. 36a PITCHER (LNS 338 G)**
**Iranian region**
**11th century**

Dimensions: hgt. 15.8 cm; max. diam. 9.4 cm;
th. 0.21 cm; wt. 227.4 g; cap. ca. 500 ml

Color: Translucent yellowish colorless

Technique: Blown; applied; tooled;
worked on the pontil

Description: This nearly cylindrical, slightly flared
pitcher has a sunken base and a slightly
flared neck. An L-shaped handle of the
same color was applied at the rim and
at the shoulder; a thumb rest was
created by folding the handle and
pinching it into a small globe at the top.

Condition: The object was broken and repaired;
about 10 percent of the body is missing.
The surface is entirely weathered,
resulting in a milky white coating,
heavy iridescence, and some corrosion.
The glass includes frequent small
bubbles.

Provenance: Reportedly from Tashkent, Uzbekistan

Related Works: 1. MMA, inv. no. 40.170.62
(Kröger 1995, no. 112)
2. TRM, inv. no. GLS-0426-TSR

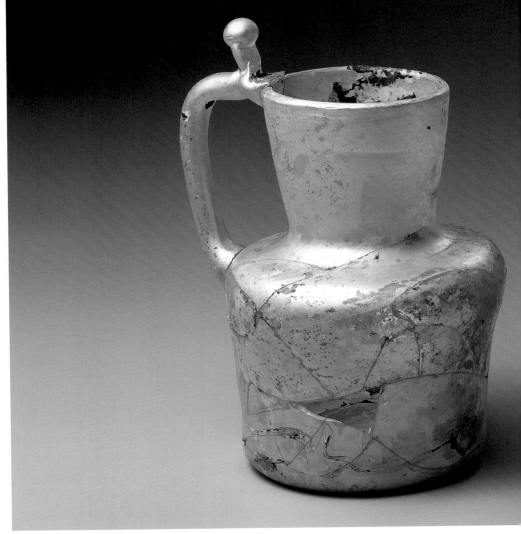

Cat. 36a, b

Pitchers (or ewers) were widespread in the Islamic world, especially those with a globular shape and a flared neck and those with a piriform profile and a drop-shaped opening.[29] The two undecorated pitchers in the Collection (cat. 36a, b) are relatively unusual, as their profiles do not conform to the two common types and they can therefore be attributed to more specific areas of production.

Cat. 36b presents a low circular foot, a flattened globular body, and a cylindrical neck, the diameter of which is only slightly less than that of the vessel itself, resulting in a squat unassuming object that nevertheless has a vigorous quality. Its relatively small size and large mouth may suggest that it was intended as a drinking cup for individual or communal use rather than as a container used to pour liquids into smaller goblets or beakers. Its L-shaped handle and tall, flat thumb rest would have been appropriate for both functions.

Interesting parallels for the unusual profile of cat. 36b are provided by two pitchers that were found in the tomb of Princess Chenghuo and her husband at Naiman, Inner Mongolia (Related Work 3).[30] This princess of the Liao dynasty died in 1018; therefore, a dating *ante quem* for this type of vessel is established as the beginning of the eleventh century. The two pitchers, made of brown glass, are almost identical in shape; one of them is plain, the other is decorated with applied threads. Compared to cat. 36b, their bodies have a similar flattened profile, their necks are taller but proportionally as large, and the objects clearly belong to the same typology. Another similar pitcher was uncovered in a tomb, dated 1019, excavated in the province of Liaoning, thus confirming that these objects

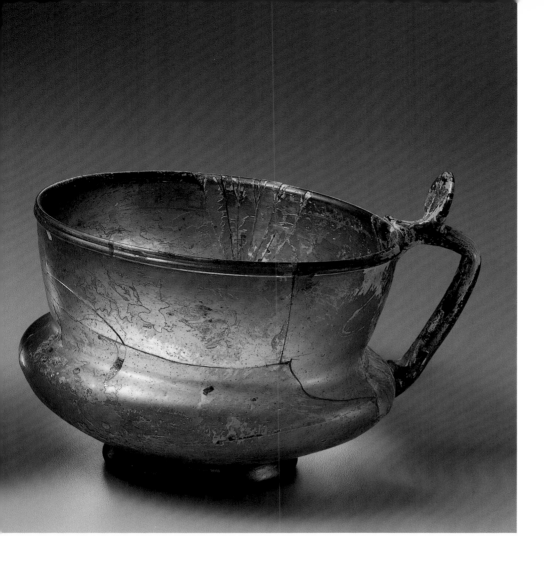

**Cat. 36b PITCHER (LNS 342 G)**
**Central Asian or Iranian region**
**10th–11th century**

Dimensions: hgt. 8.5 cm; max. diam. 12.5 cm;
th. 0.20 cm; wt. 180.3 g; cap. ca. 700 ml
Color: Translucent pale bluish green (green 2)
Technique: Blown; applied; tooled;
worked on the pontil
Description: This flattened bulbous pitcher has a
large, slightly flared neck that is taller
than the body itself. A circular foot ring
(hgt. ca. 1 cm) was probably attached to
the base, though it is possible that it
was simply tooled by folding the base
twice. The rim has a pronounced lip.
An L-shaped handle of the same color
was applied at the rim and at the center
of the body; a thumb rest was created
by pulling the handle and pinching it
into a flattened circle at the top.
Condition: The object was broken and repaired but
is complete. The surface is weathered,
resulting in heavy silvery and golden
iridescence, brown patches, and
extensive abrasion. The glass includes
frequent small bubbles and one large
bubble at the base.
Provenance: Eliahu Dobkin collection; Bonhams,
London, sale, October 18, 1995, lot 402
Literature: Hoare 1985, no. 143
Related Works: 3. Archaeological Research Institute of
Inner Mongolia, Hohhot (An 1991,
fig. 11; Taniichi 1988, figs. 1, 2, 7, 8;
and *Treasures* 2000, p. 227)
4. MKG, Hamburg, inv. no. 1963.22
(von Saldern 1968a, fig. 18)
5. Benaki, inv. no. 3216
(Clairmont 1977, pl. 14, no. 241)

were traded over long distances and prized in China at the beginning of the eleventh
century.[31] Two other pitchers are comparable in shape to cat. 36b. One (Related Work 4),
attributed to the eastern Islamic world, is made of similar pale bluish green glass, has a
slightly more rounded body, the same disc-shaped thumb rest, and molded honeycomb
decoration. The second one (Related Work 5) is smaller and made of dark amber glass and
has a tall neck comparable to the examples from China and a pinched decoration of small
rhomboids around the upper section of the neck. Although the latter object has been
attributed to the eastern Mediterranean,[32] there seems to be little doubt that this type of
drinking or pouring vessel was made in the eastern Islamic regions. When published in 1985,
cat. 36b was attributed to ninth- or tenth-century Iran,[33] a dating that may now be moved
slightly later in light of the archaeological evidence from China.

The nearly cylindrical body and neck, angular shoulder, and solid globular top of
the thumb rest make cat. 36a even more unusual than cat. 36b. Only one good parallel can
be found, in a fragmentary pitcher excavated at Nishapur that presents a more sloping
shoulder and a flared neck (Related Work 1).[34] The shape, therefore, seems to be related
to eastern Islamic metalwork, rather than glass, of the tenth and eleventh centuries.[35]
An Iranian origin is unquestionable for this type of vessel, considering that its nearly
cylindrical, slightly flared body and angular shoulder are also characteristic features
of the many bottles created in this region (see cat. 35).

**Cat. 37a** *QUMQUM*
**(PERFUME SPRINKLER)**
**(LNS 108 KG)**
**Syrian region**
**12th–13th century**

Dimensions: hgt. 13.0 cm; w. 7.5 cm; l. 5.7 cm;
th. 0.23 cm; wt. 64.0 g; cap. 150 ml
Color: Translucent dark green (green 5)
Technique: Blown; tooled; worked on the pontil
Description: This *qumqum* has a globular body
flattened at two sides, a small flattened
base with a slight kick in the center,
and a long tapered neck with a narrow
opening.
Condition: The object is intact. The surface is
lightly weathered, resulting in a milky
white coating and some corrosion.
The glass includes frequent small
bubbles and several larger ones.
Provenance: Kofler collection
Literature: Lucerne 1981, no. 583

**Cat. 37b** *QUMQUM*
**(PERFUME SPRINKLER)**
**(LNS 38 G)**
**Syrian region**
**12th–13th century**

Dimensions: hgt. 14.0 cm; w. 7.6 cm; l. 5.6 cm;
th. 0.18 cm; wt. 56.0 g; cap. ca. 170 ml
Color: Translucent pale yellowish green
(green 1)
Technique: Blown; tooled; worked on the pontil
Description: This *qumqum* has a globular body
flattened at two sides, a flattened base
with a kick in the center, and a long
tapered neck with a narrow opening.
Condition: The object is intact. The surface is
weathered, resulting in heavy
iridescence and corrosion.
Related Works: 1. Newark, inv. nos. 50.1662–4
(Auth 1976, nos. 217, 218, 531)
2. CMNH, inv. no. 24037/2
(Oliver Jr. 1980, no. 269)
3. MMA, inv. no. 34.132.53
4. V&A, inv. nos. 992-1901, 1185-1905
5. CMG, inv. no. 54.1.73

One type of bottle commonly produced in Egypt and Syria is known as a *qumqum* or an *omom*.[36] Its manufacture probably began in the late Fatimid period but became widespread under the Ayyubids and the Mamluks (12th–14th century).

A flattened globular shape, long neck, and extremely narrow opening characterize this type of vessel, which was almost certainly used as a sprinkler for perfumed water, such as rosewater. Easily identifiable among the many types of Islamic glass vessels, *qamāqim* may differ in a number of details, such as the presence of a bulge at the base of the neck, the length of the neck itself, the extent of the compression of the sides, or the depth of the kick underneath the base.

Undecorated *qamāqim* were first made in twelfth-century Syria for utilitarian purposes. By the mid-thirteenth century, in the late Ayyubid and the early Mamluk periods, they were commissioned by, or made for, wealthier patrons and were decorated with either multicolored enamels and pincered "snaky" handles at opposite sides of the base of the neck (cat. 95), with white opaque marvered threads (cat. 83), or were molded with vertical ribs and subsequently optic blown, manipulated, and twisted (cat. 60).

In addition to the many intact objects reported to have been purchased in Egypt or Syria and presently in private and public collections (Related Works 1–5), a provenance from this geographical area is confirmed by vessels and fragments excavated at Hama and Quseir al-Qadim,[37] for example, as well as by their absence in excavations from the Mesopotamian and Iranian areas and the easternmost Islamic lands. The popularity of this type of *qumqum* began to wane during the late Mamluk period as part of the progressive decline of the glassmaking industry, although long-necked perfume sprinklers of related shape became popular in Iran and India in the eighteenth and nineteenth centuries.

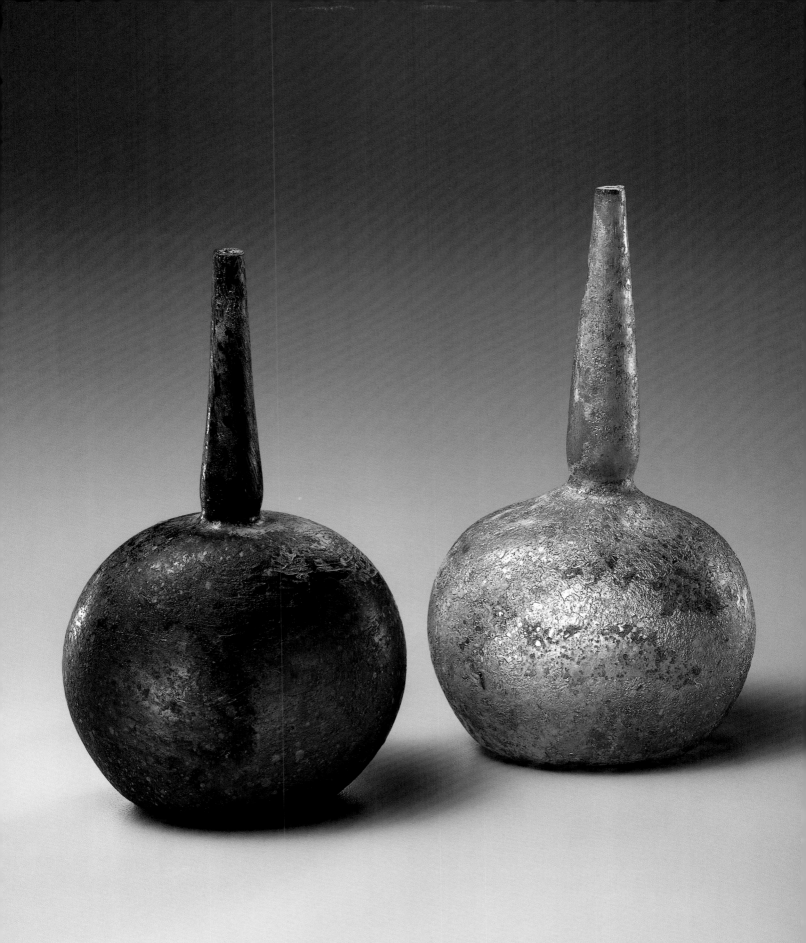

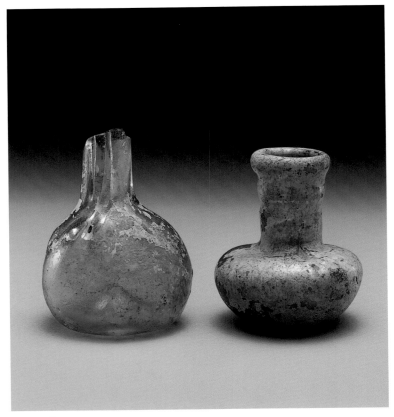

Cat. 3.1a, b

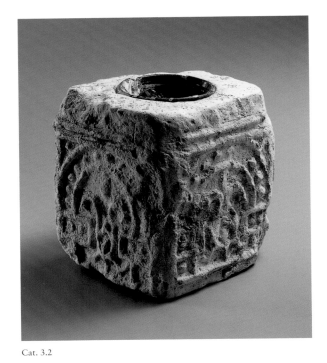

Cat. 3.2

### Cat. 3.1a SMALL BOTTLE (LNS 262 G)
**Possibly Mesopotamian region**
**8th–9th century**

Dimensions: hgt. 3.5 cm; max. diam. 2.5 cm;
th. 0.12 cm; wt. 6.6 g; cap. 4 ml
Color: Translucent bluish colorless
Technique: Blown; tooled; worked on the pontil
Description: This miniature bottle has an irregular
globular body, a flattened base with a
kick, a cylindrical neck, and an
unusually small pontil mark. A large
vertical pincered mark runs along the
shoulder and the neck.
Condition: The object is intact. The surface is
partially weathered, resulting in a milky
white coating and iridescence. The
vertical pincered line was created
accidentally during tooling. The glass
includes frequent tiny bubbles.
Provenance: Kofler collection; gift to the Collection

### Cat. 3.1b SMALL BOTTLE (LNS 19 KG)
**Possibly Mesopotamian region**
**8th–9th century**

Dimensions: hgt. 3.0 cm; max. diam. 2.5 cm;
th. 0.20 cm; wt. 6.4 g; cap. 4 ml
Color: Translucent pale green (green 1)
Technique: Blown; tooled; worked on the pontil
Description: This flattened globular bottle has a
convex base, a long slightly flared neck
with small bulges, and a lipped
opening.
Condition: The object is intact. The surface is
entirely weathered, resulting in a milky
white coating and iridescence.
Provenance: Kofler collection
Literature: Lucerne 1981, no. 577

### Cat. 3.2 INKWELL (LNS 144 G)
**Probably Syrian region**
**8th–9th century**

Dimensions: (glass inkwell) hgt. 4.5 cm;
diam. 5.5 cm at mouth; cap. 60 ml
(plaster vessel) hgt. 9.8 cm;
l. 9.0 cm each side; wt. ca. 900 g
Color: Translucent green (green 3–4)
Technique: Blown; tooled; inserted in a bed
of plaster
Description: The glass inkwell probably has a
flattened globular profile; it is embedded
into a heavy cubic vessel made of plaster.
The inkwell has a short neck and ends
in a flared opening, the rim of which
was folded inward. The four sides of
the plaster container were molded: each
includes the motif of a rounded arch,
filled with dots in relief, under which is
an unclear pseudovegetal pattern.
Condition: The glass inkwell was broken and
repaired and some small parts are
missing. The surface is heavily
weathered, resulting in a whitish
coating and iridescence.
Provenance: Christie's, London, sale, April 28, 1992,
lot 181
Related Work: Cat. 33c

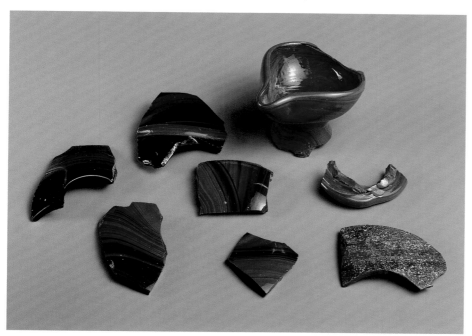

Cat. 3.3a–h

## Cat. 3.3a–h EIGHT FRAGMENTS
(LNS 121 KGa, b; LNS 122 KGb–d;
LNS 127 KGa, b; LNS 197 KG)
Syrian region
8th–9th century[38]

Dimensions: a, b (b is larger fragment): max. l.
3.0 cm; max. w. 2.8 cm; th. 0.22 cm
c–e (c is largest fragment): max. l.
3.2 cm; max. w. 2.0 cm; th. 0.27 cm
f, g (f is larger fragment): max. hgt.
2.4 cm; max. w. 3.4 cm; max. l. 3.7 cm;
th. 0.25 cm
h: max. l. 2.8 cm; max. w. 3.0 cm;
th. 0.18 cm
Color: Opaque dark red streaked with brown;
translucent dark blue (blue 5)
Technique: Blown; tooled
Description: These eight fragments are dark
brownish, *sang-de-boeuf* red, with
streaks of a darker brown color.
Exceptionally, the same colors were
applied on top of a translucent dark
blue layer of glass in the case of
fragments a and b, which probably
belonged to a small bottle of globular
shape. Fragments c to e almost certainly
belonged to the same vessel. Fragment f
includes the upper part of the neck of a
small ewer with a teardrop- or heart-
shaped opening; g, from the same
vessel, seems to include part of an
applied ring around the ewer's neck.
Fragment h is curved and belonged to
the wall of a bottle or bowl.
Condition: The surface of fragment h is partially
weathered, resulting in white pitting.
All the other fragments are in good
condition.
Provenance: Kofler collection

## Cat. 3.4a SMALL BOTTLE (LNS 22 G)
Probably Iranian or
Mesopotamian region
9th–10th century

Dimensions: hgt. 4.2 cm; max. diam. 1.5 cm;
th. 0.18 cm; wt. 11.8 g; cap. 1 ml
Color: Translucent greenish colorless
Technique: Blown; tooled; worked on the pontil
Description: This cylindrical bottle has a flat base,
a round shoulder, and a flared neck.
Condition: The object was broken into two pieces
that were reassembled. The surface is
lightly weathered, resulting in abrasion.
The glass includes frequent tiny
bubbles.

## Cat. 3.4b BOTTLE (LNS 57 G)
Probably Iranian or
Mesopotamian region
9th–10th century

Dimensions: hgt. 7.0 cm; max. diam. 4.6 cm;
th. 0.43 cm; wt. 73.4 g; cap. 54 ml
Color: Translucent yellowish colorless
Technique: Blown; tooled; worked on the pontil
Description: This cylindrical bottle has a flat base,
an angular shoulder, and a cylindrical
neck ending in a lipped opening.
Condition: The object is intact. The surface is
entirely weathered, resulting in
iridescence and abrasion. The glass
includes frequent small bubbles.

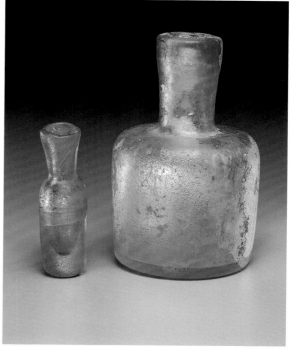

Cat. 3.4a–b

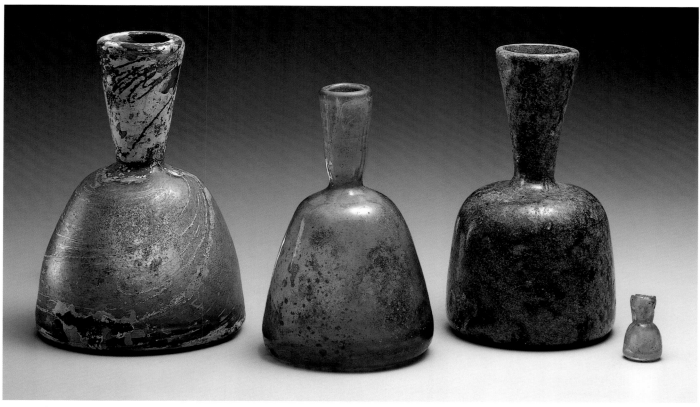

Cat. 3.5a–d

### Cat. 3.5a BOTTLE (LNS 1 KG)
**Probably Iranian region**
**9th–10th century**

Dimensions: hgt. 13.0 cm; max. diam. 8.8 cm;
th. 0.62 cm; wt. 179.4 g; cap. 250 ml
Color: Translucent green (green 2)
Technique: Blown; tooled; worked on the pontil
Description: This bottle has a domed body with a
flat base, a flared neck that is thicker
than the body, and an opening that has
an interior lip.
Condition: The object is intact. The surface is
heavily weathered, resulting in a dark
brown coating and iridescence. The
glass includes frequent small bubbles.
Provenance: Kofler collection
Literature: Lucerne 1981, no. 579

### Cat. 3.5b BOTTLE (LNS 75 G)
**Probably Iranian region**
**9th–10th century**

Dimensions: hgt. 11.4 cm; max. diam. 6.8 cm;
th. 0.32 cm; wt. 103.3 g; cap. 144 ml
Color: Translucent yellow (yellow/brown 1)
Technique: Blown; tooled; worked on the pontil
Description: This bottle has a domed body, a flat
base, and a flared neck.
Condition: The object is intact. The surface is
partially weathered, resulting in a dark
brown coating and whitish pitting. The
glass includes frequent small bubbles
and a dark streak on the neck.

### Cat. 3.5c BOTTLE (LNS 294 G)
**Probably Iranian region**
**9th–10th century**

Dimensions: hgt. 12.4 cm; max. diam. 7.2 cm;
th. 0.32 cm; wt. 154.8 g; cap. 188 ml
Color: Translucent dark blue (blue 4)
Technique: Blown; tooled; worked on the pontil
Description: This bottle has a domed body with a
flat base, a low shoulder, and a flared
neck.
Condition: The object is intact. The surface is
entirely weathered, resulting in a brown
coating, and abrasion. The glass
includes scattered small bubbles.
Provenance: Reportedly from Herat, Afghanistan

### Cat. 3.5d MINIATURE BOTTLE
(LNS 23 G)
**Probably Iranian region**
**9th–10th century**

Dimensions: hgt. 2.5 cm; max. diam. 1.5 cm;
th. 0.20 cm; wt. 5.2 g; cap. 0.8 ml
Color: Translucent brownish colorless
Technique: Blown; tooled; worked on the pontil
Description: This miniature bottle has a domed
body, a flat base, and a flared neck.
Condition: The object is intact except for a chip at
the opening. The surface is partially
weathered, resulting in milky white and
reddish brown coatings. The glass
includes scattered small bubbles.

Cat. 3.6a BOTTLE (LNS 18 G)
**Probably Iranian or
Mesopotamian region
9th–10th century**

Dimensions: hgt. 6.0 cm; w. 1.9 cm; l. 1.9 cm;
th. 0.29 cm; wt. 18.1 g; cap. 8 ml
Color: Translucent brownish colorless
Technique: Blown; tooled; worked on the pontil
Description: This bottle has an irregular square
body, a flat base, an angular shoulder,
and a cylindrical neck.
Condition: The object is intact. The surface is
partially weathered, resulting in a milky
white film and gray pitting. The glass
includes scattered small bubbles.

Cat. 3.6b BOTTLE (LNS 26 G)
**Probably Iranian or
Mesopotamian region
9th–10th century**

Dimensions: hgt. 4.8 cm; w. 1.6 cm; l. 1.6 cm;
th. 0.24 cm; wt. 16.9 g; cap. 3 ml
Color: Translucent grayish colorless
Technique: Blown; tooled; worked on the pontil
Description: This bottle has an irregular square
body, a flat base, an angular shoulder,
and a cylindrical neck.
Condition: The object is intact except for a chip at
the opening. The surface is lightly
weathered, resulting in a milky white
film, especially on the interior. The
glass includes frequent small bubbles.

Cat. 3.7a BOTTLE (LNS 325 G)
**Probably Egyptian
or Syrian region
9th–10th century**

Dimensions: hgt. 12.0 cm; max. diam. 2.7 cm;
th. 0.30 cm; wt. 37.1 g; cap. 26 ml
Color: Translucent dark olive green (green 4)
Technique: Blown; tooled
Description: This flared, four-sided bottle has a
square base, a curved shoulder, and a
flared neck with an irregular opening.
Condition: The object is intact. The surface is
partially weathered, resulting in a pale
brown coating. An amber-colored
substance was found inside the vessel.[19]
The glass includes scattered small
bubbles, one large elongated bubble,
and a black inclusion on the neck.
Provenance: Reportedly from Mharda, Syria

Cat. 3.7b BOTTLE (LNS 261 G)
**Probably Egyptian
or Syrian region
9th–10th century**

Dimensions: hgt. 6.5 cm; max. diam. 2.6 cm;
th. 0.17 cm; wt. 15.7 g; cap. 7 ml
Color: Translucent yellow (yellow/brown 1)
Technique: Blown; tooled; worked on the pontil
Description: This flared four-sided bottle has a
square, thick base, a curved shoulder,
and a flared neck.
Condition: The neck of the object is broken,
leaving only part of the rim; the
remainder of the body is intact.
The surface is lightly weathered,
resulting in a milky white film.
The glass includes frequent bubbles,
some of them large.
Provenance: Kofler collection; gift to the Collection

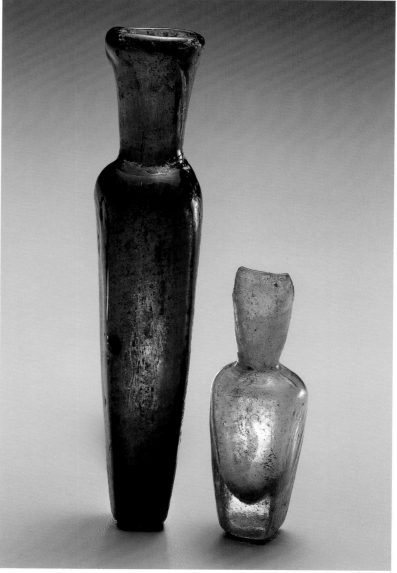

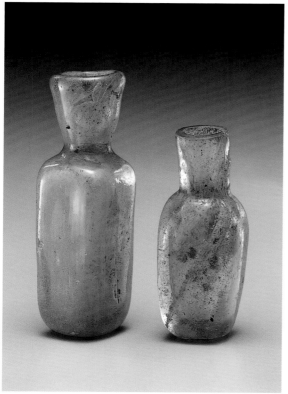

Cat. 3.6a, b

Cat. 3.7a, b

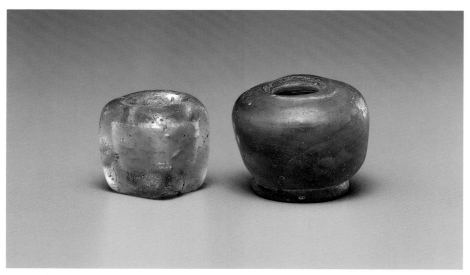

Cat. 3.8a, b

### Cat. 3.8a MINIATURE JAR
### (LNS 177 G)
### Probably Iranian region
### 9th–10th century

Dimensions: hgt. 1.8 cm; w. 1.6 cm; l. 1.6 cm;
　　　　　　wt. 7.6 g; cap. 1 ml
　　　Color: Translucent grayish yellowish colorless
Technique: Blown; tooled; worked on the pontil
Description: This nearly cubic jar has a small
　　　　　　off-center circular opening at the top
　　　　　　(diam. 0.8 cm).
Condition: The object is intact except for a chip
　　　　　　at the base. The surface is partially
　　　　　　weathered, resulting in a whitish film,
　　　　　　iridescence, and abrasion. The glass
　　　　　　includes frequent small bubbles and
　　　　　　one large bubble.
Provenance: Reportedly from Mazar-i Sharif
　　　　　　(Balkh), Afghanistan

### Cat. 3.8b MINIATURE JAR
### (LNS 176 G)
### Probably Iranian region
### 9th–10th century

Dimensions: hgt. 2.0 cm; max. diam. 2.5 cm;
　　　　　　wt. 15.2 g; cap. 2 ml
　　　Color: Translucent greenish colorless
Technique: Blown; tooled; worked on the pontil
Description: This miniature jar has an irregular
　　　　　　curved body and a small circular
　　　　　　opening at the top (diam. 0.9 cm).
Condition: The object is intact. The surface
　　　　　　is lightly weathered, resulting in a
　　　　　　milky white film. The glass includes
　　　　　　scattered small bubbles.
Provenance: Reportedly from Mazar-i Sharif
　　　　　　(Balkh), Afghanistan

### Cat. 3.9a BOWL (LNS 74 G)
### Iranian or Mesopotamian region
### 9th–10th century

Dimensions: hgt. 3.8 cm; max. diam. 12.2 cm;
　　　　　　th. 0.45 cm; wt. 205.6 g; cap. ca. 350 ml
　　　Color: Translucent brownish colorless
Technique: Blown; tooled; worked on the pontil
Description: This low, heavy cylindrical bowl has a
　　　　　　slightly wavy base with a protruding
　　　　　　pontil mark and an irregular rim.
Condition: The object was broken and repaired;
　　　　　　one small fill is present near the rim.
　　　　　　The surface is weathered, resulting in
　　　　　　heavy golden iridescence. The glass
　　　　　　includes frequent small bubbles.

### Cat. 3.9b, c TWO FRAGMENTS OF
### A BOWL (LNS 189 Ga, b)
### Iranian or Mesopotamian region
### 9th–10th century

Dimensions b (larger fragment): hgt. 4.0 cm;
　　　　　　w. 2.9 cm; l. 3.1 cm; th. 0.21 cm
　　　Color: Translucent pale green (green 2)
Technique: Blown; tooled
Description: These two fragments, probably from
　　　　　　the same bowl, are from the rim and
　　　　　　base (b) and from the wall (c) of a low
　　　　　　cylindrical bowl similar to cat. 3.8a.
Condition: The surface of both fragments is
　　　　　　weathered, resulting in iridescence and
　　　　　　abrasion. The glass includes frequent
　　　　　　small bubbles.
Provenance: Kofler collection; gift to the Collection

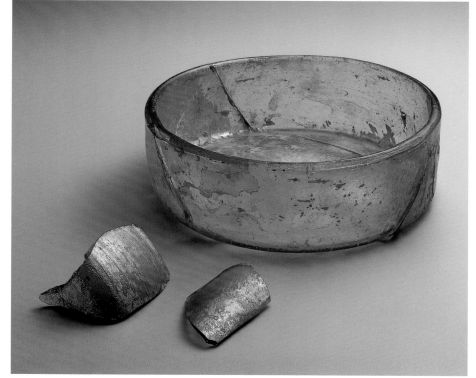

Cat. 3.9a–c

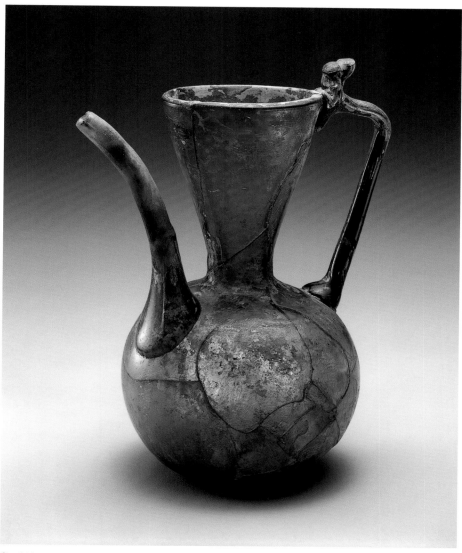

Cat. 3.10

Cat. 3.11

### Cat. 3.10 EWER (LNS 91 G)
**Iranian or Mesopotamian region**
**9th–10th century**

Dimensions: hgt. 13.5 cm; max. diam. 7.5 cm;
th. 0.29 cm; wt. 113.2 g; cap. 230 ml
Color: Translucent green (green 3)
Technique: Blown; tooled; applied; worked on
the pontil
Description: This globular ewer has a small flat base
and a long flared neck. A slightly
curved, long pouring pipe was applied
at the shoulder; set almost vertically,
it reaches the height of the opening.
Opposite the spout, an L-shaped handle
with an irregular folded thumb rest was
applied from the shoulder to the rim.
Condition: The object was broken and repaired,
and there are fills on the pipe and the
thumb rest. The surface is partially
weathered, resulting in a milky white
film. The glass includes scattered small
bubbles.

### Cat. 3.11 MINIATURE EWER (LNS 23 KG)
**Probably Iranian region**
**9th–10th century**

Dimensions: hgt. 4.7 cm; max. diam. 2.6 cm;
th. 0.26 cm; wt. 15.7 g; cap. 9 ml
Color: Translucent yellowish colorless
Technique: Blown; tooled; applied; pincered;
worked on the pontil
Description: This miniature pear-shaped ewer has a
flat base, and a heart-shaped opening
with a thickened rim. An L-shaped
handle was applied at the center of
the body and the rim.
Condition: The object is intact. The surface is
partially weathered, resulting in
iridescence and heavy abrasion. The
glass includes frequent small bubbles.
Provenance: Kofler collection
Literature: Lucerne 1981, no. 578

### Cat. 3.13 EWER (LNS 166 G)
### Probably Iranian region
### 9th–11th century

Dimensions: hgt. 11.0 cm; max. diam. 6.0 cm;
wt. 94.3 g; cap. 82 ml
Color: Translucent dark emerald green (green 5)
Technique: Blown; tooled; pincered;
worked on the pontil
Description: This flattened globular ewer has a
angular shoulder and a low tapered
foot created by folding the glass inward.
The long tapered neck ends in a heart-
shaped opening with a long upward
spout whose rim was pincered several
times. Two flattened protrusions were
created at the sides of the spout.
Condition: The object is intact except for the
missing handle (its attachment is visible
at the rim). The surface is heavily
weathered, resulting in a pale brown
coating and iridescence. Green paint was
clumsily applied to the surface before
the object entered the Collection. The
glass includes frequent small bubbles.
Provenance: Reportedly from Maimana (Faryab),
Afghanistan

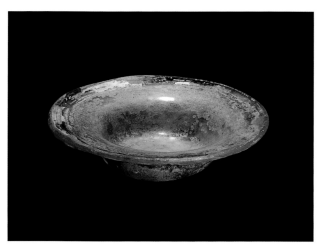

Cat. 3.12

### Cat. 3.12 MINIATURE BOWL (LNS 81 KG)
### Possibly Iranian region
### 9th–10th century

Dimensions: hgt. 1.5 cm; max. diam. 6.1 cm;
th. 0.17 cm; wt. 17.0 g; cap. 10 ml
Color: Translucent yellowish colorless
Technique: Blown; tooled; worked on the pontil
Description: This miniature bowl has a cylindrical
base, a large splayed opening, and an
unevenly thickened rim.
Condition: The object is intact. The surface is
entirely weathered, resulting in a brown
coating and iridescence. The glass
includes frequent small bubbles.
Provenance: Kofler collection

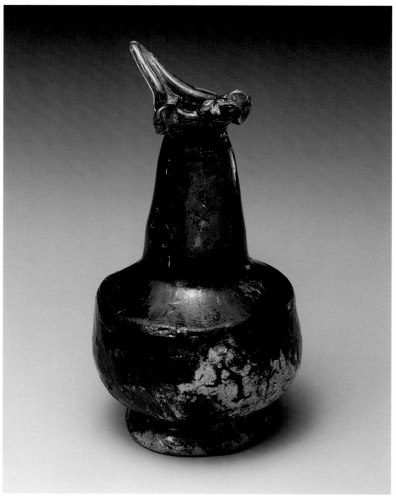

Cat. 3.13

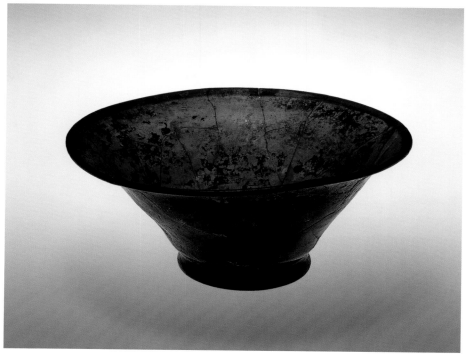

**Cat. 3.14 MORTAR (LNS 136 G)**
**Iranian or Central Asian region**
**11th–12th century**

Dimensions: hgt. 9.5 cm; max. diam. 12.3 cm;
            th. 0.70 cm; wt. ca. 750 g; cap. ca. 450 ml
Color: Translucent blackish green (green 6)[40]
Technique: Blown; tooled; worked on the pontil
Description: This mortar has a cylindrical, slightly
            bulging profile, and an everted rim and
            base that protrude horizontally about
            1 cm. The base is flat and slightly
            kicked in the center, where a large
            pontil mark is visible.
Condition: The object was shattered into many
            pieces. After reassemblage, it is almost
            complete; only part of the body and
            some minute fragments have been lost.
            The surface is lightly weathered,
            resulting in a milky white film.

Cat. 3.15

**Cat. 3.15 BOWL (LNS 101 G)**
**Probably Iranian region**
**11th–12th century**

Dimensions: hgt. 6.8 cm; max. diam. 16.5 cm;
            th. 0.16 cm; wt. 126.0 g; cap. ca. 600 ml
Color: Translucent dark purple (purple 3)
Technique: Blown; tooled; worked on the pontil
Description: This bowl has a flared and curved
            profile and stands on a low tapered foot
            that was created by inward folding. The
            rim at the opening is folded outward.
Condition: The object was broken and repaired;
            there are a few small fills and one larger
            fill. The surface is heavily weathered,
            resulting in a milky white film and
            iridescence. The glass includes scattered
            small bubbles.
Related Work: Cat. 45

Cat. 3.14

Cat. 3.16

## Cat. 3.16 FRAGMENTARY NECK OF A *QUMQUM* (PERFUME SPRINKLER) (LNS 161 KG)
### Syrian or Egyptian region
### 12th–13th century

Dimensions: hgt. 4.3 cm; max. diam. 1.2 cm; th. 0.20 cm
Color: Translucent yellowish colorless
Technique: Blown; tooled; worked on the pontil
Description: This fragment represents the upper part of the tapering neck of a *qumqum*, ending in a narrow opening.
Condition: The surface is heavily weathered, resulting in milky white and pale brown coatings. The glass includes frequent elongated small bubbles.
Provenance: Kofler collection
Related Work: Cat. 37

## Cat. 3.17 GOBLET (LNS 86 G)[41]
### Syrian or European region
### 12th–13th century

Dimensions: hgt. 12.7 cm; max. diam. 6.9 cm; th. 0.15 cm; wt. 74.2 g; cap. 134 ml
Color: Translucent yellowish greenish colorless
Technique: Blown; tooled; worked on the pontil
Description: This goblet has a conical flared cup ending in a plain rim at the opening, a knob at the top, a slightly tapered stem, and a flat circular base with a pontil mark. A solid stem was attached to the bottom of the cup.
Condition: The object was broken and repaired; it is nearly complete except for a fill on the cup. The surface is weathered, resulting in heavy iridescence and corrosion. The glass includes scattered small bubbles.
Composition: $Na_2O$: 15.2; $MgO$: 5.4; $Al_2O_3$: 0.7; $SiO_2$: 68.0; $SO_3$: 0.3; $Cl$: 0.5; $K_2O$: 3.4; $CaO$: 5.0; $MnO$: 0.5; $Fe_2O_3$: 0.4

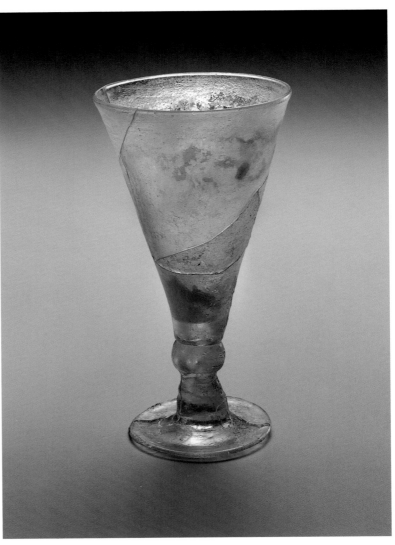

Cat. 3.17

# NOTES

1  Both quotations are in Baer 1983, p. 67.

2  It should not be forgotten that only a fraction of the population was literate in the medieval period and that the number of copyists and calligraphers was limited.

3  A number of small bottles excavated at Samarra were used as inkwells, since they apparently contained traces of ink; see Lamm 1928, no. 74, pl. 19:2.

4  See Allan (1982, p. 44), quoting the treatise on writing by the Zirid prince Ibn Bādīs (1007–61) translated in Levey 1962, esp. pp. 15–26.

5  See Levey 1962, pp. 6–7; and Allan 1982, p. 44.

6  Lamm 1935, pl. 14k. The object was found in Rayy and described as a lamp (see Related Work 3).

7  See Baer 1983, pp. 67–68; and Kröger 1995, p. 176.

8  For example, a square inkwell in the Museum für Islamische Kunst, Berlin (inv. no. I.4029; see Kröger 1984, no. 90).

9  See SPA, pl. 1439g; and Gudiol Ricart–de Artiñano 1935, no. 110.

10  On loan at the Arthur M. Sackler Gallery, Washington, D.C., from the Gellatly collection, inv. no. LTS 1985.1.147.14.

11  See Allan 1982, p. 44. Baer (1983, p. 67) wrote that "in accordance with traditional religious relationships between the art of writing . . . and the tools used for writing, various Islamic writers prohibited the use of inkwells and pen-boxes made of precious metals. They recommended wood, glass, and faience." She notes that glass vessels were widely used because "neither dirt nor powder can accumulate" and they "can easily be cleaned."

12  Kröger 1995, no. 231.

13  An inkwell of this type was found in Rayy (see note 6); cat. 33a is reported to have been found near Mazar-i Sharif; Related Work 10 was acquired in Tehran; Related Work 11, which includes two inkwells set next to each other in a rectangular plaster holder, was found in Samarqand.

14  The material was identified as quartz, calcite, muscovite, and clinochlore, which are clay minerals or soil deposits. No analytical indication of the presence of carbon was found. It cannot, therefore, be confirmed that the black material is ink.

15  See, for example, the pieces excavated in Tunisia (Ajab 1971–72, fig. 104) and at Afrasiyab (Abdullaev et al. 1991, no. 642).

16  For instance, those found at Nishapur (see Related Works 6, 7), Gurgan (see Related Work 7; and Kordmahini 1988, figs. 49, 50, 54), Rayy (see Related Work 8; and Lamm 1935, pls. 15a–d, i), and Susa (Kervran 1984, figs. 7:20, 9:5).

17  One of the best preserved is Related Work 1.

18  The majority of scholars identify these vessels as cupping glasses (see, for example, 'Abd al-Khaliq 1976, figs. 56, 57; Kordmahini 1984, figs. 49, 50, 54; and Hasson 1979, fig. 1). Some have used the term ventouse ("suction cup"; see Kervran 1984, fig. 9:5), and in one case a vessel of this type was described as an "infant feeder" (Oliver Jr. 1980, no. 246; see Related Work 9).

19  Lamm 1935, pl. 15; and Clairmont 1977, nos. 386, 387.

20  Kröger 1995, p. 186.

21  Al-Hassan–Hill 1986, pp. 135–46.

22  The set in the Science Museum is composed of four elements (with two recipients instead of one); the set in Damascus consists of three elements.

23  Maddison–Savage-Smith 1997, p. 52 n. 2.

24  See, for instance, Auth 1976, no. 248.

25  The author is especially grateful to Abdallah Ghouchani for his many useful comments on this subject.

26  A well-known miniature painting illustrating a physician's shop in a busy market from a thirteenth-century copy of al-Harīrī's Maqāmāt (Oriental Institute, St. Petersburg, inv. no. C-23, fol. 165r) shows one of these cupping glasses on the patient's back; two more cups, with their pipes clearly portrayed, sit on a shelf above the two figures (see Hasson 1979, fig. 2; and New York 1995, no. 18, pl. p. 155).

27  For North Africa, see Marçais–Poinssot 1952, pls. 55–60; Golvin 1965, fig. 98; Smith 1957, figs. a, b; and Sakurai–Kawatoko 1992, p. 613, fig. 12. The reference to Sidi Khrebish is from Derek Kennet, to whom the author is grateful. For Serçe Limanı, see Bass 1996, pl. p. 44.

28  See, for example, JGS 1986, p. 118, fig. 3; and Bass 1996, pl. p. 45.

29  See, for example, cat. 56. See also Tokyo 1979, no. 223; Kröger 1984, no. 11; Bass 1984, figs. 2e, f; and Paris 1992, no. 320.

30  For another object found in the same tomb, see cat. 40.

31  An 1991, p. 130 n. 15, citing Chaoyang 1983.

32  Clairmont 1977, p. 73, no. 241.

33  Hoare 1985, p. 163, no. 143.

34  A similar vessel was also excavated at Sadvar in Khwarazm (Armarchuk 1988, pl. 5, no. 9).

35  A good example is presently in the Archaeological Institute of the Academy of Sciences, Samarqand, Uzbekistan (Abdullaev et al. 1991, vol. 2, p. 193, no. 744).

36  Omom is a transliteration of the colloquial Egyptian pronounciation. The word qumqum or qumquma (pl. qamāqim) appears in dictionaries of classical medieval Arabic, such as those compiled by Ibn Manẓūr and Lane. Originally, the qumqum seems to have been a copper vessel with a narrow opening that was used to heat or boil water. A verse from a sixth-century mu'allaqa by the poet 'Antara compares the blackish sweat that runs down the camel's neck to the liquid flowing from a qumqum placed over a fire. Later, the qumqum became a small metal, ceramic, or glass vessel with a long narrow neck that was used for rosewater and sometimes provided with loop handles to be attached to a traveler's belt. Wehr (1976, p. 790) describes it as "a bulgy, long-necked bottle," from the verb qamqama, taqamqama or ghamghama, meaning "to complain, grumble, mutter." Perhaps the word qumqum was derived from the sound of the water bubbling over the fire. See Ibn Manẓūr, vol. 13, p. 495; Lane 1863–85, suppl. vol. 2, p. 2993; and Ibn 'Alī al-Tabrīzī, pp. 229–30. The author is grateful to Laila al-Mossawi for her help in this matter.

37  Riis–Poulsen 1957, p. 44, fig. 98; and Meyer 1992, pl. 18, no. 474.

38  Although it is difficult to date glass of this type, it seems to have been produced in the early and medieval Islamic periods in the Syrian area. In the case of these fragments, an early dating is supported by the heart-shaped opening of the ewer's neck (cat. 3.3f), which was common from the eighth century to at least the tenth. In addition, the combination of a red layer over a blue is reminiscent of the similar taste for color contrasts that is evident in stained-glass products (see especially cat. 2.3p that may represent a fragment of the rim of the same vessel as cat. 3.3c–e). Numerous fragments and almost complete vessels have surfaced from excavations in Jerusalem; they are presently in the L. A. Mayer Memorial, Jerusalem, and in the Eretz Museum, Tel Aviv.

39  The substance was identified by the laboratory of the Conservation and Technical Services Limited, Birkbeck College, London, as jarosite—potassium iron sulphate hydroxide, or $KFe_3(SO_4)_2OH_6$. According to the report, jarosite, also called misy, is a fairly rare soft mineral (a member of the alunite group), so-called by Breithaupt in 1852 after it was found in the Jaroso ravine in the Sierra Almagrera, Spain. Jarosite was used as a pigment in antiquity: it has been reported in wall paintings from Thera, in Minoan Crete (ca. 1500 B.C.); in a number of Egyptian tombs of different periods, from Karnak, Saqqara, and Roman Egypt; and on a Greek marble basin of the fourth century B.C. (see Noll et al. 1975, pp. 87–94; El Goresy et al. 1986, pp. 39–41; Le Fur 1994, p. 45; and Wallert 1995). The use of jarosite in the Islamic period is probably reported here for the first time. Stored in the present bottle, the pigment was probably lost in transit on its way to a locality in the eastern Mediterranean area where it would have been used as a wall painting pigment.

40  The thickness of this object, combined with its dark green color, make it appear almost opaque brown black. Mortars with everted rims seem to be more common than those with a straight opening, especially in bronze or brass, in the Iranian region. The examples closest in shape and proportions (so-called bucket-shaped) have recently been attributed to Transoxiana, late twelfth to thirteenth century (see Maddison–Savage-Smith 1997, nos. 191, 193).

41  Goblets were common in Islamic glass production from the mid-ninth century onward (for an example from Samarra, see Lamm 1928, pl. 2:28). Their cups are usually deep and are either slightly curved and flared or conical (for examples of both types, see Lamm 1929–30, pl. 4:11; and Kröger 1984, no. 16). When knobbed, as in the present case, the stem is usually blown rather than solid, while the most common type of solid stem is cylindrical with pinched indentations that subdivide it into regular horizontal sections (for a fragmentary goblet excavated at Siraf, see Whitehouse 1968, pl. 7a). Knobbed goblets with a conical or trumpet-shaped cup became widespread in Europe from the fifteenth century onward (see Frothingham 1963, pl. 2a). The composition reveals a much lower amount of sodium and somewhat less calcium than expected. The present vessel, which seems to be of medieval date, may be a European product or, perhaps, a Near Eastern object made for the Crusaders in the Syrian area.

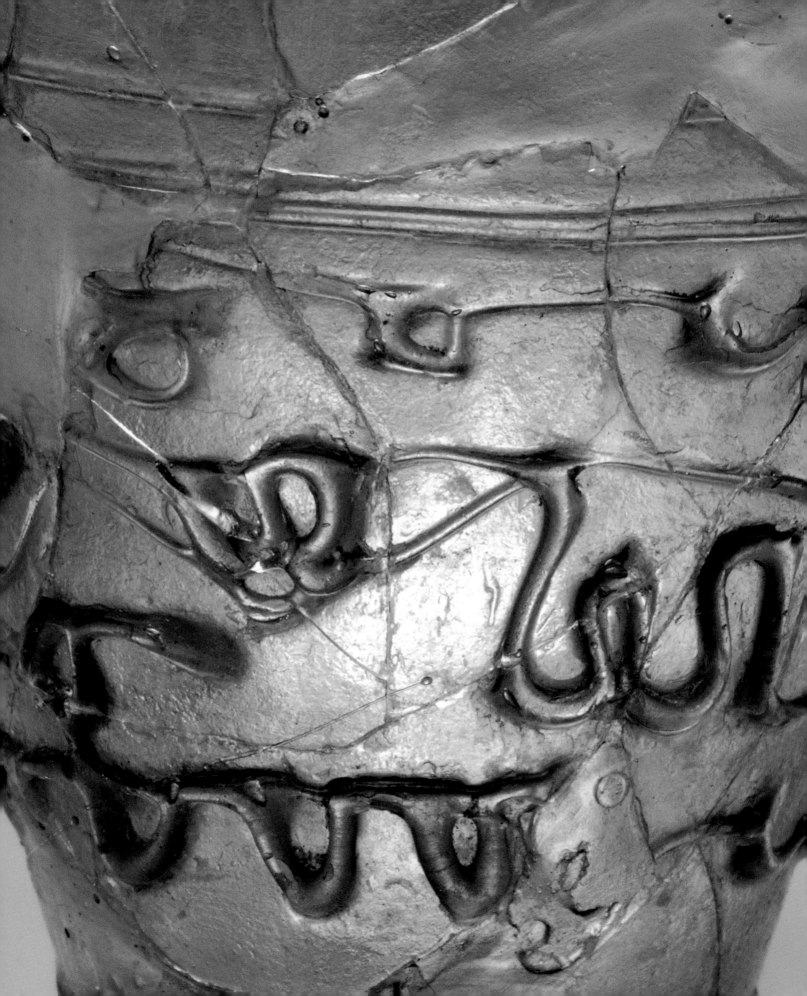

# GLASS WITH APPLIED DECORATION

CHAPTER 1 COVERS the continuity of both shapes and decorative techniques in the late Roman and early Islamic periods. Characteristic among these techniques was the surface application of glass discs and trails that were manipulated with various tools to create ornamental patterns. The applied glass was either of the same color as the vessel or a contrasting one intended to enhance the overall decorative effect. The production of these early Islamic (or, as suggested, proto-Islamic) objects was limited to areas that were once part of the Roman and Byzantine Empires, including Egypt, Syria, and Mesopotamia.

After the mid-ninth century, shapes became entirely Islamic yet the patterns created with decorative applied trails remained unchanged, spreading eastward to include the Iranian region. Simple motifs, such as snaky, wavy, and zigzag trails, survived and were disseminated throughout the glass-producing Islamic world. Applied discs fell out of fashion and gradually disappeared.

An abstract quality in the patterning of threads seems to represent the main contribution of Iranian glassmakers. The pitcher (cat. 40) and the fragmentary beaker (cat. 42) are good examples: in addition to rows of plain medallions or prunts on its neck, the main decoration of cat. 40 includes freely trailed figures resembling curls, while the ornamentation of cat. 42 is so abstract that it can be explained only as pseudocalligraphy copied from contemporaneous works in pottery.

Another innovative element derived from Iranian production is the transformation of functional elements, such as handles and suspension rings, into essential aspects of the decoration. In the case of the pitcher (cat. 40), the openwork handle is also a chainlike decorative feature. The snakelike threads applied over the suspension rings of the hanging lamp (cat. 38a) are another example of ornamental motifs applied to functional elements, in order to enhance the object's appearance.

Syrian glassmakers remained inclined to preserve traditional patterns (particularly zigzags and spiraling threads) and rarely experimented with new ornamental motifs. The major change in Syrian production was the gradual disappearance of plain or stamped medallions and their replacement, during the Ayyubid period, by small prunts that would stand in higher relief than the flat medallions. The beaker (cat. 47) shows a combination of zigzag trails and small prunts used to create an ornamental pattern in two colors. Small prunts became increasingly popular in Syria and often turned into tiny dots that would fill the entire central band of a beaker, especially after enameling gained popularity (see cat. 85d, 87). Prunted beakers were produced and became widespread in Europe at the same time or slightly later. Both the shapes of the beakers and the size of the prunts, however, indicate that there was no reciprocal influence.[1]

Another decorative element that appears on Syrian objects in the Collection is a rather thick trail, tooled into a wavy pattern, that was usually applied to the neck of a bottle or jug. This element was often the only ornament applied on the glass surface; in its simplicity, it transformed a plain object into a sophisticated, decorative vessel (see cat. 44b, c).

The use of applied glass was also conducive to the continuation of the traditional production of zoomorphic shapes (see cat. 4). In this early period, animal shapes were tooled from blown glass, while details, such as legs, mouth, ears, and tail, were applied in the same, or in a different, color (see cat. 3.20).

It remains difficult to provide a clear picture of the history of applied-glass production from the ninth through the twelfth century. Vessel shapes, however, are helpful in proposing a time and place of manufacture with some degree of accuracy. A typical example is provided by the ewer (cat. 43a): its contrasting zigzag pattern finds close parallels in seventh- or eighth-century objects

(for example, cat. 1, 1.6–1.8), but the vessel itself—that is, a large pear-shaped ewer—is distinct from earlier examples and accords well with an eleventh- or twelfth-century Iranian attribution.

Another shape that appears related to medieval—rather than the earlier, late antique—production is the hanging lamp (cat. 38a–c). This object, which is basically a vase with a large neck and a low foot, was decorated with applied snaky threads that also functioned as suspension rings. Its profile developed over four centuries from a rather squat, angular shape, such as the lamp (cat. 38a) of the eighth or ninth century, to an almost globular body with a flaring neck and foot in the thirteenth century; see, for example, the enameled mosque lamp (cat. 99).

The dissemination of objects in different media, produced in various areas of the Islamic world, played an important role in the creation of new, entirely "Islamicized" shapes in glass. While metalwork might have been the driving force behind this dissemination, it should not be taken for granted that all ceramic and glass shapes that are common to metalwork were produced in imitation of it. The common sequence of metal-to-ceramic-to-glass or metal-to-ceramic-and-glass was probably reversed, or mixed, in some cases, though current knowledge does not permit a fuller explanation.

Judging from the examples in the al-Sabah Collection, it is possible to conclude that Iranian glassmakers, who had adopted the applied technique from their western Islamic counterparts, became the masters in this particular field of glass production, at least as far as quality was concerned. This achievement is hardly surprising since, as was demonstrated in the discussion on cut glass in Chapter 2, production in Iran was revitalized in the ninth and tenth centuries, while Egyptian and Syrian glassmakers seem to have become increasingly less imaginative and resourceful during the same period. This conclusion disputes what has been implied thus far in the literature—that is, that applied glass was characteristic of the Syrian or Egyptian area, whereas Iranian glassmakers were the leaders only in the production of relief-cut, engraved and incised products.[2] Consequently, the equations "applied glass = Syria" and "cut glass = Iran" represent a simplification for classification purposes, since the subject is more complex than has thus far been postulated. One explanation for the Iranian glass revival must be the large number of western Islamic products that were exported from Syria and Mesopotamia to Iran and farther east in the ninth century, which prompted imitations and a new interest in the medium. Iranian leadership in glass production, including objects with applied decoration, lasted until the late twelfth century, when the rediscovery of the enameling technique once again propelled Syrian and Egyptian glassmakers to popularity, relegating their Iranian colleagues to a secondary position.

**Cat. 38a FRAGMENTARY HANGING LAMP (LNS 50 KG)**
Iranian region
8th–early 9th century

Dimensions: hgt. 14.0 cm; max. diam. 7.0 cm;
th. 0.30 cm; wt. 194.1 g; cap. ca. 350 ml
Color: Translucent yellow (yellow/brown 1)
Technique: Free blown; tooled; applied;
worked on the pontil
Description: This vase-shaped object has a short
shoulder, a large cylindrical neck,
and a low foot created by tooling.
A cylindrical tube (l. ca. 6.0 cm) was
attached at the bottom. Six handles
were applied from the rim to the
shoulder at regular intervals. Six
suspension rings applied over the
handles project from the base of the
object, forming large loops above the
rim and folding above each handle;
their lower section, from the base to the
shoulder, is tooled to create a snakelike
pattern. Six smaller suspension rings
alternate with the larger ones; they end
in a smaller loop at the shoulder and
are also tooled in a snakelike pattern.
Condition: The object was broken and repaired
and parts are missing. One larger
suspension ring and part of a second
one are intact; the remainder of the
upper part represents a fill. The body is
repaired but complete. The surface is
partially weathered, resulting in a milky
white coating and golden iridescence.
The glass includes frequent small
bubbles.
Provenance: Kofler collection
Literature: Lucerne 1981, no. 526
Related Works: 1. MM, inv. no. G83 (Ohm 1975,
no. 148; and Hasson 1979, no. 8)
2. MAIP, inv. no. 21929
(Kordmahini 1988, p. 74, pl. 117;
and Vienna 2000, no. 177)
3. Whereabouts unknown
(Hoare 1985, p. 161, no. 139)

Glass lighting apparatus in the early Islamic period usually consisted of a container in the shape of a vase or large beaker with a tube attached at the bottom.[3] The tube functioned as a narrow container for the wick; the vase was filled with oil and water and served as the lampshade. These lamps were freestanding, as they were always provided with a circular foot. However, a varying number of suspension rings were applied to the exterior surface of the lampshades, so that metal chains could be passed through to allow their use both as stationary hanging lamps and portable lighting devices. These objects are commonly known as "mosque lamps," but this term can be safely applied only to the enameled lanterns from Mamluk mosques in Cairo, which often include Qur'anic inscriptions (see cat. 99, 100). All extant lamps made before the thirteenth century—that is, before the increasing popularity of enameling on glass—are not inscribed and offer no clue as to whether they were intended for religious or secular use. If any distinction were made, we may assume that it was related to size, elaboration of the decoration, or the different number of suspension rings, but neither the surviving lamps nor the literary sources help to clarify this issue.

Before the hanging lamp assumed its final shape as a large, nearly globular vase with a flaring neck and a tall applied foot, it underwent changes in size, shape, and decoration. It seems to have grown in size over time and to have changed from the elongated, but often stocky, profile of a beaker or vase into a globular vessel. The beaker shape is related to Byzantine prototypes and was common in the Syro-Palestinian area before Islam;[4] the vase shape is probably an early version of the globular profile that eventually migrated westward from the Iranian area.

Three surviving lamps are virtually identical to cat. 38a (Related Works 1–3). Their height (16.5 cm,[5] 14.0 cm, and 18.0 cm, respectively), profile, and the six larger snake-patterned suspension rings alternating with six smaller ones make them almost perfect matches. Slight differences are visible in the presence of suspension loops around the base (Related Works 1, 2), in the use of a contrasting blue color for all twelve applied suspension rings (Related Work 2), and in the absence of the six smaller suspension rings (Related Work 3). The lamp in Jerusalem (Related Work 1) is said to have been found in Nishapur; the object in Tehran (Related Work 2) is labeled a "Gurgan" piece.[6] A fourth comparable lamp is also in Tehran: attributed to Gurgan, its vase has a flared, almost conical profile and applied snakelike threads decorate its suspension rings.[7] Another related object is in Liège: it shows the same snakelike threads applied around the curved vase, but its base is different, being formed by a large flattened globular lump that allows the lamp to stand; this lamp is said to have been found at Manisa, in Turkey, and is thus the only object in the group that does not have a reputed Iranian provenance.[8]

If the suggested chronology is correct and stylistic differences are related to the time, rather than the place, of production, snakelike trails were slowly replaced by simple oval medallions provided with suspension loops in the same or a different color applied around the lamp's body. An object in the British Museum seems to provide the ideal bridge between the two types of suspension rings: its height (14.2 cm) and profile are close to the type exemplified by cat. 38a, but here three snakelike threads alternate with three oval medallions.[9] With regard to shape, small globular lanterns of similar size (ca. 13–17 cm) would become widespread from Iran westward, either hanging from snakelike[10] or medallion-shaped loops, the latter becoming the rule after the tenth century. A fragmentary lantern of nearly globular shape has been found at Samarra, and thus can be dated to the mid-ninth century. It has plain elongated loops and may provide the missing link between the two types.[11]

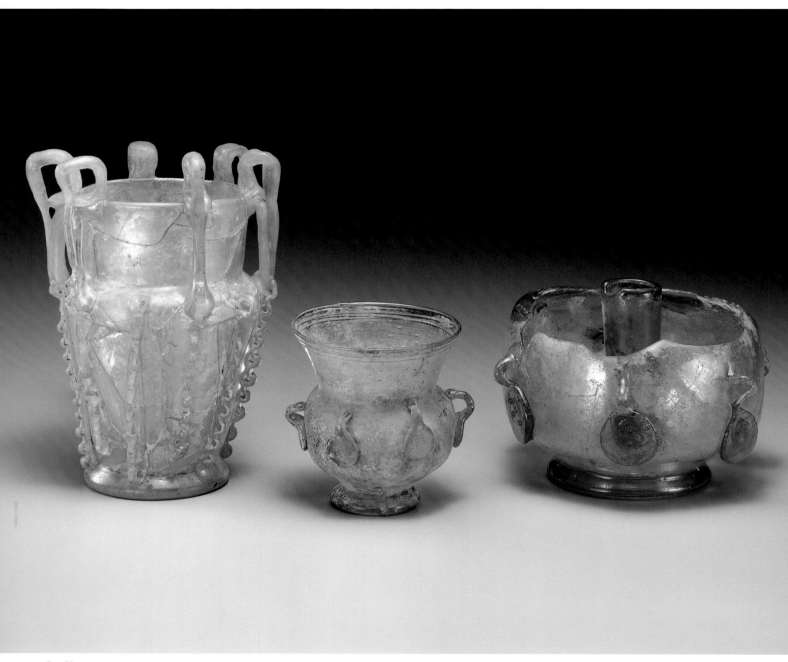

Cat. 38a–c

### Cat. 38b HANGING LAMP (LNS 400 G)
**Syrian or Iranian region**
**11th century**

Dimensions: hgt. 7.7 cm; max. diam. 6.8 cm; th. 0.19 cm; wt. 57.0 g; cap. 144 ml

Color: Translucent grayish colorless and pale blue (blue 1)

Technique: Free blown; tooled; applied; worked on the pontil

Description: This nearly globular vase-shaped object has a large flared neck (wider than the body) and a low foot created by tooling. A cylindrical tube (diam. 1.5 cm; l. ca. 5 cm) was applied at the bottom of the vase. Six suspension rings of the same color as the vessel, each in the shape of a flat disc and a looping trail, were attached on the body and shoulder at regular intervals and at uneven heights. A thin, pale blue thread is applied around and below the rim in a spiraling pattern. A drop of blue glass was mixed with the grayish batch on the foot, so that the base appears as if it were deliberately composed of two colors.

Condition: The object is intact except for small cracks. The surface is heavily weathered, resulting in a coating of pale brown soil and a milky white film. The glass includes frequent tiny bubbles and some larger ones.

Provenance: Reportedly from Qala-i naw (Badghis), Afghanistan, found in a jar together with cat. 41, 46b, and 3.21

Related Works: 4. MMA, inv. nos. 48.101.59, 64.133.1 (Kröger 1995, no. 235)
5. Whereabouts unknown (Brunswick 1963, no. 76)
6. MUA, inv. no. GW 796 (Morden 1982, fig. 23; and *INA* 24.1, 1997, p. 27)
7. Merbok Museum, Kedah, Malaysia (Lamb 1965, fig. 8)
8. KM, Düsseldorf, inv. no. P1967-11 (Ricke 1989, no. 52)
9. LACMA, inv. no. M.88.129.181 (von Saldern 1980, no. 176)

### Cat. 38c FRAGMENTARY HANGING LAMP (LNS 1376 G)
**Syrian region**
**12th century**

Dimensions: max. hgt. 7.8 cm; max. diam. 11.0 cm; th. 0.15 cm; wt. 165.2 g

Color: Translucent yellow (yellow/brown 1) and blue (blue 2)

Technique: Free blown; tooled; applied; worked on the pontil

Description: This nearly globular object has a base with a kick and a low applied foot. A cylindrical tube (diam. 2.5 cm; l. ca. 6 cm) was applied at the bottom. Six suspension rings of the same color as the vessel, each in the shape of a flat disc with a rosette in relief and a looping trail, are attached to the body at irregular intervals. Prunts in blue glass are applied in some of the spaces between the suspension rings.

Condition: The object is broken and repaired; the body is almost complete but the upper part and neck are missing. The surface is heavily weathered, resulting in pale brown coating and pitting, silvery iridescence, and abrasion. The glass includes frequent tiny bubbles.

Provenance: Reportedly from Damascus, Syria

The post-tenth-century type, with a globular body, a flared neck, medallion-shaped rings, and an applied tube inside the vessel is exemplified by cat. 38b and c and Related Works 4–9. Related Works 4 (inv. no. 48.101.59), 6, and 7 were found during excavations and have been attributed, respectively, to the tenth or eleventh century, the early eleventh century, and the eleventh to the fourteenth century. The small, well-proportioned, and elegant lamp (cat. 38b) is one of the few intact specimens of this type, which is enhanced by the decorative blue trail around the opening. Its reputed provenance from Afghanistan suggests an eastern Islamic attribution, but its harmonious shape and proportions seem to point to the final, rather than the early, stage of production of this type of lamp, when it had become popular in the Syrian region.

The fragmentary lamp (cat. 38c) is not as accomplished as cat. 38b, but it is of the same type. Its curved profile is less regular, its suspension medallions were applied in a hurry (sometimes at an angle) and at irregular intervals, and the final result is short of artistic. An attribution to the Syrian region, however, is certain, not only because of its provenance but also because of the colored prunts that were applied between the medallions, which are something of a hallmark of Syrian production in the late Fatimid and Ayyubid periods (see cat. 47). It is possible that the neck of this lamp was also similar in shape and decoration to that of cat. 38b. The similarities between cat. 38b and cat. 38c would further support a Syrian origin for both lamps.

**Cat. 39 BOTTLE (LNS 321 G)**
**Eastern Iranian or**
**Central Asian region**
**9th–10th century**

Dimensions: hgt. 14.5 cm; max. diam. 8.0 cm;
th. 0.40 cm; wt. 163.6 g; cap. 250 ml
Color: Translucent dark blue (blue 5)
Technique: Blown; tooled; applied;
worked on the pontil
Description: This nearly spherical bottle has a
straight neck that narrows near the
shoulder then becomes wider midway
and ends in a straight opening. The
tapered applied foot at the base is
1.5 cm high. A simple trail was applied
around the base of the neck and four
prunts (two are missing) were added
at regular intervals where the neck
becomes wider.
Condition: The object was broken and repaired;
it is complete except for two missing
prunts. The surface is heavily
weathered, resulting in white pitting
and abrasion. The glass includes
frequent small bubbles.
Provenance: Christie's, London, sale, April 27, 1995,
lot 255
Related Work: MHC (Kondratieva 1961, fig. 2:2)

The relationship between glass and metal objects is a close one, especially with regard to the eastern Islamic world in the ninth to eleventh century. A large number of solid, almost unbreakable, small flasks and bottles of different shapes (globular, elongated with pointed bases, "molar," and others) were produced in both cast metal and in molded, tooled, and cut glass as containers for oils and essences that were shipped via land or sea, in and beyond the Islamic world.[12]

Thus far, it has been implied that metalworkers established the various typologies that were imitated by glassmakers and ceramists. This was true in most cases, since the metalworking technology that was involved was more complex than glassmaking; metal was also considered a nobler product and was consequently prone to imitations. It should be added, however, that the manufacture of glass was more widespread than that of metal and that its larger circulation may have been more influential than scholars have assumed.

Both in shape and decoration, cat. 39 is clearly related to a group of bronze objects that were produced in Khorasan and farther east, roughly between the eighth and the twelfth century.[13] Although their profiles vary from nearly globular to ovoid and piriform, common features include drop-shaped bosses on the bodies and small protrusions around the apertures.[14] This metal group is well represented, whereas two glass pieces are the only comparable objects known (cat. 39 and Related Work); thus, it may be postulated that, in this particular case, the metal bottles provided the models for the glass ones.

The Related Work is important in suggesting both a date and place of production, since it was excavated at Afrasiyab (Samarqand) in a ninth- or tenth-century context. Other fragments from similar bottles have been given an Iranian provenance.[15] An attribution to the regions of Khorasan and Transoxiana, embracing today eastern Iran, Turkmenistan, Afghanistan, Uzbekistan, and Tajikistan, is therefore certain.

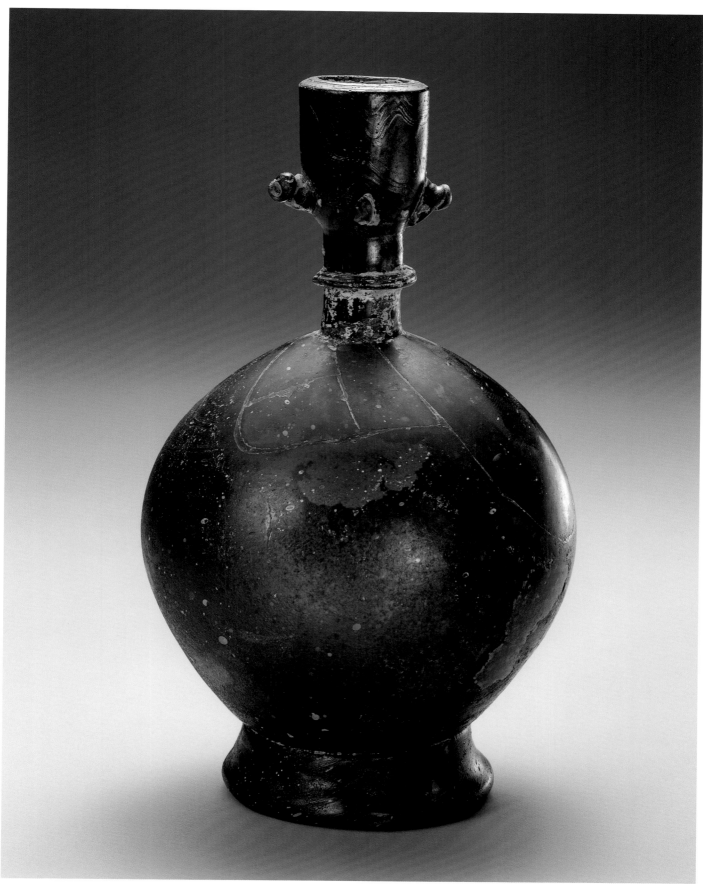

Cat. 39

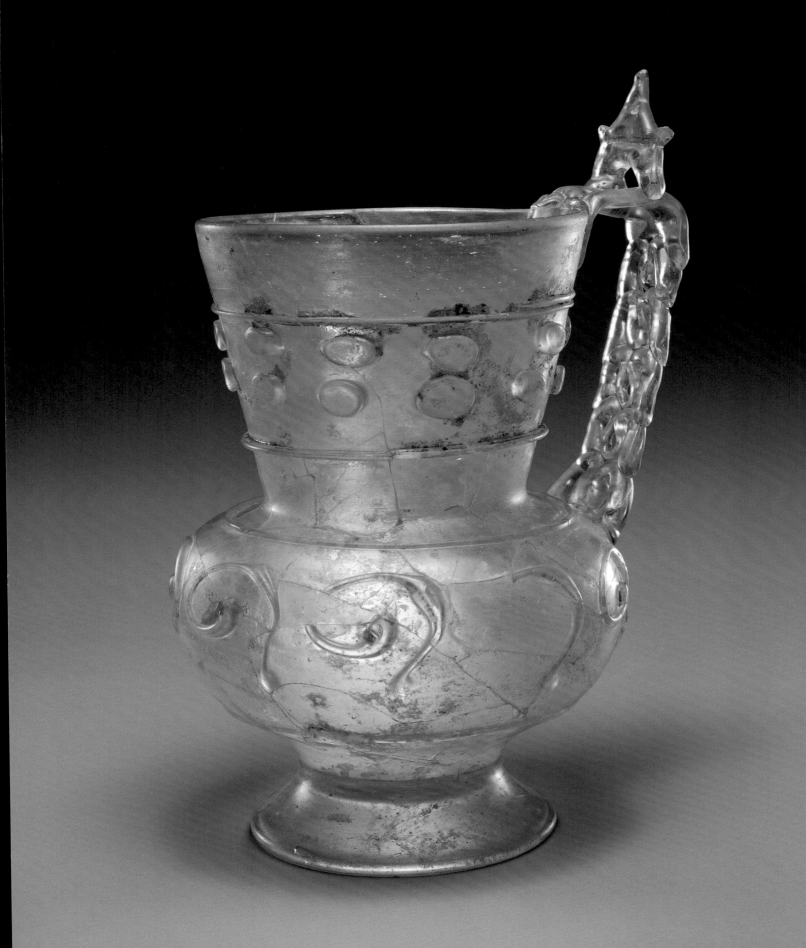

**Cat. 40 PITCHER (LNS 43 G)**
**Iranian region**
**10th–early 11th century**

Dimensions:  max. hgt. 18.5 cm; max. diam. 11.2 cm;
th. 0.22 cm; wt. 210 g; cap. ca. 750 ml

Color:  Translucent grayish colorless

Technique:  Free blown; tooled; applied

Description:  This almost globular pitcher has a
large, tall, and flared neck and an
applied splayed foot. The L-shaped
handle attached at the opening and
at the shoulder is formed by trailed
openwork and has a pointed thumb
rest at the top. The decoration on the
body consists of applied curling trails
arranged in a single row on the body
and enclosed in a band formed by
simple trails. Two horizontal rows
of small irregular discs or low prunts,
also enclosed in a band of trails, are
present around the neck.

Condition:  The object was broken and restored
before acquisition. Following the 1990
invasion of Kuwait, it probably suffered
heat damage; the adhesive sagged
and the object collapsed. Available
photographs taken before 1990 and
patient conservation work allowed for
its reconstruction. About 10 percent
of the vessel is missing. The surface is
lightly weathered, resulting in a golden
iridescence. The glass is of good quality.

Provenance:  Sotheby's, London, sale, April 21–22,
1980, lot 348

Literature:  Jenkins 1983, p. 31

Related Works:  1. Archaeological Research Institute
of Inner Mongolia, Hohhot
(An 1991, fig. 13)
2. CMG, inv. no. 59.1.515
(Smith 1957, pl. 9, no. 487)
3. MAIP, inv. nos. 21933, 4807
(Kordmahini 1988, p. 60; and
Kröger 1995, pp. 111–12, no. 160)

A fairly precise dating for this pitcher, one of the few glass objects that returned damaged from Baghdad following the Iraqi invasion of Kuwait in 1990, is luckily provided by a closely related piece found in the tomb of Princess Chenghuo and her husband in Inner Mongolia, China (Related Work 1). An epitaph inside the tomb, excavated in 1986, relates that Princess Chenghuo of the Liao dynasty died in the seventh year of the Katai reign (A.D. 1018), after the death of her husband.[16] The jug from China is not identical to cat. 40, but they share a number of similarities; namely, the nearly globular body, splayed foot, L-shaped openwork handle, and decorative prunts. The main differences are in the shape of the neck, which is more slender in the pitcher, and in the absence of the thumb rest and the curling threads on the jug. The tomb therefore provides a *terminus ante quem* for cat. 40.

Another jug and two spouted pitchers (Related Works 2, 3) represent the only other extant complete pieces with handles trailed in an openwork chainlike pattern and a thumb rest. The jug in Corning (Related Work 2) has a large neck similar to that of cat. 40, but it rises from an almost conical body.[17] The first pitcher in Tehran (Related Work 3, inv. no. 21933) has a globular body and a long, slender, tapered neck ending in a heart-shaped mouth. The second pitcher (Related Work 3, inv. no. 4807), which shares many features with the first one, was excavated in Nishapur and likely was produced in the Iranian area.

Fragmentary openwork handles found during excavations or reported as originating from various sites complicate the picture. Of the four published fragments known to the author, two are from Iran (the first was found at Rayy); the third is said to have been found in Caesarea on the Palestinian coast; and the fourth was reportedly found at Fustat, in Egypt.[18] While it is possible that this type of handle was produced in both Egypt and Iran, a provenance from the latter area for cat. 40 and for the related works is unquestionable.

**Cat. 41 GOBLET (LNS 398 G)**
**Iranian region**
**10th–11th century**

Dimensions: hgt. 12.3 cm; max. diam. 6.3 cm;
th. 0.12 cm; wt. 43.0 g; cap. 130 ml
Color: Translucent grayish colorless
and blue (blue 3)
Technique: Free blown; tooled; applied;
worked on the pontil
Description: This goblet has a conical cup with a
curved bottom and a plain opening.
The stem and a kicked conical base are
attached at the bottom of the cup. A
protruding disc formed by a continuous
spiraling trail is applied around the base
of the cup. The decoration around the
cup consists of three abstract curling
patterns applied in a single trail;
between the curling patterns are jeweled
blue dots and a fine thread was applied
in a spiral just above them. The object
is so finely blown that the decoration
can be felt at the touch of the fingers
as a sunken pattern inside the cup.
Condition: The cup of this object is intact.
Conservators established that part of
the original stem had been replaced
with a tubular glass piece (the original
stem was solid); the replacement was
left in place, though it may not match
the original length of the stem. The
foot may be original, but its slightly
darker color suggests that it once
belonged to a similar goblet. The
surface is heavily weathered, resulting
in a brown coating and gray pitting.
The glass includes frequent small
bubbles and elongated larger ones
near the opening.
Provenance: Reportedly from Qala-i naw (Badghis),
Afghanistan, found in a jar together
with cat. 38b, 46b, and 3.21
Related Works: 1. MKG, Hamburg, inv. no. 187/1963.42
(von Saldern 1968a, pl. 15)
2. CMNH, inv. no. 26543/6
(Oliver Jr. 1980, no. 247)
3. MMA, inv. nos. 2000.279.1, .2

A small number of elegant, well-proportioned goblets survive, often in fragmentary condition, featuring a small base that barely allows them to stand (thus they were probably stored upside down when not in use), a narrow stem, and a conical cup with an applied disc at the base. The general shape probably derives from the conical beakers with a circular base and a cutout protruding disc that represent some of the best products in cut glass by Iranian glassmakers,[19] though the profiles are rather different and must have evolved independently. The basic color (grayish or yellowish colorless glass) and profile of these goblets are consistent, though details may vary. For example, the small foot can be rather flat or almost conical; the stem can be long or short, thus creating a slender vertical profile or a squat one; the cup is almost invariably decorated with applied glass that consists of either simple horizontal trails or prunts, curling and wavy motifs, and combinations of these in the same color or, sometimes, in contrasting blue or green; the disc around the cup's base is usually applied as a single collar of glass, but in some cases it is formed by a trail wound in a spiral several times around the base of the cup until the desired width was created.[20]

Cat. 41 falls into the category of goblets with a conical foot (provided it is original), a combination of applied patterns (horizontal trail and curling and wavy motifs in addition to the unusual jeweled blue dots), and a trail-formed disc at the base of the cup. The original length of the stem is unknown, but the present reconstruction seems plausible. The slender profile, complex decoration, intact cup, and generally good condition of the surface make cat. 41 one of the most accomplished and best-preserved objects of this type.

The most distinctive feature of cat. 41 is the disc created with a continuous trail. This detail is shared by four other goblets, in Hamburg, Pittsburgh, and New York (Related Works 1–3), which differ in their decorations. Related Work 1 has a less elegant profile, a larger conical foot, a large applied disc, and a single horizontal trail around the cup. Related Work 2 is a better match: the stem is shorter (though the stem of cat. 41 has been replaced) and the disc is somewhat larger, but the general proportions are similar; the decoration consists of a horizontal trail above a row of jeweled dots of the same color followed by two rows of reverse S-shaped patterns, thus combining, in a different manner and chromatic effect, motifs similar to those found on cat. 41. The two goblets in New York form a pair with a decoration of colorless curling patterns but no jeweled dots.

The curling motifs and jeweled dots in blue glass of cat. 41 are found on other beakers or goblets and vessels of different shapes, including small bottles whose Iranian attribution is uncertain, since a Syrian provenance cannot be excluded (see cat. 3.22–3.25). All the stemmed goblets with a reputed provenance, however, are from the eastern Islamic world: for example, cat. 41 is said to have been found in Afghanistan; Related Work 1 is reportedly from Mazandaran, in northern Iran; and Related Work 2 was acquired from a dealer in works of art exclusively from Iran. Thus, an Iranian origin for cat. 41 is likely.

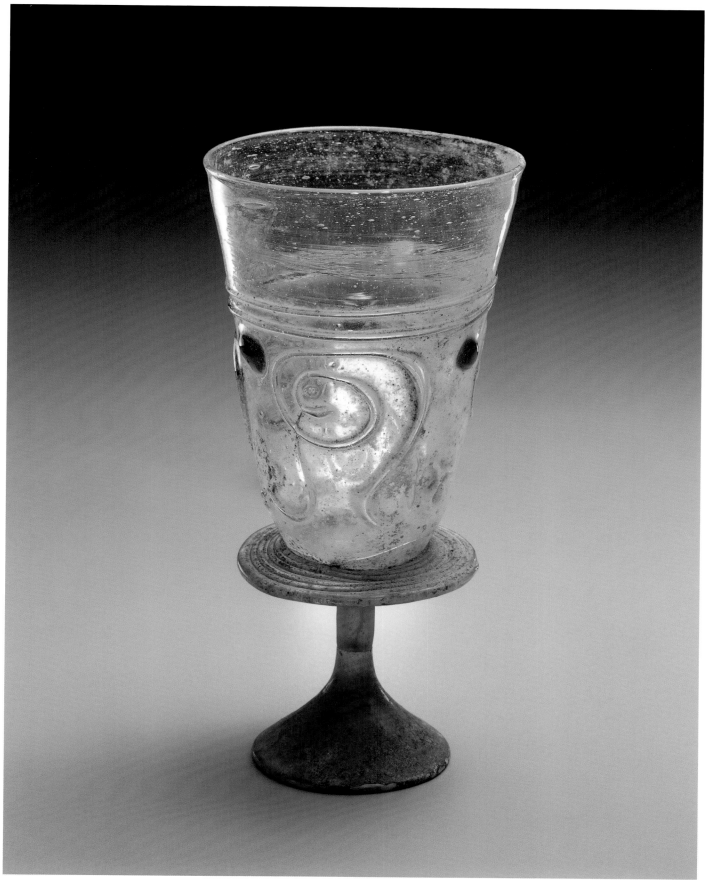

Cat. 41

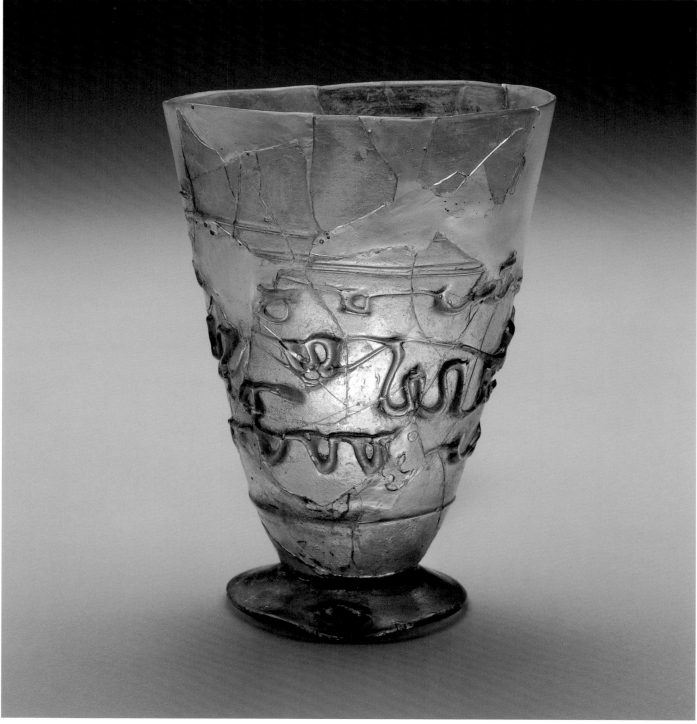

Cat. 42

## Cat. 42 FRAGMENTARY BEAKER
### (LNS 2 KG)
**Iranian region**
**10th–11th century**

Dimensions: hgt. 10.8 cm; max. diam. 8.5 cm;
th. 0.11 cm; cap. 250 ml

Color: Translucent pale blue (blue 1)

Technique: Free blown; tooled; applied;
worked on the pontil

Description: This finely blown beaker has an
irregular conical shape and stands
on an attached splayed foot. The
decoration, enclosed between thin
horizontal trails, consists of abstract
patterns.

Condition: The object was broken, repaired,
and reconstructed; about one-half
is missing. The surface is lightly
weathered, resulting in abrasion.
The glass is of good quality. A large
bubble is present on the foot.

Provenance: Kofler collection

Literature: Lucerne 1981, no. 527

Related Works: 1. CMNH, inv. no. 26543/8
(Oliver Jr. 1980, no. 249)
2. V&A, inv. no. C21-1970
3. MIK, inv. no. I.19/62
(Kröger 1984, no. 136)
4. CMG, inv. no. 79.1.246
(Strauss 1965, figs. 1–3)

A few beakers of conical shape standing on a splayed foot are related to the Iranian region, especially the site of Nishapur. Some of them are delicately carved;[21] others are finely free blown and tooled—their thickness averaging about 0.1 to 0.15 centimeters—and they are decorated with applied glass threads of either the same color (as in cat. 42) or a constrasting one. Often the decoration consists of abstract, freely drawn patterns in a "brushstroke" style[22] reminiscent of pseudocalligraphic models. The best parallels for this pseudocalligraphy are found on Samanid pottery decorated in black or brown underglaze on a white slip produced in eastern Iran and in Transoxiana, some likely in Nishapur, during the tenth and eleventh centuries.[23]

Related Works 1 to 4 are all "painted" in this style; they are similar in dimensions to cat. 42 and as finely blown (because of their fragility they are also largely incomplete but amply restored). The beakers in Pittsburgh and London (Related Works 1, 2) are almost identical to cat. 42, since their pseudocalligraphic decoration is enclosed within horizontal trails at the top and bottom and the threads are all of the same color. Both objects were acquired from the same dealer and are reported to come from Iran. The beaker in Berlin (Related Work 3) has a more complex decoration: the bands that frame the pseudocalligraphic decoration are formed by wavy and zigzag patterns and the trails are in a contrasting blue glass.

The beaker in Corning, formerly in the Strauss collection (Related Work 4), is also reputed to have been found in Iran and includes a surprising feature: tubular sections attached at the bottom. This interior structure is formed by two tubes, one inside the other. The outer tube has three openings and the innermost tube has only one, at the bottom. The outer tube is a few centimeters shorter than the height of the beaker itself. As argued by Strauss, who provides diagrams of the tubular sections, a possible explanation for the presence of this device is that the beaker belongs to the group of so-called trick glasses that were produced in the western world from the Roman period until the nineteenth century. If the glass were "filled to just over the tubes with . . . wine, handed to someone, and then promptly filled to a higher level, the pressure due to the difference between the liquid level and the top of the open tube could cause the liquid to pour out of the lower opening until the liquid level was that of the upper end of this central tube. Thus this would be one of the family of trick glasses."[24] Another, perhaps more likely, explanation is that the object might be a pastiche assembled when the fragmentary beaker was restored.[25]

The beaker in Corning is the only one known that includes a tubular device. The others do not seem to have been turned into "trick" glasses, though close investigation may reveal traces of glass attached to the bottom of their cups. Cat. 42 presents a small protrusion inside the bottom that may suggest the presence of a tube, but it is more likely that it is only a drinking vessel that was never meant to trick its users.

## Cat. 43a EWER (LNS 81 G)
### Iranian region
### 11th–12th century

Dimensions: hgt. 22.0 cm; max. diam. 10.5 cm;
th. 0.23 cm; wt. 158 g; cap. 574 ml

Color: Translucent green (green 2–3);
applied blue (blue 3) trails

Technique: Free blown; tooled; applied

Description: This pear-shaped ewer has a funneled
neck ending in a heart-shaped opening
and a spout that turns down slightly.
The decoration is formed by trails of
contrasting blue color: a trail around
and below the rim; a zigzag pattern
around the body; and a trail that starts
around the lower attachment of the
handle, runs uninterrupted to the base,
and overlaps the zigzag pattern. An
L-shaped handle with a thumb rest
was attached at the opening opposite
the spout and at the neck.

Condition: The object was broken in many pieces
and repaired; the foot was missing and
was replaced with a low splayed foot
in epoxy.[26] The surface is heavily
weathered, resulting in a pale brown
coating. The glass includes some large
bubbles.

Provenance: Sotheby's, London, sale, April 20–21,
1980, lot 234

Related Work: 1. KM, Düsseldorf, inv. no. P1974-18
(Ricke 1989, p. 49, no. 77)

The ewer and bottle (cat. 43a, b) belong to a group of objects created in the Iranian area in the eleventh and twelfth centuries that have strong links with glass production in the previous six or seven centuries. They are also representative of the last instances of the use of applied trails in a contrasting color in the medieval Iranian world.

A cursory glance at some of the objects discussed in Chapter 1 (see cat. 1, 1.6–1.8) shows how zigzag and spiral trailing in the early Islamic period had its roots in the late antique tradition in the Syrian area. Were it not for their shapes and dimensions, and other comparable objects with similar decoration that connect them to the Iranian region a few centuries later, cat. 43a and b could be easily mistaken for earlier products.

The main features that place cat. 43a at a later period are its piriform shape and its large size. Several similar ewers with a heart-shaped opening and an applied L-shaped handle are in various collections.[27] Some of them are not decorated, some have abstract trailed patterns, others have spiraling threads, but their shape and size are distinctive. To the same group also belong many globular bottles of the type of cat. 43b that have a long narrow neck; a bulging, sometimes lobed, opening; and small glass rings dangling from their necks. These piriform ewers and globular bottles, well exemplified by cat. 43a and b, are related because of their decoration: Related Works 2 to 4 present combinations of zigzag and spiraling trails in contrasting colors exactly like those on the ewer (cat. 43a). Cat. 43b has an unusual and more complex decoration composed of double zigzag trails and wavy pattern, but it clearly belongs to the same group.

Cat. 43a finds a nearly perfect match in Related Work 1, and it is likely that the two objects originated in the same workshop. They share colors (a green vessel with blue decoration), dimensions (cat. 43a is 1 cm taller, but the diameter is the same), shapes (including the handles), decoration, and technical details (judging by the overlapping trails, the zigzag decoration was applied first, then the spiraling thread, and finally the handle). The only difference is in the foot, which is original in Related Work 1 but was replaced in cat. 43a. This original foot is low and splayed and its rim is turned inward; thus it provides the model for its companion piece in the Collection.

## Cat. 43b BOTTLE (LNS 410 G)
### Iranian region
### 11th–12th century

Dimensions: hgt. 21.0 cm; max. diam. 11.0 cm; th. 0.25 cm; wt. 210 g; cap. ca. 550 ml

Color: Translucent greenish colorless; applied purple (purple 2) trails

Technique: Free blown; tooled; applied; worked on the pontil

Description: This bottle has a nearly globular shape that becomes almost conical at the bottom and a low splayed foot tooled and folded under the base; the neck is nearly cylindrical and slightly tapered. The decoration was applied in trails, both in the same color and in contrasting purple glass, in the following order (it is possible to reconstruct the sequence because they overlap): a double zigzag band (hgt. ca. 2 cm) within horizontal lines, created by overlapping two trails of purple glass; a wide green band that forms a sort of wavy pattern (hgt. ca. 4 cm), with sixteen "peaks" created with a pincer or a sharp tool; the same wavy motif, applied below the green one; and a green wavy band, present around the base of the neck.

Condition: The object was broken and repaired; the upper part of the neck had been restored using an unrelated fragment of similar greenish glass and was removed. The object is nearly complete except for small parts of the body and the upper part of the neck. The surface is partially weathered, resulting in a striped milky white film and a pale brown coating. Unusual efflorescence in the form of star- or snowflake-like golden elements on the surface can perhaps be attributed to the presence of manganese in the glass. The glass includes frequent small bubbles.

Provenance: Reportedly from Afghanistan

Related Works: 2. KM, Düsseldorf, inv. no. 1965.71 (von Saldern 1968a, fig. 16)

3. CMG, inv. no. 55.1.158 (Smith 1957, no. 488)

4. MAIP, inv. no. 22033 (Kordmahini 1988, p. 127)

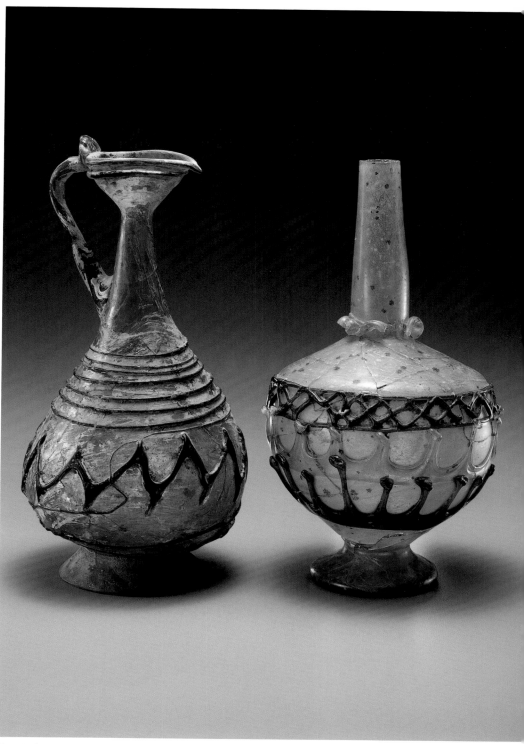

Cat. 43a, b

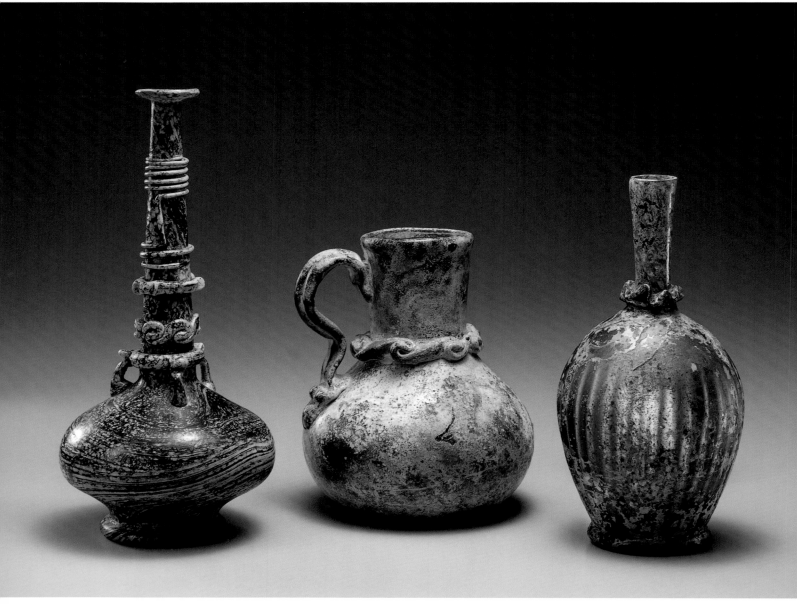

Cat. 44a–c

### Cat. 44a BOTTLE (LNS 73 KG)
### Syrian region
### 11th–12th century

Dimensions: hgt. 21.0 cm; max. diam. 10.0 cm; th. 0.27 cm; wt. 199.4 g; cap. 275 ml

Color: Translucent dark blue (blue 4)

Technique: Free blown; tooled; applied; worked on the pontil

Description: This flattened globular bottle has a splayed foot that folds underneath the base and a long tapered neck that ends in a splayed opening. The decoration (from top to bottom of the neck) consists of a continuous spiraling trail with an empty section in the middle, a thick ring with a pinched-out pattern, a thicker band tooled to create a compact wavy pattern, and a ring with three attached loops that depart from the bottle's shoulder.

Condition: The object is intact. The surface is entirely weathered, resulting in a pale brown coating that resembles marbling. The glass includes scattered small bubbles; a large bubble on the body has almost made a hole.

Provenance: Kofler collection

Related Works: 1. Formerly Antiquarium, Berlin, inv. no. 30219:211 (Lamm 1929–30, pl. 89)
2. NM, Copenhagen, inv. no. 5 A 902 (Riis–Poulsen 1957, fig. 178)

**Cat. 44b PITCHER (LNS 343 G)**
**Syrian region**
**11th–12th century**

Dimensions: hgt. 13.5 cm; max. diam. 11.1 cm;
th. 0.32 cm; wt. 291.8 g; cap. ca. 550 ml
Color: Translucent brown (yellow/brown 3)
Technique: Mold blown; tooled; applied;
worked on the pontil
Description: This onion-shaped pitcher has a base
with a shallow kick and a straight
neck that ends in a lipped rim. It was
blown in a ribbed mold and then optic
blown and twisted; thus the relief is
shallow and hardly noticeable. A thick
trail was applied around the base of
the neck and tooled to create a wavy
pattern. A wide, thick handle in the
shape of a question mark was attached
at the center of the body and halfway
up the neck; the handle (w. ca. 2 cm)
was tooled to create a band in relief
that runs lengthwise down the middle.
Condition: The object is intact. The surface is
entirely weathered, resulting in pale
brown and milky white coatings. The
glass includes scattered small bubbles.
Provenance: Eliahu Dobkin collection; Bonhams,
London, sale, October 18, 1995, lot 400
Related Works: 3. NM, Damascus, inv. no. 17953
(Riis–Poulsen 1957, fig. 153)
4. NM, Damascus, inv. no. 11868

**Cat. 44c BOTTLE (LNS 1377 G)**
**Probably Syrian region**
**11th–12th century**

Dimensions: hgt. 17.4 cm; max. diam. 8.0 cm;
th. 0.20 cm; wt. 174.5 g; cap. ca. 350 ml
Color: Translucent bluish green (green 3)
Technique: Mold blown; tooled; applied;
worked on the pontil
Description: This oval bottle has a low applied
circular foot and a tapered neck.
It was blown in a ribbed mold, then
optic blown; thus the thirty-two vertical
ribs are in low relief. A thick trail was
applied around the base of the neck
and tooled to create a wavy pattern.
Condition: The object is intact. The surface is
heavily weathered, resulting in pale
brown coating and silvery iridescence.
The glass includes scattered small
bubbles.
Provenance: Bonhams, London, sale, October 14,
1998, lot 67

These three objects have different profiles, colors, and overall decoration; in addition, two of them (cat. 44b and c) are mold blown. One detail of the applied decoration, however, is common to all three vessels and therefore provides a likely attribution for this small group. The detail consists of the thick trail that is applied around the base of the neck (cat. 44b, c) or just above the ring with three attached loops on the neck of cat. 44a and in all three instances is tooled in a compact wavy pattern. Applied and tooled trails around the neck are common to the repertoire of glassmakers in the entire Islamic world, but this particularly tight wavy motif can be regarded as a sort of hallmark of a specific workshop or, at least, of a restricted area of production.

This area may be identified as Syria on the basis of comparable excavated material, in particular from Hama. The bottle (cat. 44a), with its flattened globular shape and foot folded underneath the base, finds a good match in a fragmentary brown bottle that is missing its neck but retains the compact wavy trail at the neck's base (Related Work 2).[28] An interesting parallel for cat. 44a, including its shape, long tapered neck, splayed opening, color, and wavy trail, is provided by Related Work 1. According to Lamm, the most interesting characteristic of this bottle is that it is decorated in gold without enamels, thus providing a link between late medieval undecorated objects and the Ayyubid and Mamluk enameled and gilded glass.[29] The whereabouts of this object are unknown, making a current study impossible, but its obvious relation to cat. 44a, as well as its gilded decoration (provided it is original), make it a key work for the understanding of the development of glass production in the Syrian region during the late Fatimid and the early Ayyubid periods and help to suggest both an origin and a date for cat. 44a.

The Hama excavations also unearthed a good match for cat. 44b—namely, a pitcher in grayish colorless glass of similar shape (the neck is larger and the profile of the body is more flattened) decorated with a row of prunts in opaque turquoise glass around the middle of the neck (Related Work 3).[30] In addition to the Hama pitcher, a large fragmentary pitcher, or handled bottle, excavated in Central Syria or Raqqa (Related Work 4) share with this pitcher the color, the peculiar handle with a raised median section, and the compact wavy trail around the neck, thus making a Syrian origin almost certain for cat. 44b.

Although no immediate parallels can be found, it seems that the elegant bottle (cat. 44c), which, like cat. 44b, presents a molded and optic-blown ribbed decoration and the typical compact wavy trail at the base of the neck, should also be included in the same group and attributed to the same general area and date of production. Among the related objects in the Collection with trailed decoration around the neck (cat. 3.26a–f), the opaque greenish white bottle with small looping handles (cat. 3.26b), and the extant neck from a bottle with a wavy trail (cat. 3.26f) are clearly related to cat. 44a; the profile and simple trailed decoration of cat. 3.26c–e make their attribution uncertain, but a Syrian origin seems more likely according to details, such as the splayed opening of the bottle (cat. 3.26c) or the reputed provenance of the two bottles (cat. 3.26d, e); the pinched and protruding trail on the bottle (cat. 3.26a) links it instead to the type of prunted decoration seen under cat. 39, therefore suggesting an eastern Islamic origin.

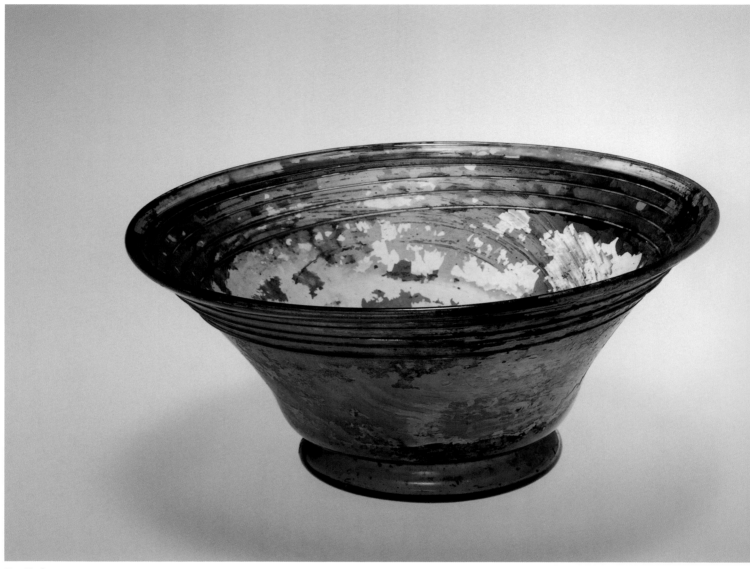

Cat. 45a, b

### Cat. 45a BOWL (LNS 103 G)
### Probably Iranian region
### 11th–12th century

Dimensions: hgt. 6.7 cm; max. diam. 15.0 cm;
th. 0.20 cm; wt. 132.4 g; cap. ca. 450 ml
Color: Translucent pale green (green 1)
Technique: Free blown; tooled; applied;
worked on the pontil
Description: This flared curved bowl has a rim
that folds outward against the exterior
wall, a low foot, and a base with a kick.
The decoration consists of a simple
glass trail that runs below the rim on
the outside wall, forming a band about
2 cm wide.
Condition: The object is intact. The surface is
heavily weathered, resulting in a pale
brown coating and golden iridescence.
The glass includes frequent small
bubbles.

The trailed decoration on the two bowls (cat. 45a, b) is useful in placing them within the group of objects produced in the Iranian area. A large number of fragments that likely belonged to flared bowls have come to light from excavations (intact objects are rarely encountered, since their open shapes make them prone to breakage). Among them, the most important in supporting the proposed attribution were found in Iran and present either a fine trailed decoration under the rim or a rim folded outward.[31] The latter characteristic (as in cat. 45a) seems to be related only to the eastern Islamic and Mesopotamian regions, since the majority of fragments with this type of rim were found in these areas.[32]

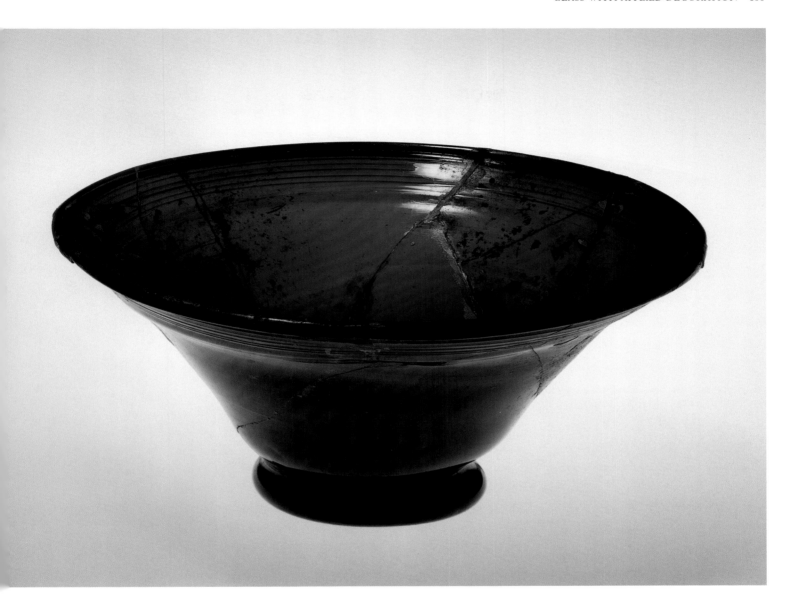

The simple decoration of these bowls, however, makes it difficult to suggest an accurate attribution. In addition, their basic shape was probably widespread in different areas and periods. Judging from the excavated material, a dating to the ninth or tenth century would seem likely. This type of flared and inconspicuously trailed bowl is, however, probably related to styles that became popular among Iranian glassmakers in the eleventh and twelfth centuries (see cat. 40–43).

**Cat. 45b BOWL (LNS 102 G)**
**Probably Iranian region**
**11th–12th century**

Dimensions: hgt. 7.9 cm; max. diam. 17.2 cm; th. 0.20 cm; wt. 183.7 g; cap. ca. 800 ml
Color: Translucent dark blue (blue 5)
Technique: Free blown; tooled; applied; worked on the pontil
Description: The shape and decoration of this bowl are similar to those of cat. 45a, except that its rim was created by folding inward and the foot was probably tooled rather than attached.
Condition: The object was broken and repaired. The missing parts (ca. 5 percent) were replaced. The surface is partially weathered, resulting in a milky coating and golden iridescence. The glass includes scattered small bubbles.

**Cat. 46a BOTTLE (LNS 129 G)**
**Iranian region**
**12th century**

Dimensions: hgt. 22.0 cm; max. diam. 14.5 cm;
th. 0.12 cm; wt. 290.9 g; cap. 1097 ml
Color: Translucent pale brown (yellow/brown 2)
Technique: Blown; tooled; worked on the pontil
Description: This large piriform bottle has a sunken
base with a pontil mark at the center,
a tapering neck that has a bulge just
below its narrowest point, and a
flowerlike opening, its rim tooled into
a series of irregular lobes. A decorative
horizontal line was created halfway
around the body with a pointed tool.
Condition: The object is intact. The surface is
heavily weathered, resulting in a milky
white coating and iridescence. The
glass includes scattered tiny bubbles.
Provenance: Christie's, London, sale, June 11–12,
1984, lot 587

**Cat. 46b EWER (LNS 397 G)**
**Iranian region**
**12th century**

Dimensions: hgt. 17.2 cm; max. diam. 8.7 cm;
th. 0.12 cm; wt. 102.2 g; cap. 330 ml
Color: Translucent yellow (yellow/brown 1),
dark brownish purple, and pale blue
(blue 1)
Technique: Blown; applied; tooled;
worked on the pontil
Description: This nearly globular ewer has a flattened
base with a pronounced kick, a slightly
flared lower half, and a slightly flared
neck with a flattened bulge below the
heart-shaped opening. A decorative
horizontal line was created around the
shoulder with a pointed tool. A spiraling
purple trail was applied between the
opening and the bulge on the neck;
a purple ring is around the base of the
neck. An L-shaped purple handle was
attached on the neck opposite the spout.
A thumb rest in the shape of a small
stylized bird, possibly a duck, in pale
blue glass was attached atop the handle.
Condition: The body of this object is intact; part
of the rim and spout are missing and
the bird is chipped. The surface is
heavily weathered, resulting in pale
brown soil; the blue bird shows a
silvery iridescence. The glass includes
frequent tiny bubbles.
Composition: Na$_2$O: 18.1; MgO: 4.9; Al$_2$O$_3$: 2.5;
SiO$_2$: 59.9; P$_2$O$_5$: 0.5; SO$_3$: 0.2; Cl: 0.7;
K$_2$O: 4.3; CaO: 7.3; TiO$_2$: 0.1;
MnO: 1.3; Fe$_2$O$_3$: 0.7
Provenance: Reportedly from Qala-i naw (Badghis),
Afghanistan, found in a jar together
with cat. 38b, 41, and 3.21

The three vessels (cat. 46a–c) are not related in shape but share a decorative horizontal line that divides their bodies into two sections. As described by Smith, the motif was "carried out by a highly refined technique. The horizontal band . . . was achieved by impressing a sharp point into the molten metal and drawing the tool around the vessel's circumference to the point of departure. This manipulation sets up a collar which is inwardly protruding, and the transmitted light through this greater thickness of glass produces the illusion of a band of darker color."[33] He uses as example a large conical beaker that he attributes (with good reason) to eastern Mediterranean workshops in the fourth or fifth century.[34]

The horizontal lines created on the bodies of cat. 46a–c were achieved using the method described above. Here, however, there is little doubt that they were produced in the Iranian area in the twelfth century. This attribution is evident, for example, from the bottle (cat. 46a), whose profile and lobed flowerlike opening find parallels in monochrome glazed, *mīnāī*, and *lājvardīna* pottery. A comparable piriform bottle, which also has an inner ring (Related Work 1), is said to have been excavated at Ābādān Tepe (near the Gunbad-i Qābūs), Iran, thus confirming the eastern Islamic association.

The remarkable quality of the vessels decorated in this technique is exemplified by the ewer (cat. 46b), with its elaborate applied trails, bird-shaped thumb rest,[35] and pleasant contrast of pale brown, purple, and blue glass. This object stands apart from the majority of ewers decorated with an inner ring (see Related Works 2–4),[36] which are usually pear-shaped, have a more rounded handle, and are less accomplished. The alleged provenance of cat. 46b is also the eastern Iranian world. The perfume sprinkler (cat. 46c) is also unusual, since its shape and the snaky trails at the sides of the neck seem to point to the Syrian, rather than Iranian, area.[37]

The basic colors of all the objects belonging to the "inner-ring" group are pale brown (cat. 46a, b) and yellowish green (cat. 46c), as confirmed by Related Works 1–4. The presence of the decorative horizontal ring created with a pointed tool is so unusual that it seems logical to consider all these objects as having been produced by a single workshop or by neighboring workshops, notwithstanding inconsistencies concerning shapes and decoration. An unlikely possibility is that the idea originated in an Iranian workshop and was soon adopted by distant glassmakers who liked the effect; this interpretation would enlarge the area of production and render the attribution of these vessels uncertain. Chemical analysis of cat. 46b and c, however, has proved that both examples have similar plant-ash composition and somewhat unusual high levels of magnesium, suggesting contiguous areas.

If Smith's attribution of the third- or fourth-century conical beaker mentioned above is correct, it is likely that the "inner-ring" technique was revived a few centuries later in the Iranian world, perhaps in imitation of objects circulating in that area. This type of decoration represents a rather simple, but effective solution that enhances the appearance of the vessels and adds one more "trick" to the already rich repertoire of glassmakers in the Islamic world.

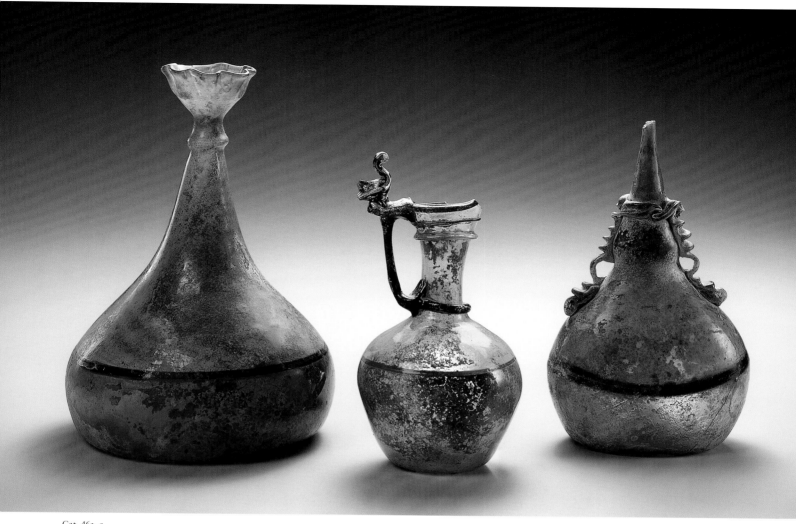

Cat. 46a–c

### Cat. 46c PERFUME SPRINKLER
### (LNS 346 G)
### Iranian region
### 12th century

Dimensions: hgt. 18.5 cm; w. 11.1 cm; l. 6.5 cm;
th. 0.12 cm; wt. 227.4 g; cap. 446 ml

Color: Translucent yellowish green (green 3)

Technique: Blown; applied; tooled;
worked on the pontil

Description: This perfume sprinkler has a piriform
body with flattened sides, a deep
conical kick under the base, and a large
pontil mark with excess glass still
attached. The tapering neck bulges
above the shoulder and the opening is
quite narrow. A decorative horizontal
line was created halfway around the
body with a pointed tool. Two handles
at the sides of the neck are tooled in
a snaky pattern and there are two
suspension loops between the shoulder
and the bulge on the neck. A wavy trail
around the neck covers the upper part
of the handles.

Condition: The object was broken and repaired.
A small fill is near the base and the
opening is chipped; the remainder of
the object is complete. The surface is
heavily weathered, resulting in milky
white and pale brown coatings and
abrasion. The glass includes scattered
small bubbles and some large ones.

Composition: Na$_2$O: 18.8; MgO: 5.8; Al$_2$O$_3$: 0.8;
SiO$_2$: 60.2; SO$_3$: 0.3; Cl: 0.8; K$_2$O: 2.5;
CaO: 9.7; MnO: 0.1; Fe$_2$O$_3$: 0.9

Provenance: Eliahu Dobkin collection; Bonhams,
London, sale, October 18, 1995, lot 383

Related Works: 1. MIK, inv. no. I.56/65
(Kröger 1984, no. 22)
2. DC, inv. no. 51/1981
(von Folsach 1990, no. 23)
3. Private collection, Tokyo
(Fukai 1977, no. 64)
4. KM, Düsseldorf, inv. no. P1966-95
(Ricke 1989, no. 56)

## Cat. 47 BEAKER (LNS 91 KG)
### Syrian region
### 12th–13th century

Dimensions: hgt. 11.5 cm; max. diam. 8.3 cm; th. 0.16 cm; wt. 87.5 g; cap. 275 ml

Color: Translucent yellowish colorless; emerald green (green 6)

Technique: Free blown; tooled; applied; worked on the pontil

Description: This almost cylindrical beaker has a slightly flared and curved opening. A ring attached at the base provides more stability. The decoration consists of an emerald green trail applied around the rim and a single continuous trail of the same color as the vessel on the central section of the beaker; this trail forms a band (hgt. ca. 4 cm) filled with three zigzag patterns applied at regular intervals and alternated with three small prunts in emerald green glass.

Condition: Half of the rim and a section of the wall were filled; the remainder of the object is intact. The surface is entirely weathered, resulting in golden iridescence and corrosion. The glass includes frequent small bubbles.

Provenance: Kofler collection

Related Works: 1. NM, Copenhagen, inv. no. 6 C 43 (Riis–Poulsen 1957, fig. 162)
2. Whereabouts unknown; formerly Krug collection (Sotheby's, New York, sale, December 7, 1981, lot 239)

The nearly cylindrical shape of this beaker leaves little doubt that it was produced in the Syrian area, likely during the Ayyubid period (ca. 1171–1260). This period may be considered a long prelude to the explosion of decorative patterns attained with enamel painting under the Mamluks (see Chapter 4). Most of the glass vessels produced for the Mamluks had already acquired a more or less definitive shape in the Ayyubid period, and, in many cases, they underwent only slight changes and refinement. Medium-sized beakers standing on an applied foot ring are typical examples (see cat. 85–87).

Cat. 47 is cylindrical and has a flared and curved opening; its appearance is therefore rather squat, but is improved by its delicate decoration. It represents an early phase of production of these beakers that later developed into slenderer forms with more imaginative flared and curved openings (see cat. 87). The applied foot also evolved from an attached foot ring into a more sophisticated type of "double chamber."

Ayyubid glass was produced mainly in the Syrian centers of Damascus, Aleppo, Hama, and Raqqa. Excavations at Hama revealed a number of beakers of cylindrical shape decorated with applied threads of the same, or a contrasting, color. The most common decoration on these beakers, presumably produced at Hama itself, seems to have been small prunts randomly applied between two thin trails, forming a wide decorated band like that on cat. 47. These beakers must have been popular at the time, since they were reportedly also found in Iran, Turkey, and Crimea.[38] Of the objects excavated at Hama, one shows a zigzag decoration in addition to the prunts (Related Work 1). Another beaker, formerly in the Krug collection (Related Work 2) is nearly identical to cat. 47 in dimensions, combination of trailed dark green and colorless glass on a colorless vessel, and type of foot ring; although its decorative scheme differs slightly from that of our beaker, its colorless prunts and green patterns provide an excellent match.

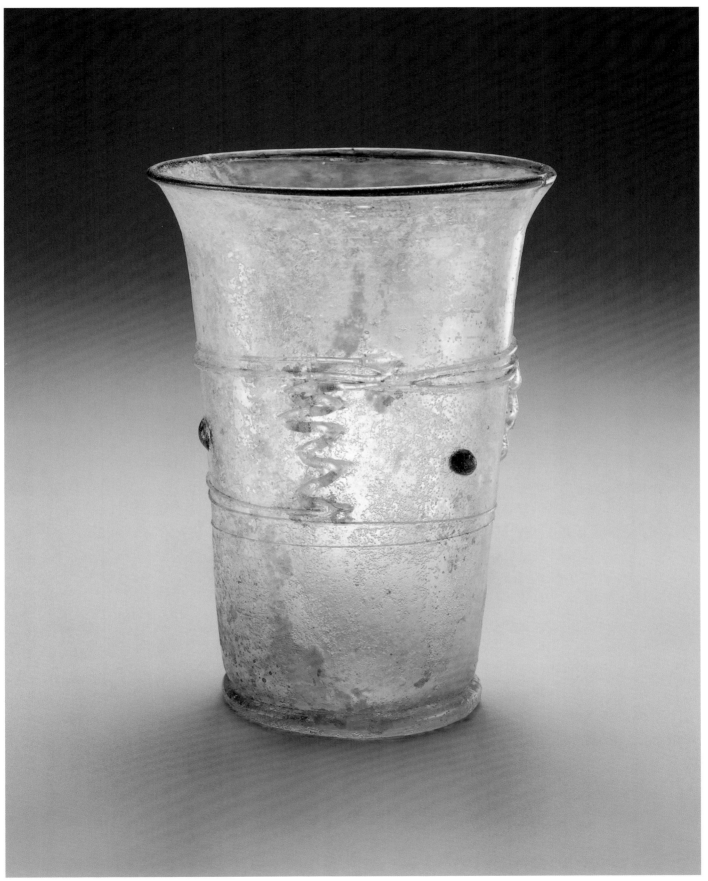

Cat. 47

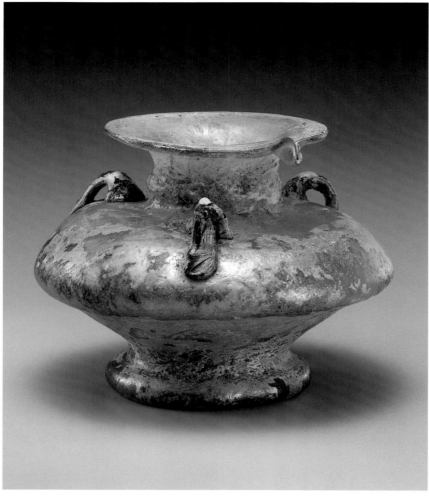

Cat. 3.18

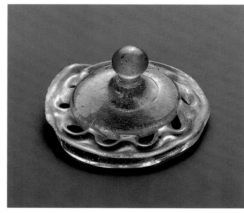

Cat. 3.19

### Cat. 3.18 HANGING LAMP (LNS 43 KG)
**Probably Syrian region**
**8th–9th century**

Dimensions: hgt. 6.5 cm; max. diam. 8.5 cm;
th. 0.17 cm; wt. 89.2 g; cap. 85 ml
Color: Translucent greenish colorless;
pale blue (blue 2)
Technique: Blown; tooled; applied;
worked on the pontil
Description: This flattened globular lamp has a
splayed foot created by tooling, a short
cylindrical neck with a splayed opening,
and a small spout. A narrow tube was
attached at the bottom of the lamp.
Three small suspension loops, probably
of pale blue glass, were applied at
regular intervals at the shoulder and
at the base of the neck.
Condition: The object is intact. The surface is
entirely weathered, resulting in
considerable iridescence, especially on
the interior, that prevents a reading of
the color of the applied rings. The glass
includes frequent small bubbles.
Provenance: Kofler collection
Related Work: Cat. 38

### Cat. 3.19 LID (LNS 20 KG)[39]
**Egyptian region(?)**
**9th–10th century**

Dimensions: hgt. 1.9 cm; diam. 4.1 cm; th. 0.26 cm;
wt. 11.0 g
Color: Translucent pale yellowish green
Technique: Tooled; applied; worked on the pontil
Description: This small lid has a solid roundel in
the center and an applied wavy band
around it that creates an openwork
pattern at the attachment to the
roundel. A knob was tooled atop the
roundel to form a handle.
Condition: The wavy band is chipped; the
remainder of the object is intact. The
surface is lightly weathered, resulting in
a milky white film. The glass includes
scattered small bubbles.
Provenance: Kofler collection
Literature: Lucerne 1981, no. 573

**Cat. 3.20b, c TWO FRAGMENTARY
ANIMAL FIGURES
(LNS 158 Ga, b)
Iranian region
10th–11th century**

Dimensions: b: hgt. 3.5 cm; w. 2.5 cm; l. 2.7 cm;
th. 0.13 cm
c: hgt. 3.6 cm; w. 2.3 cm; l. 3.3 cm;
th. 0.06 cm
Color: Translucent yellowish colorless; applied
translucent blue and opaque turquoise
(cat. 3.20b only)
Technique: Free blown; tooled; applied;
worked on the pontil
Description: Cat. 3.20b includes the forepart of an
animal with an open mouth; two large
eyes in turquoise glass were applied and
the ears are in blue glass. Cat. 3.20c has
identical features; more of the body has
survived. The applied details are in the
same color as the body: one ear, part of
the mouth, and two forelegs are extant.
Both fragments bear a pontil mark on
the animal's chest.
Condition: Both fragments are entirely weathered,
resulting in a golden whitish film and
iridescence.[41]
Provenance: Reportedly from Afghanistan

**Cat. 3.20d FRAGMENT OF A
ZOOMORPHIC VESSEL
(LNS 184 G)
Iranian region
10th–11th century**

Dimensions: diam. 2.8 cm; w. 3.5 cm; l. 3.7 cm;
wt. 31.8 g
Color: Translucent colorless; applied opaque
turquoise and pale yellow
Technique: Blown; tooled; applied
Description: This fragment of a blown vessel shows
a zoomorphic head with applied
features in opaque glass: turquoise glass
was used to create the eyes, a crest, and
details at the back of the head; pale
yellow glass forms the base of the crest
and the ears; the snout is the same color
as the vessel.
Condition: The fragment is lightly weathered,
resulting in a brown coating. The glass
includes frequent small bubbles.
Provenance: Kofler collection; gift to the Collection

**Cat. 3.20a FIGURE OF A BIRD
(LNS 116 KG)
Probably Iranian region
10th–11th century**

Dimensions: hgt. 7.8 cm; w. 5.9 cm; l. 10.6 cm;
th. 0.11 cm; wt. 73.7 g
Color: Translucent green (green 3)
Technique: Free blown; tooled; applied
Description: This bird stands on three small applied
feet, two under the chest and one under
the tail.[40] The body, roughly pear-shaped,
is finely blown. The head was applied
and the pointed beak was tooled;
circular protruding eyes formed by a
ring and a tall wavy crest were applied
at the side and top of the head. A band
(w. ca. 0.8 cm) was applied horizontally
around the bird's body and pincered
into an irregular crested pattern. A deep
conical protrusion was inserted at the
bottom center of the body, forming a
hole surrounded by a circle in relief.
Condition: The object was broken and repaired;
the tail, some body fragments, and part
of the crest are missing. About 80
percent is extant. The surface is heavily
weathered, resulting in a golden brown
coating on the interior, pale brown
pitting, iridescence, and abrasion on the
exterior. The glass includes frequent
small bubbles.
Provenance: Kofler collection
Literature: Ohm 1975, no. E52, pl. 30; and
Lucerne 1981, no. 525

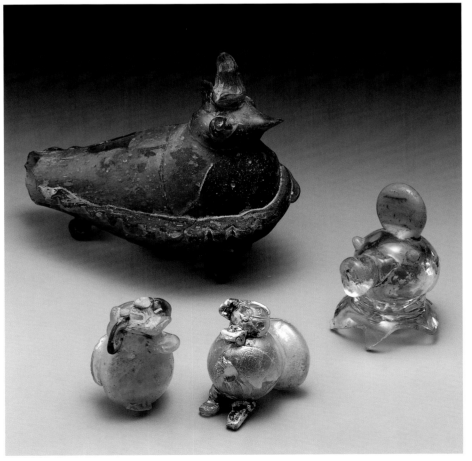

Cat. 3.20a–d

## Cat. 3.21 BOTTLE (LNS 399 G)
### Iranian region
### 10th–11th century

Dimensions: hgt. 15.2 cm; max. diam. 7.8 cm;
th. 0.18 cm; wt. 40.9 g; cap. 145 ml
Color: Translucent grayish colorless
Technique: Free blown; tooled; applied;
worked on the pontil
Description: This globular bottle has a long, narrow,
cylindrical neck[42] and a slightly kicked
base formed by an applied footring
(diam. 3.8 cm). The decoration consists
of abstract curving motifs reminiscent
of pseudocursive calligraphy enclosed by
a continuous horizontal thin trail that
overlaps the main pattern; two applied
rings encircle the base and the body of
the neck (ca. 2.5 cm above the base).
Condition: The object is intact except for chips
at the rim and elsewhere and, perhaps,
sections of the trail. The surface is
partially weathered, resulting in a milky
white film and dark brown pitting. The
glass includes scattered small bubbles.
Provenance: Reportedly from Qala-i naw (Badghis),
Afghanistan, found in a jar together
with cat. 38b, 41, and 46b

Cat. 3.22a, b

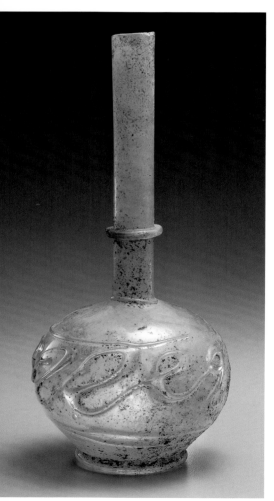

Cat. 3.21

## Cat. 3.22a BOTTLE (LNS 353 G)
### Probably Iranian region
### 10th–11th century

Dimensions: hgt. 6.9 cm; max. diam. 3.1 cm;
th. 0.14 cm; wt. 14.8 g; cap. 25 ml
Color: Translucent pale brown
(yellow/brown 2); opaque turquoise
and dark brown (or black)
Technique: Free blown; tooled; applied;
worked on the pontil
Description: This bottle is in the shape of a slightly
irregular cone with a rounded apex.
Two fine turquoise threads were applied
horizontally in a spiral about 1.5 cm
below the shoulder and above the base.
Three abstract motifs resembling
question marks, two turquoise and one
dark brown (or black), are within the
space created by the two threads.
Condition: The neck of the object is missing; a
filled chip is present on the shoulder.
The surface is weathered, resulting in a
milky brownish coating on the interior
(probably the remains of a substance)
and iridescence and flaking on the
exterior. The glass includes scattered
small bubbles.
Provenance: Eliahu Dobkin collection; Bonhams,
London, sale, October 18, 1995, lot 377

## Cat. 3.22b BOTTLE (LNS 402 G)
### Probably Iranian region
### 10th–11th century

Dimensions: hgt. 7.1 cm; max. diam. 2.4 cm;
th. 0.19 cm; wt. 17.8 g; cap. 7 ml
Color: Translucent, probably pale green
or blue
Technique: Blown; tooled; applied
Description: This bottle has the same shape as
cat. 3.22a; a small disc was attached
under the base and the neck is long and
flared. Four curly motifs between fine
horizontal trails were applied in a
continuous thread around the body.
Condition: The object is intact. The surface is
entirely weathered, resulting in silvery
white and dark brown coatings and
corrosion that prevent a reading of
the color.
Provenance: Reportedly from Balkh, Afghanistan
Related Works: Cat. 40, 41, 3.23, 3.24

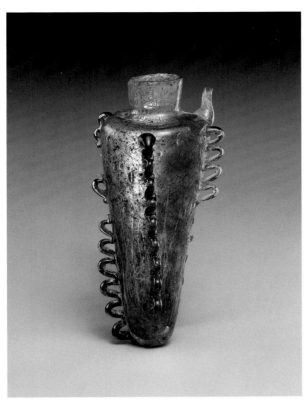

Cat. 3.23

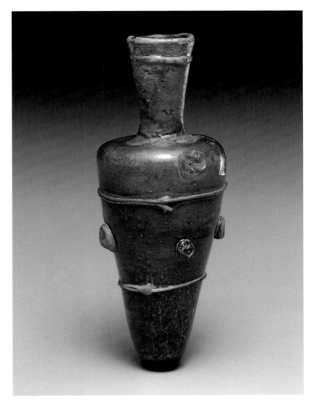

Cat. 3.24

### Cat. 3.23 BOTTLE (LNS 352 G)
**Probably Iranian region**
**10th–11th century**

Dimensions: hgt. 6.6 cm; max. diam. 2.6 cm;
th. 0.10 cm; wt. 10.1 g; cap. 13 ml

Color: Translucent pale brown
(yellow/brown 2) and dark blue (blue 4)

Technique: Free blown; tooled; applied;
worked on the pontil

Description: This bottle has the same shape as
cat. 3.22a. Four threads were applied
vertically at regular intervals from the
shoulder to the base, creating a snaky
pattern; two threads are blue and two
are brown, though the colors do not
alternate. The fragment of a handle
is visible at the shoulder.

Condition: Sections of the neck, handle, and snaky
threads are missing; the remainder of
the object is intact except for a filled
chip on the neck. The surface is
weathered, resulting in pale brown
patches on the exterior. The glass
includes frequent small bubbles and
large ones. Soil is present inside the
vessel.

Provenance: Eliahu Dobkin collection; Bonhams,
London, sale, October 18, 1995, lot 377

Related Works: Cat. 3.22, 3.24

### Cat. 3.24 BOTTLE (LNS 351 G)
**Syrian or Iranian region**
**11th–12th century**

Dimensions: hgt. 8.9 cm; max. diam. 3.3 cm;
th. 0.18 cm; wt. 19.3 g; cap. 25 ml

Color: Translucent green (green 2); pale brown
(yellow/brown 2); opaque turquoise
with dark red inclusions

Technique: Free blown; tooled; applied;
worked on the pontil

Description: This bottle has the same shape as
cat. 3.22a;[43] the neck is flared. Fine
turquoise threads were applied
horizontally around the opening and
neck below the opening and twice
around the body (ca. 1 cm below the
shoulder and 2.5 cm above the base).
Four prunts, alternately turquoise and
pale brown, were applied at irregular
intervals in between the two trails.

Condition: The neck was broken and reattached,
and the seam was painted over
inaccurately. The object is complete
except for small chips at the shoulder
and the mouth. The surface is
weathered, resulting in a brownish
coating (probably the remains of a
substance) on the interior. The glass
includes scattered small bubbles.

Provenance: Eliahu Dobkin collection; Bonhams,
London, sale, October 18, 1995, lot 377

Related Works: Cat. 47, 3.22, 3.23

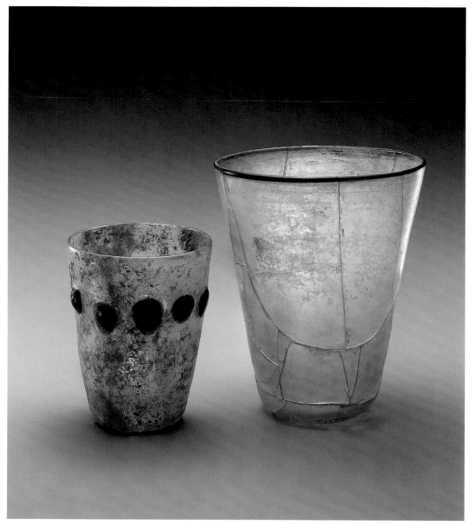

Cat. 3.25a, b

### Cat. 3.25a BEAKER (LNS 415 G)
### Syrian or Iranian region
### 11th–12th century

Dimensions: hgt. 7.5 cm; max. diam. 5.5 cm;
      th. 0.16 cm; wt. 59.5 g; cap. 110 ml
Color: Translucent grayish colorless and blue
      (blue 3)
Technique: Free blown; tooled; applied;
      worked on the pontil
Description: This flared conical beaker has a flat
      base with a slight kick. The decoration
      consists of ten jeweled blue dots
      arranged at irregular intervals about
      1.7 cm below the rim; the diameter of
      the dots varies from 1.0 to 1.5 cm.
Condition: The object is intact, assuming that it is
      not a goblet that has lost its stem and
      base.[44] The surface is heavily weathered,
      resulting in brown and milky white
      coatings and gray pitting. The glass
      includes frequent tiny bubbles and some
      larger ones.
Provenance: Reportedly from Damascus, Syria

### Cat. 3.25b BEAKER OR GOBLET
### (LNS 87 G)
### Syrian or Iranian region
### 11th–12th century

Dimensions: hgt. 10.8 cm; max. diam. 8.4 cm;
      th. 0.23 cm; wt. 65.7 g; cap. 316 ml
Color: Translucent grayish colorless;
      applied dark green (green 4–5)
Technique: Free blown; tooled; applied;
      worked on the pontil
Description: This conical vessel has a slightly
      concave base and can barely stand.
      Underneath the base is a circular break
      that may represent the pontil mark
      or the attachment of a missing stem.
      A trail in green glass was applied
      around the rim.
Condition: The object was broken and repaired
      and small missing parts were replaced;
      the remainder of the object is complete.
      The surface is partially weathered,
      resulting in a silvery white coating. The
      glass includes scattered small bubbles.
Related Work: Cat. 41

**Cat. 3.26a BOTTLE (LNS 93 G)**
**Iranian or Central Asian region**
**11th–12th century**

Dimensions: hgt. 20.0 cm; max. diam. 7.5 cm;
th. 0.21 cm; wt. 120.4 g; cap. 216 ml
Color: Translucent dark blue (blue 4–5)
Technique: Free blown; tooled; applied; pinched;
worked on the pontil
Description: This short flared bottle has a flat base
with a kick, a rounded shoulder, and a
long, straight, narrow neck that ends in
a chipped opening. A trail was applied
at the base of the neck and pinched six
times to create a protruding decorative
pattern.
Condition: The object was broken and repaired
and a missing section was replaced.
There are small cracks, but the
remainder of the object is complete.
The surface is partially weathered,
resulting in a pale grayish brown
coating that prevents a reading of the
color of the applied trail. The glass
contains scattered small bubbles and
some large ones as well as a dark
inclusion.

**Cat. 3.26b BOTTLE (LNS 345 G)**
**Syrian region**
**11th–12th century**

Dimensions: hgt. 13.5 cm; max. diam. 6.8 cm;
th. 0.24 cm; wt. 56.2 g; cap. 125 ml
Color: Opaque greenish white
Technique: Free blown; tooled; applied;
worked on the pontil
Description: This almost globular, slightly flattened
bottle has a base with a kick and a
long cylindrical neck that ends in a
large splayed opening. A low foot ring
was created by tooling. The applied
decoration in opaque white glass
consists of two pincered loops attached
at about 2 cm above the base of the
neck.
Condition: The object was broken and repaired.
There are small fills and the opening
is chipped, but the remainder of the
object is complete. The surface is
heavily weathered, resulting in dark
brown pitting, iridescence, abrasion,
and flaking.
Provenance: Eliahu Dobkin collection; Bonhams,
London, sale, October 18, 1995, lot 396

**Cat. 3.26c BOTTLE (LNS 125 G)**
**Syrian or Iranian region**
**11th–12th century**

Dimensions: hgt. 15.0 cm; max. diam. 7.7 cm;
th. 0.23 cm; wt. 88.9 g; cap. 146 ml
Color: Translucent dark blue (blue 4)
Technique: Free blown; tooled; applied;
worked on the pontil
Description: This flattened globular bottle that
flares near the base has a long, slightly
tapered neck that ends in a thick
splayed opening and a low tapered foot
ring created by tooling. The decoration,
applied around the neck, probably
in glass of the same color, forms a
continuous spiral from the base of
the neck to its center.
Condition: The object is intact. The surface is
entirely weathered, resulting in a pale
brown coating and golden iridescence
that prevents a reading of the color of
the applied decoration.
Provenance: Sotheby's, London, sale, April 18, 1984,
lot 320

**Cat. 3.26d BOTTLE (LNS 393 G)**
**Syrian or Iranian region**
**11th–12th century**

Dimensions: hgt. 16.0 cm; max. diam. 7.4 cm;
th. 0.30 cm; wt. 87.6 g; cap. 190 ml
Color: Translucent dark blue (blue 5)
Technique: Free blown; tooled; applied;
worked on the pontil
Description: This almost globular bottle that flares
near the flat, slightly kicked base has a
long, slightly tapered neck that ends in
a plain, unevenly thick opening. The
applied decoration at the base of the
neck consists of a large ring pincered
in a wavy pattern and a thin spiraling
trail that overlaps the ring.
Condition: The object is intact. The surface is
entirely weathered, resulting in milky
white and pale brown coatings.
Provenance: Reportedly from Damascus, Syria

**Cat. 3.26e BOTTLE (LNS 394 G)**
**Syrian or Iranian region**
**11th–12th century**

Dimensions: hgt. 18.2 cm; max. diam. 7.8 cm;
th. 0.26 cm; wt. 117.9 g; cap. 185 ml
Color: Translucent dark blue (blue 5)
Technique: Free blown; tooled; applied;
worked on the pontil
Description: The shape of this bottle is similar
to that of cat. 3.26d. The applied
decoration consists of a wide trail that
encircles about one-fourth of the length
of the neck from the base upward; the
trail was pincered to create a ribbed
pattern in relief.
Condition: The object is intact except for small
sections of the applied trail. The
surface is entirely weathered, resulting
in dark and pale brown coatings,
iridescence, and abrasion.
Provenance: Reportedly from Damascus, Syria

**Cat. 3.26f NECK FROM A BOTTLE**
**(LNS 41 KG)**
**Probably Syrian region**
**11th–12th century**

Dimensions: hgt. 15.0 cm; max. diam. 3.0 cm;
th. 0.28 cm; wt. 80.4 g; cap. 28 ml
Color: Translucent bright dark blue (blue 5)
Technique: Free blown; tooled; applied
Description: This object, presently provided with an
applied roundel of a similar color at the
bottom that turns it into a container, is
the neck of a large bottle similar and
somewhat larger than that of cat. 44a.
The object is slightly tapered and ends
in a large, unevenly thick, splayed
opening. The applied decoration
consists of a large band at the base,
which is pincered into a wavy pattern,
and a trail that encircles most of the
neck.
Condition: A large section of the trail is missing,
but the neck (itself a fragment of a
bottle) is intact. The surface is heavily
weathered, resulting in a golden pale
brown coating, iridescence, and
abrasion.
Provenance: Kofler collection
Related Work: Cat. 44a

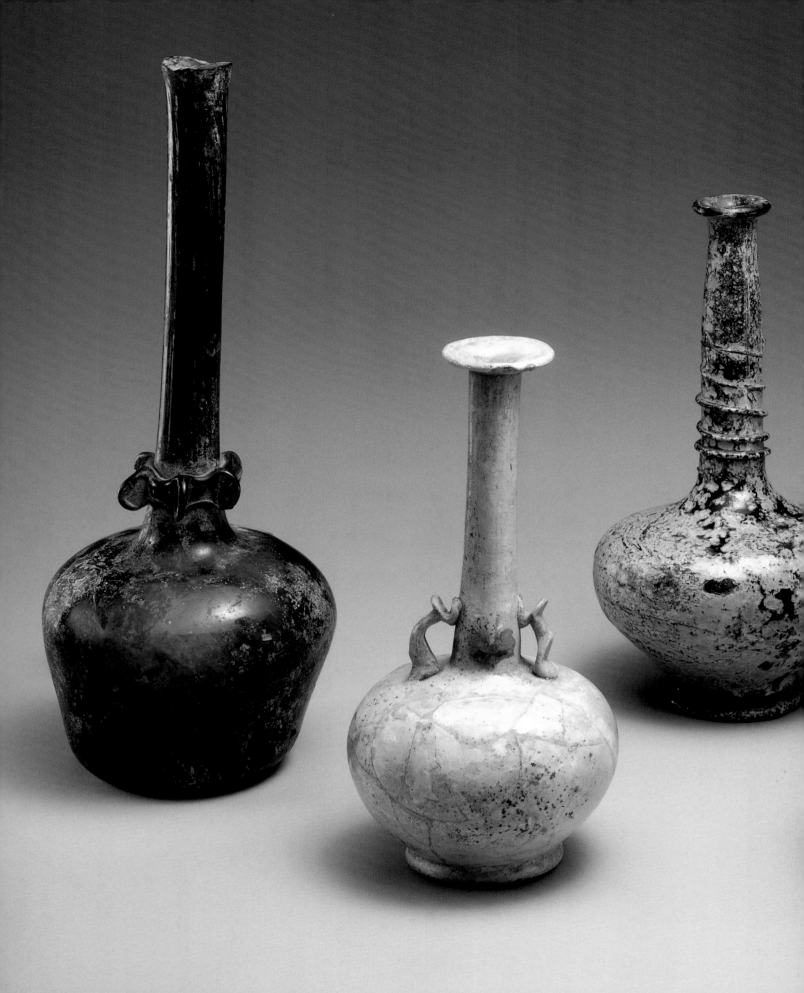

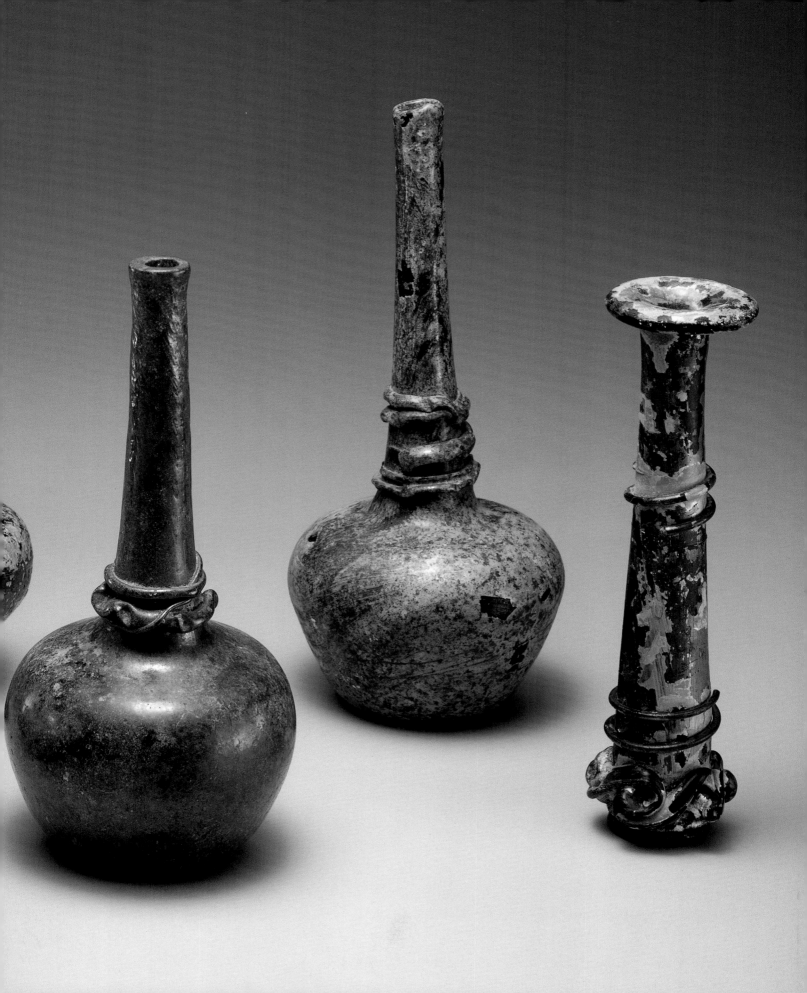

## Cat. 3.27  TWO FRAGMENTS
### (LNS 188 Ga, b)
### Syrian region
### 11th–12th century

Dimensions: (larger fragment) w. 3.7 cm; l. 2.0 cm;
th. 0.16 cm

Color: Translucent grayish colorless;
applied pale blue (blue 1–2)

Technique: Blown; tooled; applied

Description: These slightly curving fragments belong
to the same vessel. The decoration is
applied in blue glass trails on the
exterior wall, seemingly forming a
network pattern.[45]

Condition: The fragments are partially weathered,
resulting in a pale brown coating. The
glass includes frequent small bubbles.

Provenance: Kofler collection; gift to the Collection

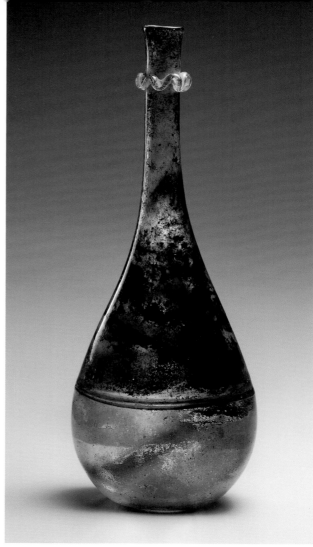

Cat. 3.28

Cat. 3.27

## Cat. 3.28  FLASK (LNS 130 G)
### Iranian region
### 12th century

Dimensions: hgt. 21.1 cm; w. 8.2 cm; l. 4.1 cm;
th. 0.17 cm; wt. 85.3 g; cap. 210 ml

Color: Translucent greenish colorless

Technique: Blown; applied; tooled;
worked on the pontil

Description: This pear-shaped flask is flattened on
two sides and has a small flattened base
with a slight kick that does not allow
the object to stand and a tapered neck
with a flared opening. A decorative
horizontal line was created halfway
around the body with a pointed tool.
A wavy band was applied around the
neck (ca. 2 cm below the opening).

Condition: The object is intact. The surface is
heavily weathered, resulting in golden
brown and dark purple coatings on the
interior. The glass includes frequent
small bubbles.

Provenance: Sotheby's, London, sale, 1985
(information obtained from the
Collection's records before the
invasion of Kuwait in 1990)

Related Work: Cat. 46

# NOTES

1 See, for example, Baumgartner–Krueger 1988, pp. 210–17.

2 A discussion on applied glass is either not included or is greatly underplayed in general articles devoted to Iranian glass; see, for example, Lamm 1939; and Charleston 1989.

3 A lamp in the form of a beaker with suspension rings is in the Museum für Islamische Kunst in Berlin, inv. no. I.2337 (Kröger 1984, no. 13; and Vienna 1998, no. 184).

4 See, for example, Rosenthal–Sivan 1978, p. 163, no. 678.

5 Measurement reported by Hasson (1979, no. 8). Ohm (1975, no. 148) gives 14.5 cm instead (see Related Work 1).

6 Kordmahini (1988, p. 74) attributes a large number of glass pieces in the Bazargan collection to Gurgan, a site excavated near the Caspian Sea. However, it has not been proven that the site was a place of glass production. Therefore, such an attribution cannot be taken literally, but an Iranian provenance seems certain nevertheless.

7 Kordmahini 1988, p. 88.

8 Philippe 1982, p. 66, no. 59.

9 Harden et al. 1968, p. 149, no. 149.

10 Christie's, London, sale, April 24, 1994, lot 469.

11 'Abd al-Khaliq 1976, fig. 111.

12 See Bumiller 1993, pp. 115–58.

13 See, in particular, Melikian-Chirvani 1982, pp. 29–31; and Malkiel 1995. A bottle in the al-Sabah Collection (LNS 539 M), reportedly from Kunduz, in Afghanistan, is close in shape to cat. 39.

14 It has been suggested that these projections were functional, since the stopper may have been secured with strings wrapped around the projections; see Ward 1993, p. 27, no. 15.

15 Lamm 1935, pls. 42e, f.

16 An 1991, p. 130; and Taniichi 1988, p. 98, fig. 3; see also cat. 36, Related Work 3.

17 Smith (1957, p. 244) suggested that "the open-work thread handle derives from rock-crystal and carved glass prototypes." Although this theory has validity and would make sense chronologically, it is not corroborated by the evidence.

18 The four fragments are published, respectively, in Pope 1931, p. 11, fig. 4; Lamm 1935, p. 14, pls. 8a, 40d; Auth 1976, p. 231, no. 533; and Lamm 1929–30, pl. 26:1.

19 One of the best examples is in the Metropolitan Museum of Art (inv. no. 1974.45; see Jenkins 1986, p. 27, no. 26).

20 Comparable examples exhibiting one or more of these details are in the Kunstmuseum, Düsseldorf (inv. no. P1973-55), which has prunts between horizontal trails

(Ricke 1989, no. 62); Los Angeles County Museum of Art (inv. no. M.89.129.189), which has a horizontal blue trail (von Saldern 1980, no. 185); and the Carnegie Museum of Natural History, Pittsburgh (inv. no. 24057/1), which is decorated with a horizontal blue trail around the cup and the edge of the applied disc (Oliver Jr. 1980, no. 248).

21 An excellent example is in the Metropolitan Museum of Art (inv. no. 1974.45; see Jenkins 1986, p. 27, no. 26).

22 So-called by Kröger (1995, p. 111, no. 160), who discusses a pitcher decorated in a similar manner.

23 See, for example, Wilkinson 1973, nos. 14, 21, and 55.

24 Strauss 1965, p. 232.4.

25 Such is David Whitehouse's interpretation in the records of the Corning Museum.

26 The photograph published in the sale catalogue (see Provenance) shows the ewer standing on a high tapered foot that was decorated with an applied spiraling thread. This foot is now missing, but it too was probably a replacement.

27 See, for example, cat. 56; and Fukai 1977, nos. 64, 76.

28 Riis–Poulsen (1957, p. 61) attribute the bottle to the fourteenth century, though it is more likely to date from the twelfth.

29 Lamm (1929–30, p. 265, no. 89) attributes it to the glass workshops of Raqqa.

30 The pitcher is dated ca. 1100–1300 by Riis–Poulsen (1957, pp. 57–58). The applied prunts are discussed as a hallmark of late medieval Syrian glass production under cat. 47; see also cat. 38c.

31 See, for example, Lamm 1935, pl. 41c; and Kiani 1984, pp. 84–85, fig. 46.

32 See Carboni forthcoming, p. 18. In addition to a large number of folded-out rims, a fragment of a large-mouthed vessel with trailed decoration was found at Mantai, Sri Lanka, which was a trading place on the Indian Ocean until the eleventh century.

33 Smith 1957, p. 213, no. 423.

34 The beaker is presently in the Corning Museum of Glass (inv. no. 55.1.97). Its shape and festoon decoration (see cat. 2, Related Works 1, 3, and 5) support Smith's attribution, though parallels for its shape can be found also in the Iranian area.

35 Handles surmounted by small animals seldom survive, since they usually break before other parts of the vessel. For another example of a fragment showing a stylized feline on top of the handle, see Kozloff 1981, no. 44.

36 A comparable ewer was sold at Sotheby's, London, sale, April 21–22, 1980, lot 328.

37 This type of sprinkler is called a *qumqum* in Arabic (see cat. 37, 60, 95).

38 See, respectively, Corning 1955, no. 64; Öney 1990, pl. 1a;

and Lamm 1929–30, pp. 89–90, pl. 27:15.

39 When published in Lucerne 1981, this lid was arbitrarily put over the small bowl (cat. 70a), probably because it happened to fit well. Two similar small lids are in the Benaki Museum, Athens (Clairmont 1977, pl. 19, no. 266), and, at the time of publication, in Carl Johan Lamm's collection (Lamm 1929–30, pls. 26:3, 4). Lamm's and Clairmont's attributions are to ninth- or tenth-century Egypt, which is presently accepted with some reservations, since it was mainly based on the association of these lids with the small bowls discussed above.

40 This bird, though slightly incomplete, is one of the few zoomorphic glass figures to survive from the Islamic period. Its function as a toy seems to be confirmed by the hole at the bottom, which probably served as the socket for a wooden stick on which the figurine could be held. Comparable examples of extant figures of animals are a bird (private collection, Tokyo; see Fukai 1977, no. 89), a perfume sprinkler in the shape of a cat (Glass and Ceramic Museum, Tehran; see Tehrani 1987, pl. 9), a fantastic animal (private collection; Lucerne 1981, no. 486), and a ewer in the shape of a stylized camel (Los Angeles County Museum of Art; see von Saldern 1980, no. 183); see also Lamm 1929–30, pls. 25:3, 5, 13.

41 These two heads came to the Collection glued together in the form of a fantastic bicephalous animal. They had been joined arbitrarily, however, since they clearly represent the two heads and foreparts of separate zoomorphic figures.

42 The shape of this bottle is strongly reminiscent of bronze and silver rosewater sprinklers attributed to the same period or slightly later; see, for example, Atıl et al. 1985, pp. 83–86.

43 Cat. 3.24 has the same shape as cat. 3.22 and 3.23, which have been attributed to the Iranian area on the basis of objects with comparable applied motifs. Its decoration, however, seems to be much closer to that on a beaker (cat. 47) that is attributed to Syria in the Ayyubid period. For this reason, either an Iranian or a Syrian origin is possible.

44 The shapes of cat. 3.25a and b seem to relate the two beakers to the general group of cat. 41. Their simple decoration and the possibility that they may represent the cups of a goblet without its stem also make it possible that they were produced in the Iranian area somewhat earlier than the proposed period.

45 A fragmentary bottle excavated at Raqqa (National Museum, Damascus) provides a good match for this type of trailed network decoration (see Damascus 1964, fig. 16, no. 171).

# GLASS WITH MOLD-BLOWN PATTERNS

ALMOST AS OLD AS THE HISTORY of blown glass itself, the technique of blowing glass in a mold was already being fully exploited in the workshops of the Roman Empire by the first or second century A.D., particularly in the Eastern Mediterranean region.[1] Such widespread use of molded glass only a century or so later than the "invention" of glass blowing suggests, on one hand, that it was dictated by the popularity that the medium enjoyed and by the consequent need for mass-production; on the other hand, it implies that molded Roman glass was not conceived as a cheap substitute for the time-consuming cut decoration, but that, like other decorative techniques, it followed its own independent development. This possibility must also be considered in the case of molded Islamic glass, which is often regarded as an expedient method to save time and effort and to produce cheaper, more marketable objects.[2]

Molded glass should be treated, therefore, as an individual branch of Islamic glassmaking, not necessarily comparable to other types, such as relief-cut glass. Admittedly, masterpieces of relief-cut glass, such as the so-called Corning and Buckley Ewers, are far more accomplished from both an artistic and a technical point of view than any surviving molded object, but this parallel is as unfair as comparing molded Roman glass objects to the Portland Vase or to one of the few surviving diatreta bowls. By its very nature, molded glass was duplicable to a certain extent (even though profile and finishing details of a given vessel may have differed from those of another object impressed in the same mold) and was therefore less costly and destined for a larger clientele. Virtually nothing is known, however, of the appreciation for molded glass in the medieval Islamic period. Hypothetically, it is possible that a single craftsman could have made a set of bowls bearing identical impressed decoration and color, in a special mold which was prepared and then discarded to avoid further duplication, and that this matching set could have been a prized possession in a wealthy person's home.

Furthermore, the technology employed for molded glass was not as simple as it may seem. Just as the finished objects were sent to the engraver for cold cutting, a mold had to be conceived, prepared, and often cast in bronze[3] before a glass vessel was created. In both cases the glassmaker had to avail himself of another craftsman's skill in order to accomplish his task, thus making the chain of production more complex. Before beginning his work, a glassmaker would have to obtain a mold from a moldmaker who was perhaps associated with the glass workshop itself or was an independent craftsman working for other craftsmen as well. It is unlikely that the moldmaker would have worked exclusively for glass factories, since a skilled metalworker certainly would not have limited himself to producing glass molds. Within a community of artisans, such as in the workshop quarters of Fustat or Nishapur, a glassmaker would have probably commissioned his molds from the neighboring metalworker.

The only two extant bronze dip molds are roughly in the shape of a beaker (hgts. 8 cm and 11.4 cm) whose interior presents the decoration meant to be impressed, in reverse, on the exterior walls of the glass vessel. The glassmaker collected a glass gob (the parison) on the blowpipe, inserted it inside the mold, and then inflated the parison until the exterior surface of the bubble was impressed neatly by the pattern of the mold. Immediately afterward, the glass was withdrawn from the mold and the process of tooling began.[4] This process often involved subsequent reblowing outside the mold (so-called optic blowing), which created a shallower relief on the exterior surface; at the same time, the decorative pattern was countersunk on the interior surface of the vessel.[5] Once the desired size of the molded bubble was achieved, the shape of the object was created by manipulation,

and the usual process of transfer of the vessel from the blowpipe to the pontil, decoration with applied trails and so on took place in order to create the finished product. Optic blowing combined with the freedom of manipulation of a mold-blown object made the process creative and exclusive.

Although only one type of mold (the dip mold) has survived, many glass objects evidently were blown into two-part molds. These vessels clearly show diametrically opposite vertical seams in relief that were not meant to be part of the decorative program. A two-part mold consisted of two hemispherical sections, both carved with decorative patterns, that were fastened together and then reopened. The parison at the end of the blowpipe was locked inside the two sections of the mold; the glassmaker blew the parison inside the mold to impress its pattern; and, finally, the two sides were reopened and the glassmaker finished the product outside the mold. Thus, the adjoining sides of the mold are also visible on the glass itself in the form of vertical lines in relief. Sometimes, the moldmaker cleverly conceived decorative patterns that included vertical lines at regular intervals, so that the actual seams would be almost unnoticeable. In a few cases, this result was so successful that it is almost impossible to tell whether a dip mold or a two-part mold was used. Lamm believed he had identified a two-part mold in two hemispherical sections made of terracotta, presently in Corning and Tel Aviv,[6] but his theory was recently disproved by von Folsach and Whitehouse, who convincingly demonstrated that such molds could not have been used to produce objects made of glass.[7] Nevertheless, there is no doubt that two-part molds were familiar tools of glassmakers in Islamic countries.

The ten similar bottles (cat. 64a–d, 3.45a–f) suggest that, in addition to beaker-shaped and two-part bronze molds, less durable and more disposable materials were employed to produce molds, though no examples survive. Most likely, they were made of terracotta or clay. Neither considerable skill nor much time were required to carve or stamp these molds (see especially cat. 64a, b) and they were probably discarded after ten or perhaps fifteen objects had been blown in them. However, the evidence provided by cat. 64a–d requires corroboration and does not clarify whether terracotta molds in one or two parts, or both types, were used.

From the eastern Mediterranean region, glass molding spread quickly during the early Islamic period to cover the entire area in which Islamic glass was produced. The following entries include objects ranging from Egypt and Syria in the west to Central Asia in the east, with an overwhelming predominance from the Iranian area—molded glass enjoyed great popularity during the Seljuq period in Iran, and, therefore, a large number of works have survived to the present day. The earlier period, however, also witnessed a considerable production of molded glass, especially in the Syrian and Mesopotamian regions, though it survives mostly in fragments.

The Central Islamic lands are represented by the two so-called Baghdad ewers (cat. 48a, b), an inscribed bottle (cat. 48c), a small bottle with palmette motifs and an eagle stamped underneath its base (cat. 49), and a Samarra-inspired bottle (cat. 50). The two inscribed ewers and the vase can be studied within a group of objects of similar shape most likely produced in the ninth or early tenth century. These works are important in that they represent those extremely rare glass objects that bear the signature of the craftsman who produced either the mold or the final work. Furthermore, though a precise reading of their inscriptions is still unresolved, cat. 48a and b, in particular, together with seven others produced in the same mold may also indicate the place of their manufacture—namely, Baghdad. The small bottle with palmette motifs (cat. 49) and the larger bottle of similar shape (cat. 50) owe their decoration to the artistic language that developed in Samarra in the ninth century. The former is extremely appealing for the ingenuity of its decoration and for the presence of a stylized bird underneath its base, which may be a factory stamp; the decoration of the latter is subtler, partly because of the dark green color of the glass itself, but it is nonetheless a rare piece that has no exact parallels in surviving objects.

The only object that can safely be attributed to Egypt or Syria, with a slight preference for the latter, is the Ayyubid *qumqum* (cat. 60). Its flattened globular shape, long neck, and pinprick-sized opening are typical of Ayyubid production from the twelfth century through the Mamluk period, in the fourteenth century. Usually left entirely undecorated or decorated with enamels or white opaque marvered threads (see, for example, cat. 37, 83, and 95), these *qamāqim* were in rare instances molded into vertical ribbed patterns and were subsequently optic blown, manipulated, and twisted to create diverse effects. Invariably, molded *qamāqim* are made of clear glass, usually green, to highlight the subtle modeling of their surface.

A number of objects that are somewhat reluctantly assigned an Iranian origin are difficult to attribute because of the paucity of secure points of reference in the study of Islamic glass. This small group includes, for example, four bowls (cat. 52a, b, 57a, b), a beaker with chevron patterns (cat. 54), a large pear-shaped ewer with ribbed decoration (cat. 56), and a large pitcher with a faded gilded pattern (cat. 61). It is possible, however, that future research will result in different conclusions and attributions.

Archaeological excavations are useful in attributing objects to specific areas east and north of Iran. The type represented by three ribbed and twisted vessels (cat. 51a–c) has consistently surfaced in present-day Uzbekistan, so it is reasonable to assign

it to this region, which has only recently been recognized as an area of glass production.[8] Two small bottles with lozenge patterns in relief (cat. 58a, b) may also be from the same area.

Before Iranian glass became standardized in the twelfth and thirteenth centuries, molded objects do not seem to have been common, possibly because of the predominance of wheel-cut glass. A bottle (cat. 55), whose shape is related to Nishapur material from the tenth and eleventh centuries, provides an excellent example of early Iranian two-part molding, which was probably inspired by Mesopotamian models, judging by its vertical inclination, symmetrical arrangement of elements, and high relief. Also unmistakably Iranian and likely Seljuq in shape is an appealing but unfortunately fragmentary bright blue bowl with a lobed profile and a bold, stylized leafy decoration that runs around its walls (cat. 59); in a pristine condition, it must have been an exquisite object.

Typical Iranian glass from the twelfth and thirteenth centuries is represented by vessels carrying a network of patterns that cover the entire surface except the neck. The motifs include variations of designs familiar in the earlier wheel-cut production, such as the honeycomb pattern (see cat. 53b, 66) or the omphalos pattern, which is often enclosed within geometrical figures

(see cat. 53a, 62). An interesting variant is provided by the heart-shaped elements that decorate a small bottle (cat. 63). The so-called concentric rosette pattern, one of the most complex designs in this group of molded Iranian glass, consists of the combination of a stylized multipetaled flower with of a series of concentric figures that vaguely resemble flower petals: the overall effect is that of a large composite flower that seems to float on the glass surface (cat. 67). On another bottle (cat. 65), simple curly vegetal patterns are joined by short stems, large sections of the glass surface having been left undecorated. The exception to the general rule of abstract—either geometric or vegetal—motifs is evident on two bottles (cat. 68a, b) that present circular medallions incorporating the figure of a peacock seen in profile; this exception may represent the survival of earlier traditions, rather than an innovation of twelfth-century moldmakers. All these patterns appear on bottles of three basic shapes: globular with a short neck (cat. 63), globular with a long neck that can be tooled in different ways and a kicked base (cat. 67, 68), and dome-shaped with a flattened base and a slightly flared neck (cat. 65). The large number of such bottles in public and private collections reveals that shapes and decorative patterns are interchangeable, making the group more homogeneous than it may seem at first.

### Cat. 48a EWER (LNS 44 KG)
**Mesopotamian region**
**9th century**

Dimensions: hgt. 10.5 cm; max. diam. 6.4 cm;
th. 0.25 cm; wt. 60.5 g.; cap. 150 ml
Color: Translucent greenish colorless
Technique: Mold blown; tooled;
worked on the pontil
Description: This small pear-shaped ewer has
a flattened base with a slight kick,
a narrow neck ending in an opening
with a pointed spout, and an applied
L-shaped handle with a folded thumb
rest. The object was blown in a two-
part mold; one of the two vertical

seams is partially covered by the
attachment of the handle. The
decoration in relief consists of two rows
of Kufic calligraphy separated by rows
of dots in relief. A horizontal line is
visible near the base; below it are dots
in relief. The inscription reads:

مما عمل (للامير؟) ببغدا[د؟]
/ عمل طيب بن احمد (برمسي؟)

("Among that which was made for the
amir in Baghda[d?] / The work of
Ṭayyib ibn Aḥmad Barmasī[?]").

Condition: The object is intact except for the
replaced tip of the spout. The surface
is entirely weathered, resulting in a
pale brown coating and iridescence.
Provenance: A. Churchill, Ltd. collection, London;
Elie Bustros collection, Beirut; Kofler
collection
Literature: Rice 1958, pls. 6a, b; and Lucerne 1981,
no. 558

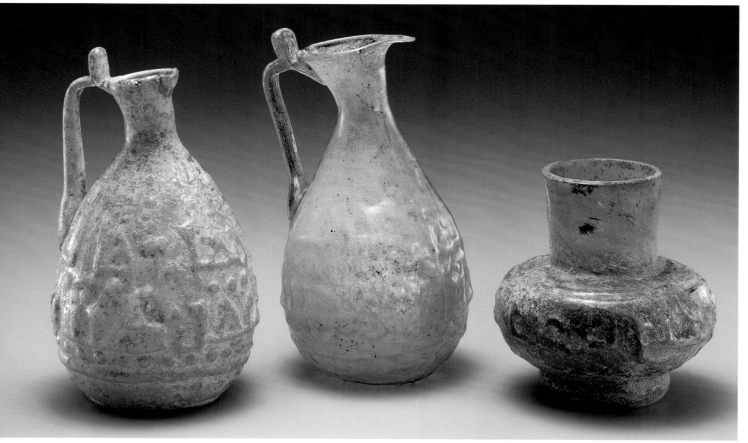

Cat. 48a–c

**Cat. 48b EWER (LNS 49 KG)**
**Mesopotamian region**
**9th century**

Dimensions: hgt. 10.8 cm; max. diam. 6.0 cm;
th. 0.21 cm; wt. 54.7 g; cap. 130 ml
Color: Translucent greenish yellowish colorless
Technique: Mold blown; tooled; worked on
the pontil
Description: This small ewer is nearly identical to
cat. 48a; it was blown in the same mold,
though the decoration is in lower relief
and barely visible.
Condition: The object is intact. The neck
was clumsily pinched, probably
unintentionally. The surface is partially
weathered, resulting in a milky white
film and iridescence.
Provenance: Elie Bustros collection, Beirut;
Kofler collection
Literature: Rice 1958, pl. 5b; and Lucerne 1981,
no. 557
Related Works: 1. Toledo, inv. no. 23.2078
(Rice 1958, pls. 4a, b)
2. MMA, inv. no. X.21.191 (Rice 1958,
pl. 5a; and Jenkins 1986, no. 14)
3. CMG, inv. no. 72.1.20
4. MFI, inv. nos. 13104, 16373
('Abd al-Ra'uf 1971, fig. 1)
5. Oppenländer collection,
inv. no. 22337 (von Saldern et al.
1974, no. 754)
6. Whereabouts unknown
(Sotheby's, London, sale,
October 10, 1990, lot 61)

**Cat. 48c BOTTLE (LNS 358 G)**
**Probably Mesopotamian region**
**9th century**

Dimensions: hgt. 7.1 cm; max. diam. 6.6 cm;
th. 0.19 cm; wt. 68.6 g; cap. 100 ml
Color: Translucent pale green (green 1–2)
Technique: Mold blown; tooled; worked on
the pontil
Description: This small bottle, created in a two-part
mold, has a flattened globular body,
a molded low circular foot, and a
cylindrical neck (hgt. ca. 3.0 cm). The
decoration around the body is enclosed
between two sunken horizontal lines; it
includes a Kufic inscription that reads:
عمل علي بن احمد (صبرا؟)
("The work of 'Alī ibn Aḥmad
Ṣabrā[?]").
Condition: The object is intact. The surface is
entirely weathered, resulting in gray,
pale brown, and whitish coatings. The
glass includes scattered small bubbles.
Provenance: Reportedly from Qala-i naw (Badghis)
or Herat, Afghanistan

Cat. 48a and b, nearly identical in shape, size, and decoration, belong to a group of about twenty known small ewers that bear molded Kufic inscriptions. In particular, Related Works 1–6 and cat. 48a and b form a smaller group of nine objects that present the same inscription and probably were blown in the same mold.[9]

Cat. 48a and ewers in Toledo and Corning (Related Works 1, 3) are the three objects of the group with inscriptions in the highest relief, and they are, therefore, the most useful when attempting to interpret the calligraphy. An accurate reading of the first line is of the utmost importance, since it may include the name of the amir who commissioned the work or, perhaps, the place of production. The name of the craftsman (either the maker of the mold or the glassmaker) is inscribed on the lower line; his *nisba* presents some interpretative problems, but the most likely reading seems to be "Barmasī" (from Barmas, in Iranian Azerbaijan; another possible reading is "Tirmisī," from Tirmis, in the region of Najd, Saudi Arabia).[10] Unfortunately, the most meaningful word (probably the name of the amir) remains unclear.[11] Meticulous study of the nine objects that belong to this group, however, does not solve the problem. The line doubtless begins: "Among that which was made (*mimmā 'umila*)." The central word, separated by one of the two vertical seams, is almost certainly "for the amir (*li-l-amīr*)." The last word, assuming that the last letter has vanished under the second vertical seam in all nine ewers, may be interpreted "in Baghda[d] (*bi-baghdā[d]*)." Unfortunately, a translation of the line as "Among that which was made for the amir in Baghdad" is far from satisfactory, as the ruler is not identified, which is unusual in Arabic inscriptions. In accepting the reading "for the amir," his proper name (and not the name of a place) would be expected to follow; otherwise, if the reading "in Baghdad" is accepted, a proper name (not just a title, such as *amīr*) would be expected to precede it. Furthermore, a translation such as "for the amir of Baghdad," which would offer a solution to the missing proper name, would read differently in Arabic, since the initial letter "b" in *bi-baghdād* would be dropped for grammatical reasons.

Notwithstanding the problems posed by the inscription, an attribution to the Mesopotamian area, possibly to Baghdad itself, is supported by related molded ewers of similar dimensions (or sometimes larger) and shape that present inscriptions or figural motifs. One of them, said to have been found in Kufa, includes the name of another maker, 'Umar ibn Ibrāhīm;[12] another, excavated in Iraq, shows two confronted birds in profile separated by a tree;[13] a third and larger ewer, found at Ghubayra in Iran, is seemingly decorated with stylized human figures.[14] If other small ewers produced in the same mold as cat. 48a and b are found in the near future, they may prove useful in completing the interpretation of the inscription. At the moment, however, an attribution to ninth-century Mesopotamia seems the most plausible.

The small bottle (cat. 48c) is rather nondescript and its profile inharmonious: the foot seems to be too high for the small, flattened globular body and the neck too large and tall compared to the rest of the object. What is interesting about this bottle is the inscription that encircles the body, which was copied in Kufic calligraphy similar to that on cat. 48a and b. Only the name of the maker (of either the mold or the glass) is recorded with the usual formula, rather common in the ninth and tenth centuries: "The work of" followed by the name. The glass craftsman 'Alī ibn Aḥmad Ṣabrā (the reading of the last part of the name is uncertain, but represents the best option) is thus far unrecorded. Notwithstanding its reputed provenance, the style of the inscription and the use of the signature formula on glass link this bottle to the two ewers (cat. 48a, b) and to the general group of molded signed objects mentioned above.

**Cat. 49 SMALL BOTTLE (LNS 70 KG)**
**Probably Mesopotamian region**
**9th–10th century**

Dimensions: hgt. 6.6 cm; max. diam. 5.0 cm;
th. 0.24 cm; wt. 67.8 g; cap. 52 ml
Color: Translucent bluish green (green 2–3)
Technique: Mold blown; tooled
Description: This small cylindrical bottle has a flat
base, an angular shoulder, a cylindrical
neck, and a large splayed opening. The
molded decoration is divided into eight
sections by vertical lines; each section
contains two stylized palmette motifs
arranged one above the other. Beneath
the base is the stylized image of an
eagle (slightly off-center), seen frontally
with open wings and its head turned to
the left, inside the outline of a circle.
Condition: The object is intact. The surface is
entirely weathered, resulting in a pale
brown coating and iridescence.
Provenance: Kofler collection
Literature: Lucerne 1981, no. 547
Related Works: 1.  MMA, inv. no. 1996.408
2.  MIK, inv. no. I.2139
(Kröger 1984, no. 87)

This small bottle seems to be one of only three surviving objects produced from the same mold, which includes palmette motifs around the body and an eagle underneath the base (Related Works 1, 2). None of the three shows evidence of a pontil mark, which suggests that they were molded and subsequently tooled while still attached to the blowpipe. The bottles bear similar reliefs and were probably blown again outside the mold (optic blown). The eagle at the bottom, which has no signs of seams, further suggests that a small, single-part, cylindrical mold was used to produce the pattern.

A recent acquisition of the Metropolitan Museum (Related Work 1) has a short neck and a large opening and is, therefore, a small jar. Previously unrecorded in the literature, it is of an appealing pale blue color and is in good condition. The object in Berlin (Related Work 2) is made of clear glass and the neck is missing, but the profile was probably similar to that of cat. 49.[15] The three pieces are also similar in size, the bottle in Berlin being 4.6 centimeters high (the neck missing) and 4.8 centimeters in diameter; the jar in New York, 5.1 centimeters high (a short neck) and 4.4 centimeters in diameter.

The palmette decoration accords well with ninth-century Samarran production, though its stylization is slightly reminiscent of later objects; it may have been executed in imitation of earlier models after the decorative language created in Samarra spread throughout the Islamic world.[16] The image of the eagle, which is itself reminiscent of the development of abstract shapes into stylized animal figures following the birth of the beveled style in Samarra, may represent a factory stamp since, for obvious reasons, it is not visible in normal conditions.

The only object of the group that has a reputed provenance is the Berlin bottle, which apparently was acquired by Friedrich Sarre in Baghdad. The Mesopotamian area remains the most likely place of manufacture for cat. 49 and Related Works 1 and 2, though an alternative attribution may be the Iranian region.

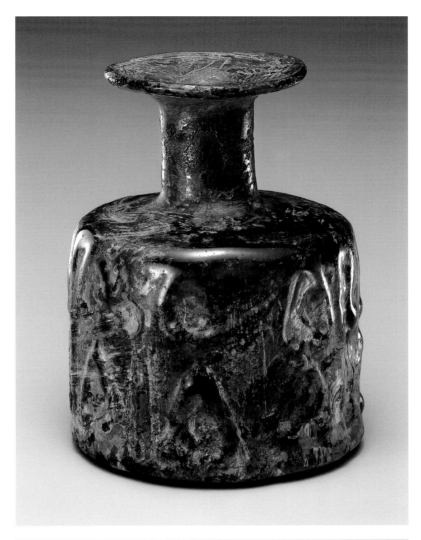

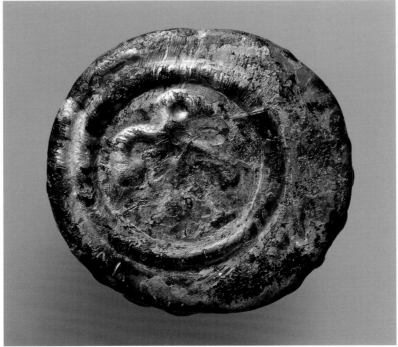

Cat. 49 and detail of base

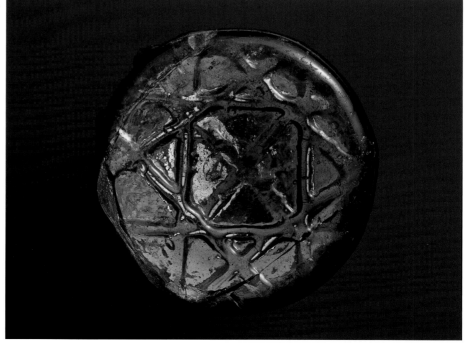

**Cat. 50 BOTTLE (LNS 94 G)**
**Probably Mesopotamian region**
**10th century**

Dimensions: hgt. 10.7 cm; max. diam. 6.5 cm;
th. 0.33 cm; wt. 185.6 g; cap. 146 ml
Color: Translucent dark green (green 4)
Technique: Mold blown; tooled;
worked on the pontil
Description: This small cylindrical bottle has a flat
base, a curved shoulder, and a slightly
flared neck. The decoration, created in
a single-part mold, consists of a series
of twelve stylized pointed arches in
relief extending from the base almost
to reach the shoulder; two of the arches
are higher, and two are not entirely in
relief at their opposite ends, which
makes the decoration less repetitive.
Semicircles in relief complete the
decoration just below the shoulder;
a sunken horizontal line is visible just
above the base. Underneath the base is
a geometric motif of intersecting lines
that form an incomplete eight-pointed
star that was also produced in the
mold. The pontil mark covers part of
the decoration underneath the base.
Condition: The object was broken and repaired;
it is complete except for small chips.
The surface is in good condition.
The glass includes frequent small
bubbles, scattered large bubbles,
and one very large bubble.

The molded decoration of this well-preserved dark green bottle was not commonly produced in the Islamic world, though it includes the rather familiar image of a series of stylized arches (see cat. 23). No other objects made in the same mold are known, but the pseudoarchitectural patterning is a conventional motif that helps to suggest both a place and date of production. The closest parallels for this type of decoration can be found in fragmentary friezes in plaster excavated at Samarra (mid-ninth century), in which arched patterns were created by means of simple vertical elements based on the combination of a circle (or concentric circles) at the bottom and a column.[17]

The impressed pattern on this bottle was produced in a single-part mold, the bottom of which was also decorated with geometric motifs. The glassmaker was evidently so accustomed to transferring an object from the blowpipe to the pontil for further tooling that he also did so here, leaving the pontil mark underneath the base and partially spoiling the pattern originally impressed. This aspect, which is seldom encountered on early Islamic glass objects,[18] supports the impression that the bottle was produced slightly later, most likely in the tenth century.

Cat. 50 detail of base                                           Cat. 50 ➤

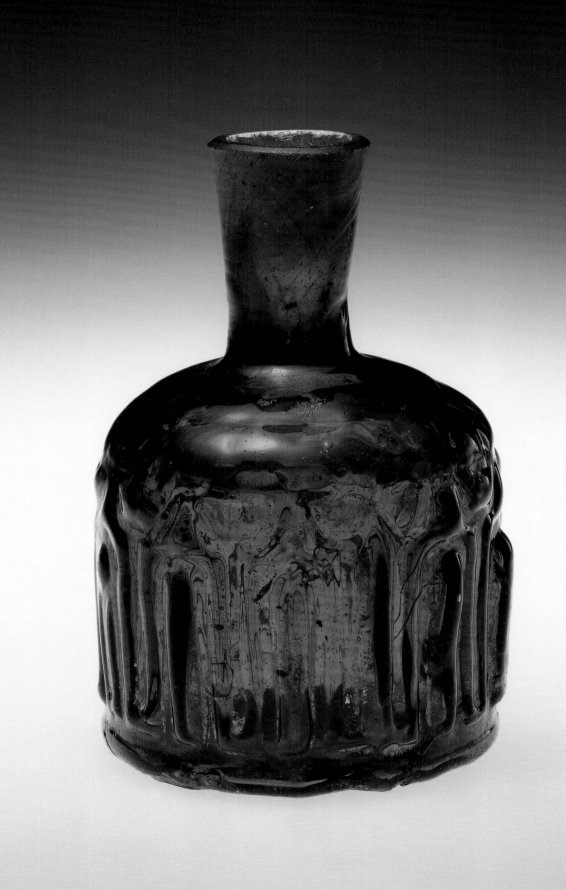

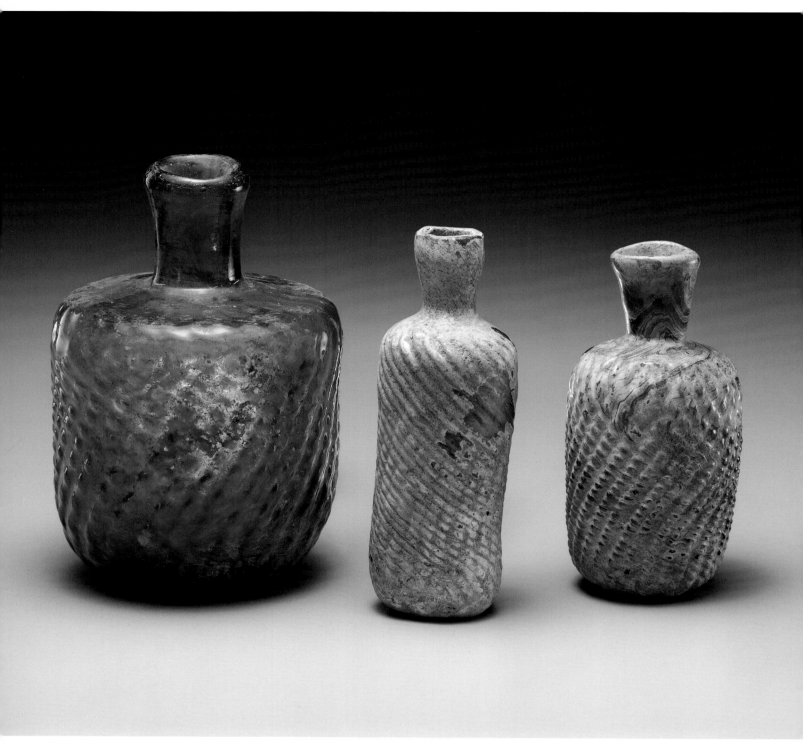

Cat. 51a–c

### Cat. 51a BOTTLE (LNS 54 G)
**Iranian or Central Asian region
10th–11th century**

Dimensions: hgt. 11.5 cm; max. diam. 7.5 cm;
th. 0.60 cm; wt. 257.9 g; cap. 222 ml
Color: Translucent green (green 2)
Technique: Mold blown; tooled; worked on
the pontil
Description: This slightly lopsided, nearly cylindrical
bottle has an angular shoulder and a
short narrow neck with a bulge at the
opening. The pontil mark under the
base is unusually large. The decoration
consists of thirty ridged vertical ribs
twisted slightly counterclockwise
outside the mold.
Condition: The object is intact. The surface is
partially weathered, resulting in a
whitish milky coating. The glass
includes scattered small bubbles.

### Cat. 51b BOTTLE (LNS 167 G)
**Iranian or Central Asian region
10th–11th century**

Dimensions: hgt. 9.7 cm; max. diam. 3.5 cm;
th. 0.30 cm; wt. 66.2 g; cap. 32 ml
Color: Translucent pale green (green 1–2)
Technique: Mold blown; tooled; worked on
the pontil
Description: This bottle has an irregular cylindrical
body, a curved shoulder, a short flared
neck that bulges at the opening, and a
slightly kicked base. The decoration
consists of twenty-five ridged vertical
ribs twisted clockwise outside the mold.
Condition: The object is intact. The surface is
entirely weathered, resulting in a pale
brown coating and iridescence.
Provenance: Reportedly from northern Afghanistan

### Cat. 51c BOTTLE (LNS 295 G)
**Iranian or Central Asian region
10th–11th century**

Dimensions: hgt. 9.0 cm; max. diam. 4.4 cm;
th. 0.30 cm; wt. 74.0 g; cap. 63 ml
Color: Translucent pale yellowish green
(green 1–2)
Technique: Mold blown; tooled; worked on
the pontil
Description: This cylindrical bottle has an angular
shoulder and a short flared neck. The
decoration consists of twenty-seven
ridged vertical ribs twisted slightly
counterclockwise outside the mold.
Condition: The object is intact. The surface is
entirely weathered, resulting in a pale
brown coating that has a marbleized
appearance.
Provenance: Reportedly from Herat, Afghanistan

Related Works: 1. MAIP, inv. nos. 3234, 21944
(Kröger 1995, no. 120; Ruhfar 1996,
glass section, no. 2; and Kordmahini
1988, p. 75)
2. MHC, inv. nos. A-31-2, A-391-3,
A-32-131 (Paris 1992, p. 26; and
Abdullaev et al. 1991, no. 638)
3. Khamza (Abdullaev at al. 1991,
no. 537)
4. MK, inv. no. 12418/5097
(Ohm 1973, no. 80)

The decoration of these three small vessels (cat. 51a–c) was created in a mold similar to one of the only two surviving molds—namely, a bronze dip mold decorated with small lozenge-shaped bosses now in the Corning Museum of Glass.[19] The vertical ribs were twisted by the glassmaker to create the final ridged decoration in the mold.

All evidence points to an eastern Iranian or a Central Asian attribution, particularly the area of Transoxiana, for this type of vessel. The group consists almost invariably of small green bottles with a cylindrical profile and a short neck that ends in a bulged opening.[20] Both the shapes of the vessels and the type of opening seem to point to an early period of Islamic glass production, probably before the eleventh century and more likely in the tenth.

Dating and provenance are confirmed by archaeological evidence gathered in Uzbekistan. Three related objects were excavated at Afrasiyab (Samarqand) in a ninth- or tenth-century context (Related Work 2) and at Gormalitepa, in the region of Tokharistan, in a tenth- or eleventh-century layer (Related Work 3). The bottle, now in Tehran (Related Work 1, inv. no. 3234), that was found in Nishapur in 1935 by a team from the Metropolitan Museum, was dated to the tenth or eleventh century by Kröger, who explained that "the pattern must have been widely used in the Nishapur region, as fragments carrying it were found at K1, Tepe Madraseh, and Sabz Pushan."[21] He further suggested, after quoting a number of parallels (including one formerly in a collection in Cairo), that the pattern was also popular west of Iran.[22] However, recently published comparative material excavated in Uzbekistan is virtually identical to cat. 51a–c in shape and decoration, unlike the examples quoted by Kröger, which relate only to the patterning, rather than the shape, of the objects. Furthermore, cat. 51b and c are said to have been found in northwestern Afghanistan, thus confirming the provenance of these small bottles from Khorasan and Transoxiana.

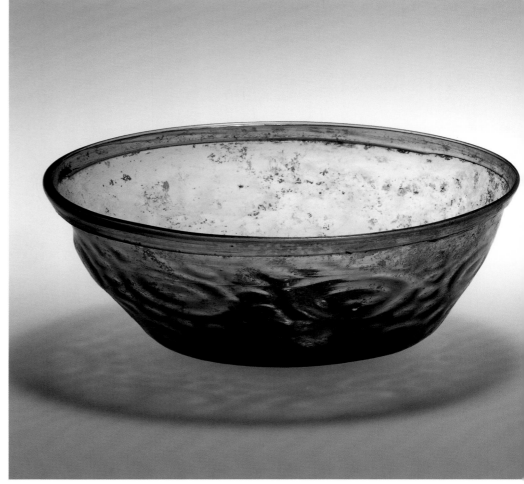

Cat. 52a, b

**Cat. 52a BOWL (LNS 172 G)**
**Iranian region**
**10th–11th century**

Dimensions: hgt. 6.2 cm; max. diam. 17.7 cm;
th. 0.16 cm; wt. 222.4 g; cap. ca. 800 ml
Color: Translucent green (green 2)
Technique: Mold blown; tooled;
worked on the pontil
Description: This slightly lopsided bowl has
irregular flared walls that curve inward
near the opening; the rim (hgt. 0.8 cm)
was created by folding the edge
outward. The molded decoration,
which is shallow and barely visible,
consists of two rows of eight omphalos
motifs framed by small circles.
Condition: The object is intact. The surface is
lightly weathered, resulting in a
brownish film and iridescence. The
glass includes scattered small bubbles
and brown filaments around the base.
Provenance: Reportedly from Mazar-i Sharif
(Balkh), Afghanistan

These two bowls, which, surprisingly, given their finely blown walls and open shapes, have survived intact, exemplify the close relationship between wheel-cut and molded glass in the Iranian world of the early Islamic period.

The decorative motifs of the omphalos (a raised disc with another small disc or prunt in relief in the center; see cat. 16) and the honeycomb pattern (a decoration of sunken hexagons; see cat. 9) belong to the Iranian area and were adopted by Islamic glassmakers who found inspiration in Sasanian decorative prototypes. When molded glass vessels also became popular in the Iranian region, the existing ornamental language, which was readily available from relief-cut glass vessels, probably provided the ideal background to create decorative patterns for molds. Since the omphalos and honeycomb patterns were among the most popular and well-known motifs by the end of the ninth century, they were promptly adopted by the metalworkers who prepared bronze molds for the glassmakers.

Unlike relief-cut glass vessels, on which the omphalos pattern stands in high relief at regular intervals against a plain background, the same motif carved on a mold was often incorporated into a more complex network, so that the pattern becomes just one element, albeit the most prominent, of the composition (in the case of cat. 52a, the omphalos motifs are framed by simple circles). Furthermore, the technique of glass molding also allowed the craftsman to express himself more freely than the glass cutter as regards the final relief

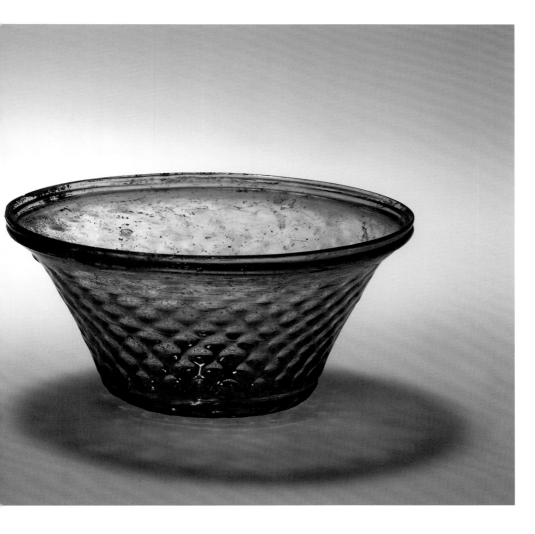

**Cat. 52b BOWL (LNS 49 G)**
**Iranian region**
**10th–11th century**

Dimensions: hgt. 6.7 cm; max. diam. 14.2 cm;
th. 0.25 cm; wt. 131.5 g; cap. ca. 550 ml
Color: Translucent pale bluish green (green 1)
Technique: Mold blown; tooled;
worked on the pontil
Description: This optic-blown bowl has flared curved
walls departing from a slightly kicked,
but otherwise flat, base; the rim is
straight and a lip tooled just below.
The decoration consists of an overall
pattern of sunken hexagons forming
a honeycomb motif; a seven-petaled
flower is visible around the pontil mark.
Condition: The object is intact. The surface is
partially weathered, resulting in a pale
brown coating. The glass includes
scattered large bubbles near the base.
Related Works: 1. MIK, inv. no. I.32/61
(Kröger 1984, no. 78)
2. KM, Düsseldorf, inv. no. P1966-59
(Ricke 1989, no. 72)
3. CMNH, inv. no. 25140/5
(Oliver Jr. 1980, no. 266)

effect he wanted to achieve. In other words, while the cutting technique was sculptural and needed strong lines and well-defined patterns, the re-blowing (or optic blowing) and tooling of a vessel after the pattern was impressed in a mold allowed the creation of softer reliefs and effects. The honeycomb motif on cut glass, for example, is often cut deeply into the surface of the vessel to create a dramatic effect of light and shade. In molded glass, on the other hand, the relief is sometimes so subtle that the pattern is barely discernible and easier to see with the aid of the shadow cast by the vessel. Cat. 52a and b clearly display these properties which make such molded-glass objects lighter and more appealing.

The decorative pattern of cat. 52b recalls the molding of three small vessels discussed previously (cat. 51a–c). The overall pattern of sunken hexagons, which creates a variation of the honeycomb pattern, was produced in a mold similar to the bronze dip mold in the Corning Museum of Glass (see cat. 51). Here, the original pattern was not twisted and manipulated as in the case of the three small vessels, though it was clearly optic blown.

There are three objects comparable to cat. 52b: a bowl in bluish glass that includes a well-defined honeycomb pattern and is said to have been found at Gurgan (Related Work 1); a second bowl, in green glass, that has a twisted pattern similar to that of cat. 51a–c (Related Work 3); and a large shallow dish in pale purple glass with an overall network of sunken hexagons (Related Work 2).

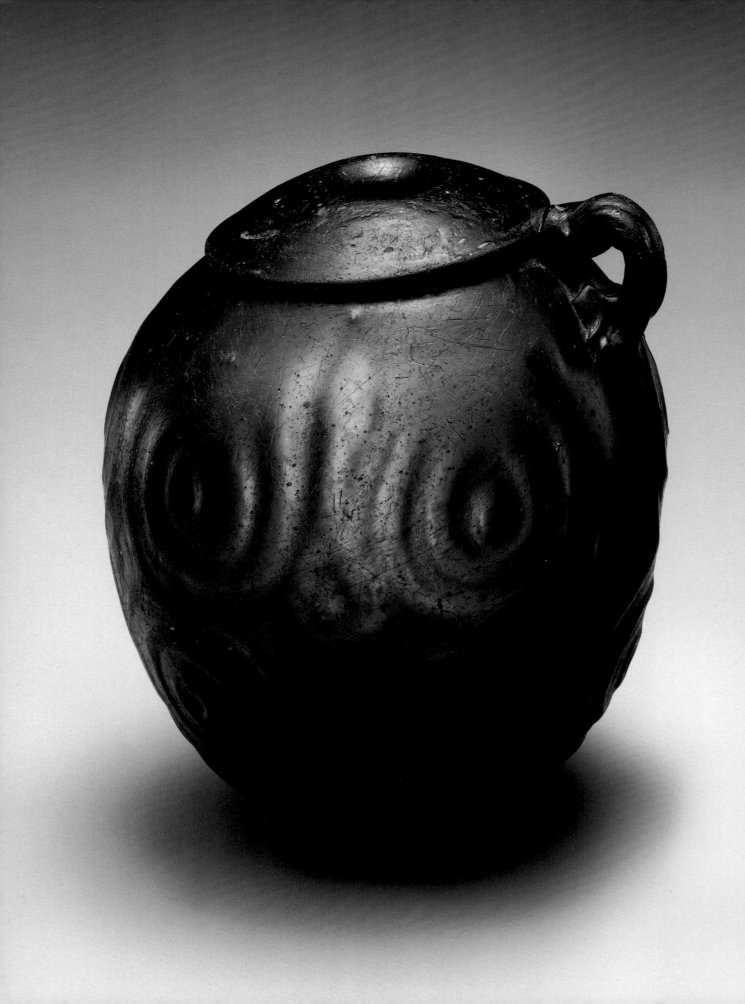

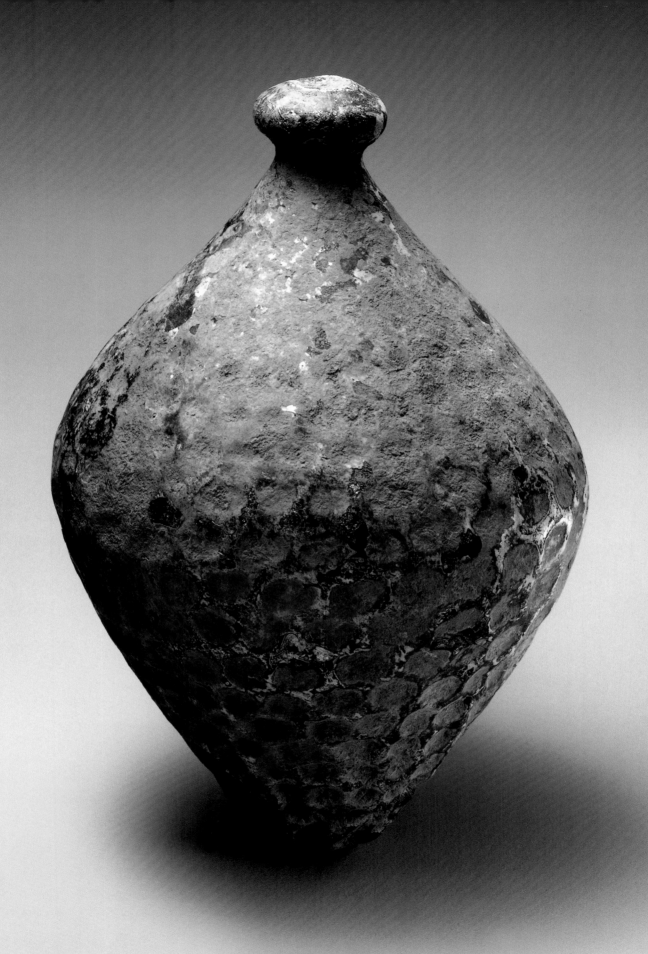

## Cat. 53a OVOID VESSEL (LNS 99 G)
### Iranian region
### 10th–11th century

Dimensions: hgt. 11.5 cm; max. diam. 9.0 cm;
th. 0.60 cm; wt. 357.8 g; cap. 360 ml
Color: Translucent dark yellowish green
(green 4)
Technique: Mold blown; tooled;
worked on the pontil
Description: This heavy, thick vessel has an ovoid
shape but no base and thus cannot
stand; a large disc, pierced in the center,
was applied on top and a small curved
handle was attached on one side of
the disc and the vessel. The molded
decoration, which is in low relief and
covers the entire surface, consists of
two rows of six omphalos patterns
separated by lozenges with a central
sunken circle; the decoration at the
bottom consists of a stylized six-petaled
flower, each petal represented by a
trefoil inside a triangle; the petals join
in the middle around the pontil mark.
The entire pattern is slightly irregular
due to subsequent tooling.
Condition: The object is intact except for a chip
on the applied disc. The surface is in
good condition with some abrasion.
The glass includes frequent small
bubbles and scattered larger ones.
Provenance: Sotheby's, London, sale, April 21–22,
1980, lot 316
Literature: Lucerne 1981, no. 546
Related Works: 1. MAIP, inv. no. 21893
(Kordmahini 1988, p. 80)
2. Whereabouts unknown
(Ohm 1975, no. 172, pl. 21)
3. Nasser D. Khalili collection, London,
inv. no. GLS 137 (Maddison–
Savage-Smith 1997, no. 212)
4. Formerly Madame Mohsen
Foroughi collection, Tehran
(Ettinghausen 1965, pl. 49a)
5. MIK, inv. no. I.4/55
(Kröger 1984, no. 91)
6. CMG, inv. no. 70.1.1

These two vessels, though different in shape and decoration, are datable to the same period and have a similar place of origin; they are also unusual in that their use and function are unclear.

The ovoid vessel (cat. 53a) displays a molded omphalos pattern similar to that on the bowl (cat. 52a), though its decoration is more complex, since it includes a geometric network and the single elements are not encircled by simple dots. A bottle in Tehran (Related Work 1) and a large beaker (Related Work 2) are good examples of similarly patterned surface ornament.

Cat. 53a is peculiar in both size and shape. Given its concave base, it would require a support to stand—unless it is supposed to hang from the small handle attached near its opening—but its large size and heavy weight seem to contradict this possibility. The closest parallels are provided by two slightly smaller vessels with almost identical profiles, one in London (Related Work 3), the other once in a private collection in Tehran (Related Work 4): the former is in blue glass (hgt. 9.4 cm; max. diam. 8.6 cm), the latter has been described as made of green glass (hgt. ca. 10 cm). The molded decoration of the London piece has a grape-cluster design within elongated ovoid panels (a similar pattern is seen on cat. 3.41); the object in Tehran includes a honeycomb motif.

Another similar vessel in Berlin (Related Work 5) presents a molded decoration, a small applied handle, and a profile like that of cat. 53a, though the base is pointed rather than curved. This object is tentatively identified as a lamp, which seems the most logical interpretation in light of the clear color of the glass, the rather large diameter of the opening at the top, and the dimensions of the object (hgt. 9.5 cm; diam. 6.5 cm). Cat. 53a, however, is larger and heavier than the so-called Berlin lamp, it is of a dark green color that would barely allow light to filter, and its opening is extremely small (diam. ca. 1 cm); thus it is unlikely that it ever functioned as a lamp (that is, a vessel filled with oil with a wick floating in the middle and suspended from a single handle). Its profile and exterior construction recall inkwells, such as cat. 33a and b, which have a cylindrical tube inserted through the opening, the upper part of which is folded over the opening itself; here, however, there is no tube and only an external band overlapping the opening. An example similar to cat. 53a but smaller (hgt. ca. 7 cm; diam. ca. 5.5 cm) in the Corning Museum (Related Work 6) seems identifiable as an inkwell, since its opening would not allow the insertion of anything but a *qalam*: made of dark blue glass, it is molded with vertical ribs, topped by a large applied disc and a single small handle, and does not have an inserted tube. The large size and weight of cat. 53a, however, make it unlikely that it was an inkwell; perhaps its purpose was symbolic and ceremonial rather than functional. Its decoration, however, leaves little doubt about its date and origin.

Cat. 53b represents a type of thick vessel that has fascinated scholars for well over a century. The lower part looks like a pinecone and the upper section is hemispherical: hence the common use of the term "sphero-conical." The great majority of sphero-conical vessels are made of unglazed earthenware or pottery: they are often plain and are sometimes decorated with incised, applied, or molded patterns and inscriptions. These objects were found at innumerable sites in the Islamic world between Egypt, Afghanistan, and the former Soviet Central Asian nations.[23] Important articles by Ettinghausen and Ghouchani–Adle demonstrate that these vessels were used for at least two purposes: as containers for quicksilver and for a fermented drink similar to beer, known as *fuqqāʿ*. In addition, they correctly dismiss former interpretations, such as those referring to hand grenades, aeolipiles (for Greek fire), and loom weights.[24]

◄ Cat. 53a, b

The number of extant sphero-conical vessels in glass is limited and represents only a fraction of those surviving in pottery (Related Works 7–14). In general, while their thickness, dimensions, and capacity can vary and some are heavy and solid, they are not as sturdy as the pottery vessels; thus, it is unlikely that they were used as containers for quicksilver or that they were transported long distances by camel. Their identification as vessels for *fuqqāʿ* seems likely: glass is less porous than pottery and thus the fermented liquid would have lasted longer and its odor would have not permeated the interior after only a few uses; in addition, the *fuqqāʿ* would have cooled faster when the vessel, with its pointed bottom, was safely inserted in a bed of crushed ice.[25] Thus a blown-glass vessel seems more appropriate and satisfactory than one made of heavy pottery.

The bulged opening of cat. 53b is typical of the majority of sphero-conical glass vessels (Related Works 8, 9, 10 [inv. no. C910-1935], 12) and was probably suitable for slowly drinking the fermented liquid. Although Related Work 7 has a decoration of sunken circles that is similar to that of cat. 53b, it has a larger, straighter neck and a wider opening that lacks a bulge. This latter type of opening and its slight variations represent the second small group of sphero-conical glass vessels (Related Works 7, 10 [inv. nos. C153-1936, C190-1937], 11, 13, 14). The narrow bulged opening would have been suitable for drinking *fuqqāʿ*; the slightly larger, second type of opening suggests that those vessels may have contained unfermented drinks and juices as well as perfumes and essences.

The chronological period for the production of sphero-conical objects in pottery has been established as ranging from the tenth to the thirteenth century and possibly the early fourteenth.[26] This span is confirmed by the glass examples, which include undecorated vessels (Related Works 8 [inv. no. GLS 569], 11, 12 [inv. no. 1975.61.1]); those with a molded pattern (Related Works 7, 8 [inv. no. GLS 553], 12 [inv. no. 1975.61.2]); some bearing mottled (Related Work 9) or enameled and gilded decoration (Related Works 10 [inv. no. C153-1936], 13, 14), and others with marvered trails (Related Work 10 [inv. nos. C910-1935, C190-1937]). Without a doubt, the Iranian region is the area of origin and all the plain and molded vessels were probably produced there, but the existence of enameled and gilded objects and the presence of marvered trails proves that the type was adopted by the Ayyubids and early Mamluks of Syria and Egypt. Two of the three known enameled examples (Related Works 10 [inv. no. C153-1936], 14) were made for the Rasulid sultan of Yemen, al-Ashraf ʿUmar (r. A.H. 694–96 /A.D. 1295–96); the third (Related Work 13) was made in the name of the Mamluk amir Alṭunbughā (ca. A.D. 1293) and confirms the popularity of this object at the close of the thirteenth century. Enameled and gilded objects were expensive and prized. These gourds were made for important personalities at the Mamluk court and were included among gifts to foreign rulers, such as the Rasulids of Yemen. They probably symbolized courtly pastimes and libation activities; it is not possible to establish whether they contained *fuqqāʿ* or other intoxicating drinks, but their function as drinking vessels is likely.[27] Indirectly, these enameled objects, therefore, confirm that the most common, or perhaps the only, use for this type of glass vessel was as a beverage container.

## Cat. 53b SPHERO-CONICAL VESSEL ("BEER" GOURD?) (LNS 1064 G)
### Iranian region
### 10th–11th century

Dimensions: hgt. 13.5 cm; max. diam. 9.0 cm; th. 0.50 cm; wt. 170.1 g; cap. 215 ml

Color: Translucent yellowish colorless

Technique: Mold blown; tooled; worked on the pontil

Description: This thick vessel has a pointed base, flared walls, and a round shoulder; the neck is short and small and ends in a thick bulged opening (diam. 0.7 cm). The pontil was separated clumsily, leaving a large mark at the base. The molded decoration, which covers the entire surface except the neck, consists of a small honeycomb pattern.

Condition: The object is intact. The surface is entirely weathered, resulting in a pale brown coating, iridescence, and soil encrustation.

Provenance: Reportedly from Maimana (Faryab), Afghanistan

Related Works: 7. Moghadam collection, Tehran (Ettinghausen 1965, pl. 47a)

8. Khalili collection, London, inv. nos. GLS 553, GLS 569 (Maddison–Savage-Smith 1997, nos. 210, 211)

9. Oppenländer collection, inv. nos. 2548, 2549 (von Saldern et al. 1974, nos. 745, 746)

10. V&A, inv. nos. C910-1935, C153-1936, C190-1937

11. CMG, inv. no. 54.149 (Ettinghausen 1965, pl. 46b)

12. MMA, inv. nos. 1975.61.1, 1975.61.2

13. MFI, inv. no. 18038 (Mostafa 1959, figs. 3–7)

14. Louvre, inv. no. 7448 (Paris 1971, no. 287)

**Cat. 54 BEAKER (LNS 50 G)**
**Iranian region**
**10th–11th century**

Dimensions: hgt. 9.0 cm; max. diam. 9.5 cm;
th. 0.27 cm; wt. 160.5 g; cap. ca. 600 ml
Color: Translucent dark green (green 4)
Technique: Mold blown; tooled; worked on
the pontil
Description: This cylindrical beaker was optic
blown. The rim curves slightly inward
and the flat base has a slight kick in the
center. The rim is uneven and a lip runs
just below it. The molded decoration,
which covers the entire surface of the
object except the underside of the base,
consists of a vertical chevron pattern
repeated eight times.
Condition: The object is intact. The surface is
partially weathered, resulting in a
milky white film and some abrasion.
The glass includes frequent small
bubbles and scattered larger ones.
Provenance: Sotheby's, London, sale, April 21–22,
1980, lot 314
Related Works: 1. MIK, 19/69 (Naumann 1976, fig. 2a)
2. MIK, inv. no. I.33/61
(Kröger 1984, no. 77)
3. Excavations at Tureng Tepe, Iran
(Boucharlat–Lecomte 1987, pl. 160a)

The harmonious proportions and excellent condition of this appealing, well-preserved dark green vessel make it one of the best molded beakers found in any glass collection worldwide. The decoration, usually described as either a chevron, zigzag, or herringbone pattern, is a common motif encountered in diverse cultures from ancient times. In cut or molded Islamic glass, however, the chevron is not common as an overall pattern and is rarely encountered on extant objects or shards, making this beaker a rare example.

An explanation for the infrequent use of the chevron pattern in Iranian Islamic glass can probably be found in its virtual absence in the Sasanian tradition that initially influenced the production of cut glass and subsequently that of molded glass (see cat. 50–53). Only three intact pieces show the same chevron pattern: a slightly smaller green beaker of similar shape to cat. 54 excavated at Takht-i Sulaiman in northwestern Iran (Related Work 1),[28] a medium-size pale green bowl allegedly excavated at Nishapur (Related Work 2), and a beaker from Tureng Tepe attributable to a post-ninth-century layer (Related Work 3). In addition, a number of fragments with similar decoration were found at Takht-i Sulaiman.[29]

Cylindrical beakers with a flat base, the diameter and height of which have similar dimensions, are often encountered, either as plain vessels or with linear-cut or impressed decoration.[30] Sometimes, as it is evident from the material unearthed at Nishapur, a beaker of similar proportions would be turned into a portable lamp by the addition of a tube at the bottom and of a small handle on the exterior wall.[31]

Cat. 54

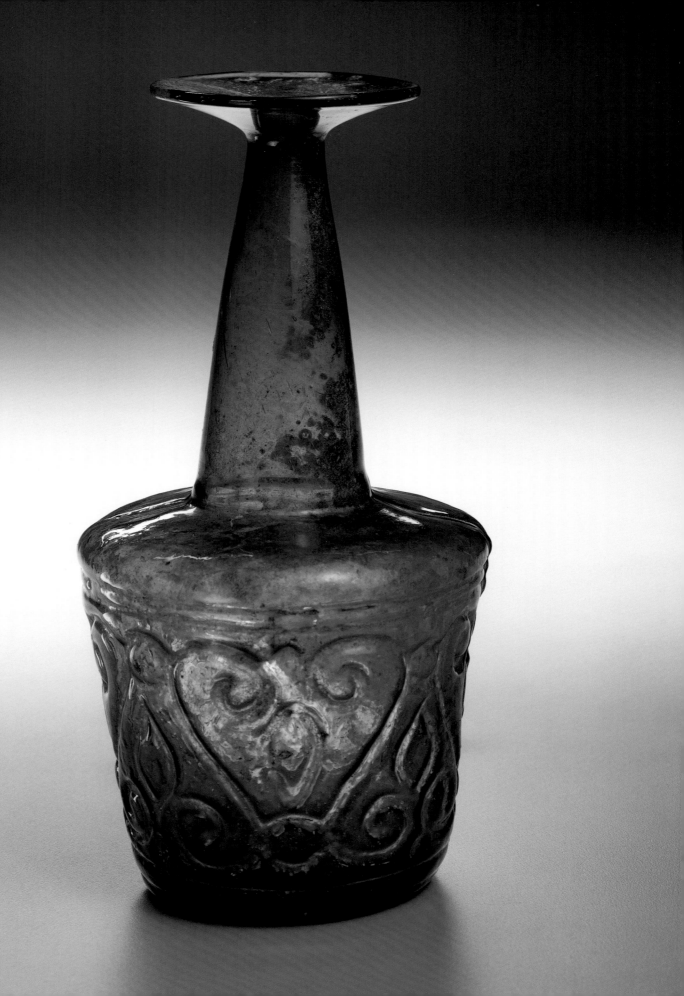

The shape of this appealing large blue bottle leaves no doubt that it was produced in the eastern Iranian area in the tenth or eleventh century (see cat. 35). When molded, this type of bottle is usually vivid green or blue and shows a variety of vegetal and geometric ornaments, while relief- or linear-cut vessels are mostly colorless (see cat. 25).

Common to these molded vessels is the use of a two-part mold: the parison was sealed inside the mold after it was closed; the vessel was then blown on the pipe inside the mold and was eventually extracted after the mold was reopened. Since no two-part molds from this period survive, it is not clear if they were made of bronze (like the single-part molds discussed at cat. 50) and their two parts were hinged or if they were made of another heat-resistant material. These molds were probably larger than the one-part dip molds that were used to impress a pattern that was often subsequently optic blown. The patterns on objects produced in two-part molds usually show higher relief than those created in single-part molds, suggesting that the vessels were not optically enlarged after they had been taken off the mold. The present bottle conforms to this rule, and its appeal lies mainly in the clear definition of its pattern.

Affronted curly S-shaped motifs separated by a lozenge and two circles probably derive from beveled Samarran patterns, though they are rather removed from that model. A similar bottle excavated at the Tepe Madraseh, in Nishapur, in 1939 shows a more complex vegetal pattern that includes stemmed palmettes and is also reminiscent of the Samarran tradition (Related Work); this bottle and cat. 55 have much in common, including dimensions, profile, color, the evident imperfect vertical seams of a two-part mold, and the simple horizontal lines in relief that frame the main decoration on the body. The decoration of cat. 55 finds a close parallel in the pattern carved on the beaker-shaped mold in Copenhagen,[32] demonstrating how single and two-part molds were produced in the same area and period.

**Cat. 55 BOTTLE (LNS 8 G)**
**Iranian region**
**10th–11th century**

Dimensions: hgt. 20.5 cm; max. diam. 10.5 cm; th. 0.29 cm; wt. 232.8 g; cap. 590 ml

Color: Translucent blue (blue 3)

Technique: Mold blown; tooled; worked on the pontil

Description: This flared bottle has a flat base with a low kick in the center, a long tapered neck, and a large splayed opening. The decoration around the body, created in a two-part mold (the vertical seams are evident on the body), consists of a series of confronted S-shaped patterns separated by two circles (alternately sunken and in relief) where they intersect, and a central pointed oval.

Condition: The object is intact. The surface is partially weathered, resulting in brown and gray coatings. The glass includes frequent small bubbles, one inclusion, and one dark filament.

Literature: Jenkins 1983, p. 58; and Atıl 1990, no. 36

Related Work: MMA, inv. no. 48.101.60 (Kröger 1995, no. 133)

Cat. 55

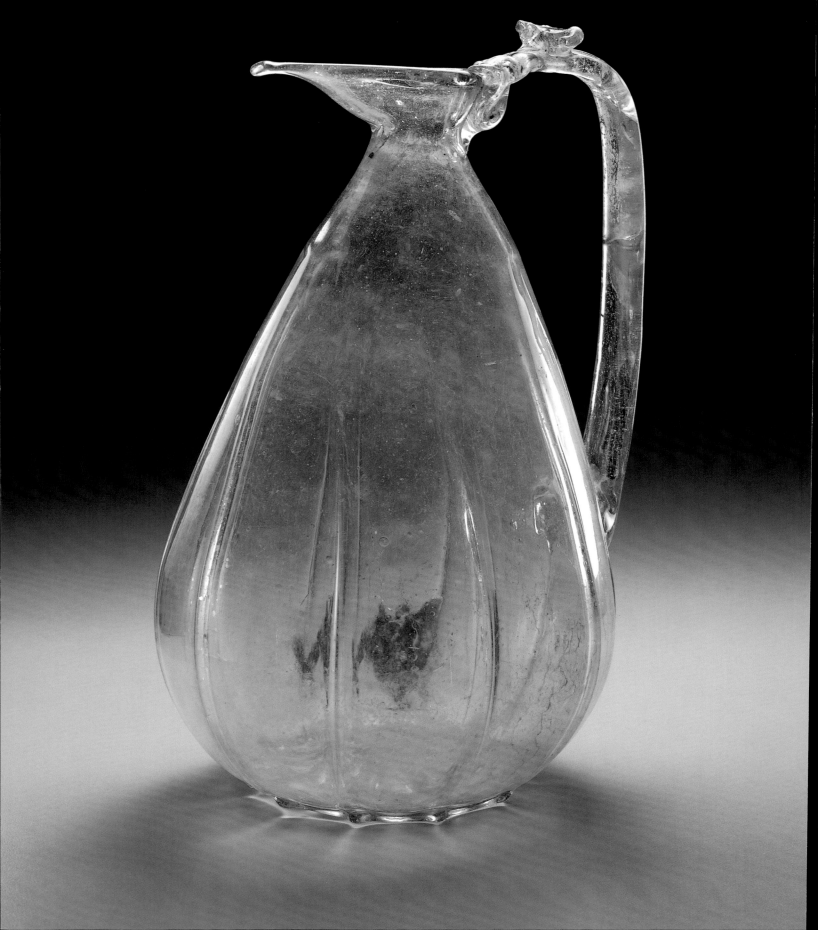

## Cat. 56 EWER (LNS 117 G)
### Probably Iranian region
### 10th–11th century

Dimensions: hgt. 20.5 cm; max. diam. 11.5 cm;
th. 0.25 cm; wt. 297.1 g; cap. ca. 1150 ml

Color: Translucent brownish colorless

Technique: Mold blown; tooled;
worked on the pontil

Description: This large pear-shaped ewer has a
narrow short neck with a tear-shaped
opening and a long spout and a flat
base. The decoration, created in a
single-part mold, consists of ten vertical
ribs in low relief at regular intervals
that depart from the base and vanish
when they reach three-quarters of the
height of the vessel. An eleven-petaled
rosette is molded underneath the base;
the pontil mark is visible at its exact
center, and thus forms the button of
the flower. A long curved handle with
a thumb rest is attached to the rim
opposite the spout and about 5 cm
above the base.

Condition: The object is intact except for a section
of the thumb rest; the handle is broken
and repaired and there are several
cracks. The glass includes frequent
small bubbles, scattered larger ones,
and some inclusions.

Pear-shaped ewers of different dimensions, from miniature objects to oversize vessels, are familiar in Islamic glass. Variations may occur in the profile of the handle (either rounded or angular), in the presence or absence of a thumb rest, in the shape of the opening (rounded or spouted, often drop-shaped), and in the way the base was tooled (often a low foot is present). The profile and proportions between body and neck are consistent, making this type of vessel one of the most frequently encountered.

The production of ewers, such as cat. 56, was probably widespread in the Islamic world by the ninth or tenth century. The shape is ultimately derived from silver and bronze vessels produced in Iran in the Sasanian period,[33] and it seems likely that these ewers were inspired by early Islamic bronze objects created in the same tradition. A glass ewer in the treasury of the Shōsō-in Temple in Japan and another excavated near Qazvin, in Iran, both attributed to the late Sasanian period, represent the earliest surviving glass objects of this type.[34] It is likely, therefore, that pear-shaped glass ewers originated in Iran and spread westward in the Islamic world. The issue, however, is more complex than it appears, since celebrated masterpieces of Islamic relief cutting, such as the Corning Ewer and a jug from the Buckley collection in the Victoria and Albert Museum, London, have a similar shape and scholars disagree as to their Iranian or Egyptian origin.[35]

A large number of surviving pear-shaped ewers are either plain or have a linear-cut decoration. Two notable examples are in the British Museum and in the Carnegie Museum of Natural History, Pittsburgh.[36] The present object is remarkable and unusual because of its size and molded decoration. It is taller (20.5 cm) than all other known ewers and is comparable to Fatimid rock-crystal ewers. Its decoration, made of simple vertical ribs in relief and a flower under its base, is encountered on various vessels, though rarely on pear-shaped ewers,[37] and is sometimes present on objects excavated in Iran.[38] Thus, the shape and decoration of cat. 56 suggest an attribution to the Iranian area.

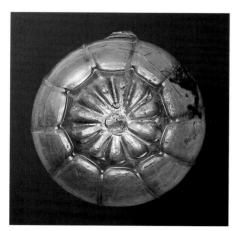

Cat. 56 detail of base

Cat. 56

## Cat. 57a BOWL (LNS 159 G)
### Iranian region
### 11th–12th century

Dimensions: hgt. 4.7 cm; max. diam. 17.3 cm;
　　　　　　th. 0.21 cm; wt. 291.3 g; cap. ca. 600 ml
Color: Translucent pale bluish green (green 1)
Technique: Mold blown; tooled; worked on
　　　　　the pontil
Description: This bowl has flared and curved walls,
　　　　　a slightly sunken base with a kick, and
　　　　　a rim that folds outward. The molded
　　　　　decoration, which is barely visible
　　　　　because the object was optic blown,
　　　　　is rather complex: from the rim to the
　　　　　base, it includes a band of lozenges,
　　　　　a band of simple dots, a ribbed band,
　　　　　a circle of dots forming a medallion
　　　　　around the base, and, under the base,
　　　　　a large composite flower with petals in
　　　　　the shape of lozenges.
Condition: The object was broken and repaired;
　　　　　it is almost complete except for fills.
　　　　　The surface is in good condition but
　　　　　shows faint iridescence. The glass
　　　　　includes scattered small bubbles.
Provenance: Reportedly from Afghanistan

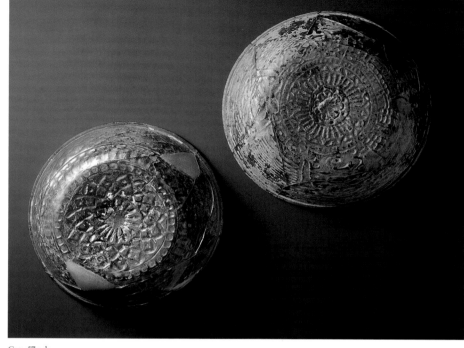

Cat. 57a, b

## Cat. 57b BOWL (LNS 341 G)
### Iranian region
### 11th–12th century

Dimensions: hgt. 4.8 cm; max. diam. 18.8 cm;
　　　　　　th. 0.50 cm; wt. 365.1 g; cap. ca. 770 ml
Color: Translucent pale green (green 1)
Technique: Mold blown; tooled; worked on
　　　　　the pontil
Description: This bowl has flared and curved walls,
　　　　　a slightly kicked thick base, and a rim
　　　　　that folds outward. From the rim to
　　　　　the base, the decoration consists of a
　　　　　complex and somewhat irregular band
　　　　　including dots, wavy patterns, and,
　　　　　perhaps, vegetal motifs; a narrow band
　　　　　filled with small triangles; a ribbed
　　　　　band; and a central flower.
Condition: The object was broken and repaired; it
　　　　　is complete except for small chips. The
　　　　　surface is heavily weathered, resulting
　　　　　in milky white and pale brown coatings
　　　　　on both sides of the walls. The glass
　　　　　includes scattered tiny bubbles.
Provenance: Eliahu Dobkin collection; Bonhams,
　　　　　London, sale, October 18, 1995, lot 390

These two unusual molded bowls are similar in their shape, dimensions, thickness, folded rim, and complex patterns. They seem to belong to a workshop active at a later date, corresponding to a "baroque" phase in the production of single-part bronze molds—that is, when metalworkers had become fully familiar with the technology of making molds for glass. Another hypothesis is that this workshop was somewhat distant from the mainstream production, considering that there was a return at a later period to simple repetitive motifs, as exemplified by many extant twelfth- and thirteenth-century bottles (cat. 64–68).

When seen in isolation, the motifs impressed on these two bowls, such as lozenges, circles of simple dots, ribs, and the petaled flower at the center, are all recognizable as belonging to customary Iranian production. The complexity of the pattern, usually arranged in concentric circles departing from the central flower, and the use of the optic-blowing technique make these motifs less conspicuous and difficult to appreciate fully. However, the same quality also gives these objects a more appealing and enigmatic appearance.

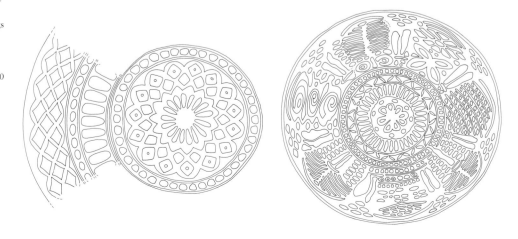

## Cat. 58a MINIATURE BOTTLE
### (LNS 171 G)
### Iranian or Central Asian region
### 11th–12th century

Dimensions: hgt. 5.5 cm; max. diam. 4.8 cm;
th. 0.15 cm; wt. 23.4 g; cap. 37 ml
Color: Translucent greenish blue (blue 2–3)
Technique: Mold blown; tooled; worked on
the pontil
Description: This miniature bottle has a flattened
globular body that rests on a low
molded foot. The neck is irregular,
bulged, and tapered and ends in a
splayed opening. The decoration,
created in a two-part mold, consists
of a single row of seven concentric
lozenges joined at the vertices.
Condition: The object is intact. The surface is
heavily weathered, resulting in a milky
white coating and silvery iridescence.
The glass includes scattered small
bubbles.
Provenance: Reportedly from Afghanistan

## Cat. 58b MINIATURE BOTTLE
### (LNS 357 G)
### Iranian or Central Asian region
### 11th–12th century

Dimensions: hgt. 4.1 cm; max. diam. 2.5 cm;
th. 0.33 cm; wt. 14.9 g; cap. 6 ml
Color: Translucent yellowish colorless
Technique: Mold blown; tooled; worked on
the pontil
Description: This miniature bottle is cylindrical
and curves gently at the base and at
the shoulder; the base is concave and
the object does not stand. The neck is
straight, bears evident tooling marks,
and ends in a bulged opening. The object
appears lopsided. The molded decoration
consists of a row of five concentric
lozenges joined at their vertices.
Condition: The object is intact. The exterior
surface is entirely weathered, resulting
in iridescence and slight abrasion;
the neck is filled with soil. The glass
is of good quality.
Provenance: Reportedly from Herat, Afghanistan
Related Works: 1. Benaki, inv. no. 3172
(Clairmont 1977, no. 205)
2. BM, inv. no. OA 1945.10-17.263
(Tait 1991, fig. 149)
3. CMG, inv. no. 79.1.203
(Corning 1955, no. 73)
4. Whereabouts unknown
(Lamm 1929–30, pl. 12:18)
5. MIK, inv. no. Lamm 969
(Kröger 1984, no. 65)
6. MHC, inv. no. A-109-76
(Abdullaev et al. 1991, no. 637)
7. MUA (Jenkins 1986, ill. p. 8)

These two small bottles were reportedly found in the eastern Islamic world, suggesting that these molded objects with lozenge patterns were produced in the Iranian or Central Asian regions rather than in the western Islamic world. This hypothesis is confirmed by an object excavated in Uzbekistan (Related Work 6). In the past, however, specialists have usually indicated Egypt, Syria, and the eastern Mediterranean coast as the places of production of this type of molded pattern,[39] even though some have also suggested the Iranian area.[40] The issue became more interesting after the discovery of a number of molded vessels with lozenge-shaped decoration in the Serçe Limanı shipwreck, off the coast of Bodrum, Turkey (see Related Work 7).[41] A complete study of the Turkish material is awaited and with it a clarification of the provenance of the large amount of glass found in the ship. The Serçe Limanı material helps to date this type of glass to the late tenth century or the first half of the eleventh. The question of its place of origin is open, however, and it would not be surprising if at least part of the glass cargo had been transported from the eastern Islamic world.[42]

Although Related Works 1–7 are of different shapes (two small jars, a bowl, a pilgrim flask, and two vases, respectively), they all present a molded decoration of one or more rows of lozenge patterns, sometimes joined at the vertices or included within a more complex network and combined with other geometric motifs. The concentric lozenge motif was popular throughout the Islamic world; objects bearing this type of decoration may have been produced in different areas, but they also may have been shipped for long distances from a limited area. Slight variations of the pattern, which ranges from simple lozenges to complex geometric arrangements, may be related to different workshops. At the moment, it seems reasonable to suggest that cat. 58a and b were produced in the Iranian or the Central Asian area.

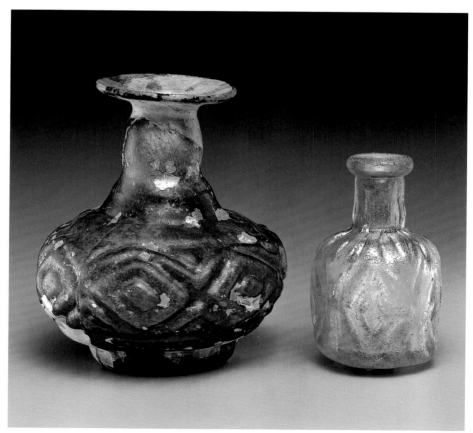

Cat. 58a, b

**Cat. 59 FRAGMENTARY BOWL**
(LNS 368 G)
Iranian region
Late 11th–early 12th century

Dimensions: hgt. ca. 7.0 cm; max. diam. ca. 11.0 cm (reconstructed); th. 0.24 cm; wt. 178.8 g (incomplete vessel)

Color: Translucent vivid greenish blue (blue 3)

Technique: Mold blown; tooled

Description: These fragments allow a reconstruction of the vessel's shape—that of a bowl with a curved shape resting on a molded, slightly tapered foot (hgt. ca. 1.5 cm; diam. ca. 5.0 cm); the opening was lobed (probably eight lobes) and the rim folded inward (hgt. 0.8 cm) and bulged slightly on the exterior, forming a sort of lip. The molded decoration, in high relief, consisted of a continuous vegetal scroll around the body of the vessel; the sinuous pattern was intercepted by eight large elongated buds, flowers, or leaves, each extending vertically at regular intervals, alternately upright and upside down.

Condition: There are six fragments, the largest of which represents about one-half of the body and of the foot. Three of the fragments, including the largest, are joined: together, they represent about one-third of the bowl. The remaining three smaller fragments, two from the rim and one from the body, cannot be joined. The surface is entirely weathered, resulting in bluish iridescence and abrasion. The glass includes frequent tiny bubbles.

Provenance: Reportedly from Mazar-i Sharif (Balkh), Afghanistan

Related Works: 1. MAIP, inv. nos. 21998, 22005 (Kordmahini 1988, pp. 111, 125)
2. MIK, inv. no. I.25/63 (Kröger 1984, no. 17)

This bowl was accomplished when in pristine condition; even in a fragmentary state, it still conveys its original charm. Its vivid turquoise blue, bold decoration in relief consisting of a characteristic sinuous vegetal scroll interrupted by large leaves, and lobed profile make it a distinctive object that is rarely encountered in molded glass production.

Two glass vessels produced in a similar, if not identical, mold are in the Bazargan collection of the Islamic Period Museum, Tehran (Related Work 1). They have in common the same bold vegetal decoration as cat. 59 but different shapes: one is a pale olive green globular bottle (inv. no. 22005) standing on a low foot similar to that of cat. 59 and having a long cylindrical neck; the second is a green cup (inv. no. 21998) with a round handle, also standing on a low foot, with a gently curved profile and a circular opening. The diameter and height of both objects are less than those of cat. 59 (as reconstructed), since they do not exceed 10 centimeters. A cup with a round handle and a polylobed rim in Berlin (Related Work 2)—in this case, with nine lobes instead of eight—provides another good parallel for the present object, also considering that its dimensions are nearly identical (hgt. 6.5 cm; diam. 11.4 cm); as a matter of fact, cat. 59 also may have been a handled cup.

The two works in Tehran are attributed to the early Islamic period and the ninth century, respectively, and have been assigned a "Gurgan" provenance. Although their shapes may be in accordance with those of an early period, especially that of the globular bottle, they should be assigned a later date in the light of the bowl discussed here, which has an almost identical molded pattern. The lobed shape of the bowl is encountered, in particular, in Iranian ceramics with overglaze- and luster-painted decoration that were produced in central and northern Iran under the Seljuqs in the twelfth and thirteenth centuries.[43] Lobed bowls were made by Iranian potters and metalworkers who often used molds to produce vessels of other shapes with similar bold vegetal decoration in relief.[44] High-relief vegetal decoration and lobed rims were also created using methods other than molding (especially relief cutting) in glass and pottery prior to the eleventh century.[45] In view of its relationship to ceramic production, cat. 59 and the related works were probably made in the late eleventh or the early twelfth century.

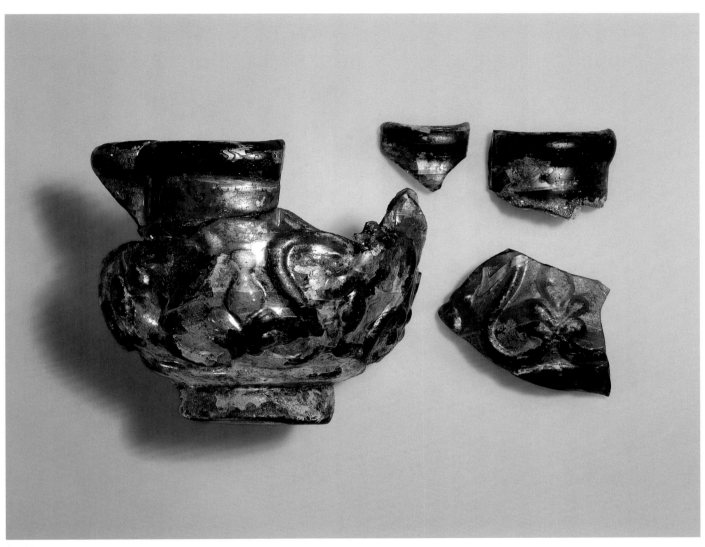

Cat. 59

**Cat. 60** *QUMQUM*
(PERFUME SPRINKLER)
(LNS 37 G)
**Egyptian or Syrian region**
**12th century**

Dimensions: hgt. 22.5 cm; max. diam. 11.5 cm;
th. 0.15 cm; wt. 169.3 g; cap. ca. 550 ml
Color: Translucent pale bluish green (green 1)
Technique: Mold blown; tooled; worked on
the pontil
Description: This tall perfume sprinkler has a
lopsided globular body flattened on
two sides, a small flattened base with
a deep kick in the center, and a long
tapered neck that has a large bulge at
the base and ends in a pinprick-size
opening. The molded decoration
consists of vertical ribs in shallow
relief. The object was optic blown and
tooled, so that the ribs appear twisted.
Condition: The object is intact. The surface is
lightly weathered, resulting in milky
white and pale brown films. The glass
includes frequent small bubbles.
Related Work: NM, Damascus, inv. no. 1953

Evidence that molded decoration was used in the Egyptian and Syrian areas at a fairly late stage (in the Ayyubid and the Mamluk periods, late twelfth to fourteenth century) is provided by cat. 60. The shape (see cat. 37) was unknown in the eastern Islamic regions and can be safely attributed to the Syrian region after the eleventh century. Perfume or rosewater sprinklers with two flattened sides, a long neck ending in a pinprick-size opening, and a well-defined kick under the base were commonly produced in the area and were either left undecorated (cat. 37) or were decorated in the mold (cat. 60), marvered (cat. 83), or enameled and gilded (cat. 95).

Molded *qamāqim* are rare and only a small number of intact vessels survive. Ribbed decoration with subsequent optic-blowing and twisting seems to have been the rule for these sprinklers that, as in the present case, were often rather large. Pale or colorless green and amber colors (Related Work) and delicately blown walls make these objects particularly light and appealing.

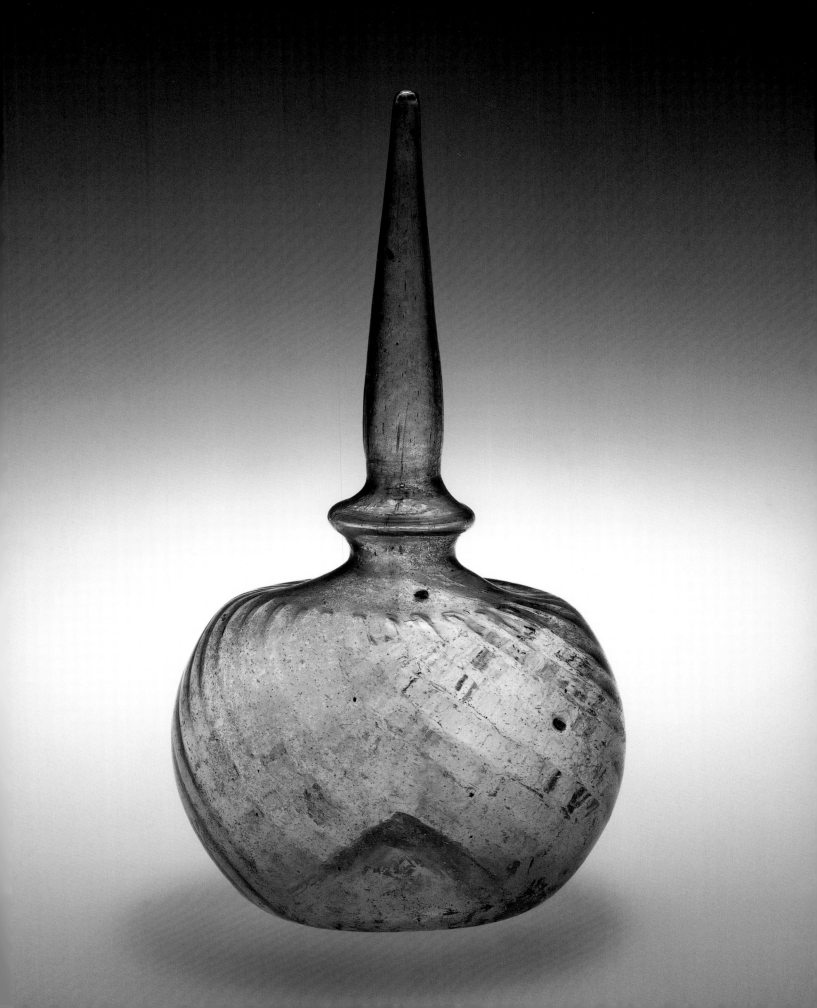

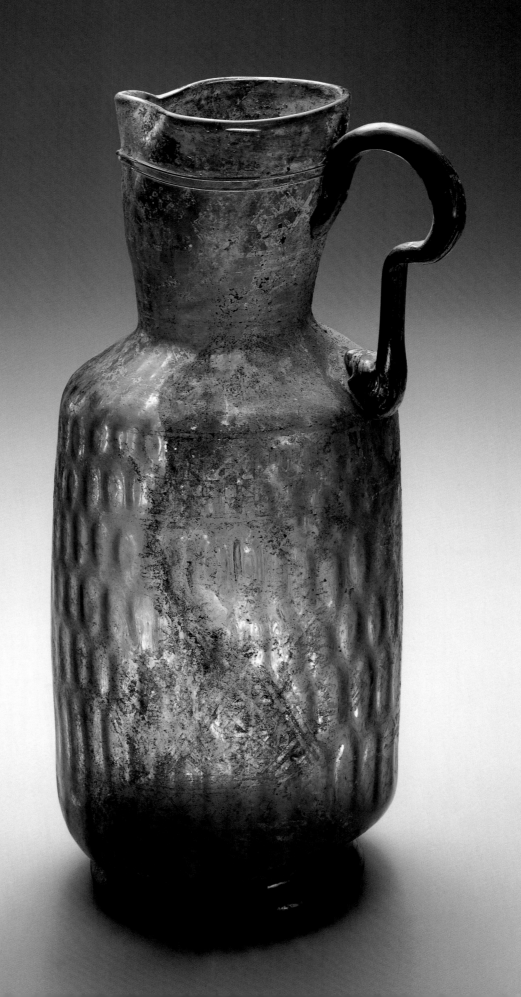

**Cat. 61 PITCHER (LNS 106 G)**
**Iranian region**
**Probably 12th century**

Dimensions: hgt. 25.5 cm; max. diam. 10.5 cm;
th. 0.35 cm; wt. 375.6 g; cap. ca. 1620 ml
Color: Translucent green (green 3–4)
Technique: Mold blown; applied; tooled; gilded;
worked on the pontil
Description: This large pitcher has a cylindrical
body resting on a low tapering foot that
was tooled, pincered, and folded inward
in order to seal the bottom; a long,
angular shoulder; a cylindrical, though
slightly flared, neck. The circular
opening was pinched on one side
to create a small pointed spout.
A handle, roughly in the shape of a
question mark, was attached to the
middle of the neck opposite the spout
and to the shoulder. A thin thread was
applied around the neck, about 2 cm
below the opening. The molded and
optic-blown decoration consists of a
honeycomb pattern in shallow relief
on the body and of vertical ribs around
the neck (the latter may have been
created by tooling after the vessel was
taken off the mold). Partially visible,
but mostly gone, is a gilded decoration
of geometric motifs enclosed between
two large bands and covering the entire
surface, including the neck.
Condition: This object is intact except for the
upper part of the handle, which has
been repaired. The surface is partially
weathered, resulting in milky white and
pale brown films; the decoration has
vanished almost entirely. The glass
includes scattered small bubbles.
Related Works: 1. CMNH, inv. no. 24414/4
(Oliver Jr. 1980, no. 263)
2. CMG, inv. no. 66.1.5
(Higashi 1991, no. 50)
3. KM, Düsseldorf, inv. no. P1973-56
(von Saldern 1974, no. 306)

This large pitcher recalls vessel shapes that were common in the tenth and eleventh centuries, especially in metal.[46] The molded and optic-blown honeycomb pattern, the thin thread applied around the neck, the unusual way in which the glass is folded inward at the base and the shape of the handle are features present on Iranian glass found at Nishapur, further supporting this dating. However, the combination, in a single object, of honeycomb pattern, thin thread, folded base, and question-mark-shaped handle is unusual for a tenth- or eleventh-century vessel and accords with a later phase of Iranian glass production; the large dimensions of cat. 61 would also be uncommon for early objects of its type. Furthermore, a similar pitcher in Corning (Related Work 2) has a lobed opening created by tooling that is reminiscent of twelfth-century Seljuq objects (see cat. 59).

The most distinctive and puzzling characteristic of cat. 61 is the gilded decoration that once covered the entire surface. The gold paint has vanished, but traces of glue or some other substance that was used to apply the gold to the glass surface are still visible. Examination through transmitted light suggests that the gilded decoration included two narrow bands (one near the base, the other below the shoulder) filled with single rows of small lozenge patterns; the main field was occupied by a geometric composition of circles inscribed inside large lozenges and triangles created in the voids left by the lozenges. Although the surface condition does not allow a reading of the decoration inside the larger geometric patterns, it may have been vegetal or pseudovegetal in nature.

The gilded decoration could be dismissed as a relatively recent addition, perhaps created in nineteenth-century Iran or in the early twentieth century in the Middle East or Europe;[47] it was cold painted without firing and thus disappeared in a few decades. In addition, the gilt was applied over a surface that was already decorated, since it included a molded honeycomb pattern. This gilded pitcher is not, however, an isolated example and it is indeed possible that the decoration was applied at the time of its creation or shortly thereafter. There are molded vessels from the early Mamluk period in Syria or Egypt with vertical ribs that were enameled and gilded.[48] Each facet of a facet-cut vase in the Victoria and Albert Museum is decorated with a gilded pattern; as in the case of cat. 61, it is not obvious that the decoration was added at a later time.[49] Gilding without enameling was certainly practiced in the twelfth century, as demonstrated by a few surviving objects, though their place of production seems most likely the Byzantine-influenced northern Syrian area rather than the Iranian.[50] If there is not enough evidence to support the theory that cat. 61 was gilded at the time of manufacture, it is possible that the decoration was added soon afterward when gilding became fashionable, in order to make it look like a more expensive, rare object.

**Cat. 62 PITCHER (LNS 100 G)**
**Iranian region**
**12th century**

Dimensions: hgt. 14.0 cm; max. diam. 9.0 cm;
th. 0.25 cm; wt. 192.8 g; cap. 464 ml
Color: Translucent dark blue (blue 4)
Technique: Mold blown; applied; tooled;
worked on the pontil
Description: This pitcher has an irregular cylindrical
body, a flat base with a kick in the
center, a short angular shoulder, and
a cylindrical neck ending in a circular
opening. An L-shaped handle with a
folded thumb rest was attached to the
rim and the shoulder. A thin trail was
applied in a spiral just below the
opening. The molded decoration
consists of two rows of seven octagons
with an omphalos pattern in the center;
the sections between the octagons are
rhomboids. The lower row includes
large octagons that fill the entire surface
of the body; the upper row, which is
confined to the base of the neck, is
much smaller, since it was compressed
by tooling.
Condition: The object is intact. The surface is
lightly weathered, resulting in a light
pale brown patina. The glass includes
scattered small bubbles, one large
bubble, inclusions, and streaks.
Literature: Lucerne 1981, no. 554
Related Works: 1. CMG, inv. no. 66.1.5
(Higashi 1991, no. 50)
2. Whereabouts unknown
(Smith 1957, no. 477)
3. LACMA, inv. no. M.88.129.179
(von Saldern 1980, no. 174)
4. CMNH, inv. no. 24414/4
(Oliver Jr. 1980, no. 263)
5. KM, Düsseldorf, inv. no. P1973-56
(von Saldern 1974, no. 306)
6. Private collection, Frankfurt
(Ohm 1975, pl. 21, no. 172)

Cat. 62 is one of the best-preserved glass objects from twelfth-century Iran. Its nearly perfect condition, appealing dark blue color, and elegant decorative pattern make it an ideal piece for the study of molded Iranian glass of the period.

In its shape and the thin thread below the opening, cat. 62 is comparable to three other pitchers, though they include a molded honeycomb pattern (Related Works 1, 4, 5); slight differences are noticeable in the handles.

The molded decoration of cat. 62, though in low relief, is crisp and centered on the body. Reminiscent of the omphalos pattern, it is more complex because of the presence of an octagon around the central circle; the octagons are joined, having one vertical side in common, and rhomboids become part of the network, filling the gaps between the octagons. This large pattern is nicely balanced by the presence of the similar, if not identical, motif that highlights the base of the neck, which was tooled in order to appear smaller and sunken, rather than in relief.

The same omphalos-within-an-octagon motif is found on a well-preserved bottle (Related Work 2) that has a domed profile and an elegant flared neck with a tooled opening; this object almost certainly dates to the twelfth century. Related Work 3, a large bowl that seems datable one or two centuries earlier, shows the same pattern and thus testifies to the success of this type of molded decoration between the tenth and the twelfth centuries. Another bowl in clear glass (Related Work 6), also from the twelfth century, is an excellent example of the decorative impact of this complex pattern.

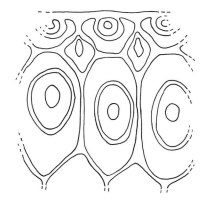

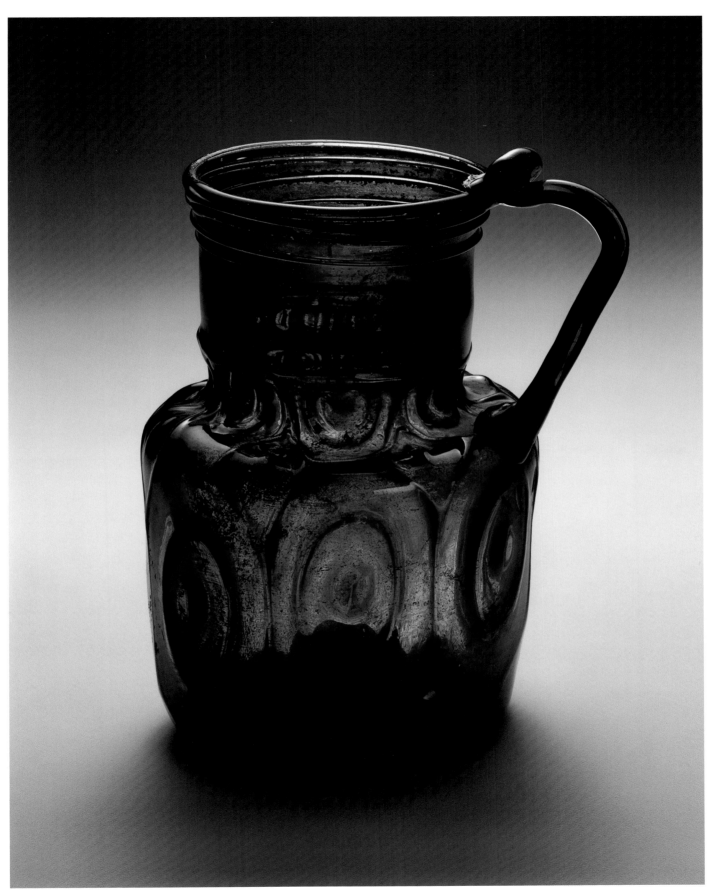

Cat. 62

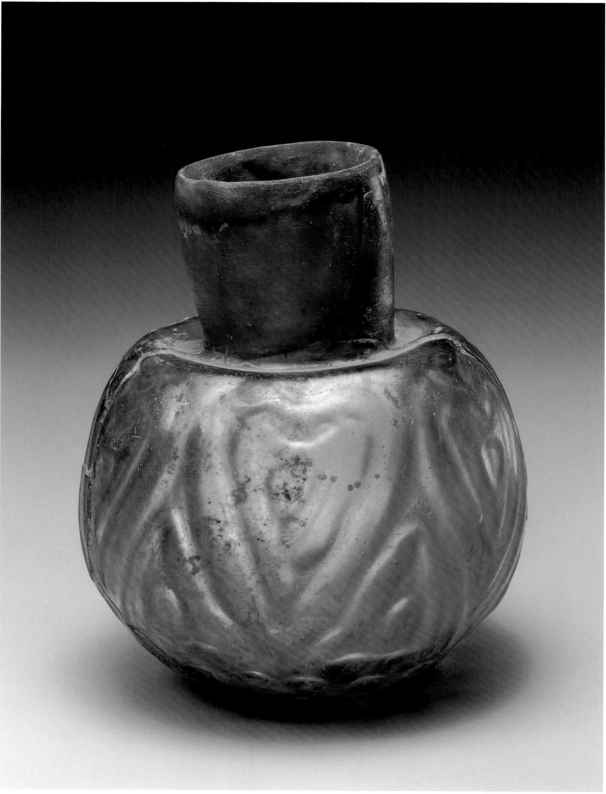

Cat. 63

Cat. 63 detail of base

### Cat. 63 BOTTLE (LNS 96 G)
### Iranian region
### 12th century

Dimensions: hgt. 10.0 cm; max. diam. 8.0 cm; th. 0.30 cm; wt. 112.9 g; cap. 224 ml

Color: Translucent pale purple (purple 1)

Technique: Molded; tooled; worked on the pontil

Description: This nearly globular bottle has a flattened base and a nearly cylindrical neck that is sunken where it joins the body. The molded decoration, blown in a single-part mold, consists of a row of six concentric heart-shaped motifs and a second row, below the first one, of concentric triangles. A row of sunken dots and a large central flower are visible under the base.

Condition: The object was broken and repaired; the greater part of the neck is filled in. The surface is lightly weathered, especially inside the vessel, resulting in iridescence. The glass includes scattered small bubbles.

This small bottle, similar in shape to cat. 64, is appealing because of its unusual color and decoration. Purple glass, made with the addition of a generous amount of manganese (hence the common name "manganese purple"), was used sparingly by twelfth- and thirteenth-century Iranian glassmakers, who employed it principally for decorative purposes (see, for example, the rims of cat. 64a–d). More common in the earlier Islamic period, dark, almost black, manganese purple enjoyed a renewed popularity in thirteenth- and fourteenth-century Syria in vessels decorated with applied and marvered trails in opaque white glass (see, for example, cat. 82–84), though it is rarely encountered without decoration.

Although concentric heart-shaped elements may be expected as part of the glassmaker's ornamental repertoire, those that form the main decoration of this bottle do not appear on any other glass vessel known. The only published comparable object (though it cannot be regarded as a related work) is a molded bottle of similar shape and size that includes a heart-shaped element within a palmette-like motif.[51] In cat. 63, the lower row of triangles follows a typical scheme in which alternating upright and upside-down elements create a network that leaves no empty background spaces. The heart shape is present in late Sasanian art, as exemplified by a splendid gilt-silver vase in Jerusalem, the surface of which is dotted with small gilded hearts.[52] During the Islamic period, the decorative language that developed in ninth-century Samarra brought with it numerous new motifs, including variations of the simple palmette pattern that might be mistaken for a heart shape. Thus true heart patterns were not common in early Islamic art, since their presence seems instead to be consistent with their transmission from late Antiquity. The motif became common after the thirteenth and fourteenth centuries, especially as the border decoration of manuscript illustrations and as an element of illumination in general. Molded concentric hearts were probably limited to Iranian glass production, in which concentric figures were common (see, for example, cat. 53a, 62, and 64a). The attribution of cat. 63 to twelfth-century Iran is, therefore, deductive rather than based on comparable examples bearing the same heart-shaped decoration.

## Cat. 64a BOTTLE (LNS 111 G)
### Possibly Iranian region
### 12th–first half of the 13th century

Dimensions: hgt. 9.8 cm; max. diam. 8.0 cm;
th. 0.47 cm; wt. 97.4 g; cap. 206 ml
Color: Translucent pale yellowish green
(green 1) and purple
Technique: Molded or stamped; applied; tooled;
worked on the pontil
Description: This nearly globular bottle has a base
with a small kick in the center and
a cylindrical neck that is slightly
constricted at its base. The opening is
decorated with an applied purple thread
fused on the rim. The decoration consists
of two rows of concentric omphalos
patterns, eight elements in the lower
row, seven in the upper; they overlap
and are arranged at irregular intervals.
Condition: The object is intact. The surface is
lightly weathered, resulting in a milky
white film and gray pitting. The glass
includes scattered small bubbles and
some large ones.

## Cat. 64b BOTTLE (LNS 112 G)
### Possibly Iranian region
### 12th–first half of the 13th century

Dimensions: hgt. 9.5 cm; max. diam. 7.0 cm;
th. 0.43 cm; wt. 78.7 g; cap. 152 ml
Color: Translucent pale yellowish green
(green 1) and purple
Technique: Molded or stamped; applied; tooled;
worked on the pontil
Description: This bottle has a slightly flared neck and
the same shape and rim decoration as
cat. 64a. The decoration, achieved like
that of cat. 64a, consists of two rows
of eight-petaled flowers with a raised
button at each center; six elements
are visible in each row.
Condition: The object is intact. The surface is
lightly weathered, resulting in a milky
white film and gray pitting. The glass
includes scattered small bubbles and
some large ones.
Related Works: 1. DC, inv. no. 45/1981
(von Folsach 1990, no. 234)

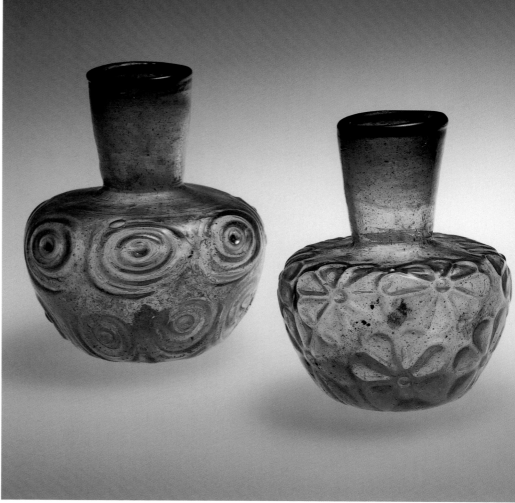

Cat. 64a–d

These four bottles, all in excellent condition, form a homogeneous group: their profile, dimensions, and tooled openings, with their purple rims, point to a single place of production. The group can be dated to the twelfth century or possibly the early thirteenth.

An unusual characteristic becomes evident upon closer investigation. The single elements that form the decoration of cat. 64a and b (a concentric omphalos pattern and a flowerlike motif, respectively) consistently overlap and are spaced unevenly. Decorative elements are usually carefully carved in bronze molds, since each mold must be used to produce a large number of objects; the overall pattern is planned in advance, so that the final result on the glass surface is orderly and clear, unlike that of cat. 64a and b. In the case of cat. 64c and d, which have almost identical decoration, it seems more likely that they were produced in a mold since cat. 64d, in particular, shows a regular and clear pattern of confronted S-shapes. The uneven distribution of patterns in cat. 64a and b would be expected if the individual elements were impressed on the glass surface with tonglike tools (see cat. 69–71). However, tongs were commonly used for vessels with an open shape, such as bowls; their utilization on a blown bottle, in any phase of its tooling, would have been too complex and laborious. It is also possible to exclude the use of one-sided stamps, as it would have been impossible to impress a decorative pattern on only the exterior surface without causing indentations in the walls of the vessel. The suggestion that cat. 64a and b may have been stamped and that cat. 64c and d were molded implies—since these objects were almost certainly produced in the same workshop—that glassmakers were at ease with both techniques and switched from one to the other, making similar objects using different tools.

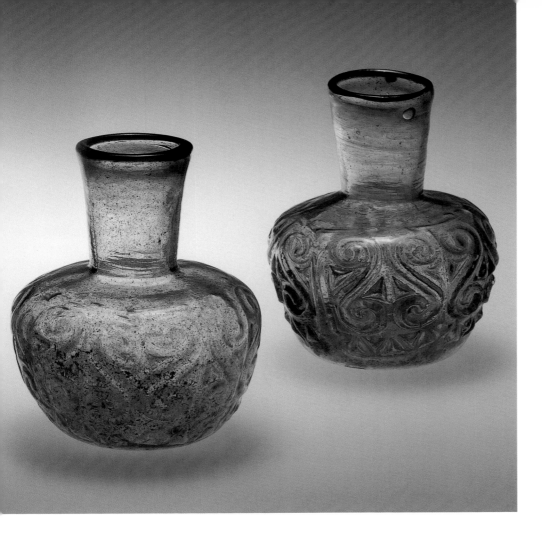

Dimensions: hgt. 9.2 cm; max. diam. 7.8 cm;
th. 0.30 cm; wt. 94.7 g; cap. 166 ml
Color: Translucent pale yellowish green
(green 1) and purple
Technique: Molded or stamped; applied; tooled;
worked on the pontil
Description: This bottle has the same shape and rim
decoration as cat. 64a. The decoration,
achieved like that of cat. 64a, consists
of thirteen confronted S-shaped
elements separated by triangles; more
triangles lie below the main elements.
Condition: The object is intact. The surface is
lightly weathered, resulting in milky
white and pale brown coatings,
especially on the interior. The glass
includes frequent tiny bubbles.
Literature: Atıl 1990, no. 37

**Cat. 64d BOTTLE (LNS 114 G)**
**Possibly Iranian region**
**12th–first half of the 13th century**

Dimensions: hgt. 10.0 cm; max. diam. 7.5 cm;
th. 0.30 cm; wt. 102.9 g; cap. 176 ml
Color: Translucent pale yellowish green
(green 1) and purple
Technique: Molded or stamped; applied; tooled;
worked on the pontil
Description: This bottle has the same shape and
rim decoration as cat. 64a. The
decoration, achieved like that of
cat. 64a, but standing in higher relief,
consists of twelve confronted S-shaped
elements separated by triangles; more
triangles, both upright and upside
down, lie below the main elements;
the individual patterns are identical
to those of cat. 64c.
Condition: The object is intact. The surface is
lightly weathered, resulting in a milky
white film and gray pitting. The glass
includes scattered small bubbles and
some larger ones. Soil is present inside
the vessel.
Related Works: 2. MM, inv. no. G 44
(Hasson 1979, no. 34)

It is more likely, however, that the overlapping and uneven spacing of the elements on the glass occurred when an individual stamp, including either an omphalos pattern or a petaled flower, was used to make several impressions against the ductile surface of a plaster or terracotta mold; if the job were not performed carefully, the individual patterns overlapped and were unevenly spaced. (A wooden stamp carved in the shape of a nine-petaled flower in the al-Sabah Collection may demonstrate the validity of this theory).[53] The imperfect pattern thus created on the mold was then repeated on the finished product in glass. Plaster or terracotta molds, similar to those used for ceramics, may have been used to make a small number of glass pieces before they were damaged and discarded; this would explain why their decoration was impressed quickly with stamps rather than carved by an accomplished craftsman. The evidence provided by these four bottles—or, at least, by cat. 64a and b—would support the theory that disposable molds were used in the production of glass, though none has survived.[54]

Stylistic considerations suggest that cat. 64a–d are related to contemporary molded Iranian glass, though the decorative patterns on these objects (S-shapes, flowers, and omphalos) were widespread by the eleventh and twelfth centuries. The Iranian area seems the most plausible place of origin, a theory supported by the similarity of the S-shaped patterns with the decoration of a molded bottle (cat. 55), which is distinctively Iranian. The other six similar bottles in the Collection (cat. 3.45a–f), however, are reportedly from Syria; so the possibility that they were produced in that region should not be discounted.

**Cat. 65 BOTTLE (LNS 1 G)**
**Iranian region**
**12th–first half of the 13th century**

Dimensions: hgt. 15.3 cm; max. diam. 7.7 cm;
th. 0.23 cm; wt. 134.9 g; cap. 308 ml
Color: Translucent pale purple (purple 1)
and dark blue (blue 4)
Technique: Molded; applied; tooled;
worked on the pontil
Description: This domed bottle has a flat base that
has a small kick in the center and a
long flared neck with two bulges—one
near the base, the other below the
opening. The rim was decorated with
an applied thread of blue glass that also
runs around the neck, above the lower
bulge. The decoration consists of two
rows of five thin curly vegetal scrolls
joined by short stems.
Condition: The object is intact. The surface is
partially weathered, resulting in a milky
white film, especially inside the neck.
The glass includes scattered large
bubbles and a few dark purple streaks.
Related Works: 1. CMG, inv. no. 58.1.2
2. Pilkington Museum, St. Helens,
England (Tait 1964, fig. 2)

Molded dome-shaped bottles with a flat base and a long flared neck are less common than globular ones with a long and narrow neck (see cat. 67, 68) in the twelfth and thirteenth centuries, but the same molds were used to decorate both types as well as other shapes.

Two other known bottles share with cat. 65 the same profile and decoration and similar tooling. The objects in Corning and St. Helens (Related Works 1, 2) are smaller and made of pale green glass. Cat. 65 is especially appealing for its pale purple color and contrasting applied blue thread.

The decoration of large curly vegetal scrolls departing from short stems has a pleasant and surprisingly light appearance; the surface of vessels of this type are usually entirely filled with elements in relief with little space left in the background. The overall decoration of cat. 65 seems weightless and freely drawn compared to other molded patterns of this period. A number of extant bottles, mostly of the common globular type with a long straight neck, bear the same curly decoration.[55] A bottle in Jerusalem is especially accomplished; the skillful manipulation of its decoration into a network of off-centered lopsided vegetal scrolls creates an effect of extraordinary movement on the glass surface. The curly pattern is also found on small globular bottles with a slightly flared neck (compare the shape of cat. 63 and 64): one of these is particularly interesting, since it was excavated in Gurgan, near the Caspian shore, in a context datable to the eleventh or twelfth century.[56]

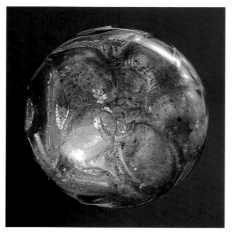

Cat. 65 detail of base

Cat. 65

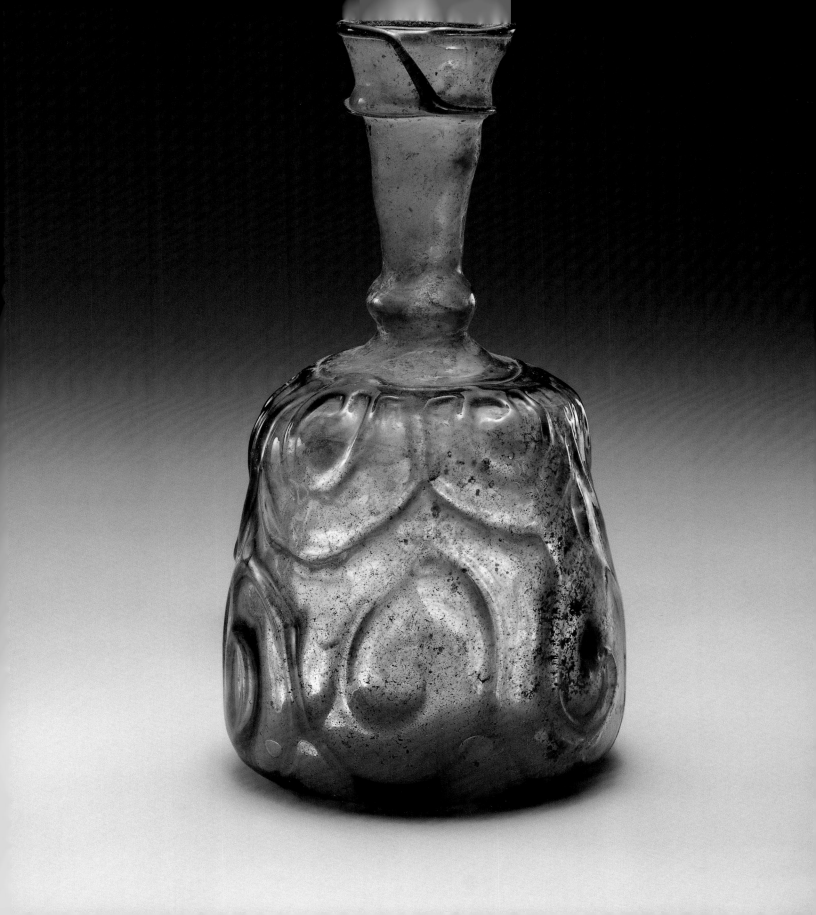

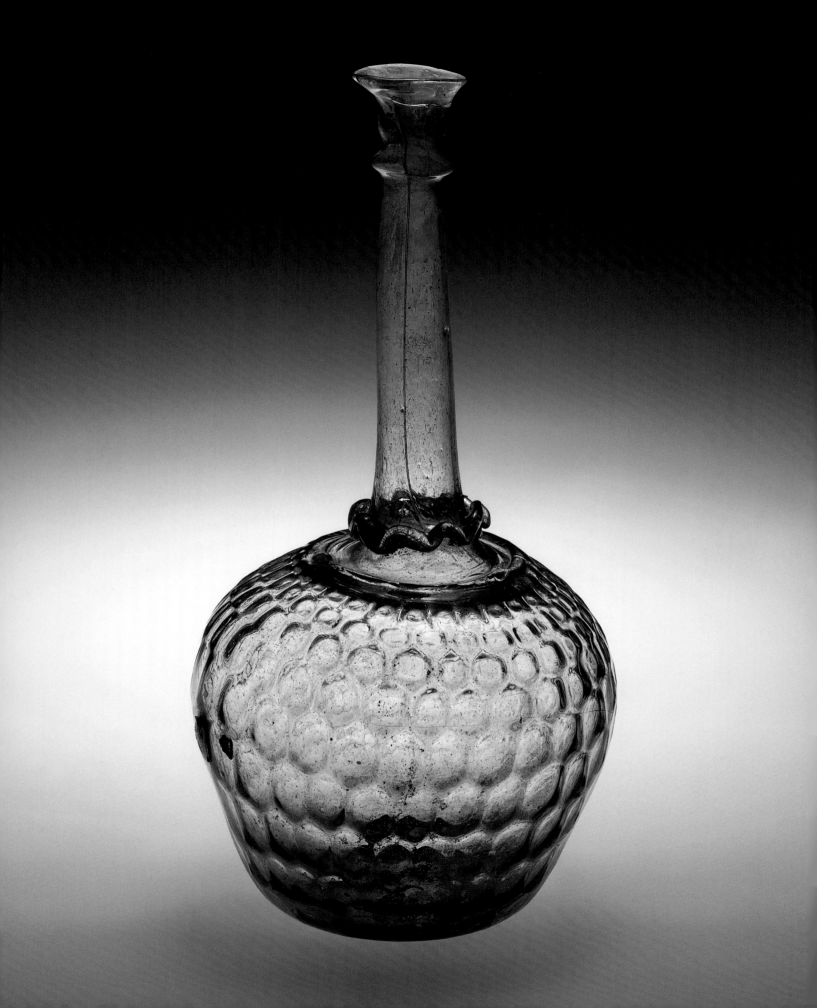

**Cat. 66 BOTTLE (LNS 104 G)**
**Iranian region**
**12th–first half of the 13th century**

Dimensions: hgt. 27.0 cm; max. diam. 13.0 cm;
th. 0.21 cm; wt. 267.9 g; cap. 990 ml
Color: Translucent brownish colorless
Technique: Mold blown; applied; tooled;
worked on the pontil
Description: This nearly globular bottle has a
flattened base with a kick in the
center, a long slightly tapered neck
with a bulge near the top, and a flared
opening. A wavy band of the same
color as the body was applied around
the base of the neck. The decoration,
created in a one-part mold, covers the
entire body and ends abruptly near
the base of the neck (probably in the
so-called post technique using two
layers of glass); it consists of a network
of eight rows of hexagons arranged
in a honeycomb pattern.
Condition: The object is intact except for its
opening, which was broken and
repaired and presents some fills. The
surface is lightly weathered, resulting in
a brown film on the interior. The glass
includes frequent small bubbles and
some small inclusions. A small lump
of glass waste is stuck on the surface.
Related Works: 1. KM, Düsseldorf, inv. P1965-200
(Ricke 1989, no. 76)
2. CMG, inv. no. 50.1.4
(Corning 1972, no. 34)
3. LACMA, inv. no. M.88.129.171
(von Saldern 1980, no. 165, pl. 14)
4. MM, inv. no. G 48
(Hasson 1979, fig. 36)
5. MAIP, inv. nos. 22032, 22037,
22053, 22055 (Ruhfar 1996,
glass section, no. 3; and
Kordmahini 1988, pp. 66, 71, 63)
7. CMNH, inv. no. 25141/2
(Oliver Jr. 1980, no. 262)
8. MKG, Hamburg, inv. no. 1955.59
(von Saldern 1968a, fig. 20)
9. Okayama, inv. no. 76.360
(Taniichi 1987, no. 116)

The large number of related works testifies to the popularity of the honeycomb pattern for this type of long-necked bottle. As remarked above (see, for example, cat. 9), this decorative motif has a long history in the ornamental language of Iran and in glass production in particular.

Probably influenced by ceramic shapes under the Seljuqs, finely blown globular bottles with long necks, which were also optic blown, became a standard product of Iranian glassmakers. All of them (see also cat. 67, 68) share characteristics: the most common type has a flattened base with a moderately deep kick in the center, a pushed-in neck that creates a depression at the transition between the shoulder and the base of the neck (where the molded decoration ends), and a slightly lopsided body due to the effect of tooling the base and neck. The most common type of neck, which is always long and narrow, includes an applied band near its base and a bulge a few centimeters below the opening; above the bulge, the neck flares toward the opening. From the following entries (cat. 67, 68), it is evident that the shape was adopted to produce vessels in different molds, of which the honeycomb-patterned was among the most popular.

All the related works are bottles with similar dimensions (usually more than 23 centimeters in height), identical honeycomb decoration, and similar shapes; there are some variations in the profile of the neck and, especially, of the opening. Related Works 7 and 8 have a large bowl-shaped opening above the cylindrical neck; the slightly tapered neck of Related Work 9 includes an applied band at the base as the sole decoration. The profiles of Related Works 1–6 are almost identical to that of cat. 66.

There is a general agreement that these objects date to the eleventh and twelfth centuries. While eleventh-century Iranian glass production was still strongly influenced by the shapes exemplified by the Nishapur findings (see, for example, cat. 35), the present type of vessel is likely related to a change in style brought about by the Seljuqs in the twelfth century. These long-necked molded bottles were probably produced until the Iranian glass factories almost ceased to exist following the advent of the Ilkhanids; they were, in that case, made until the first half of the thirteenth century.

Cat. 66

**Cat. 67 BOTTLE (LNS 105 G)**
**Iranian region**
**12th–first half of the 13th century**

Dimensions: hgt. 26.5 cm; max. diam. 13.5 cm;
th. 0.22 cm; wt. 269.8 g; cap. ca. 1150 ml
Color: Translucent pale green (green 1)
Technique: Mold blown; applied; tooled;
worked on the pontil
Description: This nearly globular bottle has a
flattened base with a pronounced kick
in the center, a long slightly tapered
neck with a bulge near the top, and a
flared opening. A trail of the same color
as the body was applied near the base
of the neck. The decoration, created in
a one-part mold, covers the entire body
and ends abruptly near the base of the
neck; it consists of three large circles
enclosing a petaled flower; outside the
circle are concentric geometric forms in
a pattern that resembles a large flower
with multiple layers of petals.
Condition: The object is intact. The surface is
lightly weathered inside the vessel,
resulting in a pale brown film. The
glass includes frequent small bubbles
and some inclusions.
Literature: Ohm 1975, pl. 20, no. 166
Related Works: 1. CMNH, inv. no. 25138/1
(Oliver Jr. 1980, no. 264)
2. MIAP, inv. no. 22108
(Kordmahini 1988, p. 58)
3. KM, Düsseldorf, inv. no. P1971-80
(Ricke 1989, no. 75)
4. Whereabouts unknown
(Smith 1957, no. 472)

A decorative motif favored by the Iranian glassmakers for molded objects was the "cellular" or "concentric rosette,"[57] a flower whose petals are duplicated by similar concentric figures to give an impression of movement, almost like waves shifting on the vitreous surface.

The majority of surviving objects with this type of decoration are long-necked globular bottles, such as cat. 67 and Related Work 1. Other shapes include, for example, a large pitcher attributed to Gurgan in the twelfth century (Related Work 2), an unusual pear-shaped bottle with a short narrow neck (Related Work 3), and a dome-shaped vessel with a funneled neck (Related Work 4).

The four bottles mentioned above, as well as others that were sold at auction in the past twenty years, are all pale green. This observation may be no more than a simple coincidence resulting from the limitations of extant complete pieces, published material, and the author's knowledge; it must be said, however, that other types of twelfth- or thirteenth-century molded Iranian vessels statistically have more varied colors ranging from colorless to dark blue, green, brown, and purple. It would not be surprising if specific molds were used only in conjunction with particular colors; in this case, pale green to highlight the ornamental qualities of the concentric rosette motif.

Cat. 67

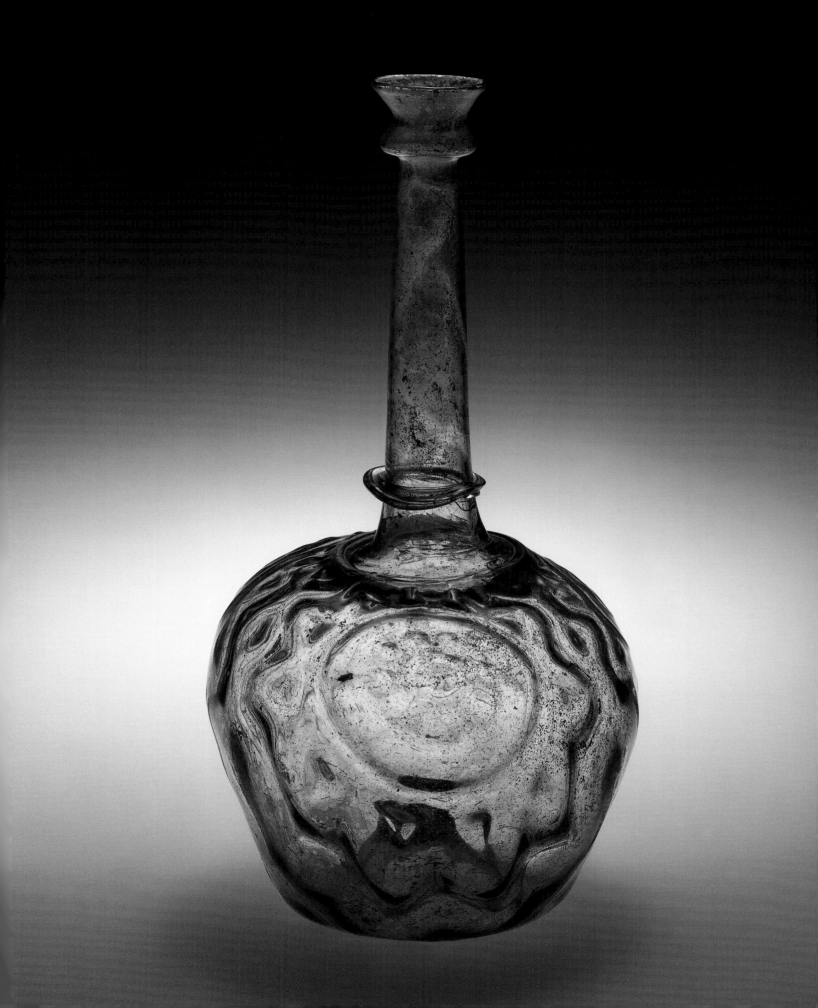

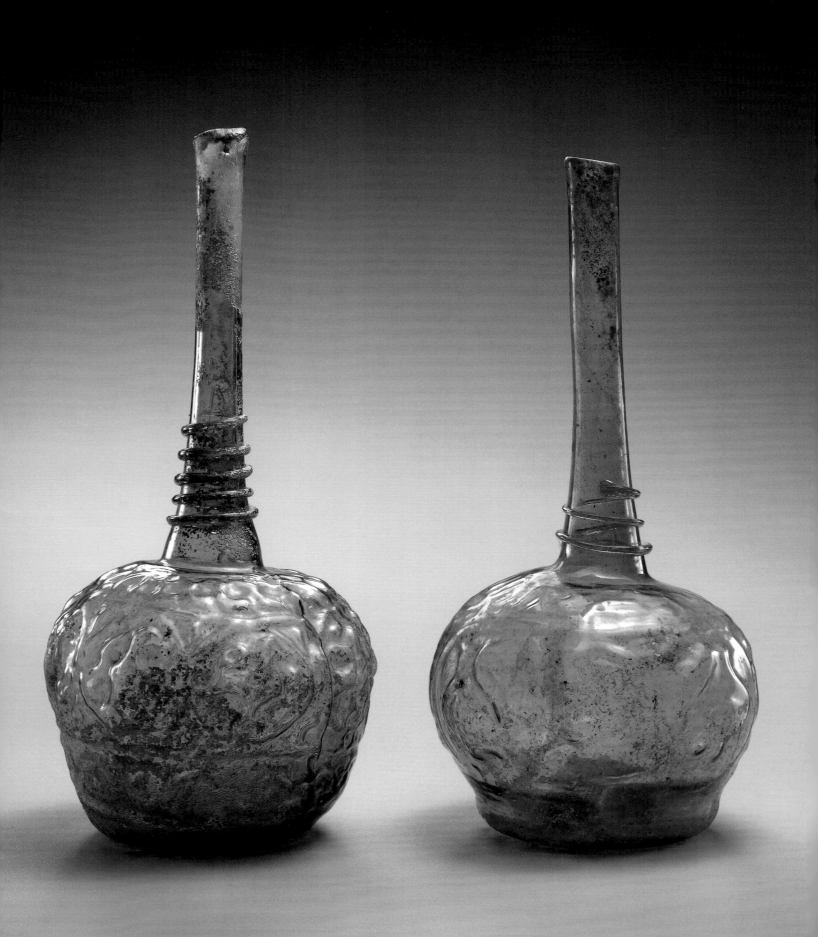

**Cat. 68a BOTTLE (LNS 93 KG)**
**Iranian region**
**12th–first half of the 13th century**

Dimensions: hgt. 21.0 cm; max. diam. 9.5 cm;
th. 0.20 cm; wt. 129.2 g; cap. 380 ml
Color: Translucent pale green (green 1)
Technique: Mold blown; applied; tooled;
worked on the pontil
Description: This nearly globular, lopsided bottle
has a flattened base with a kick in the
center and a long, cylindrical, and
slightly tapered neck. A trail of the
same color as the glass was applied in
a spiral around the base of the neck.
The decoration, created in a two-part
mold and subsequently optic blown,
consists of eight medallions containing
peacocks with raised tails facing right.
The main band containing the
medallion is enclosed by two narrow
bands that include a rope pattern; the
upper band is composed of rows of
sunken circles; the second and larger
one, of a vegetal scroll.
Condition: The object is intact except for part
of the opening, which is broken.
The surface is partially weathered,
resulting in a pale brown coating,
iridescence, and abrasion. The glass
includes scattered large bubbles.
Provenance: Kofler collection
Literature: Lucerne 1981, no. 556

**Cat. 68b BOTTLE (LNS 40 G)**
**Iranian region**
**12th–first half of the 13th century**

Dimensions: hgt. 20.0 cm; max. diam. 9.5 cm;
th. 0.25 cm; wt. 136.3 g; cap. 350 ml
Color: Translucent yellowish green (green 2)
Technique: Mold blown; applied; tooled;
worked on the pontil
Description: This bottle is similar to cat. 68a.
The decoration, in shallow relief,
was created in a two-part mold and
subsequently optic blown. It consists of
four medallions containing confronted
peacocks with raised tails facing,
alternately, right and left; between
the medallions are stylized trees or
columns. A different decoration is
above the medallions, but the relief
is too shallow to allow a proper
identification.

Condition: The object is intact. The surface is
lightly weathered, resulting in a milky
white film. The glass includes frequent
small bubbles and some large ones.
Literature: Ohm 1975, p. 48, no. 161
Related Works: 1. Whereabouts unknown
(Smith 1957, no. 468; Sotheby's,
London, sale, May 1975, lot 272)
2. NGV, inv. no. 1341-D5
(Edwards 1998, p. 50, left)
3. MM, inv. no. G57-70
4. Ohadi Museum, Maragheh
5. Okayama, inv. no. 2.69
(Taniichi 1987, no. 117)
6. Toledo, inv. no. 62.27

Another type of molded decoration on twelfth- and thirteenth-century long-necked globular vessels consists of a series of medallions including the image of a peacock with a long tail raised and curved above the body and almost touching the head. The birds are shown either oriented in the same direction (cat. 68a) or confronted (cat. 68b, Related Work 2). The medallions of cat. 68b are separated by stylized large vases, trees, or columns, a motif that could be interpreted as the tree of life.[58]

The image of the peacock recalls earlier traditions and is somewhat unexpected in this group of molded bottles, which include a variety of vegetal, geometric, or pseudovegetal patterns that provide good examples of the late medieval decorative vocabulary. These peacocks represent the only twelfth-century molded Iranian decoration to portray figural images. In shape and technique, however, the peacock bottles are similar to all the others in this group and they are certainly contemporaneous.

Birds within medallions and so-called pearl borders (that is, the narrow bands of sunken circles visible above and below the medallions, which are reminiscent of this decorative motif developed in Iran in the Sasanian period) may be compared to textile fragments from the early Islamic period that were influenced by Sasanian works.[59] A direct parallel in glass from the eighth or ninth century is provided by small stamped discs bearing the image of a peacock or a similar long-tailed bird that were often attached to the surface of blown vessels, such as large vases.[60] This survival of ancient motifs in the twelfth century makes these peacock bottles all the more remarkable compared to other contemporary vessels.

Cat. 68a, b

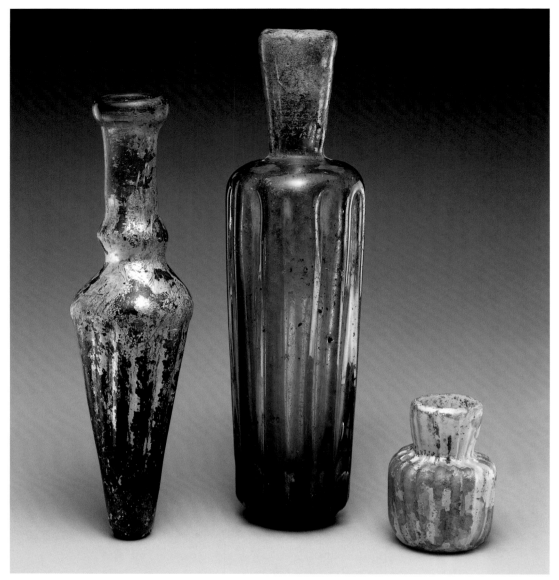

Cat. 3.29a–c

**Cat. 3.29a BOTTLE (LNS 59 KG)**
**Egyptian or Syrian region**
**8th–9th century**

Dimensions: hgt. 12.0 cm; max. diam. 3.5 cm;
th. 0.27 cm; wt. 46.3 g; cap. 22 ml
Color: Translucent greenish blue (blue 3)
Technique: Mold blown; tooled;
worked on the pontil
Description: This flared bottle has a small circular
base, a diagonal shoulder, a cylindrical
neck with a bulge near the base, and
a thickened opening. The decoration
consists of twelve vertical ribs that
vanish near the shoulder.
Condition: The object is intact. The surface is
heavily weathered, resulting in silvery
iridescence. The glass includes frequent
small bubbles.
Provenance: Kofler collection
Literature: Lucerne 1981, no. 532

**Cat. 3.29b BOTTLE (LNS 17 KG)**
**Egyptian or Syrian region**
**9th–10th century**

Dimensions: hgt. 14.0 cm; max. diam. 4.0 cm;
th. 0.40 cm; wt. 119.4 g; cap. 58 ml
Color: Translucent green (green 3)
Technique: Mold blown; tooled;
worked on the pontil
Description: This nearly cylindrical bottle has a flat
base and a flared neck. The decoration
consists of eleven vertical ribs in relief
that create a well-defined sunken
pattern in between.
Condition: The object is intact. The surface is
partially weathered, resulting in a
brown coating, especially around
the neck. The glass includes scattered
small bubbles.
Provenance: Kofler collection
Literature: Lucerne 1981, no. 533

**Cat. 3.29c MINIATURE VASE**
**(LNS 86 KG)**
**Possibly Egyptian or Syrian region**
**9th–10th century**

Dimensions: hgt. 4.0 cm; max. diam. 3.0 cm;
th. 0.24 cm; wt. 15.2 g; cap. 12 ml
Color: Translucent yellowish colorless
Technique: Mold blown; tooled;
worked on the pontil
Description: This small cylindrical vase has a
rounded shoulder and a cylindrical
neck. The decoration covers the vessel
and consists of twenty narrow vertical
ribs that were tooled and twisted
slightly clockwise.
Condition: The object is intact. The surface is
entirely weathered, resulting in a
milky white coating and iridescence.
Provenance: Kofler collection
Literature: Lucerne 1981, no. 538

**Cat. 3.30a BOTTLE (LNS 169 G)**
**Possibly Iranian region**
**9th–10th century**

Dimensions: hgt. 6.7 cm; max. diam. 1.9 cm;
th. 0.23 cm; wt. 22.9 g; cap. 6 ml
Color: Translucent pale bluish green
(green 1–2)
Technique: Mold blown; tooled
Description: This cylindrical bottle has a flat base
that curves near the wall, a long
angular shoulder, and a flared neck
ending in an irregular opening.
The six sides were created in a mold.
Condition: The object is intact. The surface
is entirely weathered, resulting in a
milky white coating and iridescence.
Provenance: Reportedly from Afghanistan

**Cat. 3.30b VASE (LNS 175 G)**
**Possibly Iranian region**
**9th–10th century**

Dimensions: hgt. 7.0 cm; max. diam. 5.5 cm;
th. 0.32 cm; wt. 71.5 g; cap. 80 ml
Color: Translucent pale green (green 2)
Technique: Mold blown; tooled;
worked on the pontil
Description: This vertical vase has a flat base with
a pronounced kick in the center, an
angular shoulder, and a slightly flared
neck. The eight sides were created in
a mold. A six-pointed star is molded
under the base around the pontil mark.
Condition: The object is intact. The surface is
entirely weathered, resulting in a
whitish coating and grayish pitting. The
glass includes frequent small bubbles.
Provenance: Reportedly from Dawlatabad (Balkh),
Afghanistan

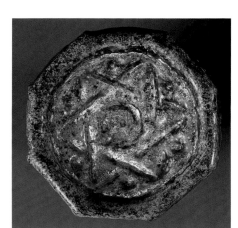

Cat. 3.30b detail of base

**Cat. 3.30c BOTTLE (LNS 6 KG)**
**Possibly Iranian region**
**9th–10th century**

Dimensions: hgt. 4.5 cm; max. diam. 3.0 cm;
th. 0.24 cm; wt. 17.5 g; cap. 10 ml
Color: Translucent grayish colorless
Technique: Mold blown; tooled;
worked on the pontil
Description: This vertical bottle has a flat base, an
angular shoulder, and a long, narrow,
slightly flared neck. The object's seven
sides were created in a mold.
Condition: The object is intact except for the base,
part of which was broken and pushed
inside the bottom of the vessel. The
surface is entirely weathered, resulting
in a milky white coating and grayish
pitting.
Provenance: Kofler collection
Literature: Lucerne 1981, no. 539

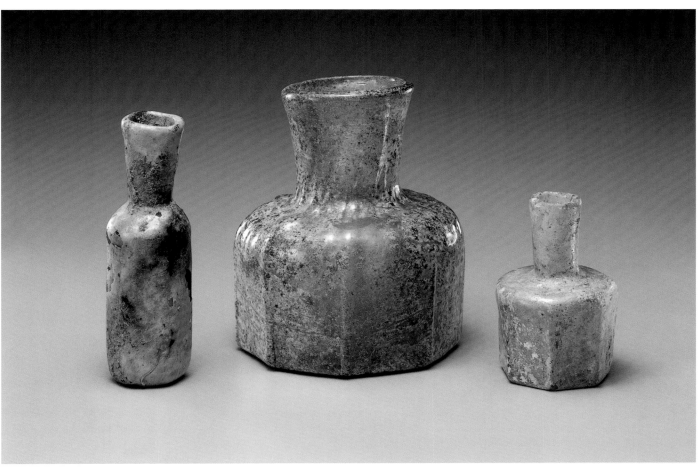

Cat. 3.30a–c

**Cat. 3.31a BOTTLE (LNS 88 KG)**
**Syrian or Mesopotamian region**
**9th–10th century**

Dimensions: hgt. 8.5 cm; max. diam. 3.0 cm;
th. 0.22 cm; wt. 42.4 g; cap. 24 ml
Color: Translucent yellowish colorless
Technique: Mold blown; tooled;
worked on the pontil
Description: This cylindrical bottle has a rounded
base and a slightly flared neck. The
decoration consists of a pseudovegetal
pattern of stemmed leaves covering the
body.[61] Tool marks are visible on the
shoulder and the base of the neck.
Condition: The object is intact except for a
deep crack on the neck. The surface
is heavily weathered, resulting in
golden iridescence. The glass includes
scattered small bubbles.
Provenance: Kofler collection
Literature: Lucerne 1981, no. 536

**Cat. 3.31b BOTTLE (LNS 102 KG)**
**Syrian or Mesopotamian region**
**9th–10th century**

Dimensions: hgt. 8.5 cm; max. diam. 3.0 cm;
th. 0.22 cm; wt. 32.5 g; cap. 25 ml
Color: Translucent, probably pale brown
(yellow/brown 2)
Technique: Mold blown; tooled
Description: This bottle has the same shape as
cat. 3.31a and a bulged opening. The
decoration, also similar to that of
cat. 3.31a but produced in a different
mold, consists of six pseudovegetal
patterns arranged vertically within
panels, so that the object looks six-sided
rather than round. The panels create
a six-petaled rosette under the base.
Condition: The object is intact. The surface is
entirely weathered, resulting in a milky
white coating and silvery iridescence.
The condition prevents a proper
reading of the color.
Provenance: Kofler collection
Literature: Lucerne 1981, no. 535

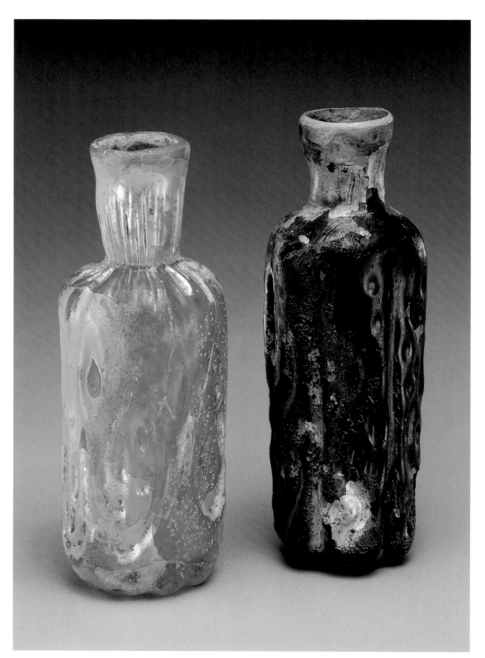

Cat. 3.31a, b

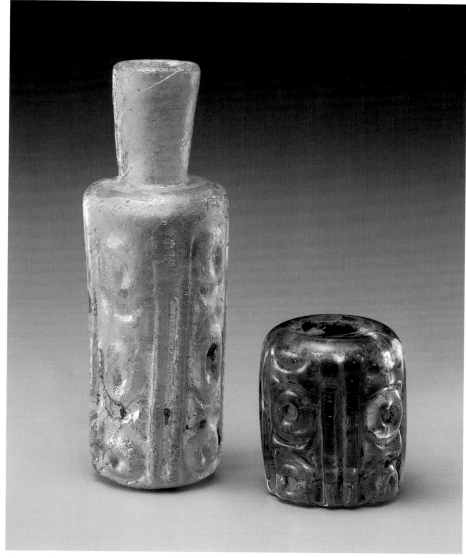

Cat. 3.33a, b

### Cat. 3.32 BOTTLE (LNS 17 G)
**Probably Iranian or
Mesopotamian region
9th–10th century**

Dimensions: hgt. 6.0 cm; w. 2.5 cm; l. 2.5 cm;
th. 0.43 cm; wt. 54.9 g; cap. 5 ml
Color: Translucent colorless with tinge
Technique: Molded; tooled; worked on the pontil
Description: This small square bottle has a flat base,
an angular shoulder, and a cylindrical
neck.
Condition: The object is intact. The surface is
entirely weathered, resulting in a
grayish white coating.

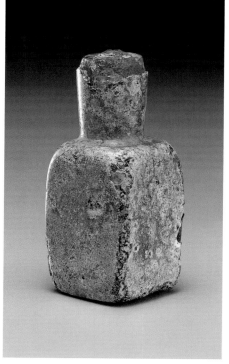

Cat. 3.32

### Cat. 3.33a BOTTLE (LNS 82 KG)
**Possibly Egyptian or Syrian region
10th–11th century**

Dimensions: hgt. 7.8 cm; max. diam. 2.6 cm;
th. 0.31 cm; wt. 34.8 g; cap. 14 ml
Color: Translucent yellowish colorless
Technique: Mold blown; tooled; worked on
the pontil
Description: This cylindrical bottle has a flat base, a
rounded shoulder, and a slightly flared
neck. The molded decoration consists
of four vertical panels each containing
three circles with a sunken center; the
panels are framed by vertical ribs.
Condition: The object is intact. The surface is
partially weathered, resulting in a milky
white coating and heavy iridescence.
The glass is of good quality.
Provenance: Kofler collection
Literature: Lucerne 1981, no. 534

### Cat. 3.33b FRAGMENTARY BOTTLE
(LNS 77 KG)
**Possibly Egyptian or Syrian region
10th–11th century**

Dimensions: hgt. 3.1 cm; max. diam. 2.5 cm;
th. 0.30 cm; wt. 23.0 g; cap. 6 ml
Color: Translucent brownish colorless
Technique: Mold blown; tooled
Description: This small cylindrical bottle has a
flat base and a rounded shoulder.
The molded decoration is the same
as that of cat. 3.33a, though the
object does not include the entire
pattern of the original mold.
Condition: The neck is missing and the incomplete
decoration suggests that the object may
have been reworked. The surface is
partially weathered, resulting in a pale
brown coating, especially inside the
vessel. The glass is of good quality.
Provenance: Kofler collection

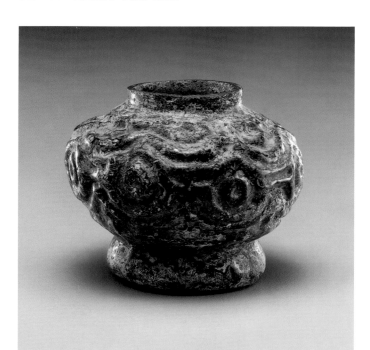

Cat. 3.34

### Cat. 3.34 FRAGMENTARY BOTTLE (LNS 344 G)
### Iranian region
### 10th–11th century

Dimensions: hgt. 4.2 cm; max. diam. 5.1 cm; th. 0.16 cm; wt. 44.6 g; cap. 30 ml
Color: Translucent colorless
Technique: Molded; tooled; worked on the pontil
Description: This bottle has a slightly lopsided globular shape and a tapered foot. The decoration, created in a two-part mold, consists of two horizontal rows of circles with a sunken center joined to one another by narrow horizontal elements.
Condition: The neck is almost entirely missing except for a small section of the base; the remainder of the object is intact. The surface is entirely weathered, resulting in pale brown and gray coatings that prevent a reading of the color.
Provenance: Eliahu Dobkin collection; Bonhams, London, sale, October 18, 1995, lot 400

### Cat. 3.35 BOTTLE (LNS 392 G)
### Probably Mesopotamian region
### 10th–11th century

Dimensions: hgt. 10.8 cm; max. diam. 7.5 cm; th. 0.29 cm; wt. 190.9 g; cap. 180 ml
Color: Translucent green (green 2)
Technique: Mold blown; tooled; worked on the pontil
Description: This slightly flared bottle has an angular shoulder, a base with a small kick in the center, and a cylindrical neck with a splayed opening. The decoration consists of a network of five rows of hexagons arranged in a honeycomb pattern.
Condition: The object is intact. The surface is entirely weathered, resulting in a pale brown crust and corrosion.
Provenance: Reportedly from Damascus, Syria

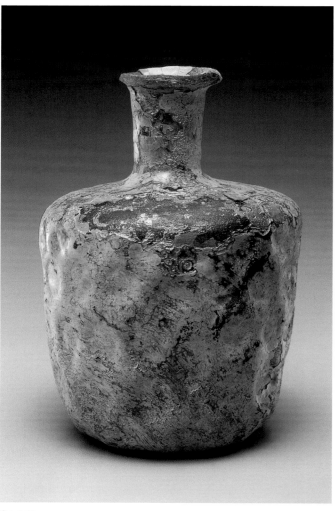

Cat. 3.35

**Cat. 3.36a BEAKER (LNS 74 KG)**
**Probably Iranian region**
**10th–11th century**

Dimensions: hgt. 7.5 cm; max. diam. 7.3 cm;
th. 0.37 cm; wt. 67.5 g; cap. 225 ml
Color: Translucent pale green (green 2)
Technique: Mold blown; tooled;
worked on the pontil
Description: This optic-blown cylindrical beaker
has a rounded slightly kicked base
and a thickened opening. The molded
decoration consists of four panels filled
with a network of small sunken dots
framed by narrow vertical bands of
chevron patterns.
Condition: The object is intact. The surface is
weathered, resulting in iridescence
and considerable abrasion.
Provenance: Kofler collection
Literature: Lucerne 1981, no. 551

**Cat. 3.36b VASE (LNS 75 KG)**
**Probably Iranian region**
**10th–11th century**

Dimensions: hgt. 7.7 cm; max. diam. 7.0 cm;
th. 0.41 cm; wt. 160.9 g; cap. 100 ml
Color: Translucent yellowish green (green 2)
Technique: Mold blown; tooled;
worked on the pontil
Description: This globular vase has a rounded
base and a short, slightly flared neck.
The decoration is similar to that of
cat. 3.36a, though the sunken dots
are replaced by rhomboids.
Condition: The object is intact. The surface is
heavily weathered, resulting in a pale
brown coating and iridescence.
Provenance: Kofler collection
Literature: Lucerne 1981, no. 549
Related Work: Cat. 54

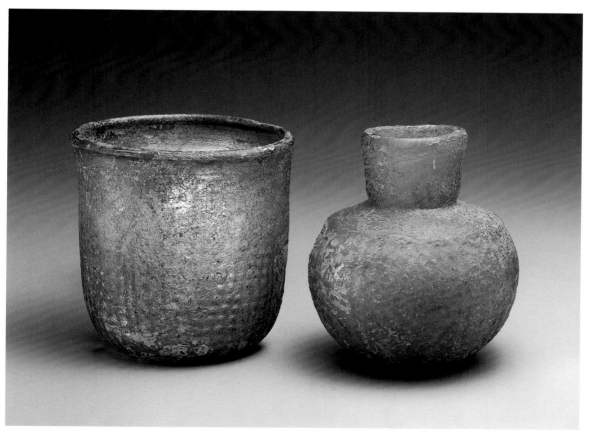

Cat. 3.36a, b

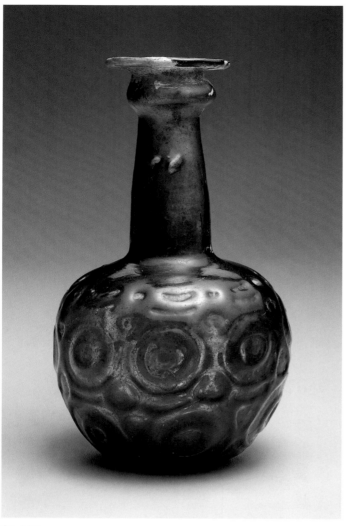

Cat. 3.37a

Cat. 3.37b

### Cat. 3.37a BOTTLE (LNS 51 G)
### Iranian region
### 10th–11th century

Dimensions: hgt. 13.5 cm; max. diam. 8.0 cm;
th. 0.32 cm; wt. 147.6 g; cap. 226 ml

Color: Translucent dark green (green 4)

Technique: Mold blown; tooled;
worked on the pontil

Description: This globular bottle has a flattened base
with a slight kick, a long cylindrical
neck with a bulge near the top, and
a splayed opening. The molded
decoration consists of two rows of
omphalos patterns surrounded by
triangles, creating a composite stylized
flower. A six-petaled flower is molded
under the base around the pontil mark.

Condition: The object is intact except for half of
the opening, which is filled. The surface
is partially weathered, resulting in a
pale brown coating, especially on the
interior. The glass includes scattered
small bubbles, one large bubble, and
a large inclusion on the neck.

### Cat. 3.37b FRAGMENTARY BOWL
### (LNS 128 G)
### Iranian region
### 10th–11th century

Dimensions: (largest fragment) w. 11.3 cm; l. 11.0 cm;
th. 0.35 cm

Color: Translucent yellowish colorless

Technique: Mold blown; tooled

Description: The decoration of this fragmentary
bowl is similar to that of cat. 3.37a.

Condition: When it entered the Collection this
object appeared to be complete
(hgt. 11.5 cm; max. diam. 19.0 cm;
th. 0.35 cm; wt. 330.7 g). It was
disassembled but not reconstructed,
since most of the fragments had
borders of infilled resin and very few
joined. The largest fragment includes a
portion of the rim. In this fragmentary
condition, it is unclear what percentage
of the original is extant. The surface
is entirely weathered, resulting in a
brownish gray coating.

Related Work: Cat. 62a

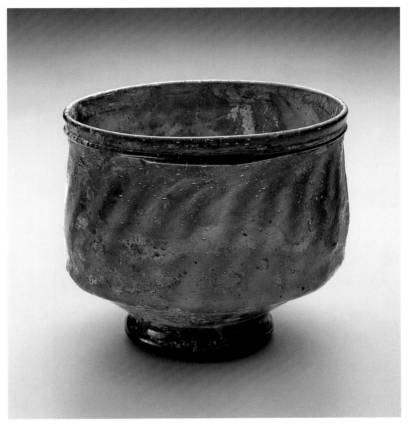

Cat. 3.39

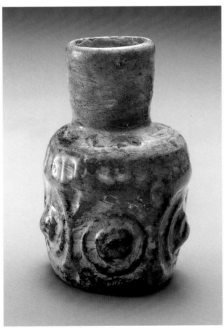

Cat. 3.38

### Cat. 3.38 BOTTLE (LNS 3 KG)
**Iranian region**
**10th–11th century**

Dimensions: hgt. 7.2 cm; max. diam. 4.0 cm;
th. 0.25 cm; wt. 69.1 g; cap. 51 ml
Color: Translucent green (green 2)
Technique: Mold blown; tooled;
worked on the pontil
Description: This cylindrical optic-blown bottle
has a flat base and a cylindrical neck.
The decoration, impressed in a one-
part mold, consists of a row of five
omphalos patterns included in a
network of sunken dots; a molded circle
is under the base and a row of sunken
dots is at the shoulder.
Condition: The object is intact. The surface is
entirely weathered, resulting in a pale
brown coating and iridescence. The
glass includes frequent small bubbles.
Provenance: Kofler collection

### Cat. 3.39 FOOTED CUP (LNS 98 G)
**Possibly Iranian or**
**Mesopotamian region**
**10th–11th century**

Dimensions: hgt. 8.7 cm; max. diam. 9.7 cm;
th. 0.27 cm; wt. 121.3 g; cap. 326 ml
Color: Translucent dark green (green 4–5)
Technique: Mold blown; applied; tooled;
worked on the pontil
Description: This large cup has a cylindrical, slightly
lopsided profile and a small foot created
by tooling; the transition between
the foot and the base is angular.
The molded decoration consists of
vertical ribs in shallow relief twisted
counterclockwise by tooling and a thin
trail of glass, in the same color as the
body, applied below the opening.
Condition: The object is intact. The surface is
heavily weathered, resulting in milky
white and pale brown coatings. The
glass includes frequent small bubbles
and scattered large ones.

## Cat. 3.40 PITCHER (LNS 92 G)
### Probably Iranian region
### 10th–11th century

Dimensions: hgt. 14.0 cm; max. diam. 9.0 cm;
  th. 0.19 cm; wt. 121.9 g; cap. 298 ml
Color: Translucent pale yellowish green
  (green 1); pale green (green 2)
Technique: Mold blown; tooled;
  worked on the pontil
Description: This globular pitcher, which was blown
  in a two-part mold (the seams are
  evident under the base), has a low
  octagonal foot and a slightly flared
  neck. An L-shaped green handle
  (green 2) with a large, flattened,
  circular thumb rest was attached at
  the rim and the middle of the body.
  The pontil was cut off clumsily and
  the mark is unusually prominent.
Condition: This object was broken and repaired; it
  is complete except for a small fill. The
  surface is partially weathered, resulting
  in a whitish film and iridescence. The
  glass includes frequent small bubbles.

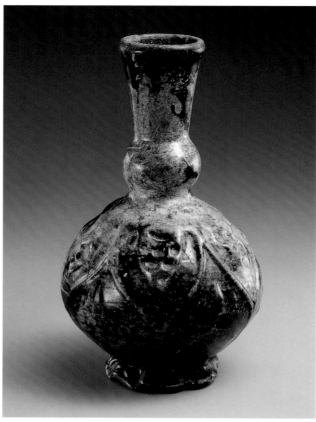

Cat. 3.41

## Cat. 3.41 BOTTLE (LNS 109 KG)
### Probably Iranian region
### 10th–11th century

Dimensions: hgt. 13.0 cm; max. diam. 7.5 cm;
  th. 0.30 cm; wt. 180.3 g; cap. 175 ml
Color: Translucent dark blue (blue 4)
Technique: Mold blown; tooled;
  worked on the pontil
Description: This globular bottle has a long flared
  neck with a large bulge at the base; a
  thick ring tooled in a wavy pattern was
  applied at the base to create a low foot.
  The molded decoration consists of a
  continuous pattern of pointed arches,
  alternately upright and upside down;
  inside each arch is a cluster of small
  sunken dots reminiscent of a grape
  motif.[62]
Condition: The object is intact except for part of
  the foot ring, which was filled with
  resinous amber-colored material and
  painted blue. The surface is entirely
  weathered, resulting in pale brown and
  whitish coatings. The glass includes
  scattered large bubbles.
Provenance: Kofler collection
Literature: Lucerne 1981, no. 548

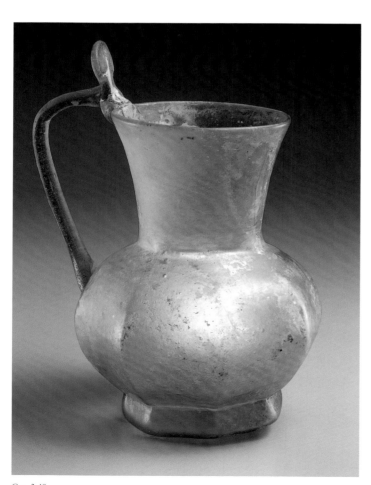

Cat. 3.40

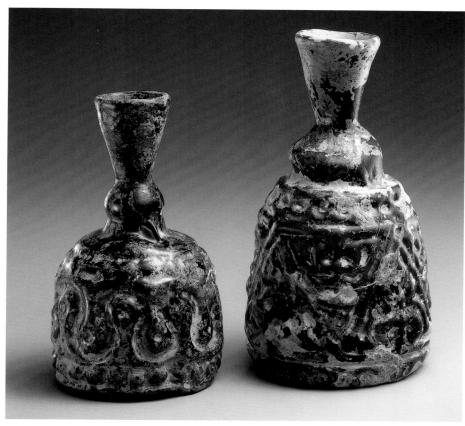

Cat. 3.42a, b

### Cat. 3.42a BOTTLE (LNS 369 G)
**Probably Iranian region**
**11th–12th century**

Dimensions: hgt. 11.2 cm; max. diam. 6.5 cm;
th. 0.26 cm; wt. 130.9 g; cap. 125 ml
Color: Translucent dark blue (blue 4–5)
Technique: Mold blown; tooled;
worked on the pontil
Description: This dome-shaped bottle has a flat base,
a rounded shoulder, and a flared neck;
there are two bulges, one between the
shoulder and the base of the neck and
another on the neck. The decoration,
created in a two-part mold (the seams
are especially evident underneath the
base), consists of two rows of small
horizontal circles in high relief framing
a large central band; the band includes
tear-shaped elements with a sunken
center that radiate from stemmed
elements and intersect. The pontil
was attached off-center and its position
was subsequently corrected.
Condition: The object is intact. The surface is
entirely weathered, resulting in brown
and gray coatings.
Provenance: Reportedly from Maimana (Faryab),
Afghanistan

### Cat. 3.42b BOTTLE (LNS 422 G)
**Probably Iranian region**
**11th–12th century**

Dimensions: hgt. 13.6 cm; max. diam. 7.1 cm;
th. 0.24 cm; wt. 135.4 g; cap. 227 ml
Color: Translucent vivid dark green (green 5)
Technique: Mold blown; tooled;
worked on the pontil
Description: This bottle is similar to cat. 3.42a; the
base is slightly kicked. The decoration,
created in a one-part mold, consists of
a continuous pattern of eight triangles,
alternately upright and upside down,
framed by two narrow bands filled
with a row of small sunken dots; each
triangle encloses a pattern of palmettes
departing from a central stem and
ending on top with a pointed, oval,
leaflike motif with a small sunken dot
at the center.
Condition: The object is intact. The surface is
entirely weathered, resulting in pale
brown soil, a yellowish coating, and
purple blue iridescence. The glass
includes frequent tiny bubbles.
Provenance: Sotheby's, London, sale, April 24,
1997, lot 3

### Cat. 3.43b PITCHER (LNS 160 G)
**Probably Iranian region**
**11th–12th century**

Dimensions: hgt. 10.5 cm; max. diam. 4.5 cm;
th. 0.19 cm; wt. 55.0 g; cap. 112 ml

Color: Translucent brownish colorless

Technique: Mold blown; applied; tooled;
worked on the pontil

Description: This cylindrical pitcher has a flat,
lopsided, slightly kicked base and a
cylindrical neck. A curved handle with
a thumb rest was attached at the rim
and the shoulder. The decoration
consists of three rows of seven tear-
shaped elements, each with a sunken
center; a circle of sunken dots is under
the base around the pontil mark.

Condition: The object is intact. The surface is
entirely weathered, resulting in gray
and brown coatings.

Provenance: Reportedly from Afghanistan

Cat. 3.43b detail of base

### Cat. 3.43a PITCHER (LNS 374 G)
**Iranian region**
**10th–11th century**

Dimensions: hgt. 15.5 cm; max. diam. 7.5 cm;
th. 0.20 cm; wt. 232.8 g; cap. 250 ml

Color: Translucent yellow (yellow/brown 1)

Technique: Mold blown; tooled;
worked on the pontil

Description: This eight-sided pitcher is slightly
lopsided and curves near the base and
at the shoulder. The base is flat with a
kick in the center and the tapering neck
ends in a tear-shaped opening with a
spout. A semicircular handle with a
thumb rest was applied to the opening
opposite the spout and at the base of
the neck. Two horizontal wavy bands
were applied around the base and the
center of the neck. Two trails were
applied vertically at the sides of the
mouth and at the wavy band around
the center of the neck; they were
pinched to create decorative patterns in
relief. The molded decoration, visible
inside the eight panels that give shape
to the body, is sunken: four alternate
sides seem to be inscriptional;[63] the
other four sides are decorated with
pseudovegetal patterns.

Condition: The object is intact. The surface is
heavily weathered, resulting in a silvery
white coating, especially on the neck.
The glass includes frequent small
bubbles.

Provenance: Reportedly from Afghanistan

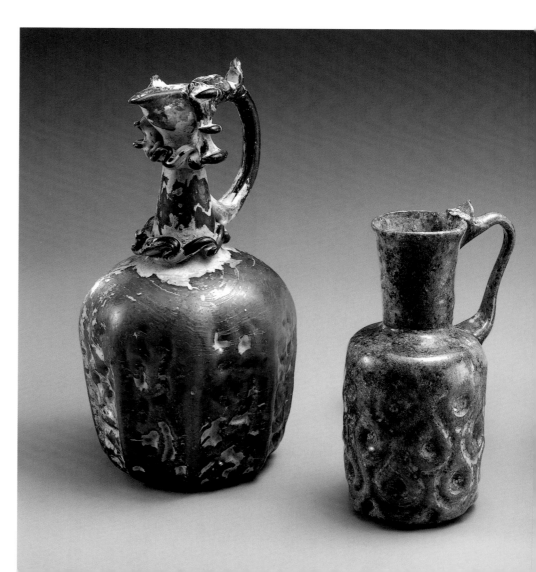

Cat. 3.43a–c

## Cat. 3.43c EWER (LNS 1066 G)
### Iranian region
### 12th–early 13th century

Dimensions: hgt. 14.0 cm; max. diam. 7.0 cm;
th. 0.25 cm; wt. 139.8 g; cap. 220 ml
Color: Translucent yellowish or brownish
colorless
Technique: Mold blown; applied; tooled;
worked on the pontil
Description: This slightly flared, cylindrical ewer has
a flat kicked base, an angular shoulder,
and a slightly flared cylindrical neck;
a large spout that points upward was
applied at the rim. A handle with a
folded thumb rest was attached at the
rim opposite the spout and at the
shoulder (the applied parts are attached
somewhat clumsily).[64] The decoration
consists of a network of small sunken
dots arranged in vertical rows and
offset horizontally.
Condition: The object is intact. The surface is entirely
weathered, resulting in pale brown and
whitish coatings and iridescence.
Provenance: Reportedly from Balkh, Afghanistan

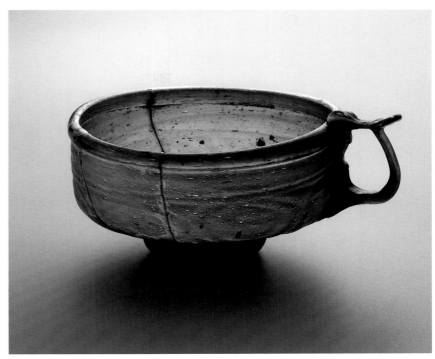

Cat. 3.44

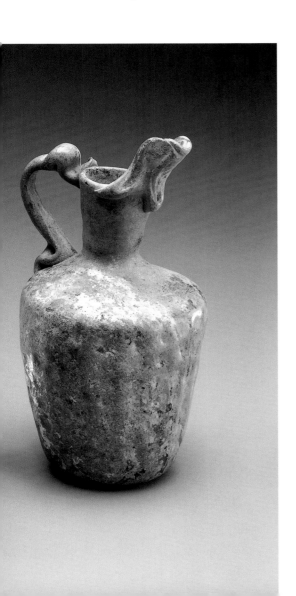

## Cat. 3.44 HANDLED CUP (LNS 95 G)
### Probably Iranian region
### 11th–12th century

Dimensions: hgt. 4.0 cm; max. diam. 7.6 cm;
th. 0.19 cm; wt. 52.2 g; cap. 112 ml
Color: Translucent blue (blue 3)
Technique: Mold blown; tooled;
worked on the pontil
Description: This low cup stands on a small thick
circular base created in the mold; the
opening folds inward. A curved handle
with a small thumb rest was attached
to the opening and the base. The low-
relief, optic-blown, molded decoration,
present only near the base, perhaps
consists of omphalos patterns or
vegetal scrolls departing from a circle.
Condition: This object was broken and repaired; it
is complete except for minor fills. The
surface is lightly weathered, resulting in
a milky white film and abrasion. The
glass includes frequent small bubbles.

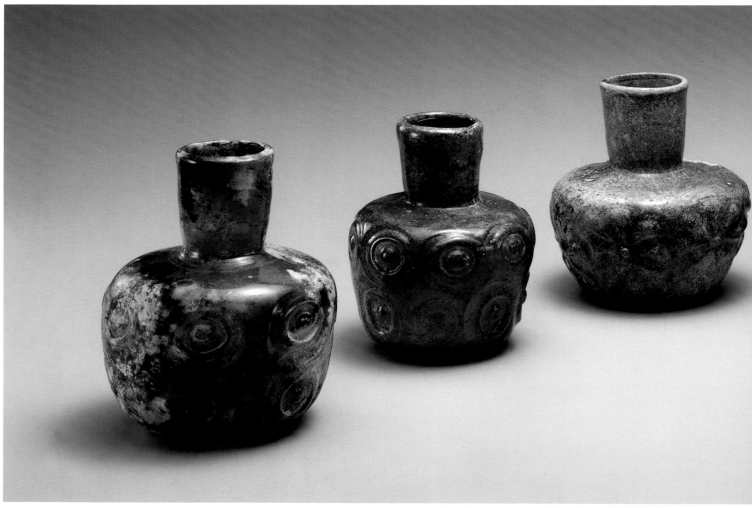

Cat. 3.45a–f

### Cat. 3.45a BOTTLE (LNS 389 G)
**Possibly Iranian region**
**12th–first half of the 13th century**

Dimensions: hgt. 9.9 cm; max. diam. 7.9 cm;
th. 0.31 cm; wt. 135.3 g; cap. 200 ml
Color: Translucent yellow (yellow/brown 1)
Technique: Molded or impressed; tooled;
worked on the pontil
Description: This elongated globular bottle has a
base with a pronounced kick in the
center and a cylindrical neck with a
small constriction at its base. The
decoration consists of two rows of
seven concentric omphalos patterns,
irregularly spaced.
Condition: The object is intact. The surface is
entirely weathered, resulting in a milky
white film, dark brown coating, and
iridescence.
Provenance: Reportedly from Damascus, Syria

### Cat. 3.45b BOTTLE (LNS 390 G)
**Possibly Iranian region**
**12th–first half of the 13th century**

Dimensions: hgt. 8.8 cm; max. diam. 6.7 cm;
th. 0.32 cm; wt. 105.8 g; cap. 150 ml
Color: Translucent yellow (yellow/brown 1)
Technique: Molded or impressed; tooled;
worked on the pontil
Description: This bottle is similar to cat. 3.45a;
the base has a small kick in the center.
The decoration consists of two rows of
concentric omphalos patterns—nine in
the lower row, seven in the upper.
Condition: The object is intact. The surface is
entirely weathered, resulting in pale
brown and darker brown coatings,
especially inside the vessel.
Provenance: Reportedly from Damascus, Syria

### Cat. 3.45c BOTTLE (LNS 385 G)
**Possibly Iranian region**
**12th–first half of the 13th century**

Dimensions: hgt. 8.9 cm; max. diam. 7.7 cm;
th. 0.27 cm; wt. 84.0 g; cap. 175 ml
Color: Translucent colorless with tinge
Technique: Molded or impressed; applied; tooled;
worked on the pontil
Description: This bottle is similar to cat. 3.45a.
The opening is decorated with an
applied thread of dark glass fused
around the rim. The decoration consists
of one row of eight-petaled flowers
with a raised button at the center.
Condition: The object is intact. The surface is
entirely weathered, resulting in gray
and pale brown coatings that prevent
a reading of the color.
Provenance: Reportedly from Damascus, Syria

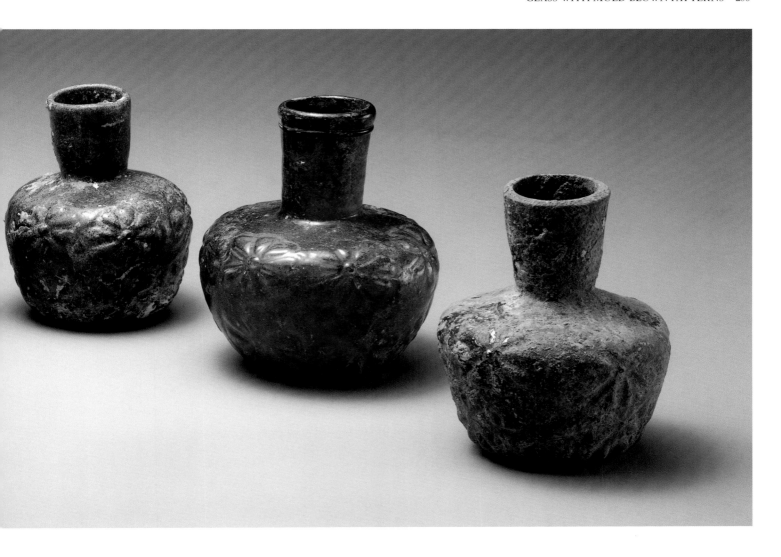

**Cat. 3.45d BOTTLE (LNS 386 G)**
**Possibly Iranian region**
**12th–first half of the 13th century**

Dimensions: hgt. 9.2 cm; max. diam. 7.3 cm;
    th. 0.44 cm; wt. 105.0 g; cap. 170 ml
Color: Translucent colorless with tinge
Technique: Molded or impressed; applied; tooled;
    worked on the pontil
Description: This bottle is similar to cat. 3.45a.
    The opening is decorated with an
    applied thread of dark glass fused
    around the rim. The decoration consists
    of two rows of six eight-petaled flowers
    with a raised button at the center.
Condition: The object is intact. The surface is
    entirely weathered, resulting in gray
    and pale brown coatings that prevent
    a reading of the color.
Provenance: Reportedly from Damascus, Syria

**Cat. 3.45e BOTTLE (LNS 387 G)**
**Possibly Iranian region**
**12th–first half of the 13th century**

Dimensions: hgt. 10.3 cm; max. diam. 8.8 cm;
    th. 0.43 cm; wt. 142.2 g; cap. 260 ml
Color: Translucent yellow (yellow/brown 1)
    and blue (blue 3)
Technique: Molded or impressed; applied; tooled;
    worked on the pontil
Description: This bottle is similar to cat. 3.45a;
    the small kick in the center of the base
    shows traces of blue glass. The opening
    is decorated with an applied thread of
    dark glass fused around the rim. The
    decoration consists of two rows of
    eight-petaled flowers with a raised
    button at the center—six in the lower
    row, seven in the upper.
Condition: The object is intact. The surface is
    entirely weathered, resulting in a milky
    white film and gray and pale brown
    coatings. The glass includes frequent
    tiny bubbles.
Provenance: Reportedly from Damascus, Syria

**Cat. 3.45f BOTTLE (LNS 388 G)**
**Possibly Iranian region**
**12th–first half of the 13th century**

Dimensions: hgt. 9.4 cm; max. diam. 7.7 cm;
    th. 0.31 cm; wt. 102.9 g; cap. 180 ml
Color: Translucent colorless with tinge
Technique: Molded or impressed; applied; tooled;
    worked on the pontil
Description: This bottle is similar to cat. 3.45a;
    the small kick in the center of the base
    shows traces of blue glass. The opening
    is decorated with an applied thread
    of dark glass fused around the rim.
    The decoration consists of two rows
    of eight-petaled flowers with a raised
    button at the center—seven in the
    lower row, six in the upper.
Condition: The object is intact. The surface is
    entirely weathered, resulting in a pale
    brown crust, silvery iridescence, and
    corrosion.
Provenance: Reportedly from Damascus, Syria
Related Works: Cat. 64a–e

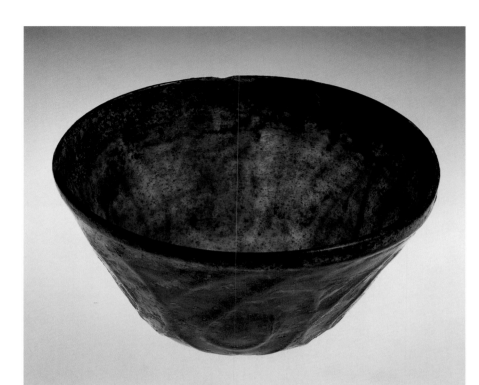

Cat. 3.46

### Cat. 3.47 BOTTLE (LNS 97 G)
**Iranian region**
**12th–first half of the 13th century**

Dimensions: hgt. 12.2 cm; max. diam. 8.5 cm;
th. 0.24 cm; wt. 142.4 g; cap. 238 ml
Color: Translucent blue (blue 3)
Technique: Molded; tooled; worked on the pontil
Description: This lopsided, nearly globular bottle
flattens at the base; the neck is nearly
cylindrical and slightly bulged. The
decoration consists of a row and a half
of five thin curly vegetal scrolls attached
by short stems; a five-petaled flower is
underneath the base.
Condition: The object was broken and repaired;
it has one large fill and several small
ones. The surface is entirely weathered,
resulting in a milky white coating,
iridescence, and abrasion. The glass
includes scattered small bubbles.
Related Work: Cat. 65

### Cat. 3.46 BOWL (LNS 396 G)
**Iranian region**
**12th–first half of the 13th century**

Dimensions: hgt. 5.7 cm; max. diam. 10.3 cm;
th. 0.21 cm; wt. 77.4 g; cap. 225 ml
Color: Translucent blue (blue 3)
Technique: Molded; tooled; worked on the pontil
Description: This flared bowl has a flattened base
with a small kick in the center and a
slightly thickened rim. The shallow
optic-blown decoration consists of
a row of six concentric tear-shaped
elements; the same pattern is partially
repeated, upside down, in a second
upper row; a stylized flower is
underneath the base.
Condition: The object is intact except for a small
chip at the rim. The surface is heavily
weathered, resulting in a pale brown
coating, dark gray pitting, and
abrasion. The glass includes frequent
small bubbles.
Provenance: Reportedly from Damascus, Syria

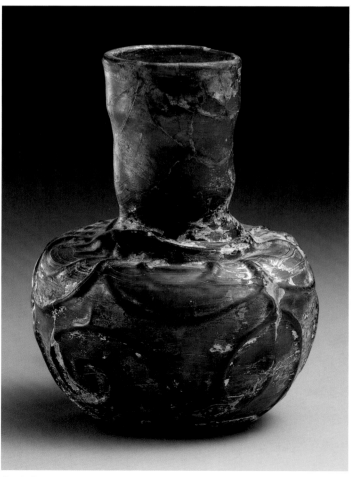

Cat. 3.47

**Cat. 3.48 BOTTLE (LNS 391 G)**
**Iranian region**
**12th–first half of the 13th century**

Dimensions: hgt. 9.8 cm; max. diam. 8.8 cm;
th. 0.13 cm; wt. 130.1 g; cap. 250 ml

Color: Translucent pale purple and brownish colorless

Technique: Mold blown; tooled; worked on the pontil

Description: This bottle has a nearly globular shape; the lower part is flattened and less rounded than the upper part. The base has a small kick in the center and the cylindrical neck constricts slightly at its base. The decoration consists of a network of eight rows of hexagons arranged in a honeycomb pattern. The pale purple glass was mixed with brownish colorless glass that produced streaks in the purple.

Condition: The object is intact except for about one-quarter of the neck. The surface is heavily weathered, resulting in iridescence and abrasion. The glass includes scattered small bubbles and two large ones.

Provenance: Reportedly from Damascus, Syria

Related Work: Cat. 66

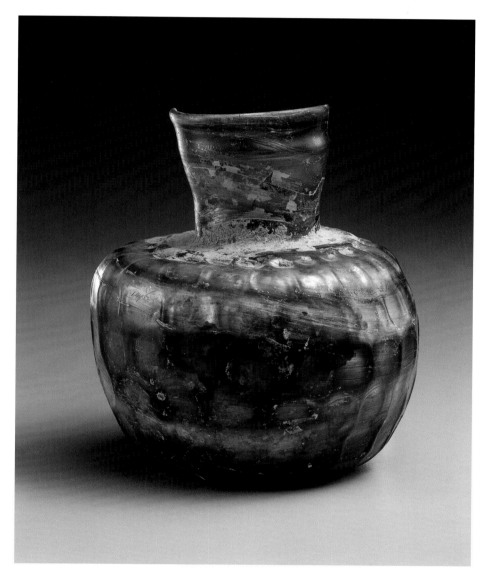

Cat. 3.48

# NOTES

1  See, for example, Lucerne 1981, nos. 237–337.

2  See Charleston 1989, p. 299.

3  Two bronze dip molds for glass have survived, one of them bearing the name of the glassmaker who owned the mold (see von Folsach–Whitehouse 1993).

4  When von Folsach and Whitehouse wrote their article (see note 3), doubts were raised about the possibility of blowing glass in a beaker-shaped mold and withdrawing it without disturbing the impressed decoration. A glassblower from the Steuben factory in Corning offered the answer: in contact with a colder surface (i.e., the metal of the mold), the glass tends to shrink for one or two seconds, and this brief period is usually enough time to allow the blower to withdraw the glass without damaging the pattern. Otherwise, breathing in a small amount of air from the blowpipe, so that the bubble deflates slightly and loses contact with the walls of the mold, would do the trick. The author is grateful to David Whitehouse for sharing this information.

5  Testing the interior surface of an open vessel, a bowl for example, is the best way to know whether the glass was optic blown.

6  Lamm 1929–30, pp. 58–59, pl. 13; and von Folsach–Whitehouse 1993, fig. 1. The two half-molds are in the Corning Museum of Glass (inv. no. 80.7.3) and in the Glass Pavilion of the Eretz Museum, Tel Aviv.

7  Von Folsach–Whitehouse 1993, p. 149.

8  On the twisted ribbed vessels, see, for example, Abdullaev et al. 1991, no. 638; and Paris 1992, p. 26. On Central Asian glass, see, for example, Trudnovskaia 1958; Amindjanova 1962 and 1965; Abdurazakov 1972; Sharakhimov 1973; Davidovich 1979; and Armarchuk 1988.

9  Rice (1958, p. 15), argues that at least two almost identical molds were used for the ewer in Toledo (Related Work 1) and the one in New York (Related Work 2). It is more likely, however, that the differences between the two objects are due to tooling rather than to the use of different molds.

10  Rice (1958, p. 13) was tempted to read it as "ibn Mutanabbī" but he also proposed other unlikely names such as "ibn Masā, Mashā, Mushī."

11  In their articles, Rice (1958) and 'Abd al-Ra'uf (1971) have read the inscriptions in different ways, so much so that the former attributed these ewers to Baghdad and the latter to Cairo. The latter's reading seems unlikely; however, since it is based on the two ewers in the Museum of Islamic Art in Cairo (Related Work 4), which I have not had the opportunity to study closely, it cannot be dismissed.

12  The ewer from Kufa is presently in the British Museum (inv. no. 1939.10-17.2; see Lamm 1929–30, pl. 13:6); another, with the same inscription, is in Corning (inv. no. 55.1.106; see Smith 1957, no. 469); a third, produced from a different mold but bearing the same artist's name, is in the Louvre (inv. no. AA 202; see Paris 1977, no. 88).

13  'Abd al-Khaliq 1976, p. 161, pl. 10b, figs. 66, 67.

14  Baker 2000, pl. 135. A small vase in the Victoria and Albert Museum, London (inv. no. C137-1936), has a similar molded pattern.

15  Lamm 1929–30, p. 63, pl. 15:8; and Kröger 1984, no. 87.

16  See, for an example, a polychrome-on-cream painted pottery bowl in the Metropolitan Museum (inv. no. 28.82) attributed to tenth-century eastern Iran or Transoxiana (Jenkins et al. 1977, pl. 233).

17  See Herzfeld 1923, vol. 1, pls. 17 (Orn. 22), 18 (Orn. 24, 28), and 19 (Orn. 27).

18  A good example of an object with a molded pattern underneath the base but finished on the blowpipe is cat. 49.

19  Inv. no. 86.7.15. The owner, whose name was scratched on the exterior wall of the mold, was the "glassmaker 'Uthmān ibn Abū Naṣr." The second mold is in the David collection in Copenhagen (inv. no. 20/1985; see von Folsach–Whitehouse 1993).

20  The only exception is a cylindrical cup decorated in the same way, now in Tehran (Related Work 1, inv. no. 21944).

21  Kröger 1995, p. 85.

22  Ibid., p. 90, no. 120.

23  For a summary of these sites, see Ettinghausen 1965, p. 218; and Ghouchani–Adle 1992, p. 72.

24  Ettinghausen's evidence (1965, pp. 219–20) is built on a number of objects found in western Central Asia that contained traces of quicksilver; in Persian, this type of vessel is also called simāb kūzehcheh, or "small jug for quicksilver." Ghouchani and Adle (1992, pp. 74–86) cite inscriptions (such as "Drink to your health") and many literary, especially poetic, passages in Persian and Arabic that mention fuqqā' as an effervescent, possibly alcoholic, drink that was stored in solid containers called fuqqā'a. These vessels were sealed with a piece of skin and secured around the neck with a tight string; when the skin was pierced, fuqqā' gushed slowly from the narrow neck, like champagne, and was consumed in this fashion. As for other suggested functions, an identification of these objects as aeolipiles or hand grenades is easy to dismiss in the case of glass vessels and also unlikely for pottery. The hypothesis of their use as loom weights is more acceptable, though questionable on the grounds that a solid glass vessel would be heavier and more effective than a blown one. Nonetheless, their use as plumb bobs has recently been suggested (Related Work 8, inv. no. GLS 569). See also Keall 1993.

25  The twelfth-century poet Suzani Samarqandi mentions that "the fuqqā' sat concealed in crushed ice" (Ghouchani–Adle 1992, pp. 78–79).

26  Ibid., p. 78.

27  Analysis of the contents of cat. 53b, unfortunately, revealed only a soil-like substance.

28  Described in Naumann 1976, no. 66, p. 33 (hgt. 7.2 cm; max. diam. 8.6 cm).

29  Kröger 1984, p. 92, no. 77.

30  For an example of each type, see Kröger 1995, nos. 51, 52, p. 61; Lamm 1935, nos. 185, 187, pp. 68–69; and Jenkins 1986, no. 17, p. 20.

31  Kröger 1995, nos. 232, 233, pp. 180–81.

32  Von Folsach–Whitehouse 1993, figs. 3, 4.

33  See, for example, SPA, pl. 243; and Marschak 1986, figs. 34, 55, 68, 71, 199.

34  Blair 1973, pl. 9, figs. 103, 104; and Fukai 1977, p. 52, figs. 56, 58.

35  Whitehouse 1993, figs. 1–5, 9.

36  The two vessels have similar dimensions (15.7 cm and 16.5 cm, respectively) and were both finished at the wheel; the London ewer is decorated with a thin incised network and the vessel in Pittsburgh is undecorated (see Harden et al. 1968, no. 142; and Oliver Jr. 1980, no. 250).

37  The only published parallel known to the author, though rather different in profile, is a small ewer excavated at Takrit (50 km from Samarra), which is, surprisingly, attributed to the end of the Ilkhanid period (14th century) by 'Abd al-Khaliq (1976, pp. 206–7, pl. 22b, fig. 142).

38  See, for example, Kordmahini 1988, pp. 67, 78; and

Toledo 1969, ill. p. 38 (bottom).

39  Among them, Lamm, Clairmont, and Kröger (see Related Works 4, 1, and 5, respectively).

40  Corning 1955, p. 34, no. 73; and Tait 1991, p. 121, fig. 149. Some fragments were also found in Nishapur, in eastern Iran (Kröger 1995, no. 124, p. 91).

41  See also cat. 29.

42  See Carboni 1999, p. 175.

43  See, for example, SPA, pls. 650a, 663a, and 678b. From a technical point of view, these ceramic vessels are a hybrid between the so-called mīnāi and lājvardina wares. The most representative object of this type, which helps to date the group, is a long-necked bottle in the Miho Museum of about 1173–86 (see New York 1996, no. 81).

44  For a metalwork example, see Melikian-Chirvani 1974, fig. 1.

45  See, for example, a glass bowl in the David collection, Copenhagen, inv. no. 70/1988 and a vase in the Louvre, inv. no. 7813 (Soustiel 1985, pl. 73).

46  See, for example, a pitcher in the Archaeological Institute in Samarqand (Abdullaev et al. 1991, no. 744).

47  There are a few examples of undecorated Roman and Islamic glass vessels that were "improved" in the nineteenth or early twentieth century with enamels and/or gilt. Two examples are provided by a dish painted with a Safavid-style angel in the British Museum (Harden et al. 1968, no. 160) and a large enameled and gilded dish in the Metropolitan Museum (Carboni et al. 1998).

48  See, for example, a bottle in Berlin with a decoration of horsemen (Berlin 1979, no. 515, pls. 10, 72; and Ward 1998, pl. 21.6) and a footed bowl in the Metropolitan Museum with an inscription in poetry (Jenkins 1986, pp. 38–39, no. 46; and Ward 1998, pl. 25.1).

49  Inv. no. C1045-1922 (Lamm 1929–30, pl. 60:6).

50  These include a plate dedicated to Ghiyāth al-Dīn Kaikhusrow III, Museum of the Karatay Medrese, Konya, inv. no. 2162 (Istanbul 1983, p. 45, no. D60; and Carboni et al. 1998, fig. 6); a fragmentary bottle in the name of 'Imād al-Dīn al-Zangī, British Museum (Mayer 1939; and Tait 1991, fig. 163); and a few long and narrow cylindrical bottles with a gilded pattern of squares and circles, excavated in Cyprus and Russia and attributed to the eastern Mediterranean region (Megaw 1959; Shelkolnikov 1966, figs. 16–18, 23, 24; and Whitehouse 1998, pls. 2.1–2.5).

51  The bottle, presently in the Nationalmuseum, Stockholm is said to have been found at Rayy, in Iran; see Lamm 1935, pl. 24d.

52  L. A. Mayer Memorial, inv. no. M 80 (Hasson 1979, fig. 50).

53  The small cylindrical stamp (LNS 139 W) has a handle for easier stamping. It is 3.6 cm high and 2.7 cm in diameter, and the pattern stands about 0.25 cm in relief, thus making it a likely candidate for the type of impression proposed for cat. 64a and b.

54  Von Folsach and Whitehouse (1993, pp. 149–50, fig. 2) point out that two halves of a terracotta mold in the Eretz Israel Museum, Tel Aviv (which Lamm regarded as a glass mold) present stylistical and technical problems and suggest that it was not destined to be used in making glass but rather to cast plaster. The reasons for rejecting Lamm's identification of that particular mold are sensible, but cat. 64a and b may prove that molds made of "soft" material were used.

55  These examples are in the Toledo Museum of Art (Toledo 1969, fig. p. 37); Museum für Islamische

Kunst, Berlin (Kröger 1984, no. 86); Musée du Verre, Liège (Philippe 1982, fig. 62); L. A. Mayer Memorial, Jerusalem (Hasson 1979, fig. 51); and David collection, Copenhagen (von Folsach 1990, fig. 239).

56  Kordmahini 1988, fig. 60.

57  On the term *cellular rosette*, see Oliver Jr. 1980, no. 264.

58  In a drawing of two of these medallions (Ohm 1975, no. 161), the stylized trees between them are interpreted as elongated, pear-shaped, footed vases. The drawing was probably modeled after cat. 68b, since the bottle, in a private collection in 1975, was acquired from Mr. Kofler in the early 1980s, though there are no records to prove that it is the same bottle. The drawing of the pattern on the present bottle confirms that the most likely reading is that of a tall footed vase with a large opening.

59  Two fragments in the Textile Museum, Washington, D.C. (inv. nos. 3230, 3241), exemplify this concept. Both fragments depict confronted peacocks separated by a stylized tree of life included within a medallion with a pearl border. The first, found in the funerary complex of Bibi Shahr Banu at Rayy, is dated A.D. 994; the second, from Seljuq Iran, is datable to the eleventh or twelfth century (see Bagnera 1994, pp. 150–54, figs. 1, 2; and May 1957, figs. 7, 37).

60  A good example is provided by a globular vase in the Metropolitan Museum of Art, inv. no. 37.56 (Jenkins 1986, no. 7); each of the six discs on the upper row includes a long-tailed bird; those on the lower row, a horse. See also cat. 3.50d, e.

61  A similar pattern, which seems to date this type of vessel to the immediate post-Samarran period, is found on date flasks, so-called because of their shape

and texture, usually attributed to the second or third century A.D.

62  A vessel produced in either the same or a similar mold is in the Nasser D. Khalili collection, London (inv. no. GLS 137); see cat. 53a, Related Work 3.

63  Rubbings and impressions of these four sides have not clarified whether the molded motif represents a meaningful inscription or is pseudocalligraphy. For this reason, though the object is accomplished and would otherwise deserve further discussion, it has been included in the present "secondary" entry.

64  The clear derivation of the shape of this ewer from metal objects with inlaid decoration, which were produced in the eastern Iranian region (Khorasan) in the twelfth and early thirteenth centuries, suggests a contemporaneous date and a similar area of production; see, for example, Carboni 1997, no. 9.

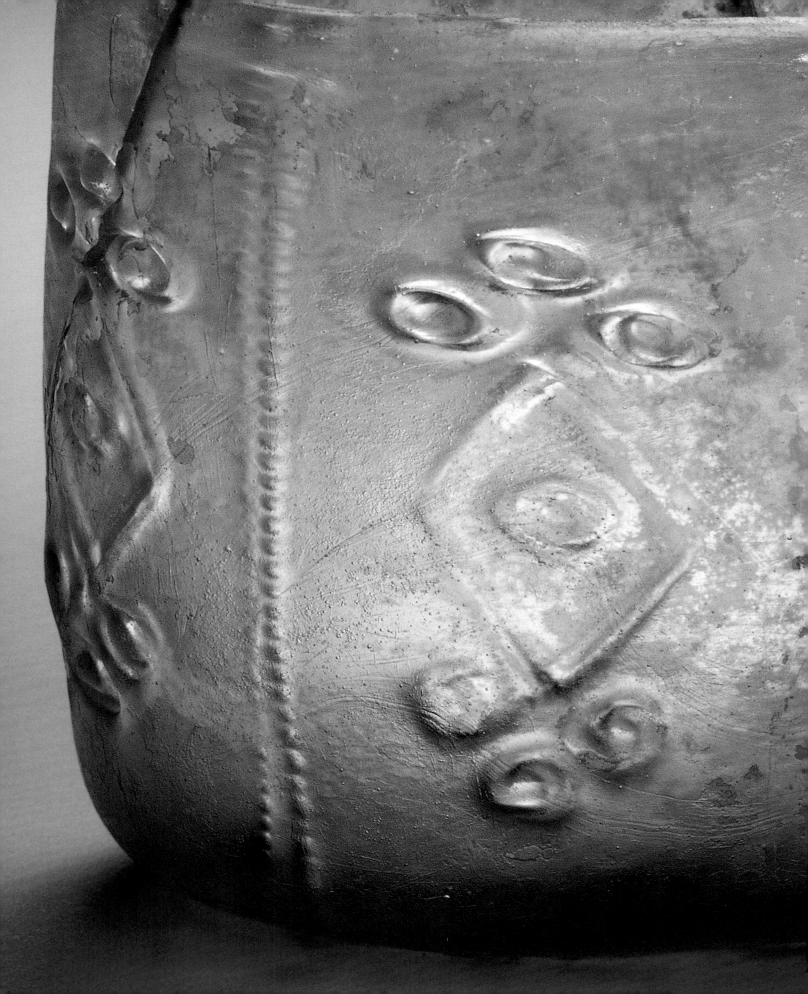

# GLASS WITH IMPRESSED PATTERNS

THIS GROUP INCLUDES blown vessels and medallions decorated with the aid of molds that differ from the one- or two-part molds discussed previously (cat. 48–68).

Decorative patterns were not impressed on these vessels during blowing inside a single or multipart mold but just after the object was taken off the kiln, when the glass was still malleable. It is assumed that the tools used to create the patterns were tongs of metal, probably iron, though none has survived. The two ends of these tongs were circular or square and bore—at least on one side—a carved motif that was impressed in relief on the glass when the object was still attached to the pontil during tooling.

The most common objects decorated with the aid of tongs are numerous extant small bowls that can be attributed with some degree of confidence to Egyptian workshops of the ninth and tenth centuries (cat. 69, 70). Pale colors, except for a small number in dark green, and the repetition of the same pattern around the walls are among the common features of these bowls. They must have been produced in large numbers and at a fast pace, since they are among the least accomplished glass objects from this early period. The repeated impressions almost invariably overlap and the pressure of the tongs against the wall often disrupts the profile of the vessel; consequently, the finished product is lopsided and sometimes looks like it should have been rejected by the glassmaker. The large number of intact bowls of this type that have survived, however, proves that they were regarded as acceptable finished products. The high relief created with the tongs gives, in few cases, a nearly three-dimensional plastic appearance to the walls; these objects are appealing and have a finished look.

A limited number of motifs were carved on the iron tongs; among the most successful were multipetaled rosettes (cat. 69a, b), quadrupeds (cat. 70a–c), and omphalos patterns (cat. 3.55a–f, 3.56). Sometimes, stylized birds appear (cat. 3.54).[1] The objects representing animals and birds are usually of better quality, as if the glassmakers regarded them more highly. Large bowls of various shapes rank among the best objects created with this technique. The most refined vessels are those in which the impressed patterns are evenly spaced and in low relief, so that the decoration is more subtle, does not occupy all the available space, and shows no overlapping.

As argued at cat. 70, the objects that bear the omphalos decoration (see also cat. 16, 53), can, in part, be regarded as belonging to the same group. The impression is often applied to larger vessels of different types, including bottles with a globular shape or long neck (see, for example, cat. 3.55e, f, 3.56). Given the closed nature of these bottles, it is not clear whether the omphalos motifs were impressed with tongs or other tools.[2] In all instances of vessels of an open nature (see cat. 3.55a–d), glassmakers almost certainly used tongs. Their dimensions and shapes, however, set them apart from the average production. For these reasons, a different and more eastern area of manufacture has been postulated.

The best objects decorated with the tong technique are beakers (or, sometimes, pitchers and bowls; see cat. 71b, 72), which were usually made of colorless glass and impressed with tongs provided with large rectangular ends. Simple, composite geometric patterns as well as Kufic inscriptions are part of the repertoire (cat. 71a, b, 72). The impressions on these objects were executed more carefully than those on the small vessels discussed above (cat. 69, 70). The tongs were applied at even distances around the walls of the objects with contiguous sides, so that the decorated surface was divided into regular rectangular sections, each including the desired pattern (either geometric or inscriptional) in the center. As a rule, inscriptions are set vertically; they include either blessings to an anonymous owner or a toast,

such as "Drink with enjoyment!" (see cat. 72), which explains the function of such vessels. Geometric motifs can vary greatly; the majority include clusters of circles and rhomboids (as in cat. 71a, b) arranged in regular patterns. In some cases, however, curved as well as diagonal lines and circles are combined into irregular designs that give the vessels a more abstract appearance.[3]

These beakers and bowls, like those decorated with an omphalos pattern, are usually tentatively assigned to Egypt. This attribution is not, however, corroborated by archaeological or hearsay evidence, with the exception of a beaker with a Kufic inscription now in the Gayer Anderson Museum, Cairo (cat. 72, Related Work 1). On the contrary, as discussed at cat. 71, the only related excavation sites are in the Syrian or Mesopotamian area, and at least two beakers of this type have reportedly been found in the Caucasus and in northern Iran. This group of impressed vessels may, therefore, help prove that the area in which tongs were included in a glassmaker's set of decorative tools was wider than previously believed.

The eastern area of production of impressed glass is well represented in the al-Sabah Collection by nineteen medallions and fragments (cat. 73a–s). These belong to the second type of glass with impressed decoration—that is, objects created by pressing a patterned mold against a cake of molten glass resting on a flat surface. Although nothing is known about the type of mold used (it may have been rather complex), the process can be compared to the production of glass coin weights that were manufactured in large quantities, especially in Egypt, from the eighth through the fourteenth century. These weights were created by stamping with an iron die, just as regular gold, silver, and copper coins were produced.

In the case of the medallions, which are larger than any coin weight or vessel stamp, it seems logical to assume that they were not made with dies similar to those used for stamps[4] but with connecting metal blocks with one side carved into a pattern, the other left undecorated, which would impress the desired motif in relief on the obverse of the medallion and leave the reverse plain and flat. In addition to a certain affinity with coin weights, a close relation with contemporary small circular bronze mirrors is evident, both in the choice of subjects portrayed (for example, heraldic eagles, falconers, and sphinxes; see cat. 73b, h, i, m, n)[5] and in the presence of a small circular depression in the center (see cat. 73b, f) that calls for an indirect comparison to hand-held bronze mirrors with a pierced knob attached at the center of the molded face. Furthermore, those medallions that do not present a circular depression can be compared to a second type of bronze mirror, which was held by an attached handle; therefore, there was no need for a pierced knob attached to the center. A preliminary survey of medallions and mirrors has thus far revealed only one almost identical mold proving a direct association between the two types of objects (see cat. 73b) and, in general, confirming the close relationship between metal and glass production.

The study of glass medallions and their inscriptions, unlike mirrors, is fairly conclusive in terms of attribution to a specific time and place of manufacture. These colorful objects that, in all probability, once decorated plaster-stained windows of Ghaznavid and Ghurid palaces, were produced in the second half of the twelfth century in an area restricted to modern northern Afghanistan. They represent a rare instance in the study of Islamic glass when a distinctive group is successfully identified and thus contributes to a better understanding of the field as a whole.

Cat. 69a

### Cat. 69a BOWL (LNS 28 KG)
**Egyptian or Syrian region**
**9th–10th century**

Dimensions: hgt. 4.0 cm; max. diam. 11.0 cm;
th. 0.41 cm; wt. 175.5 g; cap. 275 ml
Color: Translucent pale greenish blue (blue 1)
Technique: Blown; impressed with tongs; tooled;
worked on the pontil
Description: This low bowl has straight walls, a
flat base, and an opening that curves
slightly inward. The decoration consists
of sixteen circular medallions (max.
diam. ca. 1.6 cm each) impressed with
a tong at irregular intervals and often
overlapping; each medallion includes a
stylized ten-petaled rosette in relief that
is composed of two concentric circles
in the center surrounded by ten dots,
representing the petals.
Condition: The object is intact. The surface is
entirely weathered, resulting in pale
brown and whitish coatings and gray
pitting. The glass is of good quality.
Provenance: Kofler collection
Literature: Lucerne 1981, no. 570

Scholars generally assign small open vessels decorated with tongs to the Egyptian area during the early production of Islamic glass. The majority of such objects are reported to have been acquired in Egypt,[6] and Lamm had no doubts about attributing these works to ninth- and tenth-century Egypt.[7] Indeed, an object in the Museum für Islamische Kunst, Berlin, and a fragment in the Benaki Museum, Athens, were stamped with medallions that include the inscription *'amal miṣr* ("made in Cairo"), which supports the attribution of the entire group to Egypt.[8]

Although the final products may vary, such as the large low bowl and the footed cup (cat. 69a, b), the most typical objects are miniature and small bowls, usually pale-colored (yellow or green), which were badly misshapen by the impression made with tongs around their low walls (see cat. 3.52a–c, 3.53a, b).

The overall decoration, impressed with rectangular or circular metal tongs, one side of which carried the desired pattern in reverse, was usually performed rather carelessly, so that the individual motifs, which were stamped a number of times to cover the circumference of the vessel, were unevenly distributed on the surface and often overlapped, conveying the impression of a negligent job. Glassmakers, who probably obtained their iron tongs from nearby metalworkers, utilized a limited number of motifs, which included multipetaled rosettes (cat. 69a, b), omphalos patterns (cat. 3.55a–f), squares (cat. 3.53a, b),[9] animals (cat. 70a–c), and inscriptions.

Cat. 69b

## Cat. 69b FOOTED CUP (LNS 32 KG)
### Egyptian or Syrian region
### 9th–10th century

Dimensions: hgt. 4.8 cm; max. diam. 5.5 cm; th. 0.30 cm; wt. 65.1 g; cap. 49 ml

Color: Translucent yellow (yellow/brown 1)

Technique: Blown; impressed with tongs; applied; tooled; worked on the pontil

Description: This cup has curved and tapered walls and a curved opening; four small feet were created by tooling the base and a small circular handle with a thumb rest protruding horizontally was attached on the side. The decoration consists of seven circular medallions (max. diam. ca. 2.2 cm each) impressed with a tong at regular intervals. Each medallion includes the figure of a stylized eight-petaled rosette similar to that on cat. 69a.

Condition: The object is intact. The surface is lightly weathered, resulting in pale brown and pinkish red coatings and abrasion. The glass includes scattered large bubbles.

Provenance: Kofler collection

Literature: Lucerne 1981, no. 565

Related Works: 1. Whereabouts unknown (Smith 1957, no. 504)
2. MIK, inv. no. I.1307 (Lamm 1929–30, pl. 19:2)
3. MMA, inv. no. 30.115.13
4. V&A, inv. nos. C155-1936, C170-1932, C171-1932, C158-1936

The multipetaled rosette commonly has the shape of a central raised boss surrounded by a number of smaller bosses representing the petals. In some cases, the central boss is larger and more prominent than the "petals" (cat. 69b, 3.52a–d); sometimes, it is only slightly larger and is encircled by a narrow band in relief (cat. 69a). The number of petals can vary from six to ten; uneven numbers, though rare, have been found.[10] Each rosette is always enclosed within a circle. The height of the relief can vary dramatically, as seen by comparing cat. 69a and b: the low relief of the rosettes stamped around the walls of the bowl (cat. 69a) renders its decoration subtler and more refined, while the walls of the cup (cat. 69b) were turned into a plastic, almost three-dimensional, surface by the depth of the impression. Both the depth of the carving on the tongs and the glassmaker's actions produced these variations.

The low pale blue bowl (cat. 69a) has the typical angular profile of many undecorated objects from the early Islamic period. Its impressed decoration, though somewhat untidy in the distribution of the rosettes, nonetheless contributes to the object's appeal. Having no immediate parallel, its closest comparison is provided by a footed cup in Berlin (Related Work 2). Related Works 3 and 4 are useful in demonstrating the popularity of the rosette motif that is, without a doubt, the most recurrent in this group of objects with tong decoration; the Victoria and Albert Museum alone owns four good examples (unpublished) and many more can be found in other collections.

Cat. 69a and b are above-average, rather enticing pieces. The small cup (cat. 69b) has a striking appearance due to the manipulation of the surface, its feet, and its prominent round handle. An almost identical piece, but slightly larger, was once in the collection of Louis Comfort Tiffany (Related Work 1).

### Cat. 70a MINIATURE BOWL
### (LNS 30 KG)
### Egyptian or Syrian region
### 9th–10th century

Dimensions: hgt. 3.2 cm; max. diam. 5.6 cm;
th. 0.22 cm; wt. 44.2 g; cap. 49 ml
Color: Translucent yellowish green (green 1)
Technique: Blown; impressed with tongs; tooled;
worked on the pontil
Description: This bowl has tapered walls, a
flattened base, and a flared opening.
The decoration consists of five oval
medallions (max. diam. ca. 2.7 cm
each) impressed with a tong at irregular
intervals; each medallion includes the
figure of a quadruped, facing right
with its tail raised and curved.
Condition: The object is intact. The surface is
partially weathered, resulting in a pale
brown coating and some corrosion.
The glass includes frequent small
bubbles.
Provenance: Kofler collection
Literature: Lucerne 1981, no. 573 (topped by the
small lid, cat. 3.19)

### Cat. 70b MINIATURE BOWL
### (LNS 66 KG)
### Egyptian or Syrian region
### 9th–10th century

Dimensions: hgt. 3.2 cm; max. diam. 4.7 cm;
th. 0.30 cm; wt. 35.3 g; cap. 30 ml
Color: Translucent green (green 3–4)
Technique: Blown; impressed with tongs; tooled;
worked on the pontil
Description: This slightly lopsided bowl has straight
walls and a curved base. The decoration
consists of five oval medallions (max.
diam. ca. 2.8 cm each) impressed with
a tong at regular intervals, except for
two that slightly overlap. Each
medallion includes a similar quadruped
to cat. 70a, but with longer ears.
Condition: The object is intact. The surface
is partially weathered, resulting in
milky white and pale brown coatings.
The glass is of good quality.
Provenance: Kofler collection
Literature: Lucerne 1981, no. 572

### Cat. 70c MINIATURE BOWL
### (LNS 68 KG)
### Egyptian or Syrian region
### 9th–10th century

Dimensions: hgt. 4.0 cm; max. diam. 6.5 cm;
th. 0.22 cm; wt. 62.7 g; cap. 76 ml
Color: Translucent pale bluish green (green 2)
Technique: Blown; impressed with tongs; tooled;
worked on the pontil
Description: This bowl has straight walls and a
rounded base. The decoration consists
of six oval medallions (max. diam. ca.
2.9 cm each) impressed with a tong at
regular intervals, except for two that
slightly overlap. Each medallion includes
the same quadruped as cat. 70a.
Condition: The object is intact. The surface is
partially weathered, resulting in a
grayish silvery coating. The glass
includes frequent small bubbles, one
large bubble, and small impurities.
Provenance: Kofler collection
Literature: Lucerne 1981, no. 571
Related Works: 1. Benaki, inv. no. 3212
(Clairmont 1977, no. 237)
2. V&A, inv. no. C158-1936
3. Louvre, inv. no. OA 6002
(Lamm 1929–30, pl. 15:14)
4. MMA, inv. no. 08.138.2
(Jenkins 1986, no. 19)

Cat. 70a–c

A recurring pattern among the objects impressed with a tong is a medallion containing the figure of a stylized quadruped facing right. While details may vary, the animal generally has long legs, a slim body, a long curved tail, elongated head with an open mouth, and long well-separated ears. At times, a sort of decorative semipalmette is attached to the tip of the tail (Related Work 4). The animal seems to resemble a dog- or wolflike creature, an interpretation that is not, however, consistent with the common representations of animals in Islamic art of the early period, when felines and birds were clearly preferred. Its identification must, therefore, remain vague, as was probably the intention of the carvers.

Small bowls, such as cat. 70a–c, are the most common vessels tooled with quadruped-decorated tongs. Cat. 70a provides a nice variation of the profile; cat. 70b and c represent the average shape. Related Works 1–3 are also of this average type. Judging from the extant material, it seems that glassmakers paid more attention when they applied the tong to objects decorated with animals than to those with rosettes (see cat. 69)—in general, the medallions are more evenly spaced and the final product is less lopsided and more refined. An interesting object belonging to this group is a bottle in the Metropolitan Museum (Related Work 4) composed of two differently colored sections: the lower part, in the shape of a tall bowl impressed with medallions, including quadrupeds, was optic blown before it was attached to the upper section.[11]

A general discussion of tong-decorated vessels must also include those presenting omphalos patterns (see cat. 3.55a–f, 3.56, 3.57). This group is more complex, both in shape and technique, than the vessels decorated with rosette or animal medallions (cat. 69, 70) and an attribution to Egypt or Syria becomes problematic, even doubtful, in some cases. The handled cup (cat. 3.57), which was reputedly found in Afghanistan and has a clearly eastern Islamic shape, provides a good example. As explained above (see cat. 16, 52), the omphalos pattern is typically Iranian and Mesopotamian and—with the exception of the small vessels decorated with tongs discussed here—it does not seem to have traveled far westward in the early Islamic period. Its presence on the tong-decorated objects, therefore, may reflect an eastern influence on these Egyptian or Syrian works. It is puzzling, however, that small bowls represent the exception within the group of omphalos-decorated objects; beakers, nearly spherical bowls, and bottles are instead more common.[12] In addition, some of these objects, such as the bottles (cat. 3.55e, f), have closed shapes; thus, their decoration could not have been impressed with a double-sided tong, and a different technique, perhaps a combination of stamping the exterior surface and pinching, may have been employed (see also cat. 64a–d). Impressed glass objects with omphalos patterns, though belonging to the same general group, are thus distinguished from those vessels impressed with medallions containing multipetaled rosettes and quadrupeds and may have a different origin.

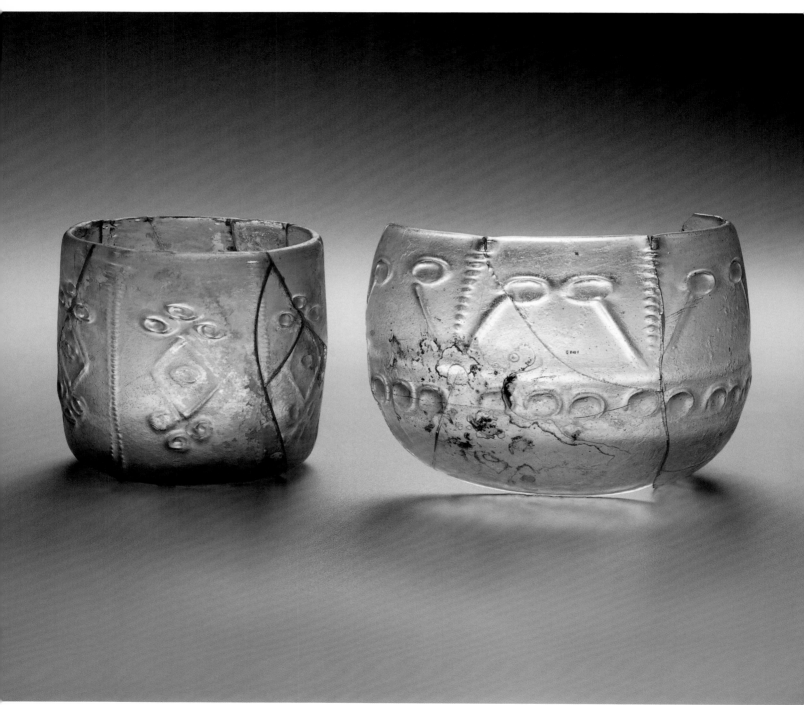

Cat. 71a, b

**Cat. 71a CUP (LNS 116 G)**
**Possibly Mesopotamian region**
**9th–10th century**

Dimensions: hgt. 7.8 cm; max. diam. 8.5 cm;
th. 0.39 cm; wt. 180.2 g; cap. 346 ml
Color: Translucent yellowish greenish colorless
Technique: Blown; impressed with tongs; tooled;
worked on the pontil
Description: This cylindrical cup has a flat base and
curves slightly inward near the opening.
The decoration consists of six panels
created with a rectangular tong; each
includes a circle inscribed in the center
of a rhomboid and two clusters of
three small circles above and below.
The lateral edges of the tong appear
as vertical lines formed by short
horizontal indentations that run
from the base to the rim.
Condition: The object was broken and repaired;
it is complete except for a small fill.
The surface is partially weathered,
resulting in milky white and pale
brown coatings and abrasion. The
glass includes scattered small bubbles
and a few large ones.
Related Works: 1.  Naturhistorisches Museum,
Vienna, inv. no. 83.790
(Lamm, 1929–30, pl. 18:7)
2.  MKG, Hamburg, inv. no. 1964.20
(von Saldern 1968a, pl. 17)
3.  BM, inv. no. I.-N. 998
(Lamm 1928, no. 165, fig. 32)
4.  NM, Copenhagen, inv. no. K7/1934
(Riis–Poulsen 1957, figs. 132, 133)

**Cat. 71b FRAGMENTARY BOWL**
**(LNS 395 G)**
**Possibly Mesopotamian region**
**9th–10th century**

Dimensions: hgt. 8.5 cm; max. diam. 12.1 cm;
th. 0.19 cm; wt. 262.2 g; cap. 775 ml
Color: Translucent greenish colorless
Technique: Blown; impressed with tongs; tooled;
worked on the pontil
Description: This large bowl has slightly curved
walls, a flat base, and an opening that
curves inward. The decoration, created
with a rectangular tong, is in higher
relief on the interior walls of the vessel.
Each section includes two dots joined
to a diagonal line and a row of four
dots below; the pattern was originally
repeated six times around the wall of
the vessel.
Condition: The object was broken and repaired;
about 40 percent is missing, including
most of the base. The surface is
partially weathered, resulting in a milky
white film, dark gray spots, and silvery
iridescence. The glass includes scattered
small bubbles and some larger ones.
Provenance: Reportedly from Damascus, Syria

Objects bearing decoration impressed with rectangular tongs that, in addition to the required pattern, also leave the indented marks of their sides, are fairly common. Most of these vessels are large beakers and bowls. Glassmakers were usually careful to apply the tongs at even intervals and make only their sides overlap, so that the lateral marks would become part of the decoration and subdivide the surface into rectangular units with identical decoration in each center. Most decorations are geometric patterns (circles, straight and curved lines, and rhomboids), but they were often applied in an inventive fashion.[13]

To date, such objects have been attributed to Egypt, since they fall into the same general category as the smaller tong-impressed pieces (see cat. 69, 70); in addition, a few fragments were found at Ehnasya, Egypt.[14] Lamm, for example, thought that fragments of this type found at Samarra (Related Work 3) were Egyptian imports.[15] An Egyptian origin for the entire group of tong-decorated objects cannot, however, be accepted without reservations. In the present case, Related Works 1–4, which represent the best parallels for the decoration of the cup (cat. 71a), were all found outside Egypt. The decoration of the fragments (Related Works 3, 4), which match almost perfectly the rhomboid-and-three-circles arrangement of cat. 71a, have an established provenance from the excavations at Samarra and Hama, respectively. The two complete, or nearly complete, beakers in Vienna and Hamburg (Related Works 1, 2) are similar in dimension and decoration to cat. 71a; they were reportedly found at Kobanj, in the Caucasus area, and in the region of Mazandaran, Iran, south of the Caspian Sea, respectively. Admittedly, glass traveled long distances and these decorated beakers may have been traded extensively in the ninth and tenth centuries; an exclusive Egyptian attribution, however, seems unlikely, since the most logical trade route would go from the Iranian or Mesopotamian areas north across the Caucasus.[16] Consequently, an attribution other than Egypt may be suggested, the Central Islamic lands representing the most likely possibility, given the group's association with Samarra and Hama.

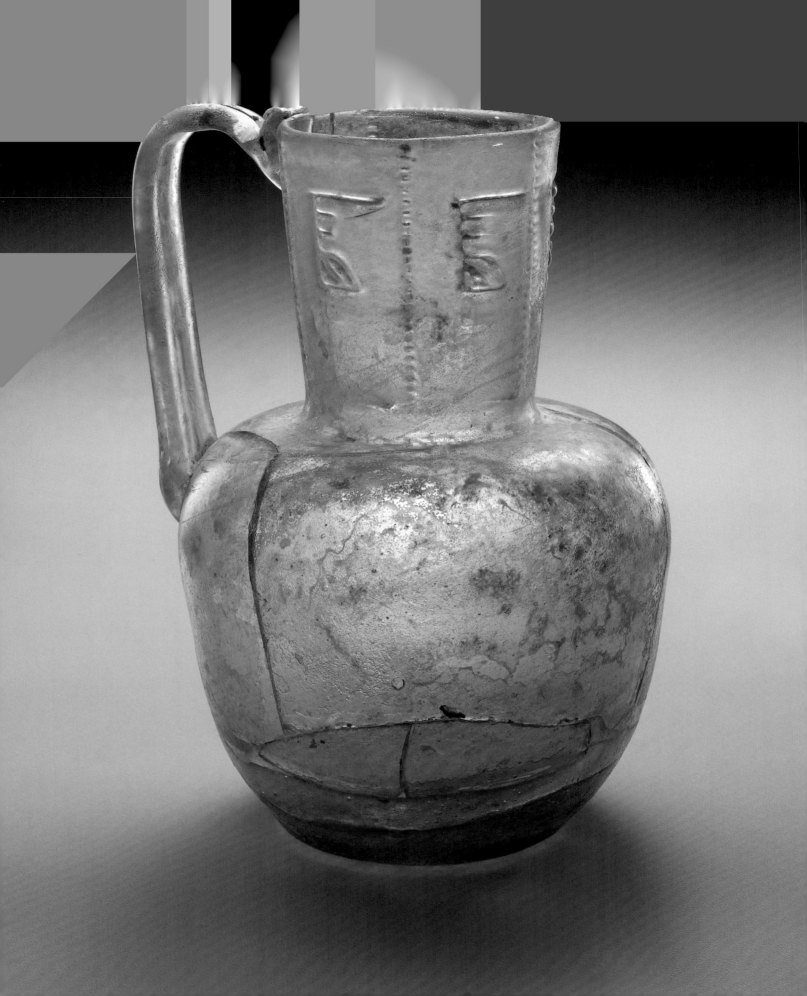

**Cat. 72 PITCHER (LNS 124 G)**
**Possibly Mesopotamian region**
**10th–11th century**

Dimensions: hgt. 16.7 cm; max. diam. 10.9 cm;
th. 0.32 cm; wt. 362.7 g; cap. 800 ml

Color: Translucent yellowish colorless

Technique: Blown; impressed with tongs; applied;
tooled; worked on the pontil

Description: This pitcher has slightly curved walls,
a rounded shoulder, a flattened base
with a ground pontil mark, a slightly
flared neck, and an opening with a
rounded rim. An indented curved
handle was attached near the opening
and below the shoulder. The body is
not decorated; the neck was impressed
vertically with a tong five times.
The impression consists of a Kufic
inscription: إشرب هنيا
("Drink with enjoyment!"). The
impression of the first word is less clear
than the second. The lateral edges of
the tong are visible as short horizontal
indentations that run along the neck.

Condition: The object was broken and repaired;
there is a large fill between the body
and the base; thus the possibility that
the two sections do not belong together
cannot be excluded. The handle may
have been added later. The surface
is partially weathered, resulting in a
milky white film and silvery iridescence.
The glass includes frequent small
bubbles and some large ones.

Provenance: Sotheby's, London, sale, April 18, 1984,
lot 319

Literature: Atıl 1990, no. 35

Related Work: Gayer-Anderson Museum, Cairo
(Lamm 1929–30, pl. 16:3)

The discussion begun at cat. 71 may be continued here, since inscribed works impressed with large rectangular tongs may be included in the same category. An extant beaker provides the link between the two groups, as its decoration incorporates both geometric patterns and an inscription, in Kufic, set vertically along the walls of the vessel: بركه لصاحبه ("Blessing to its owner").[17] Consequently, there is little doubt that these tong-decorated objects were all produced in the same or neighboring workshops.

The inscription بركه لصاحبه is the most common on vessels of this type, which are, almost invariably, large cylindrical beakers of squarish proportions. A complete beaker with the same inscription is in the Metropolitan Museum[18] and a similar, fragmentary beaker found at Saveh in Iran is in the Nationalmuseum, Stockholm.[19] A different inscription, apparently of religious significance, since, according to Lamm, it begins with the word "Allāh" followed by a seemingly ornamental pattern, is impressed on a beaker in the Museum für Islamische Kunst, Berlin.[20]

Cat. 72 appears to be the only extant pitcher with an impressed vertical inscription. Its text—"Drink with enjoyment!"—is also unusual; it defines the function of the vessel as a container for a drinkable liquid, possibly wine. The Related Work is the only other known extant fragment (from a beaker or, perhaps, from the neck of a similar pitcher) that, as far as it is possible to discern from Lamm's drawing, bears the same inscription.

Large beakers and pitchers with impressed inscriptions may have belonged to sets of drinking vessels.[21] A precise attribution for cat. 72 is difficult for the same reasons discussed at cat. 71. In this case, the only piece with a certain provenance is the fragment found at Saveh, but the Related Work and the beaker in Berlin were reportedly found in Egypt, thus adding to the confusion surrounding the origin of these appealing vessels.

Cat. 73a **MEDALLION** (LNS 364 G)
**Central Asian region**
**ca. 1160–87**

Dimensions: max. diam. 5.8 cm; th. 0.45 cm;
wt. 26.6 g
Color: Translucent dark green (green 4)
Technique: Impressed
Description: This circular medallion has a defined
border around the periphery. The
impressed decoration in relief shows
a lion about to attack a quadruped,
possibly an antelope. The bodies of
both animals are heavily textured.
The lion is facing left and looking
threateningly toward the antelope.
Its body is small compared to its head
and its long thin tail curves around
the left hind leg. The antelope has long
U-shaped horns and seems to wear
a collar; its looped tail is long and
thin and ends in a furry tassle. An
inscription in diminutive *naskh*
calligraphy is visible on the lion's body:
خسرو ملك ("Khusrow Malik").
Condition: The object is intact. The surface is
heavily weathered, resulting in a
streaked whitish coating and golden
iridescence. The glass includes frequent
small bubbles and several large ones.
Provenance: Reportedly from Ghazni, Afghanistan

Large impressed glass medallions (ranging in diameter from about 4.7 cm to 10.0 cm) have been known since the excavations of the ruins of a palace at Old Termez (Tirmidh), Uzbekistan, near the border with Afghanistan, in 1937–39.[22] There, "in clearing the northern lateral pavilion of the palace, alabaster was found, together with pieces of colored glass, parts of an alabaster grating, and decorative, oval-shaped glass medallions 5 to 7 centimeters in diameter and 2 to 5 millimeters in thickness, molded from green or reddish glass. The pictures in relief on the obverse side of the medallions refer to eight subjects: (1) an eight-petaled rosette, in a double circle, consisting of a center and a row of closely set pearls . . . [see cat. 73s]; (2) a medallion bearing a Kufic inscription, with plant ornaments around the letters and at the edges; the inscription is faint and reads either 'king' or 'kingdom'; (3) the figure of an animal running to the left, encircled by an Arabic inscription which reads 'for the most high sultan 'Abd [*sic*] al-Muẓaffar Bahrām Shāh.'[23] This inscription may refer either to the ruler of Ghazni, Yamīn al-daula Bahrām Shāh ibn Mas'ūd [A.H. 511–52 / A.D. 1117–57] or to Bahrām Shāh ibn 'Imād al-Dīn, the ruler of Termez in 1205 A.D. [A.H. 601]; (4) a bird of prey, clawing to pieces some small animal; (5) a bird of prey, holding an animal in its claws . . . [see cat. 73j]; (6) a lion in a circle . . . [see cat. 73m, n]; (7) a woman standing beside a horse; and (8) a horseman, wearing a crown surrounded by a halo, holding the reins in his right hand and with a hunting bird on his left forearm [see cat. 73h, i]."[24] Field and Prostov did not specify the exact number of medallions that were recovered from the ruins of the palace; however, at least three were found corresponding to number 8 (a falconer) in their list.[25] The number must, therefore, have been at least ten, assuming that only one specimen of the other seven types was recovered.

Three decades later, in 1968, five stamped medallions (ranging from 5.2 to 6 centimeters in diameter) entered the collection of the Museum für Islamische Kunst, Berlin; they were reportedly acquired at Ghazni in Afghanistan.[26] A large number of such medallions, many of which are as large as 10 centimeters in diameter, and fragments thereof have surfaced on the market and continue to appear in the hands of dealers and auction houses. Their commercial value is rising and at least one forgery has been revealed.[27] The majority of the medallions are presently in Kuwait, either in the al-Sabah Collection or in the Tariq Rajab Museum. Other medallions were sold at auction in April 1996 and in October 1997 and 1999;[28] a complete piece depicting the figure of a horseman was recently in the hands of two different dealers. Four fragmentary pieces were acquired recently by the David collection, Copenhagen. The known impressed medallions, therefore, include at least sixty objects and fragments, a number that will certainly increase judging from the recent interest they have generated on the market. The group is distinctive and can be studied in some detail. Furthermore, the availability of legible inscriptions that include personal names is a rare luxury and allows for precise attributions.

The diameter of these medallions varies, from less than 5 to around 10 centimeters. This variation is partly due to the variable results of the impression made on the cake of glass and to the function of the medallions. They are seldom perfectly circular and the edge is often irregular; in general, the larger the roundels the more regular the circumference. The colors also vary: usually they are dark and vivid blue, green, turquoise, and purple, though pale colors, especially yellowish green, brownish colorless, and amber, are common.

Excluding those fragmentary medallions that do not allow for a proper identification of the impressed pattern, a total of about fifteen different subjects, with some variations, are discernible in the medallions that have surfaced thus far, the great majority of which depict animals and/or human figures: birds of prey in heraldic isolation (cat. 73b) or in the act of attacking a hare (cat. 73j), a duck or a quadruped; felines in isolation or attacking

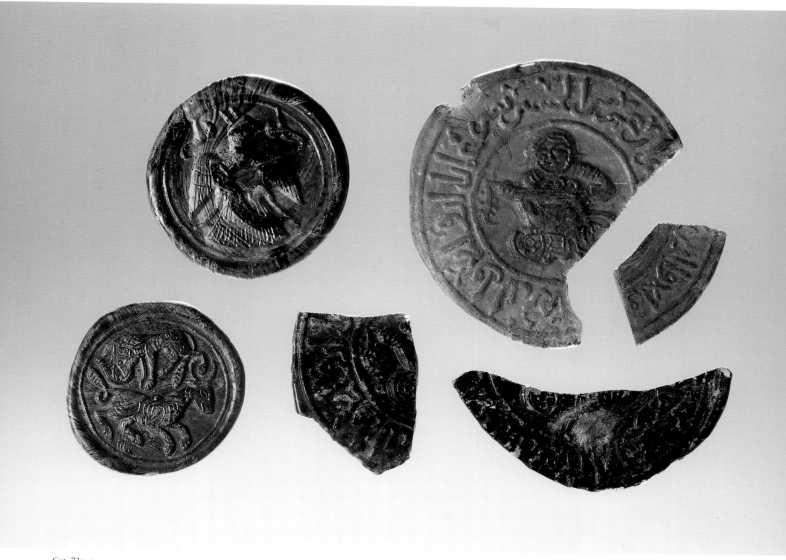

Cat. 73a–e

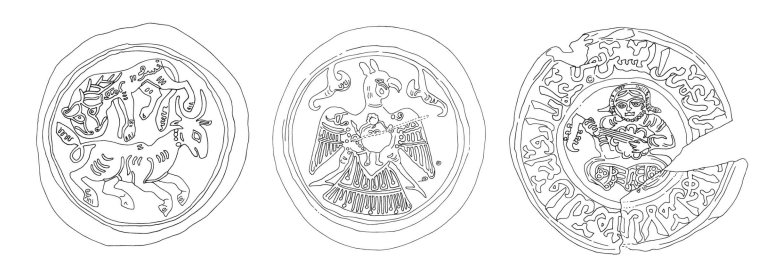

### Cat. 73b MEDALLION (LNS 365 G)
### Central Asian region
### ca. 1160–87

Dimensions: max. diam. 6.7 cm; th. 0.60 cm;
wt. 39.5 g
Color: Translucent dark green (green 4)
Technique: Impressed
Description: This circular medallion has a defined
border around the periphery. The
decoration in relief consists of a frontal
view of a heraldic eagle with stretched
talons, open wings, and extended tail.
Its head, which has two hornlike
protrusions at the top, is facing right
and its body is heavily textured to
represent feathers. A circular depression
partially hides a human figure depicted
in the center of the bird's body; only
the head, arms, and legs are visible.
Two semipalmettes, arranged
symmetrically next to the eagle's
head, stem from the border. The same
inscription as cat. 73a is visible on
the upper parts of the bird's wings.
Condition: The object is intact. The surface is
heavily weathered, resulting in a
streaked whitish coating and silvery
iridescence. The glass includes frequent
small bubbles and several large ones.
Provenance: Reportedly from Ghazni, Afghanistan
Related Works: 1.  MIK, inv. no. I.46/68a
(Kröger 1984, no. 115)
2.  TRM, inv. nos. GLS 0031 TSR,
GLS 0690 TSR
3.  Two medallions (whereabouts
unknown; Christie's, London, sale,
October 14, 1997, lot 332)

### Cat. 73c MEDALLION (LNS 378 G)
### Central Asian region
### 12th century

Dimensions: max. diam. 9.5 cm; th. 0.78 cm;
wt. 70.6 g
Color: Translucent vivid yellowish green
(green 2)
Technique: Impressed
Description: This circular medallion is decorated
in relief with a frontal view of a lute
player seated cross-legged. He wears a
long robe with prominent folds that
covers his entire body. His round face has
well-defined eyebrows joined to the nose
line and he seems to be bareheaded.
The 'ūd (lute) has an unusually small
body in the shape of an eight- or nine-
petaled flower and a long neck that
bends at a sharp angle. An inscription
in naskh calligraphy is inscribed inside
a band (ca. 1.5 cm wide) around the
periphery of the medallion :

عماد الدولة والدين مل[ك الأمراء جهان
بهل]وان علي بن الحسين نصر[ه]

("'Imād al-dawla wa al-dīn mal[ik
al-umarā' Jahān Pahla]vān 'Umar ibn
al-Ḥusain Nuṣra").
Condition: The object is broken and chipped; about
one-fifth is missing. The lower right
corner, including part of the inscription,
entered the Collection with an attached
fragment of another medallion of
similar color and perhaps from the same
mold, on which the words "al-dawla wa
al-dīn" (a repetition of words in the
inscription) are legible. The surface is
entirely weathered, resulting in pale
brown and whitish coatings, iridescence,
and abrasion. The glass includes
scattered small bubbles.
Composition: Na$_2$O: 17.8; MgO: 2.5; Al$_2$O$_3$: 4.6;
SiO$_2$: 60.1; P$_2$O$_3$: 0.4; SO$_3$: 0.3; Cl: 0.7;
K$_2$O: 6.5; CaO: 5.3; TiO$_2$: 0.2; MnO: 0.1;
Fe$_2$O$_3$: 1.0
Composition: (of attached fragment) Na$_2$O: 18.3;
MgO: 2.9; Al$_2$O$_3$: 4.9; SiO$_2$: 59.6;
P$_2$O$_3$: 0.5; SO$_3$: 0.2; Cl: 0.8; K$_2$O: 5.9;
CaO: 5.5; TiO$_2$: 0.2; MnO: 0.2;
Fe$_2$O$_3$: 1.0
Provenance: Christie's, London, sale, October 15,
1996, lot 285

### Cat. 73d FRAGMENTARY MEDALLION
### (LNS 362 G)
### Central Asian region
### 12th century

Dimensions: max. diam. ca. 10.0 cm (reconstructed);
w. 5.0 cm; l. 3.6 cm; th. 0.60 cm;
wt. 18.3g
Color: Translucent purple (purple 2)
Technique: Impressed
Description: This fragmentary medallion was
circular. The decoration in relief is the
same as that of cat. 73c. The remaining
inscription reads:

. . . [ عما]د الدوله والد[ين] . . .

(". . .['Imā]d al-dawla wa al-d[īn . . .]").
Condition: About one-fourth of the medallion
has survived. The surface is heavily
weathered, resulting in pale brown and
whitish coatings. The glass includes
frequent tiny bubbles.
Composition: Na$_2$O: 17.7; MgO: 1.8; Al$_2$O$_3$: 2.5;
SiO$_2$: 63.4; P$_2$O$_3$: 0.4; SO$_3$: 0.2; Cl: 0.8;
K$_2$O: 5.0; CaO: 5.3; MnO: 1.7;
Fe$_2$O$_3$: 0.8
Provenance: Reportedly from Aliabad (Kunduz),
Afghanistan

### Cat. 73e FRAGMENTARY MEDALLION
### (LNS 363 G)
### Central Asian region
### 12th century

Dimensions: max. diam. ca. 10.0 cm (reconstructed);
l. 8.8 cm; th. 0.59 cm; wt. 18.9 g
Color: Translucent yellowish green (green 2)
Technique: Impressed
Description: This fragmentary medallion was
circular. The decoration in relief is the
same as that of cat. 73c. The remaining
inscription reads:

. . . [الد]وله والدين ملك الامرا جها[ن . . .]

(". . . [al-da]wla wa al-dīn malik
al-umarā' Jahā[n . . .]").
Condition: About one-third of the medallion has
survived. The surface is partially
weathered, resulting in pale brown and
whitish coatings and abrasion. The
glass includes frequent tiny bubbles.
Composition: Na$_2$O: 17.2; MgO: 2.3; Al$_2$O$_3$: 3.6;
SiO$_2$: 62.6; SO$_3$: 0.3; Cl: 0.5; K$_2$O: 5.4;
CaO: 5.4; TiO$_2$: 0.2; MnO: 1.5;
Fe$_2$O$_3$: 1.1
Provenance: Reportedly from Aliabad (Kunduz),
Afghanistan
Related Works: 4.  TRM, inv. nos. GLS 0022b, g, e TSR,
GLS 0507 TSR (4 fragments)
5.  Two fragmentary medallions
(whereabouts unknown; Christie's,
London sale, October 12, 1999,
lot 324)

a quadruped (cat. 73a, m, n, p, r); hares (cat. 73o); antelopes (cat. 73q); sphinxes (cat. 74l); griffins; elephants carrying three people (cat. 73f, g); falconers riding a horse (cat. 73h, i); horsemen; female figures next a horse; and lute players (cat. 73c–e). The only nonfigural subjects are inscriptions, six-pointed stars, and rosettes (cat. 73s). The inscriptions, always in *naskh* (with the exception of the Kufic word *mulk* on one of the medallions from Old Termez), include the names of two rulers and an amir (cat. 73a–e). In general, there seems to be neither a particular relation between color and subject nor between size and color; the only relation is between subject and size (see, for example the three medallions with the same subject, cat. 73c–e), which is obviously related to the dimensions of the mold.

A precise attribution of these medallions must begin with an interpretation of the legible inscriptions. As reported by Field and Prostov, one object from Old Termez mentions "the most high sultan 'Abd al-Muẓaffar Bahrām Shāh."[29] This ruler must be the Ghaznavid sultan Yamīn al-dawla wa amīn al-milla Bahrām Shāh ibn Mas'ūd III ibn Ibrāhīm, called Abū al-Muẓaffar, who was a nominal vassal of the last Seljuq sultan Sanjar and ruled over modern Afghanistan and northwestern India from A.H. 511 / A.D. 1117 until his death, around A.H. 552 / A.D. 1157.[30]

The inscription on the medallion from Old Termez runs along the periphery, whereas the tiny *naskh* script on two medallions in the Collection, which names another Ghaznavid ruler, runs along the lion's body and the eagle's wings (cat. 73a and b, respectively).[31] The words are clearly the name Khusrow Malik, who can be safely identified as Bahrām Shāh's grandson Tāj al-dawla Khusrow Malik ibn Khusrow Shāh (r. A.H. 555–82 / A.D. 1160–86). This final Ghaznavid ruler saw his reign, which included the cities of Ghazni, Lahāwur (Lahore) and Peshawar, shrink gradually until it ceased to exist. In 1187 he was defeated by the Ghurids and imprisoned; he was put to death along with his sons about 1190 and the Ghaznavid dynasty ended. The two medallions carrying his name—somewhat understated and devoid of honorific titles, as if he felt the instability of his rule—are reportedly from the capital, Ghazni. They were probably produced during the early part of his reign, before he lost the capital in 1163, but the possibility cannot be excluded that they were destined for one of his palaces in Lahore or Peshawar, and thus date to the later period of his rule.

A third name is prominently displayed in *naskh* around the periphery of three medallions in the Collection (cat. 73c–e) as well as on three fragments in the Tariq Rajab Museum and on two others sold at auction (Related Works 4 [inv. no. TSR 0022b, e, g] and 5). The patron's name appears important in the inscription but refers to an amir, not a ruler. The inscription reads: "The Pillar of State and Religion ['imād al-dawla wa al-dīn], the Amir in Chief [malik al-umarā'] Champion of the World [Jahān Pahlavān] 'Umar ibn al-Ḥusain Nuṣra."[32] This amir can probably be identified with Shams al-Dīn Muhammad Pahlavān, a Ghurid atabeg mentioned twice in literary sources in 1181 and 1182, shortly before the Ghaznavid Khusrow Malik was deposed in 1186.[33] Thus, the inscriptions securely date these medallions to the late Ghaznavid and the Ghurid periods, in the twelfth century.

Some of the subjects illustrated on these medallions are noteworthy because they demonstrate the Ghaznavid and Ghurid interest in Sasanian iconography. The image of an elephant and three riders (cat. 73f, g), for example, is typically Iranian. The figure inside the howdah can perhaps be identified as a character from the *Shāhnāma* named Sapīnūd, the Indian bride of Bahrām Gūr.[34] This hero's actions were revived for the Ghaznavid sultan Maḥmūd (r. A.H. 388–421 / A.D. 997–1030) by the Persian poet Firdausī (ca. 940–1020), who composed his celebrated masterpiece of Persian literature for this ruler. The diffusion of images from the *Shāhnāma* in the Ghaznavid regions is therefore not surprising. The same

iconography of the bride on the elephant was also present in the central Iranian lands, as demonstrated by a *mīnāī* bowl made for the Seljuq amir Abū Naṣr Kirmānshāh in the late twelfth or early thirteenth century.[35]

The frontal image of an eagle carrying a human figure (cat. 73b) has a complex and interesting history. Zāl rescued by the *sīmurgh* in the *Shāhnāma* or the fabulous bird Rukh and Sindibād in the *Thousand and One Nights* come to mind, but the iconography of the *Shāhnāma* known from later Iranian sources, such as early fourteenth-century illustrated copies of the text, does not conform to the present stylized and strictly frontal depiction.[36] Another story from the *Shāhnāma*, that of eagles lifting Kaikāvus and his throne into the sky presents the same iconographic problem as Zāl and the *sīmurgh*.[37] The image is ultimately inspired by the Greek myth of Zeus and Ganymede (Zeus, in the guise of an eagle, kidnapped the baby Ganymede, the cupbearer of the gods), which reached the Iranian area and was transformed into an eagle holding in its talons a human figure, often a female, who appears in the middle of its body in the frontal view. A silver plate in the Hermitage attributed to the late Sasanian period (first half of the seventh century) exemplifies the Iranian interpretation of the subject.[38] Greco-Buddhist, rather than purely Greek, prototypes provided the direct models for both Sasanian and Islamic iconographies: a female figure seized by Garuda in the guise of an eagle occurs, for example, in a fourth- or fifth-century mural from near Termez, one of the sites where the present glass medallions were recovered.[39] Many other examples can be found among carved stone reliefs from modern Pakistan and Afghanistan.[40] In addition, a first-century enameled glass beaker from the Begram treasure in Afghanistan (Musée Guimet, Paris) depicts the scene of Ganymede's abduction by the eagle.[41] The same image was continued in the Islamic period, not only in Iran but also in the western Islamic world, as proved by a painting on the ceiling of the Cappella Palatina in Palermo.[42] In the Iranian and Central Asian regions, the subject was depicted on diverse media, such as pottery (an eleventh- or twelfth-century bowl in the al-Sabah Collection), metalwork (two small mirrors in the Victoria and Albert Museum and the Metropolitan), and glass (the present medallions).[43] Whatever the exact interpretation of this subject—perhaps a combination of different stories and myths that blended in medieval Iran—its association with the pre-Islamic Iranian tradition is evident.

The figure of the lute player associated with Jahān Pahlavān (cat. 73c–e), who uses his left hand to play an unusual instrument with a lobed body, may be explained as a generic image of royal entertainment. The five-stringed instrument with the pegbox pointing backward is similar to a *'ūd* or *barbat*, but the shape of its body can be traced back to the *yueh-chin*, an instrument featured in an eighth- or ninth-century Buddhist wall painting at Dunhuang.[44] The dress worn by the musician in the medallion can also be compared to that of a lute player on the so-called Airtam frieze from a second-century Buddhist temple from present-day Uzbekistan, near the border with Afghanistan.[45] A distant relation to the Sasanian tradition, however, can be demonstrated in this case as well. A similar image is found on a gold medallion (Archaeological Museum, Istanbul) showing an enthroned king on the obverse and a lute player on the reverse; both sides have a Kufic inscription around the border that identifies the patron as the Buyid ruler 'Izz al-dawla Bakhtiyār (r. A.H. 356–67 / A.D. 967–78) and dates the medal to 976.[46] 'Izz al-dawla's rival, 'Aḍud al-dawla, who fought him for control of the Buyid kingdom centered in Baghdad (and thus of the heart of the 'Abbasid caliphate), also had medals struck with his effigy as a Sasanian ruler and his name written in Pahlavi.[47] Two other medals, one in gold (Freer Gallery of Art, Washington, D.C.), the other in silver (formerly Bahrami collection, Tehran), which both depict an enthroned

**Cat. 73f MEDALLION (LNS 323 G)**
**Central Asian region**
**12th century**

Dimensions: max. diam. 6.4 cm; th. 0.54 cm; wt. 31.0 g
Color: Translucent dark bluish green (green 5)
Technique: Impressed
Description: This circular medallion has a defined border around the periphery. The decoration in relief shows a walking elephant facing right. It has a massive body, short legs (one foreleg is bent), a long trunk that bends back to touch one leg, and an unusually long tail; its right ear corresponds to a circular depression in the center of the medallion. Three people are riding the elephant: in the center, a figure, perhaps a woman, stands inside a howdah (baldachin) with a triangular top; the mahout, who wears a Sasanian-style winged crown, sits on the elephant's neck and pecks at its head with an *ankus* (elephant goad); and the third figure, who sits on the animal's hindquarters, wears a headdress and holds an object in his right hand.
Condition: The object was broken in two parts and repaired; it has a large chip at the border but is otherwise complete. The surface is entirely weathered, resulting in a whitish coating, heavy iridescence, and abrasions.
Composition: $Na_2O$: 20.0; $MgO$: 3.4; $Al_2O_3$: 2.1; $SiO_2$: 61.7; $P_2O_5$: 0.4; $SO_3$: 0.3; $Cl$: 1.0; $K_2O$: 2.3; $CaO$: 6.0; $TiO_2$: 0.2; $MnO$: 0.1; $Fe_2O_3$: 1.1; $CuO$: 1.4
Provenance: Christie's, London, sale, April 25, 1995, lot 253

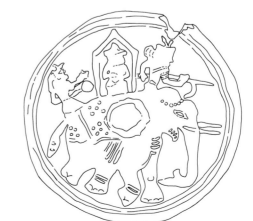

**Cat. 73g FRAGMENTARY MEDALLION**
(LNS 1060 G)
**Central Asian region**
**12th century**

Dimensions: max. diam. 6.0 cm; th. 0.52 cm;
wt. 11.9 g
Color: Translucent vivid pale blue (blue 2)
Technique: Impressed
Description: This fragmentary medallion was
circular. The decoration in relief is
the same as that of cat. 73f.
Condition: The lower half of the medallion
is missing. The surface is entirely
weathered, resulting in a whitish gray
coating, iridescence, and corrosion.
Composition: $Na_2O$: 19.2; $MgO$: 3.4; $Al_2O_3$: 1.7;
$SiO_2$: 61.7; $P_2O_3$: 0.5; $SO_3$: 0.3; $Cl$: 0.7;
$K_2O$: 4.7; $CaO$: 5.5; $TiO_2$: 0.1;
$MnO$: 0.2; $Fe_2O_3$: 1.0; $CuO$: 1.3
Provenance: Reportedly from Ghazni, Afghanistan
Related Works: 6. MIK, inv. no. I.46/68e
(Kröger 1984, no. 119)
7. CMG, inv. no. 83.1.1

ruler in Sasanian guise and a falconer on the reverse, are probably associated with the Buyid period and demonstrate the rulers' interest in Sasanian iconography combining royal scenes with courtly entertainment (the lute player) and hunting (the falconer).[48] The unidentified Ghaznavid or Ghurid patron of the medallions with the lute player (cat. 73c–e) may have borrowed this image in emulation of the Buyid effort to appear as the Iranian dynasty that intended to continue the great Sasanian tradition and, at the same time, establish itself as the champion of Islam. The medallions showing a falconer (cat. 73h, i) may also be interpreted in this manner, in view of the appearance of this image on the earlier Buyid medals.

Predatory animals, such as lions and eagles, attacking antelopes, hares, or ducks (see cat. 73j and especially 73a, where the name of Khusrow Malik is inscribed on the lion's body), fit easily with a royal iconography of power and dominance. The composition of three or four hares joined by their ears in a revolving position (cat. 73o) perhaps derived from iconography on early twelfth-century metalwork. Examples can be found on a number of plates and trays.[49] A monochrome-glazed hexagonal tile in the al-Sabah Collection (LNS 782 Cc) that belongs to a group of Ghaznavid tiles datable to the late twelfth or early thirteenth century shows a molded composition of three hares joined by their ears. An association between glass medallions and Ghaznavid molded tiles is also evident when sketchy images of single animals (such as cat. 73q, r) are compared.[50]

Revolving animals, particularly fantastic creatures such as sphinxes, can be interpreted as talismanic symbols.[51] It is noteworthy that these animals often appear on small circular mirrors of talismanic significance that have the same dimensions as the glass medallions (as, for example, the two mirrors with the image of Ganymede mentioned above and another mirror of similar dimensions depicting a falconer, now in the Metropolitan).[52] A number of glass roundels also present a small circular depression in the center (see cat. 73b, f) that seems inexplicable unless they are compared to bronze finger mirrors that have a small pierced knob in the center of the molded face through which a string may pass to enable them to be held. There is no proof that the same molds were used for both productions,[53] but the relation seems obvious and deserves further investigation. Unfortunately, there is no satisfactory explanation for the presence of the shallow circular depressions on the glass medallions: if they had been cast directly in mirror molds, they would show a knob, rather than a depression, in the center; if they had been cast in molds made from bronze mirrors, the depression would not be as shallow but much deeper, since it would correspond to the height of the protruding knob, which was cast in one piece with the mirror.[54] These depressions often interfere with the depiction of the subject (for example, the central figure of Ganymede is almost illegible on cat. 73b). One hypothesis is that the depression was meant to receive a colored stone or a pearl for decorative purposes, but no traces of glue or a similar material were found on the available samples. Another possibility is that a small rod, which would be responsible for the circular depression in the center, like a type of pontil mark, was used to lift up the medallion when the glass was still hot in order to set it in a plaster grid without touching it.

The multipetaled rosette is another recurrent motif on impressed glass.[55] The medallion (cat. 73s) and Related Work 16, the latter excavated at Old Termez, are also nearly identical in diameter and in irregular profiles.

Chemical analysis of seven fragmentary medallions (the two fragments that made up cat. 73c and cat. 73d–g and l) has proved that they are all of the plant-ash type with rather high levels of potassium, though the amounts of aluminum varied from less than 2 percent (cat. 73g) to nearly 5 percent (cat. 73c, l). Glass with aluminum and potassium levels in

these ranges is relatively uncommon in the Islamic world, but it is usually associated with its eastern lands, including Iran, Central Asia, and India. Slight variations in composition are noticeable among the four fragments of medallions illustrating the lute player (cat. 73c–e; for example, the purple medallion, cat. 73e, has lower levels of magnesium and aluminum, which have little to do with its different color). The two brightly colored pale blue medallions depicting the elephant and riders (cat. 73f, g), which were expected to have almost identical composition, have instead quite different amounts of potassium (2.3 and 4.7 percent, respectively). Since there is no doubt that they were made with the same mold, these variations only prove that different batches of glass had different compositions and that chemical analysis alone is not sufficient to suggest precise attributions.

The glass medallions found at Old Termez are associated with architectural decoration, since they were discovered in the ruins of a palace among fragments of alabaster gratings and plain colored-glass window panes. Other reported sites for these roundels include Ghazni, Maymana, and Kunduz (all in modern Afghanistan), which were important towns during the Ghaznavid period and hosted several palaces and decorated buildings. These medallions have larger dimensions than any known vessel stamps,[56] a possible function that comes to mind, and none of them, with the exception of cat. 73r, shows marks on the reverse, indicating that it was once attached to a glass vessel. The suggestion that they may have been set into stained-glass windows, thus coming to life when viewed through sunlight and at the same time providing a decorative motif, seems the most likely. Assuming, as often is the case, that the pattern of the grid of a stained window was geometric and was based, for example, on a composition of multipetaled flowers, the round medallions may have functioned as the buttons of these flowers and flat colored glass may have been cut to size to resemble petals. Yet it must be noted that no traces of plaster have been found on these roundels, which would be expected if they were used on stained-glass windows. All the objects that have surfaced are, however, weathered to various degrees and obviously were buried for a long time; therefore, any plaster once attached to them would have disappeared. Further evidence supporting the theory that such roundels were set in stucco windows is provided by a large near-domical object acquired by the Collection in 1997.[57] This convex piece, in which are set two concentric rows of glass roundels, was probably the element of a bathroom ceiling. The majority of the medallions in this restored object, now a pastiche of colors and plaster, are made of plain colored glass, but three of them are impressed (one includes the pattern of an eight-pointed star), thus representing a suitable parallel for the medallions under discussion. An octagonal glass tile in the Tariq Rajab Museum (diam. 5.3 cm), depicting a six-pointed star in relief, is also a good example in demonstrating the relationship between large medallions and roundels made for windows.[58]

In summary, it is possible to suggest that the most accomplished glass medallions served not only a decorative function but also represent an adaptation of Sasanian iconography (probably filtered through the Buyid experience and prompted by the diffusion of the *Shāhnāma*) for dynastic purposes. Glass vessel stamps from the early Islamic period may have provided generic models that were adapted to fit architectural decoration. Molded and glazed tiles, also used to adorn buildings, were never as accomplished as the most detailed glass medallions but may perhaps be understood in the same manner. These impressed glass medallions, which, in all likelihood, were produced to decorate the windows of palaces of Ghaznavid and Ghurid rulers in an area that corresponds to modern Afghanistan during the better part of the twelfth century, represent a well-defined and distinct group that greatly contributes to our understanding of the versatility and multiple functions of Islamic glass.

**Cat. 73h FRAGMENTARY MEDALLION**
(LNS 361 G)
**Central Asian region**
**12th century**

Dimensions: max. diam. 8.4 cm (reconstructed); w. 6.7 cm; l. 5.0 cm; th. 0.52 cm; wt. 26.9 g
Color: Translucent vivid pale blue (blue 2)
Technique: Impressed
Description: This fragmentary medallion was circular. The decoration in relief depicts a falconer facing left while riding a horse and holding a falcon in his left hand. The man's body (his head is partly missing), the hindpart of the horse, and the falcon are visible. The falconer, who looks backward toward the bird, wears an elaborate robe with a palmettelike decoration on the chest. The same pattern appears on the horse's body, probably representing the decoration of the saddle; the horse is caparisoned and has a knotted tail. The falcon has a long tail and its wings are slightly open.
Condition: About two-thirds of the medallion is missing. The surface is entirely weathered, resulting in a brown coating, golden brown iridescence, and corrosion.
Provenance: Reportedly from Aliabad (Kunduz), Afghanistan
Related Work: 8. Whereabouts unknown (Christie's, London, sale, October 12, 1999, lot 323)

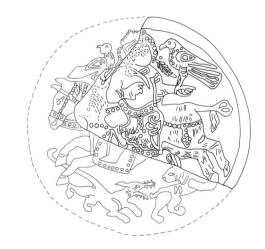

Cat. 73f–j

## Cat. 73i MEDALLION (LNS 434 G)
### Central Asian region
### 12th century

Dimensions: max. diam. 6.1 cm; th. 0.63 cm;
wt. 38.0 g
Color: Translucent vivid green (green 3)
Technique: Impressed
Description: This circular medallion has a circular
depression in the center. The decoration
in relief is similar, though not identical,
to that of cat. 73h. The falconer faces
forward; his upper body is drawn
clumsily (the arms are extremely thin
compared to the legs) and he wears
boots. The caparisoned horse is
walking. Four dots in relief form a
square pattern between the horse's
hind legs.
Condition: The object is intact. The surface is
entirely weathered, resulting in silvery
white and pale brown coatings,
iridescence, and abrasion.
Provenance: Christie's, London, sale, October 14,
1997, lot 333
Related Works: 9. MHC, inv. nos. 233/267–269
(three medallions) (Field–Prostov
1942, fig. 14; and Abdullaev et al.
1991, nos. 542–44)
10. Whereabouts unknown (Bonhams,
London, sale, April 24, 1996, lot 252)
11. TSR, inv. no. GLS 0022f TSR

## Cat. 73j MEDALLION (LNS 134 G)
### Central Asian region
### 12th century

Dimensions: max. diam. 5.0 cm; th. 0.44 cm;
wt. 14.1 g
Color: Translucent dark bluish green (green 5)
Technique: Impressed
Description: This irregularly shaped circular
medallion is decorated in relief with
a large eagle facing left; its back and
neck follow the curve of the medallion.
The eagle's talons grasp the back of a
hare below, also viewed in left profile,
looking up at its attacker.
Condition: The object was broken in two parts and
repaired; it is chipped at the repairs but
is otherwise complete. The surface is
entirely weathered, resulting in a brown
coating, golden iridescence, and
corrosion.
Related Works: 12. Termez (Field–Prostov 1942,
fig. 12; and Esin 1973–74, fig. 41)
13. MIK, inv. no. I.46/68c
(Kröger 1984, no. 117)

Cat. 73k, m–r

### Cat. 73k MEDALLION (LNS 1058 G)
#### Central Asian region
#### 12th century

Dimensions: max. diam. 5.8 cm; th. 0.35 cm; wt. 25.4 g

Color: Translucent yellow (yellow/brown 1)

Technique: Impressed

Description: This irregularly shaped circular medallion is decorated in relief with a plump bird (probably a bird of prey) facing left in the center; stylized vegetal motifs fill the remaining space. The inscriptional band in *naskh* (hgt. ca. 1.2 cm) surrounding the bird reads: والدولة والسلامة والصاحبه / نسر . . . (". . . and power and success and [?] to the owner").

Condition: The object was broken in three fragments and repaired; it is complete. The surface is heavily weathered, resulting in a pale brown coating and iridescence.

Provenance: Reportedly from Afghanistan

### Cat. 73l MEDALLION (LNS 425 G)
#### Central Asian region
#### 12th century

Dimensions: max. diam. 5.2 cm; th. 0.50 cm; wt. 15.7 g

Color: Translucent purple (purple 2)

Technique: Impressed

Description: This irregularly shaped circular medallion is decorated in relief with a crowned sphinx facing right. Its tail is raised, bent at a sharp angle, and ends in a tassel; a slender stylized wing ends in a hook near the tail. Details in low relief, such as facial features, swirls on the thigh of the right foreleg, curved lines and dots on the hindleg, and simple lines on the tassel, are barely visible.

Condition: The object was broken in two parts and repaired; the lower left corner and small sections of the border are missing. The surface is heavily weathered, resulting in a pale brown coating, iridescence, and abrasion.

Composition: $Na_2O$: 18.2; $MgO$: 2.8; $Al_2O_3$: 4.8; $SiO_2$: 58.8; $P_2O_5$: 0.4; $SO_3$: 0.3; $Cl$: 0.8; $K_2O$: 5.9; $CaO$: 5.3; $TiO_2$: 0.2; $MnO$: 2.0; $Fe_2O_3$: 1.0

Provenance: Bonhams, London, sale, April 24, 1997, lot 284

Cat. 73l

## Cat. 73m,n TWO MEDALLIONS
(LNS 435 G, LNS 436 G)
**Central Asian region**
**12th century**

Dimensions: m: max. diam. 4.7 cm; th. 0.57 cm;
wt. 14.2 g
n: max. diam. 5.3 cm; th. 0.57 cm;
wt. 15.5 g
Color: m: translucent purple (purple 2)
n: vivid turquoise green (green 3)
Technique: Impressed
Description: These irregularly shaped circular
medallions—one purple, the other
green—are both decorated in relief with
a lion facing right inside a circle. Its
long curved tail is raised and ends in a
dragon's head with an open mouth, its
forelegs are raised in a heraldic posture,
and its right paw is visible behind its
head. The animal looks powerful, with
its massive, almost disproportionate
head, large mane, and slender body.
Condition: The objects are intact though chipped.
The surface is heavily weathered,
resulting in a milky white (m) and a
pale brown (n) coating and abrasion.
Provenance: Bonhams, London, sale, October 15,
1997, lots 83, 84

## Cat. 73o FRAGMENTARY MEDALLION
(LNS 165 G)
**Central Asian region**
**12th century**

Dimensions: max. diam. 5.5 cm; th. 0.69 cm;
wt. 21.8 g
Color: Translucent brownish colorless
Technique: Impressed
Description: This fragmentary medallion was
circular. The decoration in relief
consisted of four hares facing right (two
animals and a part of a third are extant)
within a circle. They are depicted
walking around the inner border of the
circle; their forelegs are raised and the
animals are joined by their long ears,
forming a central squarish figure.
Condition: The object is broken; about one-third
is missing. The surface is entirely
weathered, resulting in a brownish
coating, iridescence, and corrosion.
Provenance: Reportedly from Ghazni, Afghanistan
Related Works: 14. MIK, inv. no. I.46/68d
(Kröger 1984, no. 118)
15. TRM, inv. no. GLS 0022 TSR

## Cat. 73p FRAGMENTARY MEDALLION
(LNS 440 G)
**Central Asian region**
**12th century**

Dimensions: max. diam. 4.8 cm (reconstructed);
max. hgt. 3.5 cm; max. w. 4.5 cm;
th. 0.33 cm; wt. 6.1 g
Color: Translucent vivid green (green 4)
Technique: Impressed
Description: This fragmentary medallion was
circular. The decoration in relief
shows the lower part of the body of
a quadruped, possibly a feline, facing
right. The animal is walking and its
left foreleg is raised; its paws are
clawed and its powerful chest is
decorated with undulating stripes.
Condition: The object is broken; more than one-
half is missing. The surface is partially
weathered, resulting in a golden pale
brown coating and abrasion. The glass
includes frequent small bubbles.
Provenance: Reportedly from Afghanistan

## Cat. 73q FRAGMENTARY MEDALLION
(LNS 438 G)
**Central Asian region**
**12th century**

Dimensions: max. diam. 6.1 cm; th. 0.72 cm;
wt. 23.7 g
Color: Translucent green (green 3)
Technique: Impressed
Description: This fragmentary medallion was
circular. The decoration in relief depicts
a stylized quadruped with long horns,
probably a gazelle or an antelope,
facing right and walking with its left
foreleg raised. The animal is framed
inside a squarish composition that
includes a long vegetal scroll rising
from under its legs and ending above
its tail; another scroll follows the
periphery of the medallion on the
right side of the animal.
Condition: The object was broken in three pieces
and repaired; the bottom left and the
top right corners are missing. The
surface is partially weathered, resulting
in a pale brown coating. The glass
includes frequent small bubbles and
several large ones.

## Cat. 73r LARGE VESSEL STAMP
(LNS 437 G)
**Central Asian region**
**8th–9th century**

Dimensions: max. hgt. 4.4 cm; max. w. 5.3 cm;
th. 1.42 cm; wt. 37.0 g
Color: Translucent green (green 2–3)
Technique: Impressed; applied
Description: This oval medallion was once attached
to a vessel, since traces of the object's
wall are still visible on the bulged back.
The decoration shows a winged lion
with a large mane facing left within a
simple circle. The animal is walking; its
tail is raised and ends in a tassel and its
wing is curled. A curly pseudovegetal
pattern appears between the lion's legs.
Condition: The object is intact. The surface is
partially weathered, resulting in a pale
brown film and slight abrasion. The
glass includes frequent tiny bubbles.

## Cat. 73s MEDALLION (LNS 401 G)
**Central Asian region**
**12th century**

Dimensions: max. diam. 4.9 cm; th. 0.51 cm; wt. 15.0 g
Color: Translucent vivid pale blue (blue 2)
Technique: Impressed
Description: This circular medallion is decorated in
relief with an eight-petaled flower; eight
dots are drawn between the petals and
a thin line separates the flower from a
series of thirty-two raised dots (only
sixteen are visible, since the medallion
was impressed off-center).
Condition: The object is intact except for small
chips. The surface is entirely weathered,
resulting in a whitish coating and
silvery marbled iridescence. The glass
includes scattered small bubbles.
Provenance: Reportedly from Ghazni, Afghanistan
Related Work: 16. Termez (Field–Prostov 1942,
fig. 11)

Cat. 73s

Cat. 3.49a–c

## Cat. 3.49a–c THREE VESSEL STAMPS
(a: LNS 312 G; b: LNS 411 Ga;
c: LNS 411 Gb)
**Probably Syrian region**
**8th–9th century**

Dimensions: a: max. diam. 2.1 cm; th. 0.41 cm;
wt. 3.9 g
b: max. diam. 3.5 cm; th. 0.39 cm;
wt. 11.0 g
c: max. diam. 2.8 cm; th. 0.39 cm;
wt. 5.7 g
Color: Translucent green (green 3) and
brownish colorless
Technique: Impressed; applied
Description: These three small circular medallions
were once attached to vessels, since the
bulged reverse retains traces of the
object's wall. The decoration consists of
a dotted circle (cat. 3.49b, c) framing a
Kufic inscription; more dots are present
within the space of the inscription of
cat. 3.49c. The inscriptions read:
a. . . . . مما أمر / الا [ مير ]
("What the [amir?] ordered . . .")
b. . . . . عمله الحسن ( المعا؟ )
("The work of al-Ḥasan al-Ma'ā . . . [?]")
c. . . . . روشن / بن احمد /( ؟ . . .)
("Rawshan ibn Aḥmad")
Condition: The objects are intact. The surface of
fragment a is streaked and lightly
weathered, resulting in a brown film; b
is in good condition, though it presents
some abrasion. Fragment c is entirely
weathered, resulting in a pale grayish
silvery coating. The glass of all three
fragments includes frequent tiny or
small bubbles.
Provenance: Reportedly from Ghur, Afghanistan
Related Works: Cat. 73a–s (see note 56)

## Cat. 3.50a–c THREE VESSEL STAMPS
(LNS 441 Ga–c)
**Probably Syrian region**
**8th–9th century**

Dimensions: a (largest stamp): max. diam. 2.8 cm;
th. 0.29 cm; wt. 5.2 g
Color: Translucent blue (blue 3)
Technique: Impressed; applied
Description: These three circular medallions may
once have been attached to the same
vessel; the bulged reverse retains traces
of the object's wall. Each medallion
shows a man wearing a tunic and a
turban, sitting frontally with crossed
legs, his head turned left, his right arm
resting on his leg, and his left arm
slightly raised as if he were addressing
someone in front of him.
Condition: The objects are intact. The surface
is weathered, resulting in abrasion.
Cat. 3.50a is entirely weathered,
resulting in a pale brown coating; b
and c are lightly weathered, resulting in
pale brown streaks. The glass of all
three includes frequent tiny bubbles.

## Cat. 3.50d, e TWO FRAGMENTARY VESSEL STAMPS
(LNS 332 G, LNS 439 G)
**Probably Syrian region**
**8th–9th century**

Dimensions: d: max. hgt. 2.7 cm; max. w. 3.7 cm; th. 0.29 cm; wt. 9.2 g
e: max. diam. 2.4 cm; th. 0.24 cm; wt. 5.6 g

Color: Translucent brownish colorless and yellow (yellow/brown 1)

Technique: Impressed, applied

Description: These two irregularly shaped circular stamps retain traces of the wall of the vessels to which they were attached. The impressed decoration of both objects shows the same winged horse facing right and walking; the most remarkable feature is the tall wing that ends in a curl. The larger medallion (cat. 3.50d) is in better condition and reveals vertical lines patterning the the mane and the wing. Cat. 3.50e is inscribed in between the wing and the tail around the border: . . . [الله] بسم ("In the name of [Allah]. . ."); cat. 3.50d also includes an inscription (now illegible), probably the same, above the horse's head.[59]

Condition: Cat. 3.50d was broken in two fragments and repaired; the right lower section is missing. The lower right corner of fragment e is missing. The surface of d is entirely weathered, resulting in a whitish coating; e is lightly weathered, resulting in abrasion. The glass of both includes scattered tiny bubbles.

Related Works: Cat. 73a–s (see note 56)

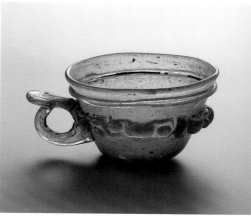

Cat. 3.51

## Cat. 3.51 SMALL CUP (LNS 11 KG)
**Egyptian or Syrian region**
**9th–10th century**

Dimensions: hgt. 2.7 cm; max. diam. 4.5 cm; th. 0.16 cm; wt. 17.8 g; cap. 21 ml

Color: Translucent pale blue (blue 1)

Technique: Blown; impressed with tongs; applied; tooled; worked on the pontil

Description: The bowl of this small cup has flared walls and a flat base. A small circular handle with a horizontal thumb rest was applied on the wall. The decoration consists of an applied horizontal band composed by sections of a multipetaled rosette (max. diam. ca. 1.8 cm) impressed with a tong; the central button and two petals are visible on each section. A trail of glass of the same color was applied about 1 cm below the rim of the vessel.

Condition: The object is intact. The surface is lightly weathered, resulting in a milky white film. The glass includes large bubbles.

Provenance: Kofler collection

Literature: Lucerne 1981, no. 501

Related Works: Cat. 69a, b

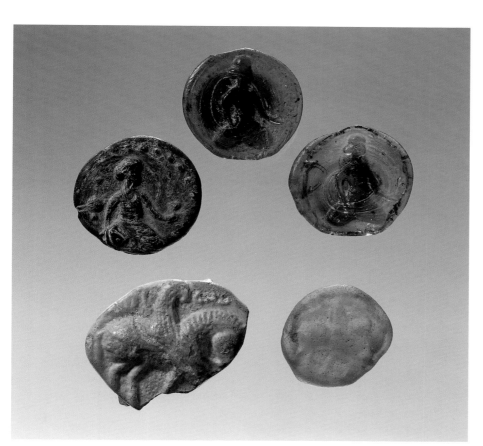

Cat. 3.50a–e

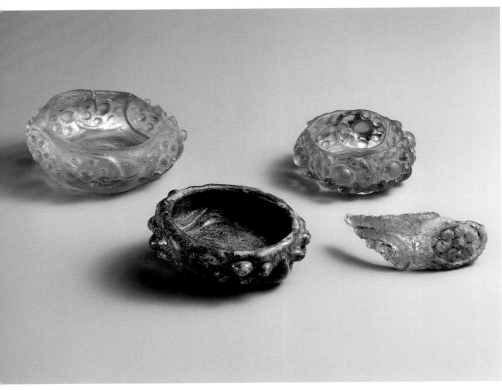

Cat. 3.52a–d

### Cat. 3.52c BOWL (LNS 60 KG)
**Egyptian or Syrian region**
**9th–10th century**

Dimensions: hgt. 1.7 cm; max. diam. 4.5 cm;
th. 0.40 cm; wt. 31.7 g; cap. 15 ml
Color: Translucent pale green (green 1)
Technique: Blown; impressed with tongs; tooled;
worked on the pontil
Description: This small bowl has lopsided walls, a
curved base, and an opening that
turns slightly inward. The decoration
consists of five circular medallions
(max. diam. ca. 2.3 cm) impressed
with a tong at irregular intervals.
Each medallion includes a stylized
six-petaled rosette similar to the
eight-petaled motif of cat. 3.52a.
Condition: The object is intact. The surface is
entirely weathered, resulting in a dark
gray coating and abrasion.
Provenance: Kofler collection
Literature: Lucerne 1981, no. 566

### Cat. 3.52a BOWL (LNS 37 KG)
**Egyptian or Syrian region**
**9th–10th century**

Dimensions: hgt. 2.2 cm; max. diam. 5.0 cm;
th. 0.25 cm; wt. 36.6 g; cap. 22 ml
Color: Translucent yellow (yellow/brown 1)
Technique: Blown; impressed with tongs; tooled;
worked on the pontil
Description: This small bowl has lopsided walls,
a curved base, and an opening that
turns slightly inward. The decoration
consists of eight circular medallions
(max. diam. ca. 1.9 cm), some
overlapping, impressed with a tong
at irregular intervals; each medallion
includes a stylized eight-petaled rosette
formed by a central boss and eight
dots in relief representing the petals.
Condition: The object is intact. The surface
is lightly weathered, resulting in
iridescence and abrasion. The glass
includes frequent small bubbles.
Provenance: Kofler collection
Literature: Lucerne 1981, no. 567

### Cat. 3.52b BOWL (LNS 45 KG)
**Egyptian or Syrian region**
**9th–10th century**

Dimensions: hgt. 1.7 cm; max. diam. 4.0 cm;
th. 0.15 cm; wt. 23.9 g; cap. 11 ml
Color: Translucent yellow (yellow/brown 1)
Technique: Blown; impressed with tongs; tooled;
worked on the pontil
Description: This small bowl has lopsided walls
and a curved base. The decoration
consists of six circular medallions
(max. diam. ca. 2.1 cm), some
overlapping, impressed with a tong
at irregular intervals. Each medallion
includes the same impression as that
of cat. 3.52a.
Condition: The object is intact. The surface is
lightly weathered, resulting in abrasion.
The glass is of good quality.
Provenance: Kofler collection
Literature: Lucerne 1981, no. 568

### Cat. 3.52d FRAGMENT OF A BOWL
### (LNS 213 KG)
**Egyptian or Syrian region**
**9th–10th century**

Dimensions: max. w. 4.6 cm; max. l. 1.9 cm;
th. 0.24 cm
Color: Translucent pale blue (blue 1–2)
Technique: Blown; impressed with tongs
Description: This fragment is from the rim of a
small bowl. The decoration consists
of a circular medallion (max. diam.
ca. 1.7 cm) impressed with a tong.
Each medallion includes the same
impression as that of cat. 3.52c.
Condition: The surface is partially weathered,
resulting in a pale brown coating
and corrosion. The glass includes
frequent bubbles.
Provenance: Kofler collection
Related Work: Cat. 69

**Cat. 3.53a BOWL (LNS 14 G)**
**Egyptian or Syrian region**
**9th–10th century**

Dimensions: hgt. 2.2 cm; max. diam. 6.2 cm;
  th. 0.24 cm; wt. 47.5 g; cap. 20 ml
Color: Translucent yellow (yellow/brown 1)
Technique: Blown; impressed with tongs; tooled;
  worked on the pontil
Description: This low bowl has straight walls and
  a slightly curved base. The decoration
  consists of seven (originally eight)
  rectangular medallions (ca. 2.0 x
  1.2 cm) impressed with a tong at
  regular intervals; each medallion
  includes a grid of twelve raised
  prunts arranged in three horizontal
  rows of four.
Condition: The object is broken; the section that
  included one of the eight original
  medallions is missing. The surface is
  lightly weathered, resulting in a milky
  white film. The glass includes frequent
  small bubbles and scattered large ones.

**Cat. 3.53b BOWL (LNS 111 KG)**
**Egyptian or Syrian region**
**9th–10th century**

Dimensions: hgt. 1.6 cm; max. diam. 3.8 cm;
  th. 0.20 cm; wt. 18.7 g; cap. 11 ml
Color: Translucent green (green 3)
Technique: Blown; impressed with tongs; tooled;
  worked on the pontil
Description: This small bowl has lopsided walls and
  a slightly curved base. The decoration
  consists of seven rectangular medallions
  (ca. 1.6 x 1.2 cm) impressed with a tong
  at irregular intervals and sometimes
  overlapping; each medallion includes
  nine raised prunts arranged in three
  horizontal rows of three.
Condition: The object is intact. The surface is
  lightly weathered, resulting in a milky
  white film. The glass is of good quality.
Provenance: Kofler collection
Literature: Lucerne 1981, no. 569

Cat. 3.54

**Cat. 3.54 FRAGMENT OF A BOWL**
**(LNS 190 G)**
**Probably Mesopotamian region**
**9th–10th century**

Dimensions: w. 6.7 cm; l. 5.4 cm; th. 0.28 cm;
  wt. 262.2 g
Color: Translucent pale bluish green (green 1)
Technique: Blown; impressed with tongs; tooled
Description: This fragment of the rim of a large
  bowl includes the impressed decoration
  of a stylized bird facing right, with a
  small round eye and a bifurcated tail.
Condition: The surface is lightly weathered,
  resulting in pale brown pitting. The
  glass includes frequent small bubbles.
Provenance: Kofler collection; gift to the Collection

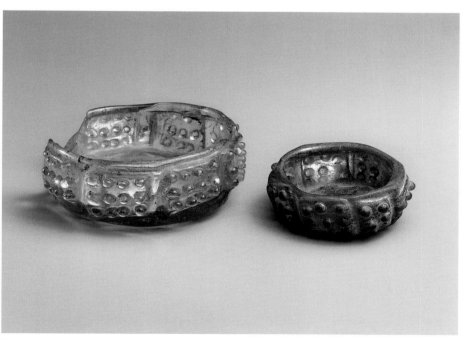

Cat. 3.53a, b

**Cat. 3.55a CUP (LNS 5 KG)**
**Possibly Mesopotamian**
**or Iranian region**
**9th–10th century**

Dimensions: hgt. 4.5 cm; max. diam. 6.0 cm;
th. 0.26 cm; wt. 69.2 g; cap. 90 ml
Color: Translucent greenish colorless
Technique: Blown; impressed with tongs; applied;
tooled; worked on the pontil
Description: This slightly lopsided cylindrical cup
has a flat base and an irregular opening.
A circular handle with a large
protruding thumb rest, attached to the
lower part of the cup, was created by
tooling. The decoration consists of two
rows of omphalos-patterned medallions
(max. diam. ca. 2.1 cm) impressed with
a tong at irregular intervals and often
overlapping. The lower row includes
eight medallions; the upper row, seven.
Condition: The object is intact. The surface is
entirely weathered, resulting in a
whitish coating and iridescence.
Provenance: Kofler collection
Literature: Lucerne 1981, no. 564

**Cat. 3.55b CUP (LNS 21 G)**
**Possibly Mesopotamian**
**or Iranian region**
**9th–10th century**

Dimensions: hgt. 4.2 cm; max. diam. 4.0 cm;
th. 0.35 cm; wt. 43.7 g; cap. ca. 30 ml
Color: Translucent yellow (yellow/brown 1)
Technique: Blown; impressed with tongs; tooled;
worked on the pontil
Description: This slightly lopsided, cylindrical cup
has a flat kicked base and an irregular
opening. The decoration consists of
two rows of omphalos-patterned
medallions (max. diam. ca. 1.5 cm)
impressed with a tong at irregular
intervals and sometimes overlapping.
The lower row includes seven
medallions; the upper row, four.
Condition: The object is broken and a large
portion of the wall is missing.
The surface is entirely weathered,
resulting in a brown coating.

**Cat. 3.55c PLATE (LNS 115 KG)**
**Possibly Mesopotamian**
**or Iranian region**
**9th–10th century**

Dimensions: hgt. 1.5 cm; max. diam. 6.4 cm;
th. 0.29 cm; wt. 24.5 g; cap. 28 ml
Color: Translucent colorless
Technique: Blown; impressed with tongs; tooled;
worked on the pontil
Description: This small plate has a curved profile.
The decoration consists of six
omphalos-patterned medallions
(max. diam. ca. 2.5 cm) impressed
with a tong at irregular intervals
and often overlapping.
Condition: The object is intact. The surface is
heavily weathered, resulting in
iridescence and abrasion. The glass
is of good quality.
Provenance: Kofler collection
Literature: Lucerne 1981, no. 561

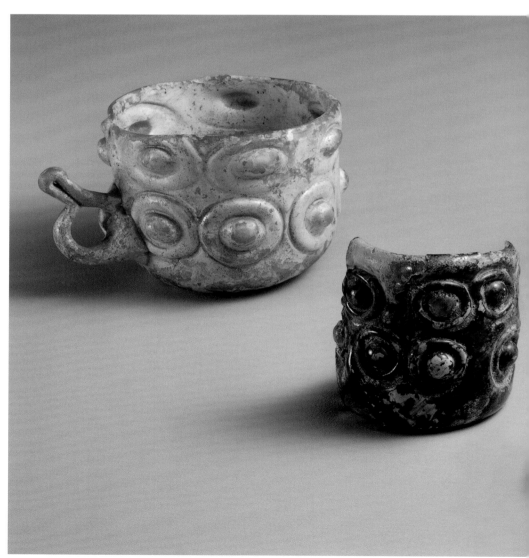

Cat. 3.55a–f

**Cat. 3.55d JAR (LNS 61 KG)**
Possibly Mesopotamian
or Iranian region
9th–10th century

Dimensions: hgt. 4.5 cm; max. diam. 5.0 cm;
th. 0.34 cm; wt. 58.5 g; cap. 45 ml
Color: Translucent purple (purple 2)
Technique: Blown; impressed with tongs; tooled;
worked on the pontil
Description: This slightly lopsided, nearly globular
jar has a flat base; the diameter of
the opening is about 3.0 cm. The
decoration consists of six omphalos-patterned
medallions (max. diam. ca. 2.2 cm)
impressed with a tong at irregular
intervals and overlapping twice.
Condition: The object is intact. The surface
is heavily weathered, resulting in a
milky white coating and iridescence.
The glass is of good quality.
Provenance: Kofler collection
Literature: Lucerne 1981, no. 562

**Cat. 3.55e SMALL BOTTLE (LNS 76 KG)**
Possibly Mesopotamian
or Iranian region
9th–10th century

Dimensions: hgt. 5.0 cm; max. diam. 4.5 cm;
th. 0.35 cm; wt. 53.1 g; cap. 25 ml
Color: Translucent pale brown
(yellow/brown 2)
Technique: Blown; impressed with tongs; tooled;
worked on the pontil
Description: This globular bottle has a flat base
and a cylindrical neck with a ground
opening. The decoration consists of
five omphalos-patterned medallions
(max. diam. ca. 2.2 cm) impressed with
a tong in high relief at regular intervals.
Condition: The object is intact. The surface is
partially weathered, resulting in whitish
pitting. The glass includes frequent
small bubbles.
Provenance: Kofler collection
Literature: Lucerne 1981, no. 563

**Cat. 3.55f SMALL BOTTLE (LNS 96 KG)**
Possibly Mesopotamian
or Iranian region
9th–10th century

Dimensions: hgt. 6.0 cm; max. diam. 3.5 cm;
th. 0.40 cm; wt. 41.2 g; cap. 20 ml
Color: Translucent pale bluish green (green 2)
Technique: Blown; impressed with tongs; tooled;
worked on the pontil
Description: This dome-shaped bottle has a flat base
and a long flared neck. The decoration
consists of six omphalos-patterned
medallions (max. diam. ca. 1.5 cm)
impressed with a tong at irregular
intervals below the shoulder.
Condition: The object is intact. The surface is
heavily weathered, resulting in silvery
iridescence. The glass includes
scattered small bubbles.
Provenance: Kofler collection
Literature: Lucerne 1981, no. 545
Related Work: Cat. 70

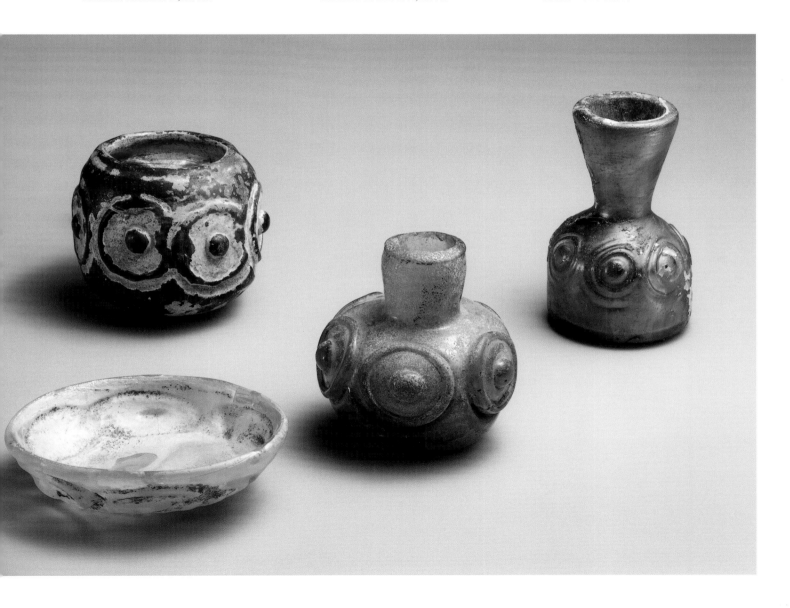

### Cat. 3.56a BOTTLE (LNS 46 KG)
### Possibly Mesopotamian
### or Iranian region
### 9th–10th century

Dimensions: hgt. 13.0 cm; max. diam. 8.5 cm;
th. 0.29 cm; wt. 102.8 g; cap. 300 ml
Color: Translucent dark brown
Technique: Blown; impressed with tongs; pinched;
tooled; worked on the pontil
Description: This slightly lopsided, globular bottle
has a flat base and a long slightly flared
neck with a bulged opening. The
decoration consists of six pinched ribs
that run vertically from the base to the
shoulder at regular intervals. In the
center of the neck, six omphalos-
patterned medallions (max. diam.
ca. 1.6 cm) were impressed with a tong
in low relief at irregular intervals.
Condition: The object is intact. The surface is
lightly weathered, resulting in whitish
pitting, iridescence, and a small
abraded patch. The glass includes
scattered small bubbles and one large
bubble.
Provenance: Kofler collection
Literature: Lucerne 1981, no. 560

### Cat. 3.56b JUG (LNS 429 G)
### Iranian region
### 10th–11th century

Dimensions: hgt. 14.3 cm; max. diam. 11.7 cm;
th. 0.28 cm; wt. 226.5 g; cap. 710 ml
Color: Translucent pale green (green 1)
Technique: Free blown; impressed; tooled, applied;
worked on the pontil
Description: This well-proportioned curved jug has a
nearly angular shoulder, a splayed foot
created by folding the glass underneath
the base, and a cylindrical neck (hgt. ca.
5.0 cm; diam. 6.7 cm). The decoration
on the neck (ca. 0.5 cm below the rim)
consists of seven omphalos-patterned
medallions, impressed at irregular
intervals, that, after tooling, have
assumed an oval shape (hgt. ca. 1.5 cm;
w. 2.5 cm). An L-shaped handle with
two thumb rests was attached at the rim
and the shoulder.
Condition: The object is intact. The surface is
entirely weathered, resulting in milky
white and dark brown coatings
(especially on the interior) and
iridescence. The glass includes frequent
tiny and large bubbles and some streaks.
Provenance: Bonhams, London, sale, October 15,
1997, lot 76
Related Work: Cat. 70

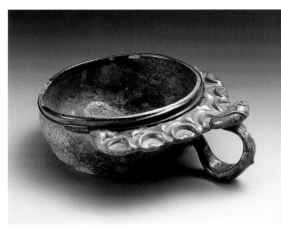

Cat. 3.57

### Cat. 3.57 CUP (LNS 420 G)
### Probably Iranian region
### 11th–12th century

Dimensions: hgt. 3.4 cm (excluding the handle);
max. diam. 7.3 cm; max. l. 10.0 cm;
th. 0.18 cm; wt. 61.2 g; cap. 116 ml
Color: Translucent colorless and purple
Technique: Free blown; applied; tooled; impressed;
worked on the pontil
Description: This handled cup has curved lopsided
walls and a flat base with a pronounced
kick. A thin dark trail, probably purple,
was applied in a spiral just below the
rim. A protruding flange (w. ca. 1.2 cm)
was applied under the purple trail
(ca. 0.7 cm below the rim) around
about half of the cup's circumference.
The flange is decorated with ten
omphalos-patterned half-medallions
impressed at irregular intervals, creating
a sort of festoon at the edge. A circular
handle with a large and flat thumb rest
was attached at the middle of the flange
and at the body; the handle is so large
that it protrudes below the base and the
object does not rest flat.
Condition: The object is intact except for small
chips. The surface is entirely weathered,
resulting in grayish and pale brown
coatings and corrosion that prevent
a proper reading of the color.
Provenance: Reportedly from Mazar-i Sharif
(Balkh), Afghanistan
Related Work: Cat. 70

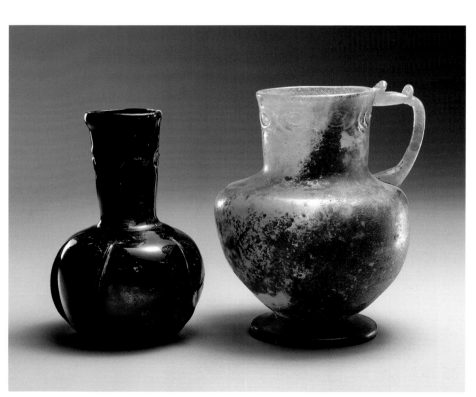

Cat. 3.56a, b

# NOTES

1   Among the best preserved are a low bowl (hgt. 4.5 cm; diam. 11.65 cm) in the Mildenberg collection, Switzerland (Kozloff 1981, no. 43, pl. 21) and a cylindrical bowl in the Museum of Islamic Art, Cairo (inv. no. 5629; see Lamm 1941, pl. 2:2).

2   See cat. 65a–d.

3   See, for example, a beaker in the Victoria and Albert Museum, inv. no. C571-1925 (Lamm 1929–30, pl.18:16) and a bowl in the Museum für Islamische Kunst, Berlin (inv. no. I.538; see Kröger 1984, no. 106).

4   See Morton 1985, esp. p. 31.

5   Two mirrors impressed with similar subjects are in the Metropolitan Museum of Art (inv. nos. 1976.158.1, .2; see also Melikian-Chirvani 1982, p. 48, no. 9).

6   See, for example, many objects in the Museum für Islamische Kunst, Berlin (Kröger 1984, nos. 96–99) and the Benaki Museum, Athens (Clairmont 1977, pl. 14:225–228).

7   Lamm 1929–30, pp. 64–65.

8   Lamm 1928, p. 42; and Clairmont 1977, no. 235.

9   Lamm 1929–30, pl. 15:12; and Smith 1957, no. 508.

10   For example, nine "petals" are present on a fragmentary bottle found in the Philippines; see Legeza 1988, p. 137.

11   Long-necked globular bottles formed from two differently colored parts (usually blue and colorless) are found in collections worldwide and are attributed to areas ranging from Egypt to Iran. The bottle in the Metropolitan Museum, with its seemingly Egyptian or Syrian tonged technique, seems to point to a similar origin for these peculiar bicolored containers. Two-part vessels decorated with the tong technique were, however, also found in Iran, as exemplified by a pitcher excavated at Nishapur, now in the Iran National Museum (Kröger 1995, no. 141). The objects found in the eastern Islamic world may represent imports, but their attribution is still uncertain.

12   As confirmed not only by cat. 3.55a–f and 3.56 but also by a survey of objects in other collections.

13   See, for example, a nearly complete beaker and fragments in the Victoria and Albert Museum (inv. no. C571-1925; see Rackham 1925–26) and objects and fragments published by Lamm (1929–30, pls. 16–18) that include a variety of these patterns.

14   Rackham 1925–26, fig. 3.

15   Lamm 1929–30, p. 66, pl. 16:1. Lamm (1935, p. 12) also noticed, however, that the number of fragments found outside Egypt may point to a different origin, such as Iraq and Iran.

16   This route was commonly exploited by glass traders in this period, as exemplified by the large number of Iranian fragments that eventually reached the Scandinavian peninsula (see Lamm 1935).

17   See Brunswick 1963, no. 73.

18   Inv. no. 1974.15 (Jenkins 1986, no. 17).

19   Lamm 1935, pl. 29c.

20   Inv. no. I.1539 (Lamm 1929–30, pl. 18:11).

21   Referring to the beaker in the Metropolitan Museum, Jenkins (1986, p. 20) observed that "the shape of this vessel is very similar to one with luster-painted decoration in the National Museum, Damascus, bearing an inscription, also arranged in vertical bands, exhorting its owner to 'drink and be delighted.' Thus, we can be sure that such cups were used for drinking—a function that would account for the large number of variously decorated vessels of this shape extant." The pitcher (cat. 72), with its convivial inscription, may represent the matching pouring vessel for such beakers.

22   Field–Prostov 1942.

23   A medallion in the name of the same ruler has appeared at auction recently; see Christie's, London, sale, April 13, 2000, lot 289.

24   Field–Prostov 1942, p. 145.

25   All three are published in Abdullaev et al. 1991, nos. 542–44. Four medallions are presently on display in Termez.

26   Kröger 1984, nos. 115–19.

27   Formerly in the al-Sabah Collection (LNS 373 G) and later deaccessioned. A deep vivid blue glass medallion depicting the figure of a sphinx, it is probably a copy after a medallion resembling cat. 73l.

28   See Related Works 3, 8, and 10.

29   The reading Abū instead of 'Abd, as confirmed by a medallion sold at auction (see note 23) seems more likely; see Field–Prostov 1942, p. 145.

30   See, for example, EIr, vol. 3, s.v. "Bahrāmšāh."

31   Two identical medallions, in Berlin and in the Tariq Rajab Museum (see Related Works 1, 2), are too worn to distinguish any inscription on the eagle's wings but it was probably once there.

32   The last word, nuṣra, may represent an abbreviation of the formula nuṣrat amīr al-mu'minīn ("The Help of the Commander of the Believers"), as may be inferred from a fragmentary medallion in the Tariq Rajab Museum (Related Work 4, inv. no. TSR 0022b), the inscription on which seems to end with the name [Ḥusa]in followed by this formula. The only dynasty known from textual sources that used the title Jahān Pahlavān was that of the Eldegüzids or Ildeghizids (ca. 1145–1225), but it can be dismissed here since they ruled as atabegs in Azerbaijan and none of their names matches that written on the glass medallions. The most important member of the family was Abū Ja'far Nuṣrat al-dīn Jahān Pahlavān Muḥammad ibn Ildeghiz (r. A.H. 571–82 / A.D. 1175–86); see de Zambaur 1927, p. 231; and Bosworth 1996, p. 199, no. 99.

33   Kafesoğlu 1956, pp. 119, 122.

34   Firdausī does not mention that Sapīnūd reached Iran with Bahrām Gūr riding an elephant, but elephants are mentioned later in the text when Sapīnūd's father and other Indian rulers went to Iran to celebrate the wedding (Mohl 1976, vol. 6, pp. 46–69).

35   The bowl is in the Freer Gallery of Art, Washington, D.C. (inv. no. 27.3); see Atil 1973, no. 39.

36   See, for example, illustrations in fourteenth-century copies of the Shāhnāma, where Zāl stands or sits next to the simurgh (Swietochowski–Carboni 1994, pp. 82–83, no. 8, figs. 25, 26). The only fourteenth-century image that shows Zāl carried in the air by the fantastic bird does not conform to the iconography of the medallions (Gray 1961, p. 41).

37   See, for example, Swietochowski–Carboni 1994, p. 91, no. 15.

38   Trever–Lukonin 1987, pp. 113–14, no. 22, pls. 57, 58. The image of a large bird seen frontally and of a smaller naked human figure in the center of its body developed as early as the first century B.C. or A.D. on glass-paste seals that were also widely circulated in Asia (see, for example, LIMC, vol. 4, no. 263).

39   Azarpay 1995, p. 105.

40   Ibid., figs. 9, 11, 13, 14, 16.

41   Ibid., fig. 17.

42   Ettinghausen 1962, pl. p. 46.

43   The bowl (inv. no. LNS 311 C) was formerly in the Kelekian collection (SPA, vol. 9, pl. 585a). The image on the two identical small mirrors (Victoria and Albert Museum, inv. no. 1536-1903; Metropolitan Museum, inv. no. 1976.158.2) is similar to that on the glass medallions; Melikian-Chirvani (1982, p. 48, no. 9) interprets it as the figure of Zāl elevated in the air by the simurgh.

44   Gray 1959, pl. 40. Yueh-chin, or "moon-chin," is the generic term for string instruments, which is played by a "celestial musician" in the painting. I am grateful to Aygul Malkeyeva and Ken Moore for their help in this matter.

45   Karomatov et al. 1983, pl. 82.

46   Bahrami 1952, fig. 3; and Ettinghausen–Grabar 1987, fig. 253.

47   Ibid., fig. 2.

48   Ibid., figs. 1, 4. Ettinghausen–Grabar (1987, p. 401, n. 238) question Bahrami's dating of the medallion in the Freer Gallery of Art.

49   For example, a plate in the Keir collection, attributed to twelfth- or early thirteenth-century Iran (Fehérvári 1976, no. 74, pl. 23a). Ettinghausen (1957, figs. L, 21) illustrates two trays, one formerly in the collection of D'Allemagne, Paris, the other in the possesion of Stuart Cary Welch in Cambridge, Massachusetts.

50   Scerrato 1962, esp. figs. 1–6.

51   See Baer 1983, pp. 172–75. The image of four sphinxes joined by their wings is found on a glass medallion in the Tariq Rajab Museum (Related Work 15).

52   Metropolitan Museum of Art (inv. no. 1978.158.1).

53   There are, to my knowledge, no identical images molded on both bronze mirrors and glass medallions that could prove they shared the same molds.

54   Microscopic analysis of the small mirror in the Metropolitan Museum (see note 52) has confirmed this integrated casting process. I am grateful to Jean-François de Lapérouse for this information.

55   See, for example, cat. 65a–d.

56   A number of early Islamic vessels from the Syrian area have small impressed medallions attached to their walls for decorative purposes; they depict birds or other animals or include inscriptions (see cat. 3.49, 3.50; and Balog 1974 for a survey of these so-called vessel stamps). Good examples are provided by a complete bottle in the Metropolitan Museum of Art (inv. no. 37.56; see Jenkins 1986, no. 7) and three bowls, in the Museum für Islamische Kunst, Berlin (inv. no. I.1537), in the Abegg-Stiftung Museum, Riggisberg (inv. no. 4.3.63), and in the Toledo Museum of Art (inv. no. 23.2014; see Kröger 1998, pp. 305–16, pls. 179–183). See also cat. 3.49, 3.50.

57   Inv. no. LNS 22 ST (hgt. ca. 10 cm; diam. ca. 37 cm); see Bonhams, London, sale, April 24, 1997, lot 289.

58   Inv. no. GLS 0562 TSR.

59   The inscription helps to date these two stamps to the early Islamic period, though the iconography is based on Sasanian seals (see Herrmann 1989, fig. 34, for an example in the British Museum, inv. no. 119564). Other Islamic seals with identical subjects are in Erdmann 1952, fig. 9; Smith 1957, no. 386; Balog 1974, nos. 8, 9; and Morton 1985, nos. 551–53.

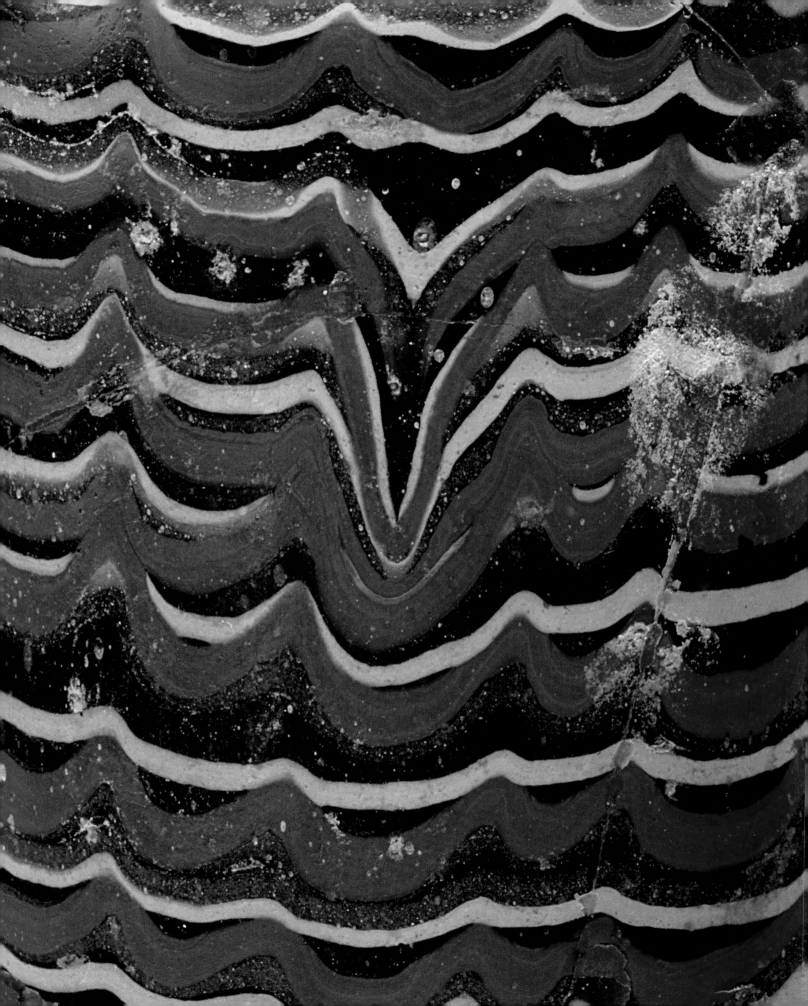

# GLASS WITH MARVERED TRAILS

S O-CALLED MARVERED GLASS from the Islamic period includes
some of the most peculiar and appealing objects produced by
medieval glassmakers. The group is easily identifiable because of
its patterned decoration and coloration, which usually includes
white or pale-colored trails marvered into a dark matrix. The
matrix, which appears almost opaque black, is actually a dark
translucent purple (in the majority of cases), blue, green, or
brown when viewed through a light source. The marvered trails,
subsequently tooled with a pointed device into wavy, arcaded,
festooned, or foliated patterns, are almost invariably white or
sometimes pale blue, grayish, red, or yellow.

Typical Islamic glass with marvered trails was made by
inflating a parison of translucent dark glass on the blowpipe and
applying a continuous spiraling trail of opaque pale colored glass
around the body. The trail was dragged up and/or down with
a pointed, perhaps toothed, tool in order to create decorative
motifs; hence, the common description of "combed patterns."
The bubble was rolled on a marver (a polished stone or iron slab
commonly used by glassmakers to give a regular shape to an
object). The trail was thus pushed into the surface of the matrix
glass, becoming "marvered"; it is even with the surface of the dark
glass and can hardly be perceived in relief at the touch of the
finger. At this point, the final shape and decoration of the object
was created: the bubble was either blown in a mold (see, for
example, the ribbed bowls, cat. 82a, c) then transferred to the
pontil or worked directly on the pontil with various utensils.
The typical result is a fancy network of patterns, which may be
arcaded (the trail is tooled with downward strokes), festooned
(upward strokes), foliated (alternately upward and downward
strokes) or wavy (light upward and downward strokes), and
which envelop the entire surface of the finished vessel (see, for
instance, cat. 80, 83).[1]

This technical description accords with typical glass with
marvered decoration produced between the late twelfth century
(possibly before the fall of the Fatimids in 1171 and the rise of
the Ayyubids) and the fourteenth, which is well represented in
the Collection by kohl bottles, bowls, *qamāqim*, a fragmentary
bottle, and a chesspiece (cat. 80–83). The vial, bottles, cup and
flasks (cat. 74–78), however, call for a partial revision of recent
studies devoted to marvered glass, in particular of two articles
recently published by James Allan and Julian Henderson.[2]
According to Allan, virtually all marvered glass was produced
between the twelfth and the thirteenth centuries, as he found no
evidence of a continuity between the Roman tradition and
medieval Islamic production. The strongest arguments for Allan's
conclusions are the unreliability of the stratification of several
early Islamic sites where marvered glass was found; the reliability
of other sites that were occupied in the Ayyubid and the Mamluk
periods; the relation to enameled glass, which was apparently
influenced by marvered pieces; and the existence of glass tokens
or weights in marvered glass between the thirteenth century and
the end of the fourteenth.[3] Allan's only possible candidates for
an earlier dating are kohl bottles of the general type discussed at
cat. 78 and 80, which he compared to earlier vessels in cut glass.[4]

Complementing Allan's art-historical approach with a
scientific and technological analysis, Julian Henderson is much
less inclined to suggest a relatively short period of production for
marvered glass. His research led him to conclude that there was a
change in the technology of glass production in the ninth century,
though it may have occurred at different times in different areas of
the Islamic world.[5] All glass made after the ninth century has, by
and large, a similar composition and there is no clear chemical
distinction between a tenth- and a thirteenth-century vessel. He
also notes that glassmakers adopted diverse approaches when

making dark-colored marvered glass as opposed to hyalescent enameled glass, thus questioning the relation suggested by Allan.[6]

Cat. 74–78 do not correspond to the typical marvered glass discussed by Allan and Henderson or to late antique marvered vessels usually assigned to the second to the fourth century, which have typically Roman shapes and finishing, are mostly translucent pale yellow and green, and are decorated with irregular festooned patterns in white or red opaque glass or, sometimes, in both.[7]

One vial (cat. 74; see also cat. 1.1) shows a combination of pale blue and red marvered threads, while a companion piece (Okayama Orient Museum, Japan) has white and red trails. Admittedly, the vial's shape suggests that it may have been produced before the Islamic era and that it represents a type of marvered container attributable to late Antiquity. In any case, it falls into a period thus far regarded as generating no marvered glass products. From a decorative standpoint, the pattern of zigzag and horizontal spiraling threads is in accordance with early Islamic applied-glass production (see, for example, cat. 5, 1.4–1.7).

The shapes of three bottles (cat. 75a, b, 76) and a cup (cat. 77), on the other hand, definitely belong to the early Islamic period. Their peculiar marvered decoration is also different from both typical Roman examples and vessels with regular festooned patterns that became popular in the twelfth and thirteenth centuries; thus, these objects can be regarded as the missing link sought by Allan.

With its combination of three marvered colors, which almost cover the background matrix color, the cylindrical bottle (cat. 75a) is one of the most lively and captivating glass objects that has survived. Its attribution to the early Islamic period is supported by its shape and by its vivid opaque colors, inspired by Roman prototypes, that fascinated glassmakers at the same time that millefiori glass was being produced, in the eighth and ninth centuries. This experimental phase is also reflected in the irregular marvered pattern: partly wavy, partly zigzag, often showing overlapping threads that create an even wider chromatic spectrum. It is somewhat unaccomplished yet marvelous at the same time.

Coloring is also the strength of the small bottle (cat. 76); its cylindrical shape indicates that it was made well into the Islamic period. Its decoration, which was probably ultimately inspired by the Roman taste for imitation of natural stones, such as agate and onyx, can be described as "featherlike" or "marbleized," because of the delicacy of the dragged marvered glass. The overall effect is rather different from that of the multicolored bottle (cat. 75a)—in a way, more refined and restrained—and imparts to this small vessel a painterly quality that was rarely matched in other periods.

A cup (cat. 77) has a different appeal and exemplifies, better than cat. 75a or 76, the continuity of the late antique tradition during the Islamic period. The chromatic approach is similar to that of its models, which usually show opaque white glass marvered into a pale colored matrix. Here, however, experimentation is evident in the uneven marvering, which left portions of white glass in low relief; in the presence of an unmarvered trail below the rim of the cup; and in the irregular pattern that has little to do with either earlier or later marvered objects. The cylindrical shape of the cup makes an attribution to the Islamic period almost certain, a dating supported by a similar piece excavated in Syria.[8] Demonstrating a more restrained approach than the multicolored bottle (cat. 75a), this cup is nonetheless among the most charming objects in the Collection.

The decoration of the small flasks (cat. 78a, b) is similar to that of cat. 77 but the color of the matrix glass is a rich dark blue. The taste for white marvering into a dark matrix makes one of its earliest appearances here, during a transitional period in which the marvered pattern was still irregular and free compared to later regularly festooned and foliated motifs.

A number of small toylike figures of stylized birds present problems of attribution (cat. 79). Of consistent dimensions, these figurines often have a small suspension ring attached to the back, and some of them contain small glass rods that rattle when the object is shaken. They were probably used, therefore, as rattlelike toys. Their appearance is charming: the marvered body is plump, and the wings, eyes, beaks, and feet are applied in different opaque colors that render them both naive and lively. Judging by archaeological evidence as well as the regularity of their marvered patterns, these figurines were made during the most prolific period of production of marvered glass, the twelfth and thirteenth centuries. Their zoomorphic shapes, however, are characteristic of the early Islamic period (see cat. 4) and thus an earlier attribution seems equally plausible. Perhaps these figurines were popular for a long time and may provide evidence of an uninterrupted production of marvered glass from the early Islamic era to the medieval period.

Another type of vessel often decorated with marvered and tooled threads is the kohl bottle, which may also attest to a continuity of production from the early Islamic to the medieval periods. As mentioned above, these bottles troubled Allan in attributing all marvered glass to the twelfth and thirteenth centuries. These sturdy containers, designed to hold a kohl stick, have survived in large numbers and are commonly found in archaeological contexts. The two best examples in the Collection, cat. 80a and b, have a regular profile, well-arranged festooned patterns, and a dark purple body and have been dated to the twelfth or thirteenth century. There are, however, many bottles with an irregularly tapered profile or with a circular, rather than

square, base and a cylindrical body (similar to the shape of cat. 76) that show a less controlled and regular marvered pattern.[9] A possible explanation is that bottles such as cat. 80 represent the final stage in the production of this type of marvered container, which enjoyed an experimental phase in the first centuries of Islam. After all, kohl bottles are among the most typical and frequently encountered utilitarian containers throughout the Islamic world; it is not surprising that they enjoyed a continuous production in marvered glass, among other mediums.

Three bowls (cat. 82a–c) and two *qamāqim* (cat. 83a, b) have characteristic Ayyubid and Mamluk shapes and there is no doubt that they belong to the "golden" era of glass with marvered decoration. Their regular white patterns—either slightly wavy (as on the bowls, cat. 82a, c), diamond-shaped (cat. 82b), foliated or festooned (cat. 83a, b)—are typical of this period. Since similar uniform patterns appear on a chess pawn (cat. 81), it is also possible to assign this object and the great majority of comparable chesspieces to the same period, even though their abstract shapes were codified a few centuries earlier. Considering that no marvered-glass chesspieces have been reported in archaeological excavations, a late attribution is based on decoration, rather than shape, and may be subject to review.

Of great interest for its relationship to both stained and gilded glass is a fragmentary cylindrical bottle (cat. 84). Its purple color and festooned white decoration point to the same period as cat. 82 and 83. In this case, the marvered pattern was not sufficiently ornamental for the craftsman who decorated the bottle, so he painted stained lusterlike scrolls on the purple sections between the marvered white trails. The effect must have been quite luxurious when the bottle was in pristine condition. This type of decoration was often exploited on marvered glass, especially when gold—instead of stain—became the rule.[10] Gilding on marvered objects also provides a link with the contemporaneous production of enameled glass, in which the chromatic possibilities (which were confined to three colors on marvered glass—purple, white, and gold) were virtually limitless. The lusterlike decoration of cat. 84 also links it to earlier objects in stained glass (see Chapter 2) and proves that the technique was still in use in the Ayyubid and Mamluk periods (see cat. 99 for an example in enameled glass). In addition, it is possible to link cat. 84 to contemporaneous decorated bottles perhaps of Byzantine origin. Thus, this fragmentary bottle is symbolic of the unity of diverse glassmaking traditions in the eastern Mediterranean during the medieval period.

**Cat. 74 VIAL (LNS 22 KG)**
**Egyptian or Syrian region**
**7th–8th century**

Dimensions: hgt. 11.0 cm; max. diam. 1.2 cm;
th. 0.20 cm; wt. 27.1 g; cap. 3 ml

Color: Translucent dark green (green 4);
opaque pale blue and red

Technique: Blown; marvered; tooled;
worked on the pontil

Description: This cylindrical vial, or phiala, has
an applied roundel that provides an
unstable base for the long narrow
container. The body is partially
marvered (the opaque glass trails are
in low relief) in a regular pattern of
alternating rows of zigzag pale blue
trails and a larger spiraling band of
red. There are three pale blue bands
and four red spirals in four sections.

Condition: The object is intact except for a small
chip near the opening. A small fragment
of green glass near the rim suggests
that two small handles are missing.
The surface is weathered, resulting in
considerable abrasion; the turquoise
threads have largely turned whitish.
The glass includes scattered bubbles.

Provenance: Kofler collection

Literature: Lucerne 1981, no. 487

Related Works: 1. Okayama, inv. no. 50.304
(Taniichi 1987, no. 111;
and Okayama 1991, p. 113)
2. Oppenländer collection, inv. no. 2319
(von Saldern et al. 1974, no. 744)
3. CMG, inv. no. 64.1.14

This small vial has a companion piece in the Okayama Orient Museum (Related Work 1) that has two small handles attached at either side just below the opening, thus providing the intact model for the present object. The vial in Okayama is of identical dimensions and is made of the same dark glass (probably green); it differs only in the use of opaque white (in place of pale blue) for the zigzag pattern and in the larger number of decorated sections, which include four white bands and five red spirals. The two vials were clearly produced in the same workshop.

The shape of cat. 74, the presence of the applied base, and the attached handles (though missing) follow the tradition of similar containers created in ancient Egypt, which was continued in the immediately pre-Islamic and in the early Islamic periods in Syria and Egypt.[11] Another vial of identical shape but having an opaque white decoration of "eyes" formed by interlaced circles, each including a dot in the center, is presently in the Oppenländer collection (Related Work 2). The object has been attributed—somewhat inexplicably, judging from the shape and the archaic decoration—to the ninth to eleventh century.[12] Another vial in the Oppenländer collection, which probably represents a transition between the present, tubular type and the later, so-called spearlike bottles (see cat. 80a, b), shows an overall opaque white zigzag pattern and still retains the small applied base and handles.[13]

An unusual object, unrelated in shape but of the same colors (dark green body, opaque pale blue and red marvered trails) is in the Corning Museum (Related Work 3). It is composed of a large solid cylindrical element (l. ca. 7.5 cm) pointed at both ends and with a small bored section attached above it; thus, it is probably the central bead of a necklace.[14] The pale blue zigzag decoration and the use of the same red color for other details represent a good parallel for cat. 74—this object was certainly produced in the same period.

Tubular vials with marvered decoration are representative of the transitional period discussed in Chapter 1 and a dating later than the early ninth century is implausible. The taste for two colors for the opaque marvered trails also suggests an early date for these objects.

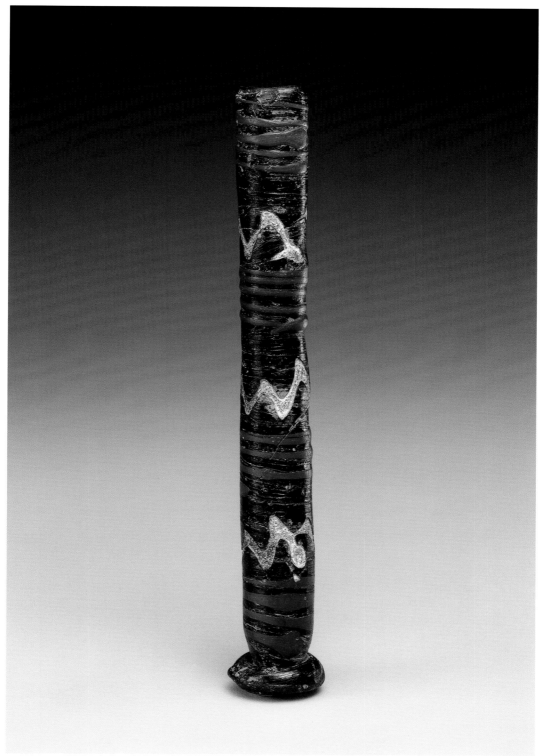

Cat. 74

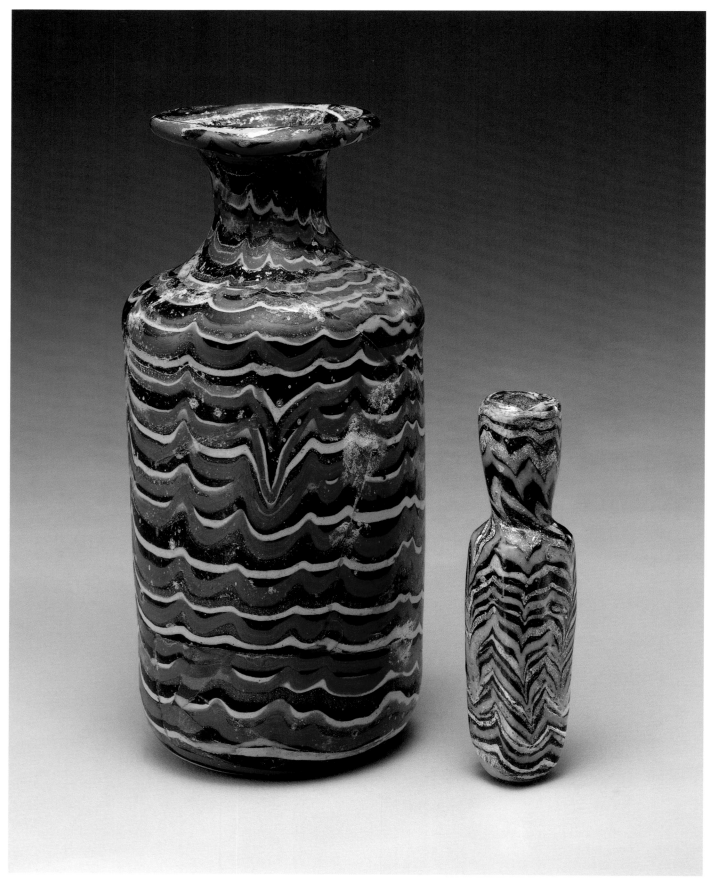

Cat. 75a, b

## Cat. 75a BOTTLE (LNS 71 KG)
### Egyptian or Syrian region
### 8th–9th century

Dimensions: hgt. 12.5 cm; max. diam. 6.0 cm;
th. 0.40 cm; wt. 127.3 g; cap. 200 ml

Color: Translucent dark purple (purple 3);
opaque brownish red, blue, and yellow

Technique: Free blown; marvered; tooled;
worked on the pontil

Description: This cylindrical bottle has a flat base,
an angular shoulder, a short curved
neck, and a thick splayed irregular
opening. Trails of opaque glass in
three colors that often overlap (blue
and yellow turn into pale green) are
marvered, forming an irregular
spiraling pattern tooled until wavy.

Condition: The object was broken and repaired but
is almost complete; small sections are
filled in and painted over. The surface
is partially weathered, resulting in a
milky white film. The glass includes
scattered bubbles.

Provenance: Kofler collection

Literature: Lucerne 1981, no. 495

Related Work: CMG, inv. no. 74.1.48

## Cat. 75b BOTTLE (LNS 359 G)
### Egyptian or Syrian region
### 7th–8th century

Dimensions: hgt. 7.3 cm; w. 1.7 cm; l. 1.5 cm;
th. 0.26 cm; wt. 32.7 g; cap. 1 ml

Color: Opaque black (probably very dark
brown or green); opaque white,
pale bluish gray, and yellow

Technique: Blown; marvered; tooled

Description: This four-sided bottle is almost square.
The base is nearly flat, the profile is
straight, and the neck is slightly flared
and curved. The body and neck were
entirely marvered into a slightly
irregular arched and wavy pattern.
The bright yellow thread is wider and
more predominant than the pale gray
and white threads. There is no sign of
a pontil mark under the base, which is
slightly convex.

Condition: The object is intact except for a chip on
the opening and a number of circular
depressions on the body caused by
corrosion. The surface is in fair
condition and only slightly abraded;
the pale gray marvered thread has
partially turned whitish.

Provenance: Reportedly from Tash Kurghan
(Mazar-i Sharif), Afghanistan

The extraordinary bottle (cat. 75a) has no known close parallels. It represents one of those rare instances in glass with marvered decoration where the base color—in this case, translucent dark purple—is entirely dominated by the opaque colored trails and becomes an integral part of the decoration itself. The result is a spirited polychromatic combination of colors that run into one another, creating additional hues (for example, overlapping blue and yellow trails result in pale green). This lively amalgamation of colors is enhanced by the irregular wavy pattern created by tooling the marvered trails along the entire surface of the bottle.

A similar combination of colors is present on a small fragment, probably from the neck of a bottle, in the Corning Museum (Related Work); the marvered decoration is tooled on a dark purple background into an irregular fish-scale motif in red, yellow, and pale blue (now turned white); an applied opaque pale blue trail encircles the neck. Only two extant objects can be compared coloristically with this bottle, though they have entirely different shapes and origins. One is a core-formed blue goblet in the Corning Museum, attributed to the New Kingdom (second half of the second millennium B.C.), that shows a wavy decoration in white, yellow, and pale blue.[15] The other is a bottle with a convex base described by Eisen as made of dark blue glass and red, ocher, and yellow threads; it is probably from the late Roman period, judging by its shape.[16] These two objects exemplify a long-standing tradition of decorative patterns and colors in the eastern Mediterranean area that continued into the early Islamic period.

It seems sensible to attribute this taste for a somewhat disorderly polychromy to a revival of core-formed Egyptian vessels as well as to Roman objects inspired by multicolored semiprecious stones, such as onyx and agate.[17] A similar revival has been observed in millefiori glass (see cat. 7). The unpretentious cylindrical shape of cat. 75a can be attributed to the early Islamic period;[18] thus, it is possible to suggest that it was created in the eighth or, possibly, early ninth century. The small squarish bottle (cat. 75b) is undoubtedly from the early Islamic period, as its shape is comparable to that of undecorated objects as well as others with cut decoration and marvered trails (see, for example, cat. 2.14, 3.6, and 3.7). The color combination of cat. 75b closely matches that of cat. 75a and strongly supports the proposed early Islamic attribution for the latter vessel, which stands out as one of the most memorable objects in the Collection.

**Cat. 76 BOTTLE (LNS 106 KG)**
**Egyptian or Syrian region**
**8th–9th century**

Dimensions: hgt. 11.5 cm; max. diam. 3.0 cm;
th. 0.18 cm; wt. 34.8 g; cap. 45 ml
Color: Translucent dark olive green body
(green 5); opaque bluish white and
dark olive green
Technique: Free blown; marvered; tooled;
worked on the pontil
Description: This tall cylindrical bottle has a
flat base and a flared neck. The
fine, irregular, featherlike marvered
decoration in two colors of opaque
glass produces a pattern that recalls
marbleized paper.
Condition: The object is intact. The surface
is lightly weathered, resulting in
milky white spots and iridescence.
The glass is of good quality.
Provenance: Kofler collection
Literature: Lucerne 1981, no. 491
Related Works: 1. CMG, inv. no. 79.1.194
(Corning 1955, no. 45)
2. FGA, inv. no. 09.442
(Washington 1962, no. 68)
3. CMG, inv. nos. 51.1.238.I–III
(fragments) and several
uncatalogued fragments

The profile of this bottle, with its nearly cylindrical body and flared neck, leaves no doubt that it belongs to the early Islamic period, when this shape became rather common (see, for example, cat. 3.4, 3.63a). The two-colored decoration against the dark olive green body of the vessel is extremely lively and busy and thus rather unusual for Islamic marvered glass. From a technical point of view, the decoration seems a sort of hybrid of marvered trails and enamel and has been described as "dragged painted stripes in several colors that appear lightly fired (as for enameling)."[19]

The rare objects and fragments that can be assigned to this group of "marbleized" or "featherlike" glass (see Related Works 1–3, cat. 3.60) have been attributed to different areas and periods, ranging from the Near East to Europe and from the Roman to the Islamic periods. For example, a footed bowl in Corning (Related Work 1, which formerly belonged to J. P. Morgan and J. Strauss) puzzled Strauss to the point that he catalogued it as "5th–8th century. Frankish? Rhenish? Syrian?" and included it under the heading "Transition or Doubtful Glasses."[20] A small bottle of seemingly earlier, Roman shape with similar, though not as busy, three-colored decoration (Related Work 2) has been regarded as "Roman period, 1st or 2nd century A.D. or later (?)."[21] Cat. 76 itself has been catalogued as "probably Syria, 9th–11th century or somewhat earlier."[22]

Cat. 76 can be regarded as another example of the continuity of the decorative taste of late antique glassmakers who settled on the eastern Mediterranean coast. The contrast between the featherlike decoration and the regular foliated and festooned pattern of the majority of marvered Islamic objects, which also probably followed earlier Egyptian sand core-formed models, is evident. Presently, it cannot be determined whether this difference is due to a limited production of the featherlike decoration in an isolated workshop or to a chronological development from the busy and lively featherlike vessels to a more formal and regular decoration with marvered trails. However, the existence of early Islamic objects that, even more than the featherlike type, prefigure the formal evolution of the pattern (see, for example, cat. 77, 78) would suggest that a contemporaneous limited production took place in the early Islamic period.

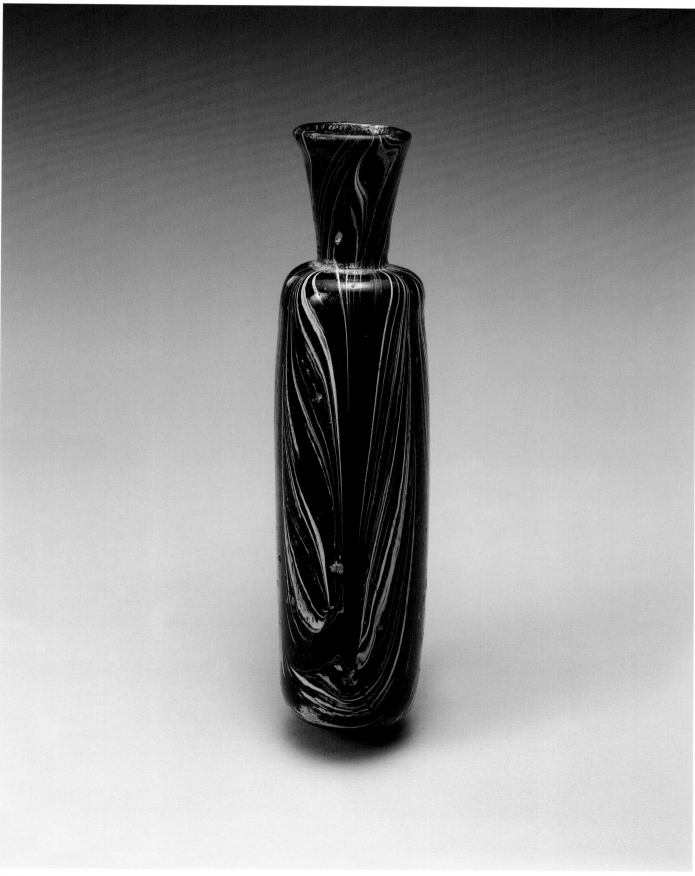

Cat. 76

**Cat. 77 CUP (LNS 52 KG)**
**Egyptian or Syrian region**
**8th–9th century**

Dimensions: hgt. 6.2 cm; max. diam. 6.2 cm;
th. 0.15 cm; wt. 56.2 g; cap. 205 ml
Color: Translucent pale blue (blue 2);
opaque white
Technique: Free blown; marvered; applied; tooled;
worked on the pontil
Description: This cylindrical cup, of uniform height
and diameter, tapers slightly near the
opening and has a flat base. A spiraling
trail of white opaque glass forms a
band (w. ca. 1 cm) below the rim. The
same white glass is partially marvered
around the body, creating an irregular
wavy, festooned pattern.
Condition: The object is cracked but complete.
The surface is lightly weathered,
resulting in brownish pitting on the
interior. The glass presents scattered
small bubbles and one inclusion.
Provenance: Kofler collection
Literature: Lucerne 1981, no. 494
Related Works: 1. NM, Damascus
2. Newark, inv. no. 50.1333
(Auth 1976, no. 234)
3. CMG, inv. no. RSW 5911 (fragments)

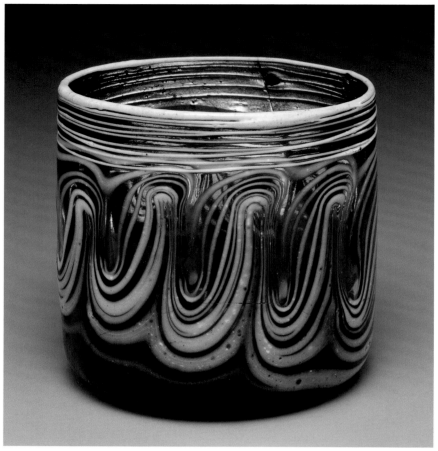

Cat. 77

This beaker or cup, which presents a peculiar marvered pattern in white glass against a pale blue body, is an exceptional piece in the Collection. Whether it was intentional or not, the wavy irregular motif is reminiscent of sea foam, a parallel emphasized by the pale blue waterlike color of the matrix glass. This beaker is a rare example of Islamic glass in which the marvered decoration is set against a transparent pale-colored surface, since other examples universally present a dark matrix made of purple, green, or blue glass.

Only two cups of similar shape and decoration, though in poor condition (Related Works 1, 2), and three unpublished fragments without a known provenance (Related Work 3) prove that this beaker is not unique. The surface of the cup in Damascus (Related Work 1), which was excavated in Syria and represents the best match for the present beaker, is entirely weathered and the original color is extremely difficult to read—it is probably an amber yellow with white marvered trails. The beaker in Newark (Related Work 2) has a more regular marvered pattern than cat. 77 and is dark purple. Of slightly darker blue than this beaker, the fragments, probably all from the same vessel (Related Work 3), offer an excellent parallel: they match the beaker's shape when they are reconstructed as well as the applied white trail below the rim.

The cylindrical profile and identical dimensions of height and diameter strongly suggest that cat. 77 belongs to the early Islamic period. The fine trails below the opening and the quality of the marvered decoration confirm this attribution. Comparable objects in good condition must come to light in order to make this interpretation irrefutable; in the meantime, the excellent condition of this beaker allows it to glow in splendid isolation.

**Cat. 78a FLASK (LNS 94 KG)**
**Egyptian or Syrian region**
**8th–9th century**

Dimensions: hgt. 6.2 cm; w. 3.0 cm; l. 2.5 cm;
th. 0.35 cm; wt. 29.1 g; cap. 13 ml
Color: Translucent dark blue (blue 5);
opaque white
Technique: Free blown; marvered; tooled;
worked on the pontil
Description: This small rectangular flask has a
flat irregularly shaped base and a
cylindrical neck that is pinched into
four bulged sections. A white marvered
trail is tooled into a wavy pattern
around the neck, in festoons on the
body, and in a spiraling trail that ends
underneath the base around the pontil
mark. Remains of copper wire,
probably from a stopper, are visible
between two sections of the neck.
Condition: The object is intact. The surface is
partially weathered, resulting in a
pale brown coating and abrasion
(especially of the white glass).
The glass is of good quality.
Provenance: Kofler collection
Literature: Lucerne 1981, no. 493

**Cat. 78b FLASK (LNS 1067 G)**
**Egyptian or Syrian region**
**8th–9th century**

Dimensions: hgt. 5.7 cm; max. w. 3.7 cm;
max. l. 1.8 cm; th. 0.30 cm;
wt. 21.3 g; cap. 10 ml
Color: Translucent dark blue (blue 5);
opaque white
Technique: Free blown; marvered; tooled;
worked on the pontil
Description: This small triangular flask has a
flat irregularly shaped base and a
cylindrical bulged neck with a thick
opening. A white marvered trail is
tooled into a wavy and festooned
pattern around the body, including
the neck, and ends at the base.
Condition: The object is intact. A depression on
the neck is probably due to careless
tooling. The surface is lightly
weathered, resulting in pale brown
pitting and abrasion. The glass is
of good quality.
Provenance: Reportedly from Qala-i naw (Badghis),
Afghanistan
Related Works: 1. MFI (Scanlon 1966, fig. 21)
2. Benaki, inv. no. 3409
(Clairmont 1977, no. 524)
3. Yoqne'am excavations, Israel
(Ben-Tor et al. 1996, fig. 17.12:1)
4. Toledo, inv. no. 23.2200

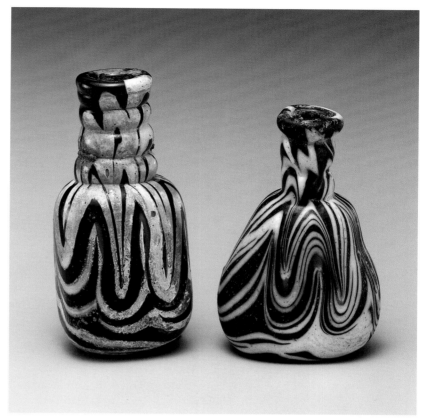

Cat. 78a, b

The marvered decoration on these two small flasks, with their irregular ample swirls, is reminiscent of the pattern on the surface of the splendid cup (cat. 77). Here, the matrix glass is dark, in accordance with the great majority of marvered objects of the Islamic period. Dark bright blue glass, however, is by far less common than purple and green and adds to the appeal of these flasks.

The squarish or triangular irregular shapes of the two vessels were created by tooling, and the bulges on the necks were shaped with the aid of pincers. The shape and diminutive size of cat. 78a find parallels in a great number of square flasks, usually containers for essences and oils, which were produced in the early Islamic period and circulated throughout the Islamic world and beyond.[23] Cat. 78b, though triangular, belongs to the same group.

Two flasks that represent the closest parallels to cat. 78a are in the Museum of Islamic Art, Cairo, and in the Benaki Museum, Athens (Related Works 1, 2). The former was excavated at Fustat in 1965 in a context datable to the late eighth century.[24] The other flask is slightly shorter as the neck is broken, but it is of the same color; both vessels have identical shapes and proportions. The marvered decoration of the flask in Cairo is similar to that of cat. 78a. The vessel in Athens has finer trails and a less regular marvered pattern; it is catalogued (without any explanation or evidence to support such an attribution) under the section on the later Islamic period and assigned an eighteenth- to nineteenth-century date.[25] Excavations in Israel, not far from Mount Carmel's ridge on the way to Akkon at the site of Yoqne'am, have revealed a fragment from the base of a seemingly identical dark blue flask with wavy white marvered decoration (Related Work 3). The stratigraphy of the site has confirmed a dating close to that suggested for the Fustat flask (Related Work 1), in the eighth century.[26]

**Cat. 79 FIGURE IN THE SHAPE
OF A BIRD (LNS 103 KG)**
**Egyptian or Syrian region**
**9th–12th century**

Dimensions: max. diam. 2.2 cm; l. 7.5 cm; wt. 26.0 g
Color: Translucent dark purple (purple 3);
opaque white and red with darker
inclusions
Technique: Blown; marvered; applied; tooled
Description: This object is blown in the shape of a
stylized bird with applied head, eyes,
beak, folded wings, and small feet
in either red or white opaque glass.
The large, raised, and bifurcated tail,
however, calls to mind the profile of
a fish or a whale rather than a bird.
There is a small opening at the
bifurcation of the tail. A marvered
wavy pattern that becomes irregular at
the tail and ends in a spiral on the chest
and under the head decorates the object.
A small semicircular red handle was
applied on the back.
Condition: The object is intact. The surface is
lightly weathered, resulting in a milky
white film and abrasion.
Provenance: Kofler collection
Literature: Lucerne 1981, no. 498
Related Works: 1.  MMA, inv. nos. 15.43.248, 30.95.196,
49.27.1, .3 (Jenkins 1986, nos. 2, 3
[nos. 15.43.248, 30.95.196])
2.  NM, Damascus, inv. nos. 2201,
8506, 14605 (al-'Ush 1976, fig. 157
[no. 14605])
3.  Billups collection, inv. no. B271A
(Corning 1962, no. 28)
4.  Art Museum, Kiev, inv. no. 3230
(Lamm 1929–30, pl. 32:9)
5.  CMG, inv. no. 55.1.101
(Smith 1957, no. 512)
6.  MFI, inv. no. 6992
(Lamm 1929–30, pl. 30:1)
7.  MAIP, inv. no. 21964
(Kordmahini 1988, p. 129)
8.  Benaki, inv. nos. 3423, 3424
(Clairmont 1977, nos. 502, 503)
9.  NM, Copenhagen,
inv. nos. 6 C 29 g, S 796 (Riis–
Poulsen 1957, nos. 181, 203)
10. Ashmolean Museum, Oxford,
inv. no. G44, excavations at Fustat
(Allan 1995, fig. 10a)
11. Excavations in Jerusalem
(Wightman 1989, pl. 72:5)
12. BM, inv. no. 1913.5-22.41

More than twenty marvered vessels and fragments thereof in the shape of a plump bird are presently in public and private collections; there are probably others that remain unpublished or unreported. Although details may vary, all of them have consistent dimensions, colors, and tooling. Cat. 79 also falls within a subgroup that includes objects with a fishlike tail and a small suspension ring (Related Work 1). A larger subgroup includes figures with a more naturalistic birdlike tail in addition to the ring (Related Works 2, 3, 4). Other comparable works are too fragmentary to be included in one subgroup or another, since only the upper part has survived and may, or may not, include the suspension ring (Related Works 2, 5–11). The only exception, though it may be included in the group of bird-shaped vessels with a marvered decoration, is a functional kohl bottle in the British Museum (Related Work 12).[27]

Relevant differences among these pieces are probably related to their different uses. These variations include vessels that are sealed and contain small glass rods that rattle when shaken (Related Work 1, inv. nos. 15.43.248, 30.95.196); are sealed and empty (cat. 79); have a minute opening at the tail (cat. 79); lack a suspension ring (Related Work 7); or have an opening the size of a kohl rod (Related Work 12).

These figures, which convey the same playful charm as the zoomorphic shapes of objects from the early Islamic period (see cat. 4), seem to have been inspired by contemporary toys, pendants, and small containers in the shape of domestic and wild animals.[28] The majority were probably suspended from the applied ring; those that rattle may have been used as windchimes. Those with a minute opening in the tail (provided it was not accidental, due to inaccurate tooling) may have been containers for perfumes, oils, and essences that could stand on their feet and tail. The absence of the suspension ring may indicate the object was a simple toy. Whatever their function, these works belong to a tradition that was popular in the early Islamic period and thus are generally dated to the first two or three centuries of the Islamic era and no later than the eleventh century.[29] Allan, however, believes that "the traditional dating of these birds is wrong" and that "they are contemporary with all the other marvered glass so far discussed," thus dating them twelfth to fourteenth century.[30]

Allan's reasoning is based on two birds that were excavated in upper levels or in a post-Crusader context at Hama and in Jerusalem (Related Works 9 and 11, respectively); in addition, he argues that there is no proof that there was a continuous tradition between late antique and Islamic marvering. However, the findspot of the birds merely proves that such objects were still in use during the Ayyubid and Mamluk periods, and all the vessels

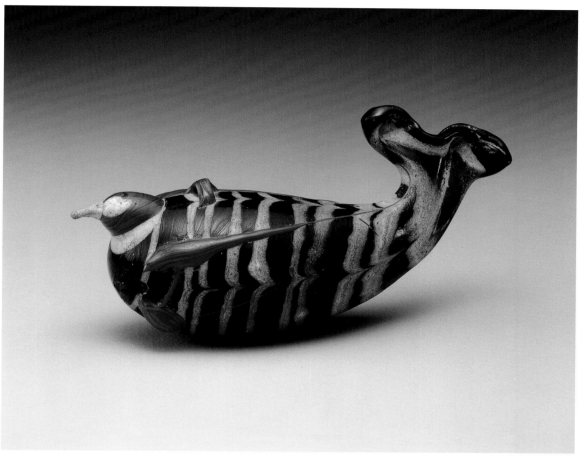

Cat. 79

discussed in the previous entries (cat. 74–78) demonstrate that the early Islamic period indeed represents a link between the two traditions.

Thus, it is difficult to offer more than a vague attribution for these playful figurines. The concept underlying their creation is, without a doubt, characteristic of the early Islamic period, but the two excavated fragments and a kohl bottle (Related Work 12) point to a later dating. Perhaps they were popular for a long period—spanning the early Islamic era and the Ayyubid period—and may be regarded as further evidence of a continuity in the production of glass with marvered decoration.

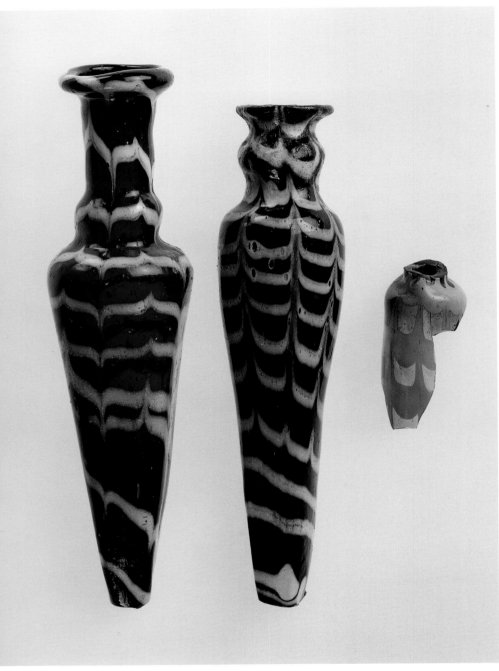

Cat. 80a–c

### Cat. 80a BOTTLE (LNS 118 G)
**Egyptian or Syrian region**
**12th–13th century**

Dimensions: hgt. 10.4 cm; max. diam. 2.5 cm;
th. 0.24 cm; wt. 27.4 g; cap. 15 ml
Color: Translucent dark purple (purple 4);
opaque white
Technique: Blown; marvered; tooled;
worked on the pontil
Description: This bottle has a small uneven square
base and a flared squarish body with
a curved shoulder; the short neck has
a bulge in the middle and a flared
opening. A white marvered trail was
tooled into a regular festooned pattern
that turns into a simple spiral and ends
just above the base.
Condition: The object is chipped at the base but is
otherwise intact. The surface is lightly
weathered, resulting in abrasion. The
glass includes frequent small bubbles.

### Cat. 80b BOTTLE (LNS 107 KG)
**Egyptian or Syrian region**
**12th–13th century**

Dimensions: hgt. 11.5 cm; max. diam. 3.0 cm;
th. 0.20 cm; wt. 23.1 g; cap. 27 ml
Color: Translucent dark purple (purple 4);
opaque white
Technique: Blown; marvered; tooled;
worked on the pontil
Description: This bottle is similar to cat. 80a; the
neck is cylindrical, has a bulge near the
base, and ends in a thick flared opening.
A white marvered trail was tooled into
a foliated pattern that becomes
irregular near the base.
Condition: The object is intact. The surface is in
good condition. The glass includes
scattered large bubbles and some
inclusions.
Provenance: Kofler collection
Literature: Lucerne 1981, no. 498

## Cat. 80c FRAGMENTARY BOTTLE
### (LNS 145 KG)
**Egyptian or Syrian region**
**Probably 12th–13th century**

Dimensions: max. w. 3.5 cm; max. diam. 1.6 cm;
th. 0.10 cm

Color: Translucent brown (yellow/brown 3);
opaque pale blue

Technique: Blown; marvered; tooled

Description: This fragment includes the upper part
of a bottle and the base of the neck.
A blue marvered trail was tooled into
a regular wide festooned decoration.

Condition: The surface is in good condition. The
glass includes frequent small bubbles.

Provenance: Kofler collection

Related Works: 1. Toledo, inv. nos. 23.2206, .2208,
.2210 (Lamm 1929–30, pls. 32:5–7)
2. Newark, inv. no. 50.1285
(Auth 1976, no. 242)
3. MAIP, inv. no. 21913
(Kordmahini 1988, p. 52)
4. CMG, inv. no. 50.1.32
(Perrot 1970, no. 51)
5. MMA, inv. nos. 30.40.7, 32.49.4
6. Eretz (Israeli 1964, pl. XI left)
7. MM, inv. no. G 64
(Hasson 1979, no. 13)
8. V&A, inv. nos. C11-1946,
1192-1905, C4-1950
9. NM, Damascus, inv. nos. 4654, 602
10. Macaya collection, Barcelona
(Gudiol Ricart–de Artíñano 1935,
no. 103)
11. Kelsey, inv. no. 68.2.100
(Higashi 1991, no. 52)
12. Benaki, inv. nos. 3.436, 3.437
(Clairmont 1977, nos. 183, 184)
13. Oppenländer collection, inv. no. 2587
(von Saldern et al. 1974, no. 741)
14. Excavations at Quseir al-Qadim
(Meyer 1992, pl. 19, nos. 551–53)
15. NM, Copenhagen, excavations at
Hama (Riis–Poulsen 1957, no. 201)
16. Excavations at al-Ṭūr
(Shindo 1993, figs. 7, 8)
17. Excavations at Fustat
(Shindo 1992, fig. 3, nos. 17–23;
and Allan 1995, fig. 12)
18. Excavations at Hira and Kish
(Allan 1995, fig. 13)

One of the most common containers with marvered decoration is a kohl bottle with a small square base, a flared body, and a curved shoulder (hence the common term "spearlike" bottle); the short neck typically has one bulge in the center and a flared opening. The body is usually decorated with opaque white marvered glass tooled into a regular foliated and festooned pattern. The dimensions are consistently between a height of 10 to 15 centimeters and a diameter of 3 to 4 centimeters. Given the configuration and dimensions of the base, these bottles cannot stand and were probably stored horizontally or supported in an upright position. Their function as kohl containers has been definitively proved by a recent find at al-Ṭūr, in the Sinai peninsula, where one of these vessels was associated with a copper rod (for the application of the kohl to the eyelids) and retained its original contents (Related Work 16).[31] The twenty-seven bottles that came to light at al-Ṭūr are predominantly dark green and blue, followed by black, dark purple, pale green, and colorless glass; the marvered trails are always opaque white. This color distribution is in accordance with finds of other marvered glass at al-Ṭūr, more than half of which is dark blue. The predominance of blue glass in the Sinai suggests that the color was popular for products exported along and near the Red Sea Coast and the Indian Ocean. This hypothesis is confirmed by the large number of blue glass fragments found at Fustat (Related Work 17),[32] where their voyage eastward presumably began. Dark purple, however, remains the most common color for glass with marvered decoration and is clearly predominant in the Syrian area, as proven by excavations at Hama (Related Work 15) and elsewhere.[33] The different color distribution in the two reputed areas of production of marvered glass may imply that the Syrian glassmakers' specialty was purple glass and that their Egyptian colleagues chiefly made blue glass for export.

Related Works 1 through 10 are all similar to the two complete bottles (cat. 80a, b), though the length of the neck, the profile, and the regularity of the marvered pattern may vary; the color distribution is in accordance with the predominance of purple glass: at least ten objects out of fourteen (including the two bottles discussed here) are purple, two are blue (Related Works 4, 8 [inv. no. C4-1950]), one is black (Related Work 5, inv. no. 30.40.7), and one is green (Related Work 8, inv. no. 1192-1905). Related Works 11 to 13 have the same profile and are purple; they also have an applied roundel under the base and, in one case, applied small handles below the opening (Related Work 13; see also cat. 74). Most likely, these bottles can be regarded as the earliest of the group, which later lost their attached parts.

Archaeological evidence, especially from Quseir al-Qadim and al-Ṭūr (Related Works 14 and 16), leaves little doubt that this type of bottle belongs to the mature phase of the production of glass with marvered decoration in the Ayyubid and early Mamluk periods. Cat. 80a and b are typical examples in excellent condition. The fragment (cat. 80c) is included because it is almost certainly part of the general group, though it is unusual in having an appealing combination of pale blue marvered trails on brown glass.[34]

**Cat. 81 CHESSMAN: PAWN**
**(LNS 354 G)**
**Egyptian or Syrian region**
**12th–13th century**

Dimensions: hgt. 3.6 cm; max. diam. 2.5 cm;
wt. 32.2 g

Color: Translucent dark brown; opaque
pale blue

Technique: Marvered; tooled

Description: This solid glass chessman has a circular
base and a tapered profile that ends in
a conical point. A pale blue marvered
trail was tooled into a regular festooned
pattern running from shoulder to base.

Condition: The object is intact. The surface is
heavily weathered, resulting in a pale
brown coating and corrosion of the
brown glass; the pale blue trail is less
weathered and almost stands in relief.

Provenance: Christie's, London, sale, October 17,
1995, lot 284

Related Works: 1. Private collection, Germany
(Eder 1997, p. 24, nos. 6a, b)
2. MFI, inv. nos. 5641, 5643, 5644
(Lamm 1929–30, pls. 31:8, 10, 13)
3. MM, inv. no. G 51
(Hasson 1979, no. 14)

Chess has been popular in Muslim countries since the beginning of Islam. Peculiar to Islamic chessmen is their abstract shape, which is usually regarded as a stylization and adaptation of figural sets.[35] The bishop, for example, is represented as an elephant in figural sets, but it soon became an abstract form with two small protrusions reminiscent of an elephant's tusks. The reason chess sets developed into abstract shapes early in the Islamic period remains the subject of debate.[36]

Pawns, which had an abstract appearance even before the Islamic period, can easily be confused with pieces for backgammon or other similar games, and it is likely that a number of objects usually recognized as pawns were not. It is, therefore, best to group "pawns" according to their shape: those with a spherical knob on top, those with a polygonal base and a pyramidal top, and those with a circular base and a domed top. Cat. 81 belongs to the last group.

A number of solid glass chessmen with marvered decoration are presently in public and private collections and at times appear at auction. The closest match for cat. 81 is Related Work 1 (6a), which shows the same profile, dimensions, festooned decoration slightly twisted to the right, and, most notably, the same unusual pale blue marvered trails. Other pawns of similar shape but with a more rounded top are in Cairo[37] and Jerusalem (Related Works 2, 3).

All glass chessmen with marvered decoration known to the author are made of dark glass (mostly purple) with white opaque threads. An obvious question comes to mind: how were the opposing players distinguished? Perhaps one set was heavily gilded[38] or was made of plain glass without marvered decoration.[39]

A dating in the Ayyubid and the Mamluk periods for these chessmen is supported by the regular patterns of the festooned decoration and by the almost exclusive use of purple combined with opaque white glass for the marvered decoration. The abstract shapes of chess sets, however, became codified in a much earlier period, making it possible that some of the existing pieces are older.

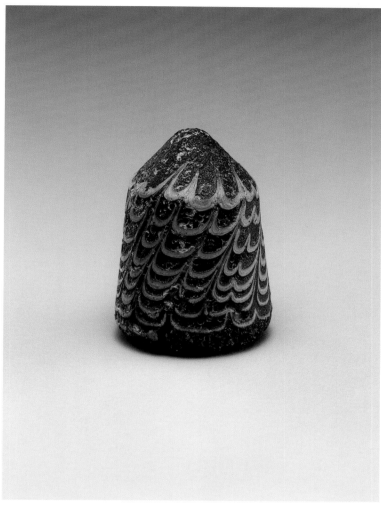

Cat. 81

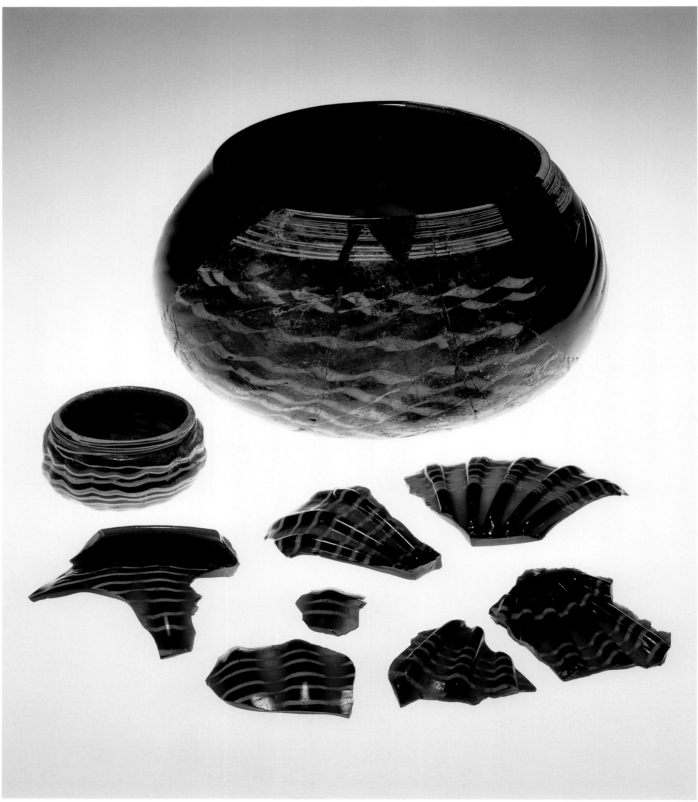

Cat. 82a–c

### Cat. 82a BOWL (LNS 72 G)
**Egyptian or Syrian region**
**12th–13th century**

Dimensions: hgt. 3.8 cm; max. diam. 7.2 cm;
th. 0.40 cm; wt. 90.5 g; cap. 88 ml
Color: Translucent dark purple (purple 3);
opaque white
Technique: Blown; marvered; mold blown; tooled;
worked on the pontil
Description: This irregular, flattened globular bowl
has a flat base and a thick rim. The
object was blown in a mold with
vertical ribs. A white marvered trail
was tooled into a spiral that forms an
irregular horizontal slightly wavy
pattern.
Condition: The object is intact except for a small
fill below the rim. The surface is
weathered, resulting in a pale brown
coating and iridescence. The glass is
of good quality.

### Cat. 82c FRAGMENTS OF A BOWL
(LNS 194 Ga–g)
**Egyptian or Syrian region**
**12th–13th century**

Dimensions: (largest fragment) w. 9.8 cm; l. 6.8 cm
Color: Translucent dark purple (purple 3);
opaque white and pale blue
Technique: Blown; marvered; mold blown; applied;
tooled; worked on the pontil
Description: These seven fragments are probably
from a single bowl that had a flattened
globular shape and a thick outsplayed
opening that curved downward. The
object was blown in a mold with
vertical ribs. A white marvered trail
was tooled into a spiral that formed
an irregular, slightly wavy horizontal
pattern; short pale blue trails were
applied around the rim and the
shoulder.
Condition: The surface is lightly weathered,
resulting in a milky white coating. The
glass includes scattered small bubbles.

Provenance: Kofler collection; gift to the Collection
Related Works: 1.  AM, inv. no. 1975-18 and fragments
(Pinder-Wilson–Ezzy 1976, no. 144;
Allan 1995, figs. 7, 8; and Newby
2000, no. 29)
2.  Toledo, inv. no. 79.55
(*JGS* 22, 1980, p. 90, no. 11)
3.  MFI, inv. no. 5669
(Lamm 1929–30, pl. 31:4)
4.  CMG, inv. no. 55.1.100
(Smith 1957, no. 510)
5.  NM, Damascus, inv. nos. 10774,
5208, 8834
6.  NM, Baghdad, inv. no. 32389
('Abd al-Khaliq 1976, fig. 24b)
7.  NM, Copenhagen, excavations at
Hama (Riis–Poulsen 1957, figs. 186,
189, 190, 192, 195, 196, 207)
8.  Excavations at the Umayyad Palace,
Jerusalem (*RGS*, 18, no. 36)
9.  Excavations at al-Ṭūr
(Shindo 1993, fig. 4)
10. Excavations at Fustat
(Shindo 1992, fig. IV-6-5:1–5)

### Cat. 82b FRAGMENTARY BOWL
(LNS 340 G)
**Egyptian or Syrian region**
**12th–13th century**

Dimensions: hgt. 11.1 cm; max. diam. ca. 20.0 cm;
th. 0.69 cm; cap. ca. 2500 ml
Color: Translucent dark purple (purple 3);
opaque white
Technique: Blown; marvered; applied; tooled;
worked on the pontil
Description: This fragmentary bowl has a flattened
globular shape and a flat base with
a small kick in the center. A white
marvered trail was tooled into a
spiral that forms a slightly irregular
horizontal wavy pattern and ends under
the pontil mark; the wavy lines are
further tooled into rows of diamond-
shaped elements. A large white trail
applied to the rim turns into a thin
thread that spirals below the opening
forming a band about 2 cm wide, below
which the marvered decoration begins.
Condition: The object is broken and repaired;
about half is original. The surface is
heavily weathered, resulting in a milky
white film and iridescence. The glass
includes frequent small bubbles and
several large ones at the base.
Provenance: Sotheby's, London, sale, October 20,
1995, lot 222

The most common type of bowl with marvered decoration has molded vertical ribs and is purple with white marvered trails. Both the small intact vessel (cat. 82a) and the larger, fragmentary piece (cat. 82c) are of this type. The small bowl is relatively unassuming, but the fragments (cat. 82c) belonged to an object that was carefully crafted; the large outsplayed opening that turned downward and the short pale blue unmarvered trails around the rim and shoulder place it within a subgroup that includes a small number of complete vessels and fragments (see Related Works 1 [fragments], 4).[40]

These molded bowls seem, without exception, to be made of dark purple glass.[41] The most popular decorative pattern is a slightly wavy motif that spirals around the body of the bowl. The typical tooling with a comblike utensil into a festooned or foliated pattern was rarely used on these vessels, in which the wavy effect of the white spiraling thread is usually created by the uneven ribbed surface. The result is simple and elegant at the same time; a good example is provided by a bowl in the Ashmolean Museum (Related Work 1, inv. no. 1975-18).

The large number of fragments excavated at Hama and elsewhere in Syria (Related Works 5, 7) and the use of purple glass point to a Syrian area of production.[42] Other fragments, however, were found in Egypt or at sites associated with trade from Egypt (Related Works 9, 10); oddly enough, a fragmentary vessel in Baghdad is reported to have an Egyptian provenance (Related Work 6).

The fragmentary bowl (cat. 82b) was not blown in a mold, but it obviously belongs to the same group, given its profile, dark purple color, white marvering, and trailed band below the opening. Most distinctive is the complex manner in which its marvered decoration was accomplished: it was not simply "combed" but was shaped in "a pattern resembling rows of diamond-shaped elements. . . . Apparently the white was trailed on in a flattened strip, which must have been pulled down to the base material at intervals in alternating directions, then marvered."[43] A bowl with a similar decoration is in Corning (Related Work 4). Given the size of cat. 82b, it may be that it was originally surmounted by a now-lost knobbed lid, judging from two such vessels of similar dimensions and proportions that have their lids.[44]

### Cat. 83a QUMQUM (PERFUME SPRINKLER) (LNS 34 G)
**Egyptian or Syrian region**
**12th–13th century**

Dimensions: hgt. 11.1 cm; max. diam. 6.9 cm; wt. 39.3 g
Color: Translucent dark purple (purple 3); opaque white
Technique: Free blown; marvered; tooled; applied; worked on the pontil
Description: This *qumqum* has a globular body flattened at two sides, a convex base that does not allow the object to stand properly, and a long tapered neck with a narrow opening. Two small purple handles were applied at opposite sides of the base of the neck. A white marvered trail was tooled into a regular arcaded pattern on the body and festooned on the neck.
Condition: The object was broken and repaired; small areas are filled. Originally there may have been an applied foot ring. The surface is entirely weathered, resulting in a golden iridescence and heavy corrosion.
Literature: Atıl 1990, no. 62
Related Works: 1. Toledo, inv. nos. 23.2561, .2367, .2355 (Lamm 1929–30, pls. 32:1, 32:8, 29:16)
2. Whereabouts unknown, inv. no. 155 (Smith 1957, no. 513)
3. MK, Frankfurt, inv. no. Stadt 260/5103 (Ohm 1973, no. 101)

### Cat. 83b QUMQUM (FOOTED PERFUME SPRINKLER) (LNS 337 G)
**Egyptian or Syrian region**
**12th–13th century**

Dimensions: hgt. 15.7 cm; max. diam. 8.8 cm; th. 0.20 cm; wt. 105.0 g
Color: Translucent purple (purple 2); opaque white
Technique: Free blown; marvered; tooled; applied; worked on the pontil
Description: This *qumqum* is similar to cat. 83a. A kicked base was tooled into a foot by folding the glass. A white marvered trail was tooled into a regular foliated pattern covering the entire object, including the neck and the underside of the foot.
Condition: The object was broken and repaired; large areas of the body are filled while the neck, shoulder, and base are original. The surface is partially weathered, resulting in iridescence and abrasion.
Provenance: Reportedly from Mharda, Syria

### Cat. 83c QUMQUM (PIERCED PERFUME SPRINKLER) (LNS 38 KG)
**Egyptian or Syrian region**
**12th–13th century**

Dimensions: hgt. 10.5 cm; max. diam. 6.5 cm; l. 2.7 cm; th. 0.18 cm; wt. 47.3 g; cap. ca. 60 ml
Color: Translucent dark purple (purple 3); opaque white
Technique: Free blown; marvered; tooled; applied; worked on the pontil
Description: This *qumqum* has a globular body flattened at two sides that was pierced in the middle (diam. ca. 2.2 cm) to form a circular opening. The neck is long and tapered and ends in a narrow opening. Two purple snaky handles were applied at opposite sides of the base of the neck. The bottle rests on four small attached feet. A white marvered trail was tooled into a regular foliated pattern that covers the body and neck.
Condition: The object is intact. The surface is entirely weathered, resulting in a grayish brown coating, iridescence, and corrosion.
Provenance: Kofler collection
Literature: Lucerne 1981, no. 496
Related Works: 4. KM, Düsseldorf, inv. no. P1965-77 (Ricke 1989, no. 78)
5. Toledo, inv. no. 23.2362 (Lamm 1929–39, pl. 29:14)
6. NM, Damascus, inv. no. 7398-A/2803 (Damascus 1964a, fig. 51)
7. MMA, inv. no. 1977.164 (Jenkins 1986, no. 42)
8. BM, inv. no. OA 1913.5-22.100 (Tait 1991, fig. 161)

Shape, dimensions, and area and period of production of *qamāqim* in the Islamic world have been discussed above (see cat. 39, 60). The production of *qamāqim* with marvered decoration, usually dark purple with white threads, is in accordance with both the popularity of this particular type of rosewater sprinkler and with the demand for appealing marvered objects under the Ayyubids and the Mamluks and possibly earlier, in the late Fatimid period.

Among the three present vessels (cat. 83a–c), cat. 83a represents the most common type and is comparable in shape to the undecorated and molded *qamāqim* (cat. 39, 60), though it is slightly smaller. Related Works 1–3 are of this common type. Almost identical in color, dimensions, and in the two applied rings at the base of the neck is Related Work 1 (inv. no. 23.2355). Related Works 2 and 3 are instead dark brown and dark blue, respectively. Two *qamāqim* are either taller (Related Work 1, inv. no. 23.2367) or do not have applied rings (Related Work 1, inv. no. 23.2561).

Cat. 83b is a more elaborate vessel than cat. 83a, as it has a tooled round foot; to the author's knowledge there are no close parallels for it, though a small number of bottles with a globular, rather than a flattened, body are known to have this type of foot.[45]

Cat. 83c is unusual, since the body was pierced with a pointed tool after the vessel was blown, marvered, and flattened. Pierced sprinklers, either marvered or decorated with other techniques, are rare, but a small number are in public collections (Related Works 7, 8). Cat. 83c is similar to two marvered objects in Düsseldorf and Toledo (Related Works 4, 5), but it is smaller (the Related Works are 12.6 cm and 15.2 centimeters high, respectively) and stands on four small feet that probably became necessary because the glassmaker did not flatten the base. The decoration of Related Work 5 is close to that of cat. 83c; Related Work 4 shows a more accomplished and regular festooned pattern. Unusual, but still belonging to the group of pierced bottles with marvered trails, is Related Work 6: the base was pulled down, possibly to avoid breakage, and thus the hole in the center has an elongated oval, rather than a circular, shape and the object does not stand.[46]

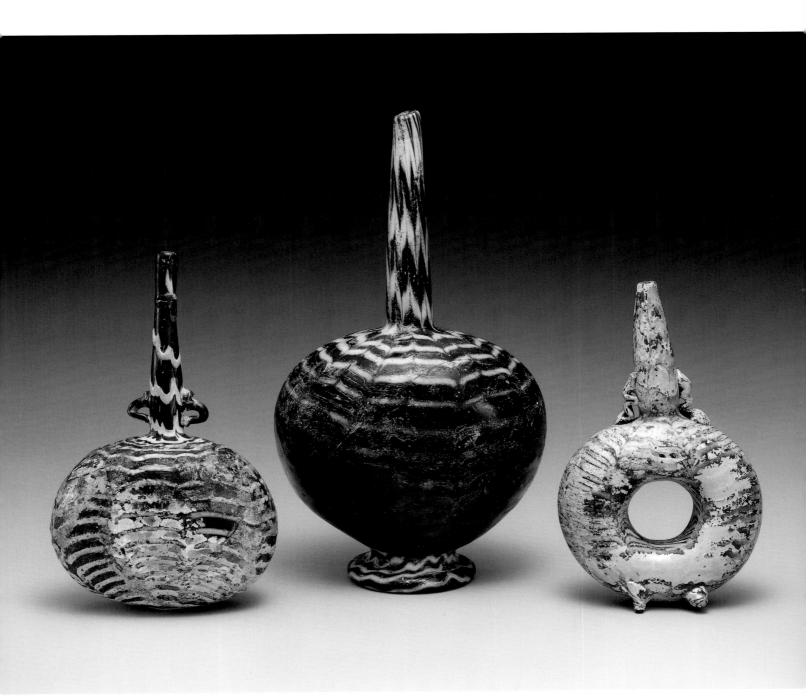

Cat. 83a–c

Cat. 84

**Cat. 84 FRAGMENTARY BOTTLE**
**(LNS 12 KG)**
**Egyptian or Syrian region**
**12th–13th century**

Dimensions: hgt. 7.0 cm; max. diam. 6.2 cm;
th. 0.24 cm; wt. 69.8 g

Color: Translucent dark purple (purple 4);
opaque white; greenish yellowish stain

Technique: Blown; marvered; tooled; stained

Description: This fragment includes the upper part
of a cylindrical bottle with a rounded
shoulder and a short thick cylindrical
neck with a small bulge near the
opening. A white marvered trail was
tooled into a regular festooned pattern
covering the body and the neck. Each
section of the background is filled with
a greenish or yellowish stain patterned
into small vegetal scrolls.

Condition: The object was broken and repaired;
about two-thirds is missing. The surface
is lightly weathered, resulting in
abrasion. The glass includes scattered
small bubbles.

Provenance: Kofler collection

Literature: Lucerne 1981, no. 499

Related Works: 1. CMG, inv. no. RSW 727
(Smith 1957, no. 527)
2. CMG, inv. no. fragment 58.1.33
3. MIK, inv. no. I.7017
4. Billups collection, inv. no. B315A
(Corning 1962, no. 29)

The most remarkable aspect of this unassuming fragmentary bottle is its lusterlike paint, almost certainly silver stain, that fills the purple areas between the white marvered patterns. The upper part of an almost identical, restored bottle in Corning shows the same decoration of dense vegetal scrolls (Related Work 1); the painted area, however, is gilded rather than stained. A fragment from the neck of a similar bottle in the same collection also includes a gilded decoration (Related Work 2). Gilding seems to have commonly been an additional decorative touch for marvered glass in this period.[47] Gilding vanishes quickly from the glass surface because of weathering and use, so it is possible that a larger number of marvered objects were originally decorated in this fashion.[48] The most remarkable marvered piece that has retained its original gilding is a vessel in Berlin, a footed beaker that may have been reworked from another object (Related Work 3). Cat. 84 belongs to the last phase of use of silver stain; just before the practice was abandoned, the staining was confined to small areas in order to create different effects and colors (see, for example, the heraldic emblem on the enameled mosque lantern, cat. 99). The decorative function of silver stain in the present example is therefore exceptional.

Another unusual characteristic of this fragmentary bottle is the narrow cylindrical shape and the short narrow neck. Parallels are provided by a small number of dark blue bottles found at Nishapur,[49] but a closer match is a complete bottle of identical shape in purple glass (hgt. ca. 20 cm) marvered into an irregular pattern without additional staining or gilding (Related Work 4). Also comparable with regard to shape, color, and the use of gilt is a fascinating group of blue or purple cylindrical bottles decorated with enamel and gold, some of which were found at Corinth, Cyprus, and as far as Novogrudok in Russia.[50] Their Byzantine origin is almost certain, judging from the figurative repertoire, but their similarity in shape, dimensions, and color to their Islamic counterparts with marvered decoration is striking and should not be overlooked. A *terminus ante quem* for the Byzantine bottles is set at A.D. 1222, since a number of fragments were found in a castle in Cyprus destroyed that year; thus, the Islamic and the Byzantine objects are nearly contemporary.

The present bottle, though fragmentary, is an important testimony to the taste for luxury glass objects in the late medieval Islamic world and exemplifies the artistic and technological exchanges that took place in the eastern Mediterranean at that time.

**Cat. 3.58 VASE (LNS 322 G)**
**Egyptian or Syrian region**
**7th–8th century**

Dimensions: hgt. 7.8 cm; max. diam. 7.4 cm;
th. 0.63 cm; wt. 144.7 g; cap. 160 ml
Color: Translucent; opaque black or dark blue,
brownish red, and yellow
Technique: Free blown; marvered; tooled;
worked on the pontil
Description: This globular vase has a flattened,
slightly kicked base and a short, wide,
flared neck. Three colored marvered
trails were tooled into a fine, regular,
and dense decoration of festooned
patterns on the body and the neck;
the pattern, which was twisted during
tooling, has a diagonal orientation.[41]
Condition: The object is intact. The surface is
entirely weathered, resulting in an
encrusted pale brown coating and
brown streaks. The condition prevents
a reading of the original colors;
it is possible that opaque white
marvering was also used in addition
to the three other colors.
Provenance: Christie's, London, sale, April 25, 1995,
lot 256
Related Work: Cat. 75

Cat. 3.59

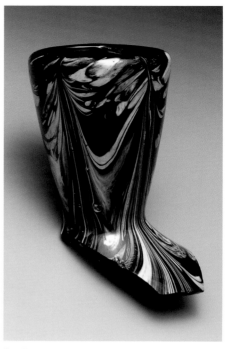

Cat. 3.60

**Cat. 3.59 FRAGMENTARY BOTTLE**
**(LNS 173 G)**
**Egyptian or Syrian region**
**7th–8th century**

Dimensions: hgt. 2.8 cm; max. diam. 2.1 cm;
th. 0.23 cm; wt. 11.4 g; cap. 3.5 ml
Color: Translucent dark brown; opaque red
Technique: Blown; marvered; tooled;
worked on the pontil
Description: This fragment from a small six-sided
bottle has a slightly flared profile and
a flat base. A marvered red trail was
tooled into a regular festooned pattern
that ends in a spiral just above the base.
Condition: The fragment represents about one-
third of the original object. The surface
is partially weathered, resulting in a
whitish coating.
Provenance: Reportedly from Afghanistan

**Cat. 3.60 NECK FROM A BOTTLE**
**(LNS 123 KG)**
**Egyptian or Syrian region**
**7th–8th century**

Dimensions: hgt. 6.0 cm; max. diam. 3.5 cm;
th. 0.41 cm
Color: Translucent dark brown; opaque pale
blue and white
Technique: Free blown; marvered; tooled
Description: This fragment represents the flared
neck and part of the shoulder of a
bottle. Colored marvered trails were
tooled into a fine, irregular, spotted,
featherlike decoration.
Condition: The surface is in good condition. The
glass includes frequent small bubbles.
Provenance: Kofler collection
Related Work: Cat. 76

Cat. 3.58

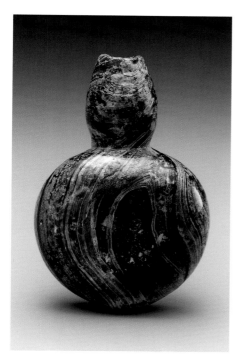

Cat. 3.61

### Cat. 3.61 LENTOID FLASK (LNS 18 KG)
### Egyptian or Syrian region
### 7th–8th century

Dimensions: hgt. 6.0 cm; w. 4.0 cm; l. 1.9 cm;
th. 0.23 cm; wt. 22.1 g; cap. 9 ml
Color: Translucent dark blue (blue 5);
opaque white
Technique: Free blown; marvered; tooled;
worked on the pontil
Description: This flask has a globular body flattened
on two sides and cannot stand on its
base; the neck is disproportionately
bulged and ends in a small opening.
A white marvered trail was tooled into
an irregular wavy pattern.
Condition: The object is intact. The surface
is heavily weathered, resulting in
iridescence and corrosion. The white
marvering is barely visible and could be
mistaken for weathering of the surface.
The glass includes scattered large
bubbles.
Provenance: Kofler collection
Literature: Lucerne 1981, no. 582
Related Work: Cat. 78

### Cat. 3.62a FRAGMENT (LNS 215 KG)
### Egyptian or Syrian region
### Probably 7th–8th century

Dimensions: max. w. 3.5 cm; max. l. 2.8 cm;
th. 0.18 cm
Color: Translucent pale blue (blue 2);
opaque white
Technique: Blown; marvered; applied; tooled;
worked on the pontil
Description: This fragment from the base and wall
of a vessel has a regular, fine festooned
marvered decoration in opaque white.[52]
A foot ring of blue glass was applied
at the base, which is slightly kicked,
suggesting that the vessel was tooled
on the pontil.
Condition: The surface is lightly weathered,
resulting in a milky white film. The
glass includes frequent small bubbles.
Provenance: Kofler collection

### Cat. 3.62b FRAGMENT (LNS 159 KG)
### Egyptian or Syrian region
### Probably 7th–8th century

Dimensions: max. w. 3.8 cm; max. l. 2.6 cm;
th. 0.18 cm
Color: Translucent blue (blue 3); opaque white
Technique: Blown; marvered; tooled
Description: This wall fragment has an irregular
swirling marvered decoration in opaque
white.
Condition: The surface is partially weathered,
resulting in a milky white film and
abrasion. The glass includes frequent
small bubbles.
Provenance: Kofler collection

### Cat. 3.62c FRAGMENT (LNS 148 KG)
### Egyptian or Syrian region
### 7th–8th century

Dimensions: max. w. 3.0 cm; max. l. 2.4 cm;
th. 0.22 cm
Color: Translucent dark brown; opaque white
Technique: Blown; marvered; tooled
Description: This wall fragment has an irregular
zigzag, featherlike marvered decoration
in opaque white that becomes pale blue
at the edges.
Condition: The surface is in good condition.
Provenance: Kofler collection
Related Work: Cat. 77

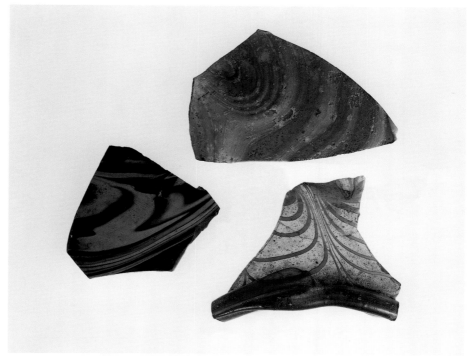

Cat. 3.62a–c

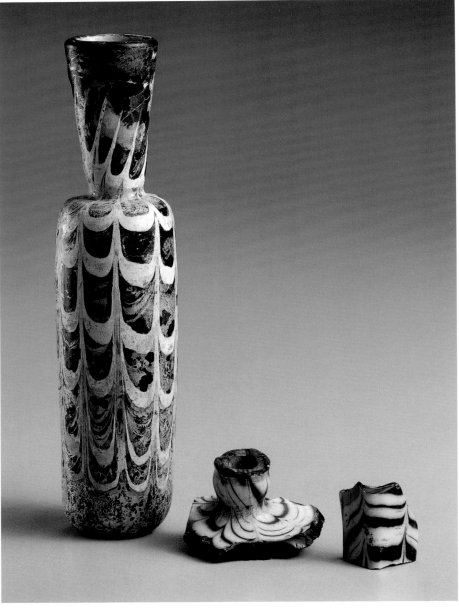

Cat. 3.63a–c

## Cat. 3.63a BOTTLE (LNS 112 KG)
### Egyptian or Syrian region
### 7th–8th century

Dimensions: hgt. 9.5 cm; max. diam. 2.5 cm;
th. 0.22 cm; wt. 27.8 g; cap. 20 ml

Color: Translucent dark brown; opaque white

Technique: Blown; marvered; tooled;
worked on the pontil

Description: This cylindrical bottle has a flat base,
an angular shoulder, and a flared neck.
A white marvered trail was tooled into
a regular festooned pattern up to the
base of the neck.[53]

Condition: The object is intact. The surface is
heavily weathered, resulting in
iridescence. The glass is of good
quality.

Provenance: Kofler collection

Literature: Lucerne 1981, no. 492

## Cat. 3.63b FRAGMENT OF A BOTTLE (LNS 124 KG)
### Egyptian or Syrian region
### 7th–8th century

Dimensions: hgt. 1.5 cm; max. diam. of neck 1.0 cm;
w. 2.4 cm; l. 1.9 cm; th. 0.27 cm

Color: Translucent dark purple (purple 3);
opaque white

Technique: Blown; marvered; tooled

Description: This fragment is from the neck and
shoulder of a bottle similar to cat. 3.63a.
A white marvered trail was tooled into
a dense regular festooned pattern
covering the body, neck, and shoulder.

Condition: The surface is in good condition. The
glass includes scattered small bubbles.

Provenance: Kofler collection

## Cat. 3.63c FRAGMENT OF A BOTTLE (LNS 153 KG)
### Egyptian or Syrian region
### 7th–8th century

Dimensions: max. l. 1.5 cm; max. diam. 1.1 cm;
th. 0.22 cm

Color: Translucent brown; opaque white

Technique: Blown; marvered; tooled

Description: This fragment is from the body of
a multisided (probably square) bottle.
A white marvered trail was tooled into
a slightly irregular festooned or arcaded
decoration.

Condition: The surface is lightly weathered,
resulting in a milky white film.

Provenance: Kofler collection

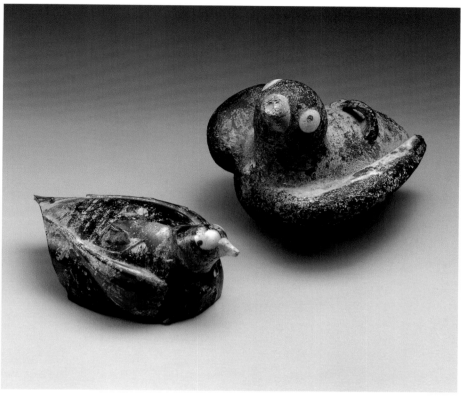

Cat. 3.64a, b

### Cat. 3.64a FRAGMENT OF A FIGURE IN THE SHAPE OF A BIRD (LNS 104 KG)
**Egyptian or Syrian region**
**8th–9th century**

Dimensions: max. w. 2.9 cm; l. 5.3 cm; th. 0.14 cm; wt. 14.0 g.

Color: Translucent dark purple (purple 4); opaque white and red glass with darker inclusions

Technique: Blown; marvered; applied; tooled

Description: This fragment includes the front of a vessel in the shape of a bird. A white marvered trail was tooled into into a regular festooned pattern, now almost vanished. The bird's wings, feet, and head and a small semicircular handle on its back were applied in red; the pointed beak and eyes were applied in white on the red head.

Condition: The fragment includes about half of the body, head, and wings. The surface is partially weathered, resulting in a milky white coating, loss of the white trail, and abrasion.

Provenance: Kofler collection

### Cat. 3.64b FRAGMENT OF A FIGURE IN THE SHAPE OF A BIRD (LNS 118 KG)
**Egyptian or Syrian region**
**8th–9th century**

Dimensions: w. 4.4 cm; l. 4.3 cm; th. 0.30 cm; wt. 26.9 g.

Color: Translucent dark purple (purple 4); opaque white and pale blue

Technique: Blown; applied; tooled[54]

Description: This thick fragment includes the front of a vessel in the shape of a bird with tooled wings. The eyes and beak were applied in opaque white and pale blue and a small semicircular handle on the back is translucent purple.

Condition: The fragment includes a large part of the body; the tail and part of the right wing and of the lower body are missing. The surface is heavily weathered, resulting in a pale gray coating.

Provenance: Kofler collection

Related Work: Cat. 79

Cat. 3.65b–d FRAGMENTS OF THREE
VESSELS (LNS 192 Ga–c)
Egyptian or Syrian region
12th–13th century

### Cat. 3.65a EIGHT FRAGMENTS OF A BOWL (LNS 126 KGa–h)
Egyptian or Syrian region
12th–13th century

Dimensions: (largest fragment) w. 7.0 cm; l. 3.7 cm; th. 0.23 cm
Color: Translucent dark purple (purple 3); opaque white
Technique: Blown; marvered; tooled
Description: These fragments are from a bowl that had a flattened globular shape and an opening that curved inward. A white marvered trail was tooled into a regular horizontal spiral pattern at the rim and about 1 cm below the opening.
Condition: The fragments are probably from the same vessel, though a reconstruction is impossible; three fragments from the rim fit together. The surface is partially weathered, resulting in a milky white film and iridescence. The glass includes frequent small bubbles.
Provenance: Kofler collection

Dimensions): b: w. 3.7 cm; l. 5.2 cm
c: w. 4.1 cm; l. 4.3 cm
d: w. 5.0 cm; l. 4.9 cm
Color: Translucent dark purple (purple 3); opaque white
Technique: Blown; marvered; molded; tooled
Description: Cat. 3.65b is from a flattened globular bowl similar to cat. 90; cat. 3.65c is from the upper part of a globular bottle with a small opening; and cat. 3.65d is from the base and wall of a vessel with a foot ring that was tooled and folded inward. Fragments b and c have mold-blown vertical ribs and a white marvered trail tooled into a slightly wavy decoration; fragment d was probably free blown and has a white marvered trail tooled into large regular horizontal bands.
Condition: The surface of cat. 3.65b is in good condition; cat. 3.65c and d are partially weathered, resulting in a milky white film and iridescence or abrasion. The glass includes scattered small bubbles.
Provenance: Kofler collection; gift to the Collection

### Cat. 3.65e FRAGMENT OF A VESSEL (LNS 193 G)
Egyptian or Syrian region
12th–13th century

Dimensions: w. 9.0 cm; l. 4.5 cm; th. 0.23 cm
Color: Translucent dark purple (purple 3); opaque white
Technique: Blown; marvered; mold blown; tooled
Description: This fragment is from the base of an open-shaped vessel, probably a bowl molded in a pattern of vertical ribs. A white marvered trail was tooled into large horizontal bands.
Condition: The surface is weathered, resulting in iridescence and loss of the white bands. The glass includes frequent small bubbles.
Provenance: Kofler collection; gift to the Collection
Related Work: Cat. 82

Cat. 3.65a–e

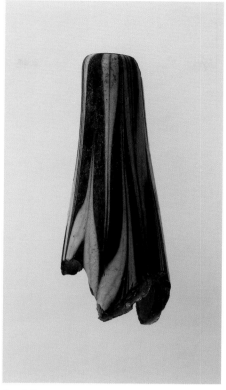

Cat. 3.66

Cat. 3.67

**Cat. 3.66 FRAGMENTARY NECK OF A *QUMQUM* (PERFUME SPRINKLER) (LNS 125 KG)**
**Syrian or Egyptian region**
**12th–13th century**

Dimensions: hgt. 4.4 cm; max. diam. 1.8 cm; th. 0.34 cm
Color: Translucent dark purple (purple 4); opaque white
Technique: Blown; marvered; tooled; worked on the pontil
Description: This fragment represents the upper part of the tapering neck of a *qumqum* that ended in a narrow opening. A white marvered trail was tooled into an irregular tall festooned pattern.
Condition: The surface is lightly weathered, resulting in a milky white film.
Provenance: Kofler collection
Related Work: Cat. 83

**Cat. 3.67 FRAGMENT OF A VESSEL WITH MARVERED AND GILDED DECORATION (LNS 137 KGc)**
**Syrian or Egyptian region**
**12th–13th century**

Dimensions: w. 0.8 cm; l. 1.8 cm
Color: Translucent dark purple (purple 3); opaque white; gilt
Technique: Blown; marvered; tooled; gilded
Description: This fragment from the wall of a vessel is decorated with a white marvered trail. The gilded background has a stylized vegetal decoration.
Condition: The surface is in good condition.
Provenance: Kofler collection
Related Work: Cat. 84

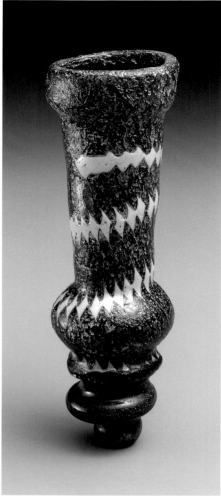

Cat. 3.68

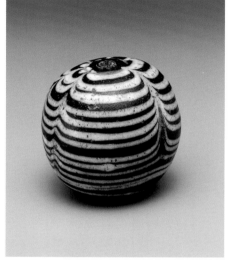

Cat. 3.69

### Cat. 3.68 BOTTLE(?) (LNS 114 KG )
**Syrian or Egyptian region**
**12th–13th century**

Dimensions: hgt. 9.5 cm; max. diam. 3.0 cm;
th. 0.28 cm; wt. 43.8 g; cap. 24 ml
Color: Translucent dark purple (purple 4);
opaque white
Technique: Blown; marvered; tooled;
worked on the pontil
Description: This vessel has a slightly flared profile
and a bulge near the base and at the
opening; the solid base is knobbed
and the object does not stand.
A white marvered trail was tooled
into a continuous pattern of small
diamondlike rhomboids.[55]
Condition: The object is intact. The surface is
heavily weathered, resulting in golden
iridescence and abrasion. The glass
includes scattered small bubbles.
Provenance: Kofler collection
Literature: Lucerne 1981, no. 490

### Cat. 3.69 SPHERE (LNS 121 G)
**Syrian or Egyptian region**
**12th–13th century**

Dimensions: diam. 2.5 cm; wt. 17.1 g
Color: Translucent dark purple (purple 5);
opaque white
Technique: Marvered; tooled; worked on the pontil
Description: This solid spherical object has a
marvered white trailed decoration
tooled into a festooned pattern around
most of the body; the spiral trail was
not tooled near the poles.
Condition: The sphere is chipped; a scar on the
pole opposite the pontil mark may
suggest that it is the finial, or knob,
of a larger unidentified object.[56] The
surface is lightly weathered, resulting
in abrasion.

# NOTES

1 This terminology for describing marvered patterns was adopted by Allan 1995 after Eisen 1916, pp. 135–37; it is maintained throughout this catalogue.

2 Allan 1995; and Henderson 1995.

3 For the tokens or weights, see Kolbas 1983, pp. 97–98.

4 Allan 1995, p. 23.

5 Henderson 1995, p. 36.

6 Ibid., p. 44.

7 See, for example, von Saldern et al. 1974, nos. 386, 387; and cat. 3.58.

8 See cat. 77, Related Work 1.

9 See, for example, cat. 3.63.

10 As discussed at cat. 84, it is possible that gilding on marvered glass was used more frequently than we can observe today, since gold vanishes quickly from a glass surface.

11 See cat. 1.1.

12 Von Saldern et al. 1974, p. 254, no. 744.

13 Ibid., p. 253, no. 741 (inv. no. 2587). The object is attributed to the eleventh or twelfth century.

14 Inv. no. 64.1.14. The object is unpublished.

15 Corning Museum of Glass, inv. no. 59.1.7; see Smith 1957, no. 4.

16 Museum of Fine Arts, Boston; see Eisen 1927, pl. 156 (bottom).

17 See, for example, Tait 1991, figs. 20–32, 58.

18 In general, late antique glassblowers favored rounded and curved profiles, while cylindrical bottles were more common in the Islamic world, especially after the ninth century.

19 Corning 1955, p. 26.

20 Ibid., p. 26, no. 45.

21 Washington 1962, p. 24.

22 Lucerne 1981, p. 121, no. 491.

23 See, for example, cat. 2.34a–c.

24 Scanlon 1966, pp. 102–3. The color of the flask is not described in the text and the black-and-white reproduction shows only that the marvered glass is white or very pale. The location of the flask is not disclosed in the article, so it is presumably in the Museum of Islamic Art, Cairo.

25 Clairmont 1977, p. 142, no. 524.

26 Ben-Tor et al. 1996, p. 212.

27 Formerly in the Durighiello collection, the object is in purple glass with an opaque white marvered decoration (l. 11.2 cm). Apparently unpublished, it is described by Allan (1995, p. 9, n. 18) as a bottle that "can be stood upright, at a slight angle, on its beak and feet," created and tooled in a manner identical to the other bird figures.

28 Other animals, such as quadrupeds and fish, are also part of the repertoire; see, for example, von Saldern et al. 1974, no. 742, and Smith 1957, no. 511.

29 Such is the case for Related Works 1, 4–6; see Lamm 1929–30, pls. 30:1, 32:9; Smith 1957, no. 512; and Jenkins 1986, nos. 1, 2.

30 Allan 1995, pp. 22–23.

31 Shindo 1993, pp. 302–4, figs. 8, 9; and Satoh et al. 1994, which includes a chemical analysis of the bottle's contents.

32 Shindo 1992, fig. IV-6-5.

33 Riis–Poulsen 1957, pp. 62–69.

34 The author is not aware of any other vessel, or fragment, with the same color combination. Brown glass with white, rather than pale blue, marvered trails is rarely found in Egypt and Syria; see Shindo 1993, p. 301.

35 A complete set in glazed pottery in the Metropolitan Museum (inv. nos. 1971.193a–ff) demonstrates the different shapes of all chessmen; see Carboni 1996, pp. 3–4.

36 Recent publications (Ferlito 1995; and Contadini 1995) help clarify this puzzling issue and provide an exhaustive bibliography on the subject of Islamic chessmen. The view that Islamic pieces became abstract to circumvent caliphal decrees against the use of figural objects in the courtyards of mosques is not shared by all scholars, some of whom have suggested that abstract chessmen originated in India before the Islamic era (see, for example, Eder 1997, pp. 3–6).

37 Nine chesspieces with marvered trails—the largest number known in a single institution—are in the Cairo museum. Only three of them are published (see Related Work 2); see Eder 1997, p. 11.

38 There are remains of gilt, for example, on a chesspiece in the Museum of Islamic Art in Cairo.

39 The latter hypothesis is less likely. A few pawns in undecorated glass have survived, but they belong to the "knobbed" subgroup and probably predate the marvered sets (see Carboni 1996, p. 8).

40 The most accomplished molded and marvered bowls have outsplayed openings, pale blue trailing, and a low footed base, though all three features are rarely present on one vessel. Among the best such pieces are intact bowls with turquoise thread decoration in the Museo Archeologico, Padua and the David collection, Copenhagen (Zampieri 1997, no. 6, pp. 19-22; and von Folsach 1990, no. 246, respectively).

41 Only free-blown, as opposed to mold-blown, marvered bowls in green glass have been reported; see Allan 1995, p. 7.

42 As suggested at cat. 81, it is likely that purple glass was a specialty of Syrian glassmakers.

43 Smith 1957, p. 253, no. 510; and cat. 3.68.

44 Related Work 5, inv. no. 10774; Metropolitan Museum of Art, inv. nos. 26.77a, b (Jenkins 1986, no. 50).

45 A well-known example in the British Museum (the so-called Durighiello bottle; OA 1906.7-2.39) was reportedly found at Adana, in Turkey (Tait 1991, fig. 162).

46 The bottle was reportedly found in the village of Qara, north of Damascus; its dimensions (hgt. 13.6 cm) are in accordance with the other qamāqim discussed here.

47 See Allan 1995, pp. 20–21; see also Sotheby's, London, sale, October 12, 1988, lot 52.

48 It is often possible to see that an object was gilded from a light, whitish impression left on the surface during the firing process.

49 See Kröger 1995, nos. 93, 94.

50 See, for example, Davidson 1952, p. 115, no. 750; Megaw 1959; and Shelkovnikov 1966, figs. 16–18, 23, 24. A color reproduction of a bottle in the British Museum (MLA 1977.7-1.1) is in Tait 1991, fig. 188.

51 A limited number of examples of this type of vase, usually marvered in opaque white and red glass, are found in public collections; see, for example, one in the Museum of Fine Arts, Boston (von Saldern 1968, no. 62), and another in the Corning Museum of Glass (inv. no. 55.1.99). See also Eisen 1927, pls. 155, 156.

52 The fine marvering and the applied, overlapping foot ring seem to point to a fairly early date for this vessel, which is in many ways related to cat. 76 and 77.

53 Many examples of this type of bottle are known; see, for example, Museum of Fine Arts, Boston (von Saldern 1968, no. 69), Carnegie Museum of Natural History, Pittsburgh (Oliver Jr. 1980, no. 241), and Queens College, New York (Manzari et al. 1976, p. 30, no. 8).

54 Although this fragment was not marvered, it is clearly related to the group of small marvered vessels in the shape of a bird discussed at cat. 79.

55 The peculiar shape of this vessel suggests that it may be a finial rather than a container. The existence of fragments showing the same diamondlike marvered decoration (see cat. 82b; and Riis–Poulsen 1957, fig. 200) guarantees its authenticity.

56 This sphere can also be interpreted as an unpierced bead.

# 4

# THE GREAT ERA OF ENAMELED AND GILDED GLASS

## (ca. 13th to 14th century)

THE LARGE NUMBER OF SURVIVING OBJECTS in enameled and gilded glass bears witness to the extent to which they were appreciated from the time they were created as well as to the special interest accorded to this type of glass in Europe in the second half of the nineteenth century. Consequently, a relatively abundant amount of literature on the subject was produced in the last century or so. Nevertheless, the origin of enameled glass in Syria during the medieval period (probably the twelfth century) is still obscure, its development in Syria and Egypt is unclear for the most part, and its gradual disappearance in the fifteenth century is puzzling. This dearth of information is unfortunate, because the painterly nature of enameled glass allows for all kinds of decorative surface patterns, including inscriptions. A substantial amount of extant pieces contain the patron's name,[1] and at least one artist's signature has been recorded.[2]

Carl Johan Lamm must be credited as the only scholar who has attempted a chronological and geographical assessment of this vast production (see Lamm 1929–30). While some of his attributions are invaluable, they should be reassessed in light of objects that have been reported more recently and of new information that has become available. For example, Lamm's subdivision of enameled glass into basic groups according to their decoration, followed by an attribution of each group to either Raqqa, Aleppo, or Damascus (thus ignoring Cairo), may be useful from an art-historical viewpoint but is not corroborated by historical evidence. Although it is almost certain that enameling on glass began in the Syrian area (Raqqa most likely being the first center of production), it is also likely that glassmakers at Fustat became active soon after the Mamluks made Cairo the true, and only, capital of their empire. Fourteenth-century enameled and gilded glass was, therefore, probably produced principally in Egypt rather than in Syria.

Recording, photographing, and studying all the enameled and gilded works (and fragments) dispersed in public and private collections would assure a better understanding and a more precise attribution of some of the most celebrated objects, such as the "Luck of Edenhall," the "Cavour Vase," and Duke Rudolf IV's pilgrim flask, all of which became prized as early as the fourteenth century and were collected by the European aristocracy and in ecclesiastical treasuries. Such a study would secure these pieces a proper position within the context of the overall production instead of leaving them as splendid but isolated examples.[3] Notwithstanding the present lack of research, however, some progress has been made in the past few years by individual authors and through a symposium organized at the British Museum.[4] The earliest date of production for the masterful enameled and gilded beakers, assumed to have been about the second quarter of the thirteenth century, has been pushed back to the last two decades of the twelfth century or the first years of the thirteenth, offering reason to believe that this technique was mastered in the Fatimid, rather than the Ayyubid, period.[5] Interest in chemical and scientific analysis of both glass and enamels has also generated important new information regarding methods of production.[6]

The goal here is not to establish a reliable chronological development of enameled glass or to find the key to a method for identifying Syrian versus Egyptian material. Nonetheless, the objects and fragments in the Collection have been studied as thoroughly as possible with an eye to comparative material of credible dating; they offer interesting insights toward an understanding of a chronological development of shapes, dimensions, and decoration.

A useful general chronological guideline is that glassmakers were requested, or challenged themselves, to produce increasingly large objects until they reached their technical limits in the

fourteenth century, with mosque lamps and long-necked decanters that are often more than 40 centimeters high and have a comparable diameter (see cat. 99, 101). The average objects, at the early stage, were probably limited to cylindrical or flared beakers and matching bottles of relatively small size (see the discussion at cat. 87), perfume sprinklers (cat. 95, 96), and small bowls. Later, probably after the shift of power from the Ayyubids to the Mamluks in the mid-thirteenth century, many different shapes proliferated and dimensions began to increase. In order to vary their output and make it more appealing to their clients, glassmakers sought inspiration in contemporary inlaid metalwork (as exemplified by a small number of large tapered bowls with a splayed rim, two candlesticks,[7] and a tray stand [cat. 97]), in pottery (the "Cavour Vase" and sphero-conical vessels with a thick mouth),[8] probably in leather (pilgrim flasks),[9] and also in ivory (a drinking horn).[10] They also created entirely original vessels that have no known parallels in other media in Islamic art, such as footed bowls covered with a knobbed lid (tazzas)[11] and slender vases with a flared neck and applied handles (cat. 98). Traditional glass shapes, including beakers, bottles of all kinds, vase-shaped lamps, and bowls continued to be made and increased in size decade by decade.

Surface decoration, on the other hand, tended to become less varied and less polychromatic over time. With few exceptions, the largest objects crafted toward the end of production are also those with the least colorful combinations and the most stylized and repetitive decorative patterns. From the ornamental standpoint, the middle of the thirteenth century (and perhaps also the beginning, in light of the recently revised chronology) may be regarded as the golden age of enameling and gilding on Islamic glass.

A full range of colors was employed, including red, blue, yellow, white, green, pale blue, pink, pale green, brown, purple, and grayish black, as well as gilt. These colors often covered the entire glass surface, sometimes concealing the translucent quality of the object itself (see, for example, cat. 89). Although red was always used to draw outlines and blue to cover large areas, no other color was especially prominent; thus, a lively polychromy was created. In addition to being used for outlining, a vivid tomato red—reminiscent of the sealing-wax effect later achieved by Iznik potters in the sixteenth century—sometimes filled small areas on vessels from mid-century (see cat. 90g). Several fragments (cat. 89–94) offer good examples of the chromatic variety common in this period. Toward the end of the thirteenth century, probably corresponding roughly to the ascent to power of Nāṣir Muḥammad ibn Qalāūn (r. A.H. 693–741 / A.D. 1293–1341 with brief interruptions), red and blue, in combination with an increasing use of gold, became the most prominent enamel colors;

all others (especially white, green, yellow, and pink) were confined to minute areas, disappeared altogether, or were used only in official emblems.[12] By the middle of the fourteenth century, the combination of red for outlines, blue for inscriptions and other large areas, and gold for the remaining surfaces became the rule (see cat. 101). The transformation from a lively, impulsive polychromy to a severe, elegant, and glittering decoration that, once again, concealed the glass surface was thus completed in about a century (today, it is difficult to fully understand the decorative role of gilding, since it has vanished from most objects).

With the disappearance of colors, the quality of painting changed. The polychrome phase included a variety of subjects and human figures were often depicted. Horsemen (see cat. 89), polo players, courtiers, musicians (cat. 90), common folk engaged in various activities (cat. 86, 90f), and Christian subjects (cat. 90i) found their place in the iconography of enameled glass. As suggested at cat. 86, the possibility that narrative scenes stemming from literary works were represented should not be discounted. Large and small figures—the former usually drawn in a detailed manner reminiscent of contemporary manuscript illustrations (see cat. 89), the latter depicted more naively, seemingly in the tradition of earlier twelfth-century Persian mīnāī pottery— embellished some of the best products of the central decades of the thirteenth century.[13] Lamm theorized that large figures were typical of glass painters based in Aleppo, whereas busier compositions with smaller figures were characteristic of artists from Damascus. This simplistic interpretation is not, however, substantiated by the objects themselves.[14]

Corresponding to a general shift in attitude toward figural subjects in the last decade of the thirteenth century and the first years of the fourteenth was the gradual disappearance of human figures and the confinement of animals to a decorative role, usually as a sequence of quadrupeds walking around the circumference of a vessel (see cat. 91). This development was not confined to glass but is also seen in other media, especially inlaid metalwork, which was at the forefront of Mamluk artistic production and thus probably influenced other workshops by default. The reason for this change is not entirely clear, but it certainly had to do, in part, with a different approach toward the arts by Nāṣir Muḥammad ibn Qalāūn, the new ruler from 1293, in keeping with his less flamboyant and more orthodox attitude toward all matters. Emblematic of this is his decision to use an epigraphic symbol for his office, thus supplanting, for example, the feline that Baybars I (r. A.H. 658–76 / A.D. 1260–77), a former Mamluk sultan, had adopted three decades earlier (see cat. 92f–h).

Figures of animals and birds became sketchier and more stylized, competing for space (and eventually losing) with a

proliferation of vegetal patterns and large inscriptions. The introduction of a stylized peony of ultimately Chinese derivation, also adopted by Mamluk metalworkers and illuminators who had become familiar with the works of their Ilkhanid counterparts, probably sounded the death knell for the depiction of animals.[15] An exception is represented by another Chinese import: the long-tailed feathered phoenix (*sīmurgh*, in Persian) floating in space, which acquired some prominence as a novel, foreign motif at the end of the thirteenth century and the beginning of the fourteenth (see cat. 97, 98).[16]

The al-Sabah Collection includes a representative range of shapes and decorative patterns—indeed, it is one of the best and most complete groups of enameled glass assembled in recent times—from the "colorful" period (mid-thirteenth century) through the "restrained but large-sized" period (mid-fourteenth century). Sixteen intact or complete objects—six beakers, a drinking vessel (cat. 85–88), four perfume sprinklers, a tray stand, two handled vases, a mosque lamp (cat. 95–99), and a decanter (cat. 101)—offer a good selection of shapes, dimensions, and decoration. These objects are complemented by a selected number of fragments (cat. 86b–d, 89–94, 100) that demonstrate the full range of color and decorative types and help to fill inevitable gaps between the complete objects.[17] In addition to common shapes, the Collection includes familiar but rare objects, such as a large decanter (cat. 101) and a pair of handled vases (cat. 98). A unique, though hardly surprising, shape, as it was inspired by inlaid metalwork models, is a tray stand (cat. 97). A "clawed" drinking vessel (cat. 88) is a truly exceptional object of European inspiration that demonstrates the artistic exchange between two worlds that were so close yet so far apart.

As mentioned earlier, the enameling technique was developed in Syria and Egypt between the twelfth and the fifteenth centuries. Vitreous polychrome enamels that stand in relief and have a glossy appearance, unlike the filmy look of their closest predecessors (mostly cold-painted Roman glass from the second to fourth century A.D.), represented a true revolution in glass technology.[18] It cannot be overemphasized that, in the medieval period,

controlling temperature in a wood-fueled kiln was not a simple matter, and enameling required being able to do so with a high degree of sophistication for prolonged periods. Basically, enamel is colored opaque glass crushed to almost a powder and applied on the glass surface by means of an oily medium and a brush or a reed pen. Due to the individual qualities of the various colors, enamels are chemically fixed on the glass surface at different temperatures; therefore, it is possible that an object was put into the kiln more than once during this process. Conservators are inclined to think that it would have been possible to apply all the colors—including gilding—at once and then fire them without having them run into one another, but the possibility that only a limited number of colors were applied at one time and that the object was fired more than once cannot be dismissed.[19]

The gradual disappearance of colors, accompanied by the increasing size of the objects, may have been related to the difficulty of firing many colors on larger vessels, since they were more likely to lose their shape and collapse during additional firings, creating an uneconomically high percentage of rejects. It may even be that glass painters paid a price for the glassblowers' virtuoso performances, as it was they who became able to create extraordinarily large vessels in a cost-effective manner.

Mamluk glass vessels decorated with enamel painting, especially those of large dimensions, are bubbly and have a brownish tinge.[20] It must be taken into account, however, that their surfaces were meant to be almost entirely covered with polychrome enamels and gilding, which diminished the importance of refinement in color. The same can be said of the bubbly texture of Mamluk glass. Nonetheless, it is clear that the chemical qualities of this glass are excellent, as it is a stable product that never became crizzled (or "diseased") in the course of six or seven centuries.[21]

By virtue of its composition, technology, technical mastery and decorative appeal, Islamic enameled glass has been sought after, collected, treasured, and imitated since the time of its creation, which explains why so many works have survived in excellent condition to this day.

**Cat. 85a BEAKER (LNS 36 G)**
**Syrian region**
**Mid-13th century**

Dimensions: hgt. 17.5 cm; max. diam. 7.6 cm;
th. 0.28 cm; wt. 117.0 g; cap. 346 ml

Color: Translucent brownish colorless; red,
blue, yellow, and white enamel; gilt

Technique: Free blown; tooled; applied; enameled;
gilded; worked on the pontil

Description: This narrow cylindrical beaker has a
flared opening that curves inward near
the rim; a ring was attached at the base,
which has a conical kick, to provide
more stability. The painted decoration,
outlined in red, consists of a large
central band (hgt. 5.0 cm) framed
by two pairs of horizontal red lines
enclosing four fish; simple trilobed
vegetal motifs are visible between each
fish, providing a sort of foreground
for the waterlike surface. A narrower
band (hgt. 1.5 cm) includes a sketchy
pseudofloral decoration outlined in
red and partially filled with red, blue,
yellow, and white enamels. A thin wavy
red line is drawn just below the rim.
Faint traces of gilding are visible,
though it is not possible to recognize
which areas were once filled.

Condition: The object is intact except for a chip
at the rim. The surface is partially
weathered, resulting in a milky white
film, pale brown coating, iridescence,
and abrasion. The red outlines are
almost entirely preserved, the
polychrome enamels are partially
decayed, and faint traces of gilding
survive. The glass includes scattered
small bubbles, many elongated, and
some larger ones.

Cat. 85a–d

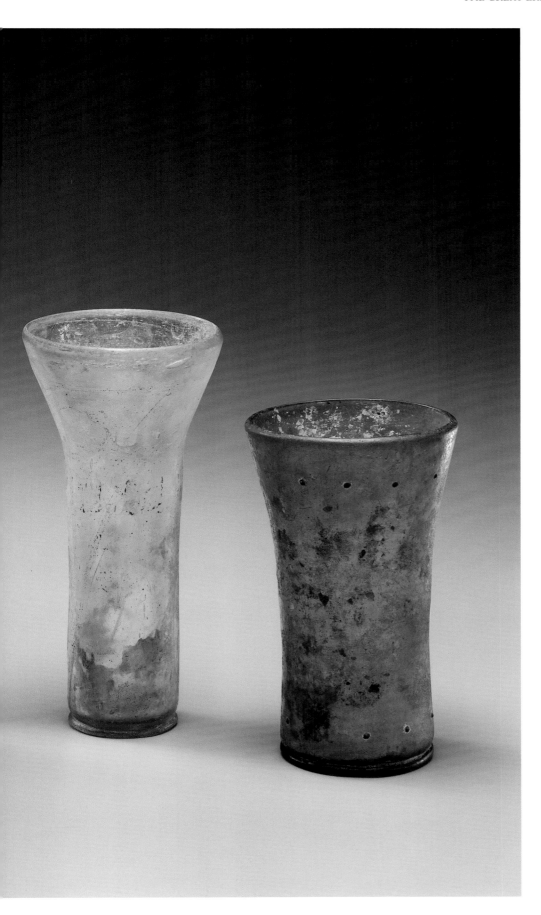

**Cat. 85b BEAKER (LNS 39 G)**
**Syrian region**
**Mid-13th century**

Dimensions: hgt. 16.1 cm; max. diam. 7.2 cm;
th. 0.29 cm; wt. 130.2 g; cap. 300 ml

Color: Translucent brownish colorless;
red enamel

Technique: Free blown; tooled; applied; enameled;
worked on the pontil

Description: The profile of this beaker is similar to
that of cat. 85a. The base is formed by
two glass layers separated by an inner
chamber. The painted decoration,
outlined in red, consists of a large
central band (hgt. 7.0 cm) framed
by horizontal red lines, enclosing a
complex vegetal motif that is barely
visible due to the surface condition.
Narrower bands were drawn above
and below (hgt. 2.5 cm and 1.0 cm,
respectively) the main band; no
decoration is visible—or left—inside
these areas. There is a thin red line
just below the rim.

Condition: The object is intact. The surface is
partially weathered, resulting in a
milky white film, pale brown coating,
iridescence, and abrasion. The red
outlines are only partially preserved;
no traces of gilding are visible. The
glass includes scattered small bubbles,
many elongated.

## Cat. 85c BEAKER (LNS 35 G)
### Syrian region
### Mid-13th century

Dimensions: hgt. 14.2 cm; max. diam. 6.7 cm;
th. 0.27 cm; wt. 104.8 g; cap. 156 ml

Color: Translucent brownish colorless;
red enamel; gilt

Technique: Free blown; tooled; applied; enameled;
gilded; worked on the pontil

Description: The profile of this beaker and its base
are similar to those of cat. 85b. Only
traces of the original painted and gilded
decoration, which was outlined in red,
are visible; the surface seems to have
been divided into horizontal bands.

Condition: The object is intact. The surface is
partially weathered, resulting in a milky
white film (especially on the interior)
and iridescence. The red enamel and
gilt have almost entirely vanished.
The glass includes frequent small
bubbles, many elongated, and
one large bubble.

Related Works: 1. MMA, inv. nos. 17.190.2039,
57.61.14, 57.61.15 (Lamm 1929–30,
pl. 167:4)
2. MIK, inv. nos. I.708, I.717 and others
formerly in the Antiquarium, Berlin,
inv. nos. 30219:170, 30219:171,
30219:176 (Lamm 1929–30,
pls. 163:7, 167:6, 177:1, 177:5, 177:9)
3. Louvre, inv. no. 5015
(Paris 1989, no. 85)
4. Kunstindustrimuseum, Copenhagen
(Lamm 1929–30, pl. 163:4)
5. Kiev, inv. no. 2585
(Lamm 1929–30, pl. 163:6)
6. KM, Düsseldorf, inv. nos. P1939-17,
P1973-67 (Ricke 1989, nos. 81, 82)

Beakers were among the most common vessels produced by the Ayyubid and Mamluk glassmakers. They can be broadly divided into two basic shapes. The first, illustrated in the present entry, consists of cylindrical beakers with a profile that begins to flare a few centimeters below the opening then curves inward near the rim. The profile of the second type (see cat. 86, 87) is more open, since the walls continue to flare all the way to the opening. As seen in the present four beakers, the proportions between the diameter of the base, that of the opening, and the height of the vessel can vary; as a result, the beakers range from slender elongated vessels (a–c) to stockier but comparatively better-proportioned objects (d). Slight variations in the profile of the flared sections also account for different shapes. The transition between the lower and the upper part of the body can be smooth, presenting a continuous and subtle curve (b). The same transition can also be more abrupt and angular, interrupting the cylindrical shape to create a truncated conical profile (a, c); in this case, the distance between the point of transition and the opening determines the final proportions of the object.[22]

These four beakers are, therefore, representative of nuances in shape that appear throughout the general production. From a technical point of view, these slight variations are hardly meaningful, since a glassmaker needed only a few seconds to tool and give shape to each beaker. Thus, the final shape was more the result of a repetitive action than a thoughtful intention. Consequently, variations are more likely to represent different hands within a single atelier or in neighboring ones, rather than diverse productions.

A clearer distinction, instead, becomes evident by comparing the different ways the bases of these beakers, which are invariably completed by an applied ring for additional stability, were created in two vessels (a, d). Here, the kick under the base was made in the manner seen most frequently before the Ayyubid period—that is, by simply attaching the pontil and pushing it slightly inside the vessel. In two others (b, c), which seem to be the most common of this type of beakers, the conical kick is formed by two layers of glass separated by an inner chamber, the uppermost often punctured.[23] The reason for creating this more elaborate type of base is not clear, apart from the need to add weight and thus

give more stability to these slender vessels, but it may indicate different areas of manufacture, one more traditional than the other.

From a decorative viewpoint, the exterior surface of these beakers is usually divided into horizontal bands of varying width outlined in red (a–c). The narrower bands, commonly drawn about one-third of the way up from the bottom to the rim, may include inscriptions,[24] polychrome floral or vegetal motifs (a), scrolling leaves, or, less often, small circular or three-lobed medallions or a sequence of animals.[25] The larger sections are often filled with stylized fish arranged in rows at regular intervals or at random (a), evidently a sign of good omen on vessels meant to receive liquids. Fish became a common and often highly decorative motif, especially on Mamluk metalwork. They were probably among the first motifs to be drawn on gilded and enameled glass beakers, in the second half of the twelfth century; the earliest datable example, which bears an inscription dedicated to Sanjar Shāh (r. A.H. 576–605 / A.D. 1180–1208 as an atabeg in the Jazira), also bears traces of gilded fish scattered around the surface.[26] Vegetal motifs (barely recognizable in b) are also frequently found on the larger decorated sections. A less common pattern, which is nonetheless present on two celebrated beakers,[27] is a central band with geometric motifs filled with a network of minute enameled dots in different colors; cat. 85d, with its dots near the opening and the base, can be regarded as a distant and less distinguished relation.

In the absence of a secure chronology, it is possible that the beakers represented here (a–d) and those with an open flared profile (cat. 86, 87), which share many decorative motifs as well as technical details, were contemporaneous. Whether this means that one type was produced in Egypt and the other in Syria,[28] or that, within the Syrian area, the glassmakers of Damascus, Aleppo, and Raqqa specialized in particular shapes, is only a matter of speculation. Following a general analysis of the enameled and gilded decoration, the production of both types probably started around the middle of the twelfth century and became less common by the end of the thirteenth. The most prolific production of these beakers occurred, therefore, in the Ayyubid period.

## Cat. 85d BEAKER (LNS 100 KG)
### Syrian region
### Mid-13th century

| | |
|---|---|
| Dimensions: | hgt. 11.5 cm; max. diam. 7.0 cm; th. 0.27 cm; wt. 98.1 g; cap. 250 ml |
| Color: | Translucent green (green 2–3); red enamel; gilt |
| Technique: | Free blown; tooled; applied; enameled; gilded; worked on the pontil |
| Description: | The profile and base of this beaker are similar to those of cat. 85a. The only visible decoration consists of two rows of enameled red dots in relief encircled in gold, one about 1.3 cm below the rim, the other about 1.0 cm above the base. Thirteen dots are arranged at even intervals in the upper row and ten in the lower. |
| Condition: | The object is intact. The surface is heavily weathered, resulting in a milky white film, brown pitting (especially on the interior), and iridescence. A number of red dots in both rows have vanished, though the gold that once encircled them is still visible. The glass includes scattered small bubbles. |
| Provenance: | Kofler collection |
| Literature: | Lucerne 1981, no. 629 |
| Related Work: | 7.  Toledo, inv. nos. 23.2170, 23.2164 (Lamm 1929–30, pls. 178:8, 178:11) |

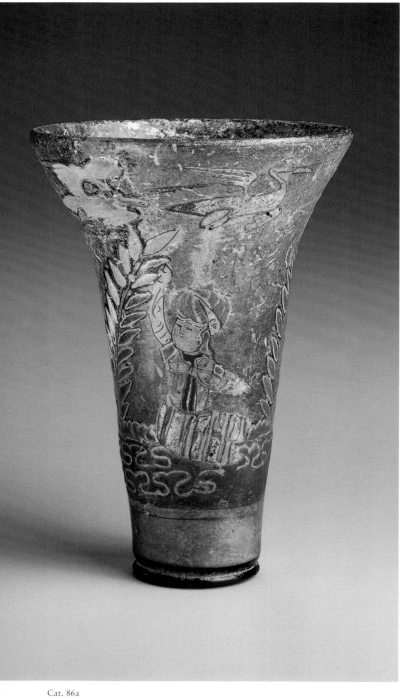

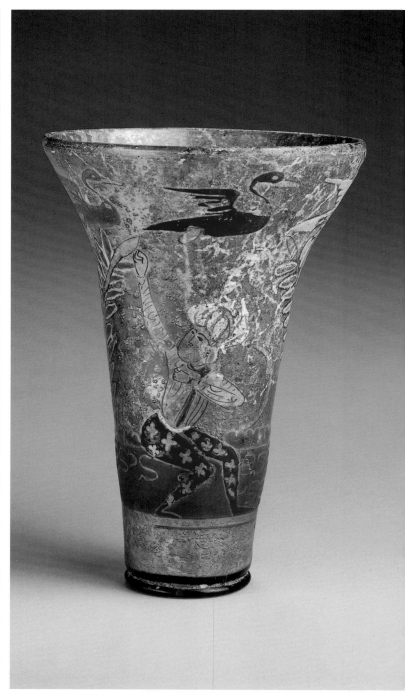

Cat. 86a

**Cat. 86a BEAKER (LNS 101 KG)**
**Probably Syrian region**
**ca. 1250–75**

Dimensions:  hgt. 12.0 cm; max. diam. 8.0 cm;
th. 0.26 cm; wt. 114.0 g; cap. 175 ml
Color:  Translucent grayish or brownish
colorless; blue, red, green, yellow,
and white enamels; gilt
Technique:  Free blown; tooled; applied; enameled;
gilded; worked on the pontil
Description:  The rim of this flared beaker curves
slightly inward. The kicked base is
formed of two layers of glass separated
by an inner chamber. A ring was
attached at the base to provide more
stability. The painted decoration,
outlined in red, consists of an open-air
scene of one man standing on the
shore of a pond or a lake and another
standing up to his knees in the water.
Both figures raise their right arm,
almost touching the top of large plants,
and seem to point toward five cranes
in flight. The man on the shore wears
a turban, tight red trousers decorated
with floral patterns, and a long-sleeved
shirt; the other wears a turban and
a striped tunic with *ṭirāz* bands.
The water is indicated in the grassy
foreground by a blue band of rippled
waves. Rising just above the band are
two plants; one is formed by two
branches with long pointed oval leaves
and the other has only one branch; the
leaves and grass are bright green. The
birds are painted at even intervals in a
single row below the rim. Beaks and legs
are drawn with red outlines; the body of
each bird is blue, red, yellow, green, or
white. Additional vegetation is outlined
in red above the grassy foreground.
Condition:  The object is intact. The surface is
heavily weathered, resulting in a whitish
gray coating, gray pitting (especially
on the interior), and corrosion. The
enamels and gilding are in fairly good
condition, though small portions have
partially decayed. The glass includes
frequent small bubbles.
Provenance:  Reportedly from Lebanon; Kofler
collection
Literature:  Lucerne 1981, no. 630, pl. F14

As discussed at cat. 85, two basic types of beakers were produced by the Ayyubid and Mamluk glassmakers. Cat. 86 (like cat. 87) belongs to the second type, which has an open flaring profile with a rather narrow base and a comparatively large opening (in cat. 86a, the diameter at the base is just over 3 centimeters and the opening is 8 centimeters). Its contemporaneity with the first type of beaker (cat. 85) is confirmed by technical details, such as the ring attached at the base and the conical kick in the base, which is formed by two layers of glass separated by an inner chamber.

The figures that dominate the composition can be regarded as a sort of hallmark of these flared beakers, described by Lamm as the group with "large figures" and attributed to thirteenth-century glassmakers in Aleppo.[29] The scenes usually include two figures separated by large plants (as in cat. 86a), either horseback riding, playing an instrument, or enjoying a convivial pastime.[30] The figures on cat. 86a are more lively than most others, perhaps because they depict an underlying story. The two men—the one on shore probably being of lesser rank, since he wears trousers instead of a tunic—seem to point at the flying birds which are either cranes, herons (*ghirnīq, kurkī,* or *mālik al-ḥazīn*), or storks (*laqlaq*), though their association with water suggests one of the first two choices. Cranes and herons are often mentioned in *adab* literature—sometimes inspired by ancient myths, such as the fight between pygmies and cranes—though no known story matches the scene represented on this beaker exactly.[31]

Whatever the interpretation of the scene, a number of complete beakers or fragments thereof depict the same, or a similar, composition (see Related Works 1–7). The famous beaker in Dresden (Related Work 1), presently encased in a gilt-silver European mount, shows one male figure sitting in the water, indicated by the same ripples. The opposite side of the beaker includes a large bushy tree instead of the second man. The flying cranes are more prominent, since they are arranged in two rows; the man sitting in the water seems to have caught the wing of one of the birds, further supporting the interpretation of the scene as a narrative illustration. The two fragments in Berlin (Related Work 3) also include a man sitting in the water and another standing, though they do not point toward the birds but rather raise a hand close to their face, as if signaling surprise. Judging from these three different scenes, it may be postulated that these vessels were elements of a set of nesting beakers intended to represent the unfolding events in a story (see also cat. 87). Only two beakers are intact, but their dimensions do vary and cat. 86a would fit inside the Dresden beaker (hgt. 18.5 cm); there were perhaps two other intermediate beakers that fit between them, including the reconstructed Berlin piece (Related Work 3) that, judging from the remaining fragments, would have been about 17 centimeters high. Two well-known beakers in the Walters Art Gallery, Baltimore—one slightly smaller than the other—have recently been interpreted as depicting events that took place in Jerusalem; thus, they also could have been elements of a nesting set.[32] The step from historical to literary illustrations on enameled beakers seems plausible.

The beaker in Cassel (Related Work 2), though belonging to the same group, shows a more restrained composition of birds flying within a band below the rim and is more

decorative than narrative in appearance. The main scene is somewhat less lively than those described above, since its figures—a lute and a tambourine player—sit quietly amid tall plants, while two footed cups and two large beakers stand next to them. Consequently, Related Work 2 should be regarded as a more standardized product compared to the others. Details, however, such as the profiles of the cranes and the cruciform pattern of the fabric of the lute player's tunic, which recalls the motif on the trousers of the figure on cat. 86a, link all these vessels and strongly suggest that they were made in the same atelier during a relatively short period of time.

Related Works 4–7, together with the fragments (cat. 86b–f) and many others in various collections, prove that beakers (and other vessels)[33] depicting flying cranes below the rim, rippled water near the base, and dominant human figures enjoyed a certain degree of popularity, most likely during the third quarter of the thirteenth century.[34] Do they illustrate a tale of men and birds that has been lost or lies within unpublished Arabic or Persian manuscripts? The answer would certainly endow enameled glass with a new meaning in the history of Islamic art.

### Cat. 86b FRAGMENT OF A BEAKER (LNS 215 G)
**Probably Syrian region**
**ca. 1250–75**

Dimensions: max. hgt. 4.8 cm; max. l. 6.9 cm; th. 0.29 cm
Color: Translucent brownish colorless; blue, red, yellow, and white enamels; gilt
Technique: Blown; enameled; gilded
Description: This fragment of a beaker similar to cat. 86a includes about one-third of the rim and a section of the wall. The reconstructed diameter of the opening is about 7.5 to 8.0 cm. The decoration includes three wading birds in flight below the rim, arranged in a row at equal intervals. The bird in the middle is visible in its entirety, the other two are seen only partially. From left to right, they are yellow, blue, and white. Below the birds, part of the face of a man wearing a red turban with a blue flap and the top of a plant suggest the same scene depicted on cat. 86a.
Condition: This fragment is assembled from two fitting pieces. The surface is partially weathered, resulting in a milky white film and corrosion of the enamel. The glass includes scattered small bubbles.
Provenance: Kofler collection; gift to the Collection

### Cat. 86c FRAGMENT, PROBABLY OF A BEAKER (LNS 210 KGc)
**Probably Syrian region**
**ca. 1250–75**

Dimensions: max. hgt. 3.4 cm; max. l. 2.8 cm; th. 0.24 cm
Color: Translucent brownish colorless; blue enamel; gilt
Technique: Blown; enameled; gilded
Description: This fragment is possibly from a beaker similar to cat. 86a, though the extant portion of the rim does not allow an exact reconstruction of the shape. The decoration includes part of the body of a blue wading bird outlined in gold flying to the left below the rim.
Condition: The surface is partially weathered, resulting in a milky white film and pale brown spots; the enamel and gilding are in good condition. The glass includes scattered small bubbles.
Provenance: Kofler collection

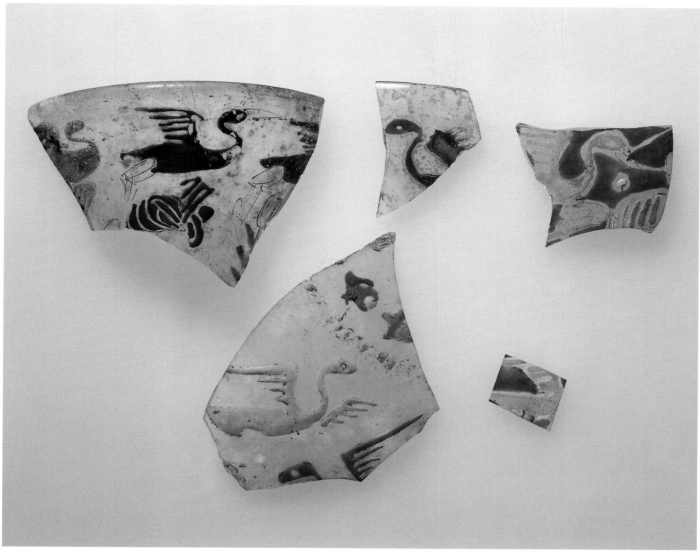

Cat. 86b–f

### Cat. 86d–f THREE FRAGMENTS
**(LNS 214 Ga, b; LNS 204 KGb)**
**Probably Syrian region**
**ca. 1250–75**

Dimensions: d: max. hgt. 7.2 cm; max. l. 4.5 cm;
th. 0.21 cm
e: max. hgt. 3.1 cm; max. l. 3.6 cm;
th. 0.26 cm
f: max. hgt. 1.3 cm; max. l. 1.6 cm;
th. 0.13 cm

Color: Translucent brownish colorless; blue,
red, yellow, green, white enamels; gilt

Technique: Blown; enameled; gilded

Description: These fragments belong to two different
vessels. Judging from their shapes, the
vessel was probably a bottle or a bowl,
rather than a beaker. The largest
fragment (d) includes two confronted
wading birds in flight—one white, the
other blue with gilded outlines—in an
almost heraldic pose. The remainder of
the decoration, set above a hatched line,
includes small floral motifs. A second
fragment (e) shows the forepart of a flying
yellow bird set against a blue background;
the beak is outlined in red while green
leaves and an undefined red area are
visible at the lower and upper right
corners, respectively. The tiny fragment
(f) almost certainly belongs to the same
vessel as e; it shows part of the body and
wing of a yellow crane, its legs outlined
in red, set against a blue background.

Condition: The surface of d is heavily weathered,
resulting in a milky white film,
iridescence, and partial decay of the
enamel; e and f are lightly weathered,
resulting in a milky white film; the
enamel is in good condition. The glass
of d includes frequent small bubbles.

Provenance: Kofler collection; gift to the Collection

Related Works: 1. Grünes Gewölbe, Dresden,
inv. no. IV 192 (Lamm 1929–30,
pl. 129:2; and Fritz 1982, pl. 357)
2. Hessisches Landesmuseum, Cassel,
inv. no. LÖ 90 A 57 (Baumgarten–
Krueger 1988, no. 65)
3. MIK(?) (Lamm 1929–30, pl. 129:1)
4. NM, Stockholm (Lamm 1929–30,
pls. 120:15–17, 19–24)
5. MFI, fragments (Lamm 1929–30,
pl. 126:3)
6. Louvre, inv. no. MAO 490/70
(Paris 1989, no. 77)
7. CMG, inv. no. F14

**Cat. 87 BEAKER (LNS 97 KG)**
**Probably Syrian region**
**ca. 1250–75**

Dimensions: hgt. 14.5 cm; max. diam. 10.3 cm;
th. 0.28 cm; wt. 134.3 g; cap. 310 ml
Color: Translucent yellow (yellow/brown 1);
blue, red, and white enamel; gilt
Technique: Free blown; tooled; applied; enameled;
gilded; worked on the pontil
Description: The shape of this beaker and its base
are similar to those of cat. 86a. The
painted decoration, outlined in red,
consists of a horizontal band (hgt. 3 cm)
divided into two outer gilded bands and
two bands with rows of white dots; the
decoration of the inner band (hgt. ca.
1.9 cm) consists of five trilobed arches
filled with pseudovegetal decoration.
The spandrels include symmetrical
palmettes. The background, outlined
in red, is filled with blue and gold.
Condition: The object is intact. The surface is
partially weathered, especially around
the opening, resulting in a dark gray
coating, milky white film, and
iridescence. The glass includes
scattered tiny bubbles.
Provenance: Reportedly from Aleppo, Syria;
Kofler collection
Literature: Lucerne 1981, no. 631, pl. F14

In shape, this beaker is comparable to cat. 86a, representing a good example of its type, but its decoration is unassuming. The enameled motifs are confined within a 3-centimeter-high band that begins at about 7 centimeters from the base. Playing on the contrast between gold and blue, with the addition of white dots and red outlines, the design of five trilobed arches intercepted by symmetrical palmettes is neither carefully drawn nor compositionally accomplished.

What makes this object interesting is that it probably represents the fourth beaker of a nest of three, presently in the Khalili collection, London, which shows identical decoration, color, and surface texture.[35] Given its height and diameter at the opening, our beaker is almost certainly the second smallest of the nest.[36] A long-necked bottle in Canada that includes a similar decorated band may also have been part of the set.[37]

Two beakers, now in Baltimore, support the hypothesized existence of nests of enameled beakers, as suggested at cat. 86. There is little doubt that the three beakers in London plus cat. 87 belong to such a set, ranging in height from about 10 to 18 centimeters. Easier, less risky transportation and space-saving storage are the first explanations of the need for nested beakers that come to mind, but there also must have been a functional purpose that no written or pictorial source has yet clarified. Today, sets of glasses of different sizes and/or shapes, usually bearing the same decoration, are familiar on Western-style dining tables: an average set includes at least two glasses of identical shape but different dimensions (for wine and for water), often complemented by a flute for champagne as well as matching wine decanters and water jugs. However, apart from some contemporary products by Finnish or Italian designers, they are never nested.

It is unlikely that enameled nesting beakers served a similar function to ours: we know that that they were used for wine, since they were often depicted filled with a red liquid, and it is fairly safe to postulate that they also held water. As for other popular drinks at the Mamluk court, such as fermented mare's milk (*qūmiz*, or kumiss) or other alcoholic beverages, it seems that Chinese porcelain bowls were used rather than glass vessels.[38] It is possible, however, that each guest at an Ayyubid or Mamluk banquet had a number of glasses and bowls of different sizes for the different drinks that were served. Perhaps literary sources, undiscovered as yet, will explain the function of the four beakers of identical shape and decoration, in progressive sizes.

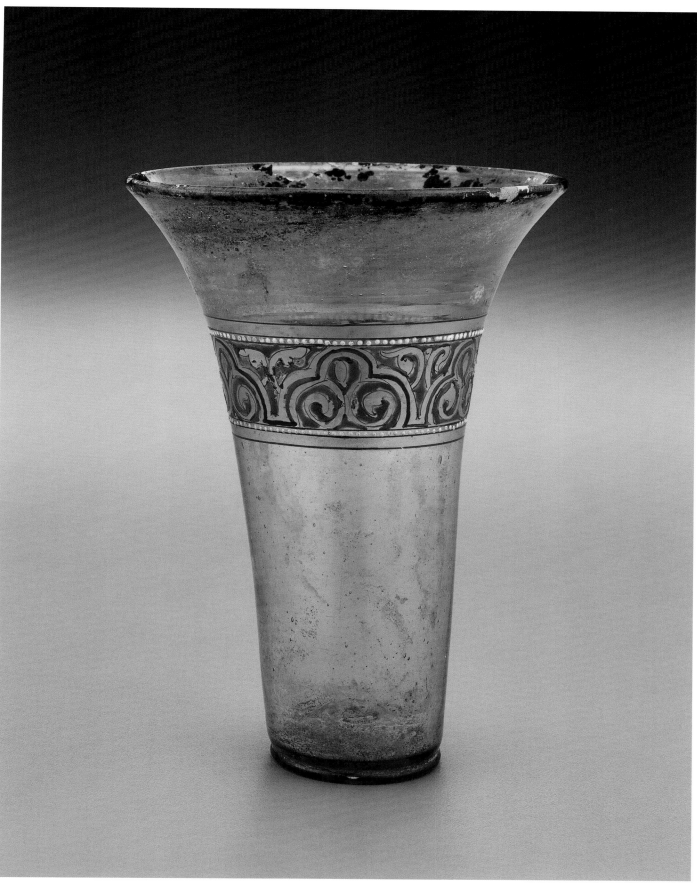

Cat. 87

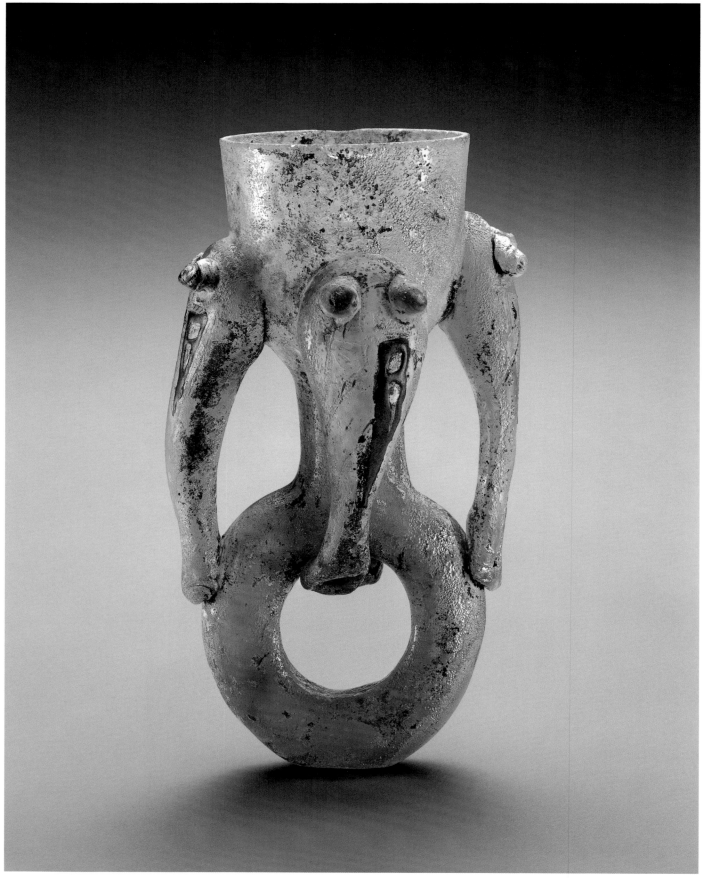

Cat. 88

**Cat. 88 DRINKING VESSEL**
**(LNS 98 KG)**
**Syrian region**
**Mid-13th century**

Dimensions: hgt. 12.5 cm; max. diam. 4.7 cm; th. 0.18 cm; wt. 127.2 g; cap. 73 ml

Color: Translucent grayish colorless; blue and red enamel; gilt

Technique: Free blown; tooled; applied; enameled; gilded; worked on the pontil

Description: This unusual drinking vessel, blown in one piece, has a hollow ring at the base (max. diam. 5.4 cm, diam. of the ring section 1.4 cm), a cylindrical stem (hgt. ca. 2.3 cm), and a slightly flared cup with a plain opening (hgt. ca. 4.5 cm). Four tubes were attached at the walls of the cup and at the ring (two on the exterior of the ring, two on the interior); the attachment to the walls was pierced, so that the liquid could flow inside the four tubes as well as in the cup, stem, and ring. An elongated rhomboid shield or coat of arms is painted on each tube: the field contains a Latin cross in gold filled with thin red lines that divide the space into four sectors: the lower fields are red (left) and blue (right); the upper fields are occupied by two applied glass prunts that were once gilded.

Condition: The object is intact except for small chips at the rim. The surface is heavily weathered, resulting in a gray coating, heavy iridescence, and abrasion.

Provenance: Kofler collection

Literature: Lucerne 1981, no. 628

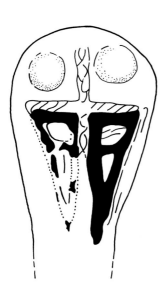

This exceptional drinking vessel, unique in the Islamic world, demonstrates the interaction between Ayyubid or early Mamluk glassmakers and the Crusaders. The quality and color of the glass and enamels leave little doubt that it is the product of a Near Eastern workshop, probably located in the Syrian area, during the last period of occupation of the Holy Land by the Crusaders.[39]

The shape and decoration of cat. 88 strongly suggest that it was meant for either a Teutonic knight, a representative of the Order of the Hospitaliers, or another Germanic Crusader. Since nothing similar in Islamic glassmaking is known, the only parallels, also under the technical aspect, are "claw-beakers," which were made in the Germanic areas between the fifth and eighth century. These products of Frankish glass (sometimes also called Merovingian, or Teutonic, glass) consisted mainly of conical beakers decorated with two or three encircling rows of hollow prunts that extended to form claws. As in cat. 88, each claw was applied as a gob of hot glass while the vessel was still on the blowpipe; the claw was inflated from the inside and then tooled on the exterior to produce its final shape. The most celebrated object of this type is the "Castle Eden" claw-beaker, which was found near Durham, England, in 1775 and is now in the British Museum. Other examples have been excavated in Germany, Belgium, France, and Scandinavia.[40]

The main difference between cat. 88 and the claw-beakers lies in the base, which, in the case of the former, is obviously nonfunctional. When not in use, the vessel was stored upside down or hung from its ring by a string, chain, or leather strap, unless it was kept in a customized case. Although it is logical to assume that local glassmakers would have reproduced an existing model (after another vessel or, perhaps, a drawing) provided by their client, there appears to be no suitable medieval European parallel. Apparently, claw-beakers were not produced after the ninth century and there was no vessel having a hollow ring instead of a flat base. The only comparison for this type of "base" is a large ring (max. diam. ca. 12–13 cm) with a section of wall, which represents the remains of a blown vessel and is presently stored in the National Museum, Damascus, among glass of the Islamic period excavated in Syria.[41] In the absence of other parallels, it is not possible to say whether it was produced locally or was imported.

The question remains whether cat. 88 is simply a copy of a European model or a clever adaptation of a Western product to Middle Eastern taste. The former seems more likely, especially considering that the decoration on the beaker is an emblem of unmistakably Western origin. The elongated pointed shield depicted on each claw is of the type used by the Crusaders. The cross is portrayed with an elongated vertical arm (the so-called Latin cross, as opposed to the Greek cross, which has arms of equal length).[42] Such details as the colored lower sections and the gilded prunts inside the two smaller upper sections seem to be less meaningful from a heraldic point of view, though future research may link this coat of arms to a specific family.

This drinking vessel is an important isolated testament to the relationship between Christian clients in the Holy Land and local glassmakers. Christian images are not uncommon on inlaid metalwork and enameled glass from the thirteenth century, but it is likely that those objects were made for a Muslim clientele.[43] It seems clear that the client and the user of the present vessel was a Crusader stationed in the Syrian area who probably left it behind when he was driven out of the Holy Land by the Muslim armies.[44]

**Cat. 89a, b EIGHT FRAGMENTS**
**(a: LNS 213 Gc–g, j, k;**
**b: LNS 171 KGa)**
**Syrian or Egyptian region**
**ca. 1240–75**

Dimensions: (when joined) a: max. hgt. 11.0 cm;
max. l. 9.2 cm; th. 0.18 cm
b: max. hgt. 5.9 cm; max. l. 5.3 cm;
th. 0.19 cm

Color: Translucent greenish or brownish
colorless; blue, pale blue, red, pinkish,
brown, green, yellow, and white
enamel; gilt

Technique: Free blown; enameled; gilded

Description: The seven fragments (cat. 89a), all
fitting together, are from a globular
bottle or from a bowl; the isolated
fragment (cat. 89b) was probably part
of a similar vessel. Cat. 89a depicts
a horseman with his head turned
backward, riding a pinkish red mount
in full gallop; a large white tassel hangs
under the horse's neck. Two pinkish red
beakers and other objects float around
the horseman in the blue enamel
background. Details and facial features
are outlined in red. Cat. 89b shows part
of a yellow horse walking against a
foreground of tall flowers outlined in
red; it wears a green saddle, a red tassel
hangs under its belly, and its hooves
are brown.

Condition: The surface of cat. 89a is partially
weathered, resulting in a milky
white film; the enamel shows some
decoloration. Cat. 89b is in fairly good
condition, though the yellow enamel
is corroded.

Provenance: Kofler collection; gift to the Collection
(cat. 89b)

The figural scene depicted in this partially reconstructed bottle or bowl (cat. 89a) is a rare example of a "large-figure" representation that shows great vitality and movement. The horse is in full gallop, as is evident from the extension of its legs and from the position of the tassel underneath its belly, which is being driven backward. The tassel of the horse on cat. 89b hangs vertically in a stationary position. The figure of the horseman has not survived in its entirety, but his head is turned backward, indicating that he is either running away from an enemy, perhaps shooting an arrow while fleeing, or playing polo.

Comparable scenes can be found on two of the most celebrated large bottles in enameled glass, one in the Metropolitan Museum of Art, the other in the Museum für Islamische Kunst, Berlin.[45] The former shows an uninterrupted wide band of mounted horsemen in battle, each shown in a different position and brandishing a different weapon, though their arrangement does not clarify who is fighting whom. The bottle in Berlin includes a more restrained scene of twelve polo players, some of them looking backward. In both objects there is a variety of enamels indicating different colors for the horses' coats, including lapis blue, yellow, and spots. The horses on the Berlin bottle wear one tassel under their belly, though it is close to the forelegs rather than in the center, and a second tassel around their neck; those on the vessel in New York do not have tassels and their tails are knotted. An almost complete bottle excavated in the northern Caucasus, presently in the Hermitage, shows a sequence of riders on horses that recall those on the New York bottle, with knotted tails but no tassels.[46]

The distinguishing feature of the present depiction—which shares its palette, presence of the tassel, and position of the horseman with one or all of the bottles mentioned above—is its monumental scale. Assuming that these fragments were part of a large vessel, then no more than three, or perhaps four, figures would have fit around its circumference. Good parallels in terms of scale and quality are provided by two well-known pilgrim flasks in the British Museum and the Treasury of St. Stephen's Cathedral in Vienna, which depict horsemen on their shorter sides.[47] A jug formerly in the collection of William Thomas Beckford, several Dukes of Hamilton and Alphonse (then Edouard and Batsheva) de Rothschild depicts six large-figure polo players and provides the best parallel for the horseman illustrated in cat. 89a,[48] which also shares the jug's blue enamel background, rather than exploiting the clear color of the glass itself. All vessels mentioned above can probably be regarded as products of workshops operating in the same timeframe, spanning the late Ayyubid and the early Mamluk periods.

Cat. 89a, b

Cat. 90a–l

## Cat. 90a–l TWELVE FRAGMENTS
(a–d: LNS 211 Ga–d;
e: LNS 212 Ga; f: LNS 99 KG;
g–j: LNS 170 KGe, f, l, m;
k: LNS 186 KGc; l: LNS 188 KGn)
Syrian or Egyptian region
Mid–late 13th century

Dimensions: a: max. hgt. 3.3 cm; max. l. 3.2 cm;
th. 0.14 cm
b: max. hgt. 6.6 cm; max. l. 4.9 cm;
th. 0.16 cm
c: max. hgt. 3.2 cm; max. l. 3.7 cm;
th. 0.16 cm
d: max. hgt. 5.2 cm; max. l. 1.7 cm;
th. 0.13 cm
e: max. hgt. 5.9 cm; max. l. 3.8 cm;
th. 0.20 cm
f: max. hgt. 8.7 cm; max. l. 11.9 cm;
th. 0.65 cm
g: max. hgt. 4.2 cm; max. l. 2.7 cm;
th. 0.17 cm
h: max. hgt. 5.9 cm; max. l. 4.3 cm;
th. 0.20 cm
i: max. hgt. 7.9 cm; max. l. 4.6 cm;
th. 0.16 cm
j: max. hgt. 5.5 cm; max. l. 4.1 cm;
th. 0.19 cm
k: max. hgt. 3.8 cm; max. l. 4.3 cm;
th. 0.10 cm
l: max. hgt. 4.8 cm; max. l. 5.4 cm;
th. 0.22 cm
Color: Translucent grayish or brownish
colorless; blue, red, green, yellow, and
white enamel; gilt
Technique: Free blown; enameled; gilded
Description: All twelve curved fragments were parts
of beakers or bottle necks (b, h–j, l) or
bowls (f, k). The decoration, outlined
in red, includes gilt and at least two
colored enamels. All the fragments
(except l) depict haloed or turbaned
figures wearing tunics. Two figures are
shown playing music in a landscape
with trees and birds (f). One figure
stands next to a large tree (a), one holds
a yellow book (e), another a red beaker
(g). Three figures stand in a row (i) and
two look out the window of a building
(h); one figure is bending to pick up an
object inside a building (k). The only
fragment that does not include a human
figure (l) is nonetheless related, since it
depicts a brick building.
Condition: The surface of some fragments (b, i, j)
is lightly weathered, resulting in a milky
white film and decay of the enamel;
most are in fairly good condition.
Provenance: Kofler collection; gift to the Collection
(a–e)

Human figures in the decoration of enameled glass belong principally to the thirteenth century (see also cat. 89). During this period, they were as popular as any other decorative pattern on beakers and other vessels. They gradually disappeared with the new and largely nonfigural decorative language established toward the end of the century. The present fragments represent a selection of figural images in the Collection.[49]

The most notable fragment (f)—also the largest and most accomplished—depicts the heads of two musicians set in a complex vegetal landscape where a bird of prey is in pursuit of either a swan or a duck. The glass is thick and slightly curved; thus the fragment likely belonged to the base of a large bowl or footed tazza. The two musicians are framed by a pointed-arch pattern. The person on the right appears to be a female harp player: the pointed tip of the harp is visible before her face, and a scarf, or veil, knotted around her headdress, falls on her shoulders.[50] The figure on the left seems to be a man wearing a turban with floating ends; as no indication of a musical instrument has survived, he may have been a singer or a member of the audience. Stylistically, the scene belongs to the "large-figure" group discussed at cat. 89. The complexity and richness of the gilded background, though so incomplete, rank this scene among the best ever produced by the Ayyubid and Mamluk glass painters. When in pristine condition, this object must have been one of the most sumptuous of its kind.

A second fragment (i), probably from the neck of a bottle, includes a standing man and two half-figures of turbanless men wearing cloaks, thus representing Christians. As mentioned at cat. 88, the incorporation of such figures was not uncommon in late Ayyubid and early Mamluk works in metal and glass. When complete, the neck would have included a number of these men (probably seven or eight, judging from the curvature of the fragment) standing next to one another. Two intact pieces show comparable compositions: one is a famous drinking horn, or rhyton, in the Hermitage; the second is a little-known bottle in a private collection in London.[51]

The remaining fragments mostly show single male figures, often with haloes, in different positions and engaged in various activities, though their incompleteness prevents a proper understanding of the scenes. The figures wear assorted types of turbans and tunics, offering a panorama of the models that were familiar to glass painters at the time. Particularly notable is the miniaturelike scene of a figure kneeling down inside a building, perhaps to collect an object, while a second person stands outside (k). This fragment, together with h and l, belongs to a number of enameled and gilded objects illustrating complex miniature scenes populated with numerous figures and buildings that were perhaps inspired by literary subjects; two beakers in Baltimore (see discussion at cat. 86, 87) and the bottle in London mentioned above provide excellent comparative pieces for these fragments.

## Cat. 91a FRAGMENT OF A BEAKER
(LNS 150 KGb)
**Egyptian or Syrian region**
**Mid–late 13th century**

Dimensions: max. hgt. 5.0 cm; max. l. 4.2 cm;
th. 0.20 cm
Color: Translucent brownish colorless;
blue and red enamel; gilt
Technique: Free blown; enameled; gilded
Description: This fragment includes part of the
applied foot ring and base of a
cylindrical beaker. The forepart of a
cheetah and the rear of a quadruped,
painted in gold with red outlines,
are seen against a blue background
filled with gold vegetal scrolls.
Condition: The surface is lightly weathered,
resulting in a milky white film.
The general condition is good.
Provenance: Kofler collection

## Cat. 91b FRAGMENT OF A BEAKER
(LNS 207 KGa)
**Egyptian or Syrian region**
**Mid–late 13th century**

Dimensions: max. hgt. 3.7 cm; max. l. 5.9 cm;
th. 0.20 cm
Color: Translucent brownish colorless;
blue and red enamel; gilt
Technique: Free blown; enameled; gilded
Description: This fragment is from the rim of
a beaker with a flared opening (see
cat. 86a, 87). The figure of a saluki
dog, painted in red against a blue
background amid red vegetal scrolls, is
depicted inside the band below the rim.
Condition: The surface is partially weathered,
resulting in a milky white film and
the dull appearance of the enamels.
Provenance: Kofler collection

Cat. 91a, b, d

All sorts of animals were commonly represented on enameled glass in the early Mamluk period. Compared to the lively monumental horses discussed at cat. 89, however, it is clear that the animals presented here are standardized: their dimensions and posture, as well as the quality of the drawing, are obviously less accomplished. In addition, though they can be identified as individual illustrations, they are also elements in a sequence of animals that encircle the glass surface as if they were walking endlessly, one behind the other. Such arrangements, originally inspired by inlaid metalwork decoration, became standard in enameled glass, where narrow horizontal bands were often filled with real and fantastic quadrupeds shown in profile (especially facing right—that is, walking counterclockwise) one after the other.[52]

As demonstrated by cat. 89, a rich coloration appears on objects of the mid- to late thirteenth century. Also typical of this period are the quadrupeds depicted on the two beaker fragments (cat. 91a, b), which represent part of a cheetah and of a saluki dog, respectively. Both fragments once belonged to the typical flared beaker described at cat. 86a and 87. Although they are not as accomplished from an artistic point of view and are representative of a standardized production, both the gold cheetah (together with the rear part of an unidentified quadruped) and the red dog were featured prominently on their respective vessels. Their coloration makes them stand out, and it is clear that only four, or perhaps five, quadrupeds would have fit around the circumference of the beaker, thus allowing for better individualization of each animal.

Around the turn of the fourteenth century, sequences of animals became less prominent, sketchier, and more decorative. As the objects produced by the Mamluk glassmakers grew in size, bands with animals became merely a way to fill space on the glass surface of vessels destined for secular use. The base and fragment (cat. 91c, d) belong to this period. The sequence of five animals around the base may seem prominent at first, but the original complete vessel—a large footed bowl (tazza), judging from the base—would have featured conspicuous inscriptions and large floral patterns following the style of the period.

### Cat. 91c BASE OF A FOOTED BOWL
### (LNS 4 G)
**Egyptian or Syrian region**
**First quarter of the 14th century**

Dimensions: hgt. 11.8 cm; max. diam. 16.6 cm;
th. 0.49 cm; wt. 597.3 g

Color: Translucent brownish colorless;
blue, red, green, yellow, and white
enamel; gilt

Technique: Free blown; tooled; enameled; gilded;
worked on the pontil

Description: This large splayed foot is from a
hemispherical bowl. The rim folds
under and there is a prominent bulge
at midpoint, a short cylindrical stem,
and a splayed upper part (diam. 8.3 cm)
where the bottom of the bowl was
attached. The decoration, outlined in
red, consists of a large band around the
foot that includes a series of five winged
quadrupeds walking in right profile.
Their bodies are gilded and their wings
are enameled in red, green, yellow, and
white. The five can be identified
(counterclockwise) as a unicorn, a
rooster-headed quadruped, a human-
faced animal, a bear (or a wolf), and a
bull. A narrow band with vegetal motifs
in gold against a blue background is
painted around the short stem.

Condition: This portion of a footed bowl is intact.
The surface is in good condition,
though most of the gilding has vanished
and the enamels show some corrosion.
The glass includes frequent small
bubbles.

### Cat. 91d FRAGMENT OF A BOWL
### (LNS 210 Gc)
**Egyptian or Syrian region**
**First quarter of the 14th century**

Dimensions: max. hgt. 8.5 cm; max. l. 6.1 cm;
th. 0.25 cm

Color: Translucent colorless with tinge; blue,
red, green, yellow, and white enamel;
gilt

Technique: Free blown; enameled; gilded

Description: This fragment is from the central
section of the body of a curved bowl.
The decoration inside the band shows
a winged horselike quadruped facing
right. The body was originally gilded
and the wing is painted in polychrome
enamels. Above the band, a figure
wearing a red tunic with gold dots
is partially visible against a vegetal
background.

Condition: The glass surface and the enamels are
in good condition, though the gilding
has largely vanished.

Provenance: Kofler collection; gift to the Collection

The draftsmanship is less accomplished here than it is on the beaker fragments (cat. 91a, b): in addition to having sketchier outlines, the background is more impressionistic and muddled than their uniform scroll-and-leaf motif. Although originally gilded (the gilding has almost entirely vanished, further evidence of the inferior quality of the gold pigment and the firing technique), the chromatic effect is not as rich and the colored enamels are confined to small areas (the animal's wings).

Wings seem to be a hallmark of decorative animals depicted in this later period. The intent was the representation of fantastic creatures that perhaps had a generic apotropaic significance as opposed to the earlier illustrations of actual animals. Winged quadrupeds were completed by identifiable animal heads and different types of tails. The results, as evident from the base of the large footed bowl (cat. 91c), could be naive and amusing at the same time. The winged bear, bull, and horse (cat. 91d) and the oft-encountered unicorn, as well as the rooster-headed and human-faced quadrupeds, demonstrate the decorative role that sequences of animals had assumed by the end of the thirteenth century.

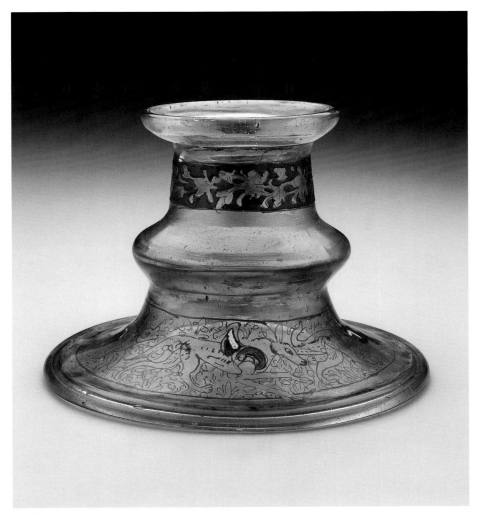

Cat. 91c

Cat. 92a–j TEN FRAGMENTS
(a–c: LNS 202 Ga, d, e;
d, e: LNS 203 Ga, b;
f–h: LNS 204 Ga–c;
i: LNS 223 G; j: LNS 174 KGc)
Syrian or Egyptian region
Mid–late 13th century

Dimensions: a. max. hgt. 6.8 cm; max. l. 8.9 cm;
th. 0.33 cm
b. max. hgt. 9.6 cm; max. l. 3.9 cm;
th. 0.21 cm
c. max. hgt. 3.7 cm; max. l. 4.4 cm;
th. 0.22 cm
d. max. hgt. 6.0 cm; max. l. 5.6 cm;
th. 0.23 cm
e. max. hgt. 5.0 cm; max. l. 5.3 cm;
th. 0.23 cm
f. max. hgt. 5.5 cm; max. l. 4.3 cm;
th. 0.14 cm
g. max. hgt. 2.4 cm; max. l. 9.9 cm;
th. 0.18 cm
h. max. hgt. 6.0 cm; max. l. 4.2 cm;
th. 0.15 cm
i. max. hgt. 5.4 cm; max. l. 6.3 cm;
th. 0.23 cm
j. max. hgt. 6.3 cm; max. l. 2.3 cm;
th. 0.15 cm

Color: Translucent colorless with various tints;
blue, pale blue, red, pinkish red, and
white enamel; gilt

Technique: Free blown; enameled; gilded

Description: These ten fragments, originally from
different types of vessels—including
beakers (f, j), a mosque lamp (a), bowls
and bottles (all the others)—all depict
an emblem inside a circular medallion.
The emblems are: (a) a red cup on a
gilded field, below a red band; (b) a red
crescent outlined in gold on a white
field; (c) a red band framed by two
white bands; (j) a napkin of unclear
color on a white field surrounded by a
teardrop-shaped pale blue field; (d, e)
(probably not from the same vessel) a
double-headed eagle with dragonlike
heads and spread wings, seen frontally
and surrounded by an inscription in
cursive; the eagle is white with red
talons on a blue field. The inscription,
white against a red background painted
on the reverse, reads:

عز لـ[ـمـ]ـولا انا [ . . . ] السلطا[ن ]
[ . . . المـ]ـجاهد

("Glory to our Lo[rd] . . . the Sultan . . .
the Warrior . . ."); (i) an eagle with
dragonlike heads, painted in gold
without enamels; (f–h) a feline—white
on a red field (f, h) or pinkish red on a
white field (g)—facing left, the right
forepaw raised, the tail long and curved.

Condition: The surface of most of the fragments
is partially weathered, resulting in a
milky white film and discoloration or
corrosion of the enamel; the gilding
has almost vanished on all fragments.

Provenance: Kofler collection; gift to the Collection
(cat. 92a–i)

Emblems were widely used during the Mamluk period to identify the office of an important amir.[53] They were reproduced on all objects that belonged to his household and on buildings that he commissioned. The emblems are not comparable to the coats of arms of noble European families, since the amirs had the right to use them only while they were in office. The most commonly encountered emblems include a footed cup representing the royal cupbearer (sāqī; cat. 92a), a napkin for the keeper of the wardrobe (jamdār; cat. 92j), a penbox for the royal secretary (dawādār), and two curved sticks for the polo master (jūkāndār). The representations varied over time and, from the late fourteenth century on, often became individual elements included in composite emblems, thus reflecting different official functions of the amir. For this reason, the emblems of the Mamluk amirs, though still only partially understood, are useful to art historians, since they often allow for a more precise attribution of many objects.

The origin of Mamluk emblems lies in heraldic symbols adopted earlier by the Seljuqs and the Urtuqids in Anatolia that probably represented generic emblems of sovereignty and were not related to a hierarchical system. In the Ayyubid and early Mamluk periods, they were probably used in a similar way—for example, the symbol of a lion, widely recognized as the emblem of the sultan Baybars I (r. A.H. 658–76 / A.D. 1260–77). Baybars's lion was generally depicted as a nondescript feline facing left; almost invariably, the right forepaw is raised and the long tail curves over its back. Judging by the three fragments (cat. 92f–h) and by a number of other examples, the color code was variable (the animal is painted white against a red field in cat. 92f and h, whereas it is pinkish against a white field on cat. 92g). Red and white were, however, the most common colors for Baybars's feline. Later sultans, especially after Nāṣir Muḥammad ibn Qalāūn, were represented only by epigraphic emblems.

An unusual emblem in the Collection is a double-headed eagle with outspread wings. It is present on two enameled fragments (cat. 92d, e) and on another with gilding alone (cat. 92i). The image of the double-headed eagle represents an obvious transmission from southeastern Anatolia to Mamluk Syria and Egypt: one of the most common symbols of power, from Konya to Diyarbakir and from Hisn Kayfa to Mardin during the twelfth and thirteenth centuries, it featured mainly on carved stone and on painted tiles.[54] One may infer from the incomplete inscription on cat. 92d and e ("Glory . . . to the Sultan") that the emblem referred to a ruler, which would place it within the small group of thirteenth-century royal emblems mentioned above. An almost identical image is repeated several times on a well-known spherical incense burner in the British Museum that was unquestionably made for the powerful amir Badr al-Dīn Baysarī (d. A.H. 698 / A.D. 1298), probably in Damascus, between 1264 and 1279.[55] The inscription on the incense burner states that this amir served both Baybars I and Baraka Khān (r. A.H. 676–78 / A.D. 1277–79). The symbol of the double-headed eagle may, therefore, be tentatively attributed to Baraka Khān, since Baybars I had apparently adopted the image of a feline. Given the eagle's royal meaning in Anatolia, it is not surprising that it was adopted by one of the first Mamluk sultans, but the possibility cannot be excluded that the objects to which these fragments once belonged were made in Syria in the first half of the thirteenth century for a Jaziran atabeg (see, for example, cat. 85).

The remaining fragments can be attributed to amirial, rather than royal, sponsorship. The cup (cat. 92a), red against a gilded field topped by a red band, was a popular emblem, perhaps because the number of cupbearers (sāqī) exceeded that of any other comparable courtly position. This particular combination of colors and the presence of a single band on the upper field is reminiscent of the emblem of the amir Alṭunbughā as it appears on a mosque lamp in the Museum of Islamic Art in Cairo, which is almost contemporary.[56]

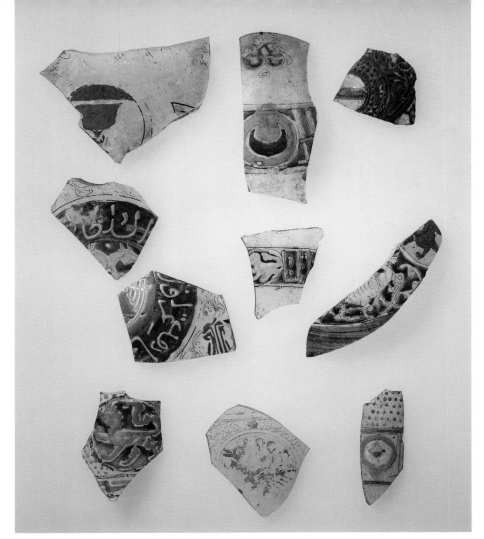

Cat. 92a–j

A rhomboid napkin (cat. 92j) is another emblem that often appears on enameled glass. Called *buqja* in Arabic sources, it was the emblem of the Keeper of the Robes (*jamdār*).[57] The composition of the present emblem is rather simple: a colored napkin against an undivided circular white shield surrounded by an upside-down pointed pale blue shield. An early Mamluk date, probably in the last two decades of the thirteenth century, can be hypothesized for the beaker it once decorated.

Many shields did not include any particular stylized objects, or "simple charges," in technical terms. The shield on cat. 92c, which presents a horizontal red band framed by two white bands, is an example of the so-called fess, the central band that creates a three-fielded shield, without simple charges. It is not clear to which office or function this shield corresponded,[58] but it is certain that it was common at the end of the thirteenth century and in the first half of the fourteenth and was rarely used in the fifteenth.

The emblem of a crescent appears often on pottery shards, but is rare on architectural details and metalwork. It is also unusual on enameled glass, though a few shards bearing the motif were excavated at Hama, in Syria.[59] Its interpretation is unclear, since it does not seem to correspond to any of the amir's offices; instead, it may be an unusual instance of a personal coat of arms, which would justify its rarity and short-lived appearance.[60] The fragment illustrated here (cat. 92b), showing a red crescent outlined in gold against a white field, represents a rare example on a glass object and is datable to the late thirteenth or the early fourteenth century.

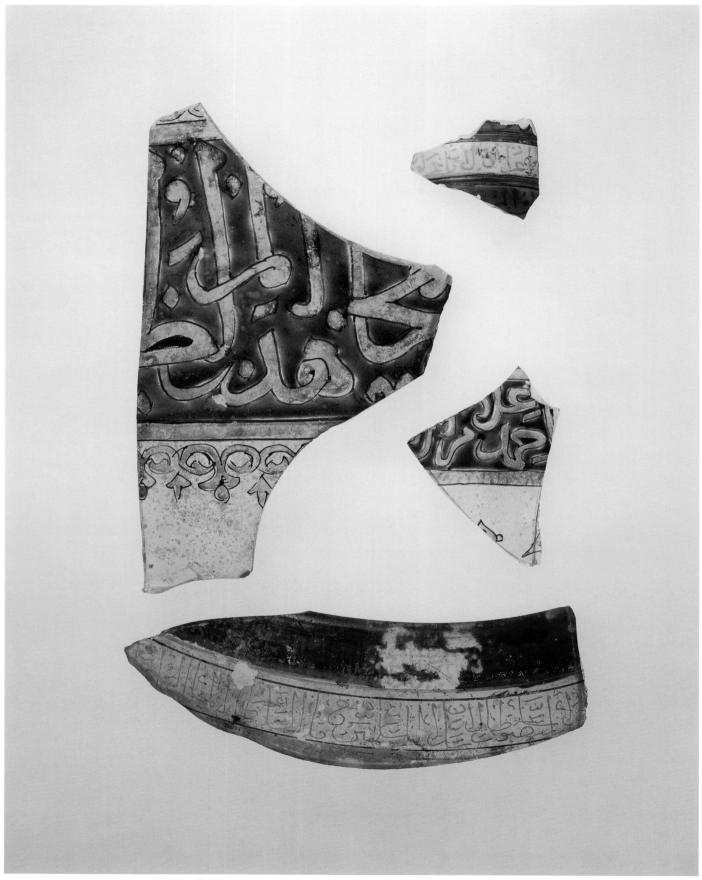

Cat. 93a–d

## Cat. 93a–d FOUR FRAGMENTS
(a: LNS 229 Gb; b: LNS 235 G;
c: LNS 173 KGa; d: LNS 203 KGa)
Syrian or Egyptian region
Mid-13th–early 14th century

Dimensions: a: max. hgt. 4.7 cm; max. l. 3.4 cm;
th. 0.24 cm
b: max. hgt. 3.4 cm; max. l. 10.5 cm;
th. 0.27 cm
c: max. hgt. 11.5 cm; max. l. 7.4 cm;
th. 0.36 cm
d: max. hgt. 2.4 cm; max. l. 2.9 cm;
th. 0.13 cm

Color: Translucent colorless with various tints;
blue, red, and white enamel; gilt

Technique: Free blown; enameled; gilded

Description: These four fragments, originally from
different vessels—including a bowl (b),
a beaker (d), and a large nearly
cylindrical object (c)—all have
inscriptional bands. Cat. 93a has an
inscription in *naskh* outlined in red
and filled with gold against a blue
background. Cat. 93b, from the rim
and part of the walls of a low bowl,
has two inscriptions copied in minute,
crowded gold cursive script; the upper
band has a red background painted on
the interior wall, the lower band was
left unpainted so that the gold letters
stand out against the glass. Cat. 93c has
a monumental inscription in *thuluth;*
it is outlined in red, filled with gold
against a blue background, and the
empty spaces inside some letters are
filled with red enamel. Cat. 93d has two
inscriptions copied in minute, crowded
gold cursive script; the upper band has
a white background, the lower band
(only the upper parts of the letters
are extant) has a blue background.
The inscriptions read:

a: احمد بن ... علا ...
("Aḥmad ibn . . . ʿAlā . . .")

b: السلطان الملك العالمي العادلي
المجاهدي المرابط[ي]
(". . . the Sultan, the King, the Learned,
the Just, the Warrior, the Defender")

... المنصور سلطان الاسلا[م و]
المسلمين( ...؟) السلطان الملك
(". . . the Victorious, the Sultan of
Islam and of the Muslims . . . the
Sultan, the King . . .")

c: ... [ا]لمجاهد[ي] ...
المر[ا]بطي ا[لظ]اهري
(". . . [the] Warrior, the Defen[der] . . .,
the Con[queror] . . .")

d: ... عز لمولانا
("Glory to our Lord . . .")

Condition: The surface of most of the fragments is
partially weathered, resulting in a milky
white film and some discoloration or
corrosion of the enamels; the gilding
has almost vanished from all fragments.

Provenance: Kofler collection; gift to the Collection
(a, b)

These four fragments were selected to represent the variety of inscriptions found on different types of enameled glass.[61] A hurried, almost spidery cursive (*naskh*) calligraphy was common on vessels from the late Ayyubid and the early Mamluk periods, when long eulogistic inscriptions were copied on small objects, such as bowls and beakers. Cat. 93b and d (from a bowl and a beaker, respectively) are good examples of this type. The inscriptions are copied in gold with a fine pen or brush inside different colored bands; thus, the gold letters stand out, producing diverse visual effects against a natural, red, white, or blue background. Probably for technical, rather than artistic, reasons, only the red background was usually painted on the interior surface of the vessel (cat. 93b), while white and blue background enamels (cat. 93d) offered a good surface on which the gold ink was applied directly and fired.

The inscriptions on cat. 93b and d are dedicated to a sultan. In the case of the bowl (cat. 93b), about one-quarter of the original opening survives; the extant section, however, suggests that the inscription included a personalized series of titles, which probably ended with the name of the ruler. Unfortunately, this vital part of the inscription is missing. The short text on cat. 93d, though probably referring to the ruling sultan, is on what was either a beaker or the neck of a bottle that appears to have been a standardized product intended for the general market—that is, for a potential buyer rather than a patron.

The monumental inscription on cat. 93c is also addressed to a sultan, and its bold and elegant *thuluth* script, copied in gold and outlined in red against a blue background, ranks among the best achievements of Mamluk calligraphers on glass vessels. *Thuluth* was one of the most suitable calligraphic scripts for the Mamluk taste and was chosen to copy royal Qurʾans in a few instances. The style of this fragment is close to the Qurʾanic text copied by the calligrapher Ibn al-Waḥīd for the sultan Baybars al-Jāshnagīr between 1304 and 1306, a similarity also confirmed by the color-filled empty spaces inside some letters, which are also common to both.[62] Although the text on the glass fragment is too incomplete to suggest a precise attribution, the original vessel probably dated to the beginning of the fourteenth century and, judging from the curve of the fragment, must have been large and important.

Cat. 93a has an inscription in bold *naskh*, leaning toward *thuluth*, that is outlined in red and filled with gold against a blue background—the most common combination of colors and gilding on glass vessels. The quality of the calligraphy is not particularly engaging, but the surviving text includes a portion of a name (Aḥmad ibn . . . ʿAlā . . .). Thus, the object to which this fragment once belonged included either the name of the patron (or, perhaps, the maker) and was probably made on commission rather than produced for the general market, although the incomplete inscription does not allow for a proper identification of the patron.

Mamluk glass painters—and probably Ayyubid before them—sometimes decorated vividly colored glass vessels with enamels and gilding. The two most popular colors were deep purple (produced using generous amounts of manganese) and a rich dark blue. The striking effect of the applied enamels against a colored background makes the few known intact objects of this type particularly attractive and visually engaging.[63]

These vessels were probably inspired by contemporary objects with marvered trails, which, as discussed in Chapter 3, continued to be produced in the Fatimid and Ayyubid periods. Glass with marvered decoration typically consists of a dark matrix over which opaque white (or sometimes pale blue) glass was applied and worked into a festooned pattern (see, for example, cat. 80). The festooned pattern on cat. 94d, for instance, clearly imitates marvered threads; the tiny gilded scrolls between the painted strokes also have close parallels in glass with marvered decoration (see cat. 84).[64] It is not possible to establish whether the two productions coexisted for a relatively long period or if the enameled pieces were short-lived. It may be that these objects belong to an early phase of enameling, since enormous technical improvements soon allowed glass painters to apply additional colors and employ more complex patterns (see, for example, cat. 94c). The third quarter of the thirteenth century must, therefore, represent the latest period of the production of marver-inspired enameled objects, whereas cat. 94c, with its interlaced pattern in white, blue, and red, is typical of vessels made in the early fourteenth century.

Belonging to the same class of objects is the decoration of cat. 94e: a network of hexagons with different colored sides, each filled with a gilded "asterisk" or "snowflake" pattern. There are no known exact parallels for this peculiar motif among the intact objects or fragments. Three vessels having similar decoration are a fragmentary elongated bottle in the Museo Civico in Bologna, another bottle in the Corning Museum of Glass, and a small beaker in the Victoria and Albert Museum in London.[65] According to their shape and size, it seems likely that objects decorated with this particular pattern were popular in the middle and latter part of the thirteenth century.

The objects represented by cat. 94a and b are certainly rare, though there is no doubt that they belong to the late Ayyubid or early Mamluk periods. The former is typical in shape (a molded ribbed bowl; see cat. 82 for examples with marvered trails) and decoration (pseudovegetal motifs filled with colored dots on both sides), but the vessel itself was made of opaque pale blue glass, which has parallels only in fragments recently excavated in Israel and presently in the Eretz Israel Museum, Tel Aviv. Even more puzzling is the latter fragment, a multicolored piece of translucent blue glass dappled with opaque white streaks that can loosely be compared with much earlier, as well as much later, material, but is thus far unrecorded in thirteenth-century Egypt or Syria.[66] Its decoration, however, which includes gilded vegetal scrolls and a circular medallion divided into a checkerboard pattern filled with colored enamels, clearly falls within the early phase of Ayyubid and Mamluk enameling and gilding. Perhaps these two fragments belong to a short-lived experimental phase, of which almost nothing has survived, whereas enamels and gilding applied on clear translucent glass soon became overwhelmingly popular.

**Cat. 94a–e FIVE FRAGMENTS**
**(a: LNS 217 G; b: LNS 218 G;**
**c, d: LNS 219 Ga, d;**
**e: LNS 136 KG)**
**Syrian or Egyptian region**
**Mid–late 13th century**

Dimensions: a: max. hgt. 5.1 cm; max. l. 7.1 cm; th. 0.39 cm
b: max. hgt. 2.6 cm; max. l. 2.8 cm; th. 0.12 cm
c: max. hgt. 4.7 cm; max. l. 4.8 cm; th. 0.51 cm
d: max. hgt. 3.7 cm; max. l. 2.5 cm; th. 0.20 cm
e:. max. hgt. 2.9 cm; max. l. 4.5 cm; th. 0.24 cm

Color: Opaque pale grayish blue, translucent dark purple, and translucent blue with opaque white dappling; blue, pale blue, red, yellow, and white enamel; gilt

Technique: Mold blown; free blown; enameled; gilded

Description: Cat. 94a is from the rim and part of the walls of a ribbed opaque pale blue bowl. Decorated on both sides with a pseudovegetal band just below the rim and larger vegetal motifs below, its patterns are outlined in red and sparsely filled with red and yellow enameled dots. Cat. 94b is blue dappled with opaque white streaks. Decorated on both sides, it has a gilded vegetal scroll on one side (see the illustration) and part of a circular medallion on the other; the interior of the medallion is divided into a checkerboard pattern, each small square containing an X-shaped pattern in alternating red and white enamel. The remaining three fragments (c–e) are dark purple. Cat. 94c represents about one-quarter of the bottom of a vessel, probably a low cylindrical bowl with a thick folded foot; the enameled decoration depicts intersecting stylized vegetal patterns. Cat. 94d, probably from the rim and wall of a beaker, has a pale blue enameled festooned decoration filled with tiny gilded scrolls. Cat. 94e, probably from a bowl, shows a horizontal gilded line above a network of hexagons, the sides of which are represented by small pointed ovals in alternating blue, red, and white enamels; in the center of each hexagon is a six-pointed snowflakelike element in gold.

Condition: The surface of all five fragments is partially weathered, resulting in a milky white film and some discoloration of the enamel (especially e). The overall condition is fairly good.

Provenance: Kofler collection; gift to the Collection (a–d)

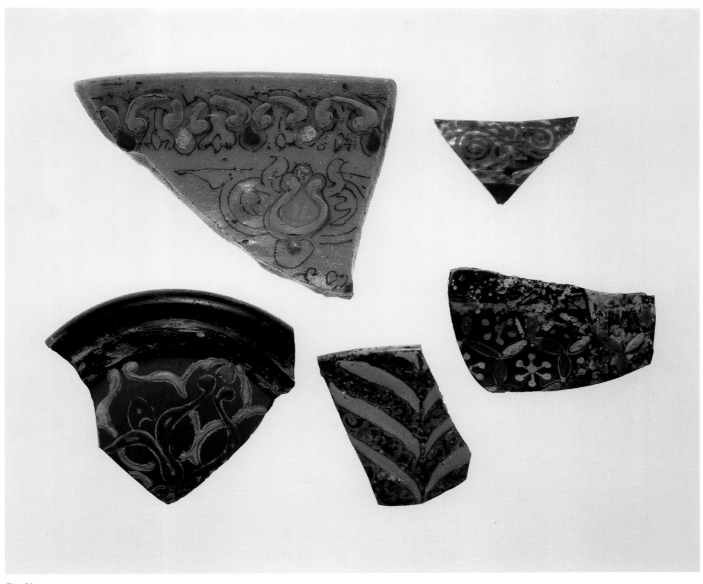

Cat. 94a–e

**Cat. 95a** *QUMQUM* (PERFUME
SPRINKLER) (LNS 2 G)
**Probably Syrian region**
ca. 1260–80

Dimensions: hgt. 8.3 cm; max. diam. 6.6 cm;
w. 3.9 cm; th. 0.28 cm; wt. 44.4 g;
cap. 76 ml

Color: Translucent grayish colorless; blue, red,
green, and white enamel; gilt

Technique: Free blown; tooled; applied; enameled;
gilded; worked on the pontil

Description: This round flattened *qumqum* has a
small flattened base that is slightly
kicked and a tapered neck that ends in
a narrow opening. Two snaky handles
were applied at either side of the neck.
The enameled and gilded decoration,
outlined in red, consists of a central
gilded inscription (hgt. of band
ca. 1.2 cm) against a blue background,
two large fish "swimming" on the
transparent surface below the
inscription, and, on the shoulder, four
lobed cartouches framed by a green and
a blue line and filled with floral and
vegetal motifs in blue, green, and white.
The inscription reads:

مما عمل برسم مولانا الملك العالمي
العادلي مالك رقاب الامم ركن
الدو[له؟].[..؟

("What was made for our Master, the
King, the Learned, the Just, the Master
of the Fate of the Nations, [Rukn
al-D. . . ?]").

Condition: The object is intact. The surface is
partially weathered, resulting in a milky
white film (especially on the interior)
and some corrosion of the enamel; the
white enamel seems to have turned pale
pink, but it is possible that parts of it
were originally pink. The glass includes
frequent small bubbles.

Literature: Paris 1996, no. 121

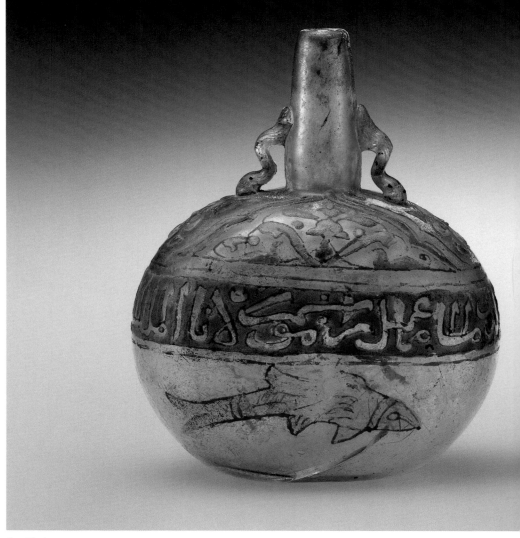

Cat. 95a, b

These two vessels can be regarded as miniature versions of the typical long-necked *qumqum*
(see cat. 37, 60, 83). While the profile of their flattened globular bodies is similar to that
of the larger bottles, their necks are much shorter in proportion to their height.

A small number of intact *qamāqim* of this type have survived; their decoration
suggests that they were produced during the early Mamluk period, perhaps between 1260
and 1280 (see Related Works 1, 2). The two *qamāqim* discussed here are no exception and
date from around the same time. Cat. 95a bears an inscription in a typical *naskh* script of
the early Mamluk period. Unfortunately, the last words are difficult to interpret and are
probably shortened, but it is clear from the legible first section that the sprinkler was
commissioned by or for a sultan. If the suggested reading of the beginning of the name is
correct, the sultan can be identified as Rukn al-Dīn Baybars I (r. A.H. 658–76 / A.D. 1260–77).[67]
The remainder of the enameled decoration, which consists of vegetal motifs above the
inscriptional band and two large fish below it, can be regarded as decorative, especially
considering that the image of the fish was popular as early as the end of the twelfth
century.[68] A small *qumqum* in the Metropolitan Museum (Related Work 1) bears an
inscription in a similar *naskh* script as well as an emblem consisting of a red fess against

**Cat. 95b** *QUMQUM* **(PERFUME SPRINKLER) (LNS 92 KG)**
Probably Syrian region
ca. 1260–80

Dimensions: hgt. 7.6 cm; max. diam. 5.7 cm; w. 3.7 cm; th. 0.34 cm; wt. 44.6 g; cap. 46 ml

Color: Translucent yellowish or brownish colorless; blue, red, and white enamel; gilt

Technique: Free blown; tooled; applied; enameled; gilded; worked on the pontil

Description: The shape of this *qumqum* is similar to that of cat. 95a. The enameled and gilded decoration is outlined in red on both of the wider sides and consists of two circular medallions, each enclosing a male figure sitting frontally and holding an object in his right hand. Two smaller medallions on the shorter sides, covering part of the shoulder, each include a red lion with a curved and raised tail seen facing left in a walking, almost heraldic, posture against a white background. Unclear patterns outlined in red are visible on the shoulder.

Condition: The object is intact. The surface is heavily weathered, resulting in iridescence, corrosion, flaking, and decay of the enamel, making it difficult to read the colors and details of the decoration. The glass includes frequent small bubbles.

Provenance: Kofler collection

Literature: Lucerne 1981, no. 627

Related Works: 1. MMA, inv. no. 1974.120
2. CMG, inv. no. 69.1.2 (Atıl 1985, no. 46)
3. Whereabouts unknown (Christie's, London, sale, April 28, 1992, lot 187)

a white background, which was common in the second half of the thirteenth century (see cat. 92c).

An attribution to the period of Baybars I may also be proposed for the second sprinkler (cat. 95b). It is not inscribed, but the presence of a feline in profile leaves little doubt that it is contemporaneous with cat. 95a. The lion emblem is identifiable with Baybars I himself or, in any case, with his reign (see cat. 92). The colors (red for the feline and white for the background) are also in accordance with one of the two most common patterns for this particular emblem (see cat. 92g). Another *qumqum* belonging to this group bears an even more prominent image of Baybars's lion (Related Work 2).[69] The decoration on the two larger sides of cat. 95b, showing a young man holding an object (possibly a beaker) in his right hand, is probably a traditional court scene with no particular meaning.

The use of these miniature *qamāqim* is not clear, but two applied snaky handles were usually attached at the shoulder and neck. These handles suggest that the objects may have been suspended by the belt as a sort of portable perfume or rosewater container. Perhaps the larger long-necked *qumqum* was the bottle from which the precious liquid was poured into the smaller portable one; thus, they may represent objects from the same toiletry set.

## Cat. 96a PERFUME FLASK (LNS 48 G)
### Probably Syrian region
### Second half of the 13th century

Dimensions: hgt 11.8 cm; max. diam 8.7 cm;
w. 2.9 cm; th. ca. 0.4 cm; wt. 118.2 g;
cap. 95 ml

Color: Translucent brownish colorless; blue,
red, yellow, and white enamel; gilt

Technique: Free blown; tooled; enameled; gilded;
worked on the pontil

Description: This flask has a circular flat body.
The enameled and gilded decoration
on both sides consists of a central
medallion outlined in red enclosing
a seated, haloed male figure wearing
a tunic with tiraz bands and holding
a beaker in his raised right hand.
The blue background is filled with
clouds and pseudovegetal motifs.
On the shoulders are lobed medallions
displaying vegetal patterns.

Condition: The original neck is missing and has
been replaced by a long tapered neck in
resin, though there is no evidence that
it reproduces the original. The pontil
mark at the bottom of the flask may
have been the attachment of a small
splayed foot, but this is unlikely. The
remainder is in fairly good condition,
though there is some decay of the
enamel. The glass includes frequent
bubbles.

Provenance: Sotheby's, London, sale, April 21–22,
1980, lot 341

Literature: Atıl 1990, no. 63

## Cat. 96b PERFUME FLASK (LNS 70 G)
### Probably Syrian region
### Second half of the 13th century

Dimensions: hgt. 10.9 cm; max. diam. 7.7 cm;
w. 2.8 cm; th. 0.45 cm; wt. 101.6 g;
cap. 92 ml

Color: Translucent yellow (yellow/brown 1);
blue, pale blue, red, and white enamel;
gilt

Technique: Free blown; tooled; enameled; gilded;
worked on the pontil

Description: This flask is similar to cat. 96a but has
a short bulged neck. The enameled and
gilded decoration on both sides consists
of a central medallion outlined in red,
enclosing an eleven-pointed sun with
a human face drawn in red; the circle
containing the sun is set within a larger
concentric circle that it joins at the top.
The remaining area of the larger
medallion is thus in the shape of a
crescent moon and is filled with vegetal
scrolls and palmette motifs in gilt
against a blue or white background.
Similar vegetal motifs are visible on
the shoulders of the flask, where the
background is either pale blue or red.

Condition: The object is intact (assuming the
mark in the base is a pontil mark and
not the remains of a foot). The interior
is weathered, resulting in a milky white
film; the exterior is in fairly good
condition. One side of the flask has
retained more gilding than the other,
though the enamel on that side shows
more wear. The glass includes many
scattered bubbles and some large ones.

Provenance: Comtesse de Béhague, Paris

Literature: Lamm 1929–30, pl. 98; and
Paris 1996, no. 122

Related Works: 1. Louvre, inv. no. 7244
(Paris 1989, no. 200)
2. MMA, inv. no. 30.95.14
3. Whereabouts unknown
(Christie's, London, sale,
October 12, 1999, lot 319)

These perfume flasks, which are similar in shape and dimensions, form a unique pair among the extant enameled glass objects. Their necks were probably similar, since there is no evidence that the reconstructed long tapered neck of cat. 96a is faithful to the original. The two objects share a lump of glass at the base that represents either a broken foot or simply a pontil mark that was not ground off; the latter seems more likely. Related Works 1–3 are the only known close parallels as regards shape and/or dimensions, since all other small *qamāqim* (see cat. 95) have wider flat bodies and a base on which they stand. The present flasks, instead, either need a stand, are meant to rest on one of their flat sides, or were suspended from a chord tied around the compressed base of the neck.

Cat. 96a and b were probably produced during the early Mamluk period. This attribution is supported not only by their shape but also by their decoration, which is common in the second half of the thirteenth century and, indeed, rather traditional from an iconographic point of view. The stereotypical courtiers depicted on cat. 96a, who sit cross-legged and hold a beaker in their raised hands, are conventional images that do not need much explanation. More interesting is the depiction of a humanized sun inscribed within a circle on cat. 96b. The pseudovegetal motifs below the sun's circle seem to depict stylized affronted dragon heads with wide-open mouths, a popular astrological motif in the Jazira in the late twelfth and thirteenth centuries.[70] Astrological images are frequently encountered on Mamluk inlaid metalwork, where the complete cycle of the eight planets, including the Dragon (or Jawzahr) and the twelve signs of the zodiac, often appear, but they are extremely rare on enameled glass.[71] This combination in a single composition of sun, moon, and the pseudoplanet Jawzahr is unique on glass and must have imbued this flask with a special talismanic and apotropaic meaning. (Related Work 3 depicts a harpy, which is usually understood to have a similar meaning.) These three heavenly bodies are also those invested with the strongest talismanic significance and their presence here may be indicative of a close association with the Jazira—the place of origin and early diffusion of these images. Consequently, a Syrian, rather than an Egyptian, provenance for cat. 96b and, by extension, also for cat. 96a, is proposed.

**Cat. 97 TRAY STAND (LNS 53 G)**
Egyptian or Syrian region
Late 13th–early 14th century

Dimensions: (overall) hgt. 18.7 cm; max. diam.
18.5 cm; th. 0.40 cm; wt. ca. 900 g
(larger half) hgt. 11.0 cm;
max. diam. 18.5 cm;
(smaller half) hgt. 7.7 cm
max. diam. 17.7 cm

Color: Translucent brownish colorless; blue,
pale blue, red, pink, green, yellow,
and white enamel; gilt

Technique: Free blown; tooled; enameled; gilded;
worked on the pontil

Description: This tray stand is formed by two bell-
shaped sections, one slightly larger
and taller than the other, joined at
their tops. There is a large ring at the
attachment of the two halves; the rims
at the base of the two sections fold
outward. The decoration is similar on
both halves: regardless of which half is
used as the foot, the design is oriented
logically on the part that is being used
as the foot and is upside down on the
other part. Outlined in red and filled
principally in gold, the decoration
(from bottom to top) consists of a
lower band with scrolling leaves set
against a blue background, followed
by a larger section enclosing three
concentric medallions, each including
the emblem of a bow and two arrows
painted in green with red details. Each
of the spaces between the medallions
of the larger half depicts a *simurgh* in left
profile with open wings and a large
floating tail; the smaller part presents
colorful peonies painted in tones of
blue, red, pink, green, yellow, white,
and gold. The upper band shows a
series of animals painted in gold—
gazelles, lions, sphinxes, griffins,
hares, bears, and other quadrupeds—
walking in right profile in random
order. The compressed section where
the two parts join is gilded.

Condition: The object is intact. The surface is in
good condition; some of the gilding
has vanished, while the enamels
are in pristine condition. The glass
includes scattered small bubbles
and some large ones.

This unique enameled object is a straightforward example of the transfer of metalwork models to other media—here, glass. A substantial number of silver-inlaid brass tray stands from the Mamluk period consist of two truncated conical halves joined at the top, so that one half serves as the foot and the other provides a horizontal support for a large circular tray, many of which are also found today in public and private collections.[72] Trays were used to carry food from the kitchen to the dining room, and tray stands functioned as portable tables that could be stored easily when not in use. All these inlaid metalwork trays—some of them anonymous, others dedicated to Mamluk amirs, others made for the Rasulid sultans of Yemen—are easily datable to the long reign of Sultan Nāṣir Muḥammad ibn Qalāūn (r. A.H. 693–741 / A.D. 1293–1341, with brief interruptions).

Based on comparisons with its inlaid metal counterparts, the present enameled glass object is clearly a tray stand, although it is unique and no large glass tray has survived that might prove it was functional. Like similar metal objects, it can be attributed to the late thirteenth century or the first decades of the fourteenth. The decoration also supports this dating, since it includes elaborate and accomplished flying *simurghs* with long ribbonlike tails, blooming multicolored peonies, and sequences of walking animals, all of which were part of the traditional Mamluk repertoire, especially in the last decade of the thirteenth century and the first two decades of the fourteenth.

The presence of the emblem of a bow with two arrows further supports this dating but, unfortunately, does not narrow it down or help to identify with certainty the amir for whom this tray stand was made. Only one other example of the same emblem has been reported—on a ceramic potsherd in the Museum of Islamic Art, Cairo. In the fragmentary inscription there, the name of the amir is given as Baktamur, who has been tentatively identified as the *silāḥdār* (Keeper of the Sword) Baktamur ibn ʿAbdallāh, an amir of Sultan Qalāūn and of his son Muḥammad, who died in A.H. 703 / A.D. 1304.[73] It has been surmised, however, that "there were several amirs of this name" and that the emblem would be more appropriate for a *bunduqdār* (Keeper of the Bow) than for a *silāḥdār*.[74] Indeed, a similar emblem, showing two addorsed bows without arrows, is found on a mosque lamp made for the mausoleum in Cairo of the *bunduqdār* Aydakīn (d. A.H. 684 / A.D. 1295).[75] Although it is not possible to prove that this tray stand was commissioned by an amir named Baktamur, there is little doubt that it was produced during the Mamluk period for a *bunduqdār* of one of the first Mamluk sultans. An extraordinary and accomplished piece, it stands today in splendid isolation among the creations of Mamluk glassmakers.

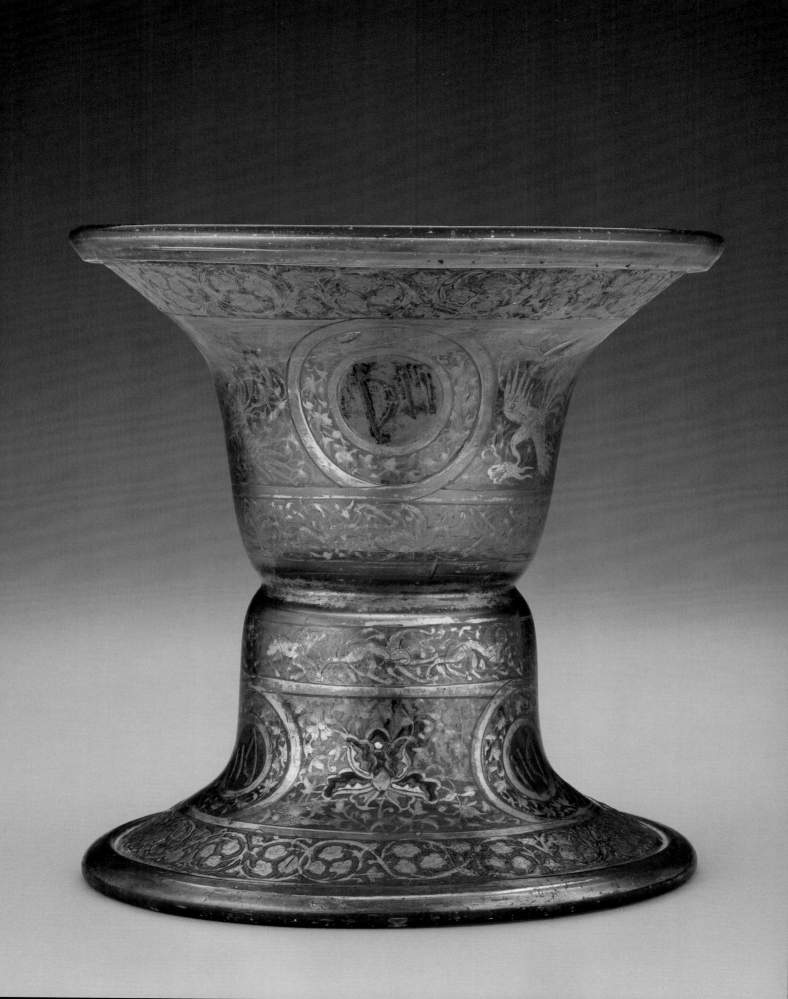

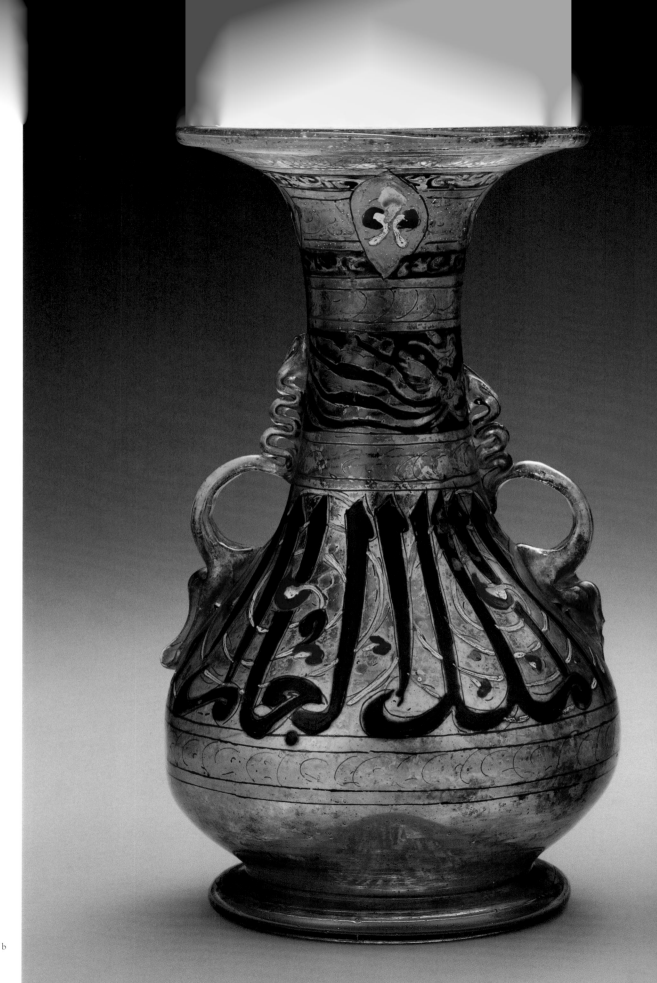

Cat. 98a, b

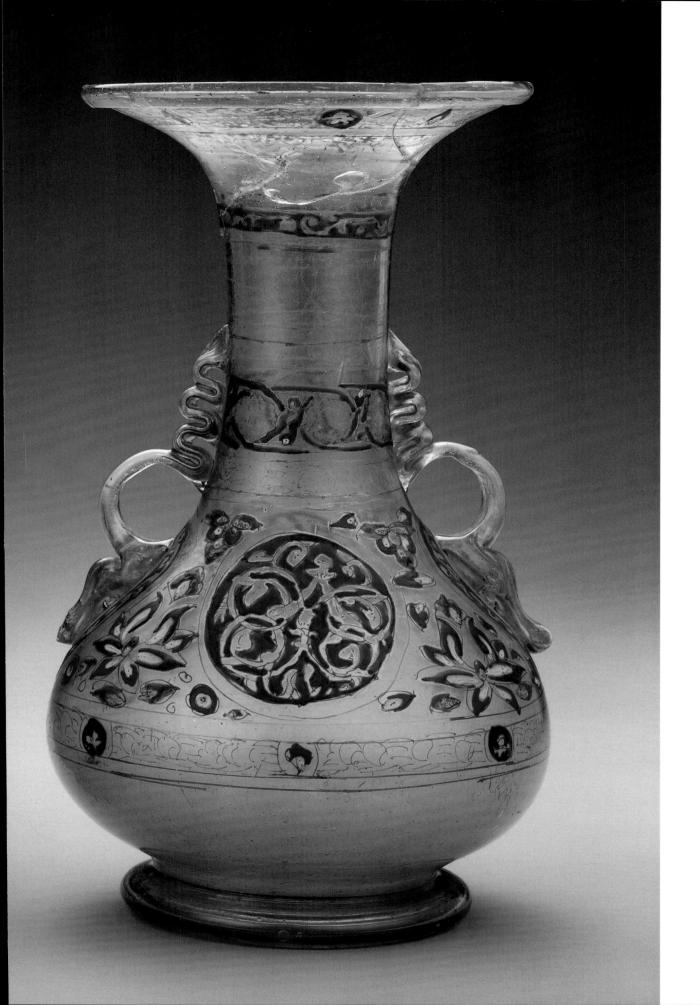

## Cat. 98a HANDLED VASE (LNS 69 G)
### Syrian or Egyptian region
### Early 14th century

Dimensions: hgt. 29.0 cm; max. diam. 17.0 cm;
th. 0.82 cm; wt. ca. 1000 g;
cap. ca. 2000 ml

Color: Translucent brownish colorless; blue,
red, green, and white enamel; gilt

Technique: Free blown; tooled; applied; enameled;
gilded; worked on the pontil

Description: This large piriform vase has a long,
slightly flared, cylindrical neck with a
large splayed opening. A foot ring was
applied under the kicked base and two
round handles with protruding wavy
trails were attached on either side
where the body meets the neck. A
large inscriptional band in blue letters,
outlined in red and divided into two
sections by the handles, dominates the
decorative program; the inscription,
in bold *thuluth* script, reads:
عز لمولانا السلطان / الملك العالمـي
("Glory to our Lord the Sultan, the
King, the Learned"). The inscription
is set against a background of white
vegetal spiral scrolls highlighted with
touches of red and green enamel.
A narrower band around the neck
includes two stylized *sīmurgh*s with
long ribbonlike tails, on either side
of the neck, in gold against a blue
background. The remainder of the
decoration, divided into horizontal
narrow bands, is sketchier and fills the
spaces between the two main bands,
below the neck, and near the base.
Below the opening on either side of
the handles are two almond-shaped
medallions, each filled with a single
flower.

Condition: The object is intact. The surface is
in good condition; some gilding and
flakes of blue enamel are missing.
The glass includes frequent bubbles.

Provenance: Comtesse de Béhague, Paris

Literature: Qaddumi 1987, p. 116; Atıl 1990,
no. 64; and Stierlin 1996, p. 92

The unusual shape and large size of these two-handled vases (cat. 98a, b) make them rare examples of monumental Mamluk glass. Their rarity is underscored by the absence of parallels in other media, either metalwork or pottery, though it has been suggested that they imitate the shape of Chinese Longquan celadon vases and that at least one Mamluk blue-and-white ceramic version exists.[76] These vases are, therefore, exclusive and original products of Mamluk glassmakers. Their shape is a loose variation of the typical mosque lamp (see cat. 99, 100), in which the neck becomes longer and narrower and ends in a splayed mouth while the tall foot turns into a supportive base. The circular handles are also reminiscent of the suspension rings of lamps. It is clear, however, that these vessels were containers for liquids and not lamps, since the shape of the neck is not suitable for the latter function.

The six known objects that comprise this group of large handled vases (cat. 98a, b and Related Works 1–4) are virtually identical in profile, applied parts, and technique, though their dimensions vary (Related Works 1 and 2 are 37.8 centimeters and 30.2 centimeters high, respectively). While their decoration differs, it always falls within the established canons of Mamluk glass painters.

The vase in the Metropolitan Museum (Related Work 1) presents the best match for cat. 98b. The division of the main area of the body is similar, showing a large central medallion filled with vegetal motifs at either side of the handles; the appealing peonies at either side of the medallions of cat. 98b, however, are replaced by simple cartouches. On the other hand, the principal decorated band around the neck of Related Work 1 includes the inscription *al-'ālim* ("the learned") twice, whereas the design of the same area of cat. 98b is simpler and sketchier.

The vase in Cairo (Related Work 4) represents a good match for cat. 98a and b: the text of the inscription, though confined to a narrower band and consequently less prominent, is the same as that of cat. 98a. A large medallion intercepts the inscription on either side of the handles, while the *sīmurgh* depicted around the neck of cat. 98b is replaced by two walking quadrupeds in profile.

The bold inscription of cat. 98a finds a good parallel in the splendid object in Corning (Related Work 2), although the latter's inscriptional band is less prominent and includes

only the word *al-ʿālim* (thus also linking it to the decoration of Related Work 1) repeated several times around the body and intercepted by two circular medallions. The remainder of the decoration of the Corning vase is truly spectacular—large horizontal bands filled with colorful and well-executed complex vegetal patterns or with symmetrical schools of fish cover the entire surface. The decorative program is completed by multicolored peonies and by six-petaled rosettes in gold against a red background. Compared to the lavish decoration of Related Work 2, cat. 98a is closer in style and general ornamental character to cat. 98b and to Related Works 1 and 4.

The decoration of the vase in Apt (Related Work 3) stands apart from that of the other five: the division in bands is abandoned in favor of an overall pattern of large flowers and leaves, which includes the typical Mamluk peony in profile as well as a fantastic open flower, seen from above, that looks like a hybrid carnation/daisy. Also unique to this vase is the colored background: the vegetal patterns, outlined in red, are entirely gilded and set against a blue background that covers the surface of the object, thus giving the false but deliberate impression that it is made of blue glass.[77]

The peculiar shape and construction of the six vases forming this small group suggest that they were made in the same workshop (or in neighboring ones) in a relatively short period. The best clue as to their date is the presence of the white-on-red six-petaled rosette on the Corning piece (Related Work 2), which has tentatively been identified as the emblem of Kāfūr al-Rūmī, a governor of the fortress of Damascus who died in A.H. 684 / A.D. 1285.[78] The six-petaled rosette certainly belongs to the early Mamluk period (and probably to the late Ayyubid as well), and its presence on an object guarantees that it was made within the first two decades of the reign of Nāṣir Muḥammad ibn Qalāūn—that is, between about 1310 and 1315. The swimming fish and the multicolored peonies help confirm this *post quem* dating. The Corning vase is probably the earliest object of the group (late thirteenth century), judging by its decorative program. The four pieces that share decorative elements (cat. 98a, b, and Related Works 1, 4) were all produced around the beginning of the fourteenth century. The object in Apt represents the end of the production of these spectacular vessels, probably in the third quarter of the fourteenth century.

## Cat. 98b VASE (LNS 6 G)
### Syrian or Egyptian region
### Early 14th century

Dimensions: hgt. 30.2 cm; max. diam. 18.0 cm; th. 0.67 cm; wt. ca. 1150 g; cap. 2500 ml

Color: Translucent brownish colorless; blue, red, yellow, green, and white enamel; gilt

Technique: Free blown; tooled; applied; enameled; gilded; worked on the pontil

Description: This large vase is similar to cat. 98a. The decoration of the main area consists of a central round medallion filled with a complex vegetal pattern in gold against a blue background; the area outside the medallion, enclosed by narrow horizontal bands on top and bottom and by other bands drawn around the handles, includes a large multicolored peony on either side of the medallion and smaller flowers that fill the available space. The rest of the decoration, divided into narrow horizontal bands, includes a band with interlaced polylobed figures near the base of the neck and others enclosing sketchy vegetal motifs.

Condition: The upper part of the neck, including the opening, was broken and repaired; the remainder of the object is intact. The surface is in good condition, though most of the gilding has vanished and the yellow and white enamels are slightly corroded. The glass includes frequent small bubbles and some large ones.

Literature: Bamborough 1976, p. 98; and Florence 1993, p. 322

Related Works: 1. MMA, inv. no. 91.1.1531
2. CMG, inv. no. 55.1.36 (Lamm 1929–30, pl. 179:8; and Charleston 1990, no. 32)
3. Cathedral treasury, Apt (Magne 1913, fig. 12 [right]; Bussagli–Chiappori 1991, pl. 12; and Rogers 1998, fig. 17.2)
4. Gazira, inv. no. 172 (Cairo 1969, pl. 30)

## Cat. 99 MOSQUE LAMP (LNS 5 G)
**Probably Egyptian region**
**ca. 1319**

Dimensions: hgt. 26.2 cm; max. diam. 21.2 cm;
th. 0.43 cm; wt. ca. 1250 g;
cap. ca. 2800 ml (excluding the neck)

Color: Translucent brownish colorless; blue,
red, yellow, green, and white enamel;
silver stain; gilt

Technique: Free blown; tooled; applied; enameled;
gilded; worked on the pontil

Description: This flattened globular lamp has a long
flared neck and six small suspension
rings applied at even intervals around
the upper body. On the neck, two
narrow horizontal bands (hgt. ca.
2.5 cm), enclosing floral scrolls outlined
in red and filled with gold, frame a
wider band (hgt. 7.6 cm) containing an
inscription in blue *thuluth* script on a
background of large scrolling patterns.
The wider band is intercepted by three
circular medallions (diam. ca. 7.5 cm),
each enclosing a floral band with an
emblem at the center that is divided
into four horizontal sections painted
(from top to bottom) in silver stain
(an orange yellow film), red enamel,
gold, and (probably) white enamel.
A narrow band (hgt. ca. 1.9 cm) under
the base of the neck includes a row of
blue, red, and white peonies alternating
with red, yellow, and white six-petaled
flowers amid a vegetal background. The
main band (hgt. ca. 6.0 cm) contains
a large gilded inscription against a
blue background. The underside of
the body includes two narrow bands
(hgt ca. 1.1 cm) framing a band (hgt.
ca. 6.7 cm) filled with vegetal patterns
that incorporates three medallions
depicting the same emblem described
above and three large peonies framed
by smaller flowers at the corners.
The vessel is inscribed on the neck:

هذا ما اوقفه المقر/الكريم العالي
/المولوي الا . . .؟

("This is what the Noble, the Elevated,
the Master, the . . . endowed . . .");
and on the body:

برسم الجامع المعمو/ر بذكر الله تعالى
/الشرفي امير حسين ابن /حيدر بك امير
شكار/الملكي الناصري ا/عز الله انصاره

(". . . for the mosque—built in praise
of God the Highest—of the noble amir
Husayn ibn Haydar beg, the Amir of
the Hunt of al-Malik al-Nāsir, may
God glorify his followers").

Condition: The foot is missing; the remainder of
the object is intact. The surface is in
good condition, though the gilding has
largely vanished and the enamels are
slightly corroded, especially inside the
medallions. The glass includes frequent
small and large bubbles.

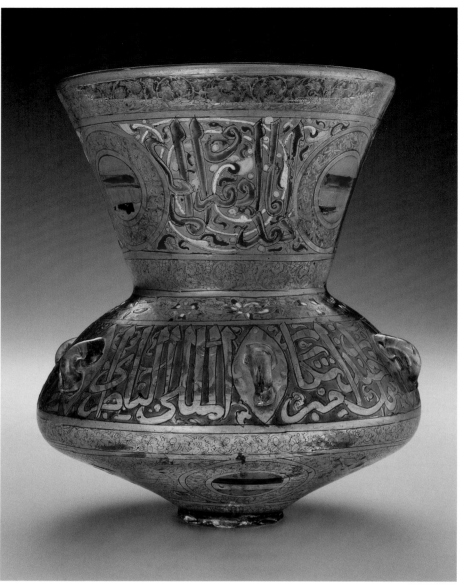

Cat. 99

This mosque lamp was commissioned by Ḥusayn ibn Abī Bakr ibn Ismāʿīl ibn Ḥaydar beg Mushrif al-Rūmī, an amir of Nāṣir Muḥammad ibn Qalāūn, who, according to al-Maqrīzī, had come to Egypt from Anatolia with his father, Abū Bakr, in A.H. 675 / A.D. 1276–77 to join the staff of Ḥusām al-Dīn Lājīn al-Manṣūrī before the latter became sultan in A.H. 696 / A.D. 1297.[79] The inscription on the body of the lamp indicates that it was meant for, and subsequently endowed to, a mosque that Ḥusayn had erected in Cairo. This mosque is extant and an inscription over the entrance mentions that the building was finished in A.H. 719 / A.D. 1319.[80] The amir died about ten years later, on Muharram 7, 729 (November 11, 1328).[81]

By the beginning of the fourteenth century, Mamluk enameled mosque lamps had attained their definitive shape (a flattened globular profile, tall neck, and truncated conical foot), large dimensions (always more than 25 centimeters, and often close to 40 centimeters, in height) and restrained palette based principally on red enamel for outlines and blue enamel and gold for the larger areas (the depiction of emblems sometimes required additional colors). The decorative program of these lamps includes large inscriptions within

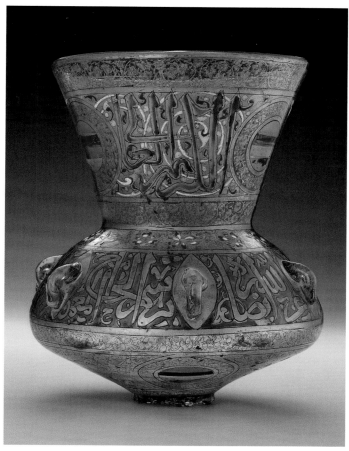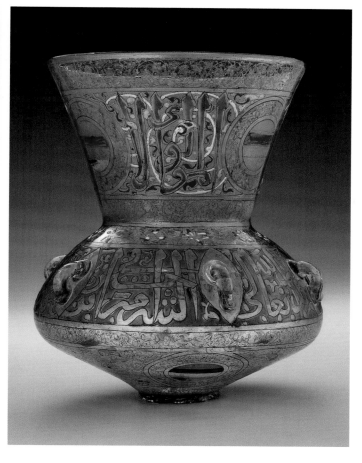

Cat. 99 alternate views

horizontal bands; the entire surface is covered with narrower bands filled with vegetal patterns. Since many amirs commissioned such lamps for the buildings they erected and endowed, the emblem of their office would also figure prominently within the larger bands.

Amirs often stipulated that these luxurious, expensive objects carry both their emblem and their name; the latter is often included in lengthy inscriptions—at once explanatory and eulogistic, in praise of God and of the reigning sultan—that begin around the neck and continue on the body. Cat. 99 falls within this category and represents one of the few extant enameled lamps datable according to the building for which it was commissioned.[82] Its inscription also offers the previously unrecorded information that Ḥusayn was Amir of the Hunt (*amīr shikyār*),[83] and it is possible to infer that the emblem of this particular office was represented by a field divided into four colored horizontal sections. Ḥusayn's *isnād*, as given by al-Maqrīzī, shows that, in the small space allotted to the inscription on the lamp, he used the patronymic of Ḥaydar beg, his great-grandfather, rather than that of Abū Bakr, his father, probably to emphasize his Anatolian origins.

**Cat. 100a FORTY-THREE FRAGMENTS, PROBABLY FROM FOUR MOSQUE LAMPS**
(LNS 256 Ga–z; LNS 257 Ga–n)
Egyptian region (Cairo)
ca. 1349–55

Color: Translucent grayish brownish colorless; blue, red, white, and grayish black enamel; gilt

Technique: Free blown; enameled; gilded

Description: The decoration, shapes, and curves of these fragments of similarly colored glass indicate that they belonged to at least four, and possibly five, lamps of similar dimensions and general characteristics.[84] Some of the fragments were joined during conservation, but the vessels are too fragmentary to reconstruct. Fragments 256a–h are from the same lamp.[85]

A gilded inscription outlined in red against a blue background appeared on the upper body and medallions enclosing a depiction of a footed cup in red enamel stood between two red bands on the underside. Fragments 256a–e and 256f–g have been joined; a suspension ring is extant on 256b. Fragments 256i–n are from a second lamp. As with the first, the object had a gilded inscription against a blue background, but the vegetal motifs and palette of the decoration between the medallions differ. Fragments 256i–k and 256l–m have been joined. A third lamp is represented by fragments 256o–s: again, the inscription was against a blue background but the lower part is unlike that of the previous lamps. Fragments 256o–r have been joined; 256r has an attached suspension ring. It was not possible to join fragments 256t–v with others from the previous three groups, nor does the legible decoration allow them to be assigned to any of the previous groups. Their inscriptions do, however, suggest that they belonged to one of the three fragmentary lamps described above. Fragments 257a–c and 257d–e have been joined; they clearly come from a fourth lamp, since the main inscription was copied in blue enamel against the glass background filled with scrolling motifs.

Fragments 256x and 257f–m (257f–g have been joined) evidently belonged to the neck of one or more lamps—six of them include part of the rim, the other three are shaped and decorated accordingly. It is not possible to determine whether they belonged to the four lamps so far identified or to others, since a relation between the body fragments and these neck fragments

cannot be established. The only rim fragment that stands out for its inscription—in reserve inside a round blue medallion—is 256x; all the others show either inscriptions in blue or medallions including the usual red cup.

Fragment 257n is the largest of the group and comprises part of a foot and a base, including the attachment between the two parts of a lamp. Once again, its scant decoration makes it impossible to say if it is the foot of one of the four lamps discussed above. The six fragments 256w, y, z and 257n–q—the first a foot shard, the others body shards (257q includes a suspension ring; 257o and p have been joined)—are the remaining floating pieces of this puzzle.

Condition: The surface of some fragments is partially weathered, resulting in a milky white film, some discoloration of the enamels, and the disappearance of the gilding.

Provenance: Kofler collection; gift to the Collection

All forty-three fragments (cat. 100a) belonged to lamps that hung from either the mosque or the *khānaqāh* and tomb of Shaykhū, one of the most powerful Mamluk amirs. Sayf al-Dīn Shaykhū al-ʿUmarī was born a mamluk of Nāṣir Muḥammad ibn Qalāūn at the beginning of the fourteenth century and eventually became the first amir to be given the highest title of *al-amīr al-kabīr* (Great Amir) by the sultan Ḥasan as a reward for helping him regain the throne. The powerful Shaykhū, who had numerous enemies, was murdered in A.H. 758 / A.D. 1357 when he was about fifty years old.[86] His public office and personal wealth allowed him to erect a complex in Cairo that included two facing buildings with similar plans—a mosque and a hospice for mystics (*khānaqāh*), where his tomb was placed. The mosque was finished in 1349–50; the *khānaqāh* was completed in 1355. Both buildings were furnished with numerous enameled mosque lamps ordered, in all probability, from local glassmakers.

The lamps from Shaykhū's buildings were among those taken down and treasured by European and American collectors in the second half of the nineteenth century, just before Egyptian authorities decided to store all those that remained in what would become the Museum of Islamic Art, Cairo. For this reason, only two lamps and a fragmentary neck are presently in the Cairo museum and many other examples are either in public collections in Western countries or unaccounted for. The most complete list was compiled by Lamm, who identified a total of nineteen lamps.[87]

It is likely that a number of lamps were broken during the rush to collect them from Shaykhū's buildings. The four, or perhaps more, fragmentary lamps identified in the Collection are probably part of that damaged lot. It is evident that they belonged to the "Shaykhū" group from the remaining legible inscriptions, the emblem that appears on them, and their shared characteristics, as described above. Two adjoining fragments (256o–r, 257o, p) reveal part of an inscription with the name Shaykhū. With no exceptions, all the remaining legible words, and parts thereof, on the other fragments match the recurrent inscriptions on all intact lamps (see, for example, 256a–g and 256s–v): *bi-rasm al-maqarr*

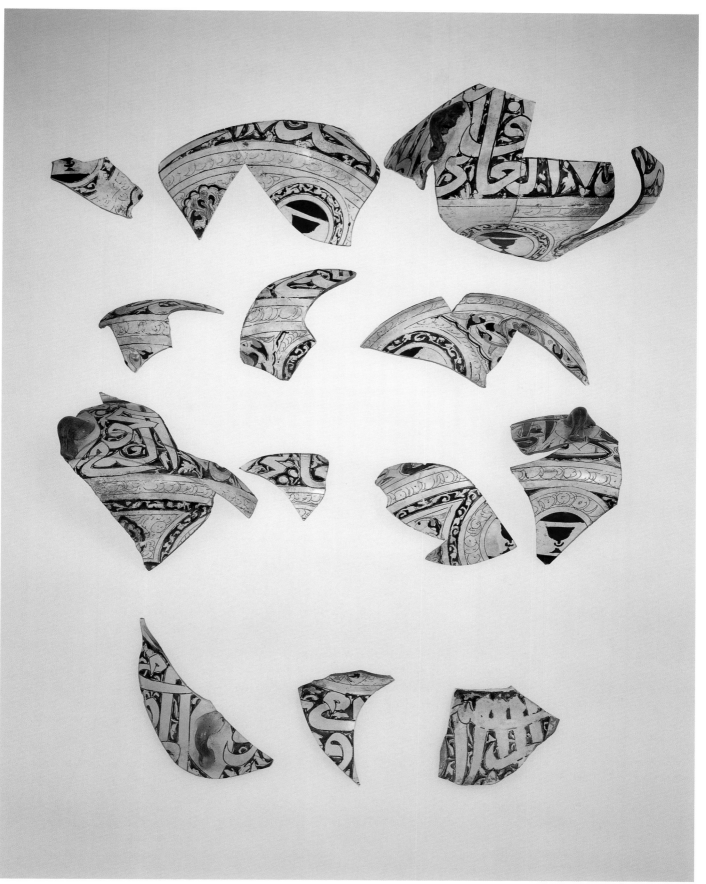

Cat. 100a

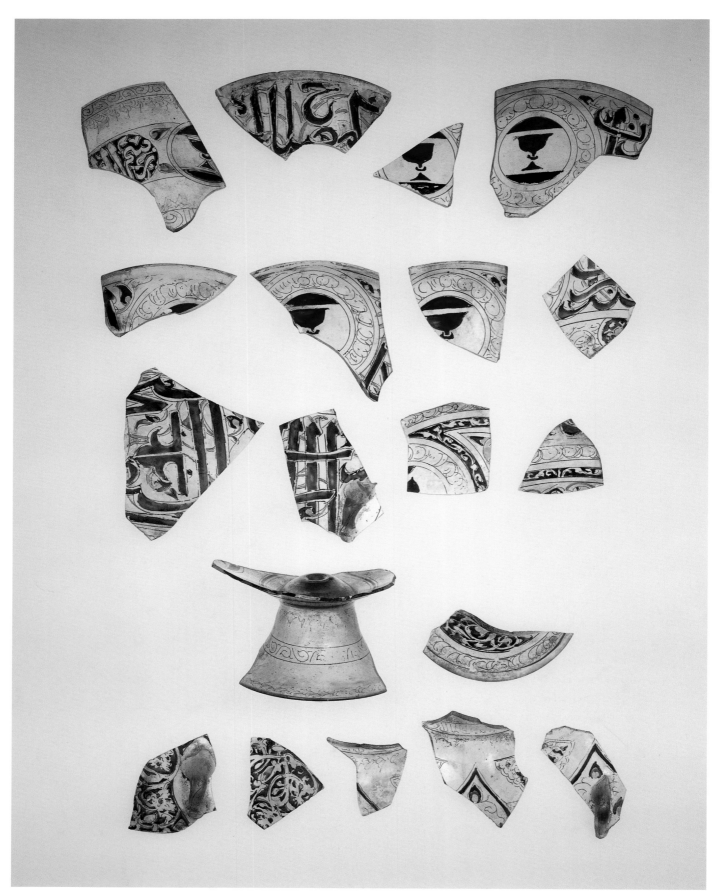

Cat. 100a–c

*al-ashraf al-ʿālī al-mawlawī al-makhdūmī al-sayfī shaykū* ("For the excellency, the most noble, the high, the lord, the well served, Sayf al-Dīn Shaykhū"). Most of the inscriptional fragments from the lamp neck also accord with the inscriptions on the majority of intact objects: they include words from the well-known Sura of the Light (Qurʾan 24:35), one of the texts most copied on mosque lamps. Further analysis of the inscriptions reveals that, for the most part, they are identical to those on the other lamps made for Shaykhū: the Qurʾanic inscription on the neck was filled in blue enamel; the main text on the body was outlined in red, filled with gilding (now largely vanished), and set against a blue background. Only a few fragments represent an exception to the general type: the inscription on fragments 257a–e and n–p, from the body of one lamp, is in blue enamel instead of the usual gold; the neck fragment 256x includes the beginning of the text "Made for the [excellency]" written against a blue background inside a medallion (this text is usually found on the body of the lamp).

The emblem depicted on many fragments is identical to that found on all the other lamps: a red cup against a gilded, or uncolored, field in the center, a red band in the upper field, and a black or dark-colored band in the lower field (see, for example, 257h). The emblem of a cup is usually attributed to the office of *sāqī*, or cupbearer, at the Mamluk court. In this case, however, it is not recorded in Arabic sources that Shaykhū ever held this particular office among his many titles. It is, however, possible that the symbol of the cup acquired a different, extended significance under the reign of Nāṣir Muḥammad ibn Qalāūn, when Shaykhū began his outstanding career.

Much less can be said about the other fragments (cat. 100b and c), since the decoration of these two lamps does not allow a precise identification. Both groups still include a suspension ring and it is possible to partially reconstruct the profile of cat. 100c, since these fragments include the transition between the neck and the body of the lamp. Only vegetal motifs remain and it is unlikely that these lamps ever included inscriptions. Stylistically, cat. 100b, with its dense scrolling vegetation and impressionistic flowers, seems to fit into Lamm's "Ḥasan group"—that is, those lamps produced during the reign of the sultan Ḥasan (r. A.H. 748–52 and 755–762 / A.D. 1347–51 and 1354–61).[88] It should, therefore, be roughly contemporary with the objects made for Shaykhū (cat. 100a). The large undecorated areas and scant decoration of cat. 100c find good parallels in lamps produced for the sultan Shaʿbān (r. A.H. 764–78 / A.D. 1363–77), though such an attribution must remain tentative, since similar examples can also be attributed to the 1350s.[89]

**Cat. 100b TWO FRAGMENTS OF
A MOSQUE LAMP
(LNS 195 Ga, b)
Egyptian region (Cairo)
Mid-14th century**

Dimensions: (larger fragment) max. w. 9.1 cm; max. l. 7.3 cm; th. 0.34 cm
Color: Translucent brownish colorless; blue, red, white, green, and yellow enamels; gilt
Technique: Free blown; enameled; gilded
Description: These two fragments belonged to the body of the same mosque lamp. LNS 195a includes a suspension ring applied within a pointed oval medallion. The dense vegetal enameled decoration, visible on both fragments, is outlined in red against a blue background and includes polychrome enameled flowers and gilded scrolls.
Condition: The surface is partially weathered, resulting in a milky white film and the disappearance of the gilding. The glass includes scattered small bubbles.
Provenance: Kofler collection; gift to the Collection

**Cat. 100c THREE FRAGMENTS OF
A MOSQUE LAMP
(LNS 196 Ga–c)
Egyptian region (Cairo)
Third quarter of the 14th century**

Dimensions: (largest fragment) max. w. 10.9 cm; max. l. 9.0 cm; th. 0.36 cm
Color: Translucent brownish colorless; blue, red, white, pink, green, and yellow enamel; gilt
Technique: Free blown; enameled; gilded
Description: These three fragments belonged to the same mosque lamp. LNS 196b and c are from the neck and part of the body; the body shard LNS 196a has an attached suspension ring. The decoration around the suspension ring consists of a pointed medallion framed by a blue line and filled with red-and-pink and green-and-yellow flowers; polylobed sections filled with polychrome enamels occupy the space between each medallion. A narrow pseudo-inscriptional band at the base of the neck is sketchily drawn in red.
Condition: The surface is lightly weathered, resulting in a milky white film, iridescence, and the disappearance of the gilding. The glass includes frequent small bubbles.
Provenance: Kofler collection; gift to the Collection

**Cat. 101 DECANTER (LNS 3 G)**
**Egyptian or Syrian region**
**Mid-14th century**

Dimensions: hgt. 41.0 cm; max. diam. 20.0 cm;
th. 0.48 cm; wt. ca. 900 g;
cap. ca. 2300 ml

Color: Translucent greenish colorless;
blue and red enamel; gilt

Technique: Free blown; tooled; applied; enameled;
gilded; worked on the pontil

Description: This large decanter, standing on
an attached tall splayed foot, has
a flattened body with an angular
shoulder; the long neck tapers slightly,
incorporates a flattened bulge, and then
flares. The decoration on the upper
body consists of three blue and gold
multilobed medallions outlined in red.
Within each medallion is the sketchy
image of a lion attacking a gazelle;
the two animals are arranged one
above the other—facing left and right,
respectively—and both are painted in
gold against a blue background. The
areas between the medallions include
small polylobed medallions and
pseudovegetal motifs outlined in red
and filled with gold. The neck is
decorated in horizontal bands, two of
which—at the base and just below the
bulge—enclose vegetal scrolls against
a blue background; the remainder is
sketchily drawn in red outlines and
filled with gold. The underside of the
body and the foot are not decorated,
though a red line on the body suggests
that the decoration has vanished.

Condition: The object is intact. The interior is
heavily weathered, resulting in a milky
white film and gray pitting. The gilding
has mostly vanished, but the enamel is
in good condition. The glass includes
frequent large bubbles.

Provenance: Collection Loo, Paris

Literature: Lamm 1929–30, pl. H; Qaddumi 1987,
p. 117

Related Works: 1. MFI, inv. no. 4261
(Pinder-Wilson–Ezzy 1976, no. 135)
2. ROM, inv. no. 924.36.2
(Lamm 1929–30, pl. 140:1)
3. DIA, inv. no. 30.416 (Atıl 1985,
no. 50; and Higashi 1991, no. 59)
4. Hermitage, inv. no. TB-50 and a
second one (Lamm 1929–30, pl. 162:3;
and Kramarovsky 1998, pl. 22.1)
5. CMA, inv. no. 44.488
(Hollis 1945, fig. 1)
6. MMA, inv. no. 36.33 (Dimand 1936,
fig. 1; and Jenkins 1986, no. 49)
7. MAD, inv. no. 4422
(Lamm 1929–30, pls. 181:8, 188)
8. Louvre, inv. no. A.O. 3365
(Paris 1977, no. 344)
9. FGA, inv. no. 34.20
(Washington 1962, fig. 87; and
Daum 1987, p. 218, bottom)

Large bottles with a long neck bulging in the middle, a compressed globular body, and a tall splayed foot are among the most popular vessel shapes produced between the late Ayyubid period and the first century of Mamluk rule. A remarkable number survive intact and in good condition and some bear inscriptions that date them with some degree of accuracy. The earliest bottle, presently in Cairo (Related Work 1), dates to the Ayyubid period, as it seems to have been dedicated to Ṣalāḥ al-Dīn Yūsuf (r. A.H. 634–58 / A.D. 1236–60), the last ruler of Aleppo. Although it is by no means the first vessel of this type to have been created, this bottle can be regarded as a sort of prototype for similar vessels produced in the Mamluk period, since its basic features remained unchanged for decades: an elegant and well-proportioned profile, with an effortless transition between the body and the tapered neck; a flattened bulge, about three-quarters of the way up the neck, which divides it into a slightly tapered section and a flared one; and a tall splayed foot that imparts an imposing stance to the object.

Slightly less graceful in profile, but exhibiting a similar decorative program, is a nearly contemporary (probably ca. 1250–75) smaller bottle in Toronto, said to have been found in a mosque in the Shaanxi province in China (Related Work 2).

A more marked transition between body and neck and a more angular profile characterize Related Work 3, which was commissioned from Mamluk glassmakers for the Rasulid sultan al-Mu'ayyad Dā'ūd ibn Yūsuf (r. A.H. 696–721 / A.D. 1296–1321) around the turn of the fourteenth century. The general organization of the decoration is close to that of the Cairo bottle (Related Work 1), including the historical inscription copied in a rather nondescript gilded *naskh* that goes almost unnoticed compared to the rest of the decoration.

Two decanters, presently in St. Petersburg (Related Work 4), were excavated near Maykop, in the northern Caucasus. The lower half of the bodies is flat and the profiles have lost their soft, rounded elegance; furthermore, the decoration consists of large figures (mounted horsemen in one case, a convivial scene in the other, which includes a depiction of this type of decanter among various libation objects) that are usually associated with the first decades of the Mamluk period.[90]

Another variation in profile is offered by a bottle (Related Work 5) probably made early in the reign of the sultan Nāṣir Muḥammad ibn Qalāūn to whom it is dedicated; it has a wide round body and a bulging neck.

During the fourteenth century this type of bottle increased in size and changed in shape. The average height often reaches 50 centimeters (Related Works 6–9) and the profile of the lower part of the body becomes almost flat, often resulting in a nearly domed shape (Related Work 6). A date in the second quarter of the fourteenth century for these decanters is provided by the inscriptions on objects in Paris and Washington (Related Works 8, 9), which are dedicated to the viceroy of Syria, Tuquztimur (in office A.H. 743–46 / A.D. 1342–45) and to the Rasulid sultan al-Mujāhid (r. A.H. 721–64 / A.D. 1321–63), respectively. These two objects share decorative compositions in which the historical inscriptions are prominently displayed inside a main horizontal band.

A bolder and more conspicuous inscription, unfortunately containing only a generic dedication to a sultan, is featured on a decanter in Paris (Related Work 7); the style of both calligraphy and decoration suggests a date in the first quarter of the fourteenth century.[91]

A bottle in New York (Related Work 6) provides the best parallel for cat. 101. It lacks an inscription, but includes a band of running animals around the base of the neck and lobed motifs enclosing the image of a bird of prey attacking a duck in the main band. Apart from small polychrome flowers, the decoration is based on a play between blue and gold

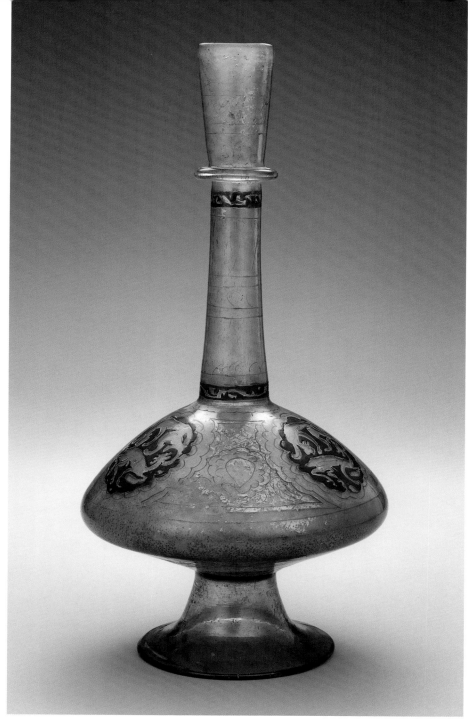

Cat. 101

(the latter has now disappeared) and on sketchy patterns outlined in red that fill the rest of the surface. Cat. 101, which has an almost identical profile, presents a simplified version of the same decorative composition: the small polychromatic elements have disappeared and only blue, red, and gold remain; the lobed medallions include an animal scene (a lion pouncing on a gazelle); and the remainder of the surface is filled with sketchy motifs outlined in red. An attribution to the middle of the fourteenth century—probably about 1350—seems the most likely for both decanters. This dating is supported by the similar decorative program of a large bottle (though of different shape) in the Victoria and Albert Museum that bears the emblem and title of Sayf al-Dīn Jurjī, an officer under four Mamluk sultans whose career flourished between 1347 and 1370, the year of his death.[92]

## NOTES

1 See, for example, the many surviving mosque lamps (see cat. 99, 100) that were ordered for or by sultans and amirs to light their mosques and madrasas. About 200 to 250 of these lamps are in good condition today and about half of them are inscribed with the patron's name.

2 A lamp in the Metropolitan Museum of Art (inv. no. 17.190.991; see Mexico City 1994, pp. 184–85) and another in the Museum of Islamic Art in Cairo (inv. no. 3154; see Wiet 1912, pp. 122–24, pl. 8), both dated 1329–30 and destined for two different buildings in Cairo, bear a signature on their foot. The name of the artist, copied in hurried *naskh* script on both lamps, has been read as either 'Alī ibn Muḥammad Āmakī (on the object in Cairo), al-Ramakī (or al-Zamakī, as it seems to read on the lamp in New York), or Ibn Makkī. The most likely reading of this artist's *nisba* is al-Barmakī.

3 The "Luck of Edenhall"—named after the family who owned this beaker, which was reputed to bring good fortune if not broken—is in the Victoria and Albert Museum, London (inv. no. C1-1959; see Liefkes 1997, pl. 25). In 1861, the Cavour Vase passed from the hands of Camillo Benso, count of Cavour, to Marchese Carlo Alfieri di Sostegno, who bequeathed it to the Italian royal family; it is presently in the collection of Sheikh Saud Bin Mohammad Ali al-Thani in Qatar (see Newby–Sheppard 1991; and Newby 1998). The pilgrim flask donated in 1365 by Duke Rudolf IV of Hapsburg to the Collegiate Chapter of St. Stephen's Cathedral in Vienna is in the Erzbischöfliche Dom-und Diözesanmuseum, Vienna (inv. no. L-6; see Saliger 1987, pp. 22–24).

4 The conference, "Gilded and Enameled Glass from the Middle East," was held at the British Museum in April 1995; the proceedings are published in Ward 1998.

5 See the discussion at cat. 85, note 24.

6 In particular through the research of Julian Henderson (Henderson–Allan 1990; and Henderson 1998).

7 See, for example, a bowl in the Gemeentemuseum, The Hague, inv. no. OG-13.1932 (London 1976, p. 143, no. 137). A candlestick in excellent condition is in the Corning Museum of Glass, inv. no. 90.1.1 (*JGS* 33, cover). For a general survey on the relation between glass and metalwork, see Ward 1998a.

8 For the Cavour Vase, see note 3 above. The best-known sphero-conical vessel is in the Victoria and Albert Museum, London, inv. no. C153-1936 (Newby 1998, pl. 10.1).

9 The pilgrim flask in the British Museum, London (inv. no. OA69.1-20.3), was published in Ward 1998, pl. E. For the second flask, in the museum of St. Stephen's Cathedral in Vienna, see note 3 above.

10 The horn, presently set in a later European gilt-silver mount, is in the Hermitage, St. Petersburg (inv. no. V3.827; see Rogers 1998, pl. 17.1).

11 The best preserved tazzas are in the Freer Gallery of Art, Washington, D.C. (inv. no. 58.16; see Washington 1962, figs. 74–77), and the Toledo Museum of Art (inv. no. 70.56; see Hoare 1971, fig. 6; and *Glass Collections* 1982, p. 166).

12 The emblem of the amir Shaykhū (cat. 100a), which includes a grayish black band in the lower field, demonstrates the survival of some enamel colors in practical applications.

13 This comparison is not intended to be specific, especially with regard to manuscript painting, since there was no clear relation between glass workshops and book ateliers (see Ettinghausen 1962, esp. pp. 84–121). The parallel with *mināī* pottery, produced in central and northwestern Iran from the mid-twelfth to the early thirteenth century, is more intriguing because the technique of overglaze painting employed on these ceramics, which required a second firing, is similar to glass enameling. Although it is still uncharted territory from a scholarly point of view, the possibility that *mināī* pottery and its figural decoration in some way influenced the earliest Syrian glass enamelers bears investigating.

14 Lamm 1929–30, esp. p. 254; see also Whitehouse 1991, pp. 44–45.

15 Peonies became common on inlaid metalwork around the beginning of the fourteenth century (see, for example, Atıl 1981, nos. 19, 25, 26). Lavishly illuminated Qur'an frontispieces, especially from the 1330s to the 1370s, included this motif (see James 1988, figs. 98, 141, 142).

16 Another notable—and unique—exception is a Chinese-style feline depicted on a well-known bottle in the Museu Calouste Gulbenkian, Lisbon (inv. no. 2370; see Lamm 1929–30, pp. 420–21, pl. 187; and Ribeiro–Hallett 1999, no. 10).

17 The al-Sabah Collection also includes a large number of fragments, most of which were formerly owned by Ernst Kofler and acquired principally in Lebanon. Because the Collection is so extensive in this area, this chapter is unique in that it presents only a selection of the most meaningful fragments. The unpublished fragments are, however, listed in the Appendix.

18 A selection is found in Harden et al. 1987, nos. 147–51, pp. 259–62.

19 Verità (1998, p. 130) quotes a fifteenth-century manuscript in Bologna that describes glass enameling in Venice, which owed much to the techniques used in the Islamic world: "Finely powdered enamels were washed and applied on to the beakers, which were then placed in the cold end of the annealing chamber and pushed slowly and gradually towards the heated zone of the lehr. Once the required temperature had been reached, the beakers were re-attached to the pontil, placed at the mouth of the furnace and heated until the enamels were evenly spread and shining. The vessels were then annealed. This complicated process required the skill of a glassmaker and implies that the characteristics (i.e. melting temperatures) of the enamels did not allow their simple firing in a muffle kiln." Mamluk glassmakers probably tried to obtain "soft" enamels—that is, enamels rich in lead that would fuse at lower temperatures and reduce the risks of vessel collapse (see Freestone–Stapleton 1998, pp. 126–27; and Gudenrath [unpublished]).

20 Some scholars have dismissed Mamluk glass as being of inferior quality; see, for example, Irwin 1997a, p. 154, fig. 120.

21 Crizzling is caused by a defective proportion of the ingredients in the batch, in particular an excess of alkali, resulting in a network of fine internal cracks. Eventually, the glass becomes "diseased" or "sick," deteriorates, and crumbles (see Newman 1977, p. 81, s.v. "crisselling").

22 For a recent study of beaker shapes, see Kenesson 1998.

23 Tait 1998, pp. 51–53.

24 See, for example, three beakers in Berlin (Lamm 1929–30, pls. 141:4, 141:5; and Ricke 1989, no. 82).

25 See Schmidt 1912, pl. 26; Lamm 1929–30, pls. 163:4–7; 164:1, 164:2, 164:6, 164:7; 174:13–16; and Paris 1989, no. 85.

26 The beaker, on loan to the Freer Gallery of Art, Washington, D.C., from the Gellatly collection (LTS 1985.1.170.8), is described and illustrated in Carboni 1999, pp. 173–74, figs. 3, 4.

27 The "Beaker of Charlemagne," in the museum at Chartres, and the "Beaker of the Eight Priests," formerly at Douai and destroyed during World War II (see Lamm 1929–30, pls. 96:1, 3; and Rouen 1989, no. 123).

28 For example, beakers with a flared profile were more popular in Syria than the other type, according to the excavations at Hama (Riis–Poulsen 1957, esp. pp. 82–92).

29 Lamm 1929–30, pp. 297–348, pls. 112–41.

30 Ibid., pls. 127, 129, 130.

31 Al-Qazvīnī writes that on the "Island of the Blind People" in the Sea of Zanj (along the east coast of Africa) the pygmies are blinded by cranes that thrust their beaks in their eyes. Al-Qazvīnī reports that Aristotle tells of cranes that come from Khurasan and fly along the Nile until they reach the island of the pygmies (Carboni 1992, p. 116, n. 99, no. 69). Stories in illustrated manuscripts of the *Kalīla wa Dimna* may also have influenced the scene on the beakers (see Grube 1991, pp. 154, 156, 163).

32 Inv. nos. 47.17, 47.18. See Carswell 1998; and Atıl 1981, nos. 44, 45.

33 Bottles or bowls, which were probably meant to match the beakers in a set, also included flying cranes, as is evident from cat. 86d–f; for the neck from a bottle with flying cranes, see Lamm 1929–30, pl. 130:1.

34 A beaker with large figures also includes the emblem of Baybars I, a feline, thus confirming this attribution (Lamm 1929–30, pl. 130:2).

35 Inv. nos. GLS 578a–c; see Lucerne 1981, no. 631; and Amsterdam 1999, no. 169.

36 The dimensions of the three beakers in the Khalili collection are, respectively, hgt. 12.5 cm, 15.8 cm, and 18.0 cm; max. diam. 8.4 cm, 11.4 cm, and 12.7 cm.

37 Royal Ontario Museum, Toronto (inv. no. 924.26.1). The bottle is said to have been acquired in China (Lamm 1929–30, p. 347, pl. 140:3).

38 See Irwin 1997, which is based on contemporary sources. Kumiss was a favorite drink of Sultan Baybars I (r. A.H. 658–76 / A.D. 1260–77) and of Barqūq (r. A.H. 784–801 / A.D. 1382–99). A passage by the chronicler Ibn Iyās quoted in Irwin (p. 149) reads: "The sultan began to drink *qūmiz* . . . and the kings had a custom of doing that. The sultan gave orders that the amirs should assemble every Wednesday and Sunday in the *maydān* below the citadel and drink *qūmiz*, and that was one of the rituals (*sha'ā'ir*) of the realm."

39 The last Crusaders were driven out of Acre (Akkon) in 1291. Little by little, their presence in present-day Lebanon, Israel, and Palestine diminished, especially after the establishment of the Mamluk dynasty and the many campaigns against the Christians led by Sultan Baybars I.

40 See Newman 1977, s.v. "Castle Eden claw-beaker" and "Claw-beaker"; Bussagli–Chiappori 1991, p. 115; and Tait 1991, fig. 130.

41 This large fragment (inv. no. 2384) is of heavily weathered green glass. The author is grateful to Dr. Sultan Muhaysin and Mona Mouazzin for allowing access to the storage area.

42 In heraldry, the Latin cross is also called the Passion cross; see, for example, Fox-Davies 1993, p. 128.

43 On Christian images on inlaid metalwork, see New York 1997, no. 283, pp. 424–26. The only discussion of Christian figures on enameled glass is in Carswell 1998.

44 When the Crusaders, in particular the Teutonic Knights, started to withdraw from the Holy Land, they bought and commissioned Venetian enameled glass beakers, a new product on the market, inspired from the technical point of view by Mamluk enameled glass; see Carboni 1998.

45 For the first (inv. no. 41.150), see Jenkins 1986, no. 48;

for the second (inv. no. I.2573), see Berlin 1979, no. 515, pls. 10 and 72; and Ward 1998, pl. 21.6.

46  Hermitage, inv. no. TB-50 (Kramarovsky 1998, pl. 22.1).

47  Inv. nos. OA691-20 and L-6, respectively; see Porter 1998, pls. D, E; and note 4.

48  Schmoranz 1898, pp. 43–44, pl. 30; Ziffer 1996, p. 53, fig. 32; and Christie's, London, sale, December 14 2000, lot 15.

49  See note 17.

50  Female musicians are usually illustrated in this manner; see, for example, a miniature from the Vienna *Maqāmāt* manuscript of 1334 (Atıl 1981, p. 250, fig. 6).

51  On the rhyton, see Rogers 1998, pl. 17.1. The bottle is discussed in Gibson 1983, pp. 39–40 and illustrated in color in Fehérvári 1987, pl. 122.

52  Examples of sequences of animals on inlaid metalwork are endless; for a survey, see Baer 1983, pp. 175–80.

53  See Mayer 1933; Meinecke 1972 and 1974; and Leaf 1983.

54  See Carboni 1993, p. 280, note 31; and Gierlichs 1993, esp. pp. 27–29.

55  Inv. no. OA 1978.12-30.686; see Ward 1993, fig. 87. On Badr al-Dīn Baysarī, see Mayer 1933, p. 112.

56  The fragmentary lamp (inv. nos. 4065, 5880–82) is datable to 1339–40; see Wiet 1912, pl. 9; and cat. 100.

57  Mayer 1933, pp. 14–15.

58  Meinecke (1972, pp. 236–38) attributes this emblem to the sultan Lājīn himself (r. 1296–98) and to a number of amirs in the first half of the fourteenth century; Mayer (1933, p. 17) suggests that it could identify the office of the dispatch-rider (*barīdī*).

59  Riis 1953, pp. 295–96, fig. 1.

60  For example, it was used by a certain 'Alī ibn Hilāl al-Dawla (d. 1338), an inspector of monuments and later superintendent of chanceries, whose name included the word Hilāl, which also means "crescent" in Arabic (Mayer 1933, p. 54; and Riis 1953, p. 298). Meinecke (1972, p. 229) identifies the crescent as the emblem of a woman, Fāṭima bint Sunqur al-A'sar, in 1309.

61  For other inscriptions, see cat. 92, 95a, and 98–100.

62  The Qur'an is in the British Library (inv. no. Add. 22406-13); for pages copied in *thuluth* with colored fillings, see James 1988, figs. 19, 20, 26, 27.

63  The Cavour Vase is the most spectacular object of this group (see Newby–Sheppard 1991; and Newby 1998).

64  A small perfume sprinkler of flattened globular shape in dark blue glass with a festooned decoration in pale blue trails and gilt, presently in the Metropolitan Museum of Art (inv. no. 1972.118.42) provides a good example of enameled objects imitating marvered models (Jenkins 1986, no. 45).

65  The objects in Corning and London are inv. nos. 71.1.14, and C139-1937, respectively; see also Venice 1993, no. 189, pp. 323–24.

66  See, for example, Chapter 1, note 32, for earlier parallels.

67  A few seventeenth- or eighteenth-century objects of Iranian or Turkish origin, usually small elongated bottles with long necks, can be compared to the present fragments (for an example in the Metropolitan Museum, see Jenkins 1986, no. 55).

67  See al-Basha 1957, p. 307.

68  See cat. 85, esp. note 26. Related Work 3 (a perfume sprinkler with a long neck), however, includes an image of three entwined fish, which may be interpreted as an emblem proper. The object has an inscription, included in two horizontal bands and stylistically related to that on cat. 95a, dedicated to an amir who held the office of *dawādār* (Keeper of the Pencase) in the early Mamluk period.

69  Related Work 2 has been tentatively attributed, based on different colored diagonal lines below the lion, to al-Manṣūr al-Muḥammad, an official from Hama in Syria who died in 1284 (see Atıl 1985, p. 128).

70  The dragon usually represents the eighth planet, Jawzahr, or *al-tinnīn* ("The Dragon"), which had special talismanic, magical, and therapeutic functions and was often associated with the image of the moon. Since Jawzahr represents the lunar nodes of modern astronomers, the dragon's head can be identified with one of the two nodes, *ra's al-tinnīn*, or "Head of the Dragon"; see Hartner 1938; Farès 1953, pp. 20–34 and pl. 1; Carboni 1992, pp. 476–79; and Carboni 1997, pp. 7, 22–23.

71  An enameled and gilded glass bowl with the twelve signs of the zodiac is in the Toledo Museum of Art (inv. no. 41.37); for a few examples in metalwork, see Carboni 1997, nos. 1, 3, 4, 17.

72  For example, four tray stands and four large trays acquired by the Metropolitan Museum of Art in 1891 (inv. nos. 91.1.528, .568, .598, .601; 91.1.602, .603, .604, .605; see Mexico City 1994, pp. 212–13; and Carboni 1997, nos. 4, 17).

73  Inv. no. 2537; see Mayer 1933, p. 98.

74  Ibid., p. 14.

75  Ibid., pp. 83–84. The lamp is in the Metropolitan Museum of Art (inv. no. 17.190.985; see Jenkins 1986, no. 47; and *MMA* 1987, pp. 51–52).

76  Museum of Islamic Art, Cairo; see Rogers 1998, pp. 72–73, esp. nn. 43, 44.

77  These unusual features have led to the improbable suggestion that the Apt vase is a fifteenth-century Venetian product inspired by original Mamluk vessels (Magne 1913, p. 23; and Bussagli–Chiappori 1991, p. 12). This attribution was revised by Rogers (1998, p. 72), who correctly assigned it to the Mamluk period.

78  Mayer 1933, pp. 135–36. The emblem is also on a lamp in the Victoria and Albert Museum (inv. no. 6280-1860; see Lamm 1929–30, p. 443, pl. 200:2).

79  Al-Maqrīzī 1853–54, vol. 2, pp. 306–7, as quoted in Creswell 1959, p. 270.

80  The mosque is described in Creswell 1959, pp. 269–70. For the inscription, see van Berchem 1894–1903, pp. 169–70; and *RCE* 14, p. 133. According to al-Maqrīzī (see note 79), Husayn was a charitable man who also built a bridge and opened a postern gate in Cairo.

81  Creswell 1959, p. 270.

82  There are also two lamps in the Museum of Islamic Art, Cairo (Wiet 1912, pls. 8, 13).

83  Neither Mayer (1933) nor Meinecke (1972) includes Ḥusayn ibn Ḥaydar beg and his emblem. The division into four horizontal bands seems to have been used only by this amir. The term *shikyār* (Turkish) or *shikār* (Persian) means "chase," "hunt," or "prey."

84  A proper description of this large number of fragments was possible thanks to the painstaking work of conservator Lieve Hibler-Vandenbulcke, who examined, sorted, and joined those fragments that belonged together in March 1997.

85  Although the fragments were originally assigned two accession numbers, LNS 256 G and LNS 257 G, they are described here together, since some catalogued under the former belong instead under the latter. They will be described here by the numerical prefix of their accession number followed by the letter assigned to each fragment.

86  See Mayer 1933, p. 202; and *EI²*, vol. 3, p. 239, s.v. "Ḥasan."

87  Lamm (1929–30, pp. 449–51) lists Shaykhū's lamps in the Metropolitan Museum of Art, New York; British Museum and Wallace Collection, London; Petit Palais and Musée du Louvre, Paris; Baron Stieglitz Museum, St. Petersburg; Museum of Islamic Art, Cairo; and Kunsthistorisches Museum, Vienna, in addition to others in private collections in London and Paris, two of which are presently in the Fitzwilliam Museum, Cambridge, and the Los Angeles County Museum of Art. A lamp in the Toledo Museum of Art, which entered the museum in 1923, was not mentioned by Lamm. Wiet (1912, pp. 92–93, 138–39, 146, 165–66) and Mayer (1933, pp. 202–5) list only eleven lamps.

88  For parallel examples from the period of Ḥasan, see Wiet 1912, pls. 25–27, nos. 278–80; and Lamm 1929–30, p. 467, no. 169, pl. 194:5.

89  For lamps made for Sha'bān, see Wiet 1912, pls. 59–60, nos. 265–67. An earlier lamp of similar type, presently in the Benaki Museum, Athens, is datable about 1345 (Clairmont 1977, no. 484, pp. 132–33, pl. 29).

90  Lamm (1929–30, p. 375) dates the bottle with horsemen about 1300, a dating that is fairly accurate. The decoration, however, points to the third decade of the thirteenth century (see, for example, cat. 89, 90). The second bottle is unpublished.

91  Lamm (1929–30, p. 421) suggests a date about 1360.

92  Mayer 1933, pp. 134–35. The bottle in the Victoria and Albert Museum, London (inv. no. 223-1879), is published in Schmoranz 1898, p. 40, pl. 25.

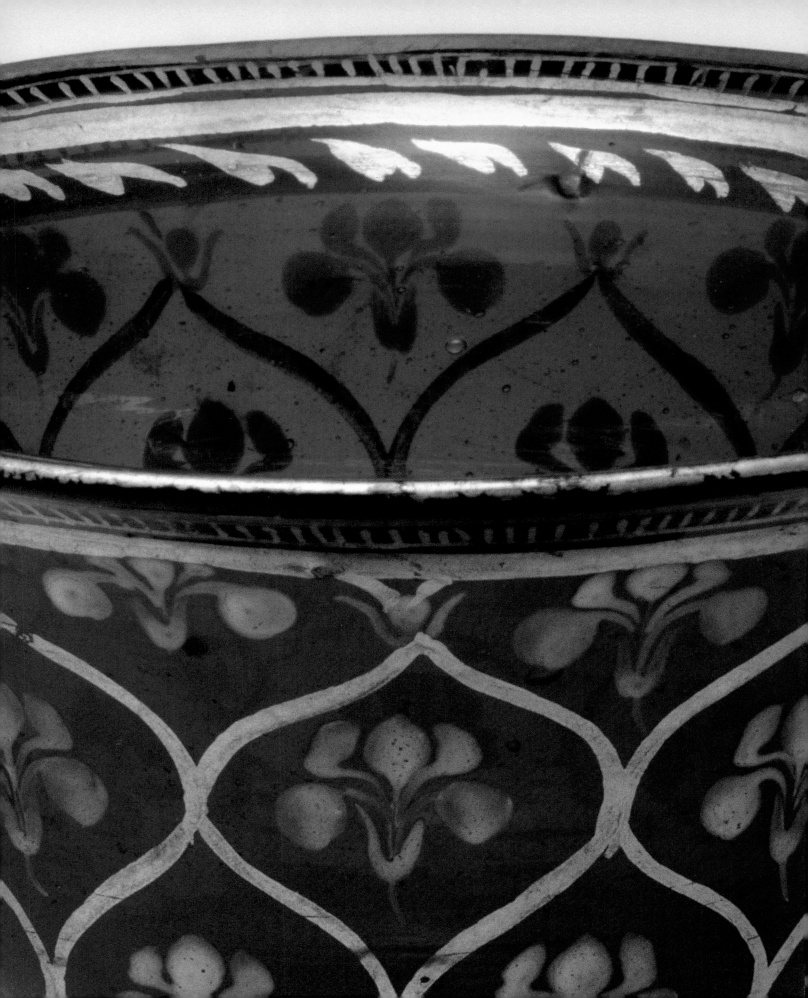

# 5

# THE REVIVAL OF GLASS IN THE ISLAMIC WORLD:
# THE EUROPEAN CONNECTION

## (ca. 17th to 19th century)

THIS CHAPTER IS BROADLY DIVIDED into three parts, each dealing with the production of glass in one of the three political areas that divided the Muslim world after the sixteenth century—the Safavid (then, Zand and Qajar), Ottoman, and Mughal empires.

The common thread that links glass production in the Islamic world in this later period is the presence and direct influence of European glass. By the end of the Mamluk period, at the beginning of the sixteenth century, the direction of the glass trade reversed and Venice became the leading producer and exporter of this commodity to the Muslim areas.[1] Fine Venetian products, many of them specifically made for the Asian market, became the fashion of the time at the Safavid and Ottoman courts after local glassmaking had almost come to a halt—at least as far as high-quality glass was concerned—in both the Iranian and the Syro-Egyptian regions. The influence of the Serenissima Republic was far-reaching and apparently played a role in the establishment of new glass factories in Shiraz at the end of the seventeenth century.

Venice was also influential in Mughal India, but it was English and central European glass—Dutch in particular—that became responsible for the Islamic glass revival in the seventeenth century. Mughal glass, especially in its surface decoration, reached a level of achievement that distinguishes it from the rather average Iranian and Ottoman glass.

Toward the mid-eighteenth century Venice lost its importance on the political and commercial scene and Bohemia took its place as leader and main partner of the Muslim empires in the glass trade. In the Ottoman capital of Istanbul, however, the flood of Venetian and Bohemian glass prompted the establishment of the Beykoz factories at the end of the eighteenth century in a deliberate attempt to create local high-quality glass, although scientific and technical advice inevitably had to be sought from their "rivals."

The history of Islamic glass in this later period is, therefore, one of strong commercial influence, European trade, local revivals that rose to high standards in only limited areas, and national pride in a world that was becoming smaller day by day.

**Cat. 102a BOTTLE (LNS 433 G)**
**Iranian region (probably Isfahan)**
**17th century**

Dimensions: hgt. 37.0 cm; max. diam. 17.0 cm;
max. w. 9.5 cm; wt. ca. 730 g;
cap. ca. 800 ml

Color: Translucent pale green (green 2)

Technique: Free blown; tooled;
worked on the pontil

Description: This large bottle has an irregular
piriform shape and a flattened body.
The base has a deep, almost conical
kick and a large pontil mark. The long
neck (ca. 22 cm) tapers to an irregularly
shaped, bulged opening and a rim that
folds inward. The longer sides are
tooled at the base, so that the bottle
does not stand upright but rather at
a 45-degree angle (it is more stable
on one of the two sides).

Condition: The object is intact. The surface is
partially weathered, resulting in a pale
brown coating, iridescence, and some
corrosion. A line of milky white residue
that looks horizontal when the bottle
is tilted confirms that the object was
meant to stand in that position. The
glass includes scattered small and large
bubbles.

Composition: $Na_2O$: 15.2; $MgO$: 3.1; $Al_2O_3$: 0.8;
$SiO_2$: 66.0; $SO_3$: 0.2; $Cl$: 1.0; $K_2O$: 2.9;
$CaO$: 9.6; $MnO$: 0.1; $Fe_2O_3$: 0.5

Provenance: Sotheby's, London, sale, October 16,
1997, lot 42

Related Works: 1.  MK, Frankfurt, inv. no. 2297
(Ohm 1973, no. 93)

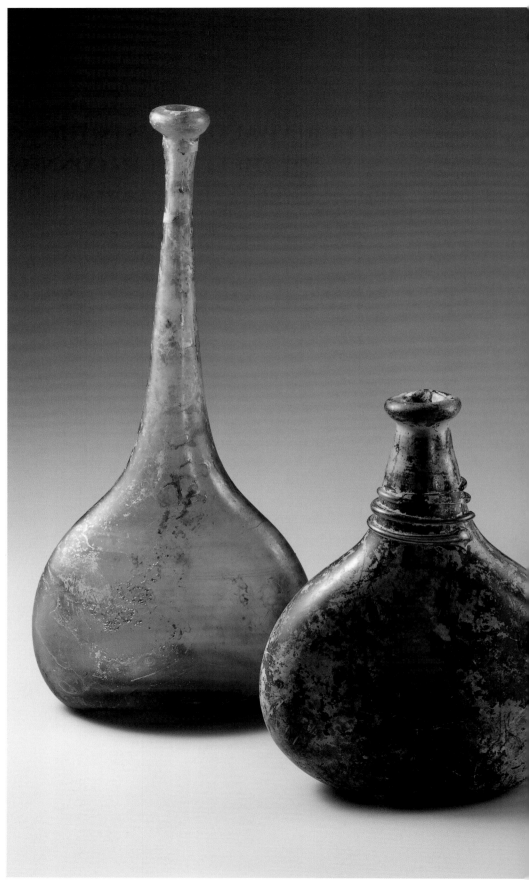

Cat. 102a–c

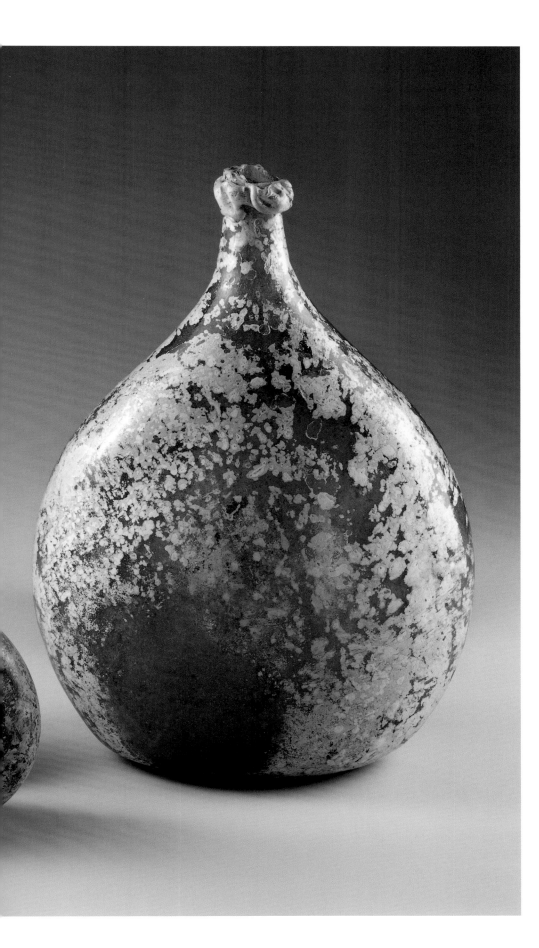

## Cat. 102b  WINE BOTTLE (LNS 1374 G)
**Iranian region**
**(Isfahan, Shiraz or Qumm)**
**18th century**

Dimensions: hgt. 21.5 cm; max. diam. 18.2 cm; max.
w. 7.8 cm; wt. ca. 1250 g; cap. ca. 660 ml

Color: Translucent green (green 4)

Technique: Free blown; tooled; applied;
worked on the pontil

Description: This ovoid bottle has a flat base and
a flattened body. The base has a deep
kick and a large pontil mark. The
short neck tapers to an irregularly
shaped and bulged opening and a rim
that folds inward. The decoration
consists of an applied trail encircling
the base of the neck.

Condition: The object is intact. The surface is
heavily weathered, resulting in a pale
brown coating, iridescence, and
abrasion.

Composition: $Na_2O$: 16.5; $MgO$: 3.9; $Al_2O_3$: 1.2;
$SiO_2$: 64.5; $SO_3$: 0.2; $Cl$: 0.9; $K_2O$: 2.3;
$CaO$: 8.6; $TiO_2$: 0.1; $MnO$: 0.1;
$Fe_2O_3$: 1.4

Provenance: Reportedly from Afghanistan

Related Works: 2. Whereabouts unknown; formerly
Strauss collection (Lamm 1939,
pl. 1450b)
3. V&A, inv. no. 387.1907
4. MMA, inv. no. 1997.358
5. Rijksmuseum, Amsterdam, inv. nos.
N.M. 5478, N.M. 5479, N.M. 4285,
R.B.K. 14556 (Ritsema van Eck–
Zijlstra-Zweens 1993–95, nos. 359–62)

## Cat. 102c  LARGE WINE BOTTLE
**(DEMIJOHN) (LNS 1071 G)**
**Iranian region (Shiraz or Qumm)**
**18th century**

Dimensions: hgt. 34.5 cm; max. diam. 25.8 cm;
max. w. 12.0 cm; wt. ca. 2100 g;
cap. ca. 5500 ml

Color: Translucent green (green 3)

Technique: Free blown; tooled; applied;
worked on the pontil

Description: This bottle is similar in shape to
cat. 102b. The base has a shallow
kick and no visible pontil mark; the
tapered neck is broken. The decoration
consists of a thick applied and pincered
irregular band (hgt. ca. 2 cm) around
the base of the neck.

Condition: The neck is broken above the applied
band; the remainder of the object
is intact. The surface is entirely
weathered, resulting in a whitish
coating, iridescence, and corrosion.

Composition: $Na_2O$: 15.8; $MgO$: 3.9; $Al_2O_3$: 3.8;
$SiO_2$: 61.2; $P_2O_5$: 0.4; $SO_3$: 0.3; $Cl$: 0.6;
$K_2O$: 5.4; $CaO$: 8.2; $TiO_2$: 0.1;
$Fe_2O_3$: 0.4

Provenance: Reportedly from Khoja Chahar Shanbe,
near Qala-i naw, Afghanistan

Glass production in the Iranian region between the Ilkhanid period (thirteenth and fourteenth centuries) and the seventeenth century remains a mystery. The last objects attributable to the medieval period are twelfth- to thirteenth-century long-necked molded bottles with various patterns (see cat. 66–68). It seems clear, however, that there was a serious crisis, possibly the Mongol invasion in the mid-thirteenth century, that brought production to a halt until it was revived a few centuries later. The popular story that Timur brought back to Samarqand artists and craftsmen from Damascus, including glassmakers, after he had conquered the city in 1401 is not corroborated by historical evidence.[2] By the beginning of the fifteenth century, the manufacture of enameled glass in Egypt and Syria was also quickly declining, thus any attempt (if it ever took place) to move the craft to Samarqand was destined to fail.

The earliest literary sources mentioning glass production in Iran after the medieval period are reports by seventeenth-century European visitors. The travelers Thomas Herbert (1627) and Jean Baptiste Tavernier (1638–63) wrote, respectively, about wine bottles made in Shiraz and of the presence of three or four glass factories in the city.[3] Apparently, Venice played a pivotal role in the revived glass industry in Iran, since its products were widely exported to the Middle East in the Ottoman, Safavid, and Mughal empires. The earliest known record of the export of glass, mirrors, and beads to the Safavid court dates to the late sixteenth century,[4] and the oft-quoted passage of the traveler John Chardin, who wrote between 1666 and 1670 that "the art of glassmaking was introduced in Persia less than eighty years ago," seems to confirm Venice's input at the end of the sixteenth century. Chardin went on to say that "an Italian, poor and avaricious, taught it [glassmaking] at Shiraz for fifty crowns," probably a reference to a Venetian glassmaker who went to Iran in search of fortune.[5]

The Collection includes four objects made in the Iranian region during the late Safavid, Zand, and Qajar periods. The long-necked bottle (cat. 102a) is probably the earliest of the four, since its shape is known from seventeenth-century Safavid paintings. Often, illustrations of single figures or couples set in simple landscapes include objects of courtly pleasures, such as wine bottles and drinking vessels. In a few cases, these vessels are clearly recognizable as being made of glass, since their transparency is revealed by the red liquid—obviously wine—with which they are half-filled.[6] Some of these jugs and bottles have shapes, ribbed decoration, and colored handles and rims that betray their seventeenth-century Venetian or *façon de Venise* origin, but a few plain piriform or globular bottles with long narrow necks and bulging or straight openings can confidently be assigned to the workshops of Shiraz or Isfahan, as described by Chardin. The bulged opening had the practical function of accommodating a funnel to facilitate pouring into the narrow necks from large jars; the opening was closed with a long leather or metal cap halfway down the neck when the bottle was not in use.[7]

The shape and bulged opening of the bottle (cat. 102a) are clearly related to the pictorial examples mentioned above. This rare object, which can only be compared to one bottle (Related Work 1), may therefore be dated to the seventeenth century and probably to Isfahan, since this type of vessel is illustrated in paintings attributed specifically to that city's ateliers. An unusual and surprising feature of this bottle is that its base was tooled so that it does not stand upright but in an inclined position (at about a 45-degree angle). That it was actually kept in this tilted position is confirmed by a line of liquid residue inside the bottle. It is difficult to explain this feature, since such bottles are always shown frontally in illustrations and there seems to be no reason for wine decanters to rest in an inclined

position. Perhaps, they not only held wine but were also used as receiving bottles (*qābila* or *muqābala*) for distillation apparatuses and were tilted in order to receive the narrow pipe of the alembic.[8]

There is no doubt that cat. 102b and c are wine containers, since one bottle that is almost identical to cat. 102b, apparently donated to Queen Anne of Great Britain by a visiting Persian emissary in 1708, still contains Shiraz wine (Related Work 2).[9] This type of bottle is made of rather bubbly dark green glass; it is round in shape, has two flattened sides (similar to the modern Portuguese Matteus wine bottle), a kicked base, a neck that can vary in height but is always decorated with an applied trail, and a thick opening. A number of examples have survived with the same dimensions as cat. 102b (capacity about 660 milliliters)—some with long necks (Related Works 3 and 5, and a bottle carrying the gilded inscripion "Elixir of Life"),[10] others with short necks (Related Work 4). The dimensions of cat. 102c, however, are exceptional (capacity ca. 5500 ml). It must have been a kind of demijohn that was stored in the cellar, its contents poured into smaller bottles for family consumption, or it may have been meant for commercial purposes. John Chardin reported that "the large bottles have the capacity of five small ones, being made of thick glass, and wickered on the outside, to make them less subject to breakage" and that Shiraz wine "is kept in large jars and sold in glass bottles of various sizes, holding from a quart to two or three gallons."[11] These wine containers were probably mass-produced in the glass factories of Shiraz during the eighteenth and nineteenth centuries; similar bottles were also made in Qumm.[12] Indeed, it seems that, judging from the surviving material, bottles and bases for waterpipes were just about the only types of vessels produced in Persia during this period, whereas drinking glasses and beakers, which had to look more sophisticated and be made of clearer glass, were imported from Europe.

Chemical analysis of cat. 102a, b, and c reveals that the first two containers have similar compositions—a sodium plant-ash type of glass—whereas the third has higher levels of aluminum and potassium; all three are well within the ranges expected for Islamic glass. Unfortunately, little compositional information is available on glass from seventeenth- and eighteenth-century Iran, so attributions must rely mostly on written sources.

The decanter (cat. 102d) is representative of a large group of molded vessels, the majority of which are today in Western countries (see Related Works 9–11), where they probably arrived shortly after their creation, toward the end of the nineteenth century. Some of these containers may have functioned as bases for waterpipes (*qaliān*). One of the most common types of molded decoration is represented by that of cat. 102d—a row of stylized cypress trees in high relief framed by vertical ribs. A three-part mold was utilized to produce the diverse shapes, from so-called swan-necked rosewater bottles (sometimes called *ashkdān*)[13] to tall decanters with a slightly flared neck standing on a knobbed stemmed foot, to gracious ewers with an applied glass "butterfly" at the end of the spout, to footless types, such as cat. 102d, with a flared neck and a decorative trail around the base.[14] The best (published) parallels for cat. 102d are provided by examples in Jerusalem, Berlin, and Copenhagen (Related Works 6–8), which are in blue or green glass, illustrating the range of colors employed by Persian glassmakers in the eighteenth and nineteenth centuries. These molded vessels were admired for their graceful shapes and vivid colors and they were often decoratively displayed within niches of private and public buildings in Tehran, Isfahan, and Shiraz as late as the second half of the nineteenth century.[15]

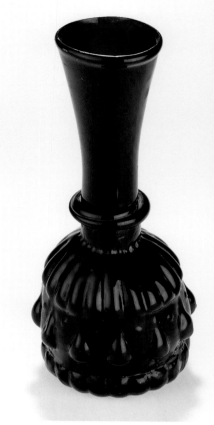

Cat. 102d

**Cat. 102d BOTTLE (LNS 107 G)**
**Iranian region (Shiraz or Isfahan)**
**Late 18th–19th century**

Dimensions: hgt. 28.0 cm; max. diam. 11.2 cm; th. 0.28 cm; wt. 438 g; cap. ca. 1150 ml
Color: Translucent dark brown
Technique: Mold blown; tooled; applied; worked on the pontil
Description: This bottle has an irregular domed body, a flat base with a kick in the center, and a long flared neck. A ring was applied near the base of the neck. The decoration in high relief, created in a three-part mold, consists of a row of twelve stylized cypress trees enclosed within two rows of thick vertical ribs.
Condition: The object is intact. The surface is lightly weathered, resulting in a milky white film. The glass includes scattered small bubbles and some larger ones.
Related Works: 6. MM (Hasson 1979, no. 63)
7. MIK, inv. no. I.7/73 (Kröger 1984, no. 201)
8. DC, inv. nos. 44/1969, 38/1967 (von Folsach 1990, nos. 255, 256)
9. V&A, inv. nos. 695.1884, 103.1877, 105.1877, 106.1887, 885.1889, 923.1889 (Charleston 1989, figs. 16a, d)
10. BM (Lamm 1939, pls. 1451a, c)
11. MMA, inv. no. 91.1.1557 (Jenkins 1986, no. 56)

**Cat. 103a  THICK GLOBULAR VESSEL
(LNS 72 KG)
Probably Turkish region (Istanbul)
16th century**

Dimensions: hgt. 8.3 cm; max. diam. 8.3 cm;
wt. 457.5 g; cap. 100 ml
Color: Translucent dark olive green (green 6)
Technique: Blown; tooled; worked on the pontil
Description: This heavy globular vessel has a
flattened base and a short flared neck.
The diameter of the opening is 1.8 cm.
Condition: The object is intact. The surface is
lightly weathered, resulting in pitting
and abrasion.
Provenance: Kofler collection
Published: Lucerne 1981, no. 584
Related Works: 1. BM, inv. nos. 73.5-2.118, S.337, S.338,
81.12-24.12, 80.8-71, 95.3-22.6,
77.5-15.14, 95.3-22.5 (Rogers
1983, pp. 258–59, pl. 64, nos. 5, 6)
2. V&A, inv. no. C1069-1901
3. Benaki, inv. nos. 3131, 3133
(Clairmont 1977, pl. 35, nos. 518–19)
4. Naval Museum, Istanbul, no. 215
(Bayramoğlu 1976, pl. 12)

**Cat. 103b, c  TWO BOTTLES
(LNS 259 G, LNS 260 G)
Eastern Mediterranean region,
probably Syrian coast
17th–18th century**

Dimensions: b: hgt. 8.8 cm; max. diam. 3.0 cm;
th. 0.18 cm; wt. 16.8 g; cap. 22 ml
c: hgt. 8.4 cm; max. diam. 3.3 cm;
th. 0.17 cm; wt. 24.8 g; cap. 20 ml
Color: Translucent dark blue (blue 5)
Technique: Blown; tooled; possibly worked on
the pontil
Description: These irregularly shaped ovoid bottles
have a square base ending in a glass gob
that represents either a clumsy pontil
mark or a deliberate addition. The
flared necks bulge near the base and
the openings are irregular.
Condition: Cat. 103b is intact and the surface is in
good condition. The interior is coated
with a blackish material that proved to
be a single-grain lead compound with
traces of copper, calcium, and silica
(probably kohl). The glass includes
frequent tiny bubbles. Cat. 103c has
a broken neck (about half is missing).
The surface is partially weathered,
resulting in a milky white film and
abrasion. The glass includes frequent
small bubbles.
Composition: (Cat. 103c) $Na_2O$: 18.4; MgO: 0.7;
$Al_2O_3$: 0.9; $SiO_2$: 67.1; $SO_3$: 0.2;
Cl: 1.1; $K_2O$: 3.7; CaO: 4.4; $TiO_2$: 0.1;
MnO: 0.4; $Fe_2O_3$: 0.5; CuO: 2.1
Provenance: Kofler collection; gift to the Collection
Related Works: 5. Excavations from Tel Erani, Israel
(Brosh 1993, figs. 5–7)

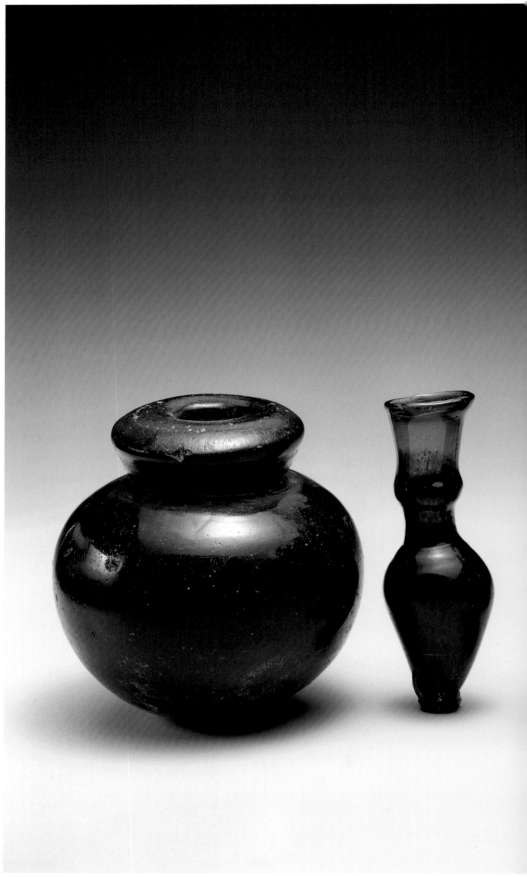

Cat. 103a–d

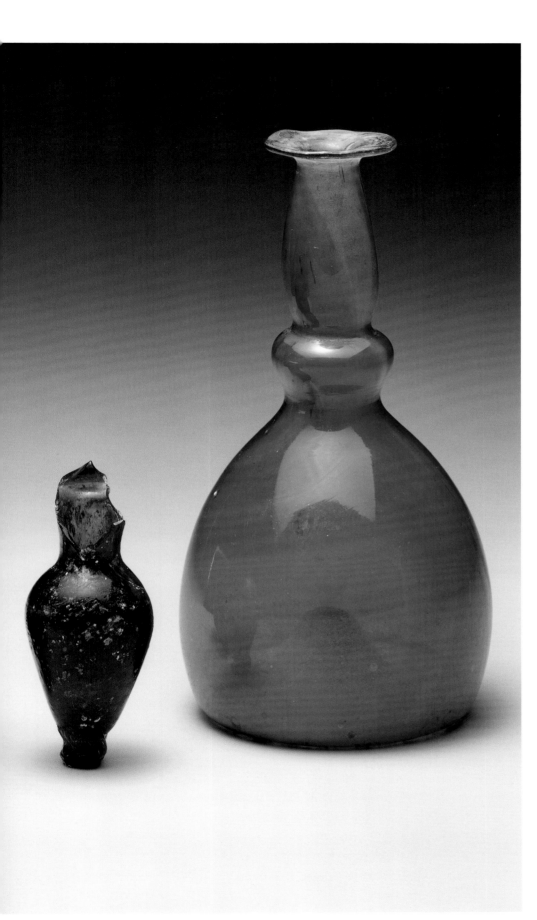

**Cat. 103d BOTTLE (LNS 57 KG)**
**Eastern Mediterranean region**
**18th–19th century**

Dimensions: hgt. 16.5 cm; max. diam. 8.3 cm;
th. 0.22 cm; wt. 94.9 g; cap. ca. 350 ml

Color: Translucent vivid pale blue

Technique: Free blown; tooled;
worked on the pontil

Description: This irregularly shaped domed bottle
has a flat base with a deep conical kick
in the center, a straight neck that bulges
at the base, and a splayed opening.

Condition: The object is intact. The surface is
partially weathered, resulting in a milky
white film especially on the interior.
The glass includes frequent tiny
bubbles, some large ones, and a few
dark streaks.

Composition: $Na_2O$: 19.3; MgO: 0.9; $Al_2O_3$: 1.0;
$SiO_2$: 68.7; Cl: 1.2; $K_2O$: 2.4; CaO: 4.1;
$TiO_2$: 0.1; MnO: 0.1; $Fe_2O_3$: 0.5;
CuO: 1.4

Provenance: Kofler collection

Literature: Lucerne 1981, no. 581

Related Works: 6. V&A, inv. nos. 585.1874, 588.1874,
590.1874, 106.1893
7. MMA, inv. nos. 91.1.1512, .1590,
.1592

The study of Ottoman glass is still in its infancy, since so little remains that can safely be attributed to workshops of Istanbul during the classical period (16th–18th century). Glass was made in Istanbul as early as the reigns of Bayezid II (r. A.H. 886–918 / A.D. 1481–1512) and Süleyman the Magnificent (r. A.H. 926–74 / A.D. 1520–66), as proven by a number of archival documents mentioning lamp-makers, mirror-makers, and windowpanes.[16]

Further evidence is provided by a famous manuscript composed to celebrate the circumcision of a son of Murad III (r. A.H. 982–1003 / A.D. 1574–95) in 1582. Two illustrations from this *Sūrnāma-i humāyūn* show a mobile glass workshop parading in front of the sultan. Some craftsmen are busy blowing and tooling the glass gathers while others are exhibiting finished products, including large long-necked bottles and hourglasses.[17] The painter carefully drew some details of the glassmakers at work as well as the glass objects (for example, he differentiated between blowpipes and pontil rods and between footed and footless bottles), but he ignored others (for example, the bottles are shown partially decorated with molded and twisted ribs, but no molds are visible among the glassmakers' tools). The most striking feature is the exceptional size of the bottles, some of which seem to be half a man's height. The painter, though intending to depict a real event, clearly exaggerated certain aspects.

The *Sūrnāma* painter's overstatement has recently been confirmed by the only archaeological evidence gathered thus far for glass manufacture in Istanbul in the classical Ottoman period. The excavations at the palace of Saraçhane revealed many fragmentary vessels of local production, in particular bottles with a spirally twisted ribbed body and a deep kick that are vaguely reminiscent of those illustrated in the *Sūrnāma*, though their height does not exceed 20 centimeters.[18] Stratigraphic data suggests a sixteenth-century date for these bottles, confirming the evidence provided in the illustrated manuscript. A miniature painting in a manuscript from the period of Sultan Ahmed III (r. A.H. 1115–43 / A.D. 1703–30), dated 1726, accurately reproduces the profiles of small globular bottles with flared necks, further linking illustrations of glass vessels to existing objects.[19]

The excavations at Saraçhane also revealed numerous fragments of glass imported from Venice and the German regions. Judging from the rudimentary quality of the local products from Saraçhane, there is no doubt that fine imported glass was far more common at the Ottoman court than glass made in Istanbul. Archival evidence, as well as extant objects in the Topkapı Saray Museum, confirm the preeminence of imported glass, for which the local production was no match.[20] It was only at the end of the eighteenth century that a factory was established near the site of Beykoz, on the Asiatic side of Istanbul, with the deliberate intention of making high-quality glass and competing with Venice and Bohemia. Some of these wares, known as *çeşm bülbül* (literally "eye of the nightingale"), were initially based on European models, such as the Venetian *vetro a fili*, but later became distinctive and successful in their own right.[21]

One rather neglected aspect of Ottoman glass is the production along the eastern Mediterranean coasts under Ottoman domain. Some workshops must have been active during the classical Ottoman period on what are today the Lebanese, Israeli, and Syrian coasts, though their products were probably close to the rather uninspired bubbly glass that is made today in Egypt, Syria, Lebanon, Israel, and Palestine. Hebron is a good example, since we know that glass bracelets were made in its workshops with some continuity throughout the centuries.[22] It is not known if glass made in the Ottoman territories was of better quality than that produced in Istanbul or if it was actually imported into the capital.

Cat. 103b and c are examples of glass of this type in a traditional shape (the so-called spear flask with a square base and a flared body used for kohl; see, for example, cat. 3.7, 80)

that was popular in the Syrian region as early as the tenth century; they were undoubtedly made in this area. These two bottles can be differentiated from earlier ones by the shape of their base, which incorporates a glass gob, perhaps of decorative, rather than practical, function (unless it represents a large pontil mark that was clumsily cut off). In addition, the glass is quite bubbly compared to medieval examples. A late dating, probably to the seventeenth or eighteenth century, is supported by archaeological finds from graves, such at those at Tel Erani, in southern Israel, that revealed similar vessels (Related Work 5).

A large group of vessels, mainly bottles, that entered public collections toward the end of the nineteenth century (in particular the Victoria and Albert, British, and Metropolitan Museums; see Related Works 6, 7), has not yet been studied but is catalogued by those institutions as "Rhodian," an attribution to the Greek island of Rhodes, situated off the southwestern coast of Anatolia, which was under Ottoman rule from 1523 to 1912. However, in the absence of further information, it is equally possible that it came from the eastern Mediterranean coast and that Rhodes was simply a trading post. This group is represented in the Collection by cat. 103d. The most common colors are deep amber, colorless, and vivid pale blue (as in the present case); these vessels usually present a deep conical kick, thin walls, frequent tiny bubbles, and dark streaks. A peculiar characteristic is that the glass composition is unbalanced and thus the majority of these objects have a sticky surface (the glass "sweats" or is "diseased");[23] in the case of cat. 103d, this process has just begun.

The soda-glass composition of cat. 103c and d differs from that of any other type of Islamic glass. With its relatively low levels of magnesium, aluminum, and calcium and relatively high level of potassium, it matches Venetian and other European glass, as well as European enamels on metal, from the fifteenth to the eighteenth century. This relationship may perhaps be explained by the ongoing trade between Venice and the eastern Mediterranean coast, even before the arrival of the Ottomans, when cullet, or broken glass, was imported to make new glass at lower costs.[24]

Another type of vessel that is commonly associated with the islands of Rhodes and Cyprus because of its reputed provenance is represented by cat. 103a. One of these thick, dark green (sometimes with dark red streaks), globular objects is reported to have been found at Famagusta, Cyprus (Related Work 2); the great majority are said to be from the arsenal of the Knights of Malta in Rhodes, which was captured in 1522 by the Ottomans (Related Work 1); and others were unearthed at excavations on the same island (Related Work 4). The objects belonging to this last group, which consists of twenty-six vessels now in the Naval Museum in Istanbul, have been identified as hand grenades (*humbara*) used during the siege of Rhodes in 1522.[25] If this interpretation is correct and they were carried on the navy's ships sailing from Istanbul, then these objects are with all probability from the Ottoman capital and date to the first quarter of the sixteenth century. Their identification as hand grenades, however, is questionable; as already remarked by Michael Rogers, there is no point in making a hand grenade so thick that it would barely crack on impact no matter which explosive was used.[26] In addition, the extant objects (Related Works 1–4) are neither cracked nor damaged and thus were never used for this purpose.

The dimensions and diameter of the opening of these objects suggest that they were multipurpose. Without excluding the possibility that they were a type of projectile, they may have been used as inkwells (see cat. 33), loom weights, or containers for quicksilver, thick juices, distilled oils, and other liquids,[27] thus relating them to the so-called sphero-conical vessels made of pottery or glass that are the subject of animated discussion among scholars of Islamic art (see cat. 53b).[28]

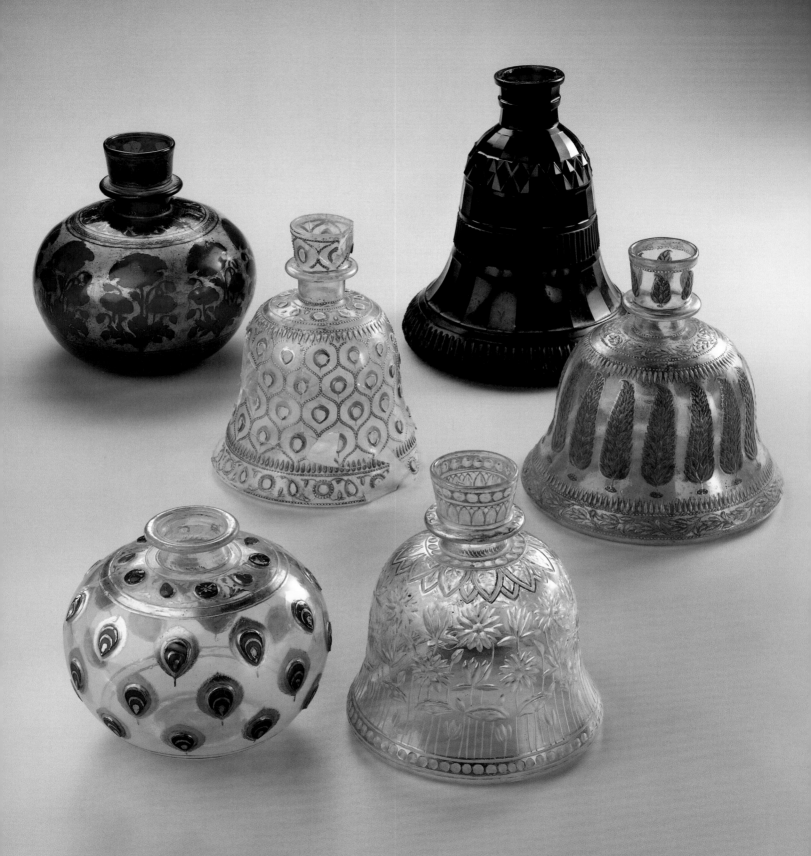

**Cat. 104a HOOKAH BASE (LNS 73 G)**
**Northern Indian region**
**ca. 1700–25**

Dimensions: hgt. 19.0 cm; max. diam. 17.5 cm;
th. 0.4 cm; wt. 545 g; cap. ca. 2550 ml

Color: Translucent dark emerald (green 4–5);
gilt

Technique: Free blown; tooled; gilded;
worked on the pontil

Description: This globular base for a waterpipe has
a small flattened base and a neck that
presents a folded, flattened bulge about
two-thirds of the way from the opening.
The decoration on the main band
consists of eight compositions of
poppies depicted in the negative space
against the gold background; details
are outlined in gold. A band including
seven-petaled flowers lies between the
shoulder and the base of the neck.
Another band with budding plants is
around the neck between the opening
and the bulge. Gilt hatched and zigzag
lines separate the sections horizontally.

Condition: The object is intact. The surface is in
good condition, though some gilt is
scratched or has vanished. The glass
includes frequent small and large
bubbles.

Provenance: Christie's, London, sale, October 13,
1982, lot 101

Literature: Qaddumi 1987, p. 119

Related Works: 1. BM, inv. no. OA 1961.10-16.1
(Tait 1991, pl. 177)
2. CMA, inv. no. 61.44
(Dikshit 1969, pl. 40)
3. V&A, inv. no. 15-1930
(Dikshit 1969, pl. 6)

Cat. 104a–f

The practice of smoking tobacco with a waterpipe, or hubble-bubble, or hookah (*ḥuqqa*, or *nārghīl*, or *qaliān* in Persian)—a device consisting of a container for scented water, a detachable bowl for tobacco (*chillam*), and a long snakelike tube through which to breathe the cooled smoke—was introduced at the Mughal court from Deccan (where its use was in turn initiated from Iran) at the beginning of the seventeenth century, toward the end of Akbar's reign (r. A.H. 963–1014 / A.D. 1556–1605). One of Akbar's officers, Asad Beg, returned from a mission to Bijapur in 1604 and introduced the practice to his emperor who, it seems, never took to it.[29] However, the custom of smoking tobacco spread rapidly in Mughal India and the *bidri* hookah bases produced in Deccan in the first half of the seventeenth century became the models for those made of jade, enamel, metal, and glass in Mughal India.[30]

Two basic shapes became standard for hookah bases in Deccan and Northern India—globular and bell-shaped (cat. 104a, b, and c–g, respectively). Both types have a short neck with a protruding ring close to the base and a slightly flared opening where the smoking tube, tobacco-burning bowl, and hookah base join.[31] For obvious reasons, the globular type needed a support in order to stand, which was provided by a thick ring that accommodated its convex base.[32] Initially, it seems that bases for waterpipes were adapted from existing objects, such as carved coconut shells or ceramic bottles, and that they were mainly portable.[33] By the mid-seventeenth century, however, the globular type was the only existing model and it was not until the 1730s or 1740s that the first bell-shaped hookah bases were made. The two forms probably coexisted for a few decades, until the bell-shaped hookahs replaced the globular ones entirely, possibly for their versatility but also because their flat bases did not require additional support.

*Bidri* ware, which is almost invariably floral or plantlike, was influential in the decoration of these hookahs. Flowering and budding lilies, carnations, poppies, irises, and many other species are arranged at even intervals around the surface of the hookah base, often in bold isolation, sometimes framed under polylobed arches, at times smaller and repeated within a latticework.[34] The same decorative repertoire was common to Mughal and Deccani artists and soon became standard throughout the subcontinent.

The large number of *bidri* hookah bases that survive and the existence of at least one dated object allow for a rather precise general chronology and evolution of this particular type.[35] Although the field of Mughal glass has received some attention in the past, unfortunately the same chronology cannot be established for the extant glass examples, which are much less numerous; in addition, no example bears a date or a name to confirm its attribution.[36] The clear chronological distinction between globular and bell-shaped waterpipe bases in metal does not apply to those in glass, since none of them appears to be datable before the eighteenth century and often the two shapes show similar artistic decoration and technique (see, for example, cat. 104b and c). In addition, no hookah base has ever been attributed to a glass workshop in Deccan, a region that does not have a strong glassmaking tradition, though it is where these shapes and decorations originated. Precise sites of manufacture in Mughal India have been suggested on the basis of comparative material, such as Lucknow in Uttar Pradesh for two objects in the Los Angeles County Museum (Related Work 9).[37] The association with Lucknow can be substantiated by comparing the colorful gilt-silver and enameled objects, including hookah bases with floral decoration, that were made there in the second half of the eighteenth century.[38] Other known centers of glass production were in Gujarat (see cat. 106), Bihar, Rajasthan, and Sind (Hyderabad).[39] It is, however, difficult to suggest specific attributions to one of the above-mentioned workshops for the majority of hookah bases.

## Cat. 104b HOOKAH BASE (LNS 10 G)
### Northern Indian region
### ca. 1725–50

Dimensions: hgt. 14.4 cm; max. diam. 15.0 cm;
th. 0.19 cm; wt. 440 g; cap. ca. 1450 ml

Color: Translucent grayish colorless; white
opaque; blue, green, and white enamel;
gilt

Technique: Free blown; tooled; enameled (applied
and fused); gilded; worked on the pontil

Description: This base for a waterpipe is similar in
shape to cat. 104a, though the neck is
shorter and has a thick splayed opening.
The decoration is painted over a layer
of white opaque enamel that was fused
to the glass surface, creating a relief
(see also cat. 104c, d and 106b, c);
the gold was probably fired separately.
The main decoration consists of three
staggered rows of "peacock feathers"
in blue and gold. A band around the
shoulder includes evenly spaced feather-
shaped green elements alternating
with blue circles; these elements are
connected by gilded vegetal motifs.
White enamel and gilt lines separate
the sections horizontally.

Condition: The object was broken and repaired;
there are small fills on the body, the
upper part of the neck, and the rim.
The enamels and gilding are in good
condition. The surface is lightly
weathered, resulting in a milky white
film, especially on the interior. The
glass includes scattered bubbles.

Literature: Qaddumi 1987, p. 118; and Atıl 1990,
no. 90, pp. 268–69

Related Works: 4. Whereabouts unknown; formerly
Krug collection (Sotheby's, London,
sale, December 7, 1981, lot 250)

## Cat. 104c HOOKAH BASE (LNS 11 G)
### Northern Indian region
### Mid-18th century

Dimensions: hgt. ca. 18.7 cm; max. diam. 15.5 cm;
th. 0.18 cm: wt. ca. 500 g;
cap. ca. 1300 ml

Color: Translucent grayish colorless;
white enamel; gilt

Technique: Free blown; tooled; enameled (applied
and fused); gilded; worked on the pontil

Description: This bell-shaped base for a waterpipe
has a flat base and a neck with a
folded, flattened bulge in the middle.
The decoration consists of four
staggered rows of "peacock feathers"
(see cat. 104b), the centers of which
are raised to accommodate a colored
glass or stone element. The pattern
is included in a beaded latticework in
white and gold, Vertical feather-shaped
elements or stylized sunrays frame the
entire field. The same pattern is around
the neck between the opening and the
bulge. A band around the shoulder
includes evenly spaced drop-shaped
elements alternating with circles; these
elements are connected by vegetal
motifs. The same composition is
enclosed in a band running around
the base of the object. White enamel
and gilt lines separate the sections
horizontally.

Condition: The object was shattered during the
invasion of Kuwait in 1990 and was
returned to the Collection in that
condition. Kirstie Norman carried out
the reconstruction. Two large portions
from the body are missing as is about
two-thirds of the base and about
one-fifth of the neck; there are a few
fragments that cannot be placed. The
surface is lightly weathered, resulting in
a milky white film. Most of the white
opaque glass that was fused on to
provide the relief is present, though
the gilding and the white enamel have
mostly vanished and all the colored
glass inserts are missing. The glass is
of good quality.

Related Works: 5. IMA, inv. no. C.01.7
6. Harish Chandra Agarwal collection,
Hyderabad (Dikshit 1969, pl. 18d)
7. NM, New Delhi
(Mittal 1983, fig. 17)

## Cat. 104d HOOKAH BASE (LNS 123 G)
### Northern Indian region
### Second half of the 18th century

Dimensions: hgt. 20.0 cm; max. diam. 18.4 cm;
th. 0.38 cm: wt. 550 g; cap. ca. 1900 ml

Color: Translucent grayish colorless; white
opaque; pale green and white enamel;
gilt

Technique: Free blown; tooled; enameled (applied
and fused); gilded; worked on the pontil

Description: This base for a waterpipe is the same
shape as cat. 104c, though it is wider
and shorter. The decoration consists
of sixteen stylized cypress trees with a
tiny trunk rising from a tuft of grass,
painted in apple green enamel and
gold over a layer of white opaque glass.
Six similar trees are repeated around
the neck between the opening and the
bulge. Vertical feather-shaped elements
or stylized sunrays frame the main field.
Vegetal scrolls in white and gold are
within bands near the base and between
the shoulder and the base of the neck.
Gilt-beaded lines separate the sections
horizontally.

Condition: The object is intact. The surface is
lightly weathered, resulting in a milky
white film, especially on the interior.
The glass includes frequent small
bubbles.

Provenance: Reportedly from Lucknow, India

Related Works: 8. SJM, inv. no. 132
(Dikshit 1969, pl. 19a)

**Cat. 104e HOOKAH BASE (LNS 13 G)**
Northern Indian region or
England, made for the
Indian market
Mid-18th century

Dimensions: hgt. 17.0 cm; max. diam. 14.8 cm;
th. 0.35 cm: wt. 520 g; cap. ca. 1250 ml
Color: Translucent grayish colorless; gilt
Technique: Free blown; cut; gilded;
worked on the pontil
Description: This base for a waterpipe is the same
shape as cat. 104c. The wheel-cut
decoration represents a blooming
pond and consists of a three-tiered
composition of multipetaled daisies,
lotuses, waterlilies, and various buds
with thin vertical stems. Large pointed
petals depart from the base of the neck
and cover the shoulder and a row of
sunken circles surrounds the base of
the object; a combination of these
two motifs decorates the neck between
the opening and the bulge. Gilding
highlights the outlines; the main
decoration seems to have been left
ungilded.
Condition: The object is intact. The surface is
lightly weathered, resulting in a milky
white film, especially on the interior.
The glass includes scattered small
bubbles that become more frequent
near the base.
Composition: $Al_2O_3$: 0.2; $SiO_2$: 55.5; $K_2O$: 7.0;
$CaO$: 0.2; $Fe_2O_3$: 0.1; $PbO$: 36.6
Related Works: 9. LACMA, inv. no. M.76.2.13
(Markel 1991, fig. 3)
10. Prince of Wales Museum of
Western India, Bombay,
inv. no. 59:24 (Dikshit 1969, pl. 17a)
11. SJM, inv. no. 150
(Dikshit 1969, pl. 18b)
12. DC, inv. no. 30/1979
(von Folsach 1990, no. 253)
13. Medelhavsmuseet, Stockholm,
inv. no. NM75/1928
(Stockholm 1982, p. 245, fig. 4)

**Cat. 104f HOOKAH BASE (LNS 281 G)**
England, made for
the Indian market
Late 18th–early 19th century

Dimensions: hgt. 23.8 cm; max. diam. 19.8 cm;
th. 0.64 cm; wt. ca. 2100 g;
cap. ca. 2200 ml
Color: Translucent emerald green (green 5)
Technique: Blown; cut; worked on the pontil
Description: This elongated bell-shaped base for
a waterpipe has a straight neck and a
splayed opening. The surface is covered
with horizontal bands of cut decoration:
two bands near the base and in the
center have vertical ribs, a diaper
pattern in relief is at the shoulder, and
the remaining bands are simply faceted.
Decorative horizontal bands on the
neck were also created by cutting.
Condition: The object is intact, except for some
chips around the base. The surface is
lightly weathered, resulting in a milky
white film. The glass is of good quality.
Provenance: Reportedly from Mumbai, India
Related Works: 14. Whereabouts unknown
(Christie's, London, sale,
October 20–22, 1992, lot 89)
15. Whereabouts unknown
(Christie's, London, sale,
October 18–20, 1994, lot 382)

If all glass hookah bases are from northern Indian Mughal territories, the earliest examples must have followed Mughal metal or hardstone prototypes and been made about the beginning of the eighteenth century or shortly before the bell-shaped types flooded the market. A base in gilded green glass in the British Museum (Related Work 1) and the celebrated object in Los Angeles (Related Work 9), for example, have been attributed to the very beginning of the eighteenth century.[40] Confirming this attribution is what is perhaps the earliest representation of a globular glass hookah base, in an illustration of a shop in a bazaar that is ascribed to Bikaner, Rajasthan and dated circa 1700.[41]

The gilded green hookah base (cat. 104a) meets the criteria for this attribution. Its composition of evenly spaced poppies closely resembles the same flowers depicted on the green hookah in the British Museum and on the blue one in Cleveland (Related Works 1, 2). Here, however, the poppies are depicted in reserve against the gold ground, instead of being gilded, thus exploiting the colored glass as the backdrop. The same effect in reserve appears on a contemporary base in the Victoria and Albert Museum (Related Work 3), which is decorated with an overall pattern of repeated stylized trees or large pointed leaves.

Cat. 104b and c must be considered together from a decorative point of view. The former having a globular shape, the latter being bell-shaped, they demonstrate the coexistence of the two basic types in glass about the middle of the eighteenth century. Both display an overall pattern of "peacock feathers," though these float on the colorless surface on the former and are enclosed within the medallions of a latticework on the latter. Cat. 104b, in which surface decoration and glass background are strictly related, is in the spirit of early eighteenth-century types (such as cat. 104a). The busier decoration of cat. 104c, has a more superficial effect as it austerely separates the glass background and the colored and gilded patterns, and prefigures artistic trends that would become common in the second part of the century.

These two objects are also interesting from a technical standpoint. The decorative motifs incorporate patterns in relief that were not achieved by simply applying drops of enamel before firing. Rather, an interim firing process took place that involved the application of low-fired white glass or enamel to create relief patterns that would be subsequently painted, gilded, and fired a second time. This use of applied and fused low-fired glass is not unique in the history of Islamic glassmaking, though it is extremely rare; the way it was transmitted to

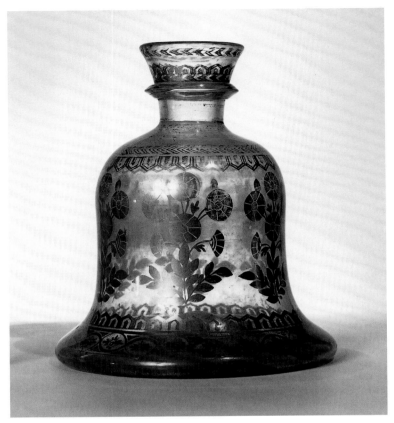

Cat. 104g

**Cat. 104g BELL-SHAPED HOOKAH BASE**
**(LNS 9 G)**[42]
**Northern Indian region**
**Mid-18th century**

Free blown, tooled, and gilded
Whereabouts unknown (missing after
the invasion of Kuwait, August 1990)

Mughal craftsmen is unknown. The same technique was used in exceptional cases by the early Mamluk glass painters who produced the so-called Palmer Cup, for example.[43] The relationship to a similar and almost contemporary technique that was applied to a group of *mīnāī* pottery vessels may also turn out to be extremely interesting.[44] On cat. 104c the reliefs of the "peacock feathers" are constructed as settings for colored glass stones (or, possibly, true precious stones, such as rubies and emeralds) that have long since disappeared.[45]

Cat. 104d displays the same technique, though the effect is less evident and dramatic. This object's slightly squatter proportions as well as its decoration point to a date in the second half of the eighteenth century. It shares a few standard features with cat. 104c, such as the horizontal beaded lines and the vertical feather-shaped elements that frame the main field. The busy row of cypress trees, their rigid appearance almost defied by their pointed tips curving to the left, is not a common depiction on hookah bases, though it is in tune with the usual, evenly spaced floral representations mentioned above (see cat. 104a). The pattern seems to have parallels in contemporary and later textiles, especially those produced in Rajasthan and Kashmir, where the motif derives from the Mughal floral composition called *buta*.[46]

Another revival in Mughal glass is represented by wheel-cut objects. As discussed in Chapter 2, cut glass had a long and distinguished tradition in the early Islamic period, but the technique was abandoned during the twelfth century. It is not clear what prompted Mughal glassmakers to create objects, especially hookah bases, using this method. Clearly, there was a longstanding tradition of stonecutting (especially rock crystal and gems) in the region, but the influence of Bohemian and English glass probably played a more important role in the production of wheel-cut glass vessels. By the end of the seventeenth century Bohemian glass, which was typically wheel-cut, was being exported to the Indian market.

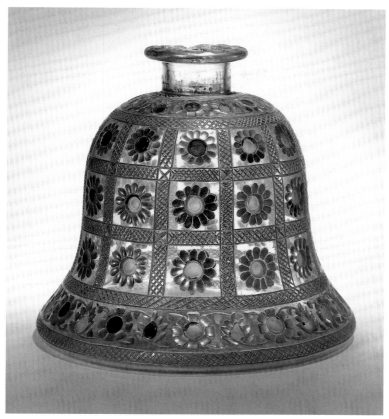

Cat. 104h

**Cat. 104h BELL-SHAPED HOOKAH BASE**
(LNS 12 G)
**Northern Indian region**
**Mid-18th century**

Free blown, tooled, cut,
set with colored glass
Whereabouts unknown (missing after
the invasion of Kuwait, August 1990)

English lead glass had flooded the same market by the second quarter of the eighteenth century. In 1642, for example, the glass cutter Jerome Johnson was selling "hubble-bubbles" for the Indian and Ottoman markets, and in 1788 *The Calcutta Chronicle* included advertisements for "Hooka Bottoms rich-cut."[47]

It does not, however, appear that all cut-glass hookah bases were imported from England, since some examples show typical features of Mughal glass and their decoration belies the Mughal artistic "spirit" embodied in many contemporary enameled objects. Cat. 104e and f exemplify the two types. Although the former is a lead-potash glass—as are a number of other hookah bases attributed to India[48]—its decoration seems directly inspired by the colorful pond scene portrayed on the famous object in Los Angeles (Related Work 9). It is compositionally more restrained and, of course, lacks color, but the general idea of arranging buds, leaves, and flowers in a somewhat disorderly fashion is common to both examples. It is, therefore, hard to imagine that an English glass cutter, such as Jerome Johnson, may have been responsible for such a design, though the object itself may have been made in Europe and subsequently cut in India.

Cat. 104f, on the other hand, is far removed from Mughal artistic traditions, for its solid and heavy appearance (both physically and artistically), color, geometric cutting, and horizontal division of the surface leave no doubt that it was made in England. Compositional analysis (lead-potash versus soda-lime types) may prove useful in the attribution of hookah bases with ambiguous characteristics, though it is clearly unnecessary in the case of cat. 104f. Two scholars, however, have cautioned that ingots of English lead glass were imported into India in the nineteenth century to make new glass, a statement that jeopardizes secure attributions on this basis alone.[49]

**Cat. 105 SPITTOON (LNS 138 G)**
**Northern Indian region**
**Mid-18th century**

Dimensions: hgt. 9.7 cm; max. diam. 8.9 cm;
th. 0.22 cm; wt. 224 g; cap. 175 ml

Color: Translucent dark blue (blue 5),
white enamel, gold

Technique: Free blown; tooled; enameled; gilded;
worked on the pontil

Description: This object, blown as a single piece, is
composed of two bell-shaped elements
joined at their tops, the smaller element
providing the base and the larger
section, upside down, forming the
open upper part. The opening is flared.
The decoration consists of a gold
latticework filled with stylized irises
in white enamel. There are horizontal
gold lines below the rim, at the meeting
point of the two sections, and near the
base. The interior is not decorated.

Condition: The object is intact. The surface is in
good condition, though some gilding is
missing. The glass includes scattered
small bubbles.

Provenance: Harish Chandra Agarwal collection,
Hyderabad, India

Related Works: 1. V&A (Dikshit 1969, pl. 30a)
2. Harish Chandra Agarwal collection,
Hyderabad (Dikshit 1969, pl. 30b)

Like hookah bases, spittoons (*pikdan*, in northern India) were familiar objects in the houses and open-air terraces of Mughal noblemen. The chewing of *pan* (betel nut) was common and *pandan*s (betel containers) and *pikdan*s (*pik* being the juice expectorated in the spittoon) were essential accessories of a rich household.

Compared to hookah bases and *pandan*s, a limited number of metal spittoons survive and glass spittoons are exceedingly rare. The form evolved during the eighteenth century. The lower section of early Deccani and Mughal spittoons was globular, while the upper part was large, splayed, and had slightly sloping walls,[50] which allowed the expectorated saliva to slowly "disappear" into the indentation in the center, be collected, and kept from view into the lower chamber. Over time, the upper part maintained this profile, whereas the lower section developed into a bell shape in the eighteenth century.[51] Although the chronology is not as clear as that of hookah bases, which underwent the same changes in the 1730s and 1740s (see cat. 104), it is likely to have been similar.

About the middle of the eighteenth century the upper section assumed an inverted bell shape of the same proportions and dimensions as the lower chamber, though at times it was slightly larger.[52] The glass spittoon (cat. 105), with its double-bell shape and somewhat larger upper half, clearly reflects this development of metal forms and thus cannot date earlier than mid-century. In size it is also comparable to the common small metal spittoons that are rarely more than 12 centimeters high and small in diameter.[53] The only two other known glass *pikdan*s help confirm the direct relationship between metal and glass shapes, as they present a globular base with a splayed upper section (Related Work 1) and a bell-shaped base with a splayed upper section (Related Work 2).

The color and decoration of cat. 105 also support an attribution to mid-eighteenth-century Mughal India. Dark cobalt blue glass was frequently used in combination with gold, creating a rich, warm contrast.[54] The overall pattern of flowers or flowering plants enclosed in the medallions of a latticework (see cat. 104) was one of the most familiar motifs on *bidri* ware and other media (such as textiles) in both Deccan and northern India.[55] Related Work 1, which, judging by its shape, is probably earlier than cat. 105, presents an overall denser decoration of violets or similar flowers arranged in rows, albeit not enclosed in a latticework. In the case of cat. 105, the representation of stylized white irises enclosed within lobed and pointed medallions and set against a dark blue background is especially successful and appealing, making this rare object one of the most significant works of Mughal glass in the Collection.

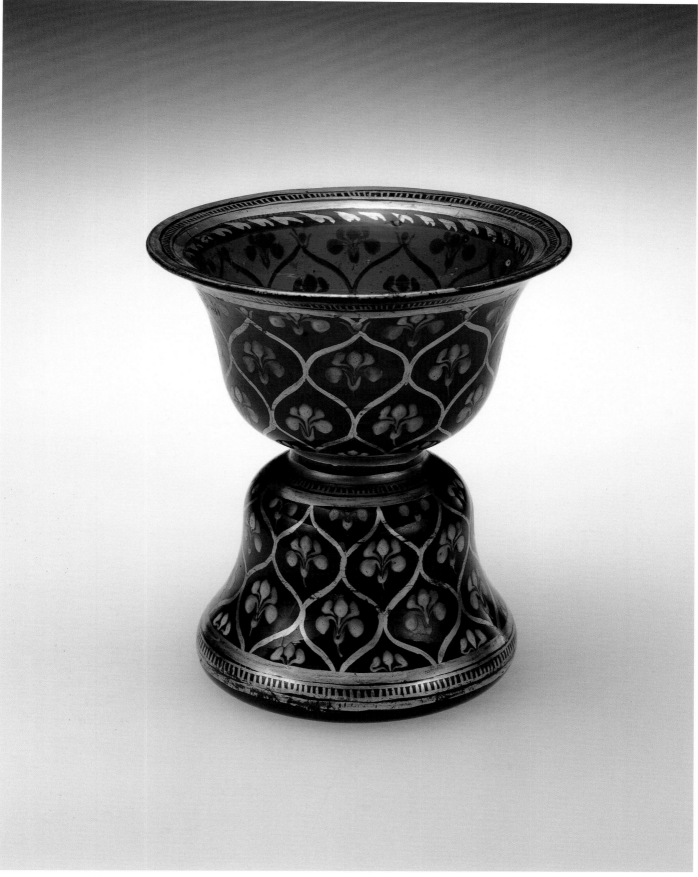

Cat. 105

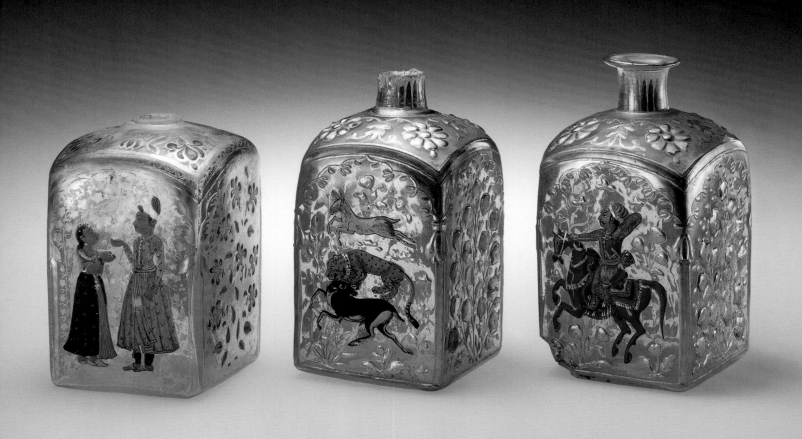

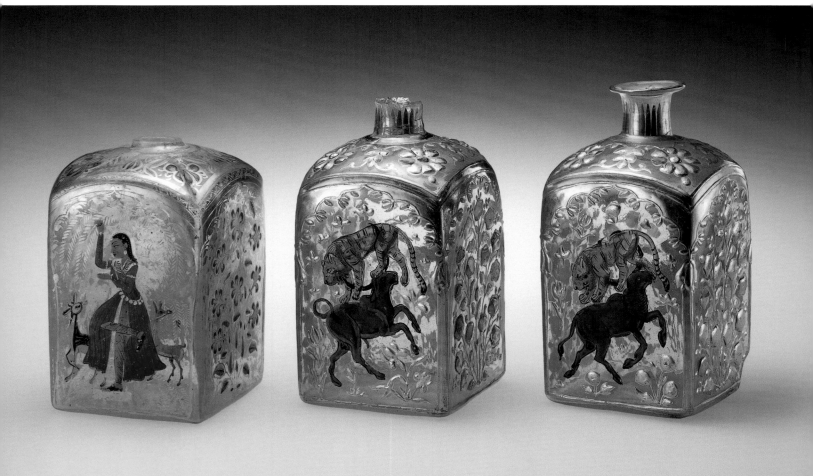

**Cat. 106a SQUARE BOTTLE (LNS 82 G)**
     **Perhaps European,**
     **painted in Gujarat**
     **Second half of the 18th century**

Dimensions: hgt. 11.8 cm; w. 7.0 cm; l. 7.0 cm;
            th. 0.36 cm; wt. 410 g; cap. 428 ml
     Color: Translucent grayish colorless; red, pink,
            pale green, black, beige, yellow, white,
            dark blue, and pale pink paint; gilt
Technique: Mold blown; tooled; painted; gilded;
            worked on the pontil
Description: This square bottle with a flat base
            was blown in a two-part mold, the
            sides of which were joined diagonally
            (a diagonal seam is evident under the
            base). Painted decoration is present
            on all four sides of the bottle. Two
            opposing sides depict similar flowering
            plants (perhaps stylized irises or lilies)
            stemming from a tuft of leaves and set
            under a polylobed arch. A third side
            shows a scene set under the same arch
            in which a man offers something to
            a woman who accepts the gift with
            open hands; tall plants in gold fill the
            background. On the opposite side, a
            woman dances atop a low stool flanked
            by two gazelles. Irises and budding
            lotuses fill the upper part of the bottle.
Condition: The body is intact; the neck is missing.
            The surface is lightly weathered,
            resulting in a milky white film,
            especially on the interior. The painted
            decoration is in fairly good condition,
            though some gilding and paint have
            vanished. The glass includes frequent
            small bubbles.

The largest number of surviving enameled glass vessels from eighteenth-century India are represented by so-called case bottles (sometimes, gin bottles) with painted decoration. The name is derived from the square shape that recalls the taller Dutch and German molded bottles produced in the second half of the seventeenth century that were made to fit in compartments in a case or a box.[56] The association with the Netherlands is particularly strong, as a few of these bottles are capped by a Dutch coin minted specifically to indicate that the object was manufactured abroad, in India in this case.[57] The Netherlands occupied a significant position in western India beginning in the early seventeenth century, when the Dutch East India Company established a factory in Gujarat.[58]

Ram Singh Malam, a craftsman who learned the art of glassmaking in the Netherlands and made two further trips to Europe in order to refine his skills, exemplifies the relationship between the two countries. His patron was Maharao Lakha (r. 1741–60), the ruler of the small kingdom of Kutch, northwest of Gujarat, who encouraged his protégée to open a glass factory in the town of Bhuj when Ram Singh returned from his final European journey.[59]

The painted bottles belonging to this group, including cat. 106a–c, most likely owe their existence to Ram Singh's influence in the region and were likely produced in glass factories in Kutch and Gujarat. The most precise attribution suggested thus far is the Kathiawar Peninsula in Gujarat in the second quarter of the eighteenth century (all the objects listed under Related Work 1).[60] A detailed study would permit a subdivision of the objects into smaller groups, leading toward an attribution to different ateliers in the region, such as Ahmedabad, Surat, Bhuj, perhaps Hyderabad in Sind, and others.

The most distinctive and unusual technical aspect of these square bottles is that they were blown in a two-part mold, the two halves of which were triangular in shape, dividing the body diagonally. Thus, the seams coincide with two corners of the bottle instead of being prominent in the center of two opposite sides, and the corners are invariably painted in order to conceal the joints; consequently, the only visible seam is a diagonal line under the base. Once the mold was opened and the two halves were joined, the pontil was attached to the base and the tooling and painting took place.

Apart from the clear foreign influence in shape and construction and the lead-potash quality of the glass, the decoration of these bottles leaves little doubt that they were at least painted in India. They were, in some cases, brought to Europe by merchants associated with the Dutch East India Company. Their former attribution, "to the Netherlands for the Indian market," should definitively be discounted, though undecorated bottles may have been exported to India from Europe.[61]

The three bottles in the Collection (cat. 106a–c) fit well within the group as regards their method of construction (a diagonal two-part mold), glass quality, and decoration. All three, for example, show figural scenes on two opposite sides and floral or plantlike motifs on the other two sides. The figures are typically set in an open space framed by architectural columns and arches painted at the corners and around the shoulder, as if the entire scene took place under the dome of a canopy or a gazebo.

The female dancer and the man and woman depicted on cat. 106a are related to figures on bottles in Los Angeles (Related Work 1, inv. no. M.88.129.198), New York, Liège, and Corning (Related Works 3–5, respectively), though details indicate that it did not belong to the same sets. Bottles painted for a set of six (or eight) items illustrated similar scenes, perhaps related to a particular story.[62] The two bottles (cat. 106b, c) are indeed so similar in subject matter and decorative details that it is safe to assume that they belonged to the

## Cat. 106b SQUARE BOTTLE (LNS 428 Ga)
**Perhaps European,**
**painted in Gujarat**
**Second half of the 18th century**

Dimensions: hgt. 14.0 cm; w. 7.0 cm; l. 7.0 cm;
th. 0.19 cm; wt. 361 g; cap. ca. 440 ml

Color: Translucent grayish colorless; whitish
enamel; green, blue, reddish brown,
pink, yellow, red, and black paint; gilt

Technique: Mold blown; tooled; enameled; painted;
gilded; worked on the pontil

Description: This bottle, identical in shape and
construction to cat. 106a, has a short
(hgt. 2.3 cm) slightly flared neck with
a splayed opening. On two opposing
sides the decoration in low relief (on
this technique, see cat. 104b) shows a
stylized flowering plant painted in gold
rising on its stem under a stylized
tentlike polylobed arch knotted at the
corners. A third side depicts an archer
facing left while riding a horse and
shooting an arrow; low flowering plants
in gold fill the background of the scene,
also set under an arch. On the opposite
side, a tiger attacks a bull, jumping over
its back; the flowering background and

arch appear again. A composition of
eight-petaled flowers and other vegetal
motifs decorates the upper part of the
bottle and a row of vertical pointed
elements in gilt surround the neck.

Condition: This object is intact, except for a
broken corner at the bottom (on the
side depicting the archer). There is
some loss of the white opaque fused
relief patterns. The surface is in good
condition, though some gilding has
vanished. Microscopic analysis revealed
that a new layer of gold may have been
recently fired to improve the appearance
of the decoration. The glass includes
frequent tiny bubbles and scattered
small ones.

Composition: $Na_2O$: 0.8; $MgO$: 0.3; $Al_2O_3$: 0.3;
$SiO_2$: 55.0; $K_2O$: 9.2; $CaO$: 0.5;
$MnO$: 0.1; $Fe_2O_3$: 0.2; $PbO$: 33.2

Provenance: Country auction sale, England;
Sotheby's, London, sale, April 25,
1997, lot 132

## Cat. 106c SQUARE BOTTLE (LNS 428 Gb)
**Perhaps European,**
**painted in Gujarat**
**Second half of the 18th century**

Dimensions: hgt. 13.7 cm; w. 7.0 cm; l. 7.0 cm;
th. 0.19 cm; wt. 349 g; cap. 450 ml

Color: Translucent grayish colorless; whitish
enamel; pink, blue, black, whitish,
and yellow paint; gilt

Technique: Mold blown; tooled; enameled;
painted; gilded; worked on the pontil

Description: This bottle is similar to cat. 106b in
shape, construction, and decorative
technique. It also shares the stylized
flowering plant on two opposite sides,
a tiger attacking a bull (with minor
variations) on another side, and the
decoration on the upper part of the
bottle. The fourth side illustrates a
leopard jumping over a black-and-white
nilgai antelope; above the two animals,
a yellow wild ass leaps at full speed.

Condition: The body of the object is intact; the
neck is missing. The surface is in good
condition. The glass includes frequent
tiny bubbles and scattered small ones.

Provenance: Country auction sale, England;
Sotheby's, London, sale, April 25,
1997, lot 132

Related Works: 1. LACMA, inv. nos. M.88.129.198–.204
(von Saldern 1980, nos. 195a–g;
and Markel 1991, figs. 9–17)
2. MK, Frankfurt, inv. nos. 13160a, b,
V 254, 13195a, b (Ohm 1973,
nos. 105–7)
3. MMA, inv. no. 21.26.11
(Jenkins 1986, no. 51)
4. Musée du Verre, Liège, inv. no. 67/16
(Philippe 1982, pl. 75)
5. CMG, inv. no. 59.1.583
(Dikshit 1969, pl. 38)

same set and were probably meant to illustrate a sultan's or a raja's prowess at hunting ferocious animals. Two bottles in Frankfurt share the same subject, a man fighting a bear and a tiger and hunting a tiger on his elephant (Related Work 2, inv. no. 13160a, b). These scenes also share a degree of gruesomeness in the depiction, for example, of blood spurting from the tiger that has just been impaled by the bull (cat. 106c). These illustrations may be described as provincial Mughal—that is, they are ultimately derived from Mughal court painting and are related to contemporary miniature painting in northwestern India.[63] Invariably, the remaining two opposite sides contain a large flowering plant that occupies much of the space available under the arch and is therefore out of scale compared to the adjacent figural scenes.

There are differences between the decorative techniques used for cat. 106a and for the pair of bottles (cat. 106b, c). In the case of cat. 106a, paint and gilt were applied directly to the glass surface. It was probably fired at a very low temperature, which was sufficient to fix the decoration in a semipermanent manner (the effect thus created is similar to cold painting). The decoration on the other two bottles was achieved in the same way as that on some hookah bases (see cat. 104b–d)—that is, the colors were applied over low-fired glass elements in relief, which were fused onto the glass surface. This difference indicates two distinct ateliers responsible for the decoration of these bottles and may suggest that the unpainted vessels were produced in the same factory and subsequently sent to the decorators. It is more likely, however, that a number of molds were available and circulated in the glass workshops of the western Indian region. A better understanding of the diffusion of the low-fused relief technique—which is found on hookah bases generically attributed to northern India and associated with Mughal rule as well as on square bottles that are identified instead with provincial regions—will certainly help shed light on glass production in India.

Cat. 107a–j TEN ROSEWATER SPRINKLERS
a: LNS 115 G; b: LNS 301 G;
c: LNS 302 G; d: LNS 298 G;
e: LNS 299 G; f: LNS 303 G;
g: LNS 137 G; h: LNS 304 G;
i: LNS 300 G; j: LNS 305 G
European, probably English,
made for the Indian market
Late 18th–19th century

Dimensions: a: hgt. 18.7 cm; max. diam. 7.7 cm;
th. 0.25 cm; wt. 147 g; cap. ca. 190 ml
b: hgt. 17.1 cm; max. diam. 6.9 cm;
th. 0.22 cm; wt. 125 g; cap. 175 ml
c: hgt. 20.0 cm; max. diam. 8.3 cm;
th. 0.23 cm; wt. 176 g; cap. 275 ml
d: hgt. 20.7 cm; max. diam. 9.2 cm;
th. 0.33 cm; wt. 288 g; cap. 350 ml
e: hgt. 20.3 cm; max. diam. 7.6 cm;
th. 0.24 cm; wt. 164 g; cap. 275 ml
f: hgt. 18.0 cm; max. diam. 7.0 cm;
th. 0.27 cm; wt. 147 g; cap. 175 ml
g: hgt. 13.8 cm; max. diam. 7.9 cm;
th. 0.24 cm; wt. 191 g; cap. 219 ml
h: hgt. 17.8 cm; max. diam. 8.5 cm;
th. 0.24 cm; wt. 266 g; cap. ca. 300 ml
i: hgt. 16.7 cm; max. diam. 6.9 cm;
th. 0.17 cm; wt. 127 g; cap. 175 ml
j: hgt. 19.9 cm; max. diam. 9.3 cm;
th. 0.23 cm; wt. 244 g; cap. 440 ml
Color: Translucent vivid purple (a, c); dark
brownish purple (b); dark emerald
green (green 5; d–g); dark cobalt blue
(blue 5; h); colorless (i); grayish
colorless (j)
Technique: Mold blown; tooled; worked on
the pontil
Description: Each sprinkler has a globular body
and a long tapered neck that ends in a
small opening. The body and neck are
molded with vertical ribs; the body is
optic blown and the neck is tooled.
The neck shows either one (f, j) or two
bulges (all the others) near the base.
The applied base forms a small low
circular foot.
Condition: The objects are all intact, except for
cat. 107g, which was broken and
repaired, is cracked, and is missing the
upper part of the neck. The surfaces
are generally in good condition; b, d,
e, i, and j are lightly weathered,
resulting in a milky white film and/or
brown pitting, especially inside. The
glass is generally of good quality,
sometimes with inclusions (a), dark
streaks (h), scattered small bubbles
(b, f, j), a few large bubbles (c), and
frequent bubbles (g).
Composition: (g) $Al_2O_3$: 0.3; $SiO_2$: 54.8; $K_2O$: 8.8;
CaO: 0.2; $Fe_2O_3$: 1.3; CuO: 1.8;
PbO: 32.2
Provenance: Reportedly from Hyderabad, India

Related Works: 1. Dikshit collection, Mumbai
(Dikshit 1969, pl. 41)
2. CMG, inv. no. 75.6.12
3. MMA, inv. no. 91.1.1603
4. Prince of Wales Museum, Mumbai;
Raja Kelkar Museum, Pune;

National Museum, Delhi; SJM;
private collections, Mumbai and
Varanasi (Dikshit 1969, p. 135)
5. V&A, inv. no. 13-1893
(London 1982, no. 394)

The British connection with India is much stronger than the Dutch (see cat. 106), which was limited to western India. English lead-potash glass, or lead crystal, with cut decoration was a major export item that took Mughal shapes, such as that of the bell-shaped hookah base (cat. 104f). Molded glass was equally prevalent on the same market, as exemplified by the earliest datable hookah base, presently in Copenhagen.[64]

Rosewater and other perfumed water sprinklers were popular at the Mughal court and became one of the main glass articles produced by English factories for export not only to India but also to the Ottoman sultanate.[65] The proof that sprinklers such as those presented in this entry were made in England is provided by a lead-glass sprinkler in the Victoria and Albert Museum (Related Work 5) that shows an optic-blown honeycomb decoration related to the pattern on the hookah base in Copenhagen.[66] The pattern on the sprinkler in London is admittedly unusual, since the majority of extant bottles of this type present an optic-blown decoration with vertical ribs that also run along the neck, including the bulges (usually two, sometimes one) at its base (as on all objects discussed in this entry), but all these vessels certainly came from the same centers of production. The quality of the glass, which is clear and bubble-free, and the stunning colors (for example, the bright purple of cat. 107a, c), which are alien to Oriental glass, provide further evidence that these sprinklers were not made in Indian glassmaking centers but were imported from Europe. Moreshwar Dikshit, suggesting Kapadwanj in Gujarat as the center of production for these vessels, also noticed that their quality is more refined than the average Kapadwanj products, which are "coarse on the surface, with large impurities," but he explained this incongruity simply by stating that two distinct categories of glass were made at Kapadwanj.[67]

These sprinklers were made predominantly for the Indian market, as suggested by two objects in Corning and London (Related Works 2, 5), which were acquired in Bijapur and Delhi, respectively, and by the overwhelming number of vessels found today in public and private collections in India (for example, Related Works 1, 4). Nine out of the ten sprinklers in the Collection (cat. 107b–j) also fall in this last category, since they are said to have come from Hyderabad in India.[68] These nine objects represent one of the largest groups presently outside the Indian subcontinent.

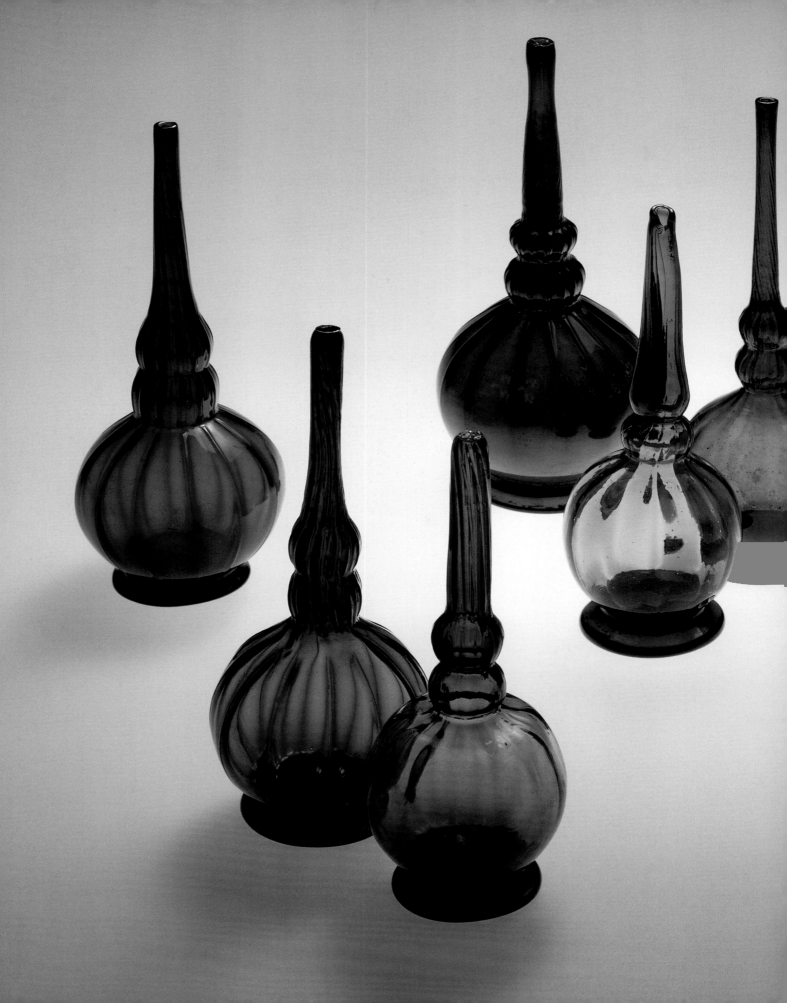

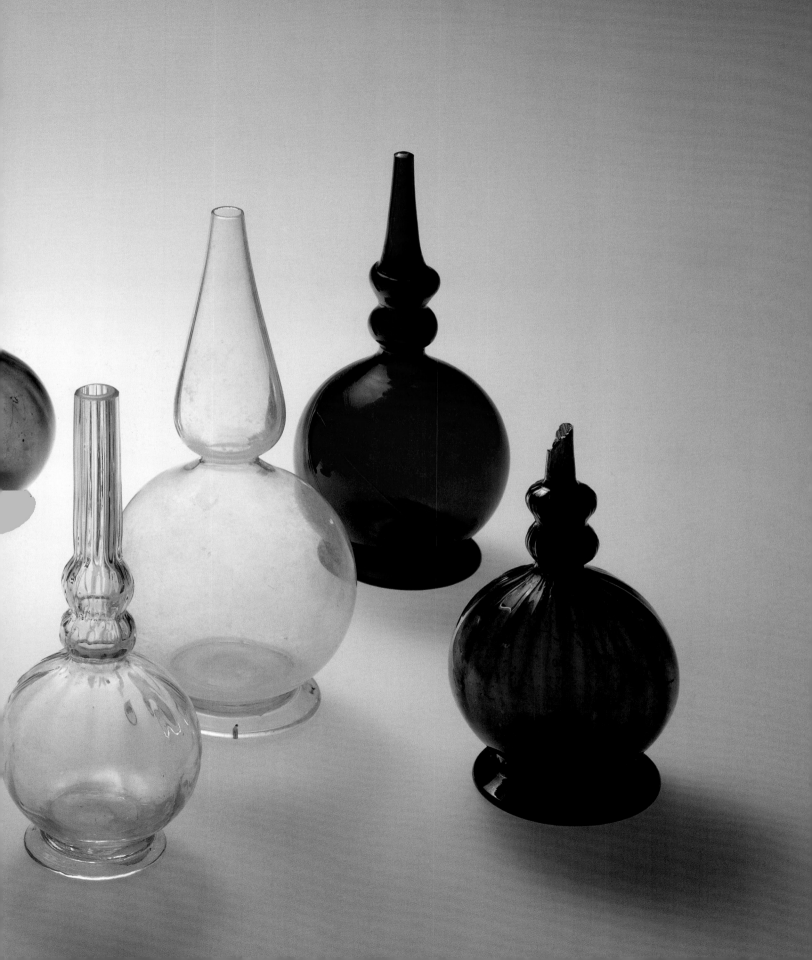

**Cat. 108a SMALL FLASK, PERHAPS
FOR SNUFF (LNS 283 G)**
European, perhaps decorated
in northern India
18th–early 19th century

Dimensions: hgt. 3.9 cm; w. 4.3 cm; l. 1.7 cm;
th. 0.16 cm; wt. 25.2 g; cap. 11.5 ml
Color: Translucent green, slightly opalescent;
bluish gray, black, orange, pale beige
paint; gilt
Technique: Blown; tooled; cut; painted; gilded
Description: This small flask has a circular flattened
body, a small flat base, and faceted
shorter sides created by cutting away
the glass surface and incising double
grooved lines. The two sides are painted
in with polychrome floral patterns
enclosed by a complex polylobed
medallion of pseudovegetal shape.
Condition: The body of the object is intact; the
neck is missing. The surface is in good
condition, though some gilding has
vanished. The glass is of good quality.
Provenance: Reportedly from Kashmir
Related Works: 1. CMG, inv. no. 74.6.2
2. MMA, inv. no. 1987.158
(*JGS*, 30, 1988, p. 105, no. 10)

The three objects consolidated in this entry, though very different and apparently unrelated, were, in all probability, made in Europe for the Indian market, but their decoration was executed only when they reached their final destination. This is certainly the case with cat. 108b and c, although cat. 108a may have been exported as a finished product.

The small neckless flask (cat. 108a) is made of a peculiar opalescent green glass that seems to be alien to India. In addition, the broken section of the neck shows an inner pale blue ring. The technique is not clear, but it is possible that this vessel is made of cased glass—that is, it is composed of two layers of different colors.[69] Cased glass, however, was usually carved in order to create decorative patterns by revealing the inner layer; this effect certainly was not sought in the present case, since the decoration is painted. Cased glass was commonly used for the production of Chinese snuff bottles from the late seventeenth through the nineteenth century; therefore, the fascinating possibility that cat. 108a is actually a Chinese export to India may also be put forth.[70] The Chinese connection, however, seems farfetched in light of considerations of shape and colors, and an European origin better suits this object, since Bohemian factories commonly produced cased glass in the early nineteenth century.

The decoration of cat. 108a is not entirely convincing as a Mughal, or northern Indian, creation. Although it is true that the general design includes traditional motifs, such as flowering plants and pseudovegetal interlaced patterns, the overall arrangement of the flowers is disorderly and asymmetrical and does not conform harmoniously with the medallionlike shape created by the interlaced patterns. In addition, the flowers themselves have an impressionistic touch that is rarely seen in Mughal art. This decoration, therefore, may have been painted in the Indian style in the original place of production of the flask.

Two plates (Related Works 1, 2) are comparable, to some degree, to the small flask (cat. 108a) and were probably manufactured in India. Both are made of opalescent green glass that includes frequent small bubbles and are therefore less clear than the flask; in addition, the glass is not cased. The small circular plate in the Metropolitan Museum (Related Work 2: diam. 10.2 cm) was molded into a polylobed shape and tooled on the pontil and presents an accomplished elaborate pink painted flower in the center. The decoration is in the best tradition of Mughal or Deccani designs and there seems to be little doubt that both glass and finishing are from that region.[71] The plate in Corning is larger and oval in shape (Related Work 1: w. 18.3 cm; l. 24.8 cm) and probably originated in the same workshop as the object in New York. The records of the Corning Museum indicate that it was acquired in Delhi, thus confirming its provenance, and offer a date of 1735 for its production, which is acceptable on art-historical grounds though inexplicably precise in the absence of further information. These two plates demonstrate that opalescent green painted glass was manufactured in Mughal India; cat. 108a, however, still does not conform exactly.

The profile of the decanter (cat. 108b) is obviously European, from the eighteenth or early nineteenth century. Its slightly tapered shape, facet-cut shoulder, complex division of the neck in horizontal sections, and oversize glass stopper that fits neatly inside the opening of the neck make it a Bohemian or English object made for export. The technique of its decoration, however, which consists of applied and fused low-fired glass on the surface (see cat. 104b–d, 106b, c), leaves no doubt that it was added in India. The thickness and quality of the glass ensured that additional firings in a different workshop would not endanger the object. The low-fusion technique was used by both Mughal and Gujarati glass decorators (see cat. 104, 106). The crudeness and approximation of the decanter's decoration indicate a late date and a provincial attribution.

**Cat. 108b DECANTER (LNS 108 G)**
European (Bohemia or England),
decorated in northern India
Late 18th–early 19th century

Dimensions: hgt. 33.0 cm (with stopper);
max. diam. 10.3 cm; th. 0.67 cm;
wt. ca. 800 g; cap. ca. 700 ml
Color: Translucent grayish colorless; white
enamel; green and red paint; gilt
Technique: Mold blown; tooled; cut; enameled;
painted; gilded
Description: This cylindrical, slightly tapered bottle
has a flat base and an angular shoulder
created by cutting. The neck, segmented
by protruding rings at the base and
below the opening, bulges near the base
and has a splayed opening; a large
molded dome-shaped stopper fits into
the opening. The entire surface of the
bottle and the stopper is covered with
paint and gilding. Some of the patterns
are in low relief, using the low-fusion
enameled technique described at
cat. 104b–d and 106b, c. The decoration
on the body consists of triangular
sections delineated by four vertical
lines and four X-shaped lines; small
medallions fill the upper and lower
triangles and stylized flowers fill the
others. Eight facet-cut sections that
mark the transition between body and
shoulder are also filled with plants and
flowers. The central section of the neck
includes oval medallions of flowers.
The decoration on the stopper echoes
all the patterns on the bottle.
Condition: The object is intact. The surface is
lightly weathered, resulting in a milky
white film, especially on the interior,
and some loss of color and gilding.
The glass is of good quality.

**Cat. 108c BOWL (LNS 282 G)**
Perhaps European, probably
decorated in northern India
19th century

Dimensions: hgt. 9.1 cm; max. diam. 14.5 cm;
th. 0.44 cm; wt. 360.7 g; cap. ca. 800 ml
Color: Translucent colorless; gilt
Technique: Blown; tooled; cut; incised; gilded
Description: This hemispherical bowl stands on a
low foot created by cutting. The surface
is cut in vertical bands into nineteen
"ribs"; the cutting is interrupted about
1 cm below the rim. Around the
opening is a horizontal band in relief
that was gilded. The bowl is decorated
with acid-etched horizontal bands on
the interior surface. Bands including
stylized flowers and leaves alternate
with bands including Qur'anic verses

(36:1–77; 2:255; 21:87) copied in a fluid
*naskh* script that can be read correctly
when looking inside the bowl. On the
bottom, a central medallion in larger
*nasta'līq* script reads:

اللهم صل على محمد النبي الأمي

("Oh God, pray for Muhammad,
the prophet of the community
[of believers]").
Condition: The object is intact. The surface is in
good condition, though most of the
gilding has vanished. The glass is of
good quality.
Provenance: Reportedly from New Delhi, India

The bowl (cat. 108c) is a most puzzling, unique object. The good quality of the glass and the cutting technique suggest an English, or otherwise European, origin. However, a comparable enameled and gilded bowl in Amsterdam is attributed to Mughal India.[72] If the bowl itself is European, the calligraphic decoration of Qur'anic verses, which was achieved through acid etching on the finished product without further heating, was certainly carried out for a Sunni, rather than a Shi'a, patron (the central inscription does not mention the name of the Imam 'Alī). The bowl was probably never intended to be decorated in this way by its makers or exporters, since its vertical faceting clashes with the horizontally arranged calligraphic and floral bands. An attribution of the decoration to India is suggested by the fact that the bowl was reportedly found in Delhi and by the calligraphic style of the circle at the bottom, which is reminiscent of inscriptions on Mughal and Deccani tinned bronze and brass.[73] The Qur'anic verses from chapter 36 (*Sūrat yā-sīn*), the so-called "Throne Verse" from chapter 2 (*Sūrat al-baqara*), and one verse from chapter 21 (*Sūrat al-anbiyā'*) are arranged in horizontal rows; the *naskh* script looks somewhat inaccurate, mainly because of the technical difficulties in writing such a small text on the hard, curved interior surface.

Even if the result is not particularly accomplished, this bowl exemplifies the unremitting compulsion of Islamic artists to fill every available surface with calligraphy. If glassmakers and glass decorators, like numerous ceramists, potters and metalworkers, had been true to this compulsion throughout history, modern-day scholars would face a much easier task in trying to make sense of this fascinating field of Islamic art.

# NOTES

1 See Charleston 1975 and 1964.

2 See, for example, the passage from Ruy González de Clavijo's *Vida y hazañas del gran Tamorlan*, quoted in Lamm 1929–30, p. 494, no. 64.

3 Cited in Charleston 1989, p. 305. See Herbert 1928; and Tavernier 1677.

4 In the diary of the Venetian consul Alessandro Malipiero of 1596; see Charleston 1974, p. 12, n. 6.

5 Lamm 1929–30, p. 500, no. 104; and Charleston 1974, p. 18. See Chardin 1927.

6 For a representative selection of illustrated bottles, see Canby 1996, nos. 60, 63, 124, and 125.

7 These details are evident, in particular, in the drawing *Page Filling Wine Flasks* in the Freer Gallery of Art, Washington, D.C. (inv. no. 53.28), attributed to Rizā-i ʿAbbāsī and dated 1639; see Canby 1996, fig. 4, p. 212 (Appendix 3, no. 66). Thomas Herbert reported that, for the purpose of transportation, these bottles were sealed with cotton and melted wax (Charleston 1974, p. 16).

8 See cat. 34.

9 The bottle is said to have remained in the cellars of the Duke of Rutland from 1758 until the first decades of the twentieth century, when it was bought by the collector Jerome Strauss. It was exhibited at the Persian Exhibition at Burlington House, London, in 1931.

10 Whereabouts unknown; see Charleston 1974, fig. 14c.

11 Ibid., pp. 16, 19.

12 H. R. Allemagne, quoted in Charleston 1974, p. 23, n. 49.

13 Persian for "container for tears," since, according to popular belief, women would collect their tears in these bottles when their husbands were away from home.

14 For examples of all these types, see Lamm 1939, pls. 1451a, c; Jenkins 1986, nos. 56–61; Charleston 1989, figs. 16a–d; and von Folsach 1990, nos. 255, 256, 258, 259.

15 See the description of a bathhouse in Lamm 1929–30, p. 501, no. 107.

16 See Bayramoğlu 1976, pp. 43–46; and Rogers 1983, pp. 241–42.

17 The manuscript is in the Topkapı Saray Library, inv. no. 44, fols. 32v–33r. For reproductions of these two illustrations, see Jenkins 1986 (inside covers).

18 Hayes 1992, p. 410, pl. 52d; and Rogers 1983, p. 251.

19 The illustration, from a manuscript in the Topkapı Saray Library (inv. no. A.3594, fol. 49r), depicts a juggler balancing glass vessels on large trays. It is reproduced in Bayramoğlu (1976, pl. 9), who also compares it (at pl. 14) with a glass vessel of identical shape in the Topkapı Saray (inv. no. 34/848).

20 The importation of glass to the Ottoman court has been given considerable attention by Western scholars; see, for example, Charleston 1975; Rückert 1963; Charleston 1964; Hettes 1964; Zecchin 1968; Gasparetto 1976; Rogers 1983; and Atasoy 1990.

21 See Eyice 1967, pp. 178–79; Bayramoğlu 1976, pp. 57–81; and Küçükerman 1985.

22 See Spaer 1992; Meyer 1992, pp. 90–94, 178, 180, pl. 20; and Carboni 1994, p. 126.

23 See Chapter 4, note 23.

24 Carboni 1998, pp. 101–2, n. 12.

25 Bayramoğlu 1976, pp. 44–45.

26 Rogers 1983, p. 257. Clairmont (1977, p. 140, nos. 518, 519) uses the term "fireball" for the two vessels in the Benaki Museum (Related Work 3).

27 Rogers 1983, p. 257, 259.

28 See, for example, Ettinghausen 1965; Rogers 1969; and Ghouchani–Adle 1992.

29 Asad Beg kept a diary during his sojourn in Bijapur, where he was sent by Akbar to escort the daughter of the Deccani sultan Ibrāhīm ʿĀdil Shāh back to the Mughal court; see London 1982, p. 384, no. 385; and Zebrowski 1997, p. 225.

30 The term *bidri* comes from Bidar, in Deccan, the place of production of a particular type of metalwork inlaid with silver or brass and made of a blackened alloy consisting mainly of zinc.

31 The earliest hookah apparatus, reported in inventories of 1765–71 and thus datable to the first half of the eighteenth century, is in the National Museum, Copenhagen (Department of Ethnography, inv. no. Eec5). Its molded globular glass base was probably made in England; see London 1982, no. 385.

32 The well-known ring in the Collection (LNS 2 J), in white enamel with polychrome floral decoration, is the most splendid surviving example of such a hookah support. The entire apparatus, which is missing its globular base, must have been one of the best achievements of enamel-on-metal craftsmanship in Mughal India, which also attests to the importance of hookahs at the royal court; see Jenkins 1983, pl. p. 127; and Zebrowski 1997, fig. 368. Glass hookah bases did not necessarily need a ring for support, since the base is usually kicked and allows the object to stand by itself.

33 Zebrowski (1997, p. 227) also discusses the first representations of such hookah bases in illustrations, in the first quarter of the seventeenth century. Portable hookahs acquired a final, conical shape in the late eighteenth century (Zebrowski 1997, figs. 406–8).

34 For examples, see Zebrowski 1997, figs. 360, 373–93, 395–99.

35 Zebrowski 1997, pp. 225–45.

36 Marcus 1962; Pinder-Wilson 1962; Dikshit 1969, pp. 82–97; Digby 1973; Diba 1983, pp. 191–93; Markel 1991; and Markel 1993, p. 119.

37 Markel 1991, pp. 85–86, figs. 3, 7; and Markel 1993, p. 119.

38 Zebrowski 1997, pp. 86–89, figs. 73, 74.

39 Digby 1973, p. 83; and Diba 1983, p. 191.

40 Pinder-Wilson 1962; and Markel 1991, fig. 3.

41 Digby 1973, pp. 85–86, pl. 3.

42 This example and the following hookah base (cat. 104g, h) cannot be included in the discussion because they fell victim to the Iraqi invasion of 1990 and have been missing since. They are known from photographs taken prior to their disappearance.

43 Tait 1998, p. 54, figs. 13.1–13.5. In addition to the Palmer Cup, many fragments survive that present the same decorative technique.

44 See, for example, a datable bottle in the Miho Museum (New York 1996, pp. 160–61, no. 81; and *Miho Museum* 1997, pp. 288–89, no. 140). The author is grateful to Dylan Smith for discussing this technique applied to *mināī* pottery.

45 A photograph taken before the object was damaged during the invasion of Kuwait shows that at least one stone inset was still in place. Related Works 5 and 7 retain a number of red "rubies," yellowish brown "topazes," and/or green "emeralds."

46 The motif of the *buta* and its endless variations is a hallmark of Kashmiri shawls in the eighteenth and nineteenth centuries; see, for example, Ames 1986, pp. 69–101.

47 Digby 1973, pp. 86–87.

48 Wypyski 1999, pp. 4–5.

49 Rednap et al. 1995; see also London 1982, p. 106; and Diba 1983, p. 193.

50 Zebrowski 1997, figs. 260, 261.

51 Ibid., p. 183, figs. 263, 264.

52 Ibid., figs. 255, 265–68.

53 Ibid., figs. 255, 265, 266.

54 See, for example, cat. 104, Related Work 2. Other well-known objects in blue glass are a teapot and cup in the Los Angeles County Museum (inv. nos. M.84.1242a–c; see Markel 1991, fig. 8) and a ewer in the British Museum (inv. no. OA S.343; see Tait 1991, fig. 175).

55 See, for example, a *bidri* hookah base in the Collection (LNS 163 M) that includes three-lobed leaves (probably clovers) and a mango-shaped base in the Victoria and Albert Museum (inv. no. I.S. 180-1984) having bell-shaped flowers with jagged petals (Zebrowski 1997, fig. 409).

56 See, for example, a bottle in yellowish green glass (hgt. 28.5 cm; diam. 10 cm) in the Rijksmuseum, Amsterdam (inv. no. K.O.G. 1709 c), datable to the second half of the sixteenth century (Ritsema van Eck–Zijlstra-Zweens 1993–95, vol. 1, p. 178, no. 279). For an Indian silver box that would have contained six such bottles, see Ohm 1973, p. 54. Dutch sets sporadically included matching glasses as well, which apparently was never the case with the Indian examples, since no glass or cup with comparable painted decoration survives.

57 Eighteenth-century six-*stuiver* pieces are found, for example, atop four bottles in the Victoria and Albert Museum (Digby 1973, p. 95; Dikshit 1969, pl. 37; and Markel 1991, pp. 87–88).

58 Digby 1973, p. 95; London 1982, p. 126, no. 396; and Liefkes 1997, p. 105.

59 See Markel (1991, p. 88, n. 14), quoting B. N. Goswami and A. L. Dallapiccola, *A Place Apart: Painting in Kutch, 1720–1820* (Delhi, 1977), pp. 58–66.

60 Markel 1991, p. 88, figs. 9–17.

61 Dikshit 1969, p. 105. Digby (1973, p. 95) was the first scholar to question Dikshit's attribution, which was still embraced, however, by Philippe (1982, p. 72, fig. 75) a few years later. For the import of glass ingots, see cat. 104.

62 For example, an Indian version of the story of Lailī and Majnūn, as depicted on a bottle in the Victoria and Albert Museum (inv. no. 14-1867); see London 1982, p. 126, no. 396; and Liefkes 1997, p. 105, no. 134.

63 Perhaps the most immediate parallels can be found in Rajput illustrations, but the style had become widespread in the area, including Gujarat, by the time these bottles were produced.

64 See note 31 above.

65 Evidence for the use of these sprinklers in Ottoman Turkey is provided, for example, by the portrait of a youth holding one in an album in the Topkapı Saray Museum Library. The portrait is signed by the Armenian artist Refaʾil and is datable to the second half of the eighteenth century (Çağman–Tanındı 1979, fig. 69).

66 Dikshit 1969, pl. 29b.

67 Ibid., p. 135, pls. 42, 43, 46. The average Kapadwanj production consisted mainly of bowls, cups, bottles, and jars in green, blue, and amber made of extremely bubbly glass; see also Markel 1991, figs. 18–27.

68 See also cat. 105.

69 See Newman 1977, p. 61.

70 For Chinese snuff bottles, see Moss 1971; and Stevens 1976.

71 The plate is presently attributed to Mughal India or Deccan, ca. 1700. The date seems somewhat too early judging by what is known about glass production in India. A Mughal attribution is more likely than a Deccani one.

72 See Ritsema van Eck–Zijlstra-Zweens 1993–95, p. 219, no. 351.

73 The bowl (cat. 108c) can be regarded as a "vessel of devotion," as described by Zebrowski (1997, pp. 335–59) in a chapter devoted to inscribed plates, bowls, and begging bowls that often include Qur'anic verses and religious invocations within concentric bands.

# APPENDIX

## Table of Concordance of Inventory Numbers and Catalogue Numbers

| Inventory | | Object | Catalogue |
|---|---|---|---|
| LNS 1 G | | | cat. 65 |
| LNS 2 G | | | cat. 95a |
| LNS 3 G | | | cat. 101 |
| LNS 4 G | | | cat. 91c |
| LNS 5 G | | | cat. 99 |
| LNS 6 G | | | cat. 98b |
| LNS 7 G | | | cat. 35 |
| LNS 8 G | | | cat. 55 |
| LNS 9 G | | | cat. 104g |
| LNS 10 G | | | cat. 104b |
| LNS 11 G | | | cat. 104c |
| LNS 12 G | | | cat. 104h |
| LNS 13 G | | | cat. 104e |
| LNS 14 G | | | cat. 3.53a |
| LNS 15 G | | | cat. 2.28j |
| LNS 16 G | | | cat. 2.6e |
| LNS 17 G | | | cat. 3.32 |
| LNS 18 G | | | cat. 3.6a |
| LNS 19 G | excluded | bottle | missing since 1984 |
| LNS 20 G | | | cat. 2.32a |
| LNS 21 G | | | cat. 3.55b |
| LNS 22 G | | | cat. 3.4a |
| LNS 23 G | | | cat. 3.5d |
| LNS 24 G | | | cat. 2.30a |
| LNS 25 G | | | cat. 2.30b |
| LNS 26 G | | | cat. 3.6b |
| LNS 27 G | | | cat. 1.15 |
| LNS 28 G | | | cat. 2.40a |
| LNS 29 G | | | cat. 2.18 |
| LNS 30 G | | | cat. 2.28n |
| LNS 31 G | | | cat. 2.28a |
| LNS 32 G | | | cat. 2.8 |
| LNS 33 G | | | cat. 2.33 |
| LNS 34 G | | | cat. 83a |
| LNS 35 G | | | cat. 85c |
| LNS 36 G | | | cat. 85a |
| LNS 37 G | | | cat. 60 |
| LNS 38 G | | | cat. 37b |
| LNS 39 G | | | cat. 85b |
| LNS 40 G | | | cat. 68b |
| LNS 41 G | | | cat. 23b |
| LNS 42 G | | | cat. 2.35 |
| LNS 43 G | | | cat. 40 |
| LNS 44 G | | | cat. 12 |
| LNS 45 G | | | cat. 1.17 |
| LNS 46 G | | | cat. 9d |
| LNS 47 G | | | cat. 16c |
| LNS 48 G | | | cat. 96a |
| LNS 49 G | | | cat. 52b |
| LNS 50 G | | | cat. 54 |
| LNS 51 G | | | cat. 3.37a |
| LNS 52 G | | | cat. 2.19 |
| LNS 53 G | | | cat. 97 |
| LNS 54 G | | | cat. 51a |
| LNS 55 G | | | cat. 28a |
| LNS 56 G | | | cat. 28b |
| LNS 57 G | | | cat. 3.4b |
| LNS 58 G | | | cat. 28c |
| LNS 59 G | | | cat. 25b |
| LNS 60 G | excluded | | re-catalogued as HS (hard stones) |
| LNS 61 G | excluded | | re-catalogued as HS (hard stones) |
| LNS 62 G | excluded | bracelet | forthcoming jewelry catalogue |

| Inventory | | Object | Catalogue |
|---|---|---|---|
| LNS 63 G | | | cat. 7b |
| LNS 64 G | excluded | | re-catalogued as HS (hard stones) |
| LNS 65 G | excluded | | re-catalogued as HS (hard stones) |
| LNS 66 G | excluded | bowl | modern |
| LNS 67 G | | | cat. 29 |
| LNS 68 G | | | cat. 2.1a |
| LNS 69 G | | | cat. 98a |
| LNS 70 G | | | cat. 96b |
| LNS 71 G | excluded | enameled fragment | |
| LNS 72 G | | | cat. 82a |
| LNS 73 G | | | cat. 104a |
| LNS 74 G | | | cat. 3.9a |
| LNS 75 G | | | cat. 3.5b |
| LNS 76 G | | | cat. 18b |
| LNS 77 G | | | cat. 22 |
| LNS 78 G | | | cat. 2.17a |
| LNS 79 G | | | cat. 25a |
| LNS 80 G | | | cat. 33a |
| LNS 81 G | | | cat. 43a |
| LNS 82 G | | | cat. 106a |
| LNS 83 G | | | cat. 2.13 |
| LNS 84 G | | | cat. 21 |
| LNS 85 G | | | cat. 2b |
| LNS 86 G | | | cat. 3.17 |
| LNS 87 G | | | cat. 3.25b |
| LNS 88 G | | | cat. 26a |
| LNS 89 G | | | cat. 33b |
| LNS 90 G | | | cat. 34b |
| LNS 91 G | | | cat. 3.10 |
| LNS 92 G | | | cat. 3.40 |
| LNS 93 G | | | cat. 3.26a |
| LNS 94 G | | | cat. 50 |
| LNS 95 G | | | cat. 3.44 |
| LNS 96 G | | | cat. 63 |
| LNS 97 G | | | cat. 3.47 |
| LNS 98 G | | | cat. 3.39 |
| LNS 99 G | | | cat. 53a |
| LNS 100 G | | | cat. 62 |
| LNS 101 G | | | cat. 3.15 |
| LNS 102 G | | | cat. 45b |
| LNS 103 G | | | cat. 45a |
| LNS 104 G | | | cat. 66 |
| LNS 105 G | | | cat. 67 |
| LNS 106 G | | | cat. 61 |
| LNS 107 G | | | cat. 102d |
| LNS 108 G | | | cat. 108b |
| LNS 109 Ga–p | | | cat. 1.13a |
| LNS 110 G | | | cat. 2.40c |
| LNS 111 G | | | cat. 64a |
| LNS 112 G | | | cat. 64b |
| LNS 113 G | | | cat. 64c |
| LNS 114 G | | | cat. 64d |
| LNS 115 G | | | cat. 107a |
| LNS 116 G | | | cat. 71a |
| LNS 117 G | | | cat. 56 |
| LNS 118 G | | | cat. 80a |
| LNS 119 G | excluded | trailed vase | Roman |
| LNS 120 G | excluded | bracelet | forthcoming jewelry catalogue |
| LNS 121 G | | | cat. 3.69 |
| LNS 122 G | | | cat. 27a |
| LNS 123 G | | | cat. 104d |
| LNS 124 G | | | cat. 72 |

| | | | |
|---|---|---|---|
| LNS 125 G | | | cat. 3.26c |
| LNS 126 G | | | cat. 4a |
| LNS 127 G | | | cat. 3 |
| LNS 128 G | | | cat. 3.37b |
| LNS 129 G | | | cat. 46a |
| LNS 130 G | | | cat. 3.28 |
| LNS 131 G | excluded | coin weight | forthcoming seal catalogue |
| LNS 132 G | excluded | coin weight | forthcoming seal catalogue |
| LNS 133 G | excluded | furniture element | |
| LNS 134 G | | | cat. 73j |
| LNS 135 G | excluded | undec. purple bottle | too fragmentary |
| LNS 136 G | | | cat. 3.14 |
| LNS 137 G | | | cat. 107g |
| LNS 138 G | | | cat. 105 |
| LNS 139 G | excluded | enameled bottle | probably German, ca. 1890 |
| LNS 140 Ga–d | excluded | mosaic fragments | Roman |
| LNS 141 G | excluded | mosaic cane | probably Roman |
| LNS 142 Ga, b | excluded | mosaic fragments | Roman |
| LNS 143 G | excluded | bead | forthcoming jewelry catalogue |
| LNS 144 G | | | cat. 3.2 |
| LNS 145 Ga–u | excluded | beads | forthcoming jewelry catalogue |
| LNS 146 Ga–q | excluded | beads | forthcoming jewelry catalogue |
| LNS 147 Ga–g | excluded | beads | forthcoming jewelry catalogue |
| LNS 148 G | excluded | bird figure | pre-Islamic Egyptian |
| LNS 149 G | excluded | cut rosette | probably modern |
| LNS 150 G | excluded | seal | forthcoming seal catalogue |
| LNS 151 G | excluded | bead | forthcoming jewelry catalogue |
| LNS 152 G | | | cat. 2.28l |
| LNS 153 G | | | cat. 2.17c |
| LNS 154 G | excluded | cut rosette | probably modern |
| LNS 155 G | excluded | cut finial(?) | probably modern |
| LNS 156 G | | | cat. 8 |
| LNS 157 G | | | cat. 2.40b |
| LNS 158 Ga, b | | | cat. 3.20b, c |
| LNS 159 G | | | cat. 57a |
| LNS 160 G | | | cat. 3.43b |
| LNS 161 Ga, b | | | cat. 1.13b |
| LNS 162 G | | | cat. 2.29 |
| LNS 163 G | | | cat. 2.14 |
| LNS 164 G | | | cat. 2.39 |
| LNS 165 G | | | cat. 73o |
| LNS 166 G | | | cat. 3.13 |
| LNS 167 G | | | cat. 51b |
| LNS 168 G | | | cat. 2.17b |
| LNS 169 G | | | cat. 3.30a |
| LNS 170 G | | | cat. 2.6f |
| LNS 171 G | | | cat. 58a |
| LNS 172 G | | | cat. 52a |
| LNS 173 G | | | cat. 3.59 |
| LNS 174 G | | | cat. 2.36a |
| LNS 175 G | | | cat. 3.30b |
| LNS 176 G | | | cat. 3.8b |
| LNS 177 G | | | cat. 3.8a |
| LNS 178 Ga | | | cat. 15a |
| LNS 178 Gb | | | cat. 15b |
| LNS 179 G | | | cat. 2.3i |
| LNS 180 G | | | cat. 11 |
| LNS 181 G | | | cat. 2.1b |
| LNS 182 Ga, b | | | cat. 2.4h, i |
| LNS 183 Ga–d | | | cat. 2.3e–h |
| LNS 184 G | | | cat. 3.20d |
| LNS 185 G | | | cat. 2.9c |
| LNS 186 G | | | cat. 2.25 |
| LNS 187 G | | | cat. 31 |
| LNS 188 G | | | cat. 3.27 |
| LNS 189 Ga, b | | | cat. 3.9b, c |
| LNS 190 G | | | cat. 3.54 |
| LNS 191 G | excluded | mosaic fragment | Roman |
| LNS 192 Ga–c | | | cat. 3.65b–d |
| LNS 193 G | | | cat. 3.65e |
| LNS 194 Ga–g | | | cat. 82c |
| LNS 195 Ga, b | | | cat. 100b |
| LNS 196 Ga–c | | | cat. 100c |
| LNS 197 Ga, b | excluded | enameled fragments | |
| LNS 198 Ga–c | excluded | enameled fragments | |
| LNS 199 Ga–c | excluded | enameled fragments | |
| LNS 200 Ga, b | excluded | enameled fragments | |
| LNS 201 Ga–c | excluded | enameled fragments | |
| LNS 202 Ga, d, e | | | cat. 92a–c |
| LNS 202 Gb, c | excluded | enameled fragments | |
| LNS 203 Ga, b | | | cat. 92d, e |
| LNS 204 Ga–c | | | cat. 92f–h |
| LNS 205 Ga–i | excluded | enameled fragments | |
| LNS 206 Ga, b | excluded | enameled fragments | |
| LNS 207 Ga–c | excluded | enameled fragments | |
| LNS 208 G | excluded | enameled fragments | |
| LNS 209 G | excluded | enameled fragment | |
| LNS 210 Ga, b | excluded | enameled fragments | |
| LNS 210 Gc | | | cat. 91d |
| LNS 211 Ga–d | | | cat. 90a–d |
| LNS 211 Ge | excluded | enameled fragment | |
| LNS 212 Ga | | | cat. 90e |
| LNS 212 Gb | excluded | enameled fragment | |
| LNS 213 Ga, b, h | excluded | enameled fragments | |
| LNS 213 Gc–g, j, k | | | cat. 89a |
| LNS 214 Ga, b | | | cat. 86d, e |
| LNS 215 G | | | cat. 86b |
| LNS 216 Ga–e | excluded | enameled fragments | |
| LNS 217 G | | | cat. 94a |
| LNS 218 G | | | cat. 94b |
| LNS 219 Ga, d | | | cat. 94c, d |
| LNS 219 Gb, c | excluded | enameled fragments | |
| LNS 220 Ga, b | excluded | enameled fragments | |
| LNS 221 Ga–c | excluded | enameled fragments | |
| LNS 222 Ga–i | excluded | enameled fragments | |
| LNS 223 G | | | cat. 92i |
| LNS 224 Ga, b | excluded | enameled fragments | |
| LNS 225 Ga, b | excluded | enameled fragments | |
| LNS 226 Ga–c | excluded | enameled fragments | |
| LNS 227 Ga–e | excluded | enameled fragments | |
| LNS 228 Ga–f | excluded | enameled fragments | |
| LNS 229 Ga, c–g | excluded | enameled fragments | |
| LNS 229 Gb | | | cat. 93a |
| LNS 230 Ga–d | excluded | enameled fragments | |
| LNS 231 Ga–h | excluded | enameled fragments | |
| LNS 232 Ga–i | excluded | enameled fragments | |
| LNS 233 G | excluded | enameled fragment | |
| LNS 234 Ga–c | excluded | enameled fragments | |
| LNS 235 G | | | cat. 93b |
| LNS 236 G | excluded | enameled fragment | |
| LNS 237 G | excluded | enameled fragment | |
| LNS 238 Ga–c | excluded | enameled fragments | |
| LNS 239 G | excluded | enameled fragment | |
| LNS 240 G | excluded | enameled fragment | |
| LNS 241 G | excluded | enameled fragment | |
| LNS 242 Ga–n | excluded | enameled fragments | |
| LNS 243 G | excluded | enameled fragment | |
| LNS 244 G | excluded | enameled fragment | |
| LNS 245 G | excluded | enameled fragment | |
| LNS 246 G | excluded | enameled fragment | |
| LNS 247 Ga, b | excluded | enameled fragments | |
| LNS 248 Ga, b | excluded | enameled fragments | |
| LNS 249 G | excluded | enameled fragment | |
| LNS 250 G | excluded | enameled fragment | |
| LNS 251 G | excluded | enameled fragment | |
| LNS 252 G | excluded | mosaic fragment | pre-Islamic Egyptian |
| LNS 253 G | excluded | mosaic fragment | Roman |
| LNS 254 G | excluded | enameled fragment | Roman |
| LNS 255 G | excluded | cut fragment | Roman |

| Object | Status | Type | Reference/Note |
|---|---|---|---|
| LNS 256 Ga–z | | | cat. 100a |
| LNS 257 Ga–n | | | cat. 100a |
| LNS 258 G | | | cat. 1 |
| LNS 259 G | | | cat. 103b |
| LNS 260 G | | | cat. 103c |
| LNS 261 G | | | cat. 3.7b |
| LNS 262 G | | | cat. 3.1a |
| LNS 263 G | | | cat. 2.28p |
| LNS 264 G | | | cat. 2.6h |
| LNS 265 G | excluded | waste | perhaps Islamic |
| LNS 266 G | | | cat. 2.30g |
| LNS 267 G | | | cat. 2.28i |
| LNS 268 G | | | cat. 2.28f |
| LNS 269 G | excluded | molded beaker frag. | Roman |
| LNS 270 G | excluded | weight | forthcoming seal catalogue |
| LNS 271 G | excluded | weight | forthcoming seal catalogue |
| LNS 272 G | excluded | weight | forthcoming seal catalogue |
| LNS 273 G | excluded | weight | forthcoming seal catalogue |
| LNS 274 G | excluded | weight | forthcoming seal catalogue |
| LNS 275 G | excluded | weight | forthcoming seal catalogue |
| LNS 276 G | excluded | weight | forthcoming seal catalogue |
| LNS 277 G | excluded | weight | forthcoming seal catalogue |
| LNS 278 G | excluded | weight | forthcoming seal catalogue |
| LNS 279 G | excluded | weight | forthcoming seal catalogue |
| LNS 280 G | excluded | weight | forthcoming seal catalogue |
| LNS 281 G | | | cat. 104f |
| LNS 282 G | | | cat. 108c |
| LNS 283 G | | | cat. 108a |
| LNS 284 G | excluded | bottle | Roman |
| LNS 285 G | excluded | reworked waste | perhaps Islamic |
| LNS 286 G | | | cat. 2.28e |
| LNS 287 G | | | cat. 2.28c |
| LNS 288 G | | | cat. 2.28o |
| LNS 289 G | | | cat. 2.28q |
| LNS 290 G | | | cat. 2.28g |
| LNS 291 G | | | cat. 2.40e |
| LNS 292 G | | | cat. 24 |
| LNS 293 G | | | cat. 2.37 |
| LNS 294 G | | | cat. 3.5c |
| LNS 295 G | | | cat. 51c |
| LNS 296 G | | | cat. 1.6c |
| LNS 297 G | excluded | knife handle | forthcoming jewelry catalogue |
| LNS 298 G | | | cat. 107d |
| LNS 299 G | | | cat. 107e |
| LNS 300 G | | | cat. 107i |
| LNS 301 G | | | cat. 107b |
| LNS 302 G | | | cat. 107c |
| LNS 303 G | | | cat. 107f |
| LNS 304 G | | | cat. 107h |
| LNS 305 G | | | cat. 107j |
| LNS 306 G | excluded | *kendi* | non-Islamic Indian |
| LNS 307 G | | | cat. 32 |
| LNS 308 G | | | cat. 2.3j |
| LNS 309 G | excluded | coin weight | forthcoming seal catalogue |
| LNS 310 G | excluded | beaker | Roman |
| LNS 311 G | excluded | fish-shaped container | possibly modern |
| LNS 312 G | | | cat. 3.49a |
| LNS 313 G | excluded | amphora | pre-Islamic Egyptian |
| LNS 314 G | excluded | amphora | pre-Islamic Egyptian |
| LNS 315 G | excluded | human figurine | pre-Islamic (Egyptian?) |
| LNS 316 G | excluded | figurine's head | pre-Islamic (Roman?) |
| LNS 317 G | excluded | facet-cut bowl | pre-Islamic Parthian or Sasanian |
| LNS 318 G | | | cat. 17b |
| LNS 319 G | | | cat. 10 |
| LNS 320 G | | | cat. 17c |
| LNS 321 G | | | cat. 39 |
| LNS 322 G | | | cat. 3.58 |
| LNS 323 G | | | cat. 73f |
| LNS 324 G | | | cat. 2a |
| LNS 325 G | | | cat. 3.7a |
| LNS 326 G | | | cat. 30a |
| LNS 327 G | | | cat. 30b |
| LNS 328 G | | | cat. 2.23 |
| LNS 329 G | excluded | enameled fragment | |
| LNS 330 G | excluded | enameled fragment | |
| LNS 331 G | | | cat. 2.28d |
| LNS 332 G | | | cat. 3.50d |
| LNS 333 G | | | cat. 2.38 |
| LNS 334 Ga, b | excluded | coin weights | forthcoming seal catalogue |
| LNS 335 G | | | cat. 2.28r |
| LNS 336 G | excluded | bird figure | pre-Islamic Egyptian |
| LNS 337 G | | | cat. 83b |
| LNS 338 G | | | cat. 36a |
| LNS 339 G | excluded | coin weight | forthcoming seal catalogue |
| LNS 340 G | | | cat. 82b |
| LNS 341 G | | | cat. 57b |
| LNS 342 G | | | cat. 36b |
| LNS 343 G | | | cat. 44b |
| LNS 344 G | | | cat. 3.34 |
| LNS 345 G | | | cat. 3.26b |
| LNS 346 G | | | cat. 46c |
| LNS 347 G | | | cat. 34c |
| LNS 348 G | | | cat. 2.27 |
| LNS 349 G | | | cat. 2.20c |
| LNS 350 G | | | cat. 2.40g |
| LNS 351 G | | | cat. 3.24 |
| LNS 352 G | | | cat. 3.23 |
| LNS 353 G | | | cat. 3.22a |
| LNS 354 G | | | cat. 81 |
| LNS 355 Ga, b | excluded | spindle whorls | forthcoming textile catalogue |
| LNS 356 G | | | cat. 2.16 |
| LNS 357 G | | | cat. 58b |
| LNS 358 G | | | cat. 48c |
| LNS 359 G | | | cat. 75b |
| LNS 360 G | | | cat. 9b |
| LNS 361 G | | | cat. 73h |
| LNS 362 G | | | cat. 73d |
| LNS 363 G | | | cat. 73e |
| LNS 364 G | | | cat. 73a |
| LNS 365 G | | | cat. 73b |
| LNS 366 G | | | cat. 2.34a |
| LNS 367 G | | | cat. 2.36b |
| LNS 368 G | | | cat. 59 |
| LNS 369 G | | | cat. 3.42a |
| LNS 370 G | | | cat. 2.34b |
| LNS 371 G | | | cat. 2.34c |
| LNS 372 G | | | cat. 33c |
| LNS 373 G | excluded | medallion | deaccessioned |
| LNS 374 G | | | cat. 3.43a |
| LNS 375 G | | | cat. 17a |
| LNS 376 G | | | cat. 1.6b |
| LNS 377 G | | | cat. 4b |
| LNS 378 G | | | cat. 73c |
| LNS 379 G | excluded | cup | Roman |
| LNS 380 G | | | cat. 1.3 |
| LNS 381 G | excluded | flask | Roman |
| LNS 382 G | excluded | flask | Roman |
| LNS 383 G | excluded | vase | Roman |
| LNS 384 G | excluded | jar | Roman |
| LNS 385 G | | | cat. 3.45c |
| LNS 386 G | | | cat. 3.45d |

| | | | |
|---|---|---|---|
| LNS 387 G | | | cat. 3.45e |
| LNS 388 G | | | cat. 3.45f |
| LNS 389 G | | | cat. 3.45a |
| LNS 390 G | | | cat. 3.45b |
| LNS 391 G | | | cat. 3.48 |
| LNS 392 G | | | cat. 3.35 |
| LNS 393 G | | | cat. 3.26d |
| LNS 394 G | | | cat. 3.26e |
| LNS 395 G | | | cat. 71b |
| LNS 396 G | | | cat. 3.46 |
| LNS 397 G | | | cat. 46b |
| LNS 398 G | | | cat. 41 |
| LNS 399 G | | | cat. 3.21 |
| LNS 400 G | | | cat. 38b |
| LNS 401 G | | | cat. 73s |
| LNS 402 G | | | cat. 3.22b |
| LNS 403 G | | | cat. 2.6c |
| LNS 404 G | | | cat. 2.41 |
| LNS 405 G | | | cat. 2.28k |
| LNS 406 G | | | cat. 2.30h |
| LNS 407 G | | | cat. 2.24 |
| LNS 408 G | | | cat. 1.16b |
| LNS 409 G | | | cat. 1.16a |
| LNS 410 G | | | cat. 43b |
| LNS 411 Ga, b | | | cat. 3.49b, c |
| LNS 412 G | excluded | coin weight | forthcoming seal catalogue |
| LNS 413 G | excluded | coin weight | forthcoming seal catalogue |
| LNS 414 G | excluded | coin weight | forthcoming seal catalogue |
| LNS 415 G | | | cat. 3.25a |
| LNS 416 G | | | cat. 2.30e |
| LNS 417 G | | | cat. 2.6g |
| LNS 418 G | excluded | dish | modern |
| LNS 419 G | | | cat. 2.5 |
| LNS 420 G | | | cat. 3.57 |
| LNS 421 G | | | cat. 2.15 |
| LNS 422 G | | | cat. 3.42b |
| LNS 423 G | | | cat. 26b |
| LNS 424 G | | | cat. 2.26 |
| LNS 425 G | | | cat. 73l |
| LNS 426 G | | | cat. 16a |
| LNS 427 G | | | cat. 34a |
| LNS 428 Ga, b | | | cat. 106b, c |
| LNS 429 G | | | cat. 3.56b |
| LNS 430 G | | | cat. 2.12a |
| LNS 431 G | | | cat. 2.12b |
| LNS 432 G | | | cat. 9c |
| LNS 433 G | | | cat. 102a |
| LNS 434 G | | | cat. 73i |
| LNS 435 G | | | cat. 73m |
| LNS 436 G | | | cat. 73n |
| LNS 437 G | | | cat. 73r |
| LNS 438 G | | | cat. 73q |
| LNS 439 G | | | cat. 3.50e |
| LNS 440 G | | | cat. 73p |
| LNS 441 Ga–c | | | cat. 3.50a–c |
| LNS 442 G | | | cat. 2.22b |
| LNS 443 G | | | cat. 16b |
| LNS 444 G | excluded | bird figure | rock crystal |
| LNS 445–1057 G | excluded | coin weights | forthcoming seal catalogue |
| LNS 1058 G | | | cat. 73k |
| LNS 1059 G | excluded | medallion fragment | |
| LNS 1060 G | | | cat. 73g |
| LNS 1061 G | excluded | oval bowl | recent acquisition |
| LNS 1062 G | | | cat. 7a |
| LNS 1063 G | excluded | incised beaker | recent acquisition |
| LNS 1064 G | | | cat. 53b |
| LNS 1065 G | excluded | miniature bottle | recent acquisition |
| LNS 1066 G | | | cat. 3.43c |
| LNS 1067 G | | | cat. 78b |
| LNS 1068 Ga, b | excluded | marvered flasks | recent acquisition |
| LNS 1069 Ga, b | excluded | marvered flasks | recent acquisition |
| LNS 1070 G | excluded | marvered bowl | recent acquisition |
| LNS 1071 G | | | cat. 102c |
| LNS 1072 G | excluded | bowl | probably Roman |
| LNS 1073 G | excluded | flask | recent acquisition |
| LNS 1074 G | excluded | small jug | recent acquisition |
| LNS 1075 G | excluded | cut flask | recent acquisition |
| LNS 1076–1373 G | excluded | coin weights | forthcoming seal catalogue |
| LNS 1374 G | | | cat. 102b |
| LNS 1375 G | excluded | lid(?) | recent acquisition |
| LNS 1376 G | | | cat. 38c |
| LNS 1377 G | | | cat. 44c |
| LNS 1378 G | | | cat. 7c |
| LNS 1379 G | excluded | cut bottle | recent acquisition |
| LNS 1380–1406 G | excluded | | recent acquisitions |
| LNS 1407 G | | | cat. 18a |
| LNS 1 KG | | | cat. 3.5a |
| LNS 2 KG | | | cat. 42 |
| LNS 3 KG | | | cat. 3.38 |
| LNS 4 KG | | | cat. 9a |
| LNS 5 KG | | | cat. 3.55a |
| LNS 6 KG | | | cat. 3.30c |
| LNS 7 KG | | | cat. 2.20b |
| LNS 8 KG | | | cat. 2.40d |
| LNS 9 KG | | | cat. 2.31 |
| LNS 10 KG | excluded | small flask | reworked bottle neck |
| LNS 11 KG | | | cat. 3.51 |
| LNS 12 KG | | | cat. 84 |
| LNS 13 KG | | | cat. 2.30c |
| LNS 14 KG | | | cat. 1.1 |
| LNS 15 KG | | | cat. 27b |
| LNS 16 KG | | | cat. 2.28b |
| LNS 17 KG | | | cat. 3.29b |
| LNS 18 KG | | | cat. 3.61 |
| LNS 19 KG | | | cat. 3.1b |
| LNS 20 KG | | | cat. 3.19 |
| LNS 21 KG | | | cat. 1.7a |
| LNS 22 KG | | | cat. 74 |
| LNS 23 KG | | | cat. 3.11 |
| LNS 24 KG | | | cat. 1.9 |
| LNS 25 KG | excluded | ewer | Roman |
| LNS 26 KG | | | cat. 1.5 |
| LNS 27 KG | | | cat. 16d |
| LNS 28 KG | | | cat. 69a |
| LNS 29 KG | | | cat. 1.4a |
| LNS 30 KG | | | cat. 70a |
| LNS 31 KG | | | cat. 20a |
| LNS 32 KG | | | cat. 69b |
| LNS 33 KG | | | cat. 2.7 |
| LNS 34 KG | | | cat. 2.32b |
| LNS 35 KG | | | cat. 2.40f |
| LNS 36 KG | | | cat. 2.20a |
| LNS 37 KG | | | cat. 3.52a |
| LNS 38 KG | | | cat. 83c |
| LNS 39 KG | | | cat. 5a |
| LNS 40 KG | | | cat. 27c |
| LNS 41 KG | | | cat. 3.26f |
| LNS 42 KG | | | cat. 1.2a |
| LNS 43 KG | | | cat. 3.18 |
| LNS 44 KG | | | cat. 48a |
| LNS 45 KG | | | cat. 3.52b |
| LNS 46 KG | | | cat. 3.56a |
| LNS 47 KG | | | cat. 5b |
| LNS 48 KG | | | cat. 6 |
| LNS 49 KG | | | cat. 48b |
| LNS 50 KG | | | cat. 38a |
| LNS 51 KG | | | cat. 1.2b |
| LNS 52 KG | | | cat. 77 |
| LNS 53 KG | | | cat. 1.2c |
| LNS 54 KG | | | cat. 1.7b |
| LNS 55 KG | | | cat. 1.2d |
| LNS 56 KG | | | cat. 17d |
| LNS 57 KG | | | cat. 103d |

| LNS | status | description | catalogue/notes |
|---|---|---|---|
| LNS 58 KG | | | cat. 1.10 |
| LNS 59 KG | | | cat. 3.29a |
| LNS 60 KG | | | cat. 3.52c |
| LNS 61 KG | | | cat. 3.55d |
| LNS 62 KG | | | cat. 1.8a |
| LNS 63 KG | | | cat. 1.4b |
| LNS 64 KG | | | cat. 1.8b |
| LNS 65 KG | | | cat. 1.11 |
| LNS 66 KG | | | cat. 70b |
| LNS 67 KG | | | cat. 1.6a |
| LNS 68 KG | | | cat. 70c |
| LNS 69 KG | | | cat. 2.22a |
| LNS 70 KG | | | cat. 49 |
| LNS 71 KG | | | cat. 75a |
| LNS 72 KG | | | cat. 103a |
| LNS 73 KG | | | cat. 44a |
| LNS 74 KG | | | cat. 3.36a |
| LNS 75 KG | | | cat. 3.36b |
| LNS 76 KG | | | cat. 3.55e |
| LNS 77 KG | | | cat. 3.33b |
| LNS 78 KG | | | cat. 20b |
| LNS 79 KG | | | cat. 23a |
| LNS 80 KG | | | cat. 2.6b |
| LNS 81 KG | | | cat. 3.12 |
| LNS 82 KG | | | cat. 3.33a |
| LNS 83 KG | | | cat. 2.28h |
| LNS 84 KG | | | cat. 2.30d |
| LNS 85 KG | | | cat. 2.28m |
| LNS 86 KG | | | cat. 3.29c |
| LNS 87 KG | | | cat. 2.6a |
| LNS 88 KG | | | cat. 3.31a |
| LNS 89 KG | | | cat. 2.30f |
| LNS 90 KG | | | cat. 2.9a |
| LNS 91 KG | | | cat. 47 |
| LNS 92 KG | | | cat. 95b |
| LNS 93 KG | | | cat. 68a |
| LNS 94 KG | | | cat. 78a |
| LNS 95 KG | | | cat. 2.21 |
| LNS 96 KG | | | cat. 3.55f |
| LNS 97 KG | | | cat. 87 |
| LNS 98 KG | | | cat. 88 |
| LNS 99 KG | | | cat. 90f |
| LNS 100 KG | | | cat. 85d |
| LNS 101 KG | | | cat. 86a |
| LNS 102 KG | | | cat. 3.31b |
| LNS 103 KG | | | cat. 79 |
| LNS 104 KG | | | cat. 3.64a |
| LNS 105 KG | excluded | enameled fragment | |
| LNS 106 KG | | | cat. 76 |
| LNS 107 KG | | | cat. 80b |
| LNS 108 KG | | | cat. 37a |
| LNS 109 KG | | | cat. 3.41 |
| LNS 110 KG | | | cat. 1.12 |
| LNS 111 KG | | | cat. 3.53b |
| LNS 112 KG | | | cat. 3.63a |
| LNS 113 KG | | | cat. 19 |
| LNS 114 KG | | | cat. 3.68 |
| LNS 115 KG | | | cat. 3.55c |
| LNS 116 KG | | | cat. 3.20a |
| LNS 117 KG | | | cat. 2.6d |
| LNS 118 KG | | | cat. 3.64b |
| LNS 119 KG | excluded | bird figure | pre-Islamic Egyptian |
| LNS 120 KG | excluded | bird figure | rock crystal |
| LNS 121 KGa, b | | | cat. 3.3a, b |
| LNS 122 KGa | | | cat. 2.3p |
| LNS 122 KGb–d | | | cat. 3.3c–e |
| LNS 123 KG | | | cat. 3.60 |
| LNS 124 KG | | | cat. 3.63b |
| LNS 125 KG | | | cat. 3.66 |
| LNS 126 KGa–h | | | cat. 3.65a |
| LNS 127 KGa, b | | | cat. 3.3f, g |
| LNS 128 KGa–c | excluded | beads | forthcoming jewelry catalogue |
| LNS 129 KGa, b | | | cat. 2.3m, n |
| LNS 130 KG | excluded | enameled fragment | |
| LNS 131 KGa–e | excluded | enameled fragments | |
| LNS 132 KGa, b | excluded | fragments | pre-Islamic Iranian |
| LNS 133 KGa–e | excluded | enameled fragments | |
| LNS 134 KGa–d | excluded | fragments | pre-Islamic |
| LNS 135 KGa–e | excluded | enameled fragments | |
| LNS 136 KG | | | cat. 94e |
| LNS 137 KGa, b | excluded | enameled fragments | |
| LNS 137 KGc | | | cat. 3.67 |
| LNS 138 KGa–d | excluded | enameled fragments | |
| LNS 139 KGa, b | | | cat. 2.3k, l |
| LNS 140 KG | | | cat. 13 |
| LNS 141 KGa | | | cat. 2.3d |
| LNS 142 KG | excluded | enameled fragment | |
| LNS 143 KG | excluded | enameled fragment | |
| LNS 144 KG | excluded | enameled fragment | |
| LNS 145 KG | | | cat. 80c |
| LNS 146 KG | excluded | enameled fragments | |
| LNS 147 KGa–d | excluded | enameled fragments | |
| LNS 148 KG | | | cat. 3.62c |
| LNS 149 KGa | | | cat. 2.10 |
| LNS 149 KGb | excluded | enameled fragment | |
| LNS 150 KGa, c, d | excluded | enameled fragments | |
| LNS 150 KGb | | | cat. 91a |
| LNS 151 KGa–i | excluded | enameled fragments | |
| LNS 152 KGa, b | | | cat. 1.2e |
| LNS 153 KG | | | cat. 3.63c |
| LNS 154 KG | excluded | enameled fragment | |
| LNS 155 KG | excluded | bracelet fragment | forthcoming jewelry catalogue |
| LNS 156 KG | | | cat. 2.9b |
| LNS 157 KG | excluded | fragment | pre-Islamic |
| LNS 158 KG | | | cat. 1.14 |
| LNS 159 KG | | | cat. 3.62b |
| LNS 160 KG | excluded | bracelet fragment | forthcoming jewelry catalogue |
| LNS 161 KG | | | cat. 3.16 |
| LNS 162 KG | excluded | coin weight fragment | forthcoming seal catalogue |
| LNS 163 KG | | | cat. 15c |
| LNS 164 KGa–e | excluded | enameled fragments | |
| LNS 165 KGa–v | excluded | enameled fragments | |
| LNS 166 KGa–l | excluded | enameled fragments | |
| LNS 167 KGa–c | excluded | enameled fragments | |
| LNS 168 KGa–x | excluded | enameled fragments | |
| LNS 169 KG | | | cat. 14 |
| LNS 170 KGa–d, g–j | excluded | enameled fragments | |
| LNS 170 KGe, f, l, m | | | cat. 90g–j |
| LNS 171 KGa | | | cat. 89b |
| LNS 171 KGb–g | excluded | enameled fragments | |
| LNS 172 KGa–e | excluded | enameled fragments | |
| LNS 173 KGa | | | cat. 93c |
| LNS 173 KGb–l | excluded | enameled fragments | |
| LNS 174 KGa, b | excluded | enameled fragments | |
| LNS 174 KGc | | | cat. 92j |
| LNS 175 KG | | | cat. 2.3o |
| LNS 176 KG | | | cat. 2.3b |
| LNS 177 KG | | | cat. 2.11 |
| LNS 178 KGa–d | excluded | enameled fragments | |
| LNS 179 KGa–k | excluded | enameled fragments | |
| LNS 180 KGa–f | excluded | enameled fragments | |
| LNS 181 KGa–f | excluded | enameled fragments | |
| LNS 182 KGa–f | excluded | enameled fragments | |
| LNS 182 KGg | | | cat. 2.3a |
| LNS 183 KGa–g | excluded | enameled fragments | |
| LNS 184 KGa–e[1] | excluded | enameled fragments | |
| LNS 185 KGa–d | | | cat. 2.4a–d |
| LNS 186 KGa, b, d–r | excluded | enameled fragments | |
| LNS 186 KGc | | | cat. 90k |
| LNS 187 KG | | | cat. 2.3c |
| LNS 188 KGa–m, p–b[1] | excluded | enameled fragments | |
| LNS 188 KGn | | | cat. 90l |
| LNS 189 KG | excluded | enameled fragment | |
| LNS 190 KG | excluded | enameled fragment | |

| | | | |
|---|---|---|---|
| LNS 191 KGa–f | excluded | enameled fragments | |
| LNS 192 KGa–e | excluded | enameled fragments | |
| LNS 193 KGa–k | excluded | enameled fragments | |
| LNS 194 KGa–h | excluded | enameled fragments | |
| LNS 195 KG | | | cat. 2.2 |
| LNS 196 KGa–s | excluded | enameled fragments | |
| LNS 197 KG | | | cat. 3.3h |
| LNS 198 KGa–c | excluded | enameled fragments | |
| LNS 199 KGa–e | excluded | enameled fragments | |
| LNS 200 KGa–c | excluded | enameled fragments | |
| LNS 201 KGa–d | excluded | enameled fragments | |
| LNS 202 KG | excluded | enameled fragment | |
| LNS 203 KGa | | | cat. 93d |
| LNS 203 KGb | excluded | enameled fragment | |
| LNS 204 KGa | excluded | enameled fragment | |
| LNS 204 KGb | | | cat. 86f |
| LNS 205 KG | excluded | molded fragment | Roman |
| LNS 206 KGa, b | excluded | enameled fragments | |
| LNS 207 KGa | | | cat. 91 |

| | | | |
|---|---|---|---|
| LNS 207 KGb, c | excluded | enameled fragments | |
| LNS 208 KGa–c | | | cat. 2.4e–g |
| LNS 209 KGa–d | excluded | enameled fragments | |
| LNS 210 KGa, b, d | excluded | enameled fragments | |
| LNS 210 KGc | | | cat. 86c |
| LNS 211 KGa–i | excluded | enameled fragments | |
| LNS 212 KG | excluded | enameled fragment | |
| LNS 213 KG | | | cat. 3.52d |
| LNS 214 KG | excluded | enameled fragment | |
| LNS 215 KG | | | cat. 3.62a |
| LNS 216 KG | excluded | enameled fragment | |
| LNS 217 KG | excluded | enameled fragment | |
| LNS 218 KG | excluded | enameled fragment | |
| LNS 219 KG | | | cat. 2.1c |
| LNS 220 KG | excluded | enameled fragment | |
| LNS 221 KG | excluded | enameled fragment | probably Venetian |
| LNS 222 KG | excluded | enameled fragment | Venetian |
| LNS 223 KG | excluded | enameled fragment | Venetian |

# TABLE OF GLASS COLORS

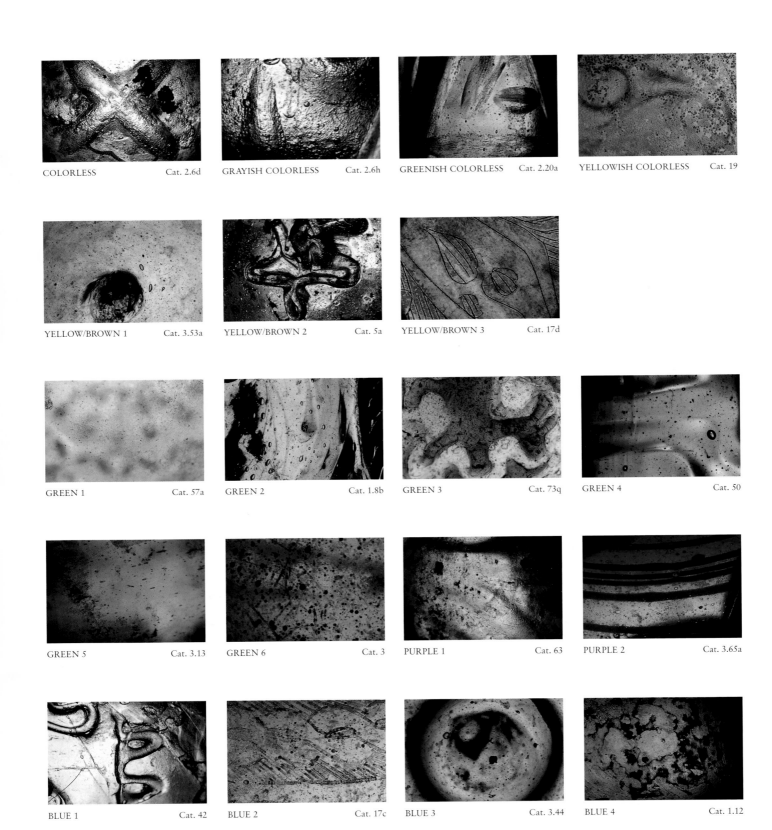

| | | | |
|---|---|---|---|
| COLORLESS Cat. 2.6d | GRAYISH COLORLESS Cat. 2.6h | GREENISH COLORLESS Cat. 2.20a | YELLOWISH COLORLESS Cat. 19 |
| YELLOW/BROWN 1 Cat. 3.53a | YELLOW/BROWN 2 Cat. 5a | YELLOW/BROWN 3 Cat. 17d | |
| GREEN 1 Cat. 57a | GREEN 2 Cat. 1.8b | GREEN 3 Cat. 73q | GREEN 4 Cat. 50 |
| GREEN 5 Cat. 3.13 | GREEN 6 Cat. 3 | PURPLE 1 Cat. 63 | PURPLE 2 Cat. 3.65a |
| BLUE 1 Cat. 42 | BLUE 2 Cat. 17c | BLUE 3 Cat. 3.44 | BLUE 4 Cat. 1.12 |

# BIBLIOGRAPHY

'Abd al-Khaliq 1976
Hana' 'Abd al-Khaliq. *Al-zujāj al-islāmī (Islamic Glass)*. Baghdad, 1976 [in Arabic].

'Abd al-Ra'uf 1971
'Abd al-Ra'uf 'Ali Yusuf. *Dirāsa fī al-zujāj al-misrī (Study on Egyptian Glass)*. Cairo, 1971 [in Arabic].

Abdullaev et al. 1991
K. A. Abdullaev, E. V. Rtveladze, and G. V. Shishkina, eds. *Culture and Art of Ancient Uzbekistan*. Moscow, 1991.

Abdurazakov 1972
A. A. Abdurazakov. "Etude chimique des verres d'Asie Centrale, datant du Moyen Age." *IXᶜ Congrès International du Verre, Communications artistiques et historiques, Versailles, 27/9–2/10, 1971*, pp. 161–78. Paris, 1972.

Ajab 1971–72
Hamed Ajab. "Les Verres musulmans d'origine orientale dans les musées de Tunisie." *Bulletin de l'Association Internationale pour l'Histoire du Verre: le verre en Tunisie* (1971–72), pp. 105–11.

Akat et al. 1984
Y. Akat, N. Fıratlı, and H. Kocabaş. *Hüseyin Kocabaş Koleksiyonu cam eserler kataloğu—Catalogue of Glass in the Hüseyin Kocabaş Collection*. Istanbul, 1984.

Allan 1982
James Allan. *Nishapur: Metalwork of the Early Islamic Period*. New York, 1982.

Allan 1995
James W. Allan. "Investigation into Marvered Glass: 1." In James W. Allan, ed. *Islamic Art in the Ashmolean Museum*, pt. 1, pp. 1–30. Oxford Studies in Islamic Art 10. Oxford, 1995.

Ames 1986
Frank Ames. *The Kashmir Shawl and Its Indo-French Influence*. Woodbridge, N.Y., 1986.

Amindjanova 1962
M. Amindjanova. "Medieval Glass Vessels in the Museums of Tashkent and Samarqand." *Istoria Materialni Kultury Uzbekistana* 2 (1962), pp. 87–100 [in Russian].

Amindjanova 1965
M. Amindjanova. "Medieval Glass from Central Asia in the Collection of the Hermitage." *Istoria Materialni Kultury Uzbekistana* 6 (1965), pp. 153–58 [in Russian].

Amsterdam 1999
Mikhail B. Piotrovsky and John Vrieze, eds. *Art of Islam: Earthly Beauty, Heavenly Art*. Exh. cat. Amsterdam, Die Nieuwe Kerk. Lund, 1999.

An 1991
An Jiayao. "Dated Islamic Glass in China." *Bulletin of the Asia Institute*, n.s., 5 (1991), pp. 123–38.

*Anatolian Glass* 1990
I. Uluslararasi Anadolu Cam Sanati Sempozyumu 26–27 Nisan 1988—First International Anatolian Glass Symposium, April 26–27, 1988. Istanbul, 1990.

Anderson 1983
R. G. W. Anderson. "Early Islamic Chemical Glass." *Chemistry in Britain* (October 1983), pp. 822–23.

Armarchuk 1988
E. A. Armarchuk. "Method of Glass Classification from the Middle Ages in Khwarazm According to Material from the Small Town of Sadvar." *Materialnaya Kultura Vostoka* 2 (1988), pp. 234–53 [in Russian].

Atasoy 1990
Nurhan Atasoy. "Belgelerde Osmanlı camı—Documentary References to Ottoman Glass." In *Anatolian Glass* 1990, pp. 87–94.

Atıl 1973
Esin Atıl. *Ceramics from the World of Islam*. Exh. cat. Freer Gallery of Art, Smithsonian Institution. Washington, D.C., 1973.

Atıl 1981
Esin Atıl. *Renaissance of Islam: Art of the Mamluks*. Exh. cat. National Museum of Natural History, Smithsonian Institution. Washington, D.C., 1981.

Atıl 1990
Esin Atıl, ed. *Islamic Art and Patronage: Treasures from Kuwait*. New York, 1990.

Atıl 1993
Esin Atıl, *Arte islamica e mecenatismo*. Translated by Stefano Carboni. Florence, 1993 [Atıl 1990 with additional entries].

Atıl et al. 1985
Esin Atıl, W. T. Chase, and Paul Jett. *Islamic Metalwork in the Freer Gallery of Art*. Exh. cat. Freer Gallery of Art, Smithsonian Institution. Washington, D.C., 1985.

Auth 1976
Susan H. Auth. *Ancient Glass at the Newark Museum from the Eugene Schaefer Collection of Antiquities*. Newark, N.J., 1976.

Azarpay 1995
Guitty Azarpay. "A Jataka Tale on a Sasanian Silver Plate." *Bulletin of the Asia Institute*, n.s., 9 (1995), pp. 99–125.

Baer 1983
Eva Baer. *Metalwork in Medieval Islamic Art*. Albany, N.Y., 1983.

Bagnera 1994
Alessandra Bagnera. "Il motivo dei volatili affrontati all'albero della vita nei tessuti islamici." In Maria Teresa Lucidi, ed. *La seta e la sua via*, pp. 151–54. Exh. cat. Palazzo delle Esposizioni. Rome, 1994.

Bahrami 1952
Mehdi Bahrami. "A Gold Medal in the Freer Gallery of Art." In George C. Miles, ed. *Archaeologica Orientalia in Memoriam Ernst Herzfeld*, pp. 5–20. Locust Valley, N.Y., 1952.

Baker 2000
Patricia L. Baker. "The Glass Finds." In A. D. H. Bivar, ed. *Excavations at Ghubayra, Iran*, pp. 197–233. London, 2000.

Balog 1974
Paul Balog. "Sasanian and Early Islamic Ornamental Glass Vessel-Stamps." In Dickran K. Kouymjian, ed. *Near Eastern Numismatics, Iconography, Epigraphy and History: Studies in Honor of George C. Miles*, pp. 131–40. Beirut, 1974.

Bamborough 1976
Philip Bamborough. *Treasures of Islam*. Poole, 1976.

Barag 1975
Dan P. Barag. "Rod-Formed Kohl-Tubes of the Mid-First Millennium B.C." *JGS* 17 (1975), pp. 23–36.

al-Basha 1957
Hasan al-Basha. *Alqāb al-islāmiyya fī al-ta'rīkh wa al-wathā'iq wa al-āthār (Islamic Names in History, Documents, and Monuments)*. Cairo, 1957 [in Arabic].

Bass 1984
George F. Bass. "The Nature of the Serçe Limanı Glass." *JGS* 26 (1984), pp. 64–69.

Bass 1996
George F. Bass. *Shipwrecks in the Bodrum Museum of Underwater Archaeology*. Bodrum, 1996.

Baumgartner–Krueger 1988
Erwin Baumgartner and Ingeborg Krueger. *Phönix aus Sand und Asche: Glas des Mittelalters*. Exh. cat. Bonn, Reinisches Landesmuseum. Munich, 1988.

Bayramoğlu 1976
Fuat Bayramoğlu. *Turkish Glass Art and Beykoz-Ware*. Istanbul, 1976.

Ben-Tor et al. 1996
A. Ben-Tor, M. Avissar, and Y. Portugali. *Yoqne'am 1: The Late Periods. Qedem Reports 3*. Jerusalem, 1996.

van Berchem 1894–1903
Max van Berchem. *Matériaux pour un Corpus Inscriptionum Arabicarum: première partie, Egypte*. Mémoires publiés par les membres de la Mission archéologique française au Caire, vol. 19. Paris, 1894–1903.

Berlin 1979
*Museum für Islamische Kunst Berlin: Katalog 1979*. Berlin, 1979.

Bezborodko 1987
David Bezborodko. *An Insider's View of Jewish Pioneering in the Glass Industry*. Jerusalem, 1987.

Blair 1973
Dorothy Blair. *A History of Glass in Japan*. Corning, N.Y., 1973.

Bosworth 1996
Clifford Edmund Bosworth. *The New Islamic Dynasties: A Chronological and Genealogical Manual*. Edinburgh, 1996.

Boucharlat–Lecomte 1987
Rémy Boucharlat and Olivier Lecomte. *Fouilles de Tureng Tepe. Vol. 1, Les périodes sassanides et islamiques*. Paris, 1987.

Brill 1970
Robert H. Brill. "Chemical Studies of Islamic Luster Glass." In Rainer Berger, ed. *Scientific Methods in Medieval Archaeology*. UCLA Center for Medieval and Renaissance Studies, Contributions 4, pp. 351–77. Berkeley, Los Angeles, and London, 1970.

Brill 1999
Robert H. Brill. *The Chemical Analyses of Early Glasses*. 2 vols. Corning, N.Y., 1999.

Brosh 1993
Na'ama Brosh. "Kohl Bottles from Islamic Periods Excavated in Israel." In *Annales du 12e Congrès de l'Association Internationale pour l'Histoire du Verre, Vienne–Wien, 26–31 août 1991*, pp. 289–95. Amsterdam, 1993.

Brunswick 1963
*2000 Jahre Persisches Glas*. Exh. cat. Städtisches Museum. Brunswick, 1963.

Buckley 1939
Wilfred Buckley. *The Art of Glass*. London, 1939.

Bumiller 1993
Manfred Bumiller. *Flugelschalen und Flakons: Typologie frühislamischer Bronzen, Bumiller Collection*. Panicale, 1993.

Bussagli–Chiappori 1991
Mario Bussagli and Maria Grazia Chiappori. *Arte del vetro*. Rome, 1991.

Çağman–Tanındı 1979
Filiz Çağman and Zeren Tanındı. *Topkapı Saray Museum: Islamic Miniature Painting*. Istanbul, 1979.

Caiger-Smith 1985
Alan Caiger-Smith. *Lustre Pottery: Technique, Tradition, and Innovation in Islam and the Western World*. London, 1985.

Cairo 1969
Ahmad Hamdy, Wafiyya Izzy, Michael Rogers, and 'Abd al-Ra'uf 'Ali Yusuf. *Islamic Art in Egypt, 969–1517*. Exh. cat. Semiramis Hotel. Cairo, 1969.

Canby 1996
Sheila R. Canby. *The Rebellious Reformer: The Drawings and Paintings of Riza-yi Abbasi of Isfahan*. London, 1996.

Carboni 1992
Stefano Carboni. "The Wonders of Creation and the Singularities of Ilkhanid Painting: A Study of the London Qazwīnī, British Library Ms. Or. 14140." Ph.D. diss., University of London, School of Oriental and African Studies, 1992.

Carboni 1993
Stefano Carboni. "Il periodo mamelucco Bahri (648/1250–792/1390)." In Venice 1993, pp. 278–82.

Carboni 1994
Stefano Carboni. "Glass Bracelets from the Mamluk Period in the Metropolitan Museum of Art." *JGS* 36 (1994), pp. 126–29.

Carboni 1996
Stefano Carboni. "Chessmen in the Department of Islamic Art at the Metropolitan Museum of Art." In *Scacchi e scienze applicate*, suppl. 7, fasc. 15, pp. 1–14. Venice, 1996.

Carboni 1997
Stefano Carboni. *Following the Stars: Images of the Zodiac in Islamic Art*. Exh. cat. Metropolitan Museum of Art. New York, 1997.

Carboni 1997a
Stefano Carboni. "The Mausoleum of Ibn Sulayman al-Rifa'i in Cairo and Its Painted Glass Tiles." *Dār al-Āthār al-Islāmiyyah Newsletter* 9 (1997), pp. 18–21.

Carboni 1998
Stefano Carboni. "Gregorio's Tale; or, Of Enamelled Glass Production in Venice." In Ward 1998, pp. 101–6.

Carboni 1999
Stefano Carboni. "Glass Production in the Fatimid Lands and Beyond." In Marianne Barrucand, ed. *L'Egypte fatimide: son art et son histoire*, pp. 169–77. Paris, 1999.

Carboni forthcoming
Stefano Carboni. "Mantai: Glass Report." Typescript. Excavation report at Mantai, Sri Lanka, 1980–84.

Carboni et al. 1998
Stefano Carboni, Lisa Pilosi, and Mark Wypyski. "A Gilded and Enamelled Glass Plate in the Metropolitan Museum of Art." In Patrick McCray, ed. *Prehistory and History of Glassmaking Technology*, pp. 79–102. Ceramics and Civilization 8. Westerville, Ohio, 1998.

Carswell 1998
John Carswell. "The Baltimore Beakers." In Ward 1998, pp. 61–63.

Chaoyang 1983
Chaoyang Museum. "The Excavation of Geng's Tombs of the Liao Dynasty at Guyingzi, Chaoyang, Liaoning." *Kaogu jikan* 3 (1983), pp. 168–95.

Chardin 1927
*Sir John Chardin's Travels in Persia*. London, 1927.

Charleston 1964
Robert J. Charleston. "The Import of Venetian Glass into the Near East, 15th–16th century." In *Annales du 3e Congrès des Journées Internationales du Verre, Damas, 14–23 novembre, 1964*, pp. 158–68. Liège, 1964.

Charleston 1974
Robert J. Charleston. "Glass in Persia in the Safavid Period and Later." *AARP—Art and Archaeology Research Papers* 5 (1974), pp. 12–27.

Charleston 1975
Robert J. Charleston. "Types of Glass Imported into the Near East: Some Fresh Examples." In *Festschrift für Peter Wilhelm Meister*, pp. 245–51. Hamburg, 1975.

Charleston 1989
Robert J. Charleston. "Glass." In Ferrier 1989, pp. 295–305.

Charleston 1990
Robert J. Charleston. *Masterpieces of Glass: A World History from the Corning Museum of Glass*. New York, 1990.

Clairmont 1977
Christoph Clairmont. *Benaki Museum: Catalogue of Ancient and Islamic Glass*. Athens, 1977.

Cocks 1988
Anna Somers Cocks. "How to Buy a Stubbs on £2,600 a year. The Fitzwilliam and the N.A.–C.F." *Apollo* 127, no. 314 (April 1988), pp. 252–58.

Contadini 1995
Anna Contadini. "Islamic Ivory Chess Pieces, Draughtsmen and Dice." In Allan 1995, pp. 111–54.

Contadini 1998
Anna Contadini. *Fatimid Art at the Victoria and Albert Museum*. London, 1998.

Corning 1955
Jerome Strauss. *Glass Drinking Vessels from the Collections of Jerome Strauss and the Ruth Bryan Strauss Memorial Foundation*. Exh. cat. Corning Museum of Glass. Corning, N.Y., 1955.

Corning 1962
*A Decade of Glass Collecting: Selections from the Melvin Billups Collection*. Exh. cat. Corning Museum of Glass. Corning, N.Y., 1962.

Corning 1972
*A Tribute to Persia: Persian Glass*. Exh. cat. Corning Museum of Glass. Corning, N.Y., 1972.

Corning 1974
*Glass from the Corning Museum: A Guide to the Collections*. Corning, N.Y., 1974.

Creswell 1959
K. A. C. Creswell. *The Muslim Architecture of Egypt, 2: Ayyūbids and Early Baḥrite Mamlūks, A.D. 1171–1326*. Oxford, 1959.

Damascus 1964
*Exposition des verres syriens à travers l'histoire organisée à l'occasion du 3e Congrès des Journées Internationales du Verre au Musée National de Damas*. Liège, 1964.

Damascus 1964a
*Bulletin des Journées Internationales du Verre, Vol. 3: Le Verre en Syrie*. Liège, 1964.

Daum 1987
Werner Daum, ed. *Yemen: Three Thousand Years of Art and Civilisation in Arabia Felix*. Innsbruck and Frankfurt, 1987.

Davidovich 1979
E. A. Davidovich. "Glass from Nisa." In *Trudy Yuzhno-Turkmenistankoi Arkheologicheskoi Expeditsii* 1, pp. 373–99. Ashgabat, 1979 [in Russian].

Davidson 1940
Gladys R. Davidson. "A Mediaeval Glass Factory at Corinth." *American Journal of Archaeology* 44 (1940), pp. 297–324.

Davidson 1952
Gladys R. Davidson. *The Minor Objects, Corinth: Results of Excavations Conducted by the American School of Classical Studies at Athens*. Vol. 12. Princeton, 1952.

Day 1953
Florence Day. "Islamic Remains." In John Garstang, ed. *Prehistoric Mersin: Yümük-Tepe in Southern Turkey, The Neilson Expedition in Cilicia*, pp. 260–62. Oxford, 1953.

Diba 1983
Layla Soudavar Diba. "Glass and Glassmaking in the Eastern Islamic Lands: Seventeenth to Nineteenth Century." *JGS* 25 (1983), pp. 187–93.

Digby 1973
Simon Digby. "A Corpus of 'Mughal' Glass." *Bulletin of the School of Oriental and African Studies* 36, no. 1 (1973), pp. 80–96.

Dikshit 1969
Moreshwar G. Dikshit. *History of Indian Glass*. Bombay, 1969.

Dimand 1936
Maurice S. Dimand. "A Syrian Enameled Glass Bottle of the Fourteenth Century."

*The Metropolitan Museum of Art Bulletin* 31 (1936), pp. 105–8.

Djanpoladian–Kalantarian 1988
R. M. Djanpoladian and A. A. Kalantarian. *Trade Links in Armenia in the Middle Ages, Sixth–Thirteenth Century: Glass Production.* Archaeological Monuments of Armenia 14, no. 6. Erevan, 1988 [in Russian, Armenian, and English].

van Doorninck 1990
Frederick H. van Doorninck. "The Serçe Limanı Shipwreck: An Eleventh Century Cargo of Fatimid Glassware Cullet for Byzantine Glassmakers." In *Anatolian Glass* 1990, pp. 58–63.

Eder 1997
Manfred A. J. Eder, ed. *Arabisch-islamische Schachfiguren (Arabian-Islamic Chessmen).* Kelkheim, 1997.

Edwards 1998
Geoffrey Edwards. *Art of Glass: Glass in the Collection of the National Gallery of Victoria.* Exh. cat. National Gallery of Victoria. Melbourne, 1998.

*EI²*
*Encyclopaedia of Islam.* 2nd ed. In press. Leiden and London, 1960–.

*EIr*
Ehsan Yarshater, ed. *Encyclopaedia Iranica.* In press. London, Boston, and Henley, 1985–.

Eisen 1916
Gustavus A. Eisen. "The Origin of Glass Blowing." *American Journal of Archaeology* 20 (1916), pp. 134–43.

Eisen 1927
Gustavus A. Eisen. *Glass.* New York, 1927.

El Goresy et al. 1986
A. El Goresy, H. Jaksch, M. Abdel Razek, and K. L. Weiner. *Ancient Pigments in Wall Paintings of Egyptian Tombs and Temples: An Archaeometric Project.* Heidelberg, 1986.

Erdmann 1952
Kurt Erdmann. "Zur Datierung der Berliner Pegasus-Schale." *Archäologischer Anzeiger: Beiblatt zum Jahrbuch des Deutschen Archäologischen Instituts, 1950–51* 65–66 (1952), pp. 115–31.

Esin 1973–74
Emel Esin. "The Turk al-'Aǧam of Sāmarrā and the Paintings Attributable to Them in the Ǧawsaq al-Ḥāqānī." *Kunst des Orients* 9 (1973–74), pp. 47–88.

Ettinghausen 1957
Richard Ettinghausen. "The 'Wade Cup' in the Cleveland Museum of Art: Its Origins and Decoration." *Ars Orientalis* 2 (1957), pp. 327–66.

Ettinghausen 1962
Richard Ettinghausen. *Arab Painting.* Geneva, 1962.

Ettinghausen 1965
Richard Ettinghausen. "The Uses of Sphero-Conical Vessels in the Muslim East." *Journal of Near Eastern Studies* 24 (1965), pp. 218–29.

Ettinghausen–Grabar 1987
Richard Ettinghausen and Oleg Grabar. *The Art and Architecture of Islam, 650–1250.* Harmondsworth and New York, 1987.

Eyice 1967
Semavi Eyice. "La Verrerie en Turquie de l'époque byzantine à l'époque turque." In *Annales du 4ᵉ Congrès International d'Etude Historique du Verre, Ravenne–Venise, 13–20 mai 1967,* pp. 162–82. Liège, 1967.

Farès 1953
Bishr Farès. "Le Livre de la Thériaque." *Art Islamique* 2 (1953).

Fehérvári 1976
Géza Fehérvári. *Islamic Metalwork of the Eighth to the Fifteenth Century in the Keir Collection.* London, 1976.

Fehérvári 1987
Géza Fehérvári. *Az Islám művészet története.* Budapest, 1987 [in Hungarian].

Ferlito 1995
Gianfelice Ferlito, ed. *Islamic Chessmen.* Suppl. to *Informazione scacchi* 2 (April 1995).

Ferrier 1989
R. W. Ferrier, ed. *The Arts of Persia.* New Haven and London, 1989.

Field–Prostov 1942
Henry Field and Eugene Prostov. "Excavations in Uzbekistan, 1937–1939." *Ars Islamica* 9 (1942), pp. 143–50.

von Folsach 1990
Kjeld von Folsach. *Islamic Art: The David Collection.* Copenhagen, 1990.

von Folsach–Whitehouse 1993
Kjeld von Folsach and David Whitehouse. "Three Islamic Molds." *JGS* 35 (1993), pp. 149–53.

Fox-Davies 1993
Arthur Charles Fox-Davies. *A Complete Guide to Heraldry.* London, 1993 [1st ed.: 1929].

Freestone–Stapleton 1998
Ian C. Freestone and Colleen P. Stapleton. "Composition and Technology of Islamic Enamelled Glass of the Thirteenth and Fourteenth Centuries." In Ward 1998, pp. 122–28.

Fritz 1982
Johann Michael Fritz. *Goldschmiedekunst der Gotik in Mitteleuropa.* Munich, 1982.

Frothingham 1963
Alice Frothingham. *Spanish Glass.* London, 1963.

Fukai 1960
Shinji Fukai. "A Persian Treasure in the Shōsō-in Repository." *Japan Quarterly* 7, no. 2 (April–June 1960), pp. 169–76.

Fukai 1977
Shinji Fukai. *Persian Glass.* Translated by Edna B. Crawford. New York, 1977.

Gabrieli–Scerrato 1979
Francesco Gabrieli and Umberto Scerrato. *Gli arabi in Italia: cultura, contatti e tradizioni.* Milan, 1979.

Gasparetto 1976
Astone Gasparetto. "Vetri veneziani da un naufragio in Dalmazia e da documenti dell'ultimo Cinquecento." *Studi veneziani* 17–18 (1976), pp. 411–46.

Ghouchani–Adle 1992
Abdallah Ghouchani and Chahriyar Adle. "A Sphero-Conical Vessel as *Fuqqā'a,* or a Gourd for 'Beer.'" *Muqarnas* 9 (1992), pp. 72–92.

Gibson 1983
Melanie Gibson. "Enamelled Glass of Syria, Twelfth to Fourteenth Centuries," M.A. diss., University of London, School of Oriental and African Studies, 1983.

Gierlichs 1993
Joachim Gierlichs. *Drache–Phönix–Doppeladler: Fabelwesen in der islamischen Kunst.* Berlin, 1993.

von Gladiss 1998
Almut von Gladiss. *Schmuck im Museum für Islamische Kunst.* Berlin, 1998.

*Glass Collections* 1982
*Glass Collections in Museums in the United States and Canada.* Corning, N.Y., 1982.

Goitein 1968–93
Shlomo D. Goitein. *A Mediterranean Society: The Jewish Communities of the Arab World as Portrayed in the Documents of the Cairo Geniza.* 6 vols. Berkeley, 1967–.

Goldstein 1982
Sidney M. Goldstein. "Islamic Cameo Glass." In Sidney M. Goldstein, Leonard S. Rakow, and Juliette K. Rakow, *Cameo Glass: Masterpieces from Two Thousand Years of Glassmaking,* pp. 30–33. Corning, N.Y., 1982.

Goldstein forthcoming
Sidney M. Goldstein. *Catalogue of Islamic Glass in the Khalili Collection.*

Golvin 1965
Lucien Golvin. *Recherches archéologiques à la Qal'a des Banū Hammād.* Paris, 1965.

Gray 1959
Basil Gray. *Buddhist Cave Painting at Tun-huang.* Chicago, 1959.

Gray 1961
Basil Gray. *La Peinture persane.* Geneva, 1961.

Grube 1976
Ernst J. Grube. *Islamic Pottery of the Eighth to the Fifteenth Century in the Keir Collection.* London, 1976.

Grube 1985
Ernst J. Grube. "A Drawing of Wrestlers in the Cairo Museum of Islamic Art." *Quaderni di studi arabi* 3 (1985), pp. 89–106.

Grube 1991
Ernst J. Grube, ed. *A Mirror for Princes from India: Illustrated Versions of the Kalilah wa Dimnah, Anvar-i Suhayli, Iyar-i Danish, and Humayun Nameh.* Mumbai (Bombay), 1991.

Gudenrath [unpublished]
William Gudenrath. "Enameling Techniques in the Middle East."

Gudiol Ricart–de Artíñano 1935
J. Gudiol Ricart and P. M. de Artíñano. *Resumen de la historia del vidrio: catálogo de la colección Alfonso Macaya.* Barcelona, 1935.

Hallett 1996
Jessica R. Hallett. "Trade and Innovation: The Rise of a Pottery Industry in 'Abbasid Basra," Ph.D. diss., Oxford University, Oriental Institute, 1996.

Harden 1936
Donald B. Harden. *Roman Glass from Karanis.* Ann Arbor, Mich., 1936.

Harden et al. 1968
Donald B. Harden, Kenneth Painter, Ralph H. Pinder-Wilson, and Hugh Tait. *Masterpieces of Glass.* Exh. cat. British Museum. London, 1968.

Harden et al. 1987
Donald B. Harden, Hansgerd Hellenkemper, Kenneth Painter, and David Whitehouse. *Glass of the Caesars.* Exh. cat. Corning Museum of Glass, Corning, N.Y.; British Museum, London; and Römisch-Germanisches Museum, Cologne. Milan, 1987.

Harper 1961
Prudence Oliver [Harper]. "Islamic Relief Cut Glass: A Suggested Chronology." *JGS* 3 (1961), pp. 9–29.

Harper 1961a
Prudence Oliver Harper. "The Senmurv." *The Metropolitan Museum of Art Bulletin* 20, no. 3 (November 1961), pp. 95–101.

Hartner 1938
Willy Hartner. "The Pseudoplanetary Nodes of the Moon's Orbit in Hindu and Islamic Iconographies." *Ars Islamica* 5, no. 2 (1938), pp. 112–54.

Hasan 1937
Zaki Muhammad Hasan. *Kunūz al-fatimiyyīn (Treasures of the Fatimids).* Cairo 1937 [in Arabic].

al-Hassan–Hill 1986
Ahmad Yusuf al-Hassan and Donald R. Hill. *Islamic Technology: An Illustrated History.* Cambridge and New York, 1986.

Hasson 1979
Rachel Hasson. *Early Islamic Glass.* L. A. Mayer Memorial Institute for Islamic Art. Jerusalem, 1979.

Hayes 1992
J. W. Hayes. *Excavations at Saraçhane in Istanbul. Vol. 2, The Pottery.* Princeton, 1992.

Heaton 1948
Noël Heaton. "The Origin and Use of Silver Stain." *Journal of the British Society of Master Glass-Painters* 10, no. 1 (1948), pp. 9–16.

Henderson 1995
Julian Henderson. "Investigation into Marvered Glass: 2." In Allan 1995, pp. 31–50.

Henderson 1998
Julian Henderson. "Blue and Other Coloured Translucent Glass Decorated with Enamels: Possible Evidence for Trade in Cobalt-Blue Colorants." In Ward 1998, pp. 116–21.

Henderson–Allan 1990
Julian Henderson and James W. Allan. "Enamels on Ayyubid and Mamluk Glass Fragments." *Archeomaterials* 4 (1990), pp. 167–83.

Herbert 1928
Sir Thomas Herbert. *Travels in Persia, 1627–1629.* London, 1928.

Herrmann 1989
Georgina Herrmann. "The Art of the Sasanians." In Ferrier 1989, pp. 61–79.

Herzfeld 1923
Ernst Herzfeld. *Die Ausgrabungen von Samarra: Der Wandschmuck der Bauten von Samarra und seine Ornamentik.* Berlin, 1923.

Hettes 1964
Karel Hettes. "Eastern Influences on Bohemian Glass in the Eighteenth and Nineteenth Centuries." In *Annales du 3ᵉ Congrès des Journées Internationales du Verre, Damas, 14–23 novembre 1964,* pp. 169–77. Liège, 1964.

Higashi 1993
Elizabeth L. Higashi, ed. *Glass from the Ancient World: So Diverse a Unity.* Exh. cat. Mardigian Library, University of Michigan. Dearborn, Mich., 1991.

Hirth–Rockhill 1911
Friedrich Hirth and W. W. Rockhill, trs. and eds. *Chau Ju-kua: His Work on the Chinese and Arab Trade in the Twelfth and Thirteenth Century, Entitled Chu-fan-chi.* Saint Petersburg, 1911.

Hoare 1971
Oliver Hoare. "The Enameled Glass of the Mamluks." *Auction* 4 (1971), pp. 32–35.

Hoare 1985
Oliver Hoare. *The Unity of Islamic Art: An Exhibition to Inaugurate the Islamic Art Gallery of the King Faisal Center for Research and Islamic Studies.* Exh. cat. King Faisal Center for Research and Islamic Studies. Riyadh, 1985.

Hollis 1945
Howard Hollis. "Two Examples of Arabic Enameled Glass." *Bulletin of the Cleveland Museum of Art* 32, no. 10 (Dec. 1945), pp. 179–81.

Honey 1946
William B. Honey. *A Handbook for the Study of Glass Vessels of All Periods and Countries and a Guide to the Museum Collection.* Victoria and Albert Museum. London, 1946.

Ibn al-Athīr 1982
Ibn al-Athīr. *al-Kāmil fī al-tārīkh.* Vol. 3. Beirut, 1982 [in Arabic].

Ibn al-Fūṭī 1996
Kamāl al-Dīn Abū al-Faḍl ʿAbd al-Razzāq ibn Aḥmad (Ibn al-Fūṭī). *Majmaʿ al-ādāb fī al-muʿjam al-alqāb.* 6 vols. Tehran, 1996 [in Arabic].

Ibn ʿAlī al-Tabrīzī
Abū Zakariā Yaḥyā ibn ʿAlī al-Tabrīzī. *Sharḥ al-qaṣāʾid al-ʿashar.* Beirut, n.d. [in Arabic].

Ibn Manẓūr
Ibn Manẓūr. *Lisān al-ʿarab.* 16 vols. Beirut, n.d. [in Arabic].

INA
*The INA Quarterly.* Institute of Nautical Archaeology.

Irwin 1997
Robert Irwin. "Eating Horses and Drinking Mare's Milk." In David Alexander, ed. *Furusiyya,* pp. 148–51. Riyadh, 1997.

Irwin 1997a
Robert Irwin. *Islamic Art in Context: Art, Architecture, and the Literary World.* New York, 1997.

Israeli 1964
Yael Israeli. *Ancient Glass: Museum Haaretz Collections.* Tel Aviv, 1964.

Istanbul 1983
*The Anatolian Civilisations, 3: Seljuk–Ottoman.* Exh. cat. Topkapı Sarayi Museum. Istanbul, 1983.

Jacobson 1990–93
Gusta Lehrer Jacobson. "A Luster-Painted Cup from Hurbat Migdal." *Israel: People and Land.* Eretz Israel Museum 7–8 (1990–93), pp. 83–90 [in Hebrew with English summaries].

Jaffé 1989
D. Jaffé. "Peiresc, Rubens, dal Pozzo and the 'Portland Vase'." *Burlington Magazine* 31, no. 137 (1989), pp. 554–59.

James 1988
David James. *Qurʾāns of the Mamlūks.* New York, 1988.

Jenkins 1983
Marilyn Jenkins[-Madina], ed. *Islamic Art in the Kuwait National Museum: The al-Sabah Collection.* London, 1983.

Jenkins 1986
Marilyn Jenkins[-Madina]. "Islamic Glass: A Brief History." *The Metropolitan Museum of Art Bulletin* 44, no. 2 (fall 1986), pp. 3–56.

Jenkins–Keene 1982
Marilyn Jenkins[-Madina] and Manuel Keene. *Islamic Jewelry in the Metropolitan Museum of Art.* New York, 1982.

Jenkins et al. 1977
Marilyn Jenkins[-Madina], Julia Meech-Pekarik, and Suzanne Valenstein. *Oriental Ceramics, The World's Great Collections: The Metropolitan Museum of Art.* Vol. 12. Tokyo, 1977.

JGS
*Journal of the Glass Society*

Kafesoğlu 1956
Ibrahim Kafesoğlu. "Tārīkh-i daulat-i khwārazmshāhīyān—Harezmşahlar Devleti Tarihi (History of the Dynasty of the Khwarazmashahi)," *Türk Tarih Kurumu Yayınlarından* 7, no. 29 (1956) [in Persian and Turkish].

Karomatov et al. 1983
F. Karomatov, V. Meskeris, and T. Vyzgo. *Mittelasien: Musikgeschichte in Bildern.* Vol. 2. Leipzig, 1983.

Keall 1993
Edward J. Keall. "One Man's Mede Is Another Man's Persian; One Man's Coconut Is Another Man's Grenade." *Muqarnas* 10 (1993), pp. 275–85.

Keene 1984
Manuel Keene. *Selected Recent Acquisitions.* Dār al-Āthār al-Islāmiyyah, Kuwait National Museum. Kuwait, 1984.

Kenesson 1998
Summer S. Kenesson. "Islamic Enamelled Beakers: A New Chronology." In Ward 1998, pp. 45–49.

Kervran 1984
Monique Kervran. "Les Niveaux islamiques du secteur oriental du tépé de l'Apadana, III: les objets en verre, en pierre et en métal." *Cahiers de la Délégation Archéologique Française en Iran* 14 (1984), pp. 211–36.

Kiani 1984
Muhammad Yusuf Kiani. *The Islamic City of Ğurğān.* Archäologische Mitteilungen aus Iran, Ergänzungsband 11. Berlin, 1984.

Koch 1998
Alexander Koch. "Der Goldschatzfund des Famensi: Prunk und Pietät im chinesischen Buddhismus der Tang-Zeit." *Jahrbuch des Römisch-Germanischen Zentralmuseums, Mainz* 42 (1998), pp. 403–542.

Kolbas 1983
Judith G. Kolbas. "A Color Chronology of Islamic Glass." *JGS* 25 (1983), pp. 95–100.

Kondratieva 1961
F. A. Kondratieva. "Green-Glazed Ceramics from Paykend." *Trudy Gosudarstvennovo Ermitazha–Kultura i Iskusstvo Narodov Vostoka* 5 (1961), pp. 216–27 [in Russian].

Kordmahini 1988
Helen A. Kordmahini. *Glass from the Bazargan Collection.* Tehran, 1988 [in Arabic and English].

Korea National Museums 1989
*Selected Treasures of National Museums of Korea.* Seoul, 1989.

Kozloff 1981
Arielle P. Kozloff, ed. *Animals in Ancient Art from the Leo Mildenberg Collection*. Exh. cat. Cleveland Museum of Art. Cleveland, 1981.

Kramarovsky 1998
Mark Kramarovsky. "The Import and Manufacture of Glass in the Territories of the Golden Horde." In Ward 1998, pp. 96–100.

Kröger 1984
Jens Kröger. *Glas*. Islamische Kunst, 1. Berlin, Museum für Islamische Kunst. Mainz am Rhein, 1984.

Kröger 1995
Jens Kröger. *Nishapur: Glass of the Early Islamic Period*. New York, 1995.

Kröger 1998
Jens Kröger. "Gläser aus spätantiker und islamischer Zeit in der Abegg-Stiftung." In *Entlang der Seidenstraße: Frühmittelalterliche Kunst zwischen Persien und China in der Abegg-Stiftung*, edited by Karel Otavsky and B. Barfuss-Weber, pp. 299–322. Riggisberger Berichte 6. Riggisberg, 1998.

Küçükerman 1985
Önder Küçükerman. *Cam Sanatı ve Geleneksel Türk Cancılığından Örnekler—The Art of Glass and Traditional Turkish Glassware*. Ankara, 1985.

Kuwait 1994
*Tareq Rajab Museum*. Kuwait, 1994.

Laing 1991
Ellen Johnston Laing. "A Report on Western Asian Glassware in the Far East." *Bulletin of the Asia Institute* 5 (1991), pp. 109–21.

Lamb 1965
Alastair Lamb. "A Note on Glass Fragments from Pangkalan Bujang, Malaya." *JGS* 7 (1965), pp. 35–40.

Lamm 1927
Carl Johan Lamm. "A Moslem Decoration in Stucco and Glass." *Burlington Magazine* 50 (1927), pp. 36–43.

Lamm 1928
Carl Johan Lamm. *Das Glas von Samarra*. Berlin, 1928.

Lamm 1929–30
Carl Johan Lamm. *Mittelalterliche Gläser und Steinschnittarbeiten aus dem Nahen Osten*. 2 vols. Berlin, 1929–30.

Lamm 1931
Carl Johan Lamm. "Les Verres trouvés à Suse." *Syria* 12 (1931), pp. 358–67.

Lamm 1935
Carl Johan Lamm. *Glass from Iran in the National Museum, Stockholm*. Stockholm and London, 1935.

Lamm 1939
Carl Johan Lamm. "Glass and Hard Stone Vessels." In *SPA* 3 (1939), pp. 2592–2606.

Lamm 1941
Carl Johan Lamm. *Oriental Glass of Mediaeval Date Found in Sweden and the Early History of Lustre-Painting*. Stockholm, 1941.

Lane 1863–93
Edward W. Lane. *Arabic–English Lexicon*. Cambridge and Edinburgh, 1863–93.

Langdon–Harden 1934
S. Langdon and Donald B. Harden. "Excavations at Kish and Barghuthiat, 1933: Glass from Kish." *Iraq* 1 (1934), pp. 131–36.

Leaf 1983
W. Leaf. "Developments in the System of Armorial Insignia during the Ayyubid and Mamluk Periods." *Palestinian Exploration Journal* (1983), pp. 61–74.

Le Fur 1994
D. Le Fur. *La Conservation des peintures murales des temples de Karnak*. Paris, 1994.

Legeza 1988
Laszlo Legeza. "Tantric Elements in Pre-Hispanic Philippines Gold Art." *Arts of Asia* 18, no. 4 (July–August 1988), pp. 129–37.

Levey 1962
M. Levey. *Medieval Arabic Bookmaking and Its Relation to Early Chemistry and Pharmacology*. Transactions of the American Philosophical Society 52, pt. 4 (1962).

Liefkes 1997
Reino Liefkes, ed. *Glass*. London, 1997.

Lillich 1986
Meredith Parsons Lillich. "European Stained Glass around 1300: The Introduction of Silver Stain." In *Europäische Kunst um 1300*, pp. 45–60; *Akten des XXV. Internationalen Kongresses für Kunstgeschichte*. Vienna, Cologne, and Graz, 1986.

LIMC
*Lexicon Iconographicum Mythologiae Classicae (LIMC)*. Vol. 4, pt. 2. Zurich and Munich, 1988.

London 1976
*The Arts of Islam*. Exh. cat. Hayward Gallery. London, 1976.

London 1982
*The Indian Heritage: Court Life and Arts under Mughal Rule*. Exh. cat. Victoria and Albert Museum. London, 1982.

Louisiana Revy 1987
"Art from the World of Islam, Eighth–Eighteenth Century." *Louisiana Revy* 27, no. 3 (March 1987).

Lucerne 1981
*3000 Jahre Glaskunst von der Antike bis zum Jugendstil*. Exh. cat. Kunstmuseum. Lucerne, 1981.

Maddison–Savage-Smith 1997
Francis Maddison and Emily Savage-Smith. *Science, Tools and Magic*. 2 vols. The Nasser D. Khalili Collection of Islamic Art, 12. London, 1997.

Magne 1913
Lucien Magne. *Décor du verre: gobeleterie, mosaïque, vitrail*. L'Art appliqué aux métiers. Paris, 1913.

Mahboubian 1970
*Treasures of Persian Art after Islam: The Mahboubian Collection*. New York, 1970.

Malkiel 1995
N. K. Malkiel. "The Toiletry from Paikend." *Ermitazhnye Chteniya 1986–1994 Godov: Pamyati V. G. Lukonina (21.I.1932–10.IX.1984)*, pp. 234–38. Saint Petersburg, 1995 [in Russian].

Manzari et al. 1976
Maria Manzari, Jamie Fuller, Mona Lang, Blossom Regan, and Jack Soultanian Jr. *Ancient and Antique Glass in the Queens College Art Collection, Queens College of the City University of New York*. New York, 1976.

al-Maqrīzī 1853–54
Taqī al-Dīn al-Maqrīzī. *Kitāb al-mawā'iz wa al-i'tibār bi-dhikr al-khiṭaṭ wa al-āthār*. Cairo, 1853–54 [in Arabic].

Marçais 1928
George Marçais. *Les Faïences à reflets metalliques de la grande mosquée de Kairouan*. Paris, 1928.

Marçais–Poinssot 1952
George Marçais and Louis Poinssot. *Objets kairouanais, IXᵉ au XIIIᵉ siécle. Reliures, verreries, cuivres et bronzes, bijoux*. Vol. 2. Tunis, 1952.

Marcus 1962
Margaret F. Marcus. "A Gilded Blue Glass Vase from Mughal India." *Bulletin of the Cleveland Museum of Art* 49, no. 10 (December 1962), pp. 243–47.

Markel 1991
Stephen Markel. "Indian and 'Indianate' Vessels in the Los Angeles County Museum of Art." *JGS* 33 (1991), pp. 82–92.

Markel 1993
Stephen Markel. "Luxury Arts of Lucknow." *Arts of Asia* 23, no. 2 (March–April 1993), pp. 108–20.

Marschak 1986
Boris Marschak. *Silberschätze des Orients: Metallkunst des 3.–13. Jahrhunderts und ihre Kontinuität*. Leipzig, 1986.

May 1957
Florence Lewis May. *Silk Textiles of Spain: Eighth to Fifteenth Century*. New York, 1957.

Mayer 1933
L. A. Mayer. *Saracenic Heraldry*. Oxford, 1933.

Mayer 1939
L. A. Mayer. "A Glass Bottle of the Atābak Zangī." *Iraq* 6 (1939), pp. 101–3.

McBain 1988
Audrey Y. McBain. "Oriental Artifacts Discovered in Madagascar." *Arts of Asia* 18, no. 5 (September–October 1988), pp. 161–68.

Megaw 1959
A. H. S. Megaw. "A Twelfth-Century Scent Bottle from Cyprus." *JGS* 1 (1959), pp. 59–61.

Meinecke 1972
Michael Meinecke. "Zur mamlukische Heraldik." *Mitteilungen des Deutsches Archäologischen Instituts, Abteilung Cairo* 28, no. 2 (1972), pp. 214–87.

Meinecke 1974
Michael Meinecke. "Die Bedeutung der mamlukischen Heraldik für die Kunstgeschichte." *Zeitschrift der Deutschen Morgenländischen Gesellschaft*. Suppl. 2 (1974), pp. 213–40.

Melikian-Chirvani 1974
Assadullah Souren Melikian-Chirvani. "The White Bronzes of Early Islamic Iran." *Metropolitan Museum Journal* 9 (1974), pp. 123–50.

Melikian-Chirvani 1982
Assadullah Souren Melikian-Chirvani. *Islamic Metalwork from the Iranian World, Eighth–Eighteenth Centuries*. Victoria and Albert Museum. London, 1982.

Melikian-Chirvani 1997
Assadullah Souren Melikian-Chirvani. "Precious and Semi-Precious Stones in

Iranian Culture, Chapter 1: Early Iranian Jade." *Bulletin of the Asia Institute* 11 (1997), pp. 123-73.

Mexico City 1994

*Arte islámico del Museo Metropolitano de Nueva York*. Exh. cat. Antiguo Colegio de San Ildefonso. Mexico City, 1994.

Meyer 1992

Carol Meyer. *Glass from Quseir al-Qadim and the Indian Ocean Trade*. Chicago, 1992.

Miho Museum 1997

*Miho Museum: South Wing*. Japan, 1997.

Mittal 1983

Jagdish Mittal. "Indo-Islamic Metal and Glassware." In Saryu Doshi, ed. *An Age of Splendor: Islamic Art in India*, pp. 60–71. Bombay, 1983.

MMA 1987

The Metropolitan Museum of Art. *The Islamic World*. Introduction by Stuart Cary Welch. New York, 1987.

Mohl 1976

Jules Mohl. *Le Livre des Rois par Abou'lkasim Firdousi*. Paris, 1976 [1st ed.: 1838–78].

Morden 1982

Margaret Elizabeth Morden. "The Glass Lamps from the Eleventh-Century Shipwreck at Serçe Limanı, Turkey," M.A. diss., Texas A&M University, 1982.

Morton 1985

Alexander H. Morton. *A Catalogue of Early Islamic Glass Stamps in the British Museum*. London, 1985.

Moss 1971

Hugh M. Moss. *Snuff Bottles of China*. London, 1971.

Mostafa 1959

Mohamed Mostafa. "Neuerwerbungen des Museums für Islamische Kunst in Kairo." In *Aus der Welt der islamischen Kunst: Festschrift fur Ernst Kühnel zum 75. Geburtstag am 26.10.1957*, pp. 89–92. Berlin, 1959.

Munsell 1929

Albert Henry Munsell. *Munsell Book of Color*. Baltimore, 1929.

Nabi Khan 1990

Ahmad Nabi Khan. *Al-Mansurah: A Forgotten Metropolis in Pakistan*. Museum and Monument Series 2. Karachi, 1990.

Naumann 1976

Rudolf and Elisabeth Naumann. *Takht-i Suleiman: Ausgrabung des Deutschen Archäologischen Instituts in Iran*. Munich, 1976.

Negro Ponzi 1968–69

Mariamaddalena Negro Ponzi. "Sasanian Glassware from Tell Mahuz (North Mesopotamia)." *Mesopotamia* 3–4 (1968–69), pp. 293–384.

Negro Ponzi 1970–71

Mariamaddalena Negro Ponzi. "Islamic Glassware from Seleucia." *Mesopotamia* 5–6 (1970–71), pp. 67–104.

Negro Ponzi 1987

Mariamaddalena Negro Ponzi. "Late Sasanian Glassware from Tell Baruda." *Mesopotamia* 22 (1987), pp. 265–75.

New York 1992

Jerrilynn D. Dodds, ed. *Al-Andalus: The Art of Islamic Spain*. Exh. cat. The Metropolitan Museum of Art. New York, 1992 .

New York 1995

Yuri A. Petrosyan, Oleg F. Akimushkin, Anas B. Khalidov, and Efim A. Rezvan. *Pages of Perfection: Islamic Paintings and Calligraphy from the Russian Academy of Sciences, Saint Petersburg*. Exh. cat. New York, The Metropolitan Museum of Art. Lugano and Milan, 1995.

New York 1996

*Ancient Art from the Shumei Family Collection*. Exh. cat. The Metropolitan Museum of Art. New York, 1996.

New York 1997

Helen C. Evans and William D. Wixom, eds. *The Glory of Byzantium: Art and Culture of the Middle Byzantine Era, A.D. 843–1261*. Exh. cat. The Metropolitan Museum of Art. New York, 1997.

Newby 1998

Martine S. Newby. "The Cavour Vase and Gilt and Enamelled Mamluk Coloured Glass." In Ward 1998, pp. 35–40.

Newby 2000

Martine S. Newby. *Glass of Four Millennia*. Oxford, 2000.

Newby–Sheppard 1991

Martine S. Newby and Christopher Sheppard. *The Cavour Vase: An Extraordinary Blue Islamic Enamelled Glass Vase*. London, 1991.

Newman 1977

Harold Newman. *An Illustrated Dictionary of Glass*. London, 1977.

Noll et al. 1975

W. Noll, L. Born, and R. Holm. "Keramiken und Wandmalereien der Ausgrabungen von Thera." *Naturwissenschaften* 62 (1975), pp. 87–94.

Norfolk 1989

Nancy O. Merrill. *A Concise History of Glass Represented in the Chrysler Museum Glass Collection*. Norfolk, 1989.

Ohm 1973

Annaliese Ohm. *Europäisches und aussereuropäisches Glas*. Frankfurt am Main, 1973.

Ohm 1975

Annaliese Ohm. *Drei Tausend Jahre Glas aus Privatsammlung Frankfurt am Main*. Exh. cat. Essen, Ruhrlandmuseum. Zwiesel, 1975.

Okayama 1991

*Okayama Orient Museum*. Okayama, 1991 [in Japanese].

Oliver Jr. 1980

Andrew Oliver Jr. *Ancient Glass in the Carnegie Museum of Natural History, Pittsburgh*. Pittsburgh, 1980.

Öney 1990

Gönül Öney. "12.–13. Yüzyıl Anadolu cam işçiliğinde kadeh" (Anatolian Glass Beakers of the Twelfth and Thirteenth Centuries). In *Anatolian Glass* 1990, pp. 64–69.

Paris 1971

*Arts de l'Islam: des origins à 1700*. Exh. cat. Musée du Louvre. Paris, 1971.

Paris 1977

*L'Islam dans les collections nationales*. Exh. cat. Musée du Louvre. Paris, 1977.

Paris 1989

Marthe Bernus-Taylor, ed. *Arabesques et jardins du paradis: collections françaises d'art islamique*. Exh. cat. Musée du Louvre. Paris, 1989.

Paris 1992

*Terres secrètes de Samarcande: ceramiques du VIIIᵉ au XIIIᵉ siècle*. Exh. cat. Institut du Monde Arabe. Paris, 1992.

Paris 1996

*A l'ombre d'Avicenne: la médecine au temps des califes*. Exh. cat. Institut du Monde Arabe. Paris, 1996.

Perrot 1970

Paul Perrot. "Glass." In *From the World of Islam*, pp. 17–20. Exh. cat. Fox-Richmond Gallery, Keuka College. Keuka Park, N.Y., 1970.

Philippe 1982

Joseph Philippe. *Glass History and Art*. Liège, 1982.

Pinder-Wilson 1962

Ralph Pinder-Wilson. "A Glass Huqqa Bowl." *The British Museum Quarterly* 25, nos. 3–4 (1962), pp. 91–94.

Pinder-Wilson–Ezzy 1976

Ralph Pinder-Wilson and Waffiya Ezzy. "Glass." In London 1976, pp. 131–46.

Pinder-Wilson–Scanlon 1973

Ralph H. Pinder-Wilson and George T. Scanlon. "Glass Finds from Fustat: 1964–71." *JGS* 15 (1973), pp. 12–30.

Pope 1931

Arthur Upham Pope. "More about Persian Glass." *Apollo* 13 (January 1931), pp. 10–12.

Porter 1998

Venetia Porter. "Enamelled Glass Made for the Rasulid Sultans of the Yemen." In Ward 1998, pp. 91–95.

Qaddumi 1987

Ghada Hijjawi Qaddumi. *Variety in Unity: A Special Exhibition on the Occasion of the Fifth Islamic Summit in Kuwait*. Exh. cat. Kuwait City, National Museum. Kuwait, 1987.

Rackham 1925–26

Bernard Rackham. "A Glass Beaker from Persia in the Victoria and Albert Museum." *Artibus Asiae* 1–4 (1925–26), pp. 307–8.

Rainwater–Felger 1976

Dorothy T. Rainwater and Donna H. Felger. *A Collector's Guide to Spoons around the World*. Hanover, Penn., 1976.

Raspopova 1985

Valentina I. Raspopova. "Decorated Glass Vessels from Panjikent." *Sovietskaya Arkheologia* 2 (1985), pp. 205–12 [in Russian with English summary].

Rawson 1988

Jessica Rawson. "An Exhibition in the Palace Museum in Peking." *Arts of Asia* 18, no. 6 (November–December 1988), pp. 96–101.

RCEA

*Répertoire Chronologique d'Epigraphie Arabe*. 18 vols. Cairo, 1931–91.

Rednap et al. 1995

M. C. Rednap, I. C. Freestone, and K. Vlierman. "Eighteenth-Century Glass Ingots from England: Further Light on the Post-Medieval Glass Trade." In D. Hook and D. Gaimster, eds. *Trade and Discovery: The Scientific Study of Artefacts from Post-Medieval Europe and Beyond*, pp. 145–59. London, 1995.

RGS

*Readings in Glass Studies*

Ribeiro–Hallett 1999
    Maria Queiroz Ribeiro and Jessica Hallett. *Os vidros da dinastia Mameluca no Museu Calouste Gulbenkian—Mamluk Glass in the Calouste Gulbenkian Museum*. Lisbon, 1999.
Rice 1958
    David S. Rice. "Early Signed Islamic Glass." *Journal of the Royal Asiatic Society of Great Britain and Ireland* (April 1958), pp. 8–16.
Ricke 1989
    Helmut Ricke. *Reflex der Jahrhunderte: Die Glassammlung des Kunstmuseums Düsseldorf mit Sammlung Hentrich: Eine Auswahl*. Düsseldorf, 1989.
Riis 1953
    P. J. Riis. "Saracenic Blazons on Glass from Ḥamā." In *Studia Orientalia Ioanni Pedersen*, pp. 295–302. Copenhagen, 1953.
Riis–Poulsen 1957
    P. J. Riis and Vagn Poulsen. *Hama: fouilles et recherches de la fondation Carlsberg, 1931–1938*. Vol. 4, no. 2. *Les verreries et poteries médiévales*. Copenhagen, 1957.
Ritsema van Eck–Zijlstra-Zweens 1993–95
    Pieter C. Ritsema van Eck and Henrica M. Zijlstra-Zweens. *Glass in the Rijksmuseum*. Translated by Mary Maclure. 2 vols. Zwolle, 1993–95.
Robinson 1976
    Basil W. Robinson, ed. *Islamic Painting and the Arts of the Book*. London, 1976.
Rogers 1969
    J. Michael Rogers. "Aeolipiles Again." In *Forschungen zur Kunst Asien: In Memoriam Kurt Erdmann, 9 September 1901–30 September 1964*, pp. 147–58. Istanbul, 1969.
Rogers 1983
    J. Michael Rogers. "Glass in Ottoman Turkey." *Sonderdruck aus Istanbuler Mitteilungen* 33 (1983), pp. 239–66.
Rogers 1998
    J. Michael Rogers. "European Inventories as a Source for the Distribution of Mamluk Enamelled Glass." In Ward 1998, pp. 69–73.
Rosenthal–Sivan 1978
    Renate Rosenthal and Renée Sivan. *Ancient Lamps in the Schloessinger Collection*. Jerusalem, 1978.
Rouen 1989
    *A Travers le verre: du moyen âge à la renaissance*. Exh. cat. Rouen, Musée des Antiquités de Seine-Maritime. Nancy, 1989.
Rückert 1963
    Rainer Rückert. "Venetianische Moscheeampeln in Istanbul." In *Festschrift für Harald Keller*, pp. 223–34. Darmstadt, 1963.
Ruhfar 1996
    Zohreh Ruhfar, ed. *An Anthology of Islamic Arts*. Tehran, 1996.
Sa'diya 1989
    Ayyub Sa'diya, ed. *Dimashq al-shām aqdam madīna fī al-'ālim (Damascus, the Most Ancient City in the World)*. Damascus, 1989 [in Arabic].
Sakurai–Kawatoko 1992
    Kiyohiko Sakurai and Mutuso Kawatoko, eds. *Egyptian Islamic City: Excavation Report, 1978–1985*. Tokyo, 1992 [in Japanese].
von Saldern 1968
    Axel von Saldern. *Ancient Glass in the Museum of Fine Arts Boston*. Boston, 1968.
von Saldern 1968a
    Axel von Saldern. "Sassanidische und islamische Gläser in Düsseldorf und Hamburg." *Sonderdruck aus dem Jahrbuch der Hamburger Kunstsammlungen* 13 (1968), pp. 33–62.
von Saldern 1973
    Axel von Saldern. "Achemenid and Sasanian Cut Glass." *Ars Orientalis* 5 (1973), pp. 7–16.
von Saldern 1974
    Axel von Saldern. *Katalog des Kunstmuseums Düsseldorf. Vol. 3, Glassammlung Heintrich Antike und Islam*. Düsseldorf, 1974.
von Saldern 1980
    Axel von Saldern. *Glas von der Antike bis zum Jugendstil: Sammlung Hans Cohn—Glass, 500 B.C. to A.D. 1900: The Hans Cohn Collection, Los Angeles, Cal*. Mainz am Rhein, 1980.
von Saldern et al. 1974
    Axel von Saldern, Birgit Nolte, Peter La Baume, and Thea Elisabeth Haevernick. *Gläser der Antike: Sammlung Erwin Oppenländer*. Exh. cat. Hamburg, Museum für Kunst und Gewerbe. Mainz am Rhein, 1974.
Saliger 1987
    Arthur Saliger, ed. *Dom- und Diözesanmuseum Wien*. Vienna, 1987.
Samarra 1940
    *Excavations at Samarra, 1936–1939—Hafriyāt Sāmarrā, 1936–1939*. Directorate of Antiquities. Baghdad, 1940.
Sarpellon 1990
    Giovanni Sarpellon. *Miniature di vetro: Murrine, 1838–1924*. Exh. cat. Doge's Palace. Venice, 1990.

Satoh et al. 1994
    Eisaku Satoh, Kayoko Yamada, Ken-ichi Hirasawa, Toshiyuki Takyu, Yoshio Akai, Yasuhiro Takeshita, Yoko Shindo, and Mutsuo Kawatoko. "Analysis of the Contents of a Glass Kohl Bottle Excavated from al-Ṭūr, Archaeological Site in South Sinai, Egypt." In *Proceedings of the Japan Academy* 70, ser. B, no. 6 (1994), pp. 77–80.
Scanlon 1966
    George T. Scanlon. "Fustat Expedition: Preliminary Report 1965, Part 1." *Journal of the American Research Center in Egypt* 5 (1966), pp. 83–112.
Scerrato 1962
    Umberto Scerrato. "Islamic Glazed Tiles with Moulded Decoration from Ghazni." *East and West* 13, no. 4 (December 1962), pp. 263–87.
Schmidt 1912
    Robert Schmidt. *Das Glas*. Berlin, 1912.
Schmoranz 1898
    Gustav Schmoranz. *Altorientalische Glas-Gefässe*. Vienna, 1898.
Sharakhimov 1973
    Sh. Sharakhimov. "New Glass Vessels from Afrasiyab." *Afrasiyab* 2 (1973), pp. 224ff [in Russian].
Shelkolnikov 1966
    B. A. Shelkolnikov. "Russian Glass from the Eleventh to the Seventeenth Century." *JGS* 8 (1966), pp. 95–115.
Shindo 1992
    Yoko Shindo. "Glass." In Sakurai–Kawatoko 1992, pp. 304–35, 572–617.
Shindo 1993
    Yoko Shindo. "Islamic Marvered Glass from al-Ṭūr, South Sinai." In *Annales du 12ᵉ Congrès de l'Association Internationale pour l'Histoire du Verre, Vienne–Wien 26–31 août 1991*, pp. 297–305. Amsterdam, 1993.
Skik 1971–72
    Khira Skik. "La Collection de verres musulmans de fabrication locale conservés dans les musées de Tunisie." *Bulletin de l'Association International pour l'Histoire du Verre: le verre en Tunisie*, pp. 87–102. Liège, 1971–72.
Smith 1957
    Ray Winfield Smith. *Glass from the Ancient World: The Ray Winfield Smith Collection*. Exh. cat. Corning Museum of Glass. Corning, N.Y., 1957.
Soucek 1978
    Priscilla Parsons Soucek. *Islamic Art from the University of Michigan Collections*. Exh. cat. Kelsey Museum of Archaeology. Ann Arbor, Mich., 1978.
Soustiel 1985
    Jean Soustiel. *La Céramique islamique*. Fribourg, 1985.
SPA
    Arthur Upham Pope, ed. *A Survey of Persian Art from Prehistoric Times to the Present*. 16 vols. London and New York, 1938–77.
Spaer 1992
    Maud Spaer. "The Islamic Glass Bracelets of Palestine: Preliminary Findings." *JGS* 34 (1992), pp. 44–62.
Stevens 1976
    Bob C. Stevens. *The Collector's Book of Snuff Bottles*. New York, 1976.
Stierlin 1996
    Henri Stierlin. *Islam*. Cologne and New York, 1996.
Stockholm 1982
    *Medelhavsmuseet: En Introduktion*. Stockholm, 1982 [in Swedish].
Strauss 1965
    Jerome Strauss. "Islamic Glasses with Internal Siphons." In *Annales du 3ᵉ Congrès International du Verre*, vol. 2, pp. 232.1–5. Brussels, 1965.
Swietochowski–Carboni 1994
    Marie Lukens Swietochowski and Stefano Carboni. *Illustrated Poetry and Epic Images: Persian Painting in the 1330s and 1340s*. Exh. cat. The Metropolitan Museum of Art. New York, 1994.
Tait 1964
    Hugh Tait. "The Pilkington Glass Museum: 1." *Connoisseur* 157, no. 634 (December 1964), pp. 230–37.
Tait 1991
    Hugh Tait, ed. *Glass: Five Thousand Years*. New York, 1991.
Tait 1998
    Hugh Tait. "The Palmer Cup and Related Glasses Exported to Europe in the Middle Ages." In Ward 1998, pp. 50–55.
Taniichi 1986
    Takashi Taniichi. "The Origin of the Cut Glass Bowl in Shosoin Treasures." *Bulletin of the Okayama Orient Museum* 5 (1986), pp. 35–46.
Taniichi 1987
    Takashi Taniichi. *Catalogue of Near Eastern Glass in the Okayama Orient Museum: Catalogue of Ancient Glass*. Vol. 4. Okayama, 1987 [in Japanese].
Taniichi 1988
    Takashi Taniichi. "Islamic Glass Vessels Recently Excavated in China."

*Bulletin of the Okayama Orient Museum* 7 (1988), pp. 97–108.

Tavernier 1677
Jean Baptiste Tavernier. *The Six Voyages of John Baptiste Tavernier, Baron of Aubonne, through Turkey, into Persia and the East Indies, for the Space of Forty Years*. London, 1677.

Tehrani 1987
Sa'id Golkar Tehrani. *Rāhnamāī mūza abgīna ve safālina hāī irān (Guide to the Glassware and Ceramics Museum of Iran)*. Tehran, 1987 [in Persian].

Tokyo 1979
*Treasures of the Orient*. Tokyo, 1979 [in Japanese].

Toledo 1961
"Ancient and Near Eastern Glass." *The Toledo Museum of Art: Museum News* (spring 1961).

Toledo 1969
*Art in Glass: A Guide to the Glass Collections*. Toledo, 1969.

Treasures 2000
*Treasures on Grassland: Archaeological Finds from the Inner Mongolia Autonomous Region*. Shanghai, 2000 [in Chinese].

Trever 1938
Kamilla Vasilevna Trever. *The Dog-Bird, Senmurv-Paskudj*. Leningrad, 1938 [in Russian].

Trever–Lukonin 1987
Kamilla Vasilevna Trever and Vladimir Grigorevich Lukonin. *Sasanian Silver in the Hermitage Collection: Artistic Culture in Iran, Third–Eighth Century*. Moscow, 1987 [in Russian].

Trudnovskaia 1958
S. A. Trudnovskaia. "Glass from the Ancient Town of Shah-Senem." In S. P. Tolstova and T. A. Jdanko, eds. *Arkheologicheskie i etnograficheskie raboti Khorezmskoi expeditsii 1949–1953*, pp. 421–30. Trudy Khorezmskoi arkheologo-etnograficheskoi expeditsii 2. Moscow, 1958 [in Russian].

al-'Ush 1971
Muḥammad Abū-l-Faraj al-'Ush. "Incised Islamic Glass." *Archaeology* 24, no. 1 (January 1971), pp. 200–3.

Venice 1993
Giovanni Curatola, ed. *Eredità dell'Islam: arte islamica in Italia*. Exh. cat. Venice, Doge's Palace. Milan, 1993.

Verità 1998
Marco Verità. "Analyses of Early Enamelled Venetian Glass: A Comparison with Islamic Glass." In Ward 1998, pp. 129–34.

Vienna 1998
*Schätze der Kalifen: Islamische Kunst zur Fatimidenzeit*. Exh. cat. Künstlerhaus. Vienna, 1998.

Vienna 2000
*7000 Jahre persische Kunst: Meisterwerke aus dem Iranischen Nationalmuseum in Teheran*. Exh. cat. Kunsthistorisches Museum. Vienna, 2000.

Wallert 1995
A. Wallert. "Unusual Pigments on a Greek Marble Basin." *Studies in Conservation* 40, no. 3 (1995), pp. 177–88.

Ward 1993
Rachel Ward. *Islamic Metalwork*. London, 1993.

Ward 1998
Rachel Ward, ed. *Gilded and Enamelled Glass from the Middle East*. London, 1998.

Ward 1998a
Rachel Ward. "Glass and Brass: Parallels and Puzzles." In Ward 1998, pp. 30–34.

Washington 1962
*Ancient Glass in the Freer Gallery of Art*. Washington, D.C., 1962.

Wehr 1976
J. Milton Cowan, ed. *Arabic–English Dictionary: The Hans Wehr Dictionary of Modern Written Arabic*. Ithaca, N.Y., 1976 [1st ed.: 1961].

Weiss 1971
Gustav Weiss. *The Book of Glass*. New York and Washington, D.C., 1971. [1st ed.: 1966].

Whitcomb 1985
Donald S. Whitcomb. *Before the Roses and Nightingales: Excavations at Qasr-i Abu Nasr, Old Shiraz*. New York, 1985.

Whitehouse 1968
David Whitehouse. "Excavations at Sīrāf: First Interim report." *Iran* 6 (1968), pp. 1–22.

Whitehouse 1991
David Whitehouse. "Islamic Glass." In David Battle and Simon Cottle, eds. *Sotheby's Concise Encyclopedia of Glass*, pp. 40–45. London, 1991.

Whitehouse 1993
David Whitehouse. "The Corning Ewer: A Masterpiece of Islamic Cameo Glass." *JGS* 35 (1993), pp. 48–56.

Whitehouse 1998
David Whitehouse. "Byzantine Gilded Glass." In Ward 1998, pp. 4–7.

Wiet 1912
Gaston Wiet. *Catalogue général du Musée Arabe du Caire: lampes et bouteilles en verre émaillé*. Cairo, 1912.

Wightman 1989
G. J. Wightman. *The Damascus Gate, Jerusalem*. BAR International Series 519 (1989).

Wilkinson 1973
Charles K. Wilkinson. *Nishapur: Pottery of the Early Islamic Period*. New York, 1973.

Wypyski 1999
Mark Wypyski. "Final Report of Analyses of Selected Glass Samples from the Islamic Art Museum, Kuwait." Typescript. New York, 1999.

de Zambaur 1927
E. de Zambaur. *Manuel de généalogie et chronologie pour l'histoire de l'Islam*. Hanover, 1927.

Zampieri 1997
Girolamo Zampieri, ed. *"Gioielli" del Museo Archeologico di Padova: vetri, bronzi, metalli preziosi, ambre e gemme*. Padua, 1997.

Zayn al-Din 1968
Naji Zayn al-Din. *Muṣawwir al-khaṭṭ al-'arabī (Atlas of Arabic Calligraphy)*. Baghdad, 1968 [in Arabic].

Zebrowski 1997
Mark Zebrowski. *Gold, Silver and Bronze from Mughal India*. London, 1997.

Zecchin 1968
Luigi Zecchin. "I primi cristalli muranesi giunti in Oriente." *Vetro e silicati* 12, no. 71 (1968), pp. 17–20.

Ziffer 1996
Irit Ziffer. *Islamic Metalwork*. Tel Aviv, 1996.

## ABBREVIATIONS

| | |
|---|---|
| AM | Ashmolean Museum, Oxford |
| Benaki | Benaki Museum, Athens |
| BM | British Museum, London |
| CMA | The Cleveland Museum of Art, Ohio |
| CMG | The Corning Museum of Glass, Corning, New York |
| CMNH | Carnegie Museum of Natural History, Pittsburgh, Pennsylvania |
| DC | David Collection, Copenhagen |
| DIA | Detroit Institute of Art, Detroit, Michigan |
| Eretz | Eretz Israel Museum, Tel Aviv |
| FGA | Freer Gallery of Art, Washington, D.C. |
| Gazira | Mathaf Gazira (Gazira Museum), Cairo |
| Hermitage | The Hermitage Museum, Saint Petersburg |
| IMA | Institut du Monde Arabe, Paris |
| Kelsey | Kelsey Museum, Ann Arbor, Michigan |
| Khamza | Khamza Institute of Art Research, Tashkent, Uzbekistan |
| Kiev | Museum of Art, Kiev, Ukraine |
| KM | Kunstmuseum |
| LACMA | Los Angeles County Museum of Art, Los Angeles, California |
| Louvre | Musée du Louvre, Paris |
| MAD | Musée des Arts Decoratifs, Paris |
| MAIP | National Museum of Iran (Iran Bastan), Museum of the Arts of the Islamic Period, Tehran |
| MFA | Museum of Fine Arts, Boston, Massachusetts |
| MFI | Mathaf al-Fann al-Islami (Museum of Islamic Art), Cairo |
| MHC | Museum of History of Culture of the Peoples of Uzbekistan, Samarqand |
| MK | Museum für Kunsthandwerk |
| MKG | Museum für Kunst und Gewerbe |
| MIK | Museum für Islamische Kunst, Berlin |
| MM | L. A. Mayer Memorial, Jerusalem |
| MMA | The Metropolitan Museum of Art, New York, New York |
| MUA | Museum of Underwater Archaeology, Bodrum, Turkey |
| Newark | The Newark Museum, Newark, New Jersey |
| NGV | National Gallery of Victoria, Melbourne, Australia |
| NM | National Museum |
| Okayama | Okayama Orient Museum, Okayama, Japan |
| ROM | Royal Ontario Museum, Toronto |
| SJM | Salar Jung Museum, Hyderabad, India |
| Termez | Museum of Local History, Termez, Uzbekistan |
| Toledo | Toledo Museum of Art, Toledo, Ohio |
| TRM | Tariq Rajab Museum, Kuwait |
| V&A | Victoria and Albert Museum, London |

# GLOSSARY

**ACID ETCHING**
The process of etching the surface of glass with hydrofluoric acid. Acid-etched decoration is produced by covering the glass with an acid-resistant substance, such as wax, through which the design is scratched. A mixture of diluted hydrofluoric acid and potassium fluoride is then applied to etch the exposed areas of glass.

**AEOLIPILE**
This Greek word was originally applied to a device in which a closed, water-filled vessel, when heated, was made to rotate by jets of steam issuing from one or more projecting bent tubes. The name is sometimes given to Islamic globular or sphero-conical objects with thick walls and narrow neck and mouth. Only a few survive in glass and these were not, in all likelihood, aeolipiles but probably simple containers for drinks or perfumes.

**ALEMBIC**
(Arabic, *al-anbīq*). The part of a distillation apparatus in which the vapor or gas turns into a liquid state. The other two parts are the cucurbit (*qar'a*) and the receiving bottle (*qābila*).

**ALKALI**
A soluble salt consisting mainly of potassium carbonate or sodium carbonate. One of the essential ingredients of glass, alkali is a flux that reduces the melting point of silica.

**ANNEALING**
The process of slowly cooling a completed object in an auxiliary part of the furnace.

**ATABEG**
Turkish term used as a title of high dignitaries under the Seljuqs (1040–1194) and their successors.

**BATCH**
The mixture of raw materials, usually silica, soda, potash, lime, and cullet, that is heated in a pot or tank to make glass.

**BLOWPIPE**
An iron or steel tube, usually about 150 to 170 centimeters long, for blowing glass.

**CAGE FLASK**
A perfume or kohl bottle surrounded by a hot-worked trailed cage and resting on the back of a zoomorphic figure. Widely produced in the Syrian region in the early Islamic period, it is sometimes called a "horse balsamarium," "dromedary flask," or "animalistic vase."

**CAMEO GLASS**
In the Islamic world, glass of one color covered with a layer of a contrasting color and subsequently relief cut.

**CERUSSITE**
Lead carbonate occurring in colorless white or yellow transparent crystals.

**CLAW BEAKER**
A beaker decorated with claw- or trunklike protrusions made by applying blobs of hot glass that melted the parts of the walls to which they were attached.

**CLINOCHLORE**
A mineral, usually of green color, of the chlorite group consisting of magnesium aluminum silicate.

**CRIZZLING**
A chemical instability in glass caused by an imbalance in the ingredients of the batch, resulting in an attack by moisture that produces a network of cracks on the surface.

**CULLET**
Raw glass or pieces of broken glass from a cooled melt. Also, scrap glass intended for recycling.

**CUPPING GLASS**
In the Islamic world, a small cup with a long curved pipe attached to the walls in which a partial vacuum is created by sucking out the air through the pipe. It was used in medicine for bloodletting.

**DIP MOLD**
A cylindrical, one-piece mold that is open at the top so that the parison can be dipped into it and then inflated.

**ENAMEL**
A vitreous substance made of finely powdered glass colored with metallic oxide and suspended in an oily medium for application with a brush or a stylus and subsequently fired.

**ENGRAVING**
The process of cutting into the surface of a finished glass object either by holding it against a rotating metal wheel or by scratching it with a hard-stone point.

**FACET CUTTING**
The process of grinding and polishing an object to give the surface a pattern of planes or facets, often resulting in the so-called honeycomb pattern in the Islamic world.

**FLUX**
A substance that facilitates fusion by lowering the fusion temperature. Potash and soda, both alkalis, are fluxes.

**FREE-BLOWN GLASS**
Glassware shaped solely by inflation with a blowpipe and manipulation with tools.

**GATHER**
A mass of molten glass (sometimes called a gob) collected at the end of the blowpipe, pontil, or gathering iron.

**GLORY HOLE**
A hole in the side of a glass furnace used when reheating glass that is being fashioned or decorated.

**HOOKAH**
(Arabic, *ḥuqqa*). A water pipe, the base of which is a bell-shaped or globular bottle. The smoke passes through the water-filled bottle before the smoker inhales it.

**INTAGLIO**
(Italian, "engraving"). A method of engraving whereby the decoration is cut into the object and lies below the surface plane.

**IRIDESCENCE**
The rainbowlike effect on the glass surface caused by the effects of light reflected from several layers of weathering, usually due to prolonged burial.

**KICK**
A concavity at the base of a vessel created by pushing with a tool, usually the pontil. A kick strengthens the bottom of a vessel.

**KOHL**
A preparation, usually with antimony as the basic ingredient, used to darken the edges of the eyelids.

**LIME**
Calcined limestone that gives stability to the batch when added in small quantities.

**LUSTER-PAINTED GLASS**
See "Stained Glass."

**MARVER**
A smooth, flat surface over which softened glass is rolled on order to smooth it or to consolidate applied decoration.

**MARVERED GLASS**
In the Islamic world, a term commonly used to describe dark-colored glass with applied opaque white trails subsequently pushed into the glass by rolling the object against the marver. The trails are often manipulated with a pointed tool to create a festooned effect on the surface. It is better described as "glass with marvered trails."

**MILLEFIORI**
(Italian, "a thousand flowers"). Objects made from preformed, multicolored, sliced glass canes placed in a mold or wrapped around a core and heated until they fuse. The technique is also known as mosaic glass.

MOLAR FLASK
A small bottle standing on short feet resembling the roots of a tooth. The feet and the decoration of molar flasks are usually created by wheel cutting.

MOLD
A form used for shaping and/or decorating molten glass.

MOLD BLOWING
Inflating a parison of hot glass in a mold.

MOSQUE LAMP
In the Islamic world, a lighting device in the shape of a globular vase with a wide, flared, and tall opening, a splayed foot, and three or six applied loops from which it was suspended by chains. The best-known, true mosque lamps, decorated with enamel and gilt, were created in Egypt and Syria in the thirteenth and fourteenth centuries; similar objects without decoration were also used for secular purposes. Sometimes a glass tube is attached to the bottom to secure the wick. In enameled and gilded mosque lamps, a small saucer containing oil, water, and the wick was suspended by short chains in the center of the vessel.

NATRON
Sodium sesquicarbonate, originally obtained from Wadi al-Natrun, northwest of Cairo. It was commonly used by Roman and early Islamic glassmakers as the alkali constituent of the batch.

NIELLO
Any of several metallic alloys of sulfur with silver, copper, or lead having a blackish color. Also, the process of decorating metal with incised designs filled with niello.

OMPHALOS PATTERN
(Greek, "navel"). A circular or oval design with a raised boss in the center created by cutting or molding.

ORPIMENT
A yellowish or orange mineral consisting of arsenic trisulfide.

PARISON
A gather of glass on the end of the blowpipe that is already partly inflated.

PILGRIM FLASK
A bottle with flat sides with a ring or loop on either side of the neck for the insertion of cords by which it may be suspended.

PIRIFORM
Pear-shaped.

PLANT ASH
In the Islamic world, an alkali used as a flux obtained by burning desert plants, in particular *ushnān,* or the soda plant (*Salsola kali*).

PONTIL
Also called punty, a solid metal rod applied to the base of a vessel to hold it during manipulation after the blowpipe is cut off at the opposite end. The use of the pontil became widespread in the early Islamic period.

PONTIL MARK
The irregular ring-shaped scar left under the base when the pontil is removed.

PRUNT
A small blob of glass applied to the surface of a glass object, usually as decoration.

*QUMQUM*
(Arabic). A sprinkler with a tall narrow neck, a pinprick-size opening, and a compressed body. Also known as *omom,* following its Egyptian pronunciation.

RELIEF CUT
A type of cut glass with decoration in high relief, made by removing the background.

RHYTON
A drinking vessel used in the ancient world. In glass, the rhyton usually takes the form of a horn with a perforated tip used to pour liquid directly in the mouth. Zoomorphic and anthropomorphic glass rhytons are also known in the Islamic world.

*SENMURV*
A fantastic composite animal—part bird, part feline, part canine—that has played a prominent role in Iranian iconography since Antiquity.

SGRAFFITO
Decoration achieved by scratching away parts of the surface to create a different colored ground.

SILICA
The mineral silicon dioxide, one of the essential ingredients of glass. The most common form of silica has always been sand.

*SĪMURGH*
(Persian, "thirty birds"). A fantastic bird, often compared to the phoenix, usually of good omen. It appears in several literary works from medieval Iran.

SODA
Sodium carbonate, commonly used as the alkali ingredient of glass. It serves as a flux to reduce the fusion point of the silica when the batch is melted. In the Islamic world, natron as well as plant ash were used for this purpose.

SODA-LIME-SILICA GLASS
The most common form of glass, including virtually all Islamic production. The average content of the three ingredients is about 60 to 75 percent silica, 12 to 18 percent soda, and 5 to 12 percent lime.

STAINED GLASS
Usually referred to as "luster-painted glass." A lustrous yellow, brown, or reddish stain is made by painting the glass with silver or copper sulfides and firing it at a relatively low temperature. The ions are absorbed within the molecular structure of the glass to permanently stain the object.

TAZZA
(Italian, "cup"). A dish or cup on a stemmed foot.

*ȚIRĀZ*
(Persian, "embroidery"). Generally textiles bearing decorative bands with calligraphy produced in state-controlled factories in the Islamic world.

TRAILING
The process of applying trails, or strands, of glass as decoration on the body of a vessel when they are hot and softened.

TRICK GLASS
A vessel, usually a beaker, designed to be as difficult as possible to drink from without spilling the contents.

WASTER
A defective object discarded during manufacture, routinely recycled as cullet.

WEATHERING
Changes and progressive disintegration of the surface of the glass caused by chemical reaction with the environment, due, for example, to moisture in the soil during burial of archaeological material. Weathering can assume different forms, including the formation of a milky white film, a thin brown coating, a thick crust, and iridescence.

WHEEL CUTTING
A process of decorating the surface of glass by the grinding action of a wheel using discs of various materials and dimensions and a greasy abrasive applied to the wheel. The object is held by the decorator against the underside of the rotating wheel.

NOTE
This glossary, which is not intended to be exhaustive, has been compiled using the following sources: *EI²*; Newman 1987; Philip Babcock Gove, ed. *Webster's Third New International Dictionary of the English Language Unabridged.* Springfield, Mass., 1986; and Whitehouse 1993.

# INDEX